CITY OF GOLD

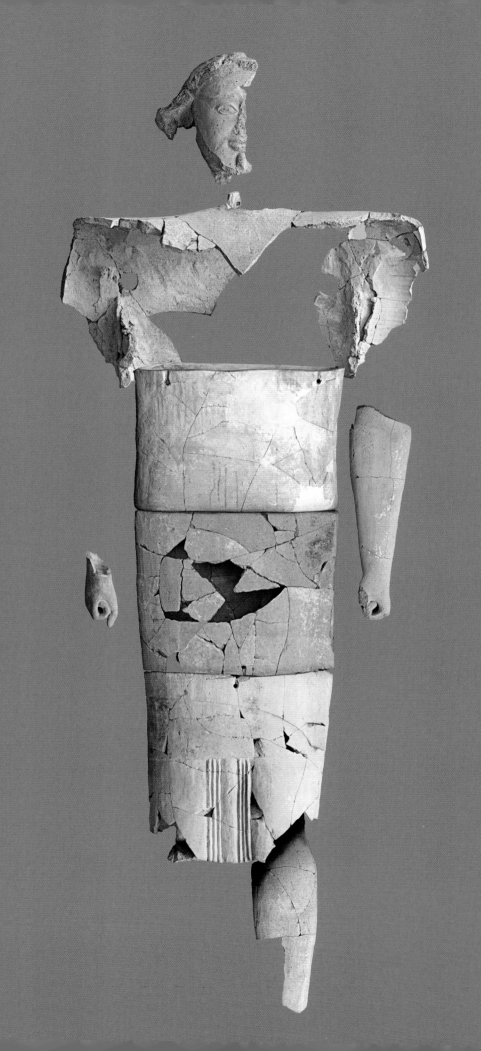

CITY OF GOLD

The Archaeology of Polis Chrysochous, Cyprus

EDITED BY

William A. P. Childs, Joanna S. Smith,
and J. Michael Padgett

ESSAYS BY William Caraher, William A. P. Childs, Tina Najbjerg, Amy Papalexandrou,
Nancy Serwint, Joanna S. Smith, and Mary Grace Weir

CATALOGUE ENTRIES BY Anastassios C. Antonaras, William A. P. Childs, Olga Karagiorgou, Thomas Kiely,
Kyle L. Killian, Sarah Lepinski, R. Scott Moore, Tina Najbjerg, Brandon R. Olson, J. Michael Padgett,
Amy Papalexandrou, Nassos Papalexandrou, Maria G. Parani, Eustathios Raptou, Nancy Serwint,
Joanna S. Smith, Alan M. Stahl, Kristina Winther-Jacobsen, and Eftychia Zachariou-Kaila

Princeton University Art Museum
Distributed by Yale University Press, New Haven and London

City of Gold: The Archaeology of Polis Chrysochous, Cyprus
is published by the Princeton University Art Museum
and distributed by Yale University Press.

Princeton University Art Museum
Princeton, New Jersey 08544-1018
artmuseum.princeton.edu

Yale University Press
P.O. Box 209040
302 Temple Street
New Haven, CT
06520-9040
www.yalebooks.com/art

This book is published on the occasion of the exhibition *City of Gold:
Tomb and Temple in Ancient Cyprus*, on view at the Princeton University
Art Museum from October 20, 2012, through January 20, 2013.

City of Gold: Tomb and Temple in Ancient Cyprus has been made possible
by major support from the A. G. Leventis Foundation, an anonymous
donor, and by the Department of Art and Archaeology and the Stanley J.
Seeger, Class of 1952, Center for Hellenic Studies at Princeton
University. Additional support has been provided by the Leon Levy
Foundation; Hicham and Dina Aboutaam; Jonathan and Jeannette
Rosen; Frederick Schultz Jr., Class of 1976; Michael and Judy
Steinhardt; the Allen R. Adler, Class of 1967, Exhibitions Fund; Ross and
Carol Brownson; Mr. and Mrs. Edward Boshell Jr.; and Donna and Hans
Sternberg, Class of 1957. The publication has been made possible by the
Barr Ferree Publications Fund, Princeton University, and by Annette
Merle-Smith. Further support has been provided by the Partners and
Friends of the Princeton University Art Museum.

Project Manager: Anna Brouwer
Copy Editor: Sharon Herson
Designer: Miko McGinty Inc.
Typesetter: Tina Henderson
Indexer: Kathleen Friello
Proofreaders: Dianne Woo and Laura Santiago
Prepress: Professional Graphics Inc.
Printer: Graphicom SrL, Vicenza

Library of Congress Control Number: 2012941003
ISBN: 978-0-300-17439-7

Front cover illustration
Cypriot, from Polis-Maratheri, late 6th century B.C.E.: male head from a
colossal statue, Egyptianizing in style. See cat. no. 71.

Back cover illustration
Mint of Constantinople, found in Polis, east of the hospital, 430–440 C.E.,
reign of Emperor Theodosius II: Roman Solidus, reverse, with a
personification of Constantinople. See cat. no. 95.

Frontispiece
Cypriot, from Polis-Maratheri, late 6th century B.C.E.: male colossal
statue reconstruction, Egyptianizing in style. Found by Princeton in
Area A.H9, in 1984 and 1985. Terracotta; reconstructed h. nearly 3 m.
Polis Chrysochous, Local Museum of Marion and Arsinoe (Princeton
Cyprus Expedition R496/TC5 et al.). See cat. no. 71.

The book was typeset in Chronicle, Topaz, and Whitney and printed
on Scheufelen PhoeniXmotion Xantur.

Printed and bound in Italy
10 9 8 7 6 5 4 3 2 1

In memory of Professor Erik Sjöqvist (1903–1975),
member of the Swedish Cyprus Expedition (1927–1931) and
Professor of Art and Archaeology, Princeton University (1951–1969)

Contents

Foreword

City of Gold: Tomb and Temple in Ancient Cyprus, organized by the Princeton University Art Museum, is the first exhibition of Cypriot antiquities dedicated exclusively to Polis Chrysochous. It focuses on the archaeological research of the area with the aim of presenting its topographical and historical evolution, together with examples of artistic production during the ancient and medieval periods.

The choice of this moment for the organization of the exhibition is particularly pertinent as the Republic of Cyprus undertakes the presidency of the Council of the European Union, and it is deemed especially significant for promoting Cyprus to a wider international audience. The Department of Antiquities has fully supported the idea from its inception, facilitating researchers whilst reinforcing the exhibition by providing hitherto unpublished items from recent excavations, thus giving the public a more complete insight into ongoing archaeological research in the area.

It is well known that Polis tis Chrysochous, situated on the northwest coast of Cyprus, covers the ruins of two ancient cities, Marion and Arsinoe. Marion was the seat of a kingdom of ancient Cyprus and one of the most important cities on the island. Its position in the center of a fertile plain and its proximity to the copper deposits of the mountainous hinterland created optimal conditions for the development of an economically strong city with an extended commercial network that encompassed the Aegean, Ionia, and Athens. The city's zenith is recorded during the Archaic and, mainly, Classical periods, as demonstrated by the impressive wealth found inside tombs. This is the epoch that fully justifies the title *City of Gold*. The development of artistic production at Marion during the Classical period is evidenced by the assimilation of Greek Classical art, making it a unique Cypriot cultural phenomenon, further justifying Marion's characterization by ancient authors as Μάριον Ελληνίς (Greek Marion).

The abolition of the Cypriot kingdoms at the start of the Hellenistic period and the incorporation of Cyprus into the kingdom of the Ptolemies transformed it from the capital of a kingdom to a regional city. The historian Diodorus reported that Marion was destroyed at the end of the fourth century B.C.E. It was re-established a generation later by Ptolemy II Philadelphos and named Arsinoe in honor of his wife. The new city, though lacking the splendor of Marion, remained the most significant urban and economic center in the area, continuing into the Roman, Byzantine, and Frankish periods, during which it became the seat of the ecclesiastical diocese and was adorned with important Christian monuments.

The archaeological wealth of the region attracted both amateur and scientific activities from as early as the nineteenth century, when archaeological interest in the island began. Since the establishment of the Department of Antiquities of Cyprus in 1934, we have tried to protect the cultural inheritance by describing the whole area of Polis Chrysochous as an "Ancient Monument." The role of the Department of Antiquities, however, has been limited to rescue excavations to salvage antiquities in areas threatened by development or construction projects.

The undertaking of systematic excavations by Princeton University, under the direction of Professor W. A. P. Childs, with the encouragement and cooperation of the Department of Antiquities, has constituted an important achievement in the archaeological research of the area. The long-standing activity of the Princeton University mission, the scientific acumen of its members, and the accurate publications of their finds have revealed these two ancient cities, recording their course for more than two thousand years through impressive visible monuments in situ.

Maria Hadjicosti
Director, Department of Antiquities, Cyprus

Director's Foreword

Princeton University has long been a leader in Classical archaeology, the principles of which have been taught and put into practice by generations of teachers and students from their inception in the late nineteenth century. The legendary Syrian expeditions (1899–1909) of Howard Crosby Butler, Class of 1892, were followed by excavations in Turkey at Sardis (1910–14 and 1922) and Antioch-on-the-Orontes (1932–39), and at the Sicilian site of Morgantina (1957–75). Since 1983, the Princeton Cyprus Expedition to Polis Chrysochous has continued this honored tradition, greatly expanding our understanding of the ancient world while offering dozens of students from Princeton and around the world their first experience of archaeological fieldwork. Under the direction of Professor Emeritus William A. P. Childs, the excavations at Polis—as it is more familiarly known—have revealed extensive remains of the ancient city of Marion and its successor city, Arsinoe, including sanctuaries, public buildings, workshops, and private residences spanning the millennia from the Early Iron Age to the medieval Crusades. The excavation's discoveries show that these cities had close ties with the Near East from Egypt to Anatolia, and that many of the city's art forms, especially the splendid terracotta sculptures of Marion and the imposing architecture of Arsinoe, drew on artistic ideas from both Greek and Near Eastern sources.

The exhibition *City of Gold: Tomb and Temple in Ancient Cyprus*, curated by Professor Childs, Joanna S. Smith, and J. Michael Padgett, takes its title from the city's modern-day name and is the first devoted exclusively to the history and archaeology of this important site. All of the 110 objects on display were found at Polis, some as early as the nineteenth century, when the cemeteries of Marion and Arsinoe were first excavated. The tombs yielded copious gold jewelry, quantities of imported Greek pottery, and distinctive terracotta sculptures of a size and character found nowhere else on Cyprus. Most splendid of all is a *kouros*, a life-size marble statue of a nude youth, imported to Cyprus in antiquity from one of the Greek islands. Max Ohnefalsch-Richter discovered the statue in 1886 in the *dromos*, or entrance passageway, of a rock-cut tomb, a suggestion of which has been artfully evoked in the exhibition's first gallery.

The exhibition, a visually arresting exploration of a previously little known aspect of ancient civilization, is accompanied by a splendid scholarly volume—*City of Gold: The Archaeology of Polis Chrysochous, Cyprus*. Edited by the curators, it is the first book ever devoted to the archaeology of both Marion and Arsinoe. In addition to essays by Childs, Smith, William Caraher, Tina Najbjerg, Amy Papalexandrou, Nancy Serwint, and Mary Grace Weir, the objects in the exhibition are described and interpreted by nineteen contributors. Almost half of the objects are previously unpublished, and another third are described in detail for the first time. They include miniature, nearly life-size, and colossal figural sculptures in stone and terracotta, along with architectural sculpture, wall painting, gold and silver jewelry, faience, seals, coins, bronzes, and ceramics that represent the changing identities of Polis through the centuries. The publication of detailed site plans reveals for the first time the site's rich architectural history, from sanctuaries and a possible palace structure of the Archaic period to religious and secular structures of the Classical, Hellenistic, Roman, Late Antique, Byzantine, and Crusader periods, including two Christian basilicas.

City of Gold is the result of an enormously positive and fruitful collaboration with three generous lenders, whom it is my pleasure to recognize: the Department of Antiquities of the Republic of Cyprus, under the direction of Maria Hadjicosti; the British Museum, directed by Neil MacGregor; and the Musée du Louvre and its director, Henri Loyrette. Throughout the long planning of the exhibition and publication, the expert advice and cheerful

cooperation of the professional staff of these institutions made the difficult seem simple and, on occasion, the impossible attainable. In an age in which international loans of great works of art are ever more embattled, their generosity and readiness to share these treasures with a wider audience has been exceptional.

In this century, the costs of an ambitious loan exhibition such as *City of Gold* have escalated to a staggering degree, and this project would likely have foundered but for an extraordinarily generous, multiyear commitment of support by the University's Department of Art and Archaeology and its chair, Professor Thomas Leisten— a tribute to a shared history between Museum and Department that dates to 1882 and to the esteem in which Professor Childs is held by his colleagues. The Stanley J. Seeger, Class of 1952, Center for Hellenic Studies, under its director, Dimitri Gondicas, provided major support for the exhibition and also secured a leadership grant from the A. G. Leventis Foundation, to whose director, A. P. Leventis, we are most grateful. Additional funding has been generously provided by Shelby White and the Leon Levy Foundation; Hicham and Dina Aboutaam; Jonathan and Jeannette Rosen; Frederick Schultz Jr., Class of 1976, and the Schultz Family Foundation; Judy and Michael Steinhardt; the Allen R. Adler, Class of 1967, Exhibitions Fund; Ross and Carol Brownson; Mr. and Mrs. Edward Boshell Jr.; Donna and Hans Sternberg, Class of 1957; and an anonymous donor. Production of the accompanying publication has been generously supported by the Barr Ferree Publications Fund, Princeton University, and by Annette Merle-Smith. As always, we are grateful for the ongoing support provided by the Partners and Friends of the Princeton University Art Museum.

City of Gold: Tomb and Temple in Ancient Cyprus arrives at a ripe moment in the history of the Princeton University Art Museum, as we undertake more expansive programming that builds on a rich history of scholarly endeavor, and in an important era in the history of museum-based study of antiquities. Princeton's distinguished collections of antiquities—Classical, Asian, Pre-Columbian—in some cases predate the formal establishment of the Art Museum in 1882 and have been formed more by gift, purchase, and bequest than as the result of archaeological fieldwork. From the dawn of collecting at Princeton in the 1750s, works of art have had a central place in University teaching. Even in the twenty-first century, when ownership of the ancient past, in the form of its surviving works of art, is a contested domain, we remain committed to studying that past through the tools of art history and Classical archaeology, bringing together important exhibitions such as this while also judiciously continuing to grow our collections to the highest standards of cultural property ownership, for the collective benefit of our students, of scholars, and of the wider public.

James Christen Steward
Director

Preface and Acknowledgments

City of Gold, the title of the exhibition and the publication, is a gloss on the modern name of the town in and around which Princeton University conducted archaeological excavations from 1983 to 2007: Polis Chrysochous translates roughly to "city flowing with gold." As Joanna Smith points out in her study of the history of the archaeology of the area, the origin of the name is obscure, though the name itself is many hundreds of years old. There is no known source of gold in the vicinity or any record of one. My own preference is to think that gold is a metaphor for prosperity, since one compelling reading of the town's name is "the city of the valley flowing with gold." Though many of the objects selected for the exhibition are and were precious, the choice was guided by the desire to convey as complete a picture as possible of the ancient remains uncovered by archaeologists at Polis over the past 130 years.

The decision to open an excavation on Cyprus came after the then director of the Department of Antiquities, Vassos Karageorghis, suggested that Princeton continue an old and illustrious connection to the island, begun by Professor Erik Sjöqvist, who was a member of the Swedish Cyprus Expedition between 1927 and 1931 and later a professor at Princeton from 1951 to 1969, and to whose memory this volume is fondly dedicated. Consequently, in the spring of 1980, I looked at a variety of sites with Sophocles Hadjisavvas as my guide. Interest quickly settled on Polis tis Khrysokhou, as the town was then known, since all published accounts of archaeological work there were uniquely focused on its rich cemeteries without any but the most cursory mention of the place where so many prosperous people had lived. A survey of the area around the town of Polis in 1983 with Dr. Kenneth Hamma, then of the University of Southern California, and graduate students, including Nancy Serwint, led to a series of trial trenches of 1 x 1.5 meters on the basis of which excavation began in 1984.

Marion was the name of the first ancient city in the region of modern Polis. After it was sacked in 312 B.C.E., a new city, Arsinoe, was founded in the 270s that lasted well into the medieval period, as the following essays document. The earliest excavators of antiquities on Cyprus in the late nineteenth century were faced with a huge body of heretofore unknown material that posed an intellectual issue still unresolved. This is well illustrated by a comment on the ancient material recovered from around Polis in a guide to the island written in 1907:

> The objects of native make which the soil of Cyprus has yielded to the explorers are curious and historically valuable. But if we except some dainty bits of gold work, a few coins, and some exquisitely iridised [*sic*] glass, they are not beautiful. The vases are clumsy and monotonous in form, and the principle of decoration generally wrong. The statues are faulty in proportion, and the expression of the face is either dull or frankly comic. The influence of Egypt, Assyria, and Phoenicia is everywhere present; but for a single spark of originality, or of inspiration caught from the living model, or from Greek art, we may look in vain. The products of Greek art, imported into the island, have not been found in abundance. A certain number of fine examples, mostly consisting of vases and other small objects, have been discovered, especially at Polis-tes-Chrysochou, but of larger sculpture almost nothing (Hutchinson and Cobham 1907, 53).

Not until the Swedish Cyprus Expedition began extensive and well-documented excavations in the late 1920s

could a comprehensive study of native Cypriot art begin; the publication volumes laid out detailed typologies for all manner of Cypriot objects and architecture but did not try to treat the inherent clash of the Cypriot forms with those that had been admired for centuries from the Graeco-Roman world. The evidence is clear that the Cypriots prized the objects they imported from the Greek world and deposited them in their tombs. Nonetheless, it is equally clear that the abstractions and radical simplifications of the local traditions were not abandoned: Cypriot art is not a provincial reflection of Hellenism or, for that matter, of the art of the ancient Near East. It is an independent vision of the world that is striking in its forceful expression of those elements of the visual world that were considered worthy of record for which, I suspect, the contemporary world has a great deal more sympathy than had the authors of the guidebook quoted above. It is true that the forms of Greek art gradually altered the local Cypriot forms and eventually almost replaced them, but it is also evident on closer inspection that a distinctive Cypriot sense of form is preserved well into the Hellenistic period. The material recovered from ancient Marion and Arsinoe in the excavations of the last 130 years well illustrates the complexity and originality of ancient Cypriot culture.

The active excavations by Princeton University lasted from 1983 to 2007; this period was followed by a series of study seasons to prepare the final publication. Study will continue for a number of years to come; this book represents a preliminary assessment of the site and its remains.

The excavations owe warm acknowledgment to many people for the active support that they have given the enterprise. There are too many individuals to list them all, but those whose contribution arose through official position or professional specialty deserve mention here. We are particularly grateful to the directors of the Department of Antiquities, Cyprus—Vassos Karageorghis, Athanasios Papageorghiou, Michaelis Loulloupis, Demos Christou, Sophocles Hadjisavvas, Pavlos Flourentzos, and Maria Hadjicosti—for their constant support and help. In the planning of the exhibition and its final preparation, special thanks are due to Despina Pilides, curator of antiquities, and to archaeologist-museologist Nikolas Papadimitriou. Thanks are also due to George Masouras, Chrysanthos Chrysanthou, and Maria Hadjinikolaou of the Cyprus Museum and Peter Ashdjian of the Pierides Museum. The regional directors of the Paphos district, Dimitris Michaelides, Sophocles Sophocleous, Yiannis Ionas, and Eustathios Raptou, and their associates in the Paphos District Museum, Takis Herodotou, Neoptolemos Neoptolemou, and Elena Meranou, endured the at times chaotic end-of-season logistics and offered unparalleled assistance. We thank Dora Matar, director of the Local Museum of Marion and Arsinoe in Polis since 2008, who materially aided preparation of the exhibition, and the always able Andreas Symeonides, who even in his younger days worked on the excavations. Finally and most importantly, we offer heartfelt thanks to our excavation foreman from 1985 to the present, Alexandros Koupparis, whose efforts on a daily basis kept the work on track and who became a major aid in planning.

The project has benefited from the talents of many excellent conservators; most recently, Christoph von Bieberstein, Ressortleiter Konservierung, Erziehungsdirektion des Kantons Bern, Amt für Kultur Archäologischer Dienst, Bern, Switzerland, who set up the system that has been used since he began in 1994, and who was joined later by his wife, Aurélie; since 1998, they have sent us their advanced students from Germany, France, and Switzerland to carry on the work they began. Nancy Corbin served for many years as an excellent and resilient registrar of the vast numbers of finds. We are indebted to architects David Bylund, Nora Laos, Charles Nicklies, Chris Panfil, Veronica Conkling, Kelley des Roches, Elise Chassé, and Krista Ziemba for their tireless work in the field and for meticulous drawings, plans, and sections, done almost always with good humor despite the often outrageous demands placed on them by the whole team.

Others stand out who do not fit into either the official or the professional category in having provided significant assistance to the excavations. In the early days of the excavation, the Brown Foundation contributed desperately needed funds to buy our first theodolite and our beloved 1968 Land Rover 109. In Polis, it was Taxis Stavrou who in 1983, in the main square of town, was the first to sign a permit for us to dig on his land. The then mayor of the town was Pavlos Serafides, who actively supported the nascent expedition. In 2006, Andreas Stephanou arranged for a helicopter belonging to the Cypriot National Police to take an aerial photographic record of the excavations as completed.

The success of an archaeological expedition has one clear and fundamental foundation: the people who keep the scholars and students in the field. In this regard, Georgios Constantinou and his successor, Kostas Sophocleous, kept the dig house and its surroundings in perfect functioning order, and our numerous cooks over the years treated us to first-rate cuisine: Theodora Stefanidi, Elli Antoniou, Miriathe Reno and her daughter Angela Gagaï, Agni Dionysiou, and Eirene Kyriakou.

After almost thirty years, the expedition has found many friends and incurred innumerable debts to the people of Polis and the Chrysochou Valley. It was the boys and girls of the town and valley who did the hard work of digging and washing pottery six days a week for weeks on end; they numbered in the hundreds, and I thank them all as a vast group. It was their parents who made the logistics of the expedition possible. Though I have surely omitted many individuals, the following list is representative, and I beg the forgiveness of those I have unintentionally omitted: Nathanaelis Andreou; Archimandritis Archangelos; Andreas and Katerina Arkofilos; Central Point Café; Papa Joseph Christodoulou; Savvas Christodoulou; Ioannis Constantinides and Georgios Koliaros; Stephanos Constantinides; Simon Constantinou; Kostas Dionysiou; Eleni, Leontios, and Androula Georgiou; Andreas Hadjigeorghiou; Christaki Karouzis; Ruth Kishishian (Moufflon Bookstore, Lefkosia); Kypros and Andreas Kissonergis (Consolidated Construction Company, Lefkosia); George Koumbaris; Maria, Theodora, Marianna, Michaelina, and Andreas Koupparis; Helen Loizou; Simon Moustakalli; Vathoula Moustoukki (CAARI, Lefkosia); Andreas and Georgios Odysseas; Andros, Angelos, Anthoulis, and Savvas Paraskevas; Andreas and Yiannis Petrides; Dr. Georgios Petrou; Artemis Prodromou; Christakis Psaropoulos; Chris Roussot; Pavlos Savva; Bambos Silas; Skevi Simeonidou; Socrates Socratous; Androula and Chris Spiritis; Petros Stavrou; Christos Yakovou (Paphos Photography Shop).

On a very different tack is recognition of the people who have made the exhibition and publication a reality. The hard work and total dedication of Joanna Smith and Michael Padgett have guided both projects at every step; to them I owe a personal as well as an institutional debt of gratitude. Along the way, the project has had the enthusiastic support of Thomas Leisten, chair of the Department of Art and Archaeology, and of James Steward, director of the Princeton University Art Museum. Dimitri Gondicas, director of the Center for Hellenic Studies, offered strong support and advice, as did the Leventis Foundation's Charalambos Bakirtzis. I join James Steward in thanking the lenders to the exhibition, who from the beginning understood the importance of this project and lent it their unstinting support. In addition to our colleagues in Cyprus, mentioned above, we are indebted to Lesley Fitton, Thomas Kiely, Judith Swaddling, Trevor Coughlin, and Philip Attwood at the British Museum, London; and to Béatrice André-Salvini and Elisabeth Fontan at the Musée du Louvre, Paris. We would also like to acknowledge the Medelhavsmuseet in Stockholm, Sweden, especially Kristian Göransson, Frederik Helander, and Ove Kaneberg, for help with photographs of the Swedish Cyprus Expedition.

The catalogue was beautifully designed by Miko McGinty and Rita Jules, while the entire publication project was skillfully managed by assistant editor Anna Brouwer. Copyediting was attended to by Sharon Herson with her usual attention to detail. The index is the work of Kathleen Friello, while proofreading was ably provided by Dianne Woo and Laura Santiago. The catalogue was printed in Italy by Graphicom under the direction of Claudia Fuchs and Roberto Piva. Patrick Goley and his team at Professional Graphics expertly processed the images for the book supplied by Jeffrey Evans, the Museum's talented imaging specialist, who handled hundreds of images for both the exhibition and the publication.

The success of an exhibition on this scale requires the combined efforts of many people. A very special debt is owed to associate registrar Alexia Hughes, who negotiated with patient aplomb the complex loan arrangements and the movement of objects from distant sources. It is with special pleasure that we thank Daniel Kershaw for the stunning exhibition design. The exhibition was installed with skill and efficiency by a team led by Todd Baldwin, under the supervision of Michael Jacobs, manager of exhibition services. The exhibition graphics were produced by Gene Clarici; the copious mount-making was done by David and Mair La Touche, of Benchmark. Caroline Harris, associate director for education and programming, assisted in the preparation of labels, wall texts, and other didactic material and also coordinated a range of associated educational programming. Erin Firestone and Kristina Giassi

provided the publicity for the exhibition. Albert Wise Jr. and Tracy Craig supervised exhibition security; Mike Brew oversaw the budget and expenditures; Craig Hoppock and Edward Murfit supervised the installation of new security cameras in the galleries; Nancy Stout, associate director for institutional advancement, assisted with fundraising; Cathryn Goodwin, manager of collection information and access, coordinated the digital object packages, assisted by Marin Lewis. Janet Strohl-Morgan, associate director for information and technology, oversaw the production of the exhibition video, whose innovative 3-D modeling was the creation of Princeton students in a computer-science class taught by Joanna Smith and Professor Szymon Rusinkiewicz. For work on the original object scans we thank Ian McLaughlin and Mali Skotheim. Szymon Rusinkiewicz assembled the complex model of the Ionic capital used to create its mount in the exhibition. Revisions to the 3-D models were achieved by Nikitas Tampakis. We are grateful for funding from the John S. Latsis Public Benefit Foundation and the Council of the Humanities at Princeton University for work in this class and on this video. The final video was completed with the help of Dave Hopkins, Lance Herrington, Paula Brett, Jill Moraca, and Sorat Tungkasiri.

For the satellite images used for the maps in the catalogue and exhibition, we are grateful to Wangyal Shawa and William Guthe for their advice and support as well as to Andreas Christodoulou, Andreas Demosthenous, and Klito Demetriou of the Department of Lands and Surveys of Cyprus.

Finally, the authors of the essays and the catalogue entries have done a yeoman's job in succinctly composing the texts you are about to read: essay authors William Caraher, Tina Najbjerg, Amy Papalexandrou, Nancy Serwint, Joanna Smith, and Mary Grace Weir; and writers of the catalogue entries Anastassios C. Antonaras, Olga Karagiorgou, Thomas Kiely, Kyle L. Killian, Sarah Lepinski, R. Scott Moore, Tina Najbjerg, Brandon R. Olson, J. Michael Padgett, Amy Papalexandrou, Nassos Papalexandrou, Maria G. Parani, Eustathios Raptou, Nancy Serwint, Joanna S. Smith, Alan M. Stahl, Kristina Winther-Jacobsen, and Eftychia Zachariou-Kaila.

To all who made our work possible, no words of thanks are sufficient.

William A. P. Childs

Notes to the Reader

Each of five essays on the site and its history is followed by a selection of the 110 object entries in the catalogue, which conforms to the arrangement of the exhibition. An entry contains a heading of basic information, followed by a brief summary of the object's condition and a full description and analysis, with notes and selected bibliography. The author's initials appear at the end of the entry (see the list at right). With few exceptions, bibliographic references are in abbreviated form: author and year of publication. The full reference of every work abbreviated in this fashion can be found in the Bibliography. Greek titles are in Greek and not transliterated. There is one list of abbreviations, listing journals and standard reference works, using the system set forth by the *American Journal of Archaeology*, as well as unpublished archival sources. Master Plans of the four principal excavated settlement sites, along with Phase Plans and preliminary reconstructions of the four building phases most featured in the volume, are provided in a section toward the end of the book. Three maps, including one showing the location of excavated sites in the town of Polis, appear toward the front of the book. The spellings of site names retain the form used at the time of the object's initial discovery, as recorded in inventory lists and/or original publications. For example, Necropolis II, excavated by Max Ohnefalsch-Richter, is the same field as Williamson's vineyard, which today is known by the locality name Ambeli tou Englezou. Slight variations in locality names occur over time, as in the case of Evrethades, which today

is known as Evretes. Similarly, the name of the town, Polis Chrysochous, has changed; its older forms, such as Polis tis Khrysochou, are used where appropriate. Throughout the volume, the full name of the Princeton excavations, Princeton University Archaeological Expedition to Polis Chrysochous, is referred to as the Princeton Cyprus Expedition for convenience.

AA	Anastassios C. Antonaras
AMS	Alan M. Stahl
AP	Amy Papalexandrou
BRO	Brandon R. Olson
ER	Eustathios Raptou
EZK	Eftychia Zachariou-Kaila
JMP	J. Michael Padgett
JSS	Joanna S. Smith
KLK	Kyle L. Killian
KWJ	Kristina Winther-Jacobsen
MGP	Maria G. Parani
NP	Nassos Papalexandrou
NS	Nancy Serwint
OK	Olga Karagiorgou
RSM	R. Scott Moore
SL	Sarah Lepinski
TK	Thomas Kiely
TN	Tina Najbjerg
WAPC	William A. P. Childs

Chronology

Chronology of Cyprus		Timeline of Marion, Arsinoe, and Polis Chrysochous
Akrotiri Phase	10,000–9500 B.C.E.	
Aceramic Neolithic	9500–5800/5500 B.C.E.	
Ceramic Neolithic	4900/4500–3900/3700 B.C.E.	
Chalcolithic	3900/3700–2500/2300 B.C.E.	Scattered sherd material Remains dated by carbon 14 as early as ca. 2500 B.C.E.
Early Bronze Age	2500/2300–1950 B.C.E.	Scattered sherds at Petrerades and scattered chamber tombs
Middle Bronze Age	1950–1650 B.C.E.	Scattered sherds at Petrerades and a few more chamber tombs
Late Bronze Age	1650–1050 B.C.E.	First possible settlement remains on Peristeries Plateau; scattered sherds at Petrerades
Geometric Period	1050–800 B.C.E.	Few sherds at Petrerades
I/II	1050–925/900 B.C.E.	More tombs, with concentration of tombs at Evretes Earliest defined settlement remains at Peristeries (Area B.D7)
III	925/900–800 B.C.E.	Earliest possible evidence for exploitation of the Limni copper mine First evidence for votive material on Peristeries Plateau
Archaic Period	800–475 B.C.E.	Many more tombs, larger spread from east to west
I	800–700/650 B.C.E.	First use of Cypriot syllabic in Polis to write Greek First multiroom structure preserved in B.D7 sanctuary
II	700/650–475 B.C.E.	Marion develops a denser urban form, including an expansion of the sanctuary in Area B.D7, the earliest use of the sanctuary in Area A.H9, the "palace" in Areas B.F8 and B.F9, as well as structures in Area B.C6 in Peristeries, and buildings in Areas E.F2 and E.G0 in Petrerades Earliest East Greek import (early 7th cent. B.C.E.) Earliest reference to Marion possibly as Nuria (673/672 B.C.E.) in an inscription of the Assyrian king Esarhaddon Earliest evidence for bronze working in Polis Earliest Attic imports (ca. 580 B.C.E.) Development of Marion jugs with a woman holding a jug or a bull affixed to the shoulder Egyptian imports (second half of the 6th cent. B.C.E.) Achaemenid import (after ca. 520 B.C.E.) Earliest Greek marble sculptural import Possible destruction of Marion ca. 500 B.C.E. during Ionian Revolt (498–497 B.C.E.) A.H9 sanctuary possibly enlarged, B.D7 sanctuary of reduced scale (after 500 B.C.E.)
Classical Period	475–310 B.C.E.	
I	475–400 B.C.E.	King Sasmas (earliest coinage of Marion) (470–450 B.C.E.) Athenian general Kimon on Cyprus (450/449 B.C.E.) Marion concentrates settlement in western part of town, Peristeries abandoned King Stasioikos I (450–late 5th cent. B.C.E.) Funerary stelai of Greek style first appear Large terracotta tomb sculptures first appear
II	400–310 B.C.E.	King Timocharis (early 4th cent. B.C.E.) Increase in quantity of imports of pottery from Athens Some use of Greek alphabet Copper from Marion at Eleusis, Greece, late 4th cent. B.C.E. King Stasioikos II (330–312 B.C.E.) City wall in Area A.H9 built and patched on several occasions in a short span of time after death of Alexander in 323, possibly beginning in 321 B.C.E. Destruction in 312 B.C.E. of Marion by Ptolemy I Soter; population moved to Paphos Deserted harbor mentioned by Pseudo-Skylax (last third of 4th cent. B.C.E.)

Chronology of Cyprus

		Timeline of Marion, Arsinoe, and Polis Chrysochous
Hellenistic Period	**310–58 B.C.E.**	Refoundation of Marion as Arsinoe by Ptolemy II Philadelphos in honor of his sister and wife, Arsinoe II (ca. 270) Greek alphabet used regularly Porticoed building in Area E.G0 with possible military purpose Workshops for terracotta (including figures from New Comedy), metal, and glass manufacture in Area E.F2 and near the current archaeological museum Statue base from Chrysochou recording that Theodoros, general, admiral, and archpriest of the island, was a benefactor of Arsinoe (before 124 B.C.E.) Harbor at Latchi
Roman Period	**58 B.C.E.–330 C.E.**	Arsinoe connected to Nea Paphos and Soloi by Roman road system Greek geographer Strabo mentions a grove of Zeus (1st cent. B.C.E.–1st cent. C.E.) Possible continued use of porticoed building in Area E.G0, continued use of Area E.F2 for workshops, including metallurgy and lamp production
Late Antique Period	**330–750**	Inscription of Sabinos, archbishop, and Photinos, bishop, cosponsors of the construction of a building (mid-5th cent.) Church in Area E.G0 built in 6th cent. Church in Area E.F2 built in mid- to late 6th cent. Church in Area E.F2 at its most elaborate form in 7th cent. Burial areas encroach on E.F2 church after 7th cent.
Byzantine Period	**750–1191**	Final collapse of E.F2 church building (ca. 11th cent.)
Medieval Period	**1191–1571**	A bishop in the 14th-century ecclesiastical court at Arsinoe Lusignan coin hoards in Area E.G0, one after 1369 and another soon after 1398, in area of large building next to church Church in Area E.G0 modified and redecorated more than once, with burials encroaching on more of the church over time Makhairas records a bishopric at Arsinoe in early 15th cent. Church in Area E.G0 still in use in 16th cent.
Ottoman Period	**1571–1878**	Shift of sub-district to Chrysochou Étienne de Lusignan describes the area without mention of Marion or Arsinoe (1573, 1580) Church of Panagia Chrysopolitissa (18th cent.) Name Polis linked with Chrysochou (19th cent.) Ludwig Ross suggests that Polis was Marion (1845) Edmond Duthoit acquires inscription (1862) that confirms Polis as location of Arsinoe, already associated with Polis through the study of ancient authors Possible visit by Luigi Palma di Cesnola (1876?)
British Period	**1878–1960**	Inscriptions purchased by Alessandro di Cesnola acquired by the British Museum (1884) Excavations by Max Ohnefalsch-Richter (1885–86) Observations of Eugen Oberhummer (1887) Cyprus Exploration Fund in Polis (1889–90) Visit by George Jeffrey, Curator of Monuments (1910) Excavations by Menelaos Markides (1916 and 1918) Excavations by Rupert Gunnis (1927) The Swedish Cyprus Expedition in Polis (1929) Department of Antiquities acquisitions and excavations (1936 onward)
Republic of Cyprus	**1960–present**	Cyprus Archaeological Survey by Kyriakos Nicolaou (1960) Survey of the Khrysokhou drainage by J. M. Adovasio et al. (1972–73) Survey centered on Limni by Paul Raber (1980) Princeton Cyprus Expedition (1983–present) Polis-Pyrgos Archaeological Project (Survey, 1992–99) Department of Antiquities excavations by Yiannis Ionas (1995) Department of Antiquities excavations by Eftychia Zachariou-Kaila (1997) Department of Antiquities excavations by Eustathios Raptou (1999–present) Opening of the Local Museum of Marion and Arsinoe (2000)

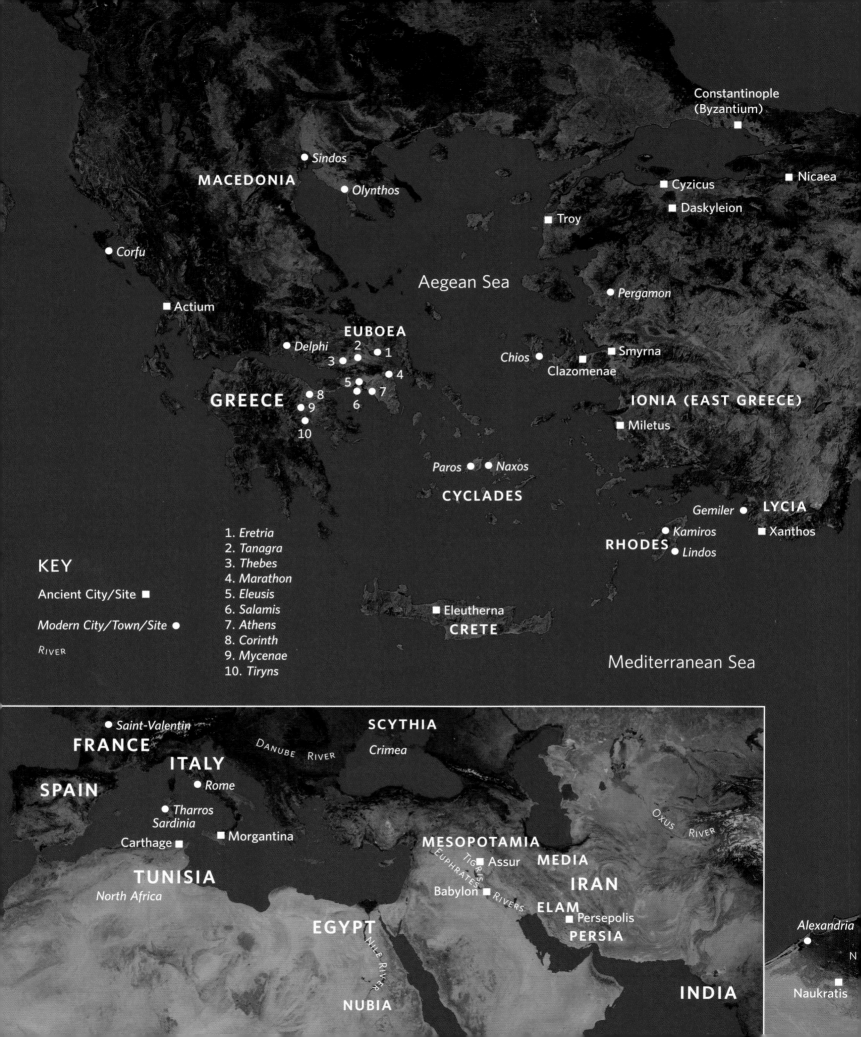

Constantinople
(Byzantium)

Nicaea

MACEDONIA

Sindos

Olynthos

Cyzicus

Daskyleion

Troy

Corfu

Aegean Sea

Pergamon

Actium

EUBOEA

Delphi 2 1

Chios

Smyrna

3 4

Clazomenae

5
7

GREECE 8
9
6

IONIA (EAST GREECE)

Miletus

10

Paros Naxos

CYCLADES

Gemiler LYCIA

Kamiros Xanthos

RHODES Lindos

KEY

1. Eretria
2. Tanagra
3. Thebes
4. Marathon

Ancient City/Site ■

5. Eleusis
6. Salamis

Eleutherna

Modern City/Town/Site ●

7. Athens
8. Corinth

CRETE

RIVER

9. Mycenae
10. Tiryns

Mediterranean Sea

Saint-Valentin

SCYTHIA

FRANCE

DANUBE RIVER

Crimea

ITALY

SPAIN

Rome

Tharros
Sardinia

MESOPOTAMIA

MEDIA

Carthage ■ Morgantina

EUPHRATES TIGRIS Assur IRAN

TUNISIA

North Africa

Babylon RIVERS

ELAM

OXUS RIVER

Alexandria

EGYPT

Persepolis

PERSIA

NILE RIVER

N

NUBIA

INDIA

Naukratis

Maps

TURKEY
(ANATOLIA/ASIA MINOR)

Zeugma ■

■ Alahan ● Tarsus
 CILICIA

■ Ugarit SYRIA

CYPRUS

LEBANON
● Byblos

PHOENICIA

● Tel Anafa

● Tel Dor

● Jerash

● Jerusalem
JUDAH

● Beer-sheba

ELTA

ISRAEL JORDAN

Tell-el Yahudieh

MAP 1. Satellite view of the Eastern
Mediterranean region showing place names
mentioned in the text with an inset of
the Mediterranean and Western Asia.

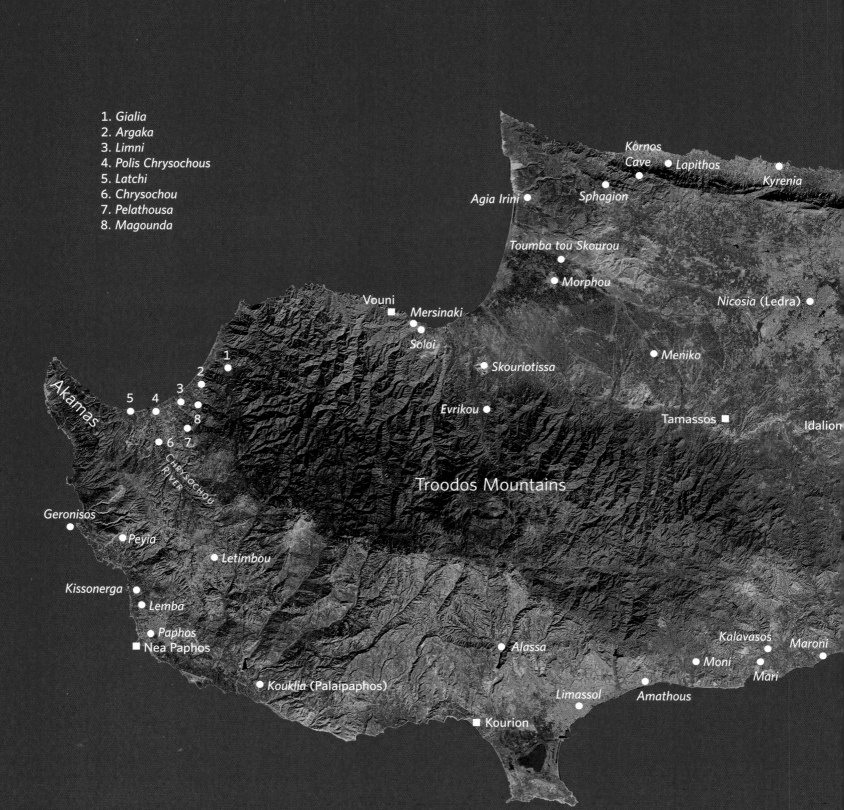

1. *Gialia*
2. *Argaka*
3. *Limni*
4. *Polis Chrysochous*
5. *Latchi*
6. *Chrysochou*
7. *Pelathousa*
8. *Magounda*

Akamas

Kornos Cave
Lapithos
Kyrenia
Agia Irini
Sphagion

Toumba tou Skourou
Morphou

Nicosia (Ledra)

Vouni
Mersinaki
Soloi

Skouriotissa
Meniko

1
2
3
5 4
8
6 7

Evrikou

Tamassos
Idalion

CHRYSOCHOU RIVER

Troodos Mountains

Geronisos

Peyia

Letimbou

Kissonerga
Lemba

Paphos
□ Nea Paphos

Kalavasos
Maroni

Alassa
Moni
Mari

Kouklia (Palaipaphos)

Limassol
Amathous

□ Kourion

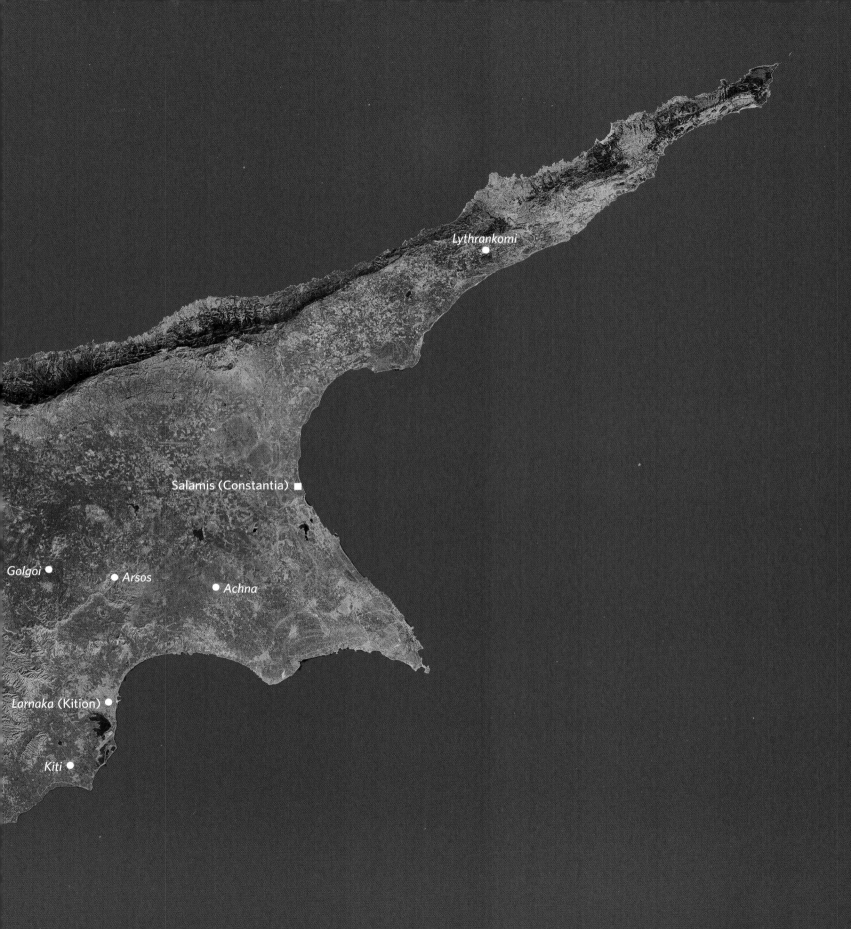

Lythrankomi

Salamis (Constantia) ■

Golgoi ●

● Arsos

● Achna

Larnaka (Kition) ●

Kiti ●

MAP 2. Satellite view of Cyprus showing
place names mentioned in the text.

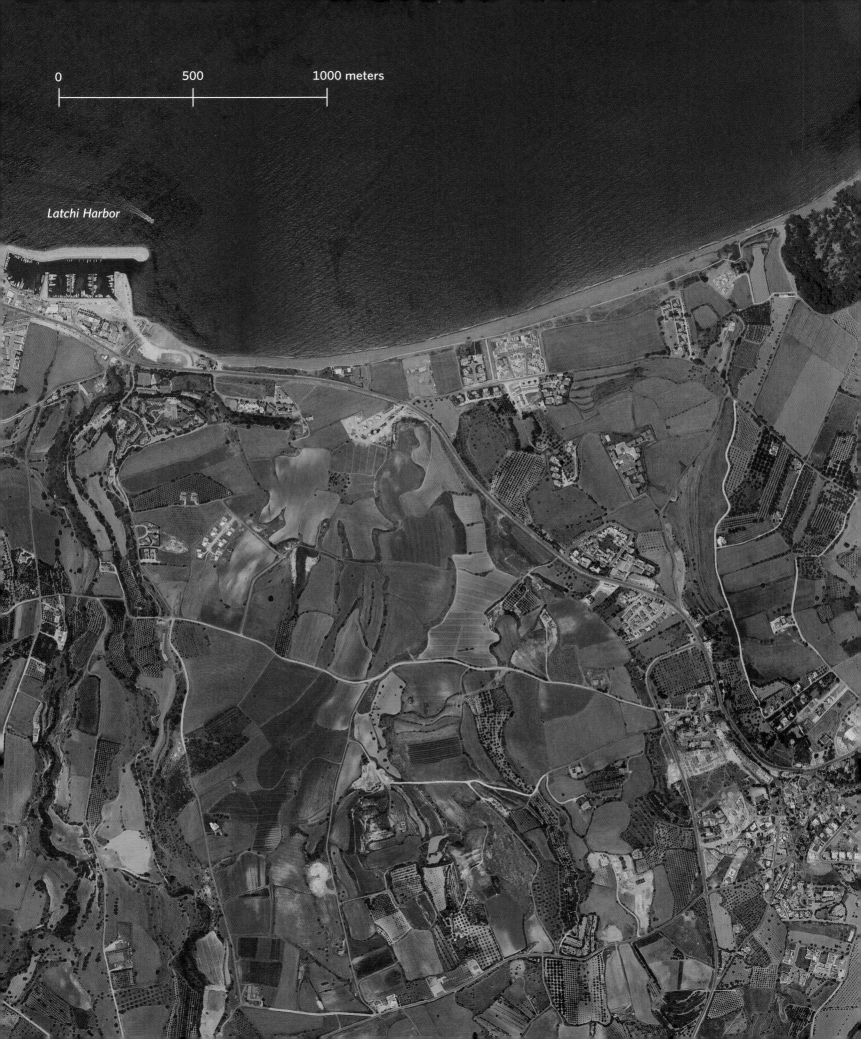

Latchi Harbor

0 500 1000 meters

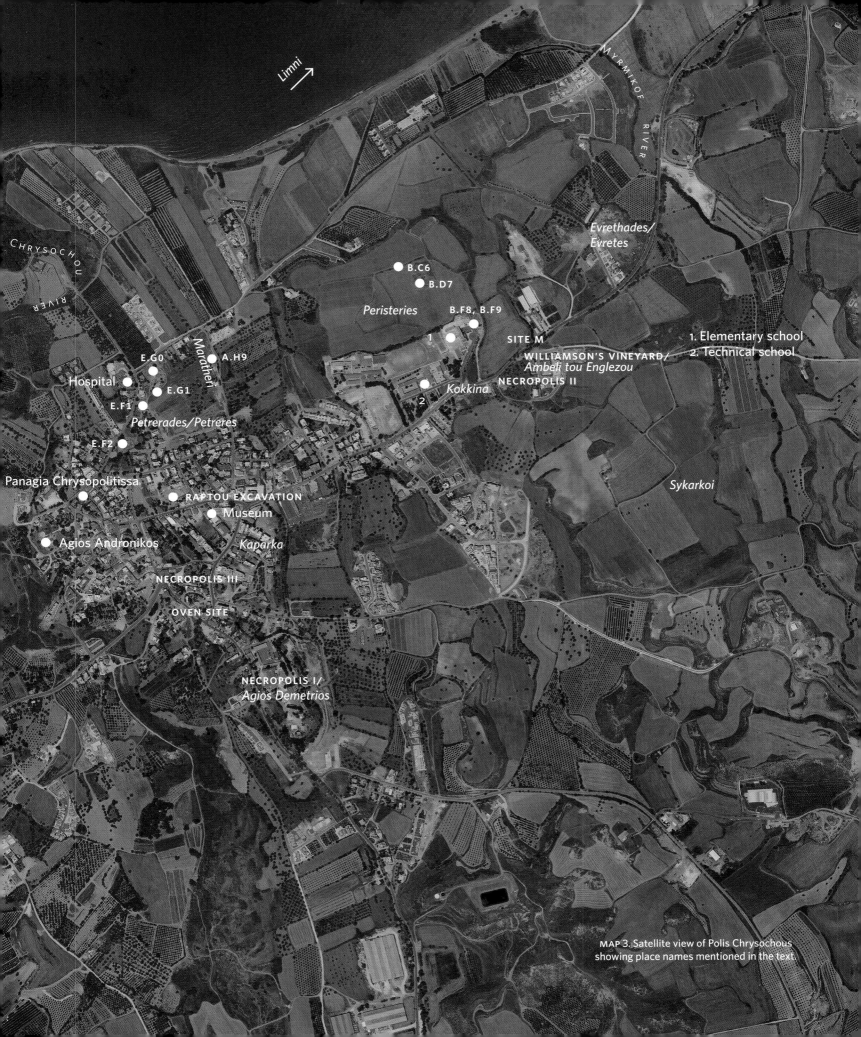

CHRYSOCHOU RIVER

MYRMIKOF RIVER

Limni →

Evrethades/
Evretes

B.C6

B.D7

Peristeries

B.F8, B.F9

1

SITE M

E.G0 A.H9

Hospital Maratheri

E.G1

E.F1

Petrerades/Petreres

E.F2

Panagia Chrysopolitissa

WILLIAMSON'S VINEYARD/
Ambeli tou Englezou
NECROPOLIS II

2 Kokkina

1. Elementary school
2. Technical school

Sykarkoi

RAPTOU EXCAVATION

Museum

Agios Andronikos Kaparka

NECROPOLIS III

OVEN SITE

NECROPOLIS I/
Agios Demetrios

MAP 3. Satellite view of Polis Chrysochous
showing place names mentioned in the text.

I.

HISTORIES OF ARCHAEOLOGY
AT POLIS CHRYSOCHOUS

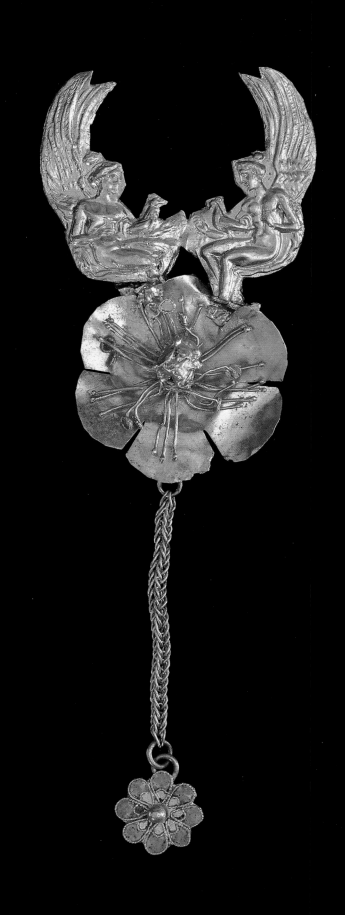

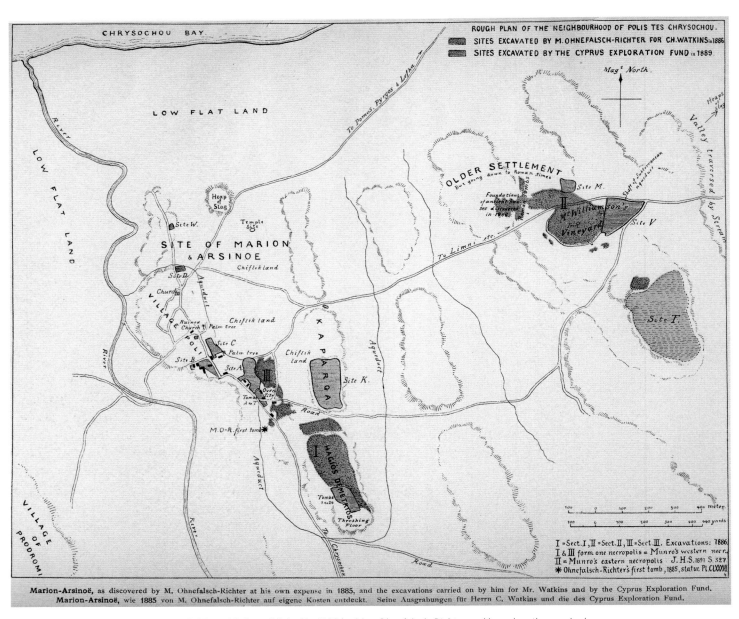

FIGURE 1.0. Map of Polis, published in 1893 by Max Ohnefalsch-Richter and based on the rough plan
originally drawn up by E. A. Gardner and J. A. R. Munro.

HISTORIES OF ARCHAEOLOGY AT POLIS CHRYSOCHOUS

Joanna S. Smith

Material remains are rich and plentiful resources for the study of Cypriot art and history, especially when their discovery is documented in detail.[1] People in Polis have always forged their histories with physical remains—using tombs over several generations, incorporating parts of older structures into new ones, redesigning objects, and encountering antiquities while tilling their fields. However, writing about the remains of the past in Polis, and in Cyprus as a whole, is a practice begun, for the most part, only in the nineteenth century.

Unlike other parts of the island, the well-watered Chrysochou Valley (Maps 2, 3) was a relatively late destination, perhaps as late as 1885, for early archaeologists who sought systematically to unearth antiquities for financial gain. The tombs of the area drew the prospectors, their methods of recording becoming more accurate with each new generation, quickly shifting the chief purpose of excavation from personal profit to the expansion of museum collections. This improved record keeping is what makes it possible to study objects and use evidence from older excavations despite their scientific limitations. Only since the start of the Princeton Cyprus Expedition in 1983 have the ancient settlements, including the Late Antique and medieval cities, been explored systematically.

Ancient authors focus mostly on the political history of ancient Marion and Arsinoe, which lie below modern Polis Chrysochous (see essay II).[2] From the perspective of sailing around the island, the Greek geographer Strabo (1st century B.C.E.–1st century C.E.) mentions a grove of Zeus. The *Stadiasmos Maris Magni*, of the same period, mentions the city's deserted harbor, possibly drawing on a fourth-century B.C.E. text listing the same detail. Ancient inscriptions and coins from Polis (cat. nos. 23, 40–44, 46, 49) mention the names of men and women, professions, or family connections, but not topography. Most inscriptions are on stelai that were purposely buried in tombs instead of being erected for posterity.

It was not until the Ottoman conquest of the island in 1571 that there was a glimmer of antiquarian interest in texts about Cyprus. Writing in Paris, Étienne de Lusignan drew on the work of ancient authors in recounting the legendary connection of the Akamas Peninsula to the west of Polis with Accamantis, a hero of the Trojan war.[3] He describes a ruined harbor west of Polis at Fontana Amorosa, near the modern fishing village of Latchi,[4] as well as the fauna and natural resources of the area, especially gold in the village of Chrysochou, just south of Polis on the Chrysochou River. He locates ancient Marion, however, on the south coast at Mari, east of Amathous, and omits the city of Arsinoe, located in the northwest, citing only cities of the same name in the vicinity of Paphos and Salamis. During the latter years of Lusignan rule in the early fifteenth

FIGURE 1.1. Camel train on the road from Polis to Nicosia, 1929.

century, Polis was still known as Arsinoe, the seat of a bishopric on the island.[5] In the Ottoman period, though, it was Chrysochou rather than Polis that was the main sub-district for the area within the larger district of Paphos.[6]

The oldest church still standing in Polis, built in the middle of the eighteenth century, is named Panagia Chrysopolitissa, Our Golden and Sophisticated Lady.[7] Similarly, by the nineteenth century, the name of the town, Polis, meaning simply "the city," was linked with Chrysochou, and referred to as Polis tis Chrysochou or Polis Chrysochous, City of Gold. While this name may reference gold-bearing soil or a goldsmith at Chrysochou, it more likely reflects the fertility of this beautiful river valley.[8]

Travel by donkey, camel (fig. 1.1), or horse over rough terrain to the northwestern part of Cyprus was a challenge. Ancient Roman roads in the area date as early as the mid-first century B.C.E.,[9] yet by the end of the Ottoman period in 1878, the only road fit for wheeled carriages was that between the capital in Nicosia and the port at Larnaka.[10] In 1889, one British excavator described the route from the capital city of Nicosia: "We bade farewell to civilization, as we turned our mules on the track toward Morphou" and on toward Polis, where "the rough bridle-track runs, or rather crawls, through rugged picturesque country, now skirting the cliffs along the shore, now mounting steeply inland, only to descend with equal abruptness into the next valley."[11] Even in 1929, the Swedish team found travel difficult in their Volvo (fig. 1.2); still, as they arrived from the east, they appreciated the beauty of the valley: "suddenly, from the crest of a hill, the smiling plain of Marion comes into view. To the west, Cape Akamas juts out like the foaming prow of a war galley, while the mountains of Paphos and Troodos form a wooded background. . . . The plain is a delta, formed by numerous small rivers coming down the hills."[12]

Luigi Palma di Cesnola

Bad roads seem not to have deterred the best known of all the early excavators on Cyprus, the American consul, Luigi Palma di Cesnola (1832–1904); he wrote in his book, *Cyprus: Its Ancient Cities, Tombs, and Temples*, that he made a two-day visit to Polis. Possibly this was in 1876.

Awareness that Polis was ancient Arsinoe may have drawn his interest, but, like Lusignan, he still placed Marion on the south coast, only at Maroni rather than at Mari. His prolific excavations around the island, colorfully described but imprecisely documented, might lead one to doubt the accuracy of his account, given that he places Polis on the west bank of the river.[13]

He wrote that there were open rock-cut tombs west of Polis and tombs cut into the earth to the east that contained undecorated pottery, Egyptian amulets and scarabs, and Ptolemaic coins. Yet, he laid no claim to finding anything there himself. In the publication of his collection, no objects are said to be from Polis, even art forms now known to be practically unique to that city, such as jugs with a terracotta figure on the shoulder (see cat. nos. 6–8) and terracotta funerary sculpture (see cat. nos. 2–4).[14]

His account provides the earliest commentary about the extensive quarrying of ancient stones in Polis. He attributed the general lack of antiquities to be found in Polis to "boatmen" who "load their crafts with the hewn stones of the district" as well as "inscriptions and sculptures" and

take them away to the south coast of Turkey.[15] Toward the end of Cesnola's years on Cyprus, a series of inscribed stones that had been found in clandestine excavations in the area of Polis were brought to Paphos, where they were transcribed. They were purchased by Cesnola's brother, Alessandro, then also on the island, and eventually acquired by the British Museum in 1884.[16]

Max Ohnefalsch-Richter, 1885–86

By 1845, Ludwig Ross had already suggested that Marion was located in the northwestern part of Cyprus. By 1891, the weight of the ancient sources led scholars to link Polis not only with Arsinoe but also with Marion.[17] Perhaps the identification of the ancient city-kingdom of Marion, the promise of gold in its modern name, or the knowledge that there were inscriptions and sculptures as reported by Cesnola called Polis to the attention of a young German, Max Ohnefalsch-Richter (1850–1917).[18] He first came to Cyprus as a reporter in 1878, the year that the administration of Cyprus passed from the Ottoman Empire to the British.

FIGURE 1.2. The Swedish Cyprus Expedition's Volvo in the town center of Polis, 1929.

Building on an earlier background in art, history, and language, Ohnefalsch-Richter manifested an interest in archaeology, publishing on the subject within a year of being on Cyprus. By 1883, a year after the establishment of the Cyprus Museum,[19] he was acting as an excavation inspector.

He proposed his initial work in Polis on April 21, 1885, when he requested a permit for one month "in the interest of diggings and Museum" so that he could search for tombs. Contrary to new laws limiting excavators to one site at a time, instituted to stem the tide of tomb looting as in the days of Cesnola, Ohnefalsch-Richter was granted a permit for multiple sites that limited him to four days in each place. He was required to keep a journal and to prepare a catalogue and report. His interest in the finds was based on their value; those worthy of the expense would be sent to Nicosia, while "worthless" pieces would remain in the local village or at the site. He thought it was "desireable" [sic] to "encourage" private individuals to dig, "not to degrade the whole to a commercial speculation" but to "unite" money with archaeology to enrich the "knowledge of art and archaeology."[20] This first short period of excavation in Polis was especially successful in the field owned by Mullah Mehemed in the eastern part of town that later would be labeled as Necropolis (cemetery) II (Map 3).

These brief excavations led to an application later in 1885 by Charles Watkins, director of the Imperial Ottoman Bank on Cyprus, for excavation in Polis in which John W. Williamson, agent for the English-Cyprus Copper Mine Company, and Charles Christian, also of the Imperial Ottoman Bank,[21] were induced to take part. Williamson even put up the money to buy the land owned by Mehemed. For this second venture in Polis, Ohnefalsch-Richter wrote

that his aim was to find vases and jewelry.[22] He fulfilled that aim and more with discoveries such as an Attic white-ground alabastron by the Pasiades Painter (cat. no. 21) in a tomb together with a unique silver ring topped by a gold fly (cat. no. 53).

On February 25, 1886, excavations began with Ernst Foot serving as the government overseer and continued into August.[23] Ohnefalsch-Richter pitched tents that would serve as the main recording area for the excavation (fig. 1.3, left). Each tomb in which objects were found was marked with a post and given a number. "The contents of each grave were laid out separately and . . . a number was attached at once to every object collected." The tombs themselves were measured and drawn. Some objects were drawn in the diary, and selected objects were documented in watercolors and photographs. In all, 441 tombs were opened in three areas, referred to as Necropolis I, II, and III. They declared this archaeological speculation in Polis a success, for the tombs had "yielded abundantly."[24]

In spite of the attention given to groups of objects from the same tomb, a detail even valued by Watkins in the sale of the objects,[25] the tomb locations within each necropolis were not recorded. Find spots of objects within a tomb were usually not recorded either. No overall map of the excavations survives; even in his final publication, Ohnefalsch-Richter relied on the one made by the British excavators who came after him in order to document the locations of the three tomb fields (fig. 1.0).[26] The dispersal of the objects to buyers in several European countries makes it difficult today to locate the contents of each tomb.

Even so, Ohnefalsch-Richter would later emphasize that some had described his work as bringing "order and

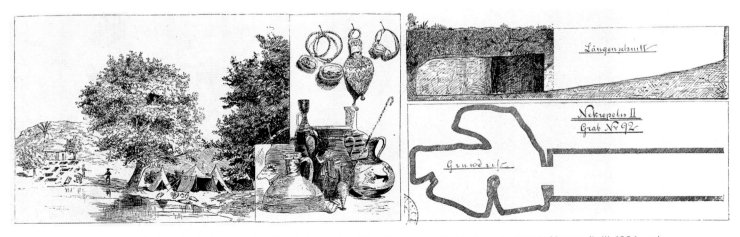

FIGURE 1.3. Left: Drawing by Louis Joutel after photographs of Max Ohnefalsch-Richter's excavations in Necropolis III, 1886, and selected amphorae and jewelry. Right: Plan and section of Necropolis II, Tomb 92.

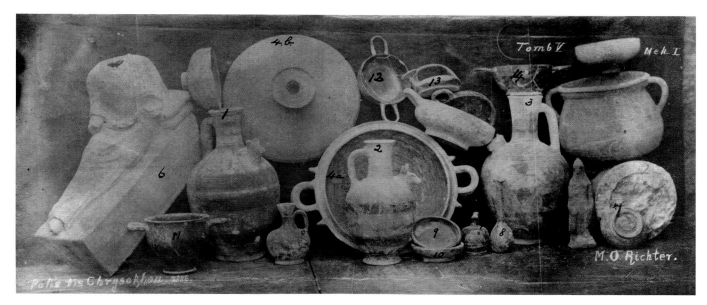

FIGURE 1.4. Objects found in Necropolis I, Tomb 5, at Polis-Agios Demetrios; excavated in 1886 and offered for sale to the British Museum by Max Ohnefalsch-Richter.

arrangement" into Cypriot archaeology,[27] and, in spite of its limitations, he did begin to set a path toward using find locations to understand the meanings of objects for people in the past. For example, he was interested in the dates of tombs as a tool for determining how the ancient city had developed from the seventh century B.C.E. down to the Roman period.

He was also interested in whether sculpture had been used to mark the tombs. He specifies that the marble *kouros* (cat. no. 1) was not found above the tomb but rather in the *dromos*, the long entryway leading to the door of the tomb (fig. 1.3, right). He also notes that the terracotta statuette of a mourning woman (cat. no. 2) was found on the staircase of a dromos.[28] These *dromoi* were probably filled in after the tomb was closed; hence the sculptures were not visible after completion of the funerary rites. Breakage of the sculptures placed in dromoi might have occurred deliberately before burial or as a result of the reopening of a tomb. The broken face of the limestone lion grave stele (cat. no. 23), now reconstructed, could have been part of the same practice.

Ohnefalsch-Richter also made valuable observations about the arts of ancient Marion. He was the first to propose that the tall jugs with women on the shoulder were made there. Based on their discovery in tombs with different kinds of imported pottery from Athens, Greece, he suggested which of these vessels were earlier (see cat. no. 6) and which later (see cat. no. 7). Some recall the detailing of Attic Greek vessels (cat. no. 7) and therefore added

to the considerable interest aroused by the quantities of Greek pottery found in Polis, the first such copious discoveries on Cyprus. Attic drinking vessels (kylixes), one by the Hermaios Painter (cat. no. 45) and another featuring Dionysos (cat. no. 30), as well as other shapes augmented ideas fueled by ancient sources describing Marion as a Greek city (see essay II). In 1990, several unnumbered Attic vases probably from Ohnefalsch-Richter's excavations were unpacked from a box in the Cyprus Museum (cat. no. 36);[29] scholars continue to learn from his discoveries.

Christian corresponded with the British Museum about objects that they would eventually purchase without the intermediary of a dealer (cat. nos. 1, 21, 53).[30] Among objects exported by him[31] some remain whose provenance still confuses the village of Mari with ancient Marion (cat. no. 48). Ohnefalsch-Richter also approached the sale of antiquities by writing letters to institutions such as the British Museum (cat. nos. 1, 21, 45, 53), providing photographs or watercolors of the pieces (fig. 1.4). At first he kept them together in tomb groups, but eventually he grouped them into "Elite" collections by time period or object type[32] to make them more appealing to buyers. While some pieces might have been sold to Cypriot collectors, such as the Pierides family (see cat. no. 3), ultimately Watkins exported most finds. An auction of antiquities from Polis took place in May 1887 in Paris that named Ohnefalsch-Richter as the excavator; its contents had been exported by Watkins and Christian.[33] Items sold there went to museums in Paris (cat. nos. 2, 7), Berlin, Copenhagen,[34] and other cities.

Given the richness of the tombs in Polis, Watkins wished to continue excavating. Christian had bought much land in town for excavation, and objects continued to turn up, for example, in Williamson's vineyard (cat. no. 9).[35] By this time, however, Sir Henry Bulwer had become High Commissioner of Cyprus, and he wanted to put a "stop to all speculative diggings."[36] Privately funded excavations were not having the result so fervently hoped for by Ohnefalsch-Richter; instead, they were thought only to lead to the extensive export and sale of antiquities. Favor, therefore, shifted to institutionally backed excavations,[37] which remains the practice today.

The Cyprus Exploration Fund, 1889–90

On December 7, 1887, Ernest A. Gardner (1862–1939), director of the British School of Archaeology at Athens (BSA), requested permission for a "tour of exploration."[38] This was the beginning of what became known in 1888 as the Cyprus Exploration Fund (CEF), which would acquire antiquities especially for the Ashmolean, Fitzwilliam, and British Museums (see cat. nos. 10, 13, 31, 46, 49, 91).[39] Knowledge of Ohnefalsch-Richter's work through a review by a member of the CEF of its initial summary publication by Paul Herrmann and a visit to Polis by another member sparked the CEF's interest in the place and in the problem of the location of ancient Marion.[40] Gardner requested permission for excavation in January 1889, leaving J. Arthur R. Munro, then a student at the BSA, in charge.[41]

Sophocles Stavrinides was appointed as the government overseer. Permissions were secured from the owners of land, largely with the help of Williamson, who also sold them his excavation rights for a share of the commercial value of the finds.[42] Foreman Gregori Antoniou, who had worked with Ohnefalsch-Richter, set out from Limassol by donkey with the excavation tools, and Munro traveled with Henry A. Tubbs on donkeys from Nicosia to Polis. The excavations ran from February to April.[43]

Although Munro referred to their finds in February as "rubbish," he came to think of Polis as the "best tomb site at present known in Cyprus."[44] They investigated over 200 tombs, 165 of which contained objects they recorded, producing a "rich harvest of the products of the minor arts,"[45] including more Greek painted vessels. In addition to Attic vases, they found a Euboean plate depicting a sphinx and a swan (cat. no. 31). By April, the government held the CEF in such high regard that they were given "first refusal of sites applied for by foreign bodies."[46]

When Munro requested permission for a second season of excavation, his aims were to figure out "the difficult problems in the history of Greek and Cypriote pottery" and to acquire antiquities for museums for "the advancement of the knowledge of ancient art."[47] He and Stavrinides worked in late June and July, the hottest part of the year, opening another eighty tombs.[48] The speed with which communications traveled and the CEF's efficiency in delivering objects to the museum are remarkable given that there still was no post office in Polis.[49]

Munro and Tubbs were both keenly interested in ancient Cypriot writing, noting even the smallest of marks on the bottoms of vessels. For example, a pair of marks on a skyphos (cat. no. 46) is the same as those on other vessels in the same tomb, possibly being an abbreviation of the name of a person buried there. While Munro and Tubbs did not set out to excavate tombs of the Roman period, they recorded what they found, including glass vessels (cat. no. 91), and included them in their publications.

Munro paid more attention to contextual detail than did Ohnefalsch-Richter. On his overall plan of Polis, he plotted the locations of tombs by marking Xs. Munro also took greater note of the location of finds during excavation. Furthermore, he described the condition of tombs, including whether there was more than one use of a tomb. Although his tomb plans still did not include the specific locations of objects, he did describe tomb contents and not just those found in the dromoi.

In the case of Tomb 10 in the locality of Agios Demetrios, where a fine green jasper scarab (cat. no. 61) and a pair of silver bracelets with golden rams' heads (cat. no. 10) were found, he recorded that there were two skeletons, one on either side of the door into the tomb. He took them to be a man and his wife. While the gender of these individuals cannot be confirmed, bracelets of this type were usually worn in pairs by women. In taking note of the skeletal remains, some sketched on tomb plans, Munro showed that he thought of tombs not just as receptacles full of potential museum acquisitions but as the burial places for the people of Marion and Arsinoe.

Munro's comments on the structure and condition of the tombs indicate that within any one tomb there might be several groupings of artifacts from different burial episodes, as well as groupings disturbed in antiquity or the modern period by those moving objects inside or removing objects from the tombs. For Munro, a sign of an unlooted tomb was the presence of precious metal objects. For example, in Tomb 66 "the door was intact, and the stone

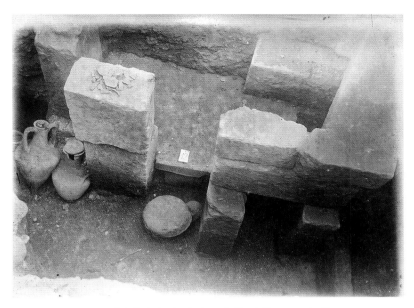

FIGURE 1.5. Finds in situ in Area B, Tomb 12; excavated by
Menelaos Markides in 1916 at Polis-Kaparka.

slabs which closed the bed-niche were all in place."[50] Found here was the gold ring depicting Athena with her owl and shield that might have belonged to someone named Anaxiles (cat. no. 49). In Tomb 67, "on one of the two upright stone slabs that formed the door was painted in purple the Cypriote symbol *sa*. Outside the door were found the fragments of a reclining terracotta figure of the usual type and scale"[51] (compare cat. no. 4). In this tomb was the gold pendant of Erotes together with gold beads, gold star-shaped flowers, and gold rosette-shaped flowers (cat. no. 13).

By 1890, government opinion was beginning to shift yet again. Officials began to question why permissions for the export of antiquities were allowed at all.[52] Attention turned toward the vast number of artifacts that now crammed the new but neglected Cyprus Museum. In 1894, Ohnefalsch-Richter teamed up with John L. Myres, a professor at Oxford and an archaeologist who had also been a member of the CEF. For the first time, they compiled a detailed catalogue attempting a classification of antiquities on Cyprus.[53] Polis had risen from obscurity to become such an important place in the minds of those organizing the museum that of all ancient sites then known on the island, only it had a gallery with its name in the title.

Menelaos Markides, 1916 and 1918

In 1908, there were plans for a new Cyprus Museum, and a new curator of antiquities was appointed, Menelaos Markides (1878–1947), who held a Ph.D. in philology

and taught at the Pancyprian Gymnasium. He took up his post in 1912, after he went to Oxford to study archaeology with Myres, and served until 1931.[54] He was to classify material scientifically to make catalogues of the antiquities in the museum, in the commissioner's office, and elsewhere, including private collections. But from the time he began his job, he dealt with the seizure of objects from illegal excavations in Polis, attempts to purchase gold from the tombs there, and the transfer, especially of stones inscribed in the Cypriot syllabary, to Nicosia. By September 1912, he had begun to plan his own excavations in the town.[55]

Travel conditions were improving; heavy finds could now be sent by mail carriage from Polis to Morphou and then by railway to the museum in Nicosia. The real problem was funding, and it was not until he received private funds from Charles G. Gunther, owner of the Skouriotissa mine,[56] that Markides could begin. He excavated in Polis from October to November 1916, again with Antoniou as his foreman. He returned in May 1918. In total, he opened some sixty tombs. Except for a few objects, especially inscriptions, all these tombs remain unpublished.[57]

Markides referred to Munro's town plan to describe his excavation areas (see fig. 1.0). In his notebooks and reports he recorded details about objects not just by keeping lists but also by showing their associations with tomb architecture and burials. This is the first excavation in Polis for which there are surviving photographs of the tombs. One shows stone sarcophagi, as in his Tomb 12 (fig. 1.5) on the

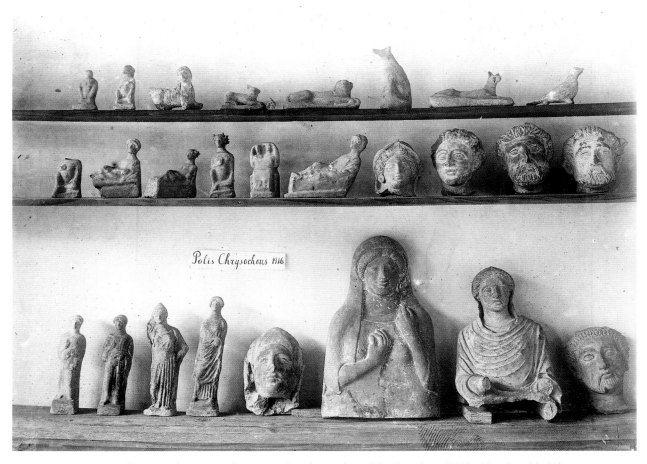

FIGURE 1.6. Terracotta figurines and statuettes found in tombs at Polis-Kaparka in 1916 by Menelaos Markides.

Kaparka hill. This scientific recording is critical for understanding ancient history through material remains. He marked the locations of sarcophagi and objects on some of his drawn and measured tomb plans; these include objects in the dromoi, such as a marble grave stele, and terracotta funerary statuettes and smaller figurines in similar poses (fig. 1.6). He also drew in the skeletons when the remains were preserved and appeared to be in place.

Rupert Gunnis, 1927

Rupert Forbes Gunnis (1899–1965) arrived in Cyprus in 1926 as the "Aide-de-Camp and Private Secretary" for the new governor, Ronald Storrs.[58] Although Gunnis had no formal training in archaeology, he involved himself in the work of the Cyprus Museum soon after his arrival and acted as an inspector of antiquities, a kind of policeman like Ohnefalsch-Richter before him.[59] Before leaving Cyprus in 1939, he served briefly as acting director for the new Department of Antiquities in 1934.

In June 1927, Gunnis investigated antiquities in Polis and reported back to Markides.[60] Like his predecessors, he excavated tombs; he planned and described one located on the Kaparka hill. Gunnis also investigated the town site, attempted but generally avoided by earlier archaeologists because it seemed too complicated and expensive. He encountered two sites later to be excavated in greater detail by the Princeton Cyprus Expedition.

His narrative report suggests that his first site was most likely in Petrerades, in Princeton's Area E.G0, where he uncovered part of the apse of a Byzantine basilica and tombs. The Princeton excavations in E.G0 found the apse of a basilica that was considerably disturbed. He describes the next area he excavated as a "tongue of raised land"; from his report, this appears to be at Maratheri, in Princeton's Area A.H9. In three days there, he uncovered five hundred statues, statuettes, and figurines, both male and female. Among these was a terracotta foot belonging to a colossal statue (compare cat. no. 71). A photograph taken in 1929 by a member of the Swedish Cyprus Expedition (fig. 1.7; see essay III)

FIGURE 1.7. Photograph taken in 1929 by a member of the Swedish Cyprus Expedition looking southeast across the 1927 excavations by Rupert Gunnis of the area known as Maratheri in Polis, equivalent to Princeton grid A.H9. Compare fig. 3.13.

makes it possible to connect Gunnis's excavation with the temple forecourt and part of the city wall.

Objects were his main interest. As inspector his role was to protect antiquities, yet he picked out duplicates that could be sold to tourists to raise money for the museum and had his own collection of antiquities. In 1933, his "property" was sold at auction.[61] Myres noticed that three lots sold to the Ashmolean had Cyprus Museum labels, which indicate that they came from Polis.[62]

The Swedish Cyprus Expedition, 1929

In 1926, the King's Custodian of Antiquities in Sweden, Sigurd Curman, requested permission for a Swedish archaeological expedition to Cyprus, the aim of which was the "scientific exploration of its prehistory and history and to throw light upon the part played by Cyprus as a connecting link between the early Eastern and Western cultures."[63] Acquisition of objects for museum collections in Sweden was also a priority to facilitate the study of

cultural interaction.[64] As private secretary, Gunnis made sure there would be "as liberal an interpretation" of the law on exports as possible.[65] Einar Gjerstad (1897–1988), together with two students, Erik Sjöqvist and Alfred Westholm, and an architect, John Lindros, formed the Swedish Cyprus Expedition (SCE), which excavated sites across the island from 1927 to 1931.[66] Sjöqvist (1903–1975) alone of all the early excavators had a close association with Princeton University, where he was a visiting professor (1948–49) and later professor of art and archaeology (1951–69). He shaped Princeton's program in Classical archaeology.[67]

Markides's "clear and scientific manner of exhibition" had appealed to Gjerstad during his first visit to Cyprus; he had trained in prehistoric archaeology and rigorous typological methodology in Sweden.[68] The SCE at first planned to investigate prehistoric sites, with one example each of a cemetery, a settlement, and a sanctuary. When their aims were expanded to the study of the island from its earliest prehistory through the Roman period, Gjerstad requested

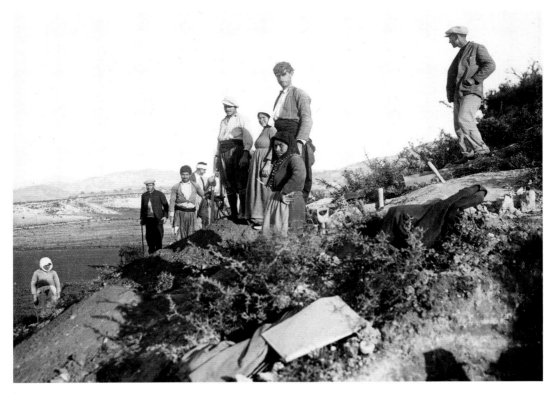

FIGURE 1.8. Men and women who worked on the Swedish Cyprus Expedition excavations in Polis at the locality of Evrethades, 1929.

permission to excavate in Polis. He emphasized that "the examination of the cultural connections between Cyprus and Greece will be finished by the excavations in Polis tis Chrysochou."[69]

From late March through early July 1929, Sjöqvist conducted the excavations in Polis. Communications with team members were facilitated by improvements in the roads and postal system. Although the roads continued to be rough, the SCE made good use of their Volvo and also loaded up transport animals, such as camels, with objects to take back to Nicosia (figs. 1.1, 1.2).[70] Like all the earlier excavators, the SCE employed both men and women (fig. 1.8). Women usually pulled up buckets of earth from tombs and searched them for finds, but occasionally women were to be found in the tomb shaft digging alongside the men.

The Swedish team thought highly of the people who worked with them and often participated in the life of the villages where they stayed. In Polis, Sjöqvist became involved in a tragic way when one of the men from the town was killed in a tomb collapse. Sjöqvist became the foster father of the man's daughter, Chrysanthou, and he and Gjerstad saw to it that she received a substantial dowry. Tomb collapse was a regular occurrence, given the friable limestone bedrock into which many tombs were dug;

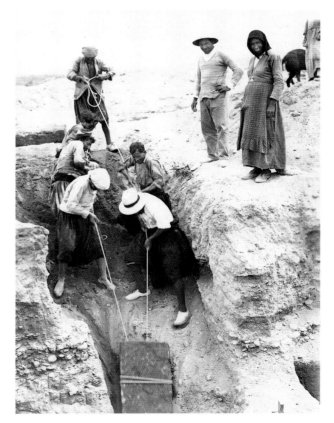

FIGURE 1.9. Removal of a stone block during the excavation of Swedish Cyprus Expedition Tomb 53 at Polis-Kaparka, 1929.

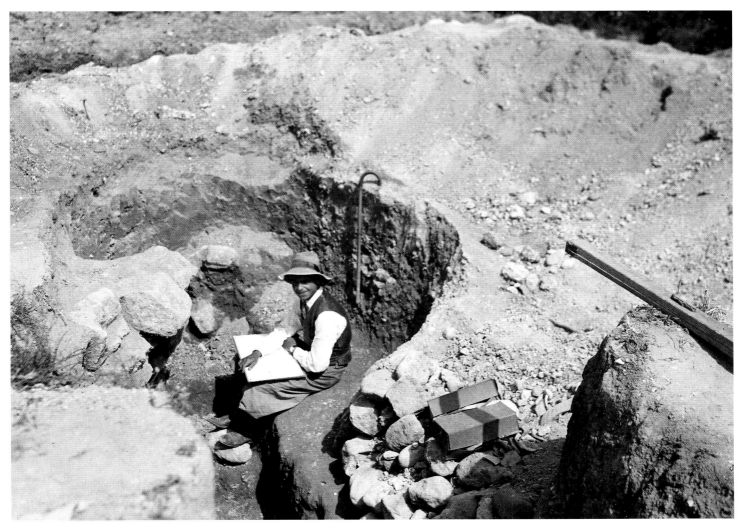

FIGURE 1.10. Erik Sjöqvist of the Swedish Cyprus Expedition working on a plan of a chamber tomb at Polis-Evrethades, 1929.

Sjöqvist himself had been caught in landslides.[71] Entering and exiting tombs, especially when removing large and heavy finds, was a challenge (fig. 1.9).

Gjerstad called Sjöqvist a "born archaeologist."[72] He was particularly fond of working with ceramics, and in choosing a comical costume for a party, he opted to appear as a white-slip pot of "degenerate style" being "painted in horrible colors."[73] Westholm reported that during the excavations they called him not just Erikos, a hellenized version of his first name, but also the "Duke de Maré" (Duke of Marion) because his archaeological work in Polis was "exceptionally successful."[74] Describing a visit to Sjöqvist's excavations, Westholm wrote:

> We arrived in the afternoon at Polis, where Erikos was just enjoying one of the expedition's luckiest excavating days with fabulous Greek graves full of red-figure

vessels and terracotta statues. It was a pure delight to see it all, and with Erikos's own finder's joy. We spent a pleasant evening together divided between Erikos's lodgings in a palace-like Greek house, and the largest coffee shop in the village. The joy of the Polites at having got the talked-of Swedes to their village was obvious.[75]

During one visit they even drank gin from ancient Attic drinking cups.[76]

Fun was to be had, but not at the expense of careful excavation (fig. 1.10). For the first time, a measured plan and cross section of every tomb was drawn, all consistently showing the locations of artifacts and the different periods of use for each tomb, making it possible to discern changes over time within a particular tomb. Also, the SCE plans of the necropoleis show the locations of tombs relative to one another and to the topography of the landscape. One

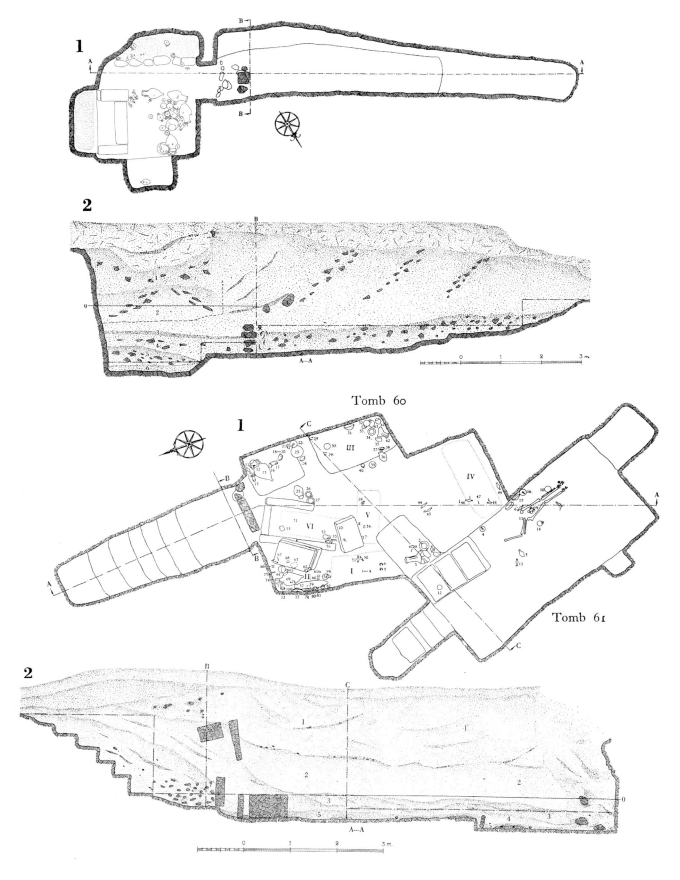

Tomb 60

Tomb 61

FIGURE 1.11. Plans and sections of Swedish Cyprus Expedition Tombs 41 (at top) and 60 and 61 (at bottom) at Polis-Kaparka.

can begin to see how one tomb cut into another, as with Tomb 60 (fig. 1.11, bottom), which in the Hellenistic period became conjoined with Tomb 61. Still, individual plans were not situated on a full town map, making it unclear where in each area these groups of tombs were found.

A total of ninety-eight tombs were uncovered in the eastern part of town and at Kaparka. For the first time, tombs of the Geometric period were located to the east at Evrethades (often known as Evretes) near Peristeries (see essay III). Detailed observation of tomb shapes and contents showed that there was great variety; necropoleis were found to be mixed chronologically, contradicting the ideas of earlier excavators who thought that the earlier cemetery was to the east and the later one to the west. The SCE showed that built stone sarcophagi became current in the fourth century B.C.E., that by the end of that century there was less emphasis on a long dromos and a shift away from rounded tomb chambers,[77] and that by the end of the Classical period tombs were rectangular with multiple tunnel-shaped niches, a form that persisted into the Roman period (see fig. 1.11).

The careful documentation of object locations provided further evidence for the use of the dromos. In addition to terracotta statuettes, Sjöqvist unearthed a limestone statuette of a seated woman and her attendant (cat. no. 5). More jugs with women holding jugs or with bulls on the shoulder (cat. no. 8) were found. Gjerstad suggested that some stelai or statuettes might have stood above the tomb, but most evidence showed that they were placed in dromoi and buried.[78]

The SCE determined, through close observation of the soil, which tombs had been disturbed by flooding as opposed to human activity. In Tomb 41 (fig. 1.11, top), some objects remained close to where they were likely positioned in antiquity on a bench, as in the case of a gold pomegranate pendant (cat. no. 12), while other objects, such as an imported Attic lekythos by the Providence Painter (cat. no. 22), had pooled at the center of the tomb and were found as if floating, suspended as they were in the soil. In Tomb 67, when a new burial was interred, an earlier body and the objects buried with it were pushed to the side, including an Attic askos (cat. no. 37).[79]

The SCE also documented how people wore jewelry. Among the Late Cypro-Classical burials in Tomb 60, one person wore a gold necklace of beads and an amphora-shaped pendant (cat. no. 15), and another had silver bracelets with snakes' heads (cat. no. 16) and a gold finger ring with a double palmette (cat. no. 17). Early Hellenistic burials in the same tomb included gold earrings ending in calf heads (cat. no. 18). The excavation showed how necklace beads had fallen away from the body around the neck and head.[80] Other burials preserved evidence that ornaments often interpreted as made for the hair were, in fact, made for the ears (see cat. no. 11).[81]

The Department of Antiquities, 1934–present

Soon after the establishment of the Department of Antiquities in 1934,[82] A.H.S. Megaw was appointed as director. From 1936 onward, several chance finds and excavations were made in Polis; Late Classical through Roman period tombs were uncovered at Louri, Tipozita,[83] and other localities. Publications of objects acquired during these years focus on ceramics, especially Chian pottery (cat. no. 32) and sgraffito wares (see cat. nos. 106, 107).[84]

By 1954, the District Museum in Paphos had been created and reorganized.[85] While objects on display there still represent the kinds of objects found in Polis, such as stone funerary reliefs (cat. no. 44) and terracotta funerary sculptures, today most objects from Polis are to be found in the Local Museum of Marion and Arsinoe, which opened in 2000.[86] The contents of the displays chosen by Maria Hadjicosti, who later became the director of antiquities, feature older finds (cat. nos. 6, 15, 23, 36, 38) and more recent discoveries and artifacts from prehistory to the Archaic and Classical periods (cat. nos. 11, 19, 20, 27, 28, 38, 39, 57, 67, 77), as well as objects from the Hellenistic through the Roman era (cat. no. 86) and from the Late Antique through the medieval period (cat. no. 95).

There was a blizzard of purchases and confiscations of artifacts from Polis by the Department of Antiquities under the direction of Vassos Karageorghis just after the establishment of the Republic of Cyprus in 1960.[87] Among these objects are some that find parallels in recorded tomb deposits (cat. no. 11) and others that are unique among artifacts from the town. The earliest example of Attic pottery from Polis is said to have been found in the locality of Evrethades (cat. no. 29). A large example of Cypriot pottery without context from Polis blends Cypriot red-slipped technique with painting that draws on Attic designs (cat. no. 20). A Cypriot amphora with figural designs of wading birds (cat. no. 19) is also without context. A fifth-century C.E. gold *solidus* (a type of coin) is said to come from east of the hospital (cat. no. 95).

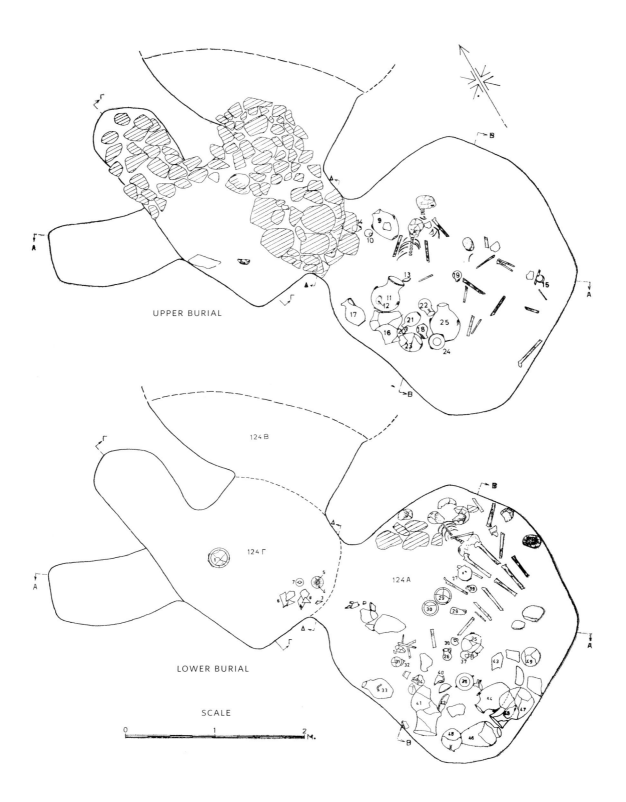

FIGURE 1.12. Plans of the two burial phases in Tomb 124 with chambers A and B;
excavated by Kyriakos Nicolaou at Polis-Kokkina in 1960.

In 1960, the Cyprus Archaeological Survey, begun in 1955 and directed by Hector Catling, came under the direction of Kyriakos Nicolaou (1918–1981). He conducted a survey of the Chrysochou Valley that documented remains from prehistory through the medieval period. His documentation pushed evidence for settlement in the area back into the second millennium B.C.E., and hints of earlier prehistoric material suggested that settlement began there even earlier.[88] Further finds from subsequent archaeological surveys have added to our knowledge of Bronze Age Polis.[89] A few Bronze Age tombs have been excavated near Polis, at Argaka and Magounda; Middle to Late Bronze Age pottery found in them (cat. nos. 24–26) point to strong artistic connections with areas to the east, past the Troodos Mountains and to the south.

Nicolaou's work in the area led him to excavate more tombs in the eastern part of town,[90] just south of the Peristeries Plateau (see essay III). Nicolaou established further evidence for the Geometric period (cat. no. 27), as well as for the Archaic (cat. no. 28) and later periods. He published detailed plans of the tombs, showing the locations of the objects within the burials and the multiple layers of burials in the same chamber (fig. 1.12). Most importantly, because he also documented the locations of the tombs not just relative to the areas where he excavated but also on a wider plan of the town, the locations of these tombs are known today.

Excavations by the Department of Antiquities in Polis continue with the work of Eustathios Raptou, archaeological officer for the District of Paphos. The rapid expansion of the town has led to the discovery, rescue, and recording of a number of tombs in which stunning gold jewelry (cat. no. 14) and imported Greek vessels have been found (cat. nos. 33, 35). In 2010, Raptou uncovered what may be a funerary monument in the eastern part of the town (fig. 1.13). Excavation across the street from the Maratheri sanctuary (see essay III) led him to discover many large female statues and statuettes (cat. no. 72).

The Princeton Cyprus Expedition, 1983–present

It was one of Sjöqvist's students, William A. P. Childs, who renewed large-scale excavations in Polis. In forming the Princeton Cyprus Expedition, Childs took on the challenge set aside by earlier excavators, for an aim of the project was "to locate and describe as fully as possible the remains of two towns thought to have existed under or near the modern

FIGURE 1.13. Site of what may be a funerary monument; excavated in 2010 by Eustathios Raptou for the Department of Antiquities of Cyprus.

FIGURE 1.14. Polis in 1946, view looking west along what today is called Griva Digeni Street; showing column and capital discovered at the site of Polis-Petreres (Petrerades), then in the possession of Mr. Argyriou (compare cat. no. 109).

village" of Polis.[91] When the team began its work in 1983, column shafts, capitals, and bases still lay along roadways, in fields, and in people's gardens, evidence of buildings that once stood at the large town site, or the *chiflik*, at the locality of Petreri or Petrerades ("field of stones"; fig. 1.14).

Remains of the town site were visible at the time of Cesnola. In 1887, Eugen Oberhummer wrote that he had seen the east and west walls of Marion and Arsinoe.[92] In 1889, Munro described the site as "a wilderness of loose

stones, one or two fragments of late plastered walls, a massive marble block or two marking the temple-site . . . and a mound of slag from the copper mines."[93] In 1910, the curator of monuments, George Jeffrey, remarked that visible traces of the "temple site" had been largely removed by the Public Works Department.[94] Gunnis noted in 1927 that stones and other objects were still being removed from the area by the landowner. Markides was the first to obtain permission to excavate the main town site; nevertheless, he thought that its many stone buildings made excavation too expensive.[95] Gunnis excavated a small area but decided in the end to leave it for Jeffrey. Gjerstad noted that "architectural debris and numerous potsherds on the surface bear witness of the ruins of the town buried below." The Swedish trial excavation was abandoned for "lack of time, and financial considerations."[96]

All agreed that the visible remains of the town site were from Arsinoe, the Hellenistic and later city. In spite of the challenges posed by this large and complex site, the Princeton team laid out a grid and explored it systematically over many summer seasons beginning in 1983. This was a task uniquely suited to modern archaeological techniques and a perfect opportunity to introduce students to the need for carefully documented recording so as to make sense of what Childs often calls the "messiness" of archaeological remains (fig. 1.15). Excavations there in Princeton Areas E.F1, E.F2, E.G0, and E.G1 revealed major, especially public, buildings from the Hellenistic, Roman, Late Antique, and medieval periods above the earlier city.

Early excavators also remarked on other settlement remains. Gunnis excavated part of a sanctuary at Maratheri, where Gjerstad also noted that he saw Late Cypro-Archaic figurines, the only visible "earlier remains of some importance" in the town. Princeton's excavations there, in grid Area A.H9, recorded the design, contents, and destruction of a Cypro-Classical sanctuary and city wall. To the east, in Peristeries, Gjerstad's team also laid in trial excavations, where they found "a suburb, as the space between it and the western, main settlement seems to have been uninhabited. Heaps of slag are found near this eastern settlement, and the datable fragments of pottery, etc. discovered on the surface are Roman." Ohnefalsch-Richter tested this same

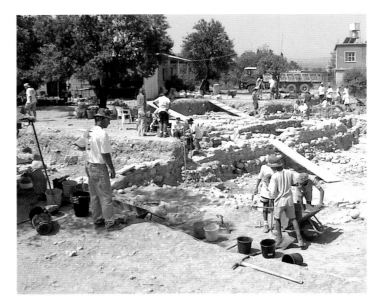

FIGURE 1.15. Princeton Cyprus Expedition excavations at Polis-Petrerades, view looking north; Princeton grid Area E.G0, showing the depth and complexity of excavating the ancient town site.

ground and suggested that it was the early city of Marion.[97] Princeton's excavations, in Areas B.C6, B.D7, B.F8, and B.F9 revealed a Cypro-Archaic sanctuary and public building as well as workshops and domestic structures. Some deposits reach back into the Geometric period and some continue into the early Cypro-Classical period.

The small town of Polis that Childs encountered in 1983 has now expanded into a center for tourism, with several of the tomb fields covered with houses, restaurants, and shops. Laws have changed, and no objects found in Polis have left the island to join the Princeton University Art Museum's collections. Although large-scale excavations ended in 2007, study and publication of the material continues. The Cypro-Archaic and Cypro-Classical city was found below buildings of Hellenistic, Roman, Late Antique, and medieval dates, with evidence that people in each subsequent period had reused the building materials of the last, just as people in the modern village of Polis were still using building stones from antiquity into the nineteenth[98] and twentieth centuries. The remaining essays examine the results of the Princeton Cyprus Expedition's investigations of Marion and Arsinoe.

NOTES

1. Thanks to many individuals in several institutions, I was able to conduct the research for this chapter: I am especially grateful to the following: the Cyprus American Archaeological Research Institute (CAARI), which granted me a fellowship sponsored by the Council on American Overseas Research Centers; the Department of Art and Archaeology at Princeton University, which supported my research in Stockholm, Sweden; the Department of Antiquities of Cyprus, including the Cyprus Museum, the Paphos District Museum, and the Local Museum of Marion and Arsinoe; the Department of Greece and Rome at the British Museum, London; the Medelhavsmuseet in Stockholm, Sweden; the State Archives, Nicosia, Cyprus; and W. A. P. Childs, who facilitated the research in the National Archive, London.
2. See Strabo 14.6; *Stadiasmos Maris Magni* 309; Pseudo-Skylax 103 (*GGM*).
3. Also known as Stefano Lusignano; see Lusignano 1573, §33, 590, and Lusignan 1580, 5, 30–31; see Kitromilidès 2006, 127–29.
4. Blocks from this harbor are still visible; see Jeffrey 1918, 445. Raban 1995, 165, dates the construction to the Hellenistic period.
5. Dawkins 1932, Makhairas §30.
6. Hill 1972, 7.
7. Jeffrey 1918, 414, gives a date of 1752; Gunnis 1936, 393, gives the date as 1742; its altar is supported by a Corinthian capital. Goodwin 1984, 1276, also gives the date as 1742, and it is his translation of the name that is used here.
8. Goodwin 1984, 787–88, 1417–18.
9. Mitford 1939; Bekker-Nielsen 2004, 142–45.
10. Castle 1971, 26; Schaar, Given, and Theocharous 1995, 37–40.
11. Munro, in Munro and Tubbs 1890, 4.
12. Gjerstad 1935b, 181, is one who comments on the remoteness of Polis; on the roads at that time, see Westholm 2012, letter of April 1, 1929.
13. Munro and Tubbs 1890, 5, n. 1; Cesnola 1877, 225–27. Masson 1983, 23, suggested that he might have visited Polis in 1874 or 1875; for summaries of the reliability of Cesnola's reporting, see Goring 1988, 10–15, and Swiny 1991.
14. Myres 1914, 110, 115, 294, 331, 350; Vandenabeele 2001, 185–86.
15. Cesnola 1877, 226.

16. Masson 1983, 152–55; see also http://www.britishmuseum.org/research/search_the_collection_database.aspx. These are not, however, the first documented discoveries from the town. The earliest discoveries recorded are from 1862, including a second-century B.C.E. inscription mentioning Arsinoe (see essay IV).
17. Reinach 1891, 188; Masson 1983, 150–52, includes references to Ross and other writers.
18. On the life and works of Ohnefalsch-Richter, see Buchholz 1989; Fivel 1989; Krpata 1992; and Brehme 2001.
19. Stanley-Price 2001, 270; Merrillees (R. S.) 2005a, 5.
20. SA1/1755/1885 contains all the correspondence about the 1885 excavation quoted here.
21. Tatton-Brown 2001b, 169.
22. Brönner 2001b, 199.
23. SA1/549/1886, SA1/720/1886.
24. Ohnefalsch-Richter 1893, 509–10, details his approach to excavation, from which quotes here are taken.
25. SA1/2287/1886.
26. Ohnefalsch-Richter 1893, pl. CCXVIII.
27. Ibid., 507.
28. On these finds in dromoi, see Ohnefalsch-Richter 1893, 361–62, 417; Sheedy 2008.
29. Flourentzos 1992.
30. BM GR, Original Letters, 1886–87, from C. Christian to A. S. Murray, nos. 125, 126, 128, 130.
31. SA1/3426/1886.
32. Fivel 1996; Brönner 2001a; Brönner 2001b, 201–4.
33. SA1/3248/1886; SA1/109/1887; BM GR, Original Letters, 1886–87, from C. Christian to A. S. Murray, no. 130; Delestre and Hoffmann 1887.
34. See, e.g., Pottier 1926; Plaoutine 1938; Hermary 1989a; Caubet et al. 1998; Fontan 2007, fig. 7; Brehme et al. 2001, 12, 67–68, 95–98, 123–25, 171, 176–77, 180–81; Nielsen 1983, 14, no. 55; Karageorghis (V.) 2001, 4, 43–46, 74–75, 98.
35. SA1/3633/1886; SA1/2287/1886; BM GR, Original Letters, 1886–87, letter of December 15, 1887, from C. Christian to A. S. Murray, unnumbered; BM GR, Original Letters, letter of January 27, 1896, from J. W. Williamson to A. S. Murray, unnumbered.
36. BM GR, Original Letters, letter of October 19, 1886, from C. D. Cobham to C. Newton, unnumbered. Also see Megaw 1988, 281; Goring 1988, 21–22.
37. Munro and Tubbs 1890, 2.
38. SA1/3365/1887; see also Gill 2011, 35.

39. SA1/3365/1887; SA1/193/1888; SA1/103/1889.
40. Herrmann 1888; Munro 1889; SA1/103/1889; Hogarth 1889, 105–8.
41. Gill 2011, 161–63.
42. SA1/103/1889; Munro and Tubbs 1890, 2, 4.
43. SA1/914/1889.
44. BM GR, Original Letters, letters of February 25, 1889 and June 2, 1890, from J. A. R. Munro to A. S. Murray, nos. 176, 191+191A; BM GR, Original Letters, letter of May 5, 1890, from J. A. R. Munro to A. S. Murray, no. 190.
45. Munro and Tubbs 1890, 2, 19; SA1/1009/1889; SA1/1237/1889.
46. SA1/1348/1889.
47. SA1/1720/1890.
48. Munro 1891, 298–99; SA1/2060/1890; SA1/1981/1890; SA1/2007/1890; SA1/2148/1890.
49. SA1/1237/1889. The post office was in operation by 1894; see Castle 1971, 89.
50. Munro 1891, 320; see also Munro and Tubbs 1890, 31.
51. Munro 1891, 323; see also SA1/2148/1890.
52. SA1/1075/1890. By 1892, there was a "hope to prevent further exports" (SA1/2476/1892).
53. Myres and Ohnefalsch-Richter 1899; on the museum, see Merrillees (R. S.) 2005a and b.
54. The new museum opened in 1909; see Roueché 2001, 155; on Markides, see Pilides 2009, 65, 68–69, 435, 642–43, and for his work with Myres, see Megaw 1988, 282–83.
55. Correspondence and records about this early work can be found in MP CM/23/esp. 1, 4, 8–9, 15, 20, 35.
56. On Gunther, see Pilides 2008, 7–8; Westholm 2012, letter of May 5, 1928, P.S. 2 Tuesday evening; SA1/848/1934; MP CM/26.
57. On the inscriptions, see Masson 1983, 172–73; and on these excavations, see Markides 1917, 20; MP CM/26.
58. Storrs 1945, 492–93; on Gunnis, see Symons 1987 and Pilides 2009, 62, 319 n. 818.
59. CO 67/249/11, Doc. 15.
60. MP CM/24 is a record of Gunnis's excavations in Polis, referred to in Gjerstad 1935b, 219.
61. Sotheby & Co. 1933.
62. Roueché 2001, 161; CO 67/253/1, Doc. 8.
63. SA1/1466/1926/5–4.
64. Houby-Nielsen 2003, 8.
65. SA1/1466/1926/6.
66. Winbladh 1994, 1997, and 2003 for summaries.

67. "University Appoints Swedish King's Aide," *Princeton Herald*, April 11, 1951; "Noted Swede Dr. Sjoqvist Joins Faculty," *Princetonian*, April 12, 1951; Edlund-Berry 2003; in Cypriot archaeology, Sjöqvist is best known for *Problems of the Late Cypriote Bronze Age*, published in 1940.

68. Pilides 2009, 72; Houby-Nielsen 2003, 5–9.

69. December 1928, SA1/1466/1926/5–4, 2.

70. Westholm 2012, letter of April 1, 1929; Winbladh 1997, 35, fig. 18.

71. Gjerstad 1980, 152–53; Westholm 2012, letter begun April 27, 1929, events of April 30.

72. Gjerstad 1994.

73. Westholm 2012, letter of February 4, 1928.

74. Ibid., letters of March 27 and April 20, 1929.

75. Ibid., letter of April 1, 1929.

76. Ibid., letter begun April 12, 1929, events of April 15.

77. Gjerstad 1935b, 456–58.

78. Ibid., 458–59.

79. On Tombs 41 and 67, see Gjerstad 1935b, 294, 380–81, figs. 117, 162.1.

80. Gjerstad 1935b, fig. 153.

81. Ibid., Tomb 57, 344, figs. 141, 142.3.

82. Pilides 2009, 62.

83. Zachariou-Kaila 2001.

84. Dikigoropoulos and Megaw 1958; Webb 2001.

85. Masson 1983, 29.

86. Hadjisavvas 2001, 743–44, fig. 1.

87. See especially Karageorghis (V.) 1965a and 1966.

88. CS nos. 1290, 1300, 1301; Catling 1962, 153, 168. On Nicolaou, see Catling 1962, 130, n. 2.

89. Adovasio et al. 1975 and 1978; Raber 1987; Maliszewski 1994, 1995, 1997, 1999, 2003, and 2007; Maliszewski et al. 2003.

90. Nicolaou (K.) 1964.

91. Childs 1999, 223, and Childs 1988, 122.

92. Maliszewski 2006, 409–10.

93. Munro and Tubbs 1890, 5, pl. III.

94. Pilides 2009, 96.

95. SA1/116/1887, SA1/415/1887, SA1/2665/1887.

96. Gjerstad 1935b, 181–83.

97. Gjerstad 1935b, 181–82, comments on the Swedish excavations at Maratheri and Peristeries; also see Ohnefalsch-Richter 1893, 504.

98. Munro and Tubbs 1890, 8.

1

Torso of a Kouros (Naked Male Youth)

Greek, Cycladic, ca. 510–500 B.C.E.
Found by Max Ohnefalsch-Richter at Polis-Necropolis II, Tomb 92, in 1886
Parian marble; h. 72 cm., max. w. 28 cm., max. th. 24 cm.
London, British Museum (1887.8-1.1)

Condition: Missing its head, arms, lower legs, and penis. The surface is generally well preserved, but there are numerous nicks in the stone, many scratches, and some damage to both nipples.

Sometime around 500 B.C.E., a large multichambered tomb, approached by an entrance passage (dromos) almost twenty-three meters long, was built in the extensive eastern cemetery of Marion. The accompanying funerary goods signal the wealth and elevated social position of the deceased. They included a rare bronze coffin, gold and silver jewelry, a gold drinking cup embossed with acorns, a silver coin minted by the kingdom of Idalion, and imported Greek fine-ware vessels.

The most striking object associated with the tomb was the torso of a marble statue depicting a naked athletic young man (kouros). According to the excavator's brief description of the tomb's contents, the torso was deliberately placed upright within the dromos in front of the tomb entrance. Made of fine crystalline marble quarried on the Aegean island of Paros but probably carved by an itinerant master sculptor who traveled—as was the custom in the Archaic period—to the location of this expensive commission, the kouros ranks among the most unusual and intriguing finds from anywhere on Cyprus at this time. The statue must have stood out from the vast quantities of contemporary Cypriot limestone sculptures by virtue of the material used, since marble is not found on Cyprus and was therefore very costly to obtain—and consequently rare. A more important difference, however, was its nudity.

Statues of naked athletic young men are very common in the Archaic Greek world, where they usually served as votive offerings to the gods in sanctuaries or as tomb markers proclaiming the physical and moral virtues of the deceased. On Cyprus, however, images of worshipers are almost always clothed, while tomb markers, though increasingly common during the later Cypro-Archaic and Cypro-Classical periods (ca. 600–300 B.C.E.), are never carved in the form of freestanding human statues. Despite the growing influence of Greek art on local Cypriot production during this time, full nudity was never employed as a cultural costume.

Given this fact, and the careful burial of the statue near the tomb entrance, it has been doubted if the kouros had the same function at Marion as its Greek cousins. One scholar has suggested that the kouros was actually a tomb guardian intended to protect the tomb in perpetuity, but this does not explain why the statue was deliberately buried in a mutilated condition. One hint is provided by the tomb itself. The size, layout, and complexity of the tomb imply that that it was intended for use over several generations. Yet even allowing for the nonscientific nature of the original excavation, the surviving finds suggest that only a single interment took place and that the tomb was prematurely abandoned.

Does this indicate a sudden change in fortune of the deceased's family or peer group? Perhaps they moved away from Marion or suffered a sudden change in fortune, whether economic or political. The experimental nudity of the subject may also have offended the community in some way, especially if it had actually been displayed in a public place,

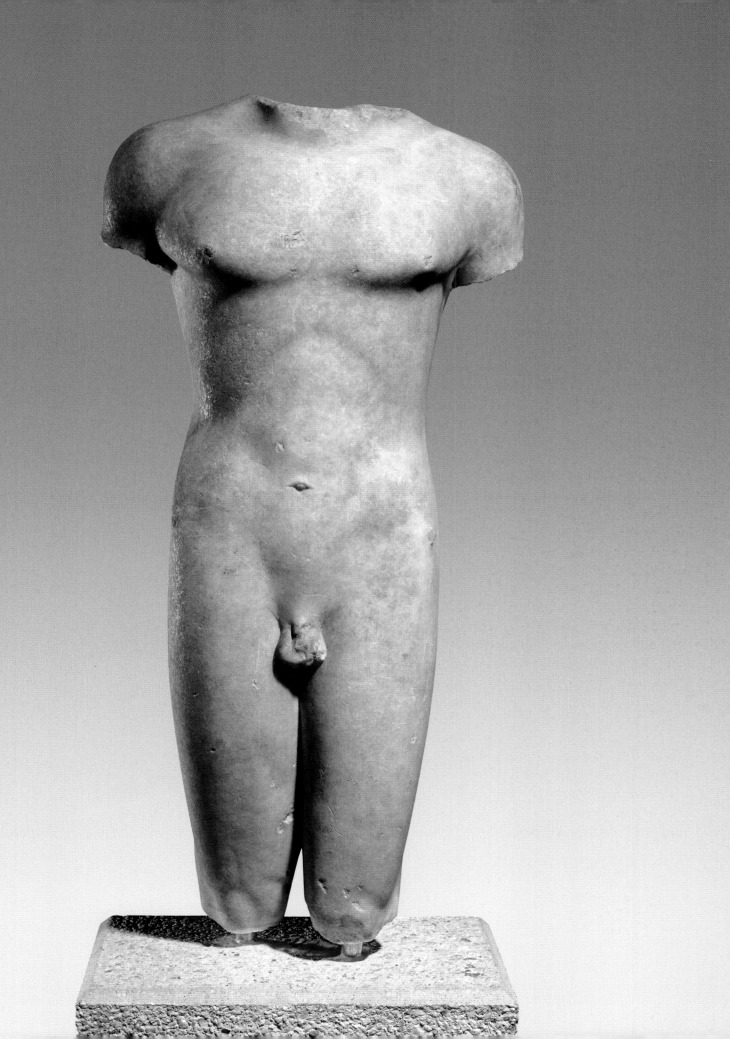

such as over the tomb. The kouros may have been damaged at this time, either as an attack on its owner or simply in order to decommission a symbolically powerful funerary or religious offering that no longer served its function. Its find spot in the dromos, therefore, must be regarded as a secondary deposit and not as its primary context.

We may never be able to establish the truth with any certainty. Nonetheless, the kouros is a sign of the strong economic and cultural links between Marion and the Greek world that become increasingly visible in the archaeological record from this period onward. The superb quality of the sculpture and associated grave goods reflects not only the wealth and taste of the patron but also the affluence of the city of Marion and its widespread connections throughout the Mediterranean.

PUBLICATIONS

Herrmann 1888, 8, figs. 2 and 22; Ohnefalsch-Richter 1893, 361–62, 497, 503, pls. XXVII.3 and CLXXIV.2; Pryce 1931, B325; Richter 1970, no. 179 and figs. 527–29; Sheedy 2008 (with full references); Williams 2009, 86.

—TK

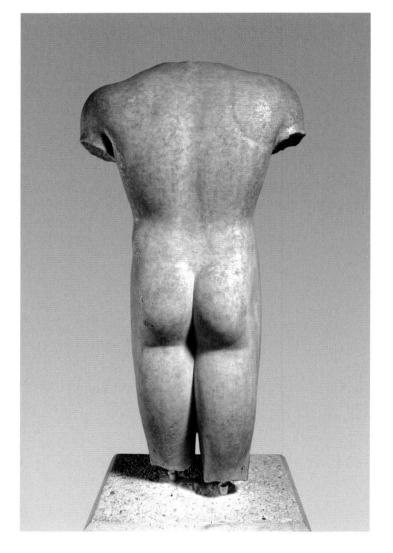

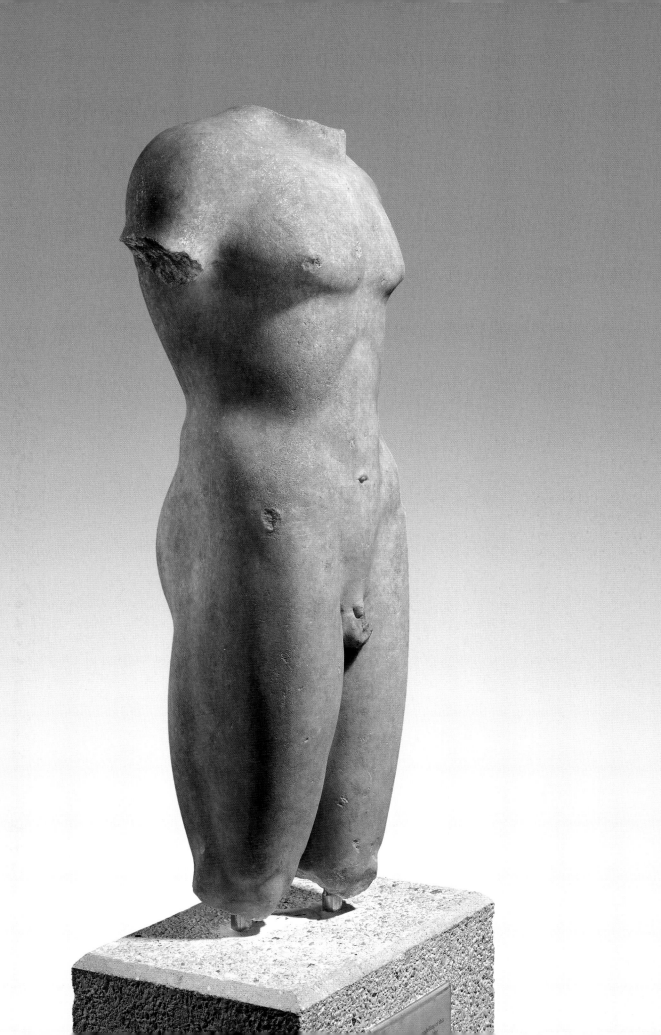

2
Statuette of a Seated Woman

Cypriot, 4th century B.C.E.
Found by Max Ohnefalsch-Richter at Polis-Necropolis III, Tomb 11, in 1886
Terracotta; h. 46 cm., l. 18.5 cm., w. 23.5 cm.
Paris, Musée du Louvre, Département des Antiquités Orientales (AM 89)

Condition: Head, torso, and arms nearly complete but assembled from several fragments; damage to fingers of left hand; lap and front of himation badly broken but now mended; lower back of figure missing.

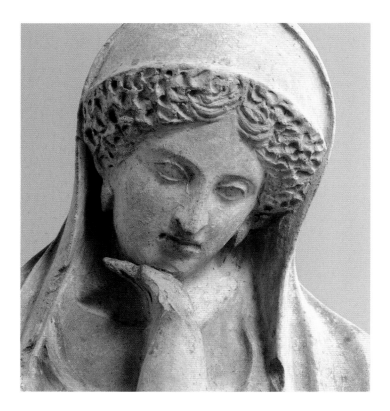

This statuette of a seated female is an exquisite example of the funerary terracotta sculpture of Marion and has much in common with catalogue numbers 3 and 4. The woman sits in a contemplative pose with her chin poised on her raised (but damaged) left hand, while her right arm and hand rest in her lap. Her head is covered by a *himation* (cloak) that falls onto her shoulders and is drawn around her thighs, while the bodice of her dress, likely a *peplos* because of the heavy folds, is portrayed with an attractive fluidity. The molded face reveals a composite of gracefully modeled features: lidded eyes beneath gently arched brows give way to a refined, elongated nose and a delicate mouth with lips slightly parted to suggest an almost ethereal detachment that the viewer cannot penetrate. The hairstyle is rather busy and was added separately to the mold-made face, as was the top of the *sakkos*, or headcloth, that binds the hair. The coloristic treatment of the hair curls, with the interplay of light and dark and secondary incisions, is in sharp contrast to the subtle modulation of the face. The disproportionately oversized arms and hands were constructed by the coroplast as separate handmade forms and added to the handmade body. Likewise, the lower part of the figure seems ill proportioned, but it should be remembered that this is the most heavily damaged part of the statuette. As was the case with all terracotta sculpture, this one would have been heavily painted, which would have added a lifelike quality. The inclination of the head downward and to the side imparts a contemplative, if not melancholy, cast to the figure. The specific pose of the head, arms, and hands derives directly from motifs of mourning women found widely on Attic funerary monuments. There is ongoing debate about the meaning of such figures: were they intended to represent the deceased, the mourners, or the participants in the funeral banquet? Whoever they are, they bear silent witness to grief and to how people in ancient Marion honored their dead.

PUBLICATIONS

Ohnefalsch-Richter 1893, pl. 185.3; Caubet et al. 1998, 468–69, no. 716; Flourentzos 1994; Raptou 1997.

NOTES

Flourentzos 1994, 162, no. 22, pl. XXXIV and Flourentzos 1996, 85; Fleischer 1983. In general, see Friis Johansen (K.) 1951; Clairmont 1993.

—NS

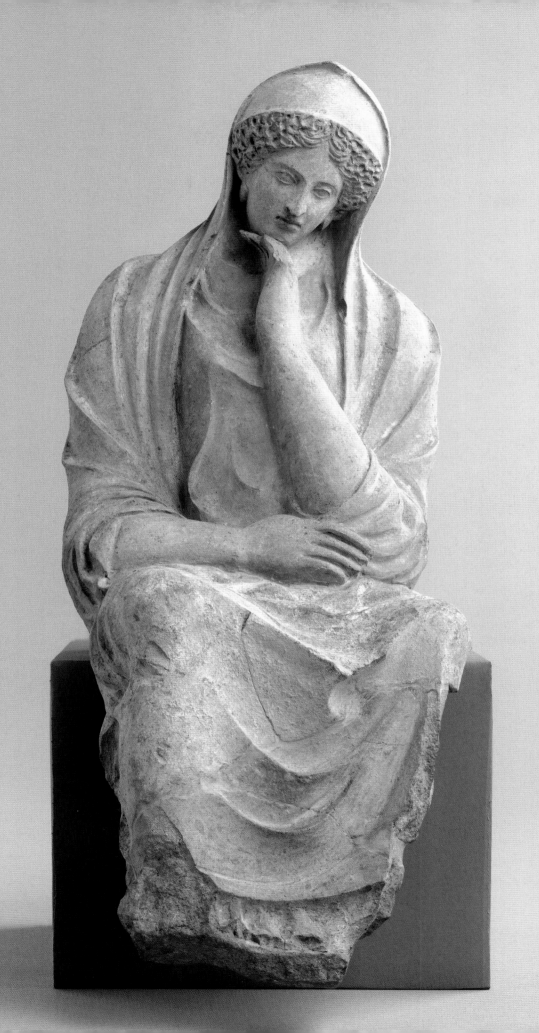

3
Statuette of a Seated Youth

Cypriot, 4th century B.C.E.
Said to have been found at Polis in an unspecified necropolis
Terracotta; h. 54 cm.
Larnaka, Pierides Museum (MIP 233; currently on loan to Nicosia, The Laiki Group Cultural Centre)

Condition: Broken at neck and mended, as are left wings of chair, left hand at wrist, lower right arm, and lower left arm and projecting flange of left side of chair. Modern restorations: feet, footrest, front of himation, part of neck, and bird. All fingers, the fillet, and the leaves of the wreath are damaged.

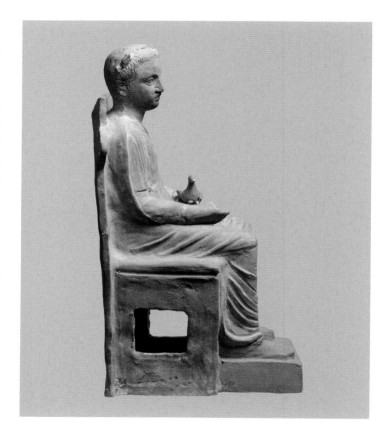

This statuette of a seated youth is similar to other terracotta funerary statues, such as catalogue numbers 2 and 4. It represents a specific category of this type of funerary sculpture at ancient Marion: a seated young man. Here the youth sits on a high-backed chair with decorative wing terminals and a cushion. Although he faces frontally, his head is turned somewhat to his right and is angled slightly downward. The face was made in a mold; details of the eyes and the area around the nostrils, however, appear to be reworked. The facial features reflect stylistic tendencies originally derived from Athenian influence, which became widespread throughout the eastern Mediterranean in the fourth century B.C.E. The youth strikes a typical pose; he positions his arms in his lap, with the right extending along the right thigh. The right palm rests open and upward. Even though all fingers are broken, there is no trace that anything was held in the hand; perhaps it was gesticulating. The left arm rests on the left thigh with the palm again opening upward on the lap; the modern addition of the bird reflects that some ancient examples held objects in their hands and, in one case, a dove. The youth wears two garments that are typical of young men, a short-sleeved *chiton* (tunic) that falls in shallow folds over the torso and a heavier himation (cloak) that is draped over the shoulders and extends over the lap, terminating in a passage of swallowtail folds along the left leg. The statue would have looked slightly different in antiquity: the wreath attached to the fillet in the hair would have been more dense and lush (compare cat. nos. 39, 69, 74), and the red and yellow paint (only traces of which remain) must have imparted a striking coloristic effect. The necessity for the modern restoration probably resulted from the placement of statues of this type in the dromos, or passageway leading into a tomb, and, after the burial, the heaping in of earth to fill the dromos, which produced significant damage. It has been suggested that the predominance of terracotta sculpture recovered from Marion might be due to the lack of good quality stone available for sculpture.

PUBLICATIONS

Karageorghis (V.) 1975, 142–43, no. 86, fig. 86; Flourentzos 1994; Raptou 1997.

NOTES

Flourentzos 1994, 161, no. 4, pl. XXX; and Hadjisavvas 2010, 159, no. 144.

—NS

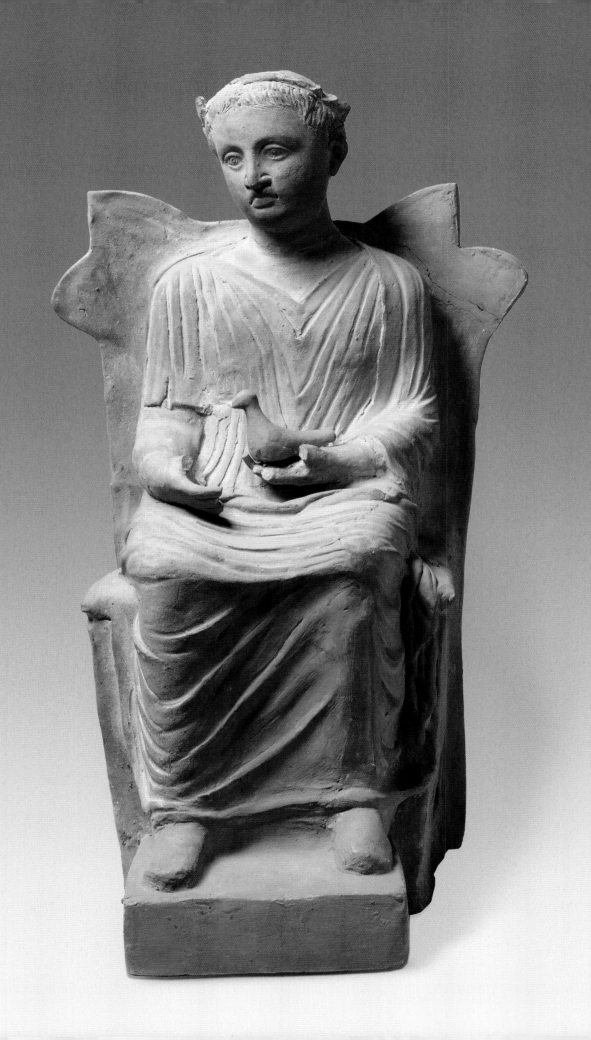

4

Statuette of a Reclining Man

Cypriot, 4th century B.C.E.
Found by the Swedish Cyprus Expedition at Polis-Kaparka, Tomb 58, in 1929
Terracotta; h. 51 cm., l. 52 cm.
Larnaka, Pierides Museum (MIP 234 CL 114)

Condition: When discovered, the statuette was badly damaged and required significant restoration of the head, the lower arms and both hands, parts of the himation draped over the legs, and parts of the couch.

This reclining man represents an important category of terracotta funerary sculpture at ancient Marion (compare cat. nos. 2, 3). Resting on a rectangular *kline*, or couch, he is positioned on his left side, torso facing nearly frontally, while his left elbow and lower arm are supported by two cushions. He wears two garments, a short-sleeved chiton (tunic) and a himation (mantle) that is draped over the left shoulder, brought around the back, and passed over the lower body and across the lap with an end drawn over the left forearm; the folds are shallow, schematic, and often stiff. The positions of the restored lower arms and hands of the figure have been changed from that of the original badly damaged statue. Photographs from the published excavation report show the left arm brought up to the face, while the right lower arm extended forward in an animated gesture. The front of the couch was originally plain and roughly worked, while the restored front of the kline resembles a rectangular box with elegantly turned legs. The head is that of a bearded middle-aged male with the facial features crafted in a mold. Details were restored, including the linear aquiline nose, the small mouth with fleshy lips, the receding hairline, the closely cropped beard and mustache, the ears placed low on the side of the head, and the stylized hair with overemphasis on linear incision.

Older bearded males with wreaths in their hair are represented reclining at funeral banquets celebrated after the interment of the deceased. Nevertheless, the reclining position of the statue is in accord with the everyday custom for dining. The animated hand gestures of the original statue suggest that funerary banquets might not have been such solemn and somber affairs as to preclude lively exchanges among the participants. Similar statues include a youthful servant in attendance, and sometimes the banqueter holds a raised wine cup to his lips.

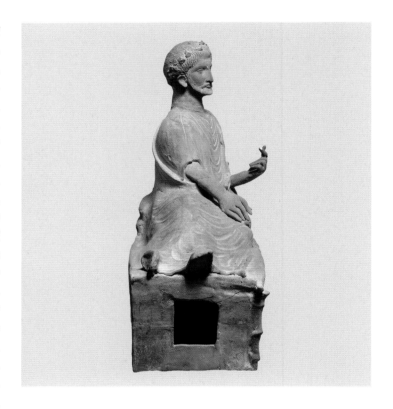

The chamber tomb in which this statue was recovered contained five burials, four females and one male. The statue was found on the floor of the tomb associated with a female burial. Objects recovered nearby were a bronze mirror, silver earrings, and a glass perfume flask.

PUBLICATIONS

Gjerstad 1935b, 345–50, pl. CLVIII, M 58.80; Karageorghis (V.) 1975, 142–43, no. 85, fig. 85; Flourentzos 1994; Raptou 1997.

NOTES

Flourentzos 1994, 161–62, see esp. pl. XXXI: no. 6, D4; no. 7, D7; no. 8, D142; no. 9, 1961/XII-7/16.

—NS

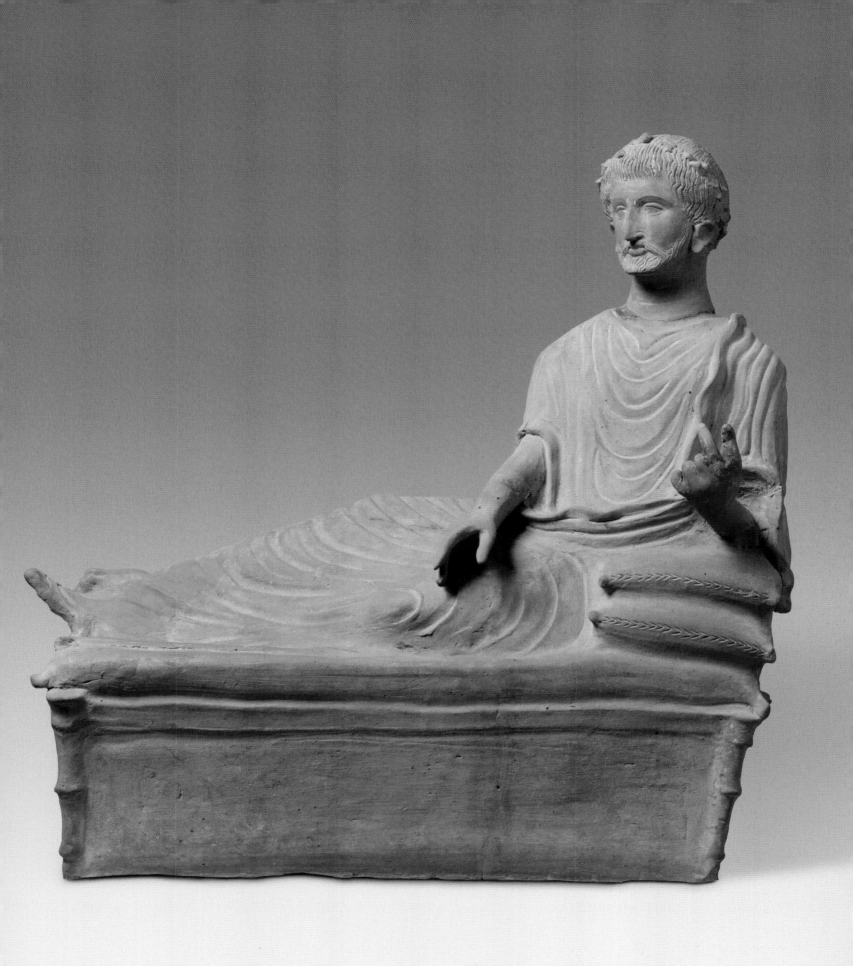

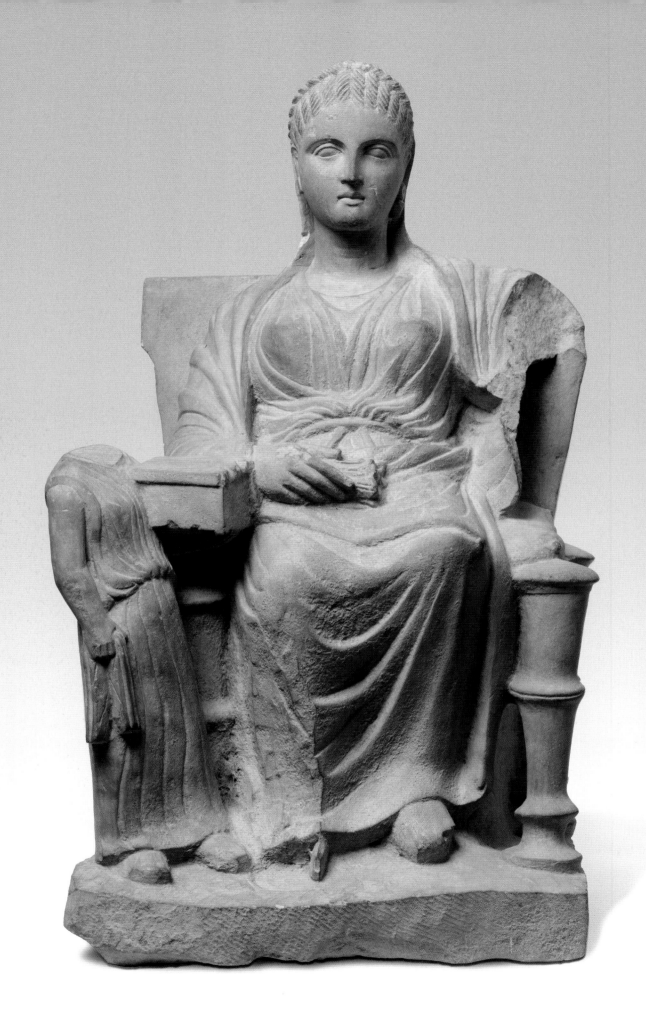

5
Statuette of a Seated Woman and Attendant

Cypriot, 330–320 B.C.E.
Found by the Swedish Cyprus Expedition at Polis-Kaparka, Tomb 53 dromos, in 1929
Limestone; h. 68.2 cm. (including base), w. 33 cm. (base), th. 26 cm.
Nicosia, Cyprus Museum (SCE Marion P.T. 53/1 Dromos)

Condition: The whole surface has a more or less light lime incrustation. The head of the seated woman has been reattached; there is a small crack and chip on her left cheek. Her right lower leg is heavily abraded; about two-thirds of the right foot was originally added in a cutting and is now missing. The back of the chair is finished moderately well, with a flat chisel 1 cm. wide, mostly in vertical lines; the bottom under the chair (23 cm. high from base) is carved out very roughly to a depth of about 10 cm. There are four or five modern pick marks at the top right of the chair back. Traces of red color remain on the side/back of the rear left chair leg. The head of the standing figure is missing.

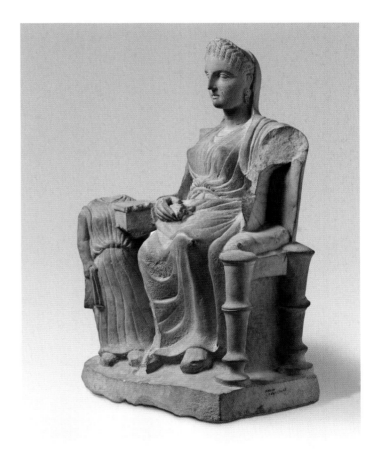

A woman dressed in a chiton and himation (see cat. nos. 3, 4) is seated on a highbacked chair or throne. Her right hand, resting in her lap, holds a flower. Her face is pronouncedly vertical with a high and elaborate hairdo containing traces of color. The type is well known in terracotta statuettes from the tombs of Marion, examples of which are all of approximately the same size. The attendant at her right leg holds a box as on Attic grave stelai. All the drapery is relatively heavy and doughlike. That and the hairdo suggest a date in the second half of the fourth century, probably 330–320 B.C.E., a date confirmed by the contents of the tomb.

The tomb, which had been robbed of its valuables, had a main chamber with two stone sarcophagi and a niche with a third sarcophagus that contained the bones of a woman. The name of one man buried there is known from a Cypriot syllabic inscription on a simple limestone block set next to one of the stone sarcophagi in the tomb. It reads from right to left as "Kypagoras the son of Kuprokleweos." The figure of the woman and her attendant was found in the dromos in the fill of the robbing trench together with fragments of terracotta statuettes and large slabs of well-dressed stone. Gjerstad surmised that the statuettes and slabs had comprised a visible monument above the tomb, though the evidence is weak.

PUBLICATIONS
Gjerstad 1935b, 330, 331, Dromos no. 1, pl. CLXI.5; Raptou 1997, 230 n. 48, 234.

NOTES
Masson 1983, 173–74, no. 155; Flourentzos 1994, 161–65, pls. 30–36; Raptou 1997, 225–37, pls. 46–48.

—WAPC

6
Jug with a Woman

Cypriot, 6th century B.C.E.
Said to have been found at Polis
Ceramic; h. 41.7 cm., max. w. 23.7 cm.
Polis Chrysochous, Local Museum of Marion and Arsinoe (MMA 121; formerly Nicosia,
Cyprus Museum C399)

Condition: Vessel: broken at lower neck and now mended; repair through upper handle; abrasion to rim,
chip to upper neck, and sporadic abrasions to surface. Figurine: lower right arm missing; broken at neck
and now repaired. Miniature jug: rim and handle missing.

This jug belongs to a specific group of jugs that include a three-dimensional figure mounted on the shoulder of a vase. They were popular from the end of the sixth century B.C.E. until the Hellenistic period. Possibly first made at Marion, a major production center, these vases have also been discovered at other sites, primarily in the western part of the island. Most of these vessels were decorated with a female figure holding a juglet and were made in Bichrome Red ware, meaning that a red-slipped vase was decorated with black and white paint. Molds were often used to craft the face of the figures, but less frequently, as here, separate molds were used for the face and the body, while other elements of the figural composition were produced by hand. Red paint was applied to the arms, the dress, and the small

clay pellets that formed the woman's feet, while black paint decorated the hair. Black bands embellish the miniature juglet, just as is the case for the larger vessel. The topmost band of decoration was crafted with a multiple brush and overlaps the front of the woman's skirt to form a decorative hem on her garment. Above this band is a large zone of repetitive decorative elements: stylized palm trees, dot rosettes, and stylized birds (compare cat. no. 19) painted in black silhouette. The slightly concave neck also carries painted decoration in four zones: black and white alternating dot rosettes; a large battlement pattern formed by white dots with dot rosettes in the center of the battlements; white dotted battlements with black dot rosettes in the center; and, finally, at the top, inverted triangles in black silhouette with the rim also painted black. A double-rolled handle rises from the lower shoulder to the upper neck; a black line is painted down the center of the front; a horizontal ladder pattern decorates the outside surface; and two large black loops appear below. What is interesting is that the two different molds used for the face and the torso were also used for crafting several other figurines found in the two Marion sanctuaries.

PUBLICATIONS

Dikaios 1961, 70, pl. XVI.3; Nys 2003, 273–75; Vandenabeele 1992; Vandenabeele 1997, 134, pl. XLII.d; Vandenabeele 1998, 116–17, no. 3.A, pl. VI.3A.

NOTES

Vandenabeele 1998, 116, cat. no. 2.A, pl. VI.2A and 142, cat. no. 81.B, pl. XXXVII.81.B; Karageorghis (V.) 2003, 274–75.

—NS

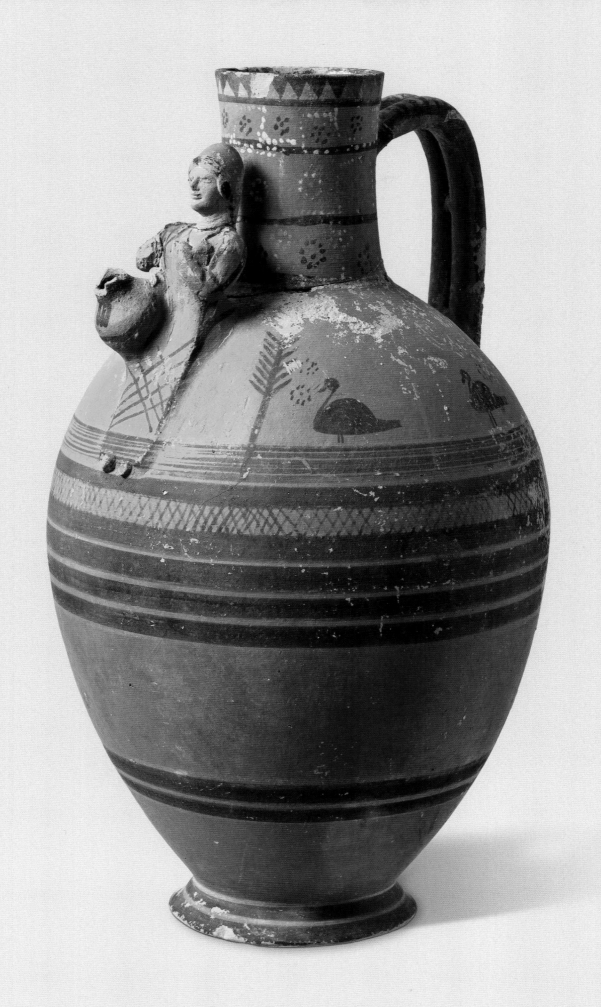

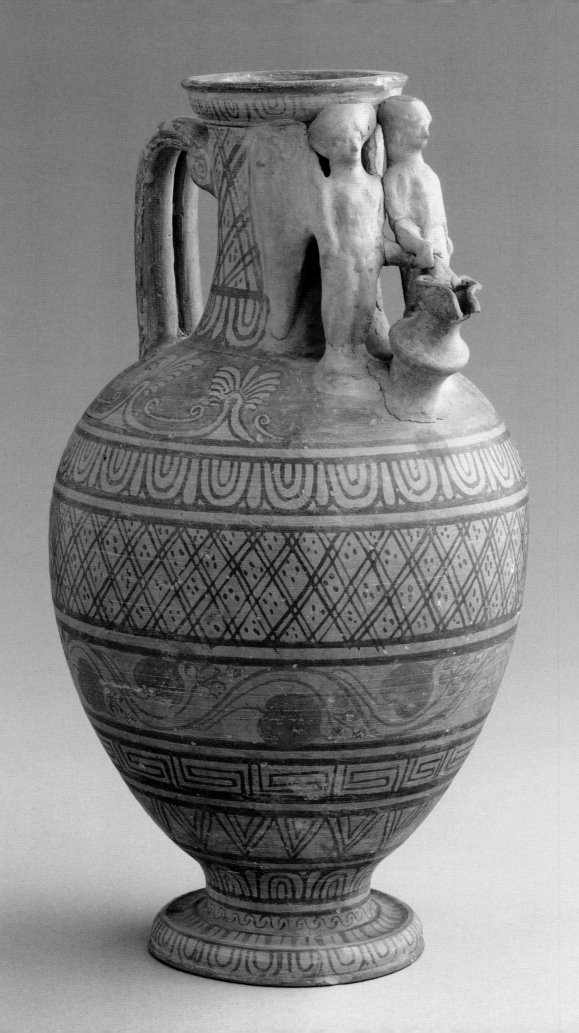

7

Jug with Eros and Female

Cypriot, 4th century B.C.E.
Found by Max Ohnefalsch-Richter at Polis-Necropolis III, Tomb 83, in 1886
Ceramic; h. 39 cm. (jug), 12.5 cm. (figurines)
Paris, Musée du Louvre, Département des Antiquités Orientales (AM 76)

Condition: Complete with some surface spalling and pitting; part of the rim of the miniature oinochoe is missing, and ancient damage at the attachment of the oinochoe to the jug is now repaired; the lower right arm of the draped female is broken and repaired; Eros is broken at ankles with feet and plinth restored.

Found in a tomb in Necropolis III, this vessel has two figures on the shoulder in the same location occupied on similar vessels by a female holding a jug (cat. no. 6) or an animal head (cat. no. 8). A nude male youth stands frontally to the right of a draped female. The youth is Eros, son of the goddess Aphrodite, identified by the presence of wings (these project awkwardly from the sides of his arms). His body is mold-made; the rather indistinct features attest that the mold was quite worn when it was used. Most interesting is the separate mold used to craft his face and hair. The mold is, in fact, that of a female, and the facial features and hairstyle are ones found on numerous other figurines from Marion. The female, perhaps Aphrodite or Psyche, standing next to Eros wears a peplos, the typical dress adopted by Greek women in the early fifth century B.C.E.; the drapery folds are nearly indistinct, suggesting that this mold, too, had become well worn. Her rather elongated neck suggests that the head and body were assembled from two different molds. Certainly the most jarring feature of the woman is the monstrously large right arm that extends forward in front of the two figures to grasp the handle of the small, biconical, trefoil-lipped oinochoe (jug). The arm was separately made by hand and is out of proportion to the mold-made figurines. The right hand is treated schematically and looks pincer-like. Figurines on other vessels of this type often show traces of paint, but here there are only sporadic vestiges of black pigment.

Unlike the figures, the vase is truly exuberant in its decoration. Arranged in zones, the complex black-painted ornament complements the orange-brown color of the clay fabric. Motifs such as the web of lozenges and the hanging concentric loops are repeated on the neck and belly. Vegetal patterns of palmettes on the shoulder and

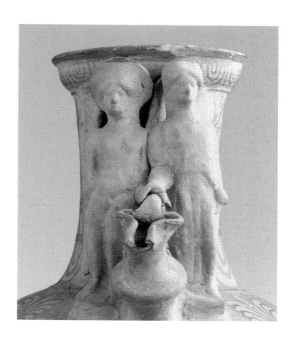

a wide band of ivy leaves on the lower belly contrast with the band of running meanders followed by massed *V*s near the foot. Above the foot is a band of standing concentric loops, and on its edge are hanging loops. The double-rolled handle is outlined in what now appears as a brownish pigment (but was once black) and is painted with a series of inclined bands.

PUBLICATIONS

Caubet et al. 1998, 407, no. 698; Vandenabeele 1998, 180–81, no. 198.H, pl. LXXXV.

NOTES

Cat. no. 6 is similar; see Vandenabeele 1998, 201, no. 260.L, pl. CXI, and 181, 199.H, pl. LXXXV.

—NS

8

Jug with a Bull Head

Cypriot, 4th century B.C.E.
Found by the Swedish Cyprus Expedition at Polis-Kaparka, Tomb 59 dromos, in 1929
Ceramic; h. 23.8 cm., w. 13.3 cm. (body)
Nicosia, Cyprus Museum (SCE Marion P.T. 59/4 Dromos)

Condition: Complete with damage at rim; tip of bull's right horn is missing;
gouge in the belly on left; paint is fugitive and indistinct in places.

This vase, crafted in a style known as White Painted VII ware, with dark paint on a light ground, has a bull's head (protome) on the shoulder opposite the handle. Marion potters from the end of the sixth century B.C.E. specialized in this type of painted vessel with plastic decoration on the shoulder. A limited range of animal protomes were chosen for representation and, as is the case with this jug, bovine heads were commonly used. Supported by an outward flaring disc base, the ovoid vessel is also covered with reddish brown banded decoration that circles the lower half of the vase. The primary decoration occupies the shoulder zone of the vase with two upright palm branches—one attenuated and the other broad and spreading (and now only faintly discernible)—filling the space on either side of the bull's head and the handle. Made by hand, the animal head depicts schematically the basic features of the bull with its broad head and narrowing muzzle, along with short, alert ears below tapering horns that curl forward. Splotches of red paint have been hurriedly applied to the eyes and also appear on the top of the horns. Below the muzzle, the dewlap is represented but is rather clumsily added, perhaps intended as much to support the animal's head on the vase as to depict that part of the bull's anatomy. The protome was used for decoration only and not for pouring,

as the front of the muzzle is pierced to simulate the animal's mouth but does not communicate with the interior of the vessel. On the back of the vase, a strap handle rises from where it was rather ineptly applied at the shoulder and attaches to the neck just below the rim, and a hurriedly painted passage of linear and semicircular forms marks the join of the handle at the shoulder. Thrown separately on the wheel, the ovoid neck is marked at its bottom by a red band, while another encircles the middle of the neck, and ten inverted triangles, solidly painted reddish brown, decorate the upper neck just below the outward-flaring rim. Found in the dromos of a Marion tomb, the vessel represents part of the funerary paraphernalia interred with the dead.

PUBLICATIONS

Gjerstad 1935b, 353, 355, Dromos no. 4, pls. LXVI.3, C.8; Nys 2003, 273–75; Vandenabeele 1992, 371–85.

NOTES

Princeton excavation R14849/TC6292 from the Classical sanctuary of Maratheri (AH.9) may have been made by the same artisan. See also Harvard Semitic Museum 1995.10.348 and British Museum 1887.8-1.64.

—NS

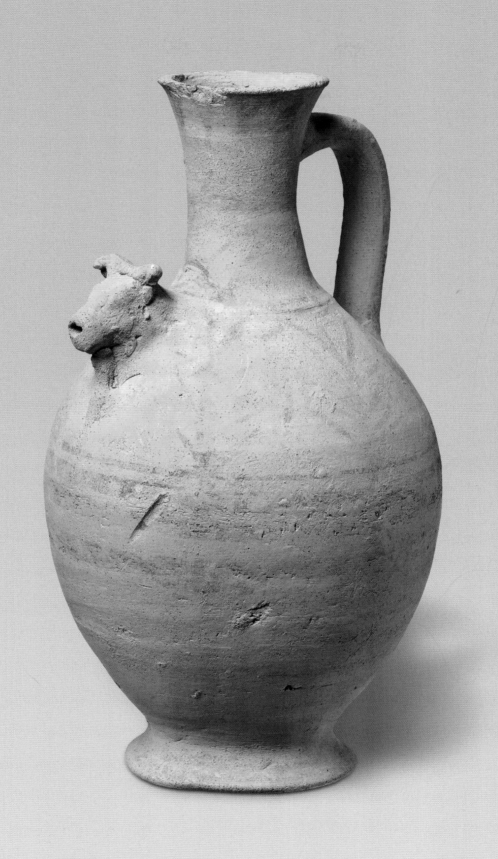

Sheep-Headed Seal-Pendant

Cypriot, second half of the 6th century B.C.E.
Found by J. W. Williamson in his vineyard at Polis-Necropolis II
Gold; l. 2.8 cm. (pendant), 1.64 cm. (sheep's head), diam. 1.36 cm. (intaglio), weight 8 grams
London, British Museum (1896.10-15.2)

Condition: Sealing surface bent, revealing the interior of the pendant.

This sheep-headed pendant is unusual for having a stamp seal device on its back side. With the exception of its ears, the sheep's head was made in one piece in a mold, as were a few other pendants. Its subject recalls ram-headed bracelets (cat. no. 10) and coins of Marion that reference the myth of Phrixos and the ram with the golden fleece (see cat. nos. 40, 41). The attached ears join with a break in the gold and could be a repair or modification of a pendant that once had ram's horns. The hammered intaglio sealing surface is affixed with wire that runs through two loops on its underside. Wire twisted around the suspension loop recalls how seals were secured on finger rings. Seals, even those set into finger rings, often were worn as pendants on a cord or chain around the neck or diagonally across the chest.

The seal design depicts a muscular, animal-headed man biting and stabbing a feline that lacks a fluffy mane. It recalls animal combats on other Archaic period gems. John Boardman described the man as dog-headed and suggested that some animal-headed men relate to the story in Book 10 of Homer's *Odyssey* in which his men are hounded by lions and wolves and then bewitched by Circe, who turns them into pigs. A close look at the figure reveals bristly hair at the neck and a long snout; its lower jaw is obscured by the neck of the feline it bites. This man could be part boar. Another scarab found in Polis by Max Ohnefalsch-Richter depicts the foreparts of a lion and a boar fused at the waist to form a hybrid creature. The feline on this seal-pendant is distinctive with its wide rounded eyes as well as its exaggeratedly long and powerful neck. These details are found on figures carved on two other seals, both from Cyprus.

Each depicts a feline attacking an animal with features of a boar, notably the long snout and bristly hair along the neck. One is an onyx scaraboid, which became part of the de Clercq collection. It came from Tomb 140 in Necropolis II, the burial ground in Williamson's orchard where this seal-pendant was found several years after excavations there had ended.

PUBLICATIONS

Marshall 1911, 167, no. 1599, fig. 49, pl. XXVI; Boardman 1968b, 154–55, 157, 161, pl. 37, no. 589; Reyes 2001, 159, no. 405, fig. 411; Boardman 2001, 146, 183, pl. 341.

NOTES

Ohnefalsch-Richter 1893, 361, 366–67, pl. 32.25, 32. Similar pendant: Williams and Ogden 1994, 248. Scarabs from Cyprus: Reyes 2001, 156–57, nos. 386, 389, 390, figs. 393, 396, 397.

—JSS

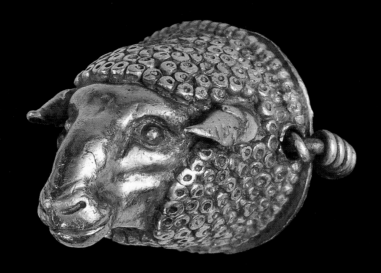
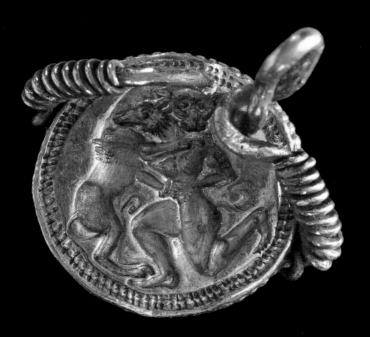

Pair of Ram-Headed Bracelets

Cypriot, second half of the 5th century B.C.E.
Found by the Cyprus Exploration Fund at Polis-Agios Demetrios, Tomb 10, in 1889
Silver-plated bronze and gold; h. 7.37 and 7.41 cm. (bracelets), l. 2.54 cm. (rams' heads),
weight 90.5 and 108.7 grams
London, British Museum (1890.7-31.6–7)

Condition: Gold slightly dented; slight silver corrosion.

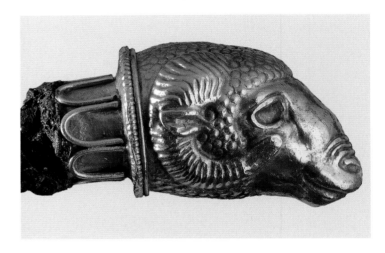

Animal-headed bracelets with pairs of lions, goats, rams, lion-griffins, and other animals facing one another are a hallmark of Achaemenid jewelry. Achaemenid bracelets, however, normally have the shape of an omega, being bent inward on the side opposite the two heads. This part was gripped by those bearing them as gifts to the king of Persia as shown on stone-carved reliefs at Persepolis in Iran. These same reliefs show a man wearing ram-headed bracelets. Bracelets featuring rams' heads were also made in the Greek world, but these usually somewhat later products have more elaborated collar decorations and often have a hoop with a twisted appearance. By the fifth century B.C.E. on Cyprus, there are several bracelets similar to this pair from Marion, additional pairs having been found, for example, at Marion, Kourion, and Amathous. The pairs from Kourion and Amathous, unlike those from Marion, were covered entirely with gold. Among the animal-headed bracelets found in the Oxus treasure from Tadjikistan, one has been shown by Dyfri Williams to be not of Achaemenid manufacture but of Cypriot. It is possible that these ram-headed bracelets were also made on Cyprus. The rams' heads were die-formed in two halves. The join is visible along the top and bottom of each head. Each was given greater detail by carving (chasing) and using a die punch for the fleece. When this pair was first discovered, one eye preserved traces of paste inlay. The eight gold wire (filigree) U-shaped sections around the collar may also have held colorful inlay, as on other Cypriot jewelry employing this Achaemenid practice (see cat. no. 11). The use of beaded wire together with a band of filigree at the start of the collar is another possible indicator of Cypriot manufacture (see cat. no. 18). These were soldered to the rams' heads and the collars, holding the terminals

in place. This pair from Marion was found in a tomb containing two skeletons along with objects that point to the mixed cultural references that comprise the artistic traditions of Cyprus: black-glazed vessels from Attica, a green jasper scaraboid of Phoenician type (cat. no. 61), amphora-shaped pendants (compare cat. no. 15), lion-headed spiral earrings (compare cat. no. 11), and armlets with snake-headed terminals (compare cat. no. 16).

PUBLICATIONS

Munro and Tubbs 1890, 54, pl. V.1; Marshall 1911, 222, nos. 1987–88; Rehm 1992, 21–25, 59–61, no. A.59.

NOTES

Marion: Pierides 1971, 36, pl. XXIV.5–6. Amathous: Laffineur 1986, 31, 33, 97, figs. 31–32. Kourion: Williams and Ogden 1994, 228–29, no. 161. Achaemenid bracelets: Curtis 2005, 132–33. Greek bracelets: Deppert-Lippitz 1998, 92–93. Cypriot manufacture: Williams 2005, 110.

—JSS

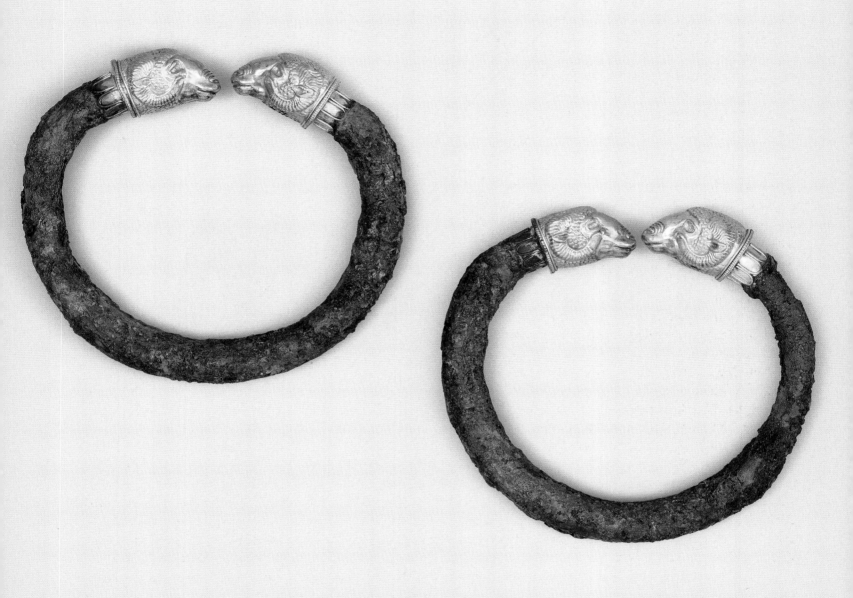

11

Pair of Spiral Earrings

Cypriot, 5th century B.C.E.
Purchased from G. Tomarides of Nicosia in 1965, said to have been found in a tomb at Polis
Gold-plated metal with enamel; l. 3.2 cm., weight 16.2 and 16.4 grams
Polis Chrysochous, Local Museum of Marion and Arsinoe (MMA 139; formerly Nicosia,
Cyprus Museum 1965/II-2/9)

Condition: Some enamel inlay and filigree have broken away; corrosion visible
below gold foil of one earring; its ball at the tip is missing.

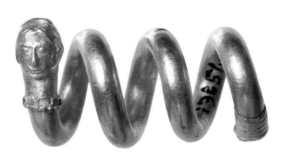

Heavy gold-covered spirals with terminals taking the form of a lion, a griffin, or a woman are sometimes called hair rings. Cypriot figures sculpted in limestone and terracotta, however, wear similar spirals threaded through piercings in their ears. At Polis in Tomb 57 of the Classical period, excavated by the Swedish Cyprus Expedition, a pair of spirals ending in female heads, nearly identical to this pair, was found along with smaller spirals midway along each side of a skull. A gold mouth-shaped cover had fallen just below the chin, and an amphoroid pendant and globular beads were strewn across the neck. Covering the entire edge of the ear with earrings was usual in women's fashion on Cyprus even in the Archaic period (compare cat. no. 57). Men also wore spiral earrings in the Archaic period, as did young boys in the Classical period. Some spiral earrings may have a copper core; the analysis of one pair identified lead alloyed with zinc.

These female heads were made in two halves using the same die form. Joined at the sides of the neck, they each cover one terminal of a triple-twisted spiral. Pulled back, the hair falls loosely over the ears and forms a bun. Details of the hair were chased; the hair of one appears braided at the back. Beaded wire encircles the lower edge of each neck, and plain gold wire (filigree) forms five or six squared loops filled with dark blue and, on one, also green, enamel. A five- or six-fluted gold sheath at the opposite end terminates in six filigree petals. A single gold bead marks where their wire ends meet at the center of a flower. Both flowers were inlaid with dark blue enamel, similar in color to lapis lazuli. This inlay technique recalls Achaemenid jewelry production. As with the lion- and griffin-headed earrings, another guardian figure with the body of a lion might have been implied here; these females may be sphinxes. The spiral shape, hidden when worn through the ear, makes reference to a snake unlikely.

PUBLICATIONS
Karageorghis (V.) 1966, 299–300, fig. 4; Pierides 1971, 29–30, pl. XIX.4 (compare no. 5).

NOTES
Gjerstad 1935b, 341–45, Tomb 57, no. 15, pl. LXIII.15; Laffineur 1986, 93–94. Earrings in sculpture: Marshall 1911, 165, esp. no. 1590, pl. XXVI; Hermary and Markou 2003, 216–19, 226. Manufacture: Brown (A. M.) 1983; Williams and Ogden 1994, 232, 237. Achaemenid inlays and Cyprus: Curtis 2005, 132; Villing 2005, 242; Williams 2005, 110.

—JSS

12
Pomegranate Pendant

Cypriot, late 5th century B.C.E.
Found by the Swedish Cyprus Expedition at Polis-Kaparka, Tomb 41, in 1929
Gold; h. 2.07 cm., weight 1.1 grams
Nicosia, Cyprus Museum (SCE Marion P.T. 41/39)

Condition: Cracked on one side, top loop partly broken.

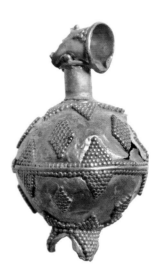

When suspended from its loop, this pendant hangs like a pomegranate, with its crown-shaped end pointing down. The clusters of granulations recall the seeds embedded in the pulp of the fruit, as if one sees both the exterior shape and a cut through revealing its interior. The pendant hoop and the stem, body, and crown of the fruit are each made of thin sheet gold. The joins among them and the edge of the hoop are masked by filigree wire. Single granules and clusters of six granulations decorate the hoop. The body of the fruit is divided into two halves by a filigree wire flanked by beads of granulation. Around the top, bottom, and both sides of the center line are rows of five triangular clusters of granulation, each with twenty-eight granules. The crown at the bottom is divided into three triangular sections, each also with a triangular cluster of twenty-eight granules.

Pomegranate-shaped pendants are found less frequently than those in the shape of an amphora (cat. no. 15). An identical example was found in a tomb at Agios Demetrios in Polis, along with two amphoroid pendants, a green jasper scarab (cat. no. 61), bracelets with ram-headed terminals (cat. no. 10), spiral earrings (compare cat. no. 11), and silver bracelets terminating in snakes' heads (compare cat. no. 16). Pomegranate-shaped beads lacking the detailed granulation have also been found in Cypro-Classical tombs in Cyprus. Much more elaborate pomegranate pendants have been found in Greece, as at Sindos, in late Archaic contexts. Pomegranates, especially their seeds, evoke the story of Persephone, daughter of the goddess Demeter. Persephone ate pomegranate seeds after she was kidnapped and taken to the underworld by the god Hades. Henceforth, she had to remain in the underworld for part of the year. A pendant in the shape of a pomegranate, especially one that reveals its seeds, would

have served as a symbol of fertility and regeneration, symbolizing the promise of return from the world of the dead to the land of the living. This golden pendant was found near one end of a burial on a bench in the chamber of a tomb. Farther toward the end of the bench, and thus possibly where the head would have been, was a cluster of spiral earrings. Although no traces of the skeleton survived, this pendant appears to have remained close to where it was worn on the upper chest of the body.

PUBLICATIONS
Gjerstad 1935b, 295, no. 39, pl. LV.1.39.

NOTES
Another pomegranate pendant from Polis: Munro and Tubbs 1890, 54; Marshall 1911, 104, 227, pl. XIV, esp. no. 1237. Pomegranate-shaped beads: Pierides 1971, 33, pl. XXII.2. Sindos pendants: Despini 1996, 131–33, 240–41, nos. 114–17.

—JSS

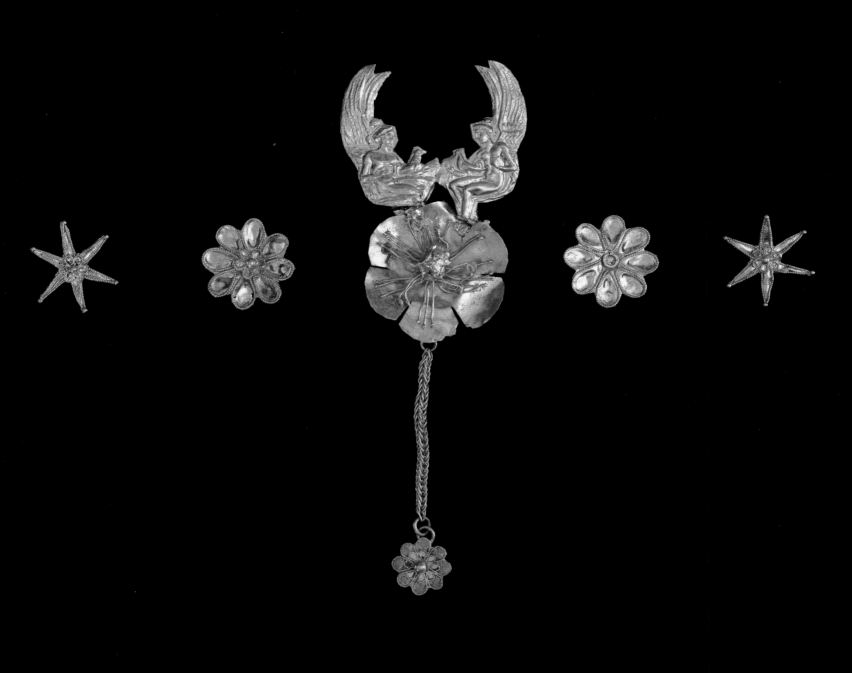

13

Necklace with a Pendant of Erotes

Cypriot, 4th century B.C.E.
Found by the Cyprus Exploration Fund at Polis-Agios Demetrios, Tomb 67, in 1890
Gold with paste; h. 7.31 cm. (pendant), diam. 1.22 cm. (rosette beads), diam. 1.3 cm. (pointed beads), weight 3.2 grams
London, British Museum (1891.8-6.88 [pendant], .89–.92 [beads])

Condition: Some enamel details now missing; feet of Eros at right and feet and lower legs of Eros at left marred by attachment to the flower in antiquity.

When first discovered in a tomb, this necklace with a long central pendant topped by two figures of Eros, the Erotes, had three kinds of beads. These beads are now divided among several museums that received objects found by the Cyprus Exploration Fund. In addition to eight of the eight-petaled rosette flowers and eight of the six-pointed narcissus flowers, there were twenty-five hemispherical gold beads, each with a loop on the back. These formed three rows of a necklace, most likely made in Cyprus, strung through the back of the pendant's large flower via three loops, one above the other. Both the small eight-petaled flower of the pendant hanging from an interlocking loop chain and the flower-shaped beads were made of cut gold sheet with details outlined in beaded wire, some filled with enamel, and accented with beads of granulation. The large flower of the pendant is sometimes described as a myrtle, which normally has five petals, but this sheet of gold is cut to form six. A golden bee pollinates the flower, bent over the tube that forms its style. Three rings of gold around it secure the long golden filaments of the stamens, twenty-one of which end in single beads of granulation. The remaining seven anthers are circlets of gold encircled by beaded wire and filled with enamel. The sharp details of the Erotes demonstrate the use of a metal die. Soldered to another thin sheet of gold, the figures were cut out and soldered to the large flower.

Eros, the son of Aphrodite, is frequently represented in jewelry. By the end of the fifth and into the fourth century B.C.E., his appearance took on an increasingly feminine aspect. While his abdominal musculature is masculine, his pose is feminine. In addition, his topknot mimics a feminine hairstyle and could reference the Classical practice of separating off a section of uncut hair on a youth who has not yet come of age. The Erotes sit back, both suspended and cradled by their wings. The roosters that stand apart, not yet engaged in the anticipated cockfight, emphasize that these Erotes represent youth on the brink of maturity.

PUBLICATIONS

Munro 1891, 323, pl. XV and Marshall 1911, 229–30, nos. 2053–57, pls. XXXIX, XL (as a necklace); Williams and Ogden 1994, 18, 38, 236–37, no. 170, fig. 9 (as a diadem).

NOTES

Eros: *LIMC* 3 (1986), *s.v.* "Eros," 914, 935–36, 940 (A. Hermary, H. Cassimatis, and R. Vollkommer). Youthful hairstyles: Harrison (E. B.) 1988, 250–51, 253–54. Roosters: Bruneau 1965.

—JSS

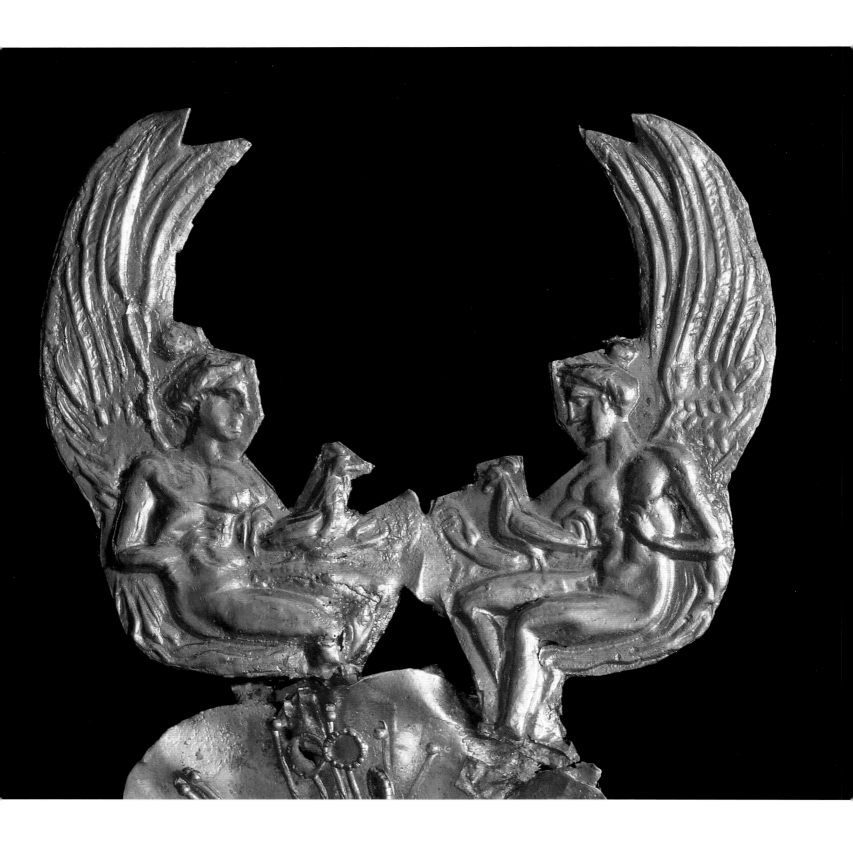

Detail of cat. no. 13

14

Pair of Eros Earrings

Cypriot, 4th century B.C.E.
Found by the Department of Antiquities of Cyprus at Polis-Agios Demetrios
in a tomb during rescue excavations
Gold; l. 1.4 cm. (MMA 644/12) and 1.1 cm. (MMA 644/13), w. 1.1 cm.
Polis Chrysochous, Local Museum of Marion and Arsinoe (MMA 644/12–13)

Condition: Complete, perfect state of preservation.

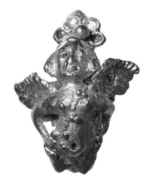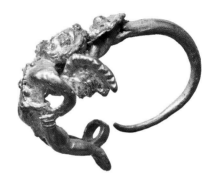

The gold earring no. 644/12 is solid, composed of a half ring of plated wire to which a nude figure of Eros is soldered, bent into a semicircle. In spite of the small size of the figure, the anatomy of the body is indicated in detail. The feet are close together, the hands placed on the hips. The open wings, soldered on the shoulders, are held behind by a horizontal strap. A cord decorated with clusters of globules passes over the figure's right shoulder and runs diagonally to his left hip. The head is quite large with rather grotesque facial features, having a large nose, deeply set eyes, and a closed mouth. There is a granulated rosette above his head, composed of six petals with a central globule. The pointed end of the hoop fastens behind, to a loop attached to his heels.

The other earring, no. 644/13, is almost identical. The hoop is composed of twisted wire, and a cord with clusters of globules passes over the figure's left shoulder and runs diagonally to the right hip.

The figure of Eros is a common motif on jewelry during the Hellenistic and Roman periods. On earrings, Eros is found hanging from a chain, holding various attributes, and he is also depicted bent into a semicircle, forming part of the hoop, probably suggesting flight. Many examples of this type of earring have been found in Cyprus, some of them from Polis when it was known as Arsinoe and dating between the Hellenistic and Roman eras. The present examples are securely dated in the fourth century B.C.E.

when the city was known as Marion, and probably toward the end of the century; they were found in a tomb with contemporary local pottery and other pieces of jewelry, including a gold chain with a fastening formed by two lion heads and small rosettes. The tomb may have belonged to a child.

PUBLICATIONS
Unpublished

NOTES
Marshall 1911, nos. 1711–20, pls. XXXI and XXXII (Eros hanging on a chain). General discussion: Pierides 1971, pl. XXXII, 5–6; Karageorghis (V.) 2002, 231, nos. 308–9.

—ER

15
Necklace with an Amphoroid Pendant

Cypriot, 4th century B.C.E.
Found by the Swedish Cyprus Expedition at Polis-Kaparka, Tomb 60, in 1929
Gold with enamel; l. 3.4 cm. (pendant), diam. 0.7 cm. (bead), weight 3.8 grams (all pieces)
Polis Chrysochous, Local Museum of Marion and Arsinoe (MMA 372; formerly Nicosia, Cyprus Museum
SCE Marion P.T. 60/1 [beads] and 60/3 [pendant])

Condition: Beads and pendant dented; some beads cracked; some paste worn off the bottom of the pendant.

Ceramic amphorae were large vessels used to store and transport commodities. Miniaturized amphora pendants of gold and of clay encapsulated these vessels' capacities for bounty and protection. The smooth and fluted beads of this necklace were found distributed around the head of a person with the pendant below the chin, just below a gold mouthpiece that would have been sewn to a burial shroud. On either side of the head were earrings with pyramidal clusters of golden granules that would have hung like abstracted bunches of grapes. Of the original thirty-two beads, each of which has a filigree wire around the perforations, one is now missing, leaving only fifteen fluted beads. The beads and pendant are hollow and thin. They must have had wooden cores if they were worn in life. The amphora pendant hangs from a flat gold loop with four grooves secured by a thin sheet of gold. Thin sheet gold also forms the neck and body of the amphora, framed at the top and bottom of the neck by beaded and filigree wire. Filigree also forms the six petals filled with paste at the bottom of the amphora, the ends of the wire alternately facing outward and inward. The characteristic pointed toe of a transport amphora, perhaps emphasizing movement rather than stasis for the wearer, emerges from the center of the flower, formed by two beads of granulation. Similar amphoroid pendants have been found in the Greek world and in other Cypro-Classical tombs, such as at Vouni and Amathous. Pendants in the shape of an amphora on Cyprus, however, are especially connected with burials at Marion. They were found with a green scarab (cat. no. 61) and ram-headed bracelets (cat. no. 10), a pendant in the shape of a pomegranate (compare cat. no. 12), and other burials in the same tomb in which this example was found (compare cat. no. 16).

PUBLICATIONS
Gjerstad 1935b, 358, 361, 364, nos. 1 and 3, fig. 153, pl. LXVIII.1, 3.

NOTES
Clay amphoroid pendants: Munro and Tubbs 1890, 54. Jewelry made for burial: Parks 2009, 215. Amphoroid pendants: Williams and Ogden 1994, 35. From Cyprus: Pierides 1971, 34, pl. XXII.5–6, 8. From Vouni: Westholm 1937b, 302–3, pl. XCVIII, Tomb 1, no. 57a. From Amathous: Laffineur 1986, 37, 42, 100. From Polis: Munro and Tubbs 1890, 54, pl. V.5; Marshall 1911, 226–27, nos. 2031–32; Gjerstad 1935b, 340–41, 344–45, 355–56, pls. LXI.5, LXIII.14, LXVI.2, Tombs 56 no. 12, 57 no. 14, 59 nos. 5–6.

—JSS

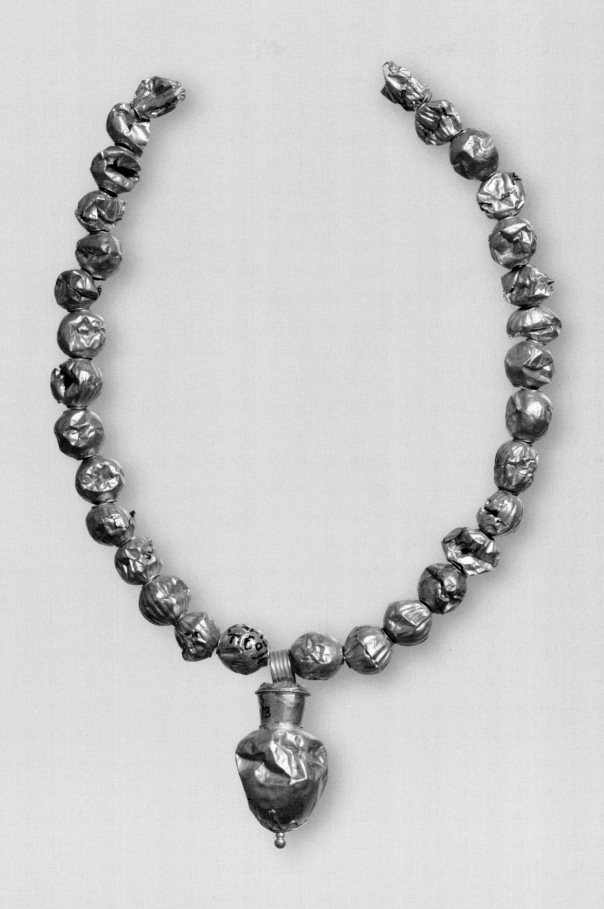

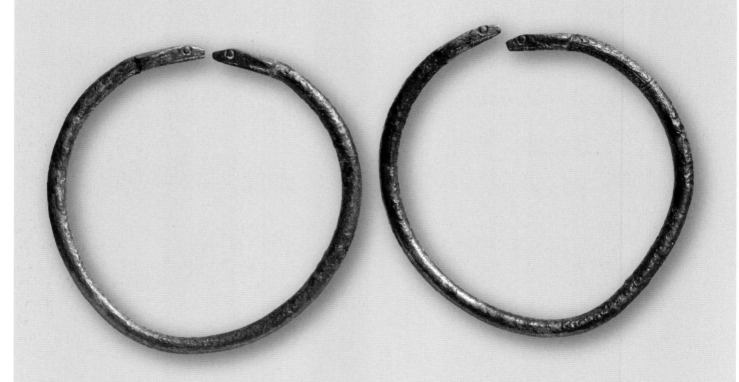

Pair of Bracelets Ending in Snakes' Heads

Cypriot, 4th century B.C.E.
Found by the Swedish Cyprus Expedition at Polis-Kaparka, Tomb 60, in 1929
Silver; h. 7.88 cm. and 7.56 cm., weight 43.2 grams and 42.5 grams
Nicosia, Cyprus Museum (SCE Marion P.T. 60/60)

Condition: Partly corroded and worn, especially on hoops; one bent.

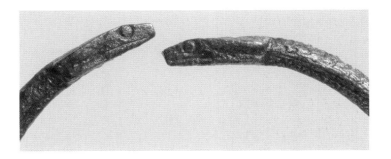

Bracelets ending in snakes' heads were worn in the Greek world as early as the second half of the eighth century B.C.E. There, by the late Archaic period, snake bracelets began to wind around the arm in multiple coils. As on similar bracelets in Greece, these silver examples from Polis each have two snakes' heads at the open terminals of the hoop. The heads, however, confront one another more like animals on Achaemenid bracelets (compare cat. no. 10) than snakes' heads on Greek bracelets that frequently overlap or angle away from one another. This pair of bracelets from Polis is most similar to other silver snake-headed bracelets from Cyprus, especially those from an early fourth-century B.C.E. deposit at the north-coast palace at Vouni. Made in a mold and shaped into a hoop, the pairs of snakes' heads are identical. Each snake has eyes formed as if with a hollow bore, a long and thin slit for a mouth, a narrowed, blunt nose, and wide, rounded jaws. The details of the snakeskin at the top and bottom of the head continue part way down the hoop before ending at a double groove.

Bracelets were worn most often in pairs by women. In the Cypro-Archaic period at Achna in southeastern Cyprus, terracotta figurines of women who may be priestesses wear two pairs of single hoop bracelets on their upper arms. Terracotta sculptures of men from the same period at Agia Irini near the north coast wear bracelets in a similar fashion. The amuletic significance of snakes (see cat. no. 81) might indicate a connection with a goddess, especially Artemis, with her powers of healing and protection of children. Snakes were also characteristic of the Egyptian god Bes, found frequently on Cyprus as an apotropaic, or protective, figure associated with childbirth. The person who once wore these heavy bracelets, discovered in a fourth-century B.C.E. tomb, may have been female if the size of the finger ring found nearby is any indication (cat. no. 17). In the same part of the tomb were multiple short spiral earrings, an amphoroid pendant (compare cat. no. 15), and a gold pendant in the shape of a seated sphinx.

PUBLICATIONS

Gjerstad 1935b, 362, no. 60, pl. LXVIII.60.

NOTES

Snake bracelets in Greece and Artemis: Deppert-Lippitz 1998, 91–92; Philipp 1981, 220–57. Snake bracelets from Cyprus: Lubsen-Admiraal 2004, 282, no. 574. From Vouni: Gjerstad 1937, 238, 278, 280, 288, no. 292h, pls. LXXXIX.16, XCII.h; Pierides 1971, 35, pl. XXIII.1–3. From Polis: Munro and Tubbs 1890, 54. Who wore bracelets and where: Deppert-Lippitz 1985, 131; Karageorghis (J.) 1999, esp. 48–51; Hermary and Markou 2003, 217. On Bes and snakes: Wilson 1975.

—JSS

Engraved Finger Ring

Cypriot, 4th century B.C.E.
Found by the Swedish Cyprus Expedition at Polis-Kaparka, Tomb 60, in 1929
Gold; h. 1.48 cm., l. 1.23 cm. (bezel), w. 1.58 cm., th. 0.04 cm. (bezel), diam. 1.42 cm. (interior),
weight 0.7 gram
Nicosia, Cyprus Museum (SCE Marion P.T. 60/76)

Condition: Scratched; edges of bezel slightly bent.

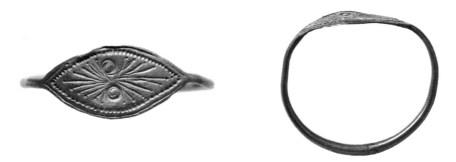

The Greek word for ring or seal-ring, δακτύλιος (*daktylios*), references the finger (*dactylos*). Even the Greek word for the veined gem called onyx (ὄνυξ), often used for seals, also meant fingernail. While these words preserve a strong association between fingers of the hand and devices for leaving one's personal mark (compare cat. no. 49), some rings with intaglio designs were worn only as jewelry. This delicate ring was fashioned out of a single hoop of gold, hammered to form the curved, leaf-shaped bezel, only a few millimeters in thickness. Most rings of this type from Cyprus come from Polis, usually from tombs of the fifth century B.C.E. Similar rings come from Greece and Etruria. Most, including all examples from Polis, are small, some barely over one centimeter in diameter. They were probably made for children, or possibly for women with very small fingers. The outer border and palmette design were carved (chased); the inner border and ends of the palmette fronds have been punched, marks that are also visible on the underside of the thin gold. A similar palmette fills the bezel of a silver ring from Necropolis III near the Kaparka hill. Among rings of this shape from Polis are several look-alikes, but not exact replicas. Popular were figures of Eros, leaping animals (e.g., lions), and palmettes. Other motifs found in Polis include a sphinx and a cicada. The sphinx and lion reference protection, Eros recalls youth and love (see cat. no. 13), and the cicada relates to ties to the land (see cat. no. 53). The palmette, a motif symbolizing fertility and regeneration, is derived from the date palm, a sacred tree often depicted on Cyprus together with a goddess and a heron (compare cat. no. 19). All of these designs were appropriate to wear on one's journey to the underworld; indeed, such rings may have been made to be worn only in death. One such ring from Polis was inscribed *ka-i-re* (χαῖρε), a Greek word meaning welcome but also goodbye. This ring with a palmette may be the latest of its kind from Cyprus. It was found among objects that included a pair of snake-headed bracelets (cat. no. 16) pushed into a corner of a Classical tomb. The excavators dated it to the end of the Classical period, but the ceramics found with it suggest a date not later than the first half of the fourth century B.C.E.

PUBLICATIONS
Gjerstad 1935b, 363–64, no. 76, pls. LXVIII.76, CLVI.5; Boardman 1967, 26, no. N 6 (compare no. N 7); Boardman 1970, 11–14, no. 51 (compare no. 49).

NOTES
Necropolis III: Ohnefalsch-Richter 1893, 495, pl. 182.38. *ka-i-re* ring: Masson 1964.

—JSS

18
Pair of Earrings Ending in Calf Heads

Cypriot, late 4th century B.C.E.
Found by the Swedish Cyprus Expedition at Polis-Kaparka, Tomb 60, in 1929
Gold with paste; l. 1.96 cm. and 2.14 cm., w. 1.31 cm. and 1.59 cm., weight 0.7 gram and 0.8 gram
Nicosia, Cyprus Museum (SCE Marion P.T. 60/7)

Condition: Paste no longer fills the right eye of each calf fully.

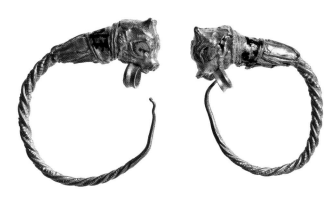

Animal-headed earrings with a wire hoop were popular throughout the Hellenistic period, spanning the time from the reign of Alexander the Great (336–323 B.C.E.) to that of the first Roman emperor, Augustus (31 B.C.E.–14 C.E.). The animal head and use of inlay recall Achaemenid jewelry designs (compare cat. nos. 10, 11). This pair is an early example because of its tapering collars. It and an identical pair, also with calf heads, were found in the same tomb. The use of the more traditional notched or beaded wire together with a plain wire for the twisted wire hoop suggests that these earrings were probably made on Cyprus. In other parts of the Greek world, notches were cut at a diagonal, forming spiral-beaded wires. Each earring would have been worn with the hoop inserted into a pierced earlobe and secured through the loop soldered below the chin of the calf. When worn, the calf head was probably placed so that it faced the earlobe, rather than hanging upside down; otherwise, the edge of the sheet gold forming its collar would have been visible. Each calf head was die-formed in two halves and then attached. The seam is blurred by chasing to produce a tuft of hair at the top and punching for detail on the back of the head. Solder and gold wire (filigree) around each collar held the pieces together and further obscured traces of the die-forming of the head.

Filigree was used in V-shaped sections to accentuate the taper leading to the hoop. On earrings of this type, lion and goat heads were also especially popular. Later examples incorporated a bead in the neck covered with gold foil, creating a bulge instead of a sharp taper. Later in the Hellenistic period, several beads placed just below the terminal added more color. Terminals for those earrings usually took the form of an animal such as a dolphin or the head of the god Bacchus. This pair of earrings was placed with the last burial in Tomb 60, at a time when it was cut into and joined with a second grave, Tomb 61. The burial dates to the early Hellenistic period, probably at the end of the fourth century in the final years of Marion before its destruction in 312 B.C.E.

PUBLICATIONS

Gjerstad 1935b, 361, no. 7, pl. LXVIII.7.

NOTES

Pierides 1971, 31–33, pl. XXI, 41–42, pl. XXVIII; Higgins 1980, 159–61; Davidson and Oliver 1984, 56–57; Laffineur 1986, 90; Lubsen-Admiraal 2004, 288–93, esp. no. 597. On beaded wire: Williams and Ogden 1994, 23–24; Williams 2005, 110.

—JSS

Bichrome Amphora with Wading Birds

Cypriot, Cypro-Archaic I
Purchased from P. Kolocassides of Nicosia in 1961, said to be from Polis
Ceramic; h. 33.5 cm., diam. 18.5–19.4 cm. (rim)
Polis Chrysochous, Local Museum of Marion and Arsinoe
(MMA 73; formerly Nicosia, Cyprus Museum 1961/XII-15/2)

Condition: Warped in firing; one side cracked in antiquity; paint worn and chipped.

Cypriot pictorial vessels are most common in eastern Cyprus. When painters in Polis chose to include figures, single fish and birds were the usual subjects, as on jugs with modeled human and animal figures (see cat. no. 6). An exceptionally detailed scene of wading birds fills the panels around this short-necked amphora. Its round-bodied shape and two-colored, or bichrome, bands of decoration are identical to vessels from Polis, especially in tombs at Evrethades. Characteristic of Polis is the short, out-turned rim. The largest bird in each section appears in profile except for a fan of tail feathers. Their bodies are all or partly outlined and filled with dots. Wings extend upward. Several wading birds are shown in ancient Egyptian art and are known to migrate to or nest on Cyprus, including herons and cranes (compare cat. no. 21). The thick necks and speckled appearance of the large birds on this amphora are features of some herons. In the first millennium B.C.E. in Mesopotamia, the heron, like the dove (see essay III), was associated with the god Dumuzi (Tammuz), the shepherd who was brought to the underworld to replace Inana (Ishtar), the lady of heaven, known on Cyprus as Astarte (see cat. no. 63). A Mesopotamian list of birds describes the heron as crowding about with his nose bent down. This habit is known as peering over. Raising the wings shades the water's surface, making it easier to catch fish. The use of silhouette and smaller scale for most birds and the placement of one bird "above" the tail of another emphasize viewing at a distance, with birds flocking, crowding one behind the other. The row of concentric circles (compare cat. no. 28) below the birds on one side of the vessel and the immersion of the especially tall bird at the handle convey their shallow aqueous context. A river-like panel runs between the two groups of birds, and two more rivers cascade through the geometrically rendered mountainous terrain on the opposite side, which includes a pair of birds and stylized plants. Probably placed in a tomb, this vessel recalls wading birds on a cremation burial urn at Amathous; herons symbolized passage to or communication with the underworld, as well as spring and rebirth.

PUBLICATIONS

Karageorghis (V.) 1962, 334–35, fig. 9; Karageorghis (V.) and Des Gagniers 1974, 478, no. XXV.h.17.

NOTES

Polis-Evrethades: Gjerstad 1935b, 375, Tomb 64 no. 3, pl. LXX.4, and 420, Tomb 82 no. 5, pls. LXXX, CVIII.1; Gjerstad 1948, fig. XXXI.9. Egypt: Houlihan 1986, esp. 18–20. Mesopotamia: Lambert 1970, esp. 117. Behavior: Sibley 2001, 170–76. Amathous: Christou 1998, 210, fig. 12.

—JSS

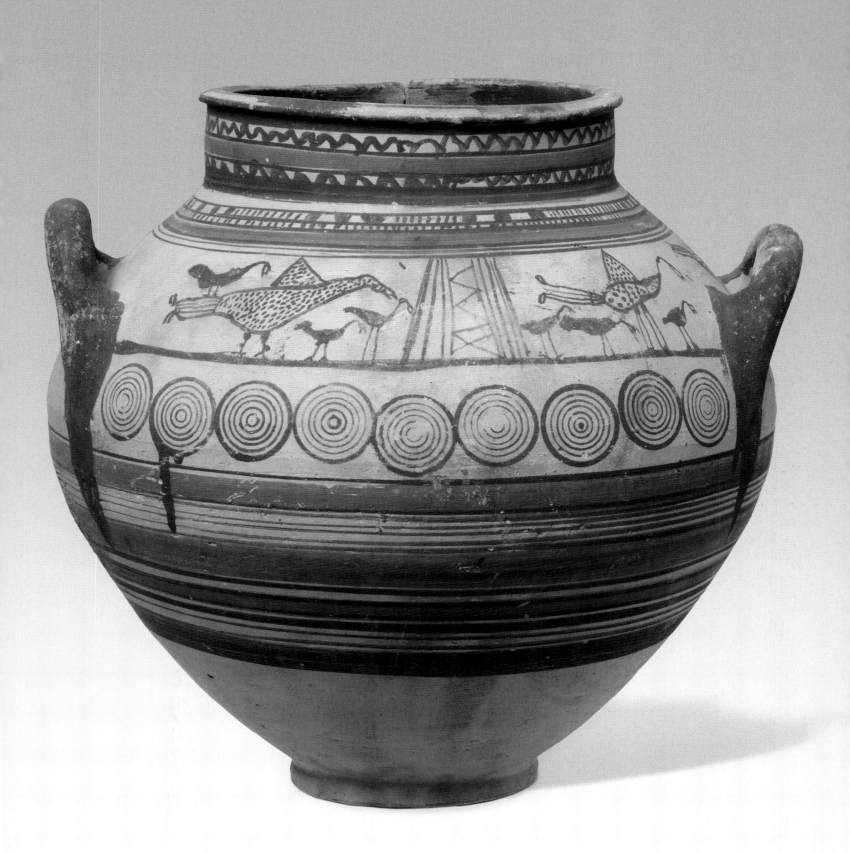

Pedestaled Krater with Geometric Decoration

Cypriot, 7th century B.C.E.
Purchased from Mr. G. Ficardos of Polis, said to have been found in a tomb
of the eastern necropolis at Polis
Ceramic; h. 59.5 cm., diam. 30 cm. (rim)
Polis Chrysochous, Local Museum of Marion and Arsinoe (MMA 2; formerly Nicosia,
Cyprus Museum 1968/IX-16/1)

Condition: Reconstructed from several fragments. Missing fragments from one handle and the lower part of the belly have been restored. Added white slip is missing from several palmettes of the neck, as well as from the dots on the horizontal surface of the rim and those below the meander panels on both sides. The black slip on the handles has largely disappeared.

This sturdy krater was found in an undocumented tomb in the eastern necropolis of Marion. The shape derives from a well-established type of Greek Geometric pottery that was imported to Cyprus as early as the eighth century B.C.E. In this case, however, the Cypriot potter has added a low vertical neck and a flaring rim. The overall decoration, identical on both sides, is somber. It includes groups of dark horizontal bands on the light background of the lower part of the biconical body and wide panels between the handles. The latter are dominated by two symmetrical angular coils of an extended meander-like pattern. The austerity of this scheme is mitigated by ornaments added in white: a band of white disks on the horizontal surface of the rim is echoed by similar bands, one beneath each meander panel where circles have been reserved against the black and filled in with white. Likewise, an elegantly drawn frieze of palmettes enlivens not only the neck but also the overall appearance of the krater.

So far, this Bichrome Red krater lacks parallels from Marion. The shape was never widely produced in Cyprus. In Aegean contexts, pedestaled kraters functioned as grave markers (e.g., in Attica) or as containers of wine at banquets. The latter may have been the case for the Marion krater before its funereal usage. A krater closely repeating both the shape and the decorative scheme was part of a funerary assemblage of a richly furnished warrior burial near Palaipaphos (Kouklia). A sumptuous burial probably was the original context of the Marion krater as well.

PUBLICATIONS
Karageorghis (V.) 1969, 444–45, no. 18, fig. 20a–b.

NOTES
For the shape, compare the White Painted IV krater from Idalion at the Medelhavsmuseet, Stockholm: Karageorghis (V.) 2003, 143–44, no. 173. For shape and decorative scheme, compare Gjerstad 1948, pl. XXXII, no. 11b (Bichrome IV). For the Palaipaphos tomb, see Karageorghis (V.) 1967, 202–45 (krater: 207, no. 1, 220–21, figs. 7a and b, 8).

—NP

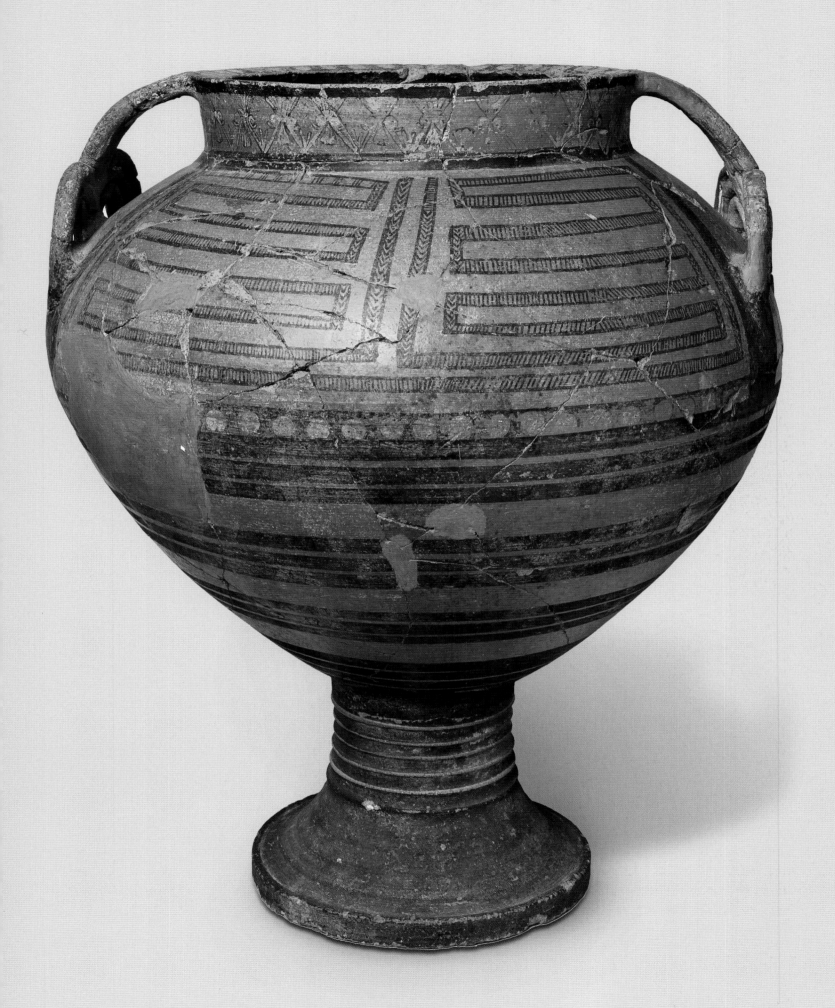

21

White-Ground Oil Bottle (Alabastron)

Greek, Attic, ca. 510–500 B.C.E., signed by the potter Pasiades, attributed to the Pasiades Painter
and the Group of the Paidikos Alabastra
Found by Max Ohnefalsch-Richter at Polis-Necropolis II, Tomb 162, in 1886
Ceramic; h. 14.56 cm., diam. 4.76 cm. (max.), 4.24 cm. (mouth)
London, British Museum (1887.8-1.61 [B 668])

Condition: Repaired, with inpainting of cracks; two pieces missing at the feet of the woman at left.
Surface wear.

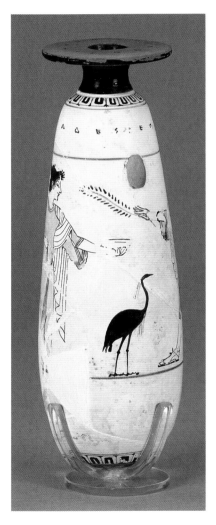 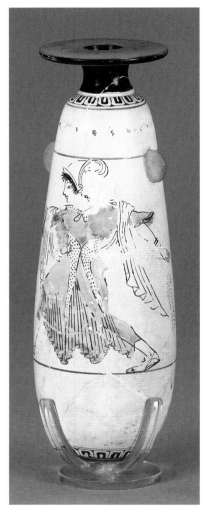

The alabastron derives its name from Egyptian vessels carved from white alabaster that Greek potters imitated in clay. Most decoration on this tall, slender flask is drawn in outline on a ground of white slip, a technique introduced, after some earlier experiments, toward the end of the sixth century B.C.E. A red-figure palmette, carefully drawn and framed by a band of egg pattern, decorates the rounded base of the vessel, which cannot stand unassisted; alabastra often are represented hanging from a cord. A pair of unpainted lugs on either side helped grip the oily flask. Another band of egg pattern circles the body below the neck. Below this is an inscription giving the name of the potter: ΠΑΣΙΑΔΗΣ ΕΠΟΙΕΣΕΝ (Pasiades made it). A second inscription on top of the flat reserved mouth states simply: Ο ΠΑΙΣ ΚΑΛΟΣ (the boy is handsome), a common declaration that, as in this case, often has no apparent connection with the subject matter.

Alabastra generally were used by women as containers of perfume and other unguents, and feminine subjects predominate. The two women who fill the figural frieze here are painted in outline with black relief lines. Between them stands a pet bird, probably a demoiselle crane, drawn in silhouette. It looks toward a woman running in from the right who is dressed in sandals, a turban-like head cloth (*kekryphalos*), a chiton, and a himation that drapes over each arm. The chiton is a striking yellow, produced by coating the white ground with a wash of diluted black glaze. Over this she wears a spotted fawn skin, a *nebris*, tied at the throat and waist. The skin and the branches that she carries suggest she is a maenad, a frenzied female follower of the wine god, Dionysos. The woman facing her also wears a himation and a yellow chiton, but is of a different character. Her hair is tied back in an elaborate queue, a *krobylos*. She stands quietly before the charging maenad, extending

in one hand a shallow dish, a phiale. We may wonder if she is an ordinary Athenian woman offering a libation to Dionysos, whose epiphany is symbolized by the advent of his intoxicated acolyte.

Another white-ground alabastron, found at Delphi and now in Athens, was made by the same painter and potter. It features an even stranger pair of women, again meeting before a bemused crane: a maenad, wearing a leopard skin and carrying a snake and a hare, runs toward a charging Amazon, armed with a hatchet and bow. The alabastron from Marion was found along with a silver ring with a gold fly (cat. no. 53) and a red-figure cup in the manner of the Euergides Painter, an artist whose workshop was the apparent milieu of the potter Pasiades.

PUBLICATIONS

Murray 1887, 318–19, pl. 82; Walters 1893, 296, no. B668; *ARV*² 98.1, 102.2, 1626; *Paralipomena* 330; Boardman 1975, 61, fig. 107; Gjerstad et al. 1977, 58, no. 558, pl. 76.2a–c; Mertens 1977, 128, no. 1, pl. 18.3; Robertson 1992, 52–53, figs. 39–40; Cohen 2006, 211–12, no. 57.

NOTES

Pasiades, the Pasiades Painter, and the Group of the Paidikos Alabastra: *ARV*² 98–104, 1626, 1700. Cranes and roll-out images of the alabastra from Polis and Delphi (Athens Nat. Mus. 15002; *ARV*² 98.2, 102.3): Böhr 2002, 44–45.

—JMP

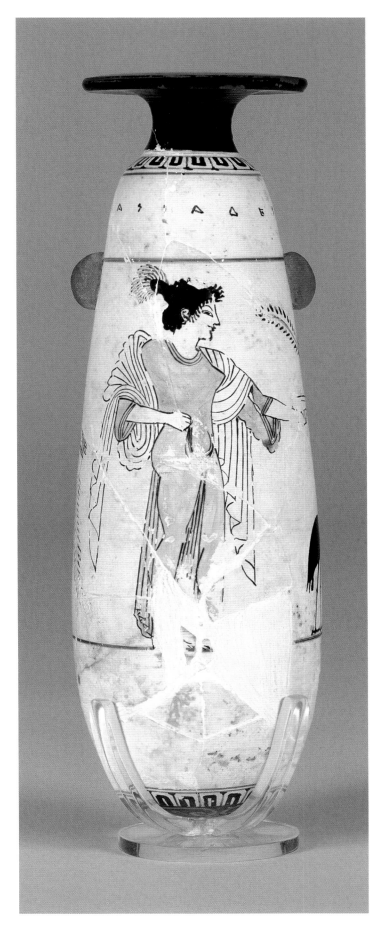

Red-Figure Oil Bottle (Lekythos)

Greek, Attic, ca. 475 B.C.E., attributed to the Providence Painter
Found by the Swedish Cyprus Expedition at Polis-Kaparka, Tomb 41, in 1929
Ceramic; h. 38 cm.
Nicosia, Cyprus Museum (SCE Marion P.T. 41.11)

Condition: Repaired from large fragments; minor repainting of cracks.

This one-handled oil bottle, or lekythos, is an elegant example of the shape at the dawn of the Early Classical period. The glossy black glaze sets off the red-figure decoration: egg pattern below the neck, palmettes and tendrils on the shoulder, and bands of meanders and checkerboards above and below the figure. A woman stands with her left leg frontal, her right leg and breast in profile, and her head turned to the right. She wears an ankle-length chiton with wide sleeves, and over this a himation that drapes over her left arm. On her torso, the folds of the chiton are drawn with brown dilute glaze. She wears earrings and, in her hair, a diadem, below which fall long tresses. In her left arm she cradles a scepter, while in her right she holds a shallow dish, a phiale, from which she pours a libation of red wine. Though she was initially identified as Persephone, Beazley recognized the woman as Zeus's wife, Hera, who frequently is depicted with a diadem and scepter, and who in this period, along with other gods, often is represented pouring a self-referential libation. One assumes that the inscription in the field—ΚΑΛΕ (pretty)—refers to the goddess.

The Providence Painter, whose real name is unknown, was both talented and prolific, decorating a range of shapes, particularly lekythoi and Nolan amphorae. Women are among his favorite subjects. His neat compositions and precise execution attest his apprenticeship in the workshop of the Berlin Painter.

Lekythoi were common funerary offerings. Of the three burials in the tomb where this example was found, two were females, identified through their jewelry and toiletries, including a bronze mirror. The three dozen ceramic vessels in the tomb could not be sorted by burial; the lekythos must derive from one of the earlier interments, as the latest should be associated with a pair of Attic red-figure askoi dating to the last quarter of the fifth century. Most of the pottery was Cypriot, including two jugs with molded figures on the shoulder of a woman holding a vessel (compare cat. no. 7) and another with a bull's head (compare cat. no. 8). The mix of Attic and Cypriot vessels speaks to Marion's trade relations with the Greek mainland and the extent to which certain Greek funerary practices—for example, burial with decorated lekythoi—had been adopted there.

PUBLICATIONS

Gjerstad 1935b, 294–95, no. 11, pls. 53.1 and 144.2–3; *ARV*[2] 640.79; Papoutsaki-Serbeti 1983, 80, no. 100; Beazley 1989, 32, no. XIII.M 41.11, pl. 15.2.

NOTES

Providence Painter: *ARV*[2] 635–46, 1663, 1702; *Paralipomena* 400–402, 514; Papoutsaki-Serbeti 1983; Robertson 1992, 174. Hera: *LIMC* 4 (1988), *s.v.* "Hera," 659–719, pls. 405–35 (A. Kossatz-Deissmann). Gods offering libations: Patton 2006. Other depictions by the Providence Painter of Hera pouring a libation: *ARV*[2] 638.52, 643.116, 643.120bis, 643.121.

—JMP

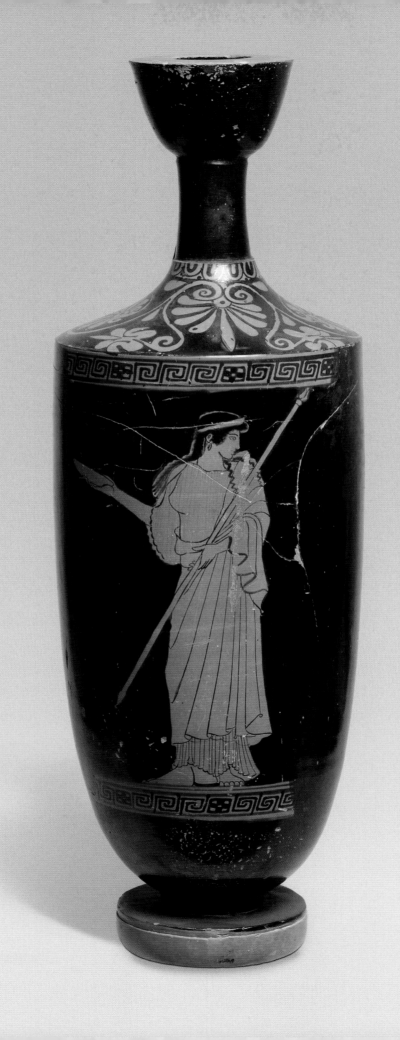

II.

MARION: A CITY-KINGDOM OF ANCIENT CYPRUS

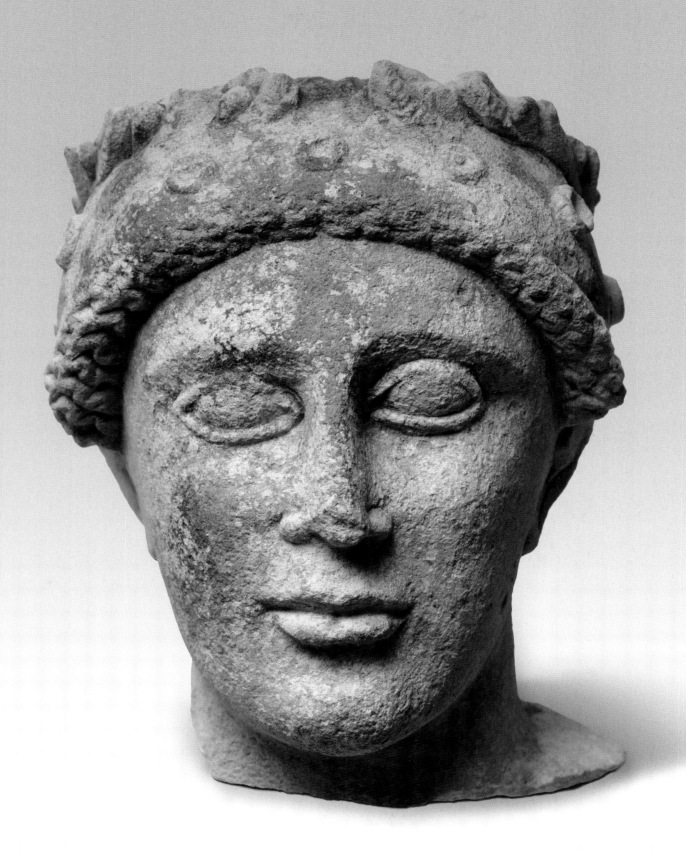

FIGURE 2.0. View across Polis-Peristeries looking west, taken from a helicopter in 2006, showing the B.D7 sanctuary, the B.F8/9 "Palace," and the spread of ancient Marion from east to west.

MARION: A CITY-KINGDOM OF ANCIENT CYPRUS

William A. P. Childs

In the first millennium B.C.E., Cyprus was divided into a number of city-kingdoms, of which Marion was one. Located at the western end of the island on a broad bay facing northwest, the city-kingdom's territory extended to the south up the fertile valley of the Chrysochou River (figs. 2.0, 2.1). The role Marion played in the political history of Cyprus is known only in the broadest terms because of a paucity of written sources. By contrast, archaeological evidence uncovered over a little more than a century, especially in the recent excavations by Princeton University, has revealed the history of the Polis area over thousands of years.

After the end of the Bronze Age, about 1050 B.C.E., little is known historically of Cyprus until the establishment of a Phoenician colony at Kition (modern Larnaka), at the southeast end of the island, probably by the end of the eighth century. The advance of the Assyrians out of their homeland on the upper Euphrates and Tigris Rivers is probably responsible for the Phoenicians taking to the sea and developing a vast commercial network across the Mediterranean. The Greek historian Herodotus (1.1) begins his great history of the conflict between the Greeks and Persians with the rape of Europa by Phoenician merchants, an excellent illustration of the use of myth by the Greeks to explain their world. The common language of much of Cyprus from sometime near the end of the Bronze Age was

a dialect of Greek, whereas the Phoenicians spoke a Semitic language. It is nonetheless apparent that the two linguistic groups intermingled, and Phoenicians appear constantly in areas otherwise preponderantly Greek. The Phoenicians did not conquer Cyprus nor apparently even aim to; but the Assyrians followed the Phoenicians to Cyprus and received tribute from the various small kingdoms under King Sargon II at the very end of the eighth century and maintained some form of control well into the seventh century.[1] Actual evidence of their presence on the island is slight, marked principally by a stele set up by Sargon II (now in Berlin).[2] After the collapse of the Assyrian Empire in the second half of the seventh century, the Cypriot kingdoms enjoyed a brief period of independence until the Egyptian Pharaoh Amasis took control of the island in 569, but all fell before the expanding might of the Persians, with Egypt and Cyprus swallowed up by about 525.[3]

A peculiarity of this prolonged foreign rule of Cyprus is that there rarely seems to have been any significant administrative or military presence on the island; a cylinder seal excavated in 1986 (cat. no. 54), however, is a rare example of an official Persian object on the island. The foreign continental powers sought control of the island on account of its wealth in copper ore and timber for shipbuilding, as well as its strategic position in the center of the eastern Mediterranean. Within this brief sketch of the

FIGURE 2.1. View of Chrysochou Bay from the Baths of Aphrodite west of Latchi.

Cypriot Iron Age, the city-kingdom of Marion definitely played a typical role, which the excavations by Princeton University have greatly helped to clarify.

The identification of the ancient remains that underlie and surround the modern village of Polis Chrysochous on the west coast of Cyprus (Map 3) as those of the ancient cities of Marion and its Hellenistic successor, Arsinoe, has been based until very recently on ancient accounts of the geography of Cyprus, principally of the Roman imperial period.[4] An inscription of the later second century B.C.E., however, identifies the site unequivocally as Arsinoe; it was acquired in 1862 by Edmond Duthoit and transferred to the Louvre. Though well known to epigraphers, it was unknown to archaeologists until rediscovered by Amy Papalexandrou and Tina Najbjerg (see essay IV). The only contemporary mention of Marion is in the *Periplous* by the author known as Pseudo-Skylax, whose treatise, composed in the last third of the fourth century B.C.E., is an account of the principal towns and geographic features encountered when sailing in the then known world.[5] He simply notes that Marion was a Greek city on the west coast of Cyprus between Soloi and Amathous, but he adds that the harbors of the towns listed were deserted (ἔρημος). Roman

geographers mention the location of the city that replaced Marion, Arsinoe, but there were three cities with that name on Cyprus, which initially led to some confusion.[6] In two cases, the earlier name of the city was recalled, which leaves no room for uncertainty.[7] Other than the inscription mentioned above, no further evidence has appeared that gives the name of the site, and, strangely, the quarter-century of excavations by Princeton University has recovered only one possible and two certain coins from the mint of Marion (cat. no. 41),[8] the city of the Archaic and Classical periods, though numerous coins of Marion have been discovered by a local antiquarian to the south and east of the modern village.[9]

Although Marion was a prosperous city with lucrative copper mines at the modern site of Limni, barely five kilometers distant to the east, it rarely appears in the historical accounts of Cyprus.[10] The first mention occurs in the history by Diodorus Siculus, who wrote in the first century B.C.E. Diodorus (12.3.3) recounts that when the Athenian general Kimon attacked the Persians on Cyprus in 450/449 B.C.E., he captured a city whose name is corrupted in the manuscripts but probably is Marion.[11] The next historical event in which Marion appears to have played a role

was over one hundred years later, in the turmoil after the death of Alexander the Great in 323 B.C.E. In a fragment of Arrian, a Roman historian of the early second century C.E. who treated these events, Marion may be the city involved in the dispute in 321 between Perdikkas and Ptolemy of Egypt, two of Alexander's generals who sought to inherit his empire, but again the name of the city is corrupt.[12] The earlier and more extensive commentary of Diodorus (19.62.6; 79.4–6)[13] relates that some few years later (315) the king of Marion, Stasioikos II, maneuvered between Antigonos, another contender for supreme power, and Ptolemy. Ptolemy won control of Cyprus and destroyed Marion in 312 B.C.E., and moved the population to his new capital of the island at Nea (New) Paphos. Arsinoe was founded sometime ca. 270 B.C.E by his son, Ptolemy II Philadelphos, who named the new city after his volatile and politically engaged wife. After that, the historical records almost disappear (see essays III–V).

The earliest evidence for human habitation on the site of the later cities of Marion and Arsinoe are scattered sherds of pottery of the Chalcolithic and the Early Bronze Age, about 2500 B.C.E. These occur broadly in washes and fills in the two trenches excavated by Princeton University in Areas E.F2 and E.G0 within the northwestern perimeter of the modern village of Polis Chrysochous (Map 3; Plans 5 and 7). The material in Area E.F2 was found at great depth in what must have been a ravine gradually filled with soil and debris from the higher ground to the west, while the sherds in E.G0 were in pits in the conglomerate sub-layer that forms a flat-topped bluff facing the sea. Bronze Age sherds were found in the lowest layers under the sanctuary on the Peristeries Plateau (Area B.D7) to the northeast, but these are too small and worn to be accurately dated. All of this evidence suggests that a series of hamlets occupied the various plateaus and bluffs of the later location of the city of Marion. Rescue excavations of a tomb next to the church of Pano Argaka in 1990 and earlier at Magounda produced pots of the late Middle Bronze Age and early Late Bronze Age (cat. nos. 24–26), and broad archaeological surveys have demonstrated that the whole northwestern end of Cyprus was covered with small communities throughout the Bronze Age (ca. 2600–1200 B.C.E.).[14] Indeed, scattered throughout Princeton's trenches are tiny sherds of the Late Bronze Age, a period when Mycenaean Greek pottery on Cyprus was prominent; but it is noteworthy that there is no Greek mythological hero recorded as founder of the city. The peninsula just to the north and west of Polis is known as the Akamas, after a Greek hero of the Trojan cycle, but

Einar Gjerstad dismisses accounts of his activities in the east as "political mythology."[15]

It is not yet clear when the inhabitants of the area that became the city of Marion, the principal seat of a kingdom, drew together to form an urban core. It has been suggested that the name Marion may occur on the inscribed clay prism of Esarhaddon, a king of Assyria, of 673/672,[16] which lists ten vassal Cypriot kings, but expert opinion is divided.[17] It is nonetheless clear that extensive and organized cemeteries were already in existence in the later eighth century B.C.E. that reveal a degree of prosperity for which both the adjacent copper mine of Limni and the fertile valley can be assumed to be responsible. The ancient city at its largest covered a series of plateaus that stretch from the high ground in the west, below which flows the Chrysochou River eastward for about 1.5 kilometers, to the eastern edge of the plateau known locally as Peristeries (Map 3). Tombs occupy the land to the south with the result that the width of the city was only about five hundred meters. The modern village is centered on the western plateau; this is separated from the equally large eastern plateau of Peristeries by a narrow ridge running north–south (locally known as Maratheri, excavation Area A.H9; Plan 3). Between these elevated areas, shallow gullies provided a path for the runoff of winter rains to reach the sea to the north. Investigation in one of these gullies revealed no ancient structures. The location of the shoreline in antiquity is still unclear. Soundings taken in the 1980s and again recently indicate that the area between the present coast and the northern edges of the plateaus are clear of ancient remains to a depth of over four meters. Just to the north of the bluff of Area A.H9, however, pottery of the Classical period and some moderately large pieces of ancient concrete were found at a depth of four meters with no significant traces of human activity above.

A preliminary interpretation suggests that the ancient shoreline was close to the northern faces of the plateaus on which Marion was built, and the pottery and concrete fragments had been dumped or fallen into the sea there. Nonetheless, no trace of a harbor has yet been found, and it has been posited that there was a lagoon along the coast that eventually silted up. As noted above, Pseudo-Skylax in the last third of the fourth century B.C.E. explicitly says that Marion's harbor was deserted, which fits this preliminary interpretation of the topography. The only known harbor nearby is that at Latchi, three kilometers to the west; large Roman breakwaters were visible here until modernization over the last two decades largely obliterated them.

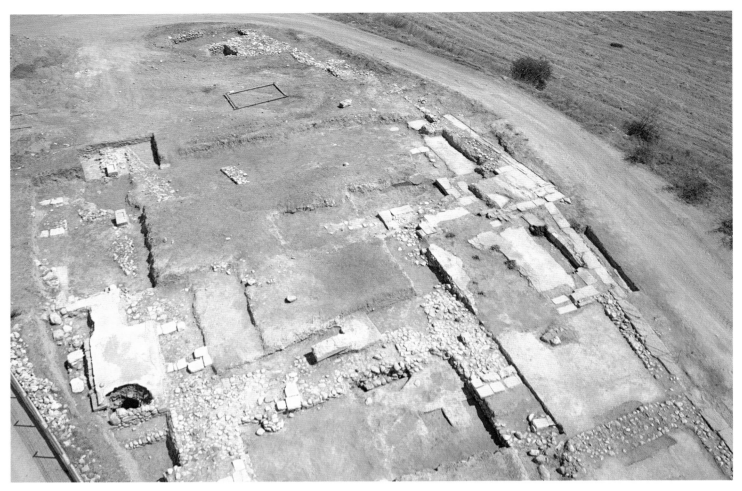

FIGURE 2.2. Areas B.F8 and B.F9 on the east side of the Polis-Peristeries plateau, as seen from a helicopter in 2006.

From the early days of excavations at Polis in the nineteenth century, it was thought that in the historical period, the earliest principal habitation area was on the plateau of Peristeries because the earliest tombs are concentrated to the east and south. This remains a reasonable hypothesis since the western part of the site has produced little material evidence after the Bronze Age until the sixth century B.C.E.,[18] at which time contemporary tombs appear in the adjacent areas to the south.

The character of the local population of the Chrysochou Valley in the Iron Age, that is, the period after the end of the Bronze Age (ca. 1050 B.C.E.), is difficult to determine. The valley is separated from the large early sites to the east by the rugged outliers of the central Troodos mountain range and from the important sites of the southern coast by high rolling terrain. Thus far, there has not been a single discovery of imported eighth-century Greek pottery, which is otherwise widely found at major Cypriot sites. This suggests that Marion did not participate in the gradual reopening of communications between the eastern and central Mediterranean that became such an important cultural factor in the eighth century B.C.E.[19]

Significant evidence of prosperity and foreign trade appeared only near the end of the seventh century and increased dramatically in the sixth century (see cat. no. 33). Despite this apparent disjunction from the rest of the island, the earliest inscriptions from Marion of the sixth century are written in the Cypriot Greek dialect and in the local syllabic script.[20] It was only during the course of the fourth century B.C.E. that the Greek alphabet made a tentative appearance and eventually replaced the local script. In addition, the presence of Phoenician influence on Cyprus can be detected right at the beginning of the formation of a real urban character; and in the course of the sixth century, objects imported from Egypt appeared. These, though not found in great numbers, are interesting because they appear to represent actual imports from Egypt rather than Cypriot versions of Egyptian themes.[21] Most notable in this respect is a small faience aryballos with the royal cartouche of Amasis.[22] Diodorus Siculus

(1.68.6) records Amasis's actions as follows: "He subdued the cities of Cyprus and adorned many sanctuaries with noteworthy votive offerings." It seems that Marion was at least the recipient of some Egyptian benefaction, and one may surmise that the fragmentary relief showing an Egyptian standing figure (cat. no. 50) may be a product of the new political situation.

It was over the course of the seventh century, and probably in its second half, that the city of Marion assumed a formal existence; until then, it has been proposed that the valley was a dependent of Paphos to the southwest.[23] About 600 B.C.E., it appears the whole site from east to west was gridded with a regular pattern of streets running north–south and east–west. On the southeastern edge of Peristeries, in Area B.F8/9, a substantial, apparently secular structure was built employing large ashlar blocks in the lower walls and mud brick above (fig. 2.2),[24] traces of which were found, but the character of these walls can be convincingly visualized only by comparison with the preserved and impressive mud-brick foundation walls of Area E.G0 (fig. 2.3). Although little pottery was collected from the rooms in Area B.F8/9, fragments of fine imported wares were found, and a small cistern produced almost complete local and imported storage vessels. These rooms around small courtyards, all with excellent concrete floors, probably served as the service wing of the building that stretched an unknown distance to the west under the recently constructed parking lot of the new elementary school. On the northern side of the building and at a slightly lower level was a series of rooms, the walls of which were made exclusively of rough stones. Here one room was filled with storage amphorae and another had a small furnace for working metal, constituting a storage and craft wing. In view of the size and fine construction of the southern part of the building, it was nicknamed the "Palace." It seems likely that another prominent building existed in the western part of Marion since an impressive Hellenistic building in Area E.G0 reused a great number of ashlar limestone blocks, several with Cypriot syllabic mason's marks (fig. 2.4; see essay IV).

The earliest excavations around Polis Chrysochous focused on the large cemetery that stretches from south of the modern village for at least some two kilometers to the east (see essay I). At various times, a limited examination of the area north of the cemetery was made, notably by Rupert Gunnis in 1927 and later by the Swedish Cyprus

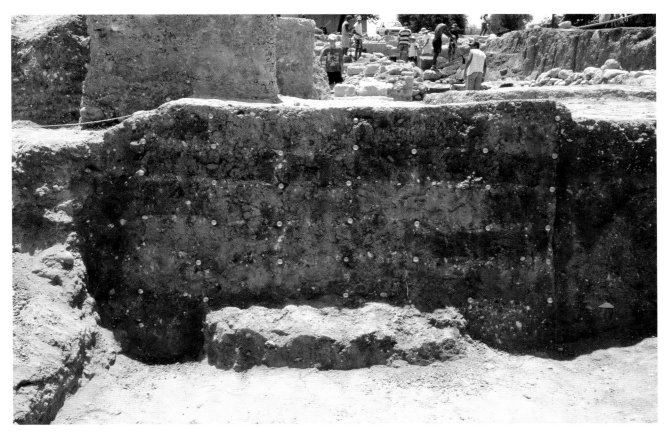

FIGURE 2.3. Mud-brick foundation wall in Area E.G0 in Polis-Petrerades, 2003.

Expedition in 1929. The results of both forays were not published. The digging of tombs continued to be exciting and lucrative since many had not been looted and contained a wealth of artifacts: local vases (cat. nos. 6–8, 27, 28), imported vases principally from Athens (cat. nos. 21, 22, 35–37, 45, 46), jewelry (cat. nos. 9–10, 12–18, 49, 53, 61), statuettes (cat. nos. 2, 4, 5), and inscriptions (cat. no. 23). The general features of the tombs are reasonably standard: the tombs are dug into the sides of the hills or sunk deep in the ground with long entrance ramps, or dromoi. The earlier tombs have a simple, single chamber roughly oval in shape. On occasion, there are niches in the dromos that probably originally held offerings to the dead; in some cases, they may have held small sculptures. The later tombs are frequently notable for their greater size and sometimes impressive architectural forms, such as rectangular plans, cut stone walls, moldings, and roofs in the form of barrel vaults (fig. 2.5), which suggests, as does so much else, a conspicuous prosperity in the later Classical period of the fourth century. The early tombs frequently held multiple burials interred over an extended period of time, but the early bodies and grave goods were simply pushed to the side to make room for the new arrival(s) with little or no decorum.

Despite the size and wealth of the tombs, it appears that until the late fifth century there were no markers set over them to proclaim the name(s) and virtues of the deceased. Indeed, the graves of Marion reveal a rather special, not to say idiosyncratic, culture in the Chrysochou Valley that differed markedly from that of the other important centers on the island. The numerous small blocks of limestone, usually with only a name carved in Cypriot syllabary, were not used as visible markers above the tombs but have been found exclusively in the dromoi or in the actual tomb chambers.[25] In the late sixth century B.C.E., a very particular type of vase was also developed at Marion and remained popular into the fourth century: the one-handled jug or pitcher with one or more plastic figures on the shoulder. These, too, have been found almost exclusively in either the dromos or the tomb chamber. In the case of a human figure, with few exceptions a woman, the figure holds a pitcher that serves as a spout (cat. nos. 6, 7); in the case of a bull protome, the head is usually the spout (see cat. no. 8). Examples of the vase type have rarely been found elsewhere on Cyprus. It should be noted, however, that a fragmentary terracotta figure of a woman belonging to such a vase was found in the jumbled fill of Area E.G0 near which there is no known tomb. Another interesting

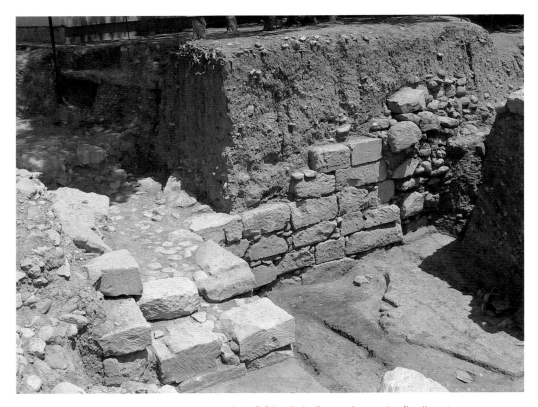

FIGURE 2.4. Ashlar construction in Area E.G0 in Polis-Petrerades reusing fine limestone ashlar blocks, many with incised Cypriot syllabary (mason?) signs, as at upper right, 2001.

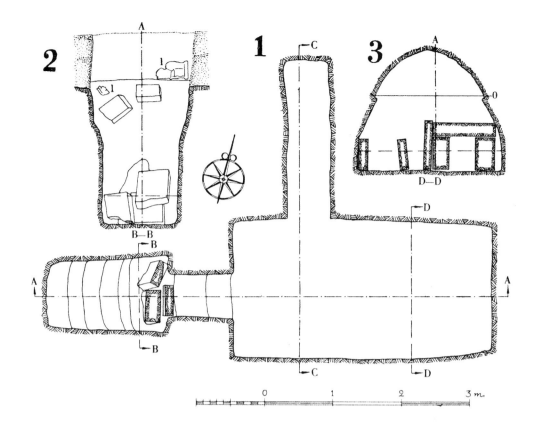

FIGURE 2.5. Plan of Tomb 53 at Polis-Kaparka, excavated by the Swedish Cyprus Expedition. Head and body of cat. no. 5 in situ at top left (2.1).

characteristic is the almost total lack of Cypriot figured pottery. The bichrome amphora with wading birds (cat. no. 19) is not unique, but it is noticeably rare in comparison to the production elsewhere on the island. Finally, one of the most remarkable customs that began in the late fifth century and lasted well into the fourth century was the placement of large statuettes in the dromoi of tombs; these are mainly of terracotta and represent men reclining on banquet couches (klinai; cat. no. 4) or women seated on more or less elaborate chairs/thrones (cat. no. 2). Since the statuettes of men and women sometimes occur in multiples in the dromos of a tomb, it has been suggested that they were intended to represent the head of the family with his entourage, but, since singletons also exist, it appears that the statuettes were sometimes intended to represent only the deceased.[26] On occasion, multiple examples in a single dromos could represent multiple burials. Two exceptions to the standard practice tend to confirm various functions of the large statuettes. The first is also the earliest: the remarkable imported marble torso of a kouros in the dromos of a tomb excavated by Ohnefalsch-Richter and now in the British Museum (cat. no. 1). This is the only

Greek marble kouros so far found on Cyprus. The damaged torso was found in the dromos of the tomb, and the question has arisen why the statue was mutilated before its deposit in the tomb. Since many of the terracotta statuettes of the later fifth and principally the fourth century were also almost certainly broken before deposit, it appears likely that the breakage sometimes had a purpose that is now inscrutable. However, the marble statue could easily have been damaged in an earlier existence in a sanctuary or on a tomb and come to Marion from anywhere under one of many different guises—booty seems eminently reasonable in a turbulent period.

The other major exception to the normal practice of the deposit of one or more terracotta statuettes in the dromos of a tomb is the magnificent limestone seated woman with attendant discovered by the Swedish Cyprus Expedition in Tomb 53 (cat. no. 5; fig. 2.5) and dated about the middle or second half of the fourth century. The type of woman and attendant with jewelry(?) box is clearly derived from Greek, principally Attic, contemporary grave stelai that stood as conspicuous monuments to the deceased in the grave plot.[27] As noted in the catalogue entry, the excavator of this

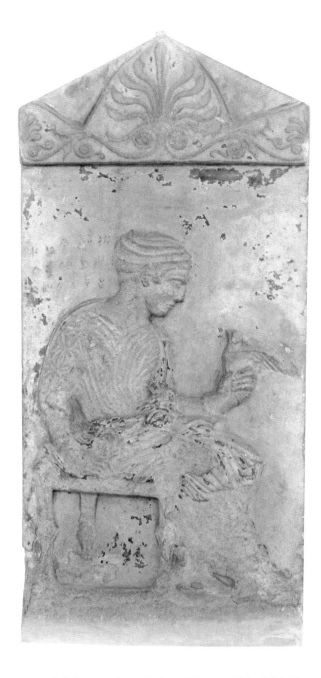

FIGURE 2.6. Cypriot, chance find, ca. 420 B.C.E.: Stele of Aristila. Limestone; h. 92.2 cm., w. 41.7 cm. Greek inscription in Cypriot syllabary: "I am Aristila of Salamis, daughter of Onasis." Polis Chrysochous, Local Museum of Marion and Arsinoe (MMA 276; formerly Nicosia, Cyprus Museum 1957/III-18/I).

statuette, Einar Gjerstad, believed it originally stood over the tomb as a visible marker, but his argument for this is not altogether convincing: the statue was found in the debris of the robbing trench in the dromos, which presupposes that it and the accompanying terracotta statuettes were still in place and in good condition when the robbing took place. Only minor elements of the limestone group were missing when it was excavated, but since elements were missing, it is possible the breakage occurred before or during the closing of the tomb. It seems reasonable to see the statuette of the seated woman as the deceased, which serves as a statement of her importance. In size and some details of the representation she resembles quite closely many of the terracotta examples. Accordingly, the type of enthroned woman could be a straightforward representation of the deceased.[28] The terracotta examples that show women in poses of mourning (cat. no. 2) could be considered adjuncts (mourners) of the deceased, except that a large limestone grave stele said to be from Golgoi (now in the Metropolitan Museum of Art) depicts an enthroned mourning woman.[29] The reclining male figures almost certainly depict the deceased, whether alone or accompanied by enthroned/ seated women. In the case of the simple inscribed blocks and the terracotta statuettes, the principal purpose of each monument type is to define in general terms the identity and prominence of the deceased, but the identification was obviously not for the living. That many were broken before deposit suggests some ritual in which breakage of the statuette(s) was a factor. The same might apply to the marble kouros, which in the Greek world would have been a proud and visible monument to the deceased. Recent excavations by Eustathios Raptou of the Department of Antiquities along the northern edge of the cemeteries has uncovered two prominent stone structures (see fig. 1.13) in the midst of tombs of the Archaic and Classical periods that must be associated with the tombs, though in what manner is unknown, but they suggest important funerary rituals.

At the very end of the fifth century, a new type of funeral monument appeared in Marion, the figural relief (cat. no. 44). In no case is there proof that the new monuments actually stood above ground as visible markers of tombs, but equally no figured relief stele has been found in a dromos or a tomb chamber. The practice of setting carved stelai over tombs goes back at least to the sixth century B.C.E. in both Greece and Cyprus.[30] The new stelai of Marion are noteworthy because they are more numerous than elsewhere on Cyprus and of high quality (fig. 2.6). They obviously imitate the contemporary stelai of Greece, and in two cases Greek marble stelai were imported.[31] At the same time, large quantities of Attic black-glaze pottery were imported to Marion, and the influence of Greece on the whole range of preserved monuments was strong.

The evidence of the daily life of the people of Marion is far more difficult to reconstruct than their funerary practices. For example, though we know from a magnetometer

survey that a large segment of the Peristeries Plateau had a regular street plan, excavation in a variety of locations on the plateau revealed that almost nothing is preserved of the houses beyond scrappy bits of foundation and an occasional patch of a lime-plaster floor (fig. 2.7). The walls are all about fifty centimeters wide and at least the lower sections were of rubble; presumably the upper walls were of mud brick. It is worth noting that the recent modern buildings of Polis and surrounding villages were extensively built of mud brick (fig. 2.8), although almost all have now been replaced by concrete and ceramic building tile covered with stucco. Small grinding stones are numerous on Peristeries, and pieces of large storage containers (*pithoi*) are scattered broadly, as are fragments of storage amphorae. Little fine pottery, whether of local manufacture or imported, was in use in contrast to the area of the large ashlar building known as the "Palace" to the southeast. In the sanctuary of Area B.D7, the frequent discovery of votives derived from industrial activity suggests that the sanctuary served a local community of artisans (see essay III). There is a notable lack of stone sculpture of any size and of imported decorated pottery.

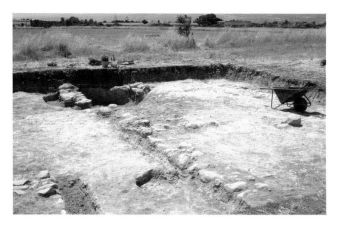

FIGURE 2.7. Sixth-century B.C.E. lime-plaster floor and rubble wall foundation in Area B.C6 at Polis-Peristeries, 1986.

Somewhat more extensive remains of houses occur in the lowest levels of Area E.G0. In this case, only sections of lime plaster floors were found, but in one case there were also numerous fragments of Cypriot painted vases together with late sixth-century B.C.E. imported varieties of storage amphorae. In one instance, a series of complete vases was found on a rough gravel floor; among these were two terracotta bells (cat. no. 83), a tripod kernos, and plain

FIGURE 2.8. Modern mud-brick building in Pelathousa, a village near Polis-Chrysochous, ca. 1985.

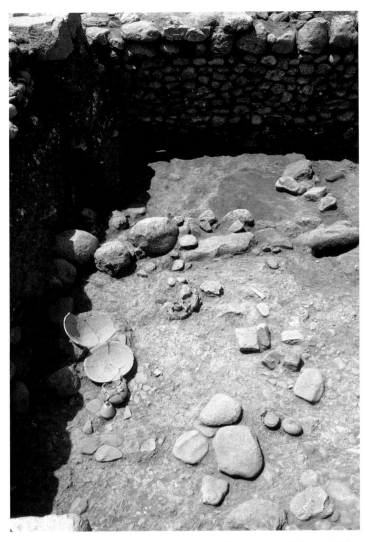

FIGURE 2.9. Late 6th-century B.C.E. pottery and terracotta bell (lower left) on gravel floor in trench E.G0:f06 at Polis-Petrerades, 1991.

deep bowls (fig. 2.9). A hearth was nearby. The bells and kernos suggest that the vases belonged to a cult place, but this could easily be within a domestic setting.

The only other remains of Marion other than the public buildings appeared in Area E.F2 at great depth. Here the evidence is ambivalent. On the eastern side of the trench, part of one building used fine ashlar blocks coupled with small, finely graded rounded stones. The other building to the west appears to have been built only of rubble (fig. 2.10). No floors were preserved in either case, though a small section of rough paving is associated with the walls on the west. It was here that a large amount of imported Attic pottery was found together with the fragments of the Fikellura amphora (cat. no. 34), an import from Miletus on the west coast of Asia Minor. But typical of all the earlier levels of Marion outside of the sanctuaries, fragments of

the Fikellura amphora were found scattered over almost the whole lower trench in Area E.F2, some one hundred square meters. Here no hearth was found, and the quantity of fine painted pottery, both Cypriot and imported, suggests a public space rather than a domestic one, though the evidence is insufficient to be certain.

The impression conveyed by both the tombs and the sanctuaries of Marion is of a homogeneous society with only moderate social distinctions, an urban center that drew on the varied cultures then prevalent on Cyprus. That there were imposing public buildings such as that on the east side of Peristeries nicknamed the "Palace" and coins minted with the names of the kings of the city does not find a corresponding element in the objects recovered, which do not suggest a powerful monarchy. There have yet to be found impressive remains suggestive of significant social ostentation; Marion appears to have been a wealthy city with wide trading contacts across the eastern Mediterranean from the sixth century on, but it does not appear to have played a major role in the power struggles of the larger kingdoms of the eastern part of the island (Salamis, Idalion, Kition, Tamassos, Amathous). This is not to say that Marion did not participate in the broader historical events on the island, such as Kimon's probable capture of the city in 450/449 in his campaign against the Persians. It is also possible that there was another, earlier event in which Marion played a role that has been revealed only through excavation of the site.

One possible interpretation of the archaeological evidence of both the large public buildings and the scrappy bits of what appear to be domestic structures is that all across the site—from the eastern edge of Peristeries (the "Palace") to the sanctuary of B.D7, to the sanctuary on the ridge of Area A.H9, and to the western part of the site in Areas E.G0 and E.F2 just discussed—there appears to be a uniform destruction horizon around the year 500 B.C.E. Evidently the precision of archaeological chronology is not sufficient to make this claim with any assurance, since each of the destructions cited could easily have taken place several years apart.[32] There is, however, an interesting historical background that is worthy of note: in the years from 499 to 494, the cities of East Greece, that is, the modern west coast of Asia Minor, revolted against their Persian overlords. There was a parallel but much briefer uprising of the Cypriot kingdoms in 498 to 497 (Herodotus 5.104–16). Herodotus mentions only three kingdoms: Salamis, where the uprising began; Amathous, which alone of all the kingdoms refused to join and remained loyal to the Persians;

and Soloi (just to the north of Marion), which held out the longest after the collapse of the rebellion. Archaeological evidence adds to the picture given by Herodotus: though the kingdom of Paphos just to the south and east of Marion is not mentioned, the city was besieged and a great mass of earth, broken statues, and bits of architecture was built up against its defensive wall; this has been interpreted as a siege ramp that the defenders tried to sap—to no avail, as the city fell.[33] Indeed, Herodotus (5.115) says that "all the cities of Cyprus were beleaguered" except for Salamis. In the case of Marion, there is neither textual nor clear archaeological evidence of any such momentous events; yet it is tempting to interpret the above evidence as a reflection of them even though the city did not have a defensive wall in the sixth century.

In an attempt to give some detail to the narrative of Herodotus, Einar Gjerstad, the leader of the Swedish Cyprus Expedition in the 1920s and 1930s, interpreted a strange discovery at the site of Vouni, which lies between Marion and Soloi.[34] Here a magnificent hoard of metal vessels and silver coins was discovered in a destruction level that is dated in the early years of the fourth century.[35] Of the 252 gold and silver coins, 150 were minted at Marion. Since extremely few coins of Marion have been found outside the territory of the kingdom and of these only in the immediate proximity of Marion,[36] Gjerstad argued that some special meaning must be attached to the presence of so many coins of Marion apparently outside its territory. In brief, Gjerstad found the clue in the name of one of the kings of Marion found on coins: Sasmas (cat. nos. 40, 41).[37] Since this is a Phoenician name, Gjerstad postulated that a Phoenician king was set over Marion after the revolt of 498/497 and in some manner was given the task of monitoring the activities of Soloi to which the palace at Vouni is very close. Gjerstad's whole hypothesis rested prominently on an interpretation of Cypriot history that found favor in the late nineteenth and the first half of the twentieth century, namely that Persia used the Phoenicians of Cyprus to control the unruly Greeks and severely curtailed all contacts with Greece after 498/497. This hypothesis and the interpretation of ethnic hostilities have been largely rejected in more recent decades.[38] Indeed, it is worth noting that to carry a Phoenician name does not mean one is Phoenician; the father of Sasmas, for instance, was Doxandros (a very Greek name).[39] At the end of the fifth century, the kings again had Greek names, Stasioikos I (cat. no. 42)[40] and Timocharis,[41] which

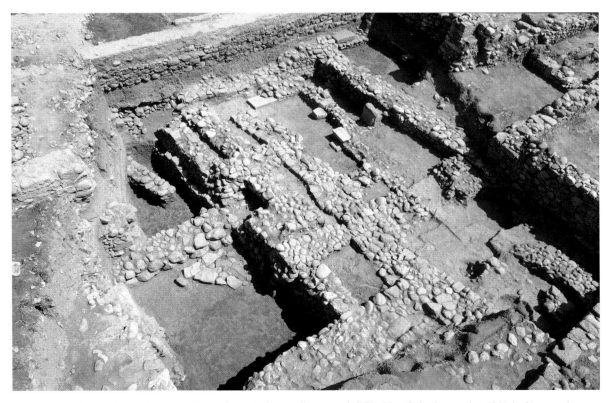

FIGURE 2.10. Hellenistic and Roman walls overlying Archaic walls in trench E.F2:r09 at Polis-Petrerades, 1991, looking northeast.

fits Gjerstad's hypothesis of a reassertion of a close Greek connection after the campaign of Kimon in 450/449 but is too circumstantial to be convincing.

If the Persians sacked Marion in the 490s, it is clear that the city revived relatively quickly. Early modern commentators believed that there was a hiatus in, or at least a diminishment of, the importation of Greek pottery after 500 and associated this with the active hostility between Greece, principally Athens, and the Persians following the great battles of Marathon and Salamis (490/480 B.C.E.). The archaeological evidence is not so clear as the early interpreters suggested: Attic pottery continued to be imported (cat. no. 22); the class of coral-red vessels produced in the early fifth century is represented by a vast quantity of sherds in Princeton's excavations and by whole examples in the tombs dug by our predecessors (cat. no. 36). Even though there was a major attempt to clean up and rebuild the sanctuary on Peristeries, the new building was far smaller than its predecessor and the material associated with it does not extend very far into the fifth century. The "Palace," too, was abandoned, as was probably the whole of the area of Peristeries; Marion shrank to its western part from the ridge of A.H9 westward. The date of the A.H9 sanctuary's reconstruction remains uncertain, but it may have been shortly after the 490s, to judge by the Late Archaic terracotta torso (cat. no. 72) and Classical terracotta statues, recently found together by Eustathios Raptou of the Department of Antiquities, and the Late Archaic limestone statue fragment found in the robbed-out footing trench of the portico of Area A.H9 (fig. 2.11; see also fig. 3.14).

The evidence of prosperity from the tombs despite the smaller size of the city contrasts with the almost total lack of stratified remains of the city itself in the Classical period—aside from the relatively well-preserved sanctuary in Area A.H9. This is due to the extensive rebuilding of the western part of the city after its thorough destruction in 312 and continually thereafter by Romans and Byzantine Christians. There are, however, two small areas within the modern village excavated by the Department of Antiquities that probably belong to the fourth century B.C.E. and provide some additional information, though both are not yet published. In 1995, Yiannis Ionas excavated a large cache of terracotta figurines of Archaic and Classical date in the new public park of the village next to the church of Agios Andronikos at the western edge of the town on the bluff above the Chrysochou River. Evidently there was a sanctuary nearby. Another area just to the

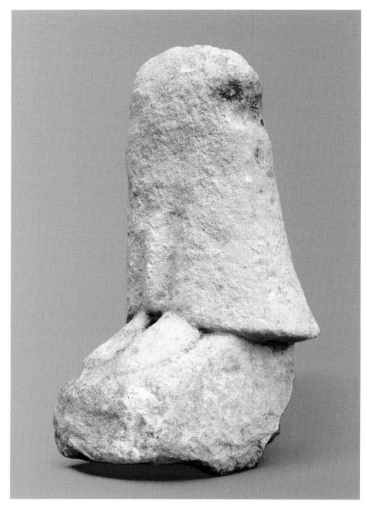

FIGURE 2.11. Cypriot, from Polis-Maratheri, Late Archaic period: fragment of a statue. Found by Princeton in trench A.H9:r13, 1986. Limestone; h. 63 cm., w. 37 cm. Polis Chrysochous, Local Museum of Marion and Arsinoe (Princeton Cyprus Expedition R3322/SC22). See fig. 3.14.

south of Princeton's excavations in Area E.F2 was recently excavated by Eustathios Raptou in which he found an extensive workshop area that might be of the late fourth century B.C.E., though an early third-century date seems more probable. Since the Princeton excavations uncovered a large area of workshops of Hellenistic and Roman date just to the south of the basilica in Area E.F2, this part of the city may have been dedicated to manufacturing during those periods.

The most impressive evidence of the fourth century excavated by Princeton University is the sanctuary of A.H9. The form of the preserved Classical sanctuary is largely symmetrical with a moderately monumental front to the temple building, or *naos* (see essay III). These characteristics differentiate the sanctuary and temple from the more rambling Archaic sanctuary of B.D7. The appearance of the sixth-century sanctuary at A.H9 is not known, but evidence of its existence comprises a scatter of Archaic pottery, terracotta statues (possibly cat. no. 72), and even fragments of stone sculpture, some belonging to life-size and nearly life-size statues (possibly fig. 2.11). These underscore another distinction between the sanctuaries of A.H9 and B.D7; in the latter, almost no stone sculpture was found, an exception being an Egyptian limestone relief (cat. no. 50). The sanctuary at A.H9 was clearly the place to dedicate large and impressive gifts to the gods—even in the sixth century.

It is not only the sanctuary here that is noteworthy but also the extensive remains of the city wall. The city wall encroached on the east side of the sanctuary as it ran north–south along the narrow raised ridge. To the south of the main complex was a small rectangular building (*naiskos*) with a fragment of a medium-sized stone statuette built into one wall. The city wall grazes the southeast corner of this naiskos. These facts suggested right from the beginning of our inquiry that the city wall was of a late date.

It is only the lowest part of the city wall that is preserved; this is built of rounded riverine stones and is 3.25 meters wide. The upper part of the wall must have been made of mud brick. Apart from the main stretch of the wall next to the sanctuary, its empty footing trench was found some 50 meters to the south. Just to the north of the sanctuary, the wall jogs to the west to avoid a particularly soft area of the lime conglomerate that forms the surface of the ridge (fig. 2.12). Ashlars were used to strengthen the corner. Traces of the city wall to the west were reported in the unpublished diaries of Eugen Oberhummer, who visited

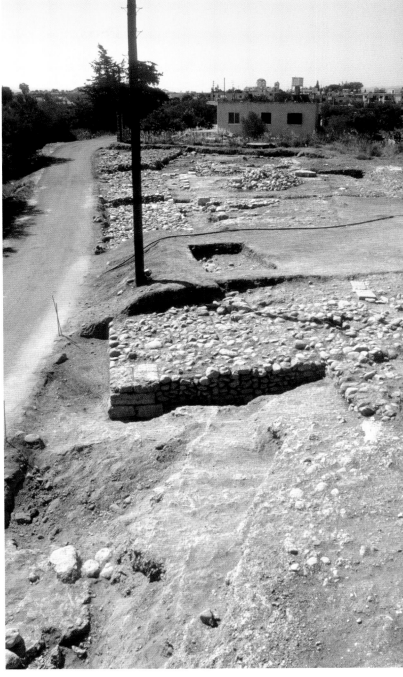

FIGURE 2.12. City wall of Marion, late 4th century B.C.E., seen from the north, Area A.H9 at Polis-Maratheri, 1997.

the site in 1887.[42] The exact location is unclear, but it was perhaps to the west of Area E.G0.

The preserved and excavated section of the city wall at A.H9 is extremely interesting. When Veronica Conkling, one of our architects, was making the detailed drawing of the wall, she noticed a number of fragments of stone sculpture incorporated in its fabric. Two small test trenches were excavated in the wall in which numerous fragments of terracotta and stone sculptures were found, including the broken statuette of a draped woman (fig. 2.13; cat. no. 77) whose fragments were scattered over a large area among the riverine stones that constitute the main material of the wall. There were also bits of broken pottery, pieces of ashlar blocks, and earth. The wall was clearly built in a hurry and anything close to hand was thrown in. It is extremely likely that the wall was quickly erected at the time of the hostilities after the death of Alexander, mentioned earlier in this essay.

There is an additional and perhaps poignant aspect of the city wall: as the plan of the sanctuary and wall shows (see Plan 3), there was a narrower diagonal wall on the eastern side of the south (excavated) end. This diagonal wall corresponds to a change in the composition of the main part of the wall: here the wall is built of relatively soft and rough limestone in even courses that contrast with the jumbled character of the rest of the wall (fig. 2.14). It would appear that there had first been an opening in the wall that was later filled. The limestone patch might have been in response to an actual attack that preceded Ptolemy's final siege. Whatever disturbances may have led to its construction, the city wall did not succeed in protecting Marion when Ptolemy laid siege in 312. Evidence of the sack of the city is eloquently expressed by the black stain on the face of the wreathed head of a man (cat. no. 39) and the headless terracotta figures of Aphrodite and Eros (fig. 2.15; see also fig. 3.3) lying facedown in the ashes of the destroyed building.[43]

FIGURE 2.13. Cutting through city wall at the sanctuary in Area A.H9 at Polis-Maratheri and discovery of 4th-century B.C.E. limestone statuette (cat. no. 77), 1995.

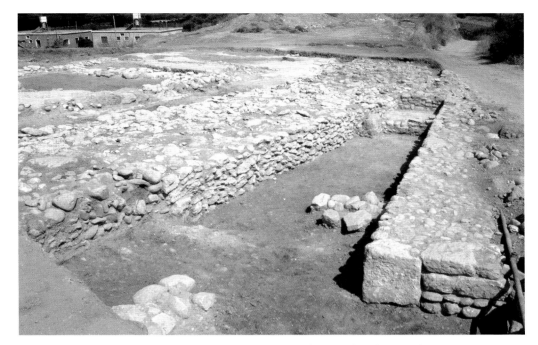

FIGURE 2.14. Patch in city wall in Area A.H9 at Polis-Maratheri, from south, 1986.

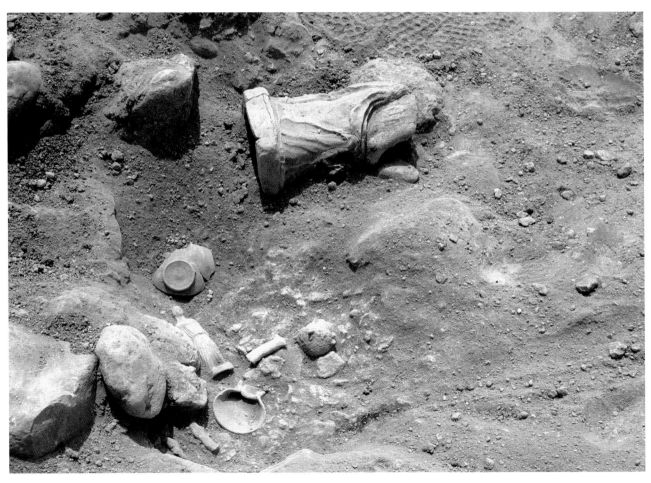

FIGURE 2.15. Terracotta statuette of Aphrodite and Eros and cat. no. 74, lying in ash layer
of temple in Area A.H9 at Polis-Maratheri, 1985. See fig. 3.3.

NOTES

1. Reyes 1994, 49–58.

2. Berlin, Vorderasiatisches Museum VA. 968: Börker-Klähn 1982, 202–3, no. 175; Radner 2010; Reyes 1997, 66; Luckenbill 1927, 2:100–103.

3. Reyes 1994, 85–97.

4. For the best account of the sources, see Peristiane 1910, 429–48, and Hill 1940, 1:122–23, 156–60.

5. Pseudo-Skylax 103 (*GGM*); Flensted-Jensen 1996, 137–67.

6. Strabo 14.6.3 (683); *Stadiasmos Maris Magni* 309 (*GGM*); Ptolemy 5.14.4 (*GGM*). Hogarth 1889, 105–8, expresses doubts about the identification of Marion with the site at Polis tis Chrysochou, as the modern village was known until recently, but none have followed his opinion on the matter. Cf. Masson 1983, 150–52, 395.

7. Pliny, *N.H.* 5, 130; Stephanos Byzantinos, *s.v.* Μάριον; Ἀρσινόη.

8. R863/NM405 AE: Circular shield/Lion's head l., roaring; R39988/NM1749: AR 1/6 siglos (cat. no. 41); R2576/NM573.

9. Destrooper and Symeonides 1998.

10. *IG* II² 1675, line 18: copper for the Propylon of the Sanctuary of Demeter at Eleusis of the late fourth century B.C.E. to come from Marion.

11. All the modern editors of Diodorus accept the emendations of this passage by Peter Wesseling in 1735. Cf. Hill 1940, 1:123 with note 2; Collombier 1991, 34 with note 35; Raptou 1999, 246.

12. Arrian, *Affairs after Alexander*, fragment 24 §6, 19–22 (Roos and Wirth 2002, 2:280); Maier 1994, 333; Hill 1940, 1:156–57.

13. Hill 1940, 1:156–60. Actually the city name is also corrupt in Diodorus 62.6, but there it is connected with the king Stasioikos and is thus unquestionable.

14. Adovasio et al. 1978, 39–57; Maliszewski 1997, 65–84; Maliszewski et al. 2003, 7–38.

15. Gjerstad 1944, 120.

16. Lipiński 1991, 62, no. 10.

17. Masson 1983, 152; Masson 1992, 29; cf. Borger 1956, 60; Collombier 1991, 27–28; Reyes 1994, 24, 58, 160.

18. Childs 1997, 39–40.

19. Gjerstad et al. 1977; a single fragment of an East Greek "bird bowl" of the early 7th cent. B.C.E. is noted in cat. no. 34.

20. Masson 1983, 152.

21. Contrast Petit 1995, 131–47, on the adoption in Amathous of Egyptian motifs.

22. Dikaios 1946, 7, pl. 1d; Dikaios 1961, 154, pl. XXXIII.6.

23. Rupp 1987, 150.

24. Papalexandrou (N.) 2006, 223–37; 2008.

25. Masson 1964, 187–88; Masson 1985, 87–89.

26. Raptou 1997, 229.

27. Clairmont 1993.

28. Raptou 1997, 233–34.

29. Karageorghis (V.) 2000, 218–19, no. 349. On the mourning statuettes, see Raptou 1997, 229–31.

30. Richter 1961; Tatton-Brown 1986. It is worth noting that many of the stelai from other sites depict seated women on elaborate thrones. Note must also be taken of the inscription on the base of the lion (cat. no. 23) that Kilikas's brother erected the monument, which suggests it stood above ground as a marker of the tomb.

31. Megaw 1979, 139–48, pls. XVII–XVIII; Tatton-Brown 1986, 450, pl. L.2.

32. Ducrey 1977, 13; Snodgrass 1985, 193–207.

33. Maier 2008.

34. Gjerstad 1935b, 455; Gjerstad 1946, 21–24; Gjerstad 1948, 453–54, 476–77.

35. Gjerstad 1937, 238–49, cat. no. 292, pls. XC–XCII, XCV–XCVII; Schwabacher 1946; Schwabacher 1947.

36. Destrooper and Symeonides 1998, 118 n. 7, 123. These are later bronzes.

37. Robinson (E. S. G.) 1932, 209–12; Masson 1983, 181–83, no. 168.

38. Zournatzi 2005.

39. Masson 1983; Zournatzi 2005, 24–26.

40. Masson 1983, 183, no. 169.

41. Ibid., 183–84, no. 170.

42. Maliszewski 2006, 409–10.

43. R1612/TC90: Serwint 1993, 207–21.

Funerary Lion for Kilikas

Cypriot, end of the 6th century B.C.E.
Found by Max Ohnefalsch-Richter at Polis-Necropolis I, Tomb 117, in 1886
Limestone; h. 38 cm. (plinth and lion), w. 40 cm., th. 16 cm.
Polis Chrysochous, Local Museum of Marion and Arsinoe (MMA 277; formerly Nicosia,
Cyprus Museum 6221)

Condition: When discovered, the face of the lion from the eye sockets down to the neck was largely destroyed, and it has been reconstructed in plaster. The left ear may be reattached; a chip at the top edge of the back of the base below about the middle of the right paw has been reattached. There are modern pick marks on the back of the rump, on the mane at the rump, and on the right leg. Old damage is on the upper right leg and along the upper front leg, the lower edge of the mane above the ribs on the right side, on the front of the right front paw at the second digit from the right. There are flat, narrow (1 cm. wide) chisel marks on the base between the front and rear paws at both the front and the back sides; on the back, these marks are also on the vertical surface between base and belly, as well as on the vertical surface between the base and the chest under the head.

The recumbent lion sits on a base three centimeters high. On its front edge and on the right rear leg is an inscription in Cypriot syllabary that reads from right to left: *ti-mo-ku-po-ro-se o-ti-mo-ke-re-te-o-se e-pe-se-ta-se ki-li-ka-wi / to-i ka-si-ke-ne-to-i* (Timokypros the son of Timokrates erected this for Kilikas, his brother). The name Kilikas is not rare on Cyprus and occurs as the father on another funerary inscription from Marion. The dedicatory nature of the inscription is exceptional for Marion and suggests that the lion was visible as a marker of the tomb.

The head of the lion is turned at ninety degrees to the side of the inscription. The tail appears primarily at the join of the right leg and torso, curling up onto the back; four ribs appear on the torso front and back; each paw is divided into four segments for claws. The mane around the head and down the center of the back to the tail is finely carved with sharp, clean divisions of the hair locks. The back side of the legs/paws is somewhat more cursorily worked than the front side, which is flatter. The lion is slightly longer than the plinth (40 cm. versus 37.8 cm.). Lions with head turned as here were particularly popular markers for graves all over Cyprus in the Archaic period, but only one other fragmentary stone lion is known from Marion—probably because visible sculptured grave markers were not customary there until the end of the fifth century.

PUBLICATIONS

Ohnefalsch-Richter 1893, 476, pl. CXCVII.3; Myres and Ohnefalsch-Richter 1899, 172, no. 6221; Dikaios 1961, 217, no. 9, pl. 34.2; Masson 1983, 157, no. 103, pl. XV.1–2; Hermary 2004, 74, pl. 33c–d.

NOTES

Caubet 1977, 170–72, nos. 2, 4, pl. LI.1–2; Tatton-Brown 1986, 439–43, pl. XLVIII; Hermary 1989a, 473–74.

—WAPC

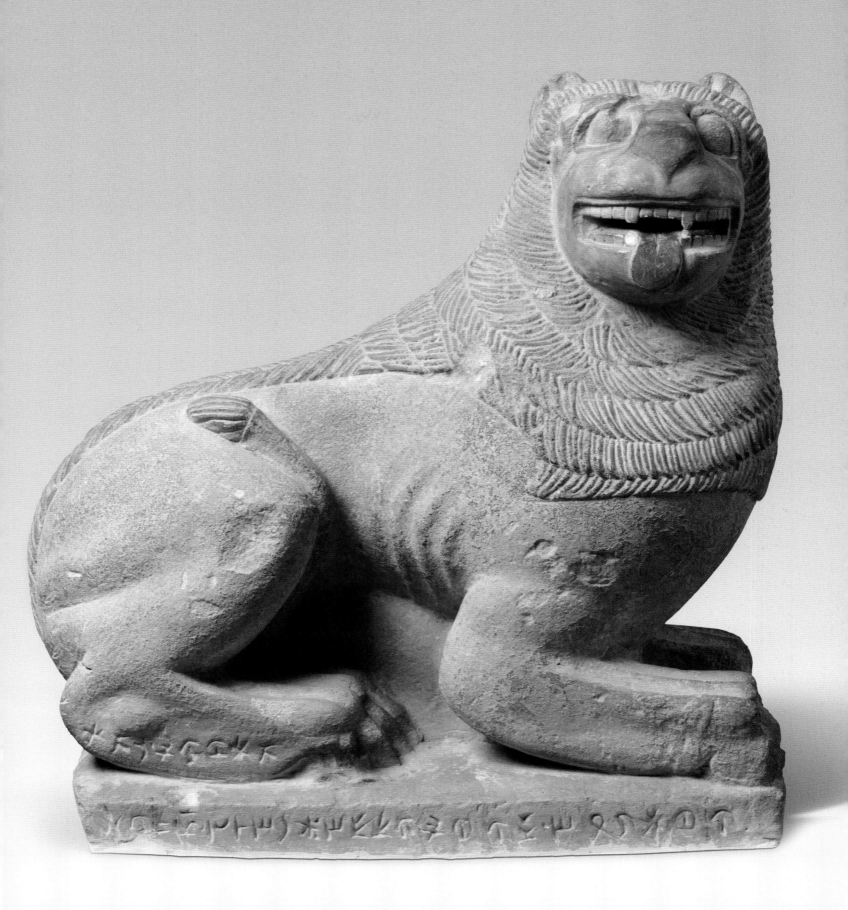

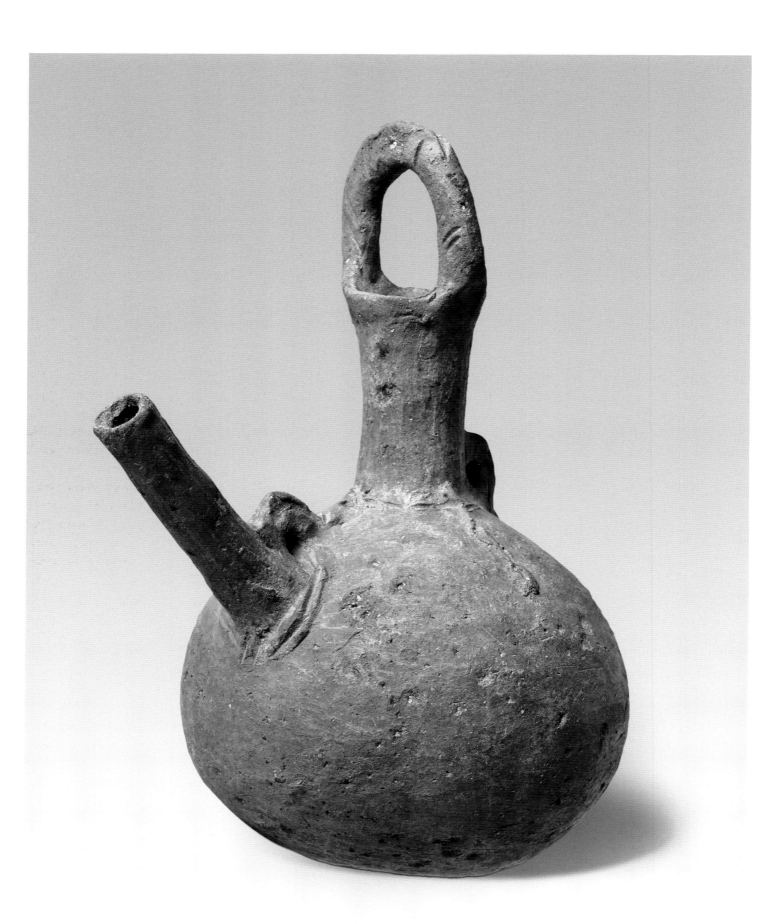

24
Drab Polished Ware Spouted Jug

Cypriot, Middle Bronze Age
Found by the Department of Antiquities of Cyprus at Pano Argaka, Tomb 1, in 1990
Ceramic; h. 20.2 cm., diam. 12 cm. (body)
Paphos District Museum (MP 3141/29)

Condition: Unbroken, core not visible.

Cypriot jugs of the Early and Middle Bronze Ages often resemble gourds with their rounded bottoms, tubular necks, and thin relief decoration that recalls a gourd's sometimes warty surface. The brown to gray color of vessels—this example with streaks of light yellowish brown—which are sometimes shiny, led to the scholarly label of Drab Polished. Potters made them without the use of a potter's wheel, using clay with bits of lime (calcium carbonate) and smoothing the surface by covering it with a thin brown slip. Firing temperatures reached at least 850 degrees Celsius. Lime decomposed and picked up moisture from the air during cooling. The resulting quicklime led to heat and expansion. The lime popped out, creating a pocked appearance. Drab Polished vessels were made and used from the end of the Early Bronze until the beginning of the Late Bronze Age. These vessels, characteristic of southwestern Cyprus, were possibly made just north of Paphos at Kissonerga; their discovery also along the south coast and east of the Troodos Mountains provides evidence for connections between village communities. This example from a tomb at Argaka extends these connections to the coastal area of the Chrysochou Valley east of Polis. Deeply incised strokes zigzagging across the top and four pairs of strokes on either side emphasize the handle. Its basket shape is unusual, being found on only a few other Middle Bronze Age vessels in the northern part of the island. It stems from the funnel-shaped neck and rim. On its own, this jug leans over, its long tubular spout weighing it down. Suspended from this handle, with adjustments using the two small string holes at the spout and neck, the vessel could have been upright. Applied low vertical relief bands impressed by short zigzag strokes extend down from the string hole at the back, on either side of the neck, and between the neck and the string hole at the spout. Potters of Drab Polished vessels formed joins between vessel parts by applying them to the outside of the body, rather than inserting them into the body as on other contemporary vessels. Jennifer Webb and David Frankel have suggested that incised lines helped to disguise and secure these attachments. Here, single marks ring the base of the neck, and pairs surround the base of the spout.

PUBLICATIONS

Papageorghiou 1991, 800–801, fig. 36.

NOTES

Sjöqvist 1934, 130–32, Lapithos Tomb 319, B.17, B.44, pls. XXXIII, CII.4, CVI.5; Karageorghis (V.) 1965b, 33, 59–61, fig. 10.57; Åström 1972a, 16, 83–84, 89, 98, figs. V.5, XXII.5; Herscher 1976, 11–16; Philip 1983, 48–53; Rice 1987, 97–98; Herscher and Fox 1993, 71; Frankel and Webb 1996, 155–60; Åström 2003, 48, no. 29; Åström and Nys 2003, 39–40, no. 15; Herscher 2003, 152–53; Crewe and Graham 2008.

—JSS

25

Black Slip Bird-Headed Jug

Cypriot, Middle Cypriot III–Late Cypriot IA, ca. 1800–1550 B.C.E.
Found by the Department of Antiquities of Cyprus at Magounda in a tomb in 1968
Ceramic with lime; h. 13 cm., diam. 7.6 cm. (body)
Paphos District Museum (MP 1929/18)

Condition: Piece missing from the top of the handle; surface chips missing.

Potters often formed vessels in the shape of an animal, especially the head or handle. The tubular flaring spout of this round-bodied juglet serves as a beak for the head of a bird. Its outlined eyes bulge on either side of the top of the neck. Although this juglet has no exact parallel, jugs in the shape of birds or with birds forming part of a surface design can be found among Cypriot vessels of the Bronze and Iron Ages (see cat. nos. 19, 28). This juglet was formed without a potter's wheel, covered with a thin clay slip, and decorated with a series of punctures and incised lines. It stands on a small indented button base. Unlike earlier vessels where lime popped out of the fabric after firing (see cat. no. 24), on this kind of vessel, lime was added to the surface, filling and emphasizing the planned decoration. In Egypt and the Levant Middle Bronze Age vessels with punctuate decoration are called Tell el-Yahudieh ware, after a site in the Nile Delta where they were first found. Some Tell el-Yahudieh ware vessels have been found on Cyprus. More common are similar Cypriot products of varying color that scholars have named Black Slip III ware. These continued to be made into the early Late Bronze Age. Always taking the form of a jug, they may have held unguents such as perfumed oil. This example from Magounda (see also cat. no. 26) east of Polis has a brown surface with areas of light reddish brown "blush" where more oxygen flowed during firing. Its flaked surface reveals the pink core. As on other early Late Bronze Age wares, it may once have had a spur or prong protruding upward from the flat strap handle. Its incised and punctuate decoration points to connections with designs characteristic of the Morphou Bay area, northeast of the Troodos Mountains, where these vessels were probably made. Viewed from the side, outlined zigzags run between counterpoised triangles filled with punctuate design in bands around the shoulder and lower body. The upper and lower zigzag points are slightly mismatched at each interval. Viewed from the top and bottom, this design transforms into a flower unfurling its six petals. The incised decoration on a Tell el-Yahudieh ware jug from Toumba tou Skourou depicts long-necked water birds among bands of lotus flowers. This example blends the same subjects in the three-dimensional form of the vase.

PUBLICATIONS
Karageorghis (V.) 1969, 478–79, fig. 80.

NOTES
Karageorghis (V.) 1965b, 29–31, 33, 48–49; Åström 1972a, 88; Prag 1973; Merrillees (R. S.) 1974. Toumba tou Skourou: Negbi 1978; Vermeule and Wolsky 1990, 296–97, 355, 358–60, 362–63, 386–87, fig. 44, pls. 182–83.

—JSS

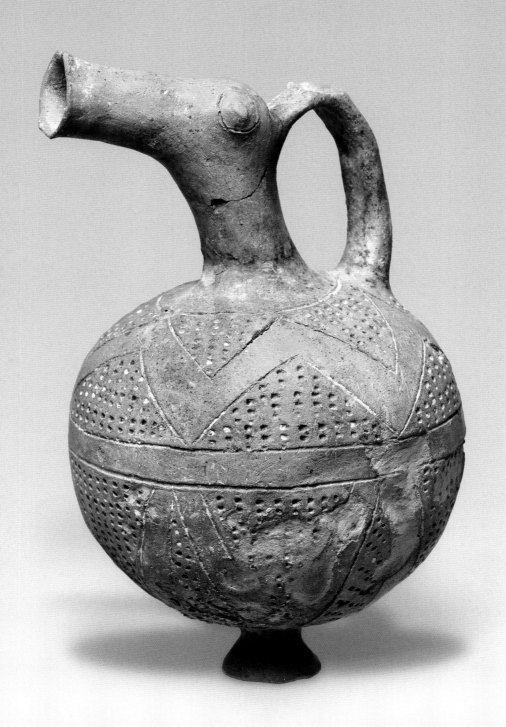

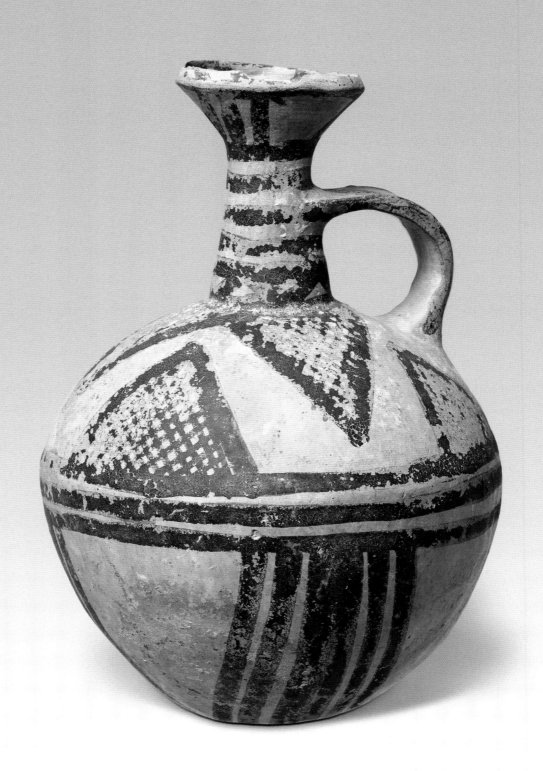

26

White Painted Jug with Funnel Rim

Cypriot, Late Cypriot I, ca. 1650–1450 B.C.E.
Found by the Department of Antiquities of Cyprus at Magounda in a tomb in 1968
Ceramic with black paint; h. 14 cm., diam. 9.63 cm. (body)
Paphos District Museum (MP 1929/17)

Condition: Black paint flaked off in places.

During the Middle Bronze Age, Cypriot potters began to make vessels that scholars call White Painted, light colored with dark painted patterns, often, as on this jug, a very pale brown with dark gray paint. Its carinated or angular shape that divides the body into two zones of decoration identifies it as Type VI of the early Late Bronze Age. This jug was made without the use of a wheel; a similar effect was achieved on wheel-made vessels in the Iron Age (cat. no. 27). The light color required careful control of oxygen during firing. Other links with increasingly sophisticated pyrotechnology are the carinated body profile, flat base, and flat strap handle that recall metal vessels. The potter smoothed the exterior by wiping when it was still wet. Several jugs of this shape have a rim that served as a spout. The funnel rim with a turned-in top edge on this vessel finds parallels especially among vessels at Toumba tou Skourou in the Morphou Bay area. This jug was found in the same tomb at Magounda as a juglet (cat. no. 25), with close parallels in the same region. They each reinforce connections in style between pottery of the Chrysochou Bay area near Polis and that of the north coast during the Late Bronze Age.

As on other vessels (see cat. no. 28), the jug's geometric decoration relates to its functions. In the lower body, four groups of five or six vertical bands anchor the jug when it rests on a flat surface. Above the three horizontal bands around the center of the body, four evenly spaced crosshatched triangles point up toward the neck. Three more counterpoised crosshatched triangles alternate with them. From above, they resemble a cracked-open seedpod. Instead of a fourth triangle, the handle extends upward from the shoulder to the neck. Framed parallel zigzags run or drip down the handle, and zigzags continue onto the shoulder. The lower neck is encircled by a wavy line with five horizontal bands above. Three sets of three parallel oblique lines mark the interior and exterior of the funnel, mimicking the swirl of liquid poured into the jug. With its lack of a rim suited for pouring, it is possible that drinking from this vessel would have required a straw, as with the drinking of beer in ancient Mesopotamia. From several centuries later in the Chrysochou Valley is an Archaic jug that also lacks a spout or pinched rim for pouring. A scene painted on its body depicts a seated person drinking through a long straw.

PUBLICATIONS

Karageorghis (V.) 1969, 478–79, fig. 81.

NOTES

Åström 1972b, 53–69. Toumba tou Skourou: Vermeule and Wolsky 1990, 231–32, 235, 268, 278. Beer drinking: McGovern 2009, 97–99. Archaic jug: Karageorghis (V.) 1974, 67–74.

—JSS

27
White Painted Stemmed Bowl

Cypriot, Early Cypro-Geometric, ca. 1000–900 B.C.E.
Found by Kyriakos Nicolaou for the Department of Antiquities of Cyprus
at Polis-Kokkina, Tomb 126, in 1960
Ceramic with black paint; h. 19.5 cm., diam. 26.4–27.2 cm. (rim)
Polis Chrysochous, Local Museum of Marion and Arsinoe (MMA 301;
formerly Paphos District Museum MP 2126/5)

Condition: Chips missing from the base and rim; paint worn in places.

Stemmed bowls are similar to the idea of a kylix, a large, stemmed drinking vessel. This example was made on the wheel and decorated in a technique known today as White Painted, referring to the use of dark paint on a light ground. This one stands on a low conical foot, has a slightly incurved body, and has low rolled lug handles, all of which support its date in the early Cypro-Geometric period, contemporary with the earliest possible settlement at what later became the city of Marion. The painted decoration in vertical panels consists on one side of columns of outlined filled and latticed lozenges flanked and separated by groups of three vertical lines. The outer edges of each panel are festooned with a single vertical wavy line. The opposite side of the vessel has a similar panel that lacks the wavy lines. It is paired with another panel in which the column of outlined filled lozenges has been replaced by a column of overlapping hatched triangles. The empty space between the two panels is connected by a large X-shaped mark. The X-shaped mark compares with other vessels from Polis and points toward decorative traditions along the north coast of Cyprus as at Lapithos, where painters often attempted to fill the design field not only with X-shaped marks but also with large patterned lozenges. The use of X-shaped marks and of an even more complete filling of the design space was the habit at Amathous on the south coast. The design of this vessel, however, also compares with the narrower vertical panels with single columns of latticed lozenges, overlapping triangles, and wavy lines at Palaipaphos to the south. Like the painter of this vessel, the painters of Palaipaphos frequently decorated the two sides of their stemmed bowls differently. Sometimes there are slight differences between seemingly similar designs,

as on this vessel, which accompany the more noticeable break in the two-sided symmetry. In pointing to the south and along the north coast, this vessel encompasses the artistic habits that shaped those who lived in ancient Polis, even as they developed their own distinctive traditions.

PUBLICATIONS

Nicolaou (K.) 1964, 156, no. 5, pl. XV.1.

NOTES

Gjerstad 1934, 230–31, Lapithos Tomb 417 nos. 21, 54, 66, 68, 115, 122–25, pl. L; Gjerstad 1935b, 372–73, Marion Tomb 63 dromos nos. 1, 2 and chamber nos. 4, 15, pl. LXX.3; Westholm 1935, 40–41, Amathous Tomb 7 nos. 224, 226, 254, pl. IX; Karageorghis (V.) 1983, 113, 115, 119–20, 122, pl. LXXXV, figs. CIX, CXI, Palaipaphos Tomb 58 nos. 4, 131 (motifs similar to cat. no. 27) and nos. 23, 86, 100 (decoration differs on each side).

—JSS

Bichrome Jug with Flower

Cypriot, Cypro-Archaic I
Found by Kyriakos Nicolaou for the Department of Antiquities of Cyprus
at Polis-Kokkina, Tomb 124a, in 1960
Ceramic with black and red paint; h. 32.5 cm., diam. 23 cm. (body)
Polis Chrysochous, Local Museum of Marion and Arsinoe (MMA 318)

Condition: One chip missing from rim.

Jugs with trefoil rims were made for pouring liquids, the pinched rim helping to direct the flow of liquid, in funerary, sanctuary, and domestic contexts. This jug's two-colored, or bichrome, decoration is black and red, faded in places to a pale brown color. The painted decoration calls attention to its function. The large concentric circles, or bull's-eye decorations, on the vessel's sides mark where hands might steady the vessel and parallel the flow of liquid and rotation of the vessel when pouring. A pair of concentric circles marks the base of the handle one would grip. A set of three long crossed lines, marked by five shorter strokes and flanked by pairs of concentric circles, lie below the rim on the shoulder where excess fluid might drip. Horizontal and vertical marks on the neck, rim, and handle mirror the vessel's position when standing. A star-shaped flower set into a bull's eye with short radiating strokes highlights the front chest of the vessel. Similar to a narcissus (daffodil) (compare cat. no. 13), the flower has ten rather than six petals. A remarkably similar jug with a nine-petaled flower was found in a tomb of the same period at Evrethades, the necropolis just next to Kokkina (see also cat. no. 27). A close look at the Kokkina vessel reveals that the potter carefully burnished its surface, making it shiny. The drips of paint show that the painter turned the vessel on its side to add the concentric circles. In firing, the vessel was stacked close enough to another with black-painted lines to have a part of that decoration fuse to its lower body.

This jug is typical of the Cypro-Archaic period with its double-rolled handle and low ring base. The neck that widens slightly toward the bottom and the body that is just slightly taller than it is wide indicate that the vessel was made sometime toward the end of the Cypro-Archaic I period in the seventh century B.C.E. Trefoil jugs with bull's-eye decorations continued to be produced into the later Cypro-Archaic period, with the lower necks made wider over time. One jug reassembled from over two hundred fragments found in the *bothros* (votive pit) of the Peristeries sanctuary has eyes on either side of the rim, giving it a bird-like appearance. Rather than depicting a flower seen from above on the vessel's lower chest, it has a flower shown in side view at the base of the neck. Both might appear to be watered by fluid dripping down from the rim.

PUBLICATIONS

Nicolaou (K.) 1964, 139, no. 17, pl. XV.6.

NOTES

Polis-Evrethades: Gjerstad 1935b, 420, Tomb 82, no. 11, pls. LXXX.3, CVII.4; Gjerstad 1948, fig. XXXIV.5 (Tomb 6A no. 8).

—JSS

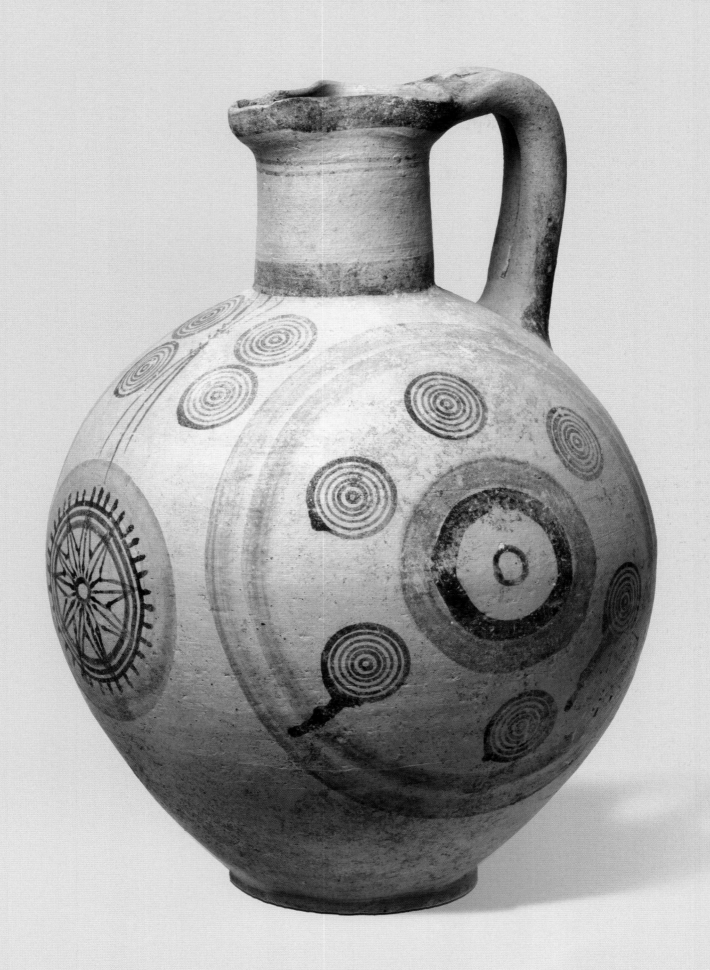

Black-Figure Oil Bottle (Lekythos)

Greek, Attic, ca. 580 B.C.E., attributed to the Deianeira Painter
Purchased from P. Kolocassides of Nicosia in 1958, said to have
been found at Polis-Evrethades in a tomb
Ceramic; h. 20 cm.
Nicosia, Cyprus Museum (1958/IV-22/3)

Condition: Unbroken and in excellent condition,
with only minor nicks, scratches, and spalls.

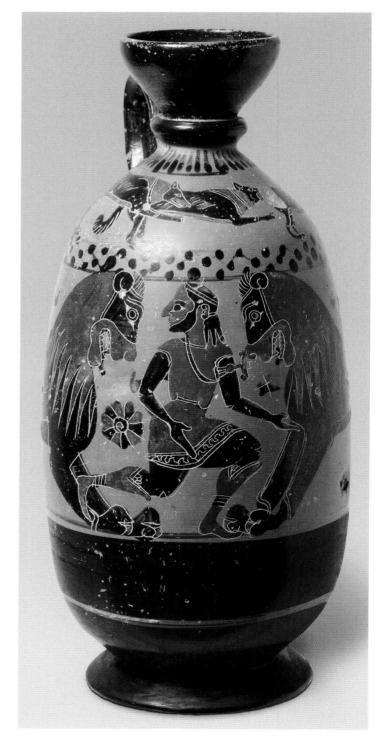

This large oil bottle is of a type called a Deianeira lekythos,
after another example, in London, with a depiction of the
centaur Nessos abducting Deianeira, the wife of Herakles.
It is the earliest known imported Attic vessel from the Polis
region. A Deianeira lekythos has a plump, tubular body
that tapers at either end, an echinus foot, a single flanged
handle, and a tall spreading mouth with a rounded rim, the
latter separated from the body by a thick torus "drip ring."
In this example, the mouth and handle are black, and there
is but a single reserved stripe, edged with red lines, on the
black lower body. Black tongues depend from the drip ring,
which is painted red, and a red line circles the top of the rim.

The principal zone of black-figure decoration on the
body features a pair of large lions with red flame-like
manes and lolling tongues. The beasts face one another on
either side of a bearded man, who runs to the right while
looking left. The man wears a red tunic and boots, and a
sword slung from a baldric. Behind him floats a red and
black rosette, a decorative motif that, like the lions, derives
ultimately from examples on contemporary Corinthian
pottery. Similar rosettes appear above the backs of the
lions, and much smaller ones throughout the background.
On the opposite side of the vessel, between the haunches
of the lions, is a large bust of a bearded man, facing left,
with red skin and a fillet in his hair. On the shoulder of
the lekythos, separated from the figures below by a band
of dotted net pattern, two hounds are chasing a hare. The
same subject recurs on the shoulder of the lekythos in
London, mentioned above, which is also by the Deianeira
Painter. A third lekythos by the artist, in Berlin, instead
has a sea monster on its shoulder, but the decoration of
the body is very similar to that of the vase from Marion,
with a bearded swordsman, now nude, between a pair of
heraldic lions, and the bust of a bearded man on the

reverse, the bust again having a curiously rounded shape. As on this example from Polis, there is no attempt at narrative, and the figures lack attributes that might identify them as specific gods or heroes. The busts are particularly unusual; large male and female heads appear frequently on Attic and Corinthian vases in this period, usually with no clue to their identity or significance.

This large lekythos held a considerable amount of olive oil, presumably also of Attic origin and of fine enough quality to justify its shipment to Cyprus, where it eventually was interred with its owner in the necropolis at Evrethades, just east of Polis.

PUBLICATIONS

Karageorghis (V.) 1959, 340–42, fig. 6; *Paralipomena*, 8, 19.bis; Gjerstad et al. 1977, 54, no. 513, pl. 63.1 and 4; Williams 1986, 62–63, fig. 3; Alexandridou 2011, fig. 44.

NOTES

Haspels 1936, 1–2; Payne 1931, 191–93; Williams 1986. Lekythoi in Berlin (inv. 3764) and London (B 30): *ABV* 11.19–20; Payne 1931, nos. 1–2, pl. 53.7 (Berlin); Williams 1986, 61–63, figs. 1–2.

—JMP

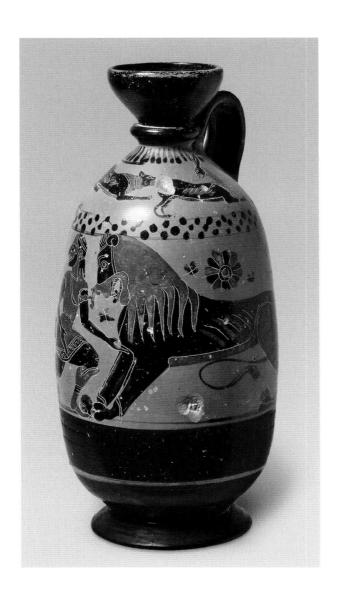

Black-Figure Wine Cup (Kylix)

Greek, Attic, ca. 530 B.C.E.
Found by Max Ohnefalsch-Richter at Polis-Necropolis II, Tomb 228, in 1886
Ceramic; h. 7 cm., diam. 19.15 cm., 8.2 cm. (foot)
Polis Chrysochous, Local Museum of Marion and Arsinoe (MMA 208; formerly Nicosia,
Cyprus Museum C658)

Condition: Repaired from fragments. Two short sections of the rim and most of one handle are restored.
A piece missing from the center of one side took with it part of Dionysos's midsection.

The shape and decoration of this wine cup, or kylix, are unique. Its features were well described by Sir John Beazley over six decades ago, and one can only paraphrase his remarks. The shape is a variety of Type C, with a straight rim and a bowl that flows in an S-curve into the foot, from which it is separated by a thick torus molding, painted red. The reserved side of the foot is not the usual torus but concave and flaring, with a wide reserved resting surface. The inner wall of the stem is black, but the base of the bowl is reserved and decorated with a dot within two circles. The interior of the cup is black, except for a reserved disk with a circled dot. On the exterior, an ivy wreath circles the lip. In the center on either side, Dionysos stands to the right, wreathed in ivy and holding an ivy vine in each hand. The bearded god wears a long white chiton and a black himation draped over his shoulders. Flanking him on either side is "a lion rampant regardant [looking backward], forelegs as if resting on the roots of the handle." The beasts have white bellies and red manes and tongues. Oddly, for an Attic cup, "there is no ground-line below the figures; they stand on nothing." Beneath each handle, and thus between each pair of lions, is a delicate design of buds, tendrils, and palmettes.

On black-figure "eye-cups," Dionysos often stands in this posture between a pair of large eyes, but the substitution of lions is highly unusual. The motif of two animals

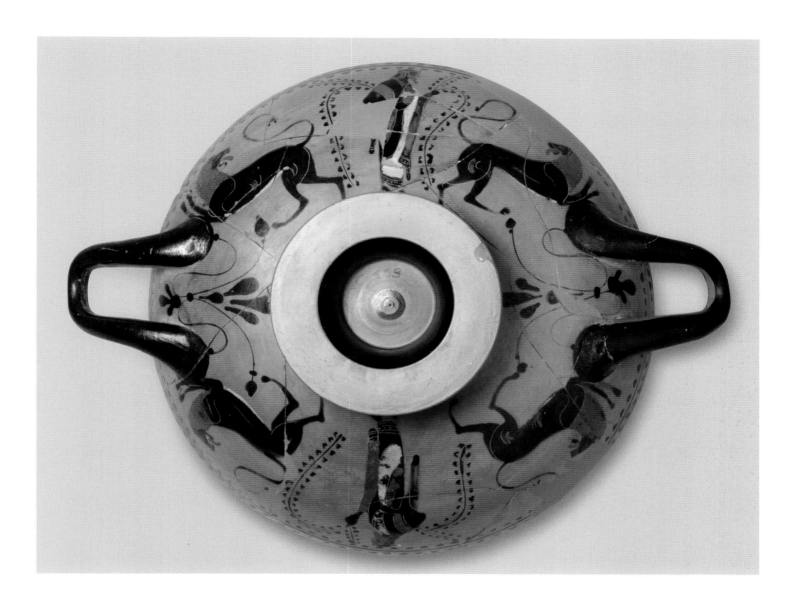

arranged heraldically on either side of a tree or plant has deep roots in Near Eastern art; it occurs frequently in Cyprus in works under Phoenician influence. Although there is no evidence that the decoration of this cup was tailored to Cypriot tastes, the motif would have been familiar to the cup's owner in Marion, where it was found in a tomb of the eastern necropolis by Ohnefalsch-Richter.

PUBLICATIONS

Ohnefalsch-Richter 1893, 471, pl. 184.2; Gjerstad et al. 1977, 49, no. 471, pl. 47.2–3; Beazley 1989, 25–26, no. III.C.658, pl. 2.

NOTES

Eye-cups in Providence (Rhode Island School of Design 22.214) and Oxford (Ashmolean 1960.1219), also of Type C and with straight rims, have feet of similar shape, but with taller, concave stems. On either side of the unpublished Oxford cup, Dionysos stands between a pair of eyes, while the Providence cup features maenads attacked by satyrs: Luce 1933, pl. 11.2; *ABV*, 631.1. On both cups, there is no ground line below the figures. For another black-figure Olympian between lions, cf. Apollo on a lip-cup in Karlsruhe (inv. 69/61): Franzius et al. 1970, 119–20, fig. 5.

—JMP

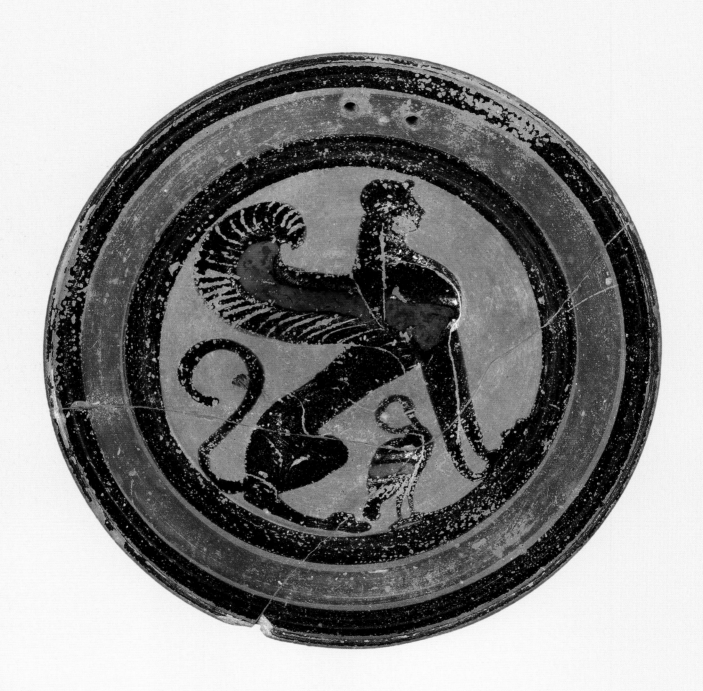

Plate with Seated Sphinx and Swan

Greek, Euboean, ca. 550–530 B.C.E.
Found by the Cyprus Exploration Fund at Polis-Site A, Tomb 7, in 1889
Ceramic; h. 2.5 cm., diam. 14.31 cm.
London, British Museum (1890.7-31.22)

Condition: Repaired from four fragments; minor modern inpainting of cracks; considerable surface wear; white slip on the face and breast of the sphinx largely lost.

This little plate has a wide offset rim that is pierced by two holes, by which means it could be hung on a wall from a cord. On the underside are an attenuated base ring and six dark concentric circles that merge into red on the pink-buff clay. Around the inner rim, a matt-red band is framed by two purplish-black bands, the innermost providing the circular frame for a seated sphinx, executed in the black-figure technique, with incisions through the creature's black silhouette. The mythical beast, with the body of a lion and the head of a woman, is seated on her haunches, facing right, her long tail curled up behind her. She wears a fillet on her head, and her long hair falls onto her shoulders. Her breast and face were painted with white slip, now worn. A red band framed with white stripes extends the length of her wing, which is recurved in the Archaic fashion. Her legs and abdomen are unnaturally slender. Beneath her stands a water bird, a swan, with its head touching its breast. Its folded wing is crossed with a red band framed in white. The design is simple and pleasing, though the loss of so much added white makes it appear redder than it would have originally.

When first published after its discovery in a tomb at Polis in 1889, the plate was taken to be a Cypriot imitation of East Greek examples known from Rhodes and Naukratis. Although Gjerstad favored an East Greek, possibly Clazomenian origin, a consensus today supports Boardman's attribution to a Euboean workshop, probably in Eretria, another indication of Marion's far-reaching trade relations.

PUBLICATIONS

Munro and Tubbs 1890, 41–42, fig. 7; Walters 1893, vol. II, 79, B 98; Boardman 1957, 20, pl. 6 (b); Gjerstad et al. 1977, 31, no. 121, pl. 12.9.

NOTES

Related Euboean plates: Boardman 1957, 19, pl. 6 (a); Kilinski 1994, 13–15; Royal-Athena Galleries, *1,000 Years of Ancient Greek Vases II* (New York, 2008), no. 60.

—JMP

32

Chalice with Seated Sphinx

Greek, Chian, ca. 580 B.C.E.
Purchased from Mayor Pavlos Georghiou of Polis in 1944, said to have been found at
Polis-Evrethades / Sykarkoi in a tomb
Ceramic; h. 13.3 cm., diam. 13 cm. (rim)
Nicosia, Cyprus Museum (1944/I-28/2)

Condition: Reconstructed from five large fragments. Missing a small piece of the rim
above the head of the sphinx. Black slip largely lost from the right handle; white slip
partially flaked away from the two reserved bands in the middle of the foot.

This fine Chian drinking cup was found in the eastern
necropolis of Marion in an undocumented tomb. Chalices
of this type often come in pairs, and this one is no exception;
it was found together with a companion piece somewhat
larger in size and decorated only in the interior. Unlike the
characteristic Chian transport amphorae, a good number
of which were imported to Marion in the Archaic period
(cat. no. 33), fine wares from the island of Chios in the
Aegean Sea seem to have been rarely imported to Cyprus.
Marion, however, is an exception, given that along with a
good number of various East Greek wares, the Princeton
excavations have uncovered numerous fragments of Chian
chalices in sanctuary and settlement deposits.

The Marion chalice belongs to a well-defined group
of vases comprising the so-called Chalice style of Archaic
Chian pottery. With its height equal in size to the rim
diameter, the splendidly isolated sphinx, seated and fac-
ing left, and the colorful interior with lotus flowers drawn
with white and purple slip that alternate with delicate qua-
druple rosettes against a lustrous black background, this
chalice is a typical specimen of the Chalice style. It may
have arrived at Polis with a cargo of Chian wine or, as Anna
Lemos has suggested, as a personal object of a merchant
or sailor.

There is nothing untypical about the elegant sphinx,
which is rendered in a combination of outline and reserve
technique. Isolated against the characteristically Chian
white background, it is a lively and engaging monster
with a large head, a powerful gaze, and a muscular body.
In a burial context, she would have been perceived as a
guardian figure, whereas among the living, she may have

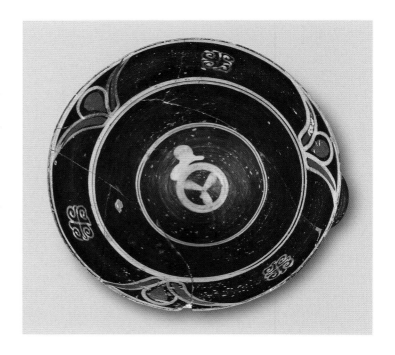

encoded a firm warning against the dangers of excessive
drinking. Sphinxes are stock figures in the Orientalizing
pictorial traditions of Archaic Greece.

PUBLICATIONS

Dikaios 1946, 5–7; Gjerstad et al. 1977, 23–59, esp. 34, nos. 157–58.

NOTES

Lemos 1991, vol. 1, 286–96; vol. 2, pl. 116 no. 822, pl. 131 no. 967, pl. 134
no. 973, pl. 124 no. 927. A sphinx on a Cypriot vessel: Karageorghis (V.)
and Des Gagniers 1974, 134–35. The second chalice found with this one:
Dikaios 1946. Chian pottery in Polis: Boardman 1968a.

—NP

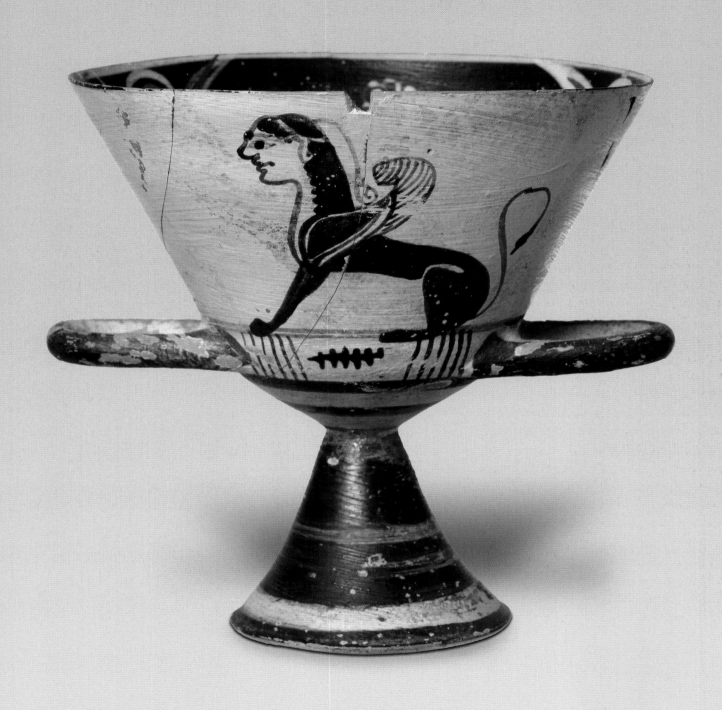

Transport Amphora

Greek, Chian, 6th century B.C.E.
Found by the Department of Antiquities of Cyprus at Polis-Evretes
Ceramic; h. 72 cm., diam. 12 cm. (rim)
Polis Chrysochous, Local Museum of Marion and Arsinoe (MMA 561/1)

Condition: Complete; reassembled from fragments; small parts missing; minor retouching of cracks.

This type of transport amphora was a wine container imported from the Greek island of Chios, which was famous for its wine in antiquity. The coarse gray clay with large white grits and the thin cream slip, partly flaked, are typical of the type, as is the matt paint varying from brown-black to orange. The body is bobbin-shaped with a tall neck leading gently into the sloping shoulder. The lip has the shape of a torus; the vertical handles rise from the shoulder to just below the lip. The foot is elongated with a hollow underside. The decoration is simple and consists of a band on the rim, one line on the neck, and three on the lower body; there is a large horizontal Ƨ on either side of the shoulder. On each handle, a vertical stripe extends down onto the body, and there are circular lines around the upper and lower handle attachments.

The shape and the fabric of the amphora, with its elongated form, tall neck, and thin slip, point to the second half of the sixth century B.C.E. That date is corroborated by other finds in the tomb, which include a Corinthian aryballos, a Cypriot basket-handled amphora, and a large amount of local pottery of the Late Archaic period. Imports to Cyprus from East Greece, the Aegean islands, and the coastal cities of Ionia during the Archaic period are many and testify to strong economic and political relations between the two regions. Amphorae from Chios are often found in the excavations of the coastal cities of Cyprus, including Salamis, Kition, Amathous, and Marion; some have even been found at inland cities, such as Ledra.

Recent excavations in the area of ancient Marion, both in the cemeteries and in the settlement, have brought to light many new examples of Chian amphorae covering the time span from the late seventh to the fourth century B.C.E. These finds represent the whole typological range of Chian amphorae, confirming the continuous relations between the two islands. Other shaped vases were also imported, such as the chalice with the sphinx (cat. no. 32).

PUBLICATIONS
Unpublished

NOTES
On the type: Cook and Dupont 1998, 146–48, fig. 23.1h. On examples on Cyprus: Gjerstad et al. 1977, 37, nos. 183–87, pl. XXI.6; Calvet and Yon 1977, 17–18, pl. X; Coldstream 1981, 18, no. 9, pls. XVI, XVIII; Johnston 1981, 39–40, pl. XXVII; Hadjicosti 1993, 181, no. 1, fig. 5, pl. XLVIII (Ledra); Papalexandrou (N.) 2006, 233, fig. 12.

—ER

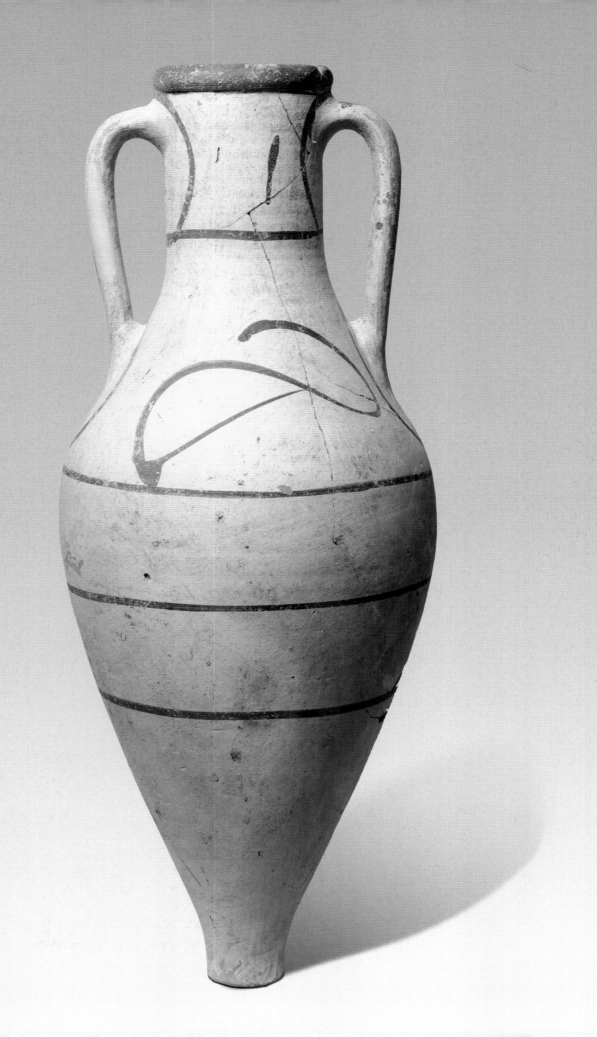

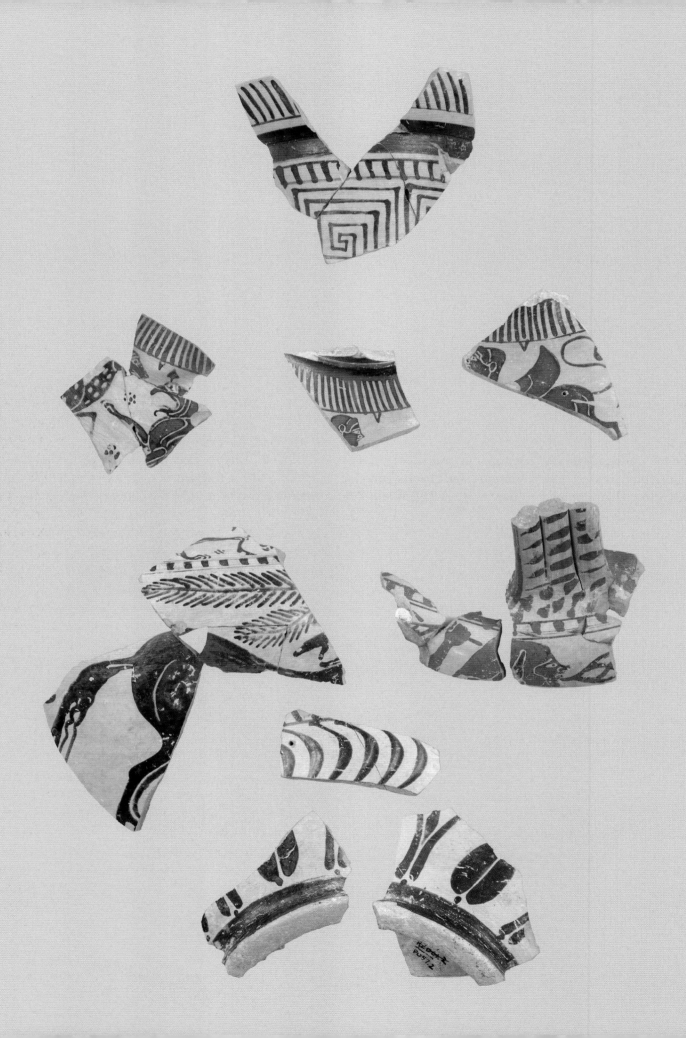

34
Fragmentary Fikellura Neck-Amphora

East Greek, Miletus, ca. 550–540 B.C.E., attributed to the Altenburg Painter
Found by Princeton at Polis-Petrerades, Area E.F2, 1986–2005
Ceramic; h. 30–35 cm. (reconstructed)
Polis Chrysochous, Local Museum of Marion and Arsinoe
(Princeton Cyprus Expedition R1245/PO52 et al.)

Condition: Eleven of a total of twenty-four fragments from the same vase. Good surface preservation.
One shoulder fragment has a small drill hole, seemingly unrelated to an ancient repair.

These fragments from a single neck-amphora were discovered scattered through deposits much disturbed by the later construction of a Late Antique basilica. The selection gives some idea of the vase's original elevation, from the echinus rim to the stout ring foot. The root of one triple-reeded handle is preserved, as is part of the pronounced flange at the juncture of neck and body. Except for the underside of the base, the pink micaceous clay is coated on the exterior with a creamy slip, a background for the painted figures and ornament that fired black to red in the kiln. A band of vertical stripes circled the rim, and on either side of the neck were pairs of large meanders below striped bands. Lotus buds, alternately open and closed, circled the lower body below a band of crescents and another of stripes. Above this, in a wide frieze running all around the body, were at least four centaurs, some galloping to the right, others to the left. As is often the case with centaurs, they wield long branches as weapons, although no trace of an enemy—perhaps Lapiths or Herakles—is preserved. Only two heads survive: one, by the handle, has long hair, equine ears, and a pointed nose; another, not illustrated, has an open mouth and a large mustache. On the shoulder of the vase, framed by tongues and a band of dentils,

individual fallow deer were framed by pairs of mythic monsters: on one side, sphinxes, on the other, griffins. All internal details are meticulously "reserved" to reveal the white ground beneath. This technique, which required considerable delicacy of execution, is typical of Fikellura ware, a distinctive East Greek pottery produced about 560–520 B.C.E. that descended from the earlier Wild Goat style of the late seventh century. Although named after a site on Rhodes, the principal center of both Wild Goat and Fikellura production was Miletus, on the Ionian coast of Asia Minor. The decoration of this amphora is of particularly high quality and can be attributed to a master known as the Altenburg Painter, whose works have been found at sites from the Crimea to the Nile Delta. Aside from a single sherd from an early seventh-century "bird bowl," no East Greek pottery has been found at Polis that predates the second quarter of the sixth century, soon after the earliest known Attic imports (see cat. no. 29).

PUBLICATIONS
Childs 1988, 124, pl. 40.4; Padgett 2009, 220.

NOTES
For Fikellura pottery: Cook 1933–34; Cook and Dupont 1998, 77–91. For the Altenburg Painter: Schaus 1986, 253–70; Cook and Dupont 1998, 78–81. For the fallow deer attacked by griffins and sphinxes, compare another neck-amphora by the Altenburg Painter (Metropolitan Museum of Art, New York, 74.51.365a–b), also from Cyprus: Gjerstad et al. 1977, 35, no. 164, pl. 19.3–5; Schaus 1986, 252, no. 1, pl. 13a–b. On a privately owned oinochoe by the artist, the griffins are omitted: Padgett 2003, 273–76, no. 68. Centaurs are rare on Fikellura vases; those on a fragmentary neck-amphora in the National History Museum, Bucharest, also carry branches but are by a different painter: Tempesta 1998, 171, no. 71, pl. 34, fig. 3.

—JMP

Red-Figure Wine Cup (Kantharos)

Greek, Attic, ca. 440–410 B.C.E., attributed to the Shuvalov Painter
Found by the Department of Antiquities of Cyprus at Polis-Arsinoe Street opposite the museum,
in a tomb, during rescue excavations
Ceramic; h. 10.9 cm., diam. 12 cm., 6.2 cm. (base)
Polis Chrysochous, Local Museum of Marion and Arsinoe (MMA 538/40)

Condition: Complete; repaired in antiquity. Reassembled from fragments;
missing parts restored and painted.

This sessile kantharos with low handles is attributed to the Shuvalov Painter, active in Athens between 440 and 410 B.C.E. The body consists of a rounded deep bowl with tall walls, slightly flaring toward the rim; the outer edge of the rim is slightly rounded. Two vertical strap handles rise from the lower body to below the rim. The base is a ring with sloping inner face. The decoration is in the red-figure technique.

A young male stands with his head in profile facing right. He rests on his left leg while his right leg bends forward. Curly hair falls onto his neck. He has a large floral wreath on his head composed of two series of leaves. His body is almost entirely wrapped in a large cloak (himation), exposing only his right shoulder and arm. The cloak falls from behind his left shoulder in a mass of folds. His body is visible through the almost transparent cloth and he is barefoot. His left hand seemingly rests on his hip, while his right hand holds a tree branch in front.

On the opposite side, again a young male stands with his head in profile but this time facing left. His body is almost frontal, though slightly turned to the left. He has short curly hair. Behind his head a *petasos* cap hangs over his shoulder. His nude body is partly covered by a short traveler's cloak tied on his right shoulder, covering his left side. He wears sandals with long, high straps. His right hand is on his hip, while his left hand holds a tall staff.

This type of cup is common in black-glaze ware from archaeological contexts of the fifth century B.C.E., but the type is rarely decorated with figures. Only two kantharoi of this type have been attributed to the Shuvalov Painter. The second, in Berlin, shows a fighting figure similar to that with the staff on this kantharos. The identity of the figures is uncertain: the young man with the branch may be Apollo because he is comparable to other representations of the god by this painter; the youth with the staff resembles other figures painted by the same painter, one of them identified as Theseus.

PUBLICATIONS
Unpublished

NOTES
ARV[2] 1206–10; Lezzi-Hafter 1976. Black-glaze examples: Sparkes and Talcott 1970, 115–16, pl. 27. Berlin kantharos: Rohde 1990, pl. 36.3–6. Identification of figures: Lezzi-Hafter 1976, pl. 88c–d and pl. 93 (Apollo); pl. 83e (Theseus). Attributed by Lezzi-Hafter.

—ER

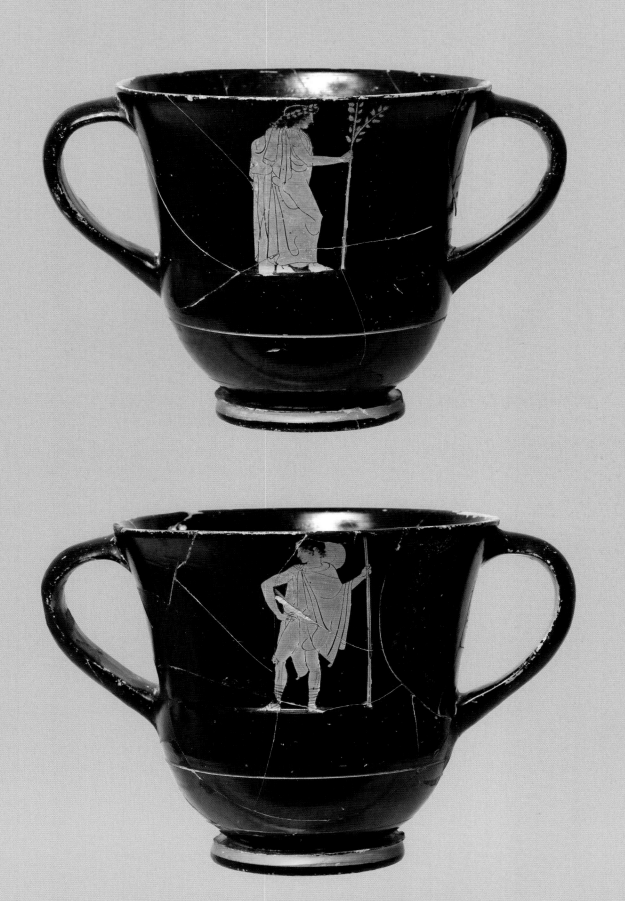

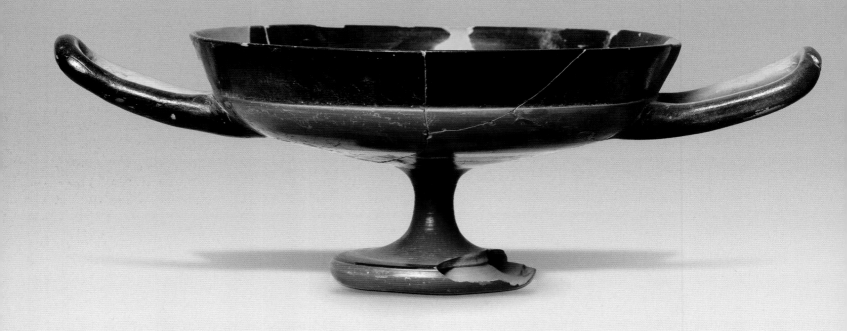

36

Coral-Red "Rattling Cup"

Greek, Attic, second quarter of the 5th century B.C.E.
Probably found by Max Ohnefalsch-Richter at Polis in a necropolis in 1886
Ceramic; h. 7.6 cm., w. 22.8 cm. (with handles), diam. 14.6 cm. (rim), 6.3 cm. (foot)
Polis Chrysochous, Local Museum of Marion and Arsinoe (MMA 203; formerly Nicosia,
Cyprus Museum C1032)

Condition: Repaired from fragments. Missing sections of the rim are restored, but not
the gap in the hollow foot. Some surface wear, particularly to the coral-red gloss.

In addition to Athenian black-figure and red-figure vases, Attic black-glazed vessels, produced in a variety of shapes and coated entirely with glossy black slip, were exported in large numbers to ancient Marion, where they are commonly found in tombs of the fifth and fourth centuries B.C.E. Among the most aesthetically pleasing are those decorated with both black and "coral-red" gloss, as on this cup, one of two apparently found at Polis in 1886. It is a wine cup, a kylix, with a shallow bowl, two horizontal handles, an offset rim, and a slender stem that runs smoothly into the foot. Its form is basically that of a "Vi-cup," a type well represented in purely black-glazed examples from Polis, but differing in having a hollow foot with a convex profile that once contained a number of small clay pellets. The foot is broken and the pellets lost, but the second cup, in Nicosia, retains its pellets, and a gentle swirling motion sends them rattling around the interior. The crisp potting and eggshell thinness of these "rattling cups" are enhanced by their striking bichrome decoration. The rim is black but the body is coral red, inside and out. The black handles have reserved inner panels. The foot is red, with a black stripe around the top edge; the resting surface is reserved, but the underside is black, with a reserved inner cone.

Rattling cups are rare but are well documented in black glaze, usually in the form of Vi-cups or cups of Type C. Coral-red examples are known only from Polis: the pair in Nicosia and four fragmentary examples from the Princeton excavations, which also have yielded other types of Attic coral-red vessels. Among the latter are stemless wine cups with either a disk foot or a base ring; salt cellars; and fluted "Achaemenid phialai," which imitate a type of Persian silver cup. The purpose of the rattling cups is unknown; they may have functioned as amusing novelties at symposia, with drinkers trying to set the pellets rolling without spilling their wine.

PUBLICATIONS

Flourentzos 1992, 152, pl. 47.7; Padgett 2009, 225.

NOTES

For Attic coral-red pottery: Sparkes and Talcott 1970, 19–20, 99–101; Cohen 2006, 44–70. For its export throughout the Mediterranean: Shefton 1999, 466–74. For rattling cups: Vickers 1970. For the second coral-red rattling cup in Nicosia (C1033): Flourentzos 1992, 152, pl. 48.1. For coral-red vessels from the Princeton excavations: Padgett 2009, 224–27, pl. 17; for a rattling cup of this type: Padgett 2009, 225–26, figs. 18–19, pl. 17D.

—JMP

37

Red-Figure Askos

Greek, Attic, first half of the 4th century B.C.E., attributed to the Group of the Cambridge Askos
Found by the Swedish Cyprus Expedition at Polis-Evrethades, Tomb 67, in 1929
Ceramic; diam. 9.5 cm.
Nicosia, Cyprus Museum (SCE Marion P.T. 67.13)

Condition: Intact and unbroken. Minor surface wear.

Askos is the name given to a type of small Greek ceramic vessel that, in its most frequent form, has a circular body with a flat base, a low, domed upper surface, a tilted trumpet spout, and an arched handle. In Athens, askoi were made from the beginning of the fifth century to the end of the fourth. They commonly are decorated in the red-figure technique, often with figures, sometimes with floral or geometric designs. Widely exported, they turn up at sites as far flung as Rhodes, Italy, and the Crimea. Many have been found on Cyprus. In Polis, this example, along with a number of imported Attic black-glazed vessels, including four askoi, accompanied the burial of a woman decked out in silver jewelry.

In style, this askos is typical of Beazley's Group of the Cambridge Askos, of which fragmentary examples have been found in the Princeton excavations at Polis. In the center, set within a circular flange decorated with egg pattern,

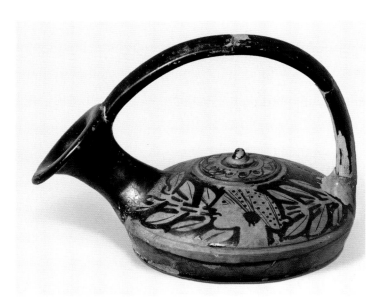

is a small knob. Painted on either side of the body is a head in profile, flanked by olive sprigs. On one side is the head of a woman wearing a cloth snood (sakkos) with a woven or embroidered design. The head opposite wears a felt or leather cap with long earflaps (see cat. no. 38), a type associated with northern and eastern "barbarians," whether real or mythical, such as Scythians or Amazons. Comparison with contemporary Attic vases allows us to identify this figure as a male Arimasp, one of a mythical northern race that was said to be locked in continual conflict with monstrous griffins. The combination of a "real" and a mythical figure is perhaps a function of the apparent funerary role of askoi, embodying the transition from this world to the next. They nearly always are found in graves, but the question of their original contents has been fiercely debated; they may have contained olive oil, a traditional offering to the dead, or a portion of wine for making a libation at the grave.

PUBLICATIONS
Gjerstad 1935b, 381, no. 13, pls. 72, 145.5; *ARV*² 1505.4.

NOTES
Attic askoi: Moon 1971; Hoffmann 1977; Massei 1978; Boardman 1981. Group of the Cambridge Askos: *ARV*² 1505, 1697. For a closely similar work, by the same hand, now in a New York private collection: Moon 1971, pl. 63; Sotheby's, New York, June 18, 1991, no. 282. An askos from Olynthos has the olive sprigs, but neither head is an Arimasp: Archaeological Museum of Thessaloniki 84; *ARV*² 1505.5; Robinson (D. M.) 1933, 173, pl. 140, no. 404.

—JMP

38

Red-Figure Askos

Greek, Attic, first half of the 4th century B.C.E., attributed to the Group of the Cambridge Askos
Said to have been found in a tomb at Polis
Ceramic; h. 9.4 cm., w. 13 cm., diam. 8.5 cm. (base)
Polis Chrysochous, Local Museum of Marion and Arsinoe (MMA 214; formerly Nicosia,
Cyprus Museum C884)

Condition: Complete except for a small restored piece of the rim of the spout.

This small clay juglet is an askos, a product of Athens that was widely exported throughout the Mediterranean in the fifth and fourth centuries B.C.E., along with many other types of red-figure and black-glazed vessels. It is similar in shape to numerous other askoi found in Cyprus, in particular at Polis (such as cat. no. 37), where there is a fuller discussion of the type. This example also was discovered in a tomb at Polis, which accounts for its excellent preservation. It has a simpler knob than the other vase but differs principally in its red-figure decoration. A band of egg pattern circles the body at its widest point. As before, each side features a profile head of differing character. On one side is a woman wearing a hair net, or sakkos; on the other, a mythical male Arimasp wearing a cap of "barbarian" type, with long earflaps. Instead of the olive sprigs on the other

askos, each figure faces the head and shoulders of a panther, so swiftly sketched that it might be taken instead for an owl; its feline character is clearer on other examples. Panthers are associated with Dionysos, the god of wine, but that need not be an indication of the vessel's original contents, a question debated by scholars. The combination of motifs, although significantly different from those on the other example, indicates that this askos, too, belongs in Beazley's Group of the Cambridge Askos.

PUBLICATIONS
Unpublished

NOTES
See the references under cat. no. 37.

—JMP

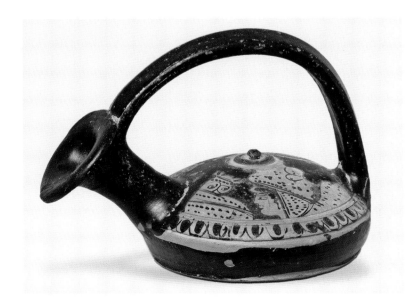

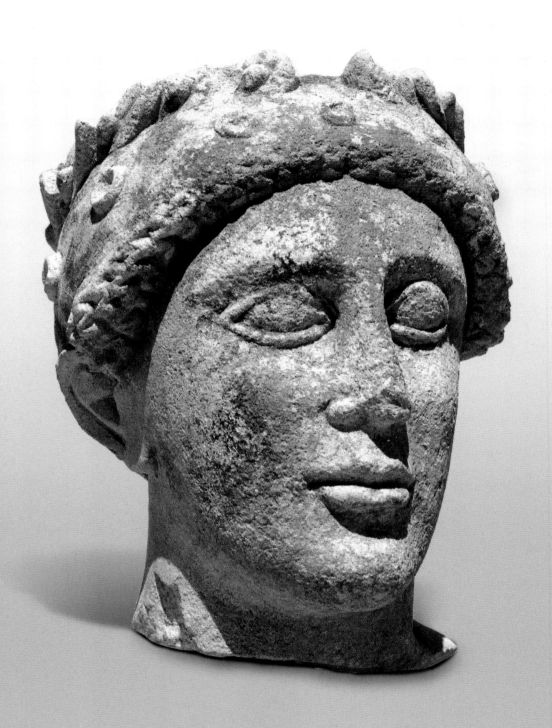

39

Male Head with a Wreath

Cypriot, middle or second half of 5th century B.C.E.
Found by Princeton at Polis-Maratheri, trench A.H9:s15, in 1985
Limestone with red paint; h. 13 cm., w. 9.7 cm., th. 9.8 cm.
Polis Chrysochous, Local Museum of Marion and Arsinoe (MMA 142;
Princeton Cyprus Expedition R1046/SC9)

Condition: The head was broken from the body at the neck. There is a black stain on the hair above the forehead below the wreath, on the forehead itself from above the left eye down into the inside edge of the eye socket, across the bridge of the nose, the right eye and socket, and the right cheek to just above the chin.

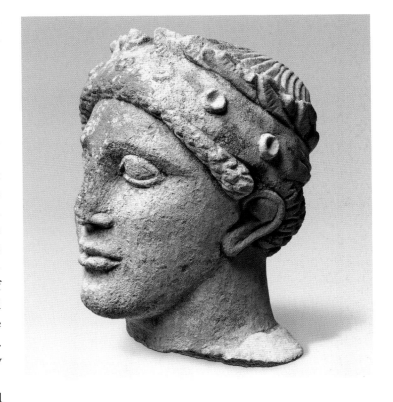

Found in the destruction level of the Classical sanctuary of A.H9, the head is broken at the neck with just a small bit of the left shoulder remaining, indicating that the figure wore a simple garment with traces of red paint. He wears a wreath consisting of an upper part of symmetrically disposed elongated leaves (laurel?) that do not join at the center above the brow, and a lower part that appears to be a band of red material decorated with seven flowers. The center of each is a raised button with the petals radiating in reserve against the red band; they were probably painted, but the color has disappeared. There is no indication of a fastener at back. The ears are sketchy, the left one more than the right. The figure's hair is rendered in two ways: on top of the head is an emphatic part down the middle from which plain, unarticulated strands cover the top of the head to the border of the wreath; over the brow, below the wreath, the vertical surface of tightly curved strands barely protrude; the same pattern recurs in the mass of hair at the back above the neck. The black stain on the right side of the face was caused by the ash layer in which the head was found.

Franz Georg Maier has noted that the flower-studded wreath harks back to Assyrian royal insignia and suggested that it may have similar meaning on Cyprus.

The strong emphasis on the eyelids and the full, unsmiling mouth indicate the influence of Early Classical Greek art (480–450 B.C.E.), which had little following outside the Greek mainland. At the same time, the elaborate treatments of the hair and wreath are reminiscent of the Late Archaic style, which appears to have lasted far longer on Cyprus than in Greece. This is perhaps the most sensitive and accomplished sculpture in the Greek Early Classical style on Cyprus, comparable perhaps only to an exquisite terracotta head from Vouni.

PUBLICATIONS
Childs 1988, 124; Childs 2008, 68.

NOTES
Maier 1989, 383, fig. 40.4; Hermary 1989b. On Vouni: Gjerstad 1937, 259, 269, pl. LXXIV.

—WAPC

Stater of Marion

Cypriot, ca. 470–450 B.C.E., reign of Sasmas, king of Marion, son of Doxandros
Provenance unknown
Silver; diam. 17 mm., weight 3.68 grams, die axis 3
London, British Museum (1842.1-10.1)

Obverse: Lion facing right, scratching right foreleg with right hind paw and head bent down to lick it; above is a double-headed axe of Minoan form; in the exergue below is a double spiral. The inscription above is in the Cypriot syllabary; it reads from right to left: *sa-sa-ma-o-se-to-ka-sa-to-ro* (Σασμᾶς ὁ Δοξά(ν)δρω).
Reverse: Nude male with hair in *crobylus* (topknot) hanging beside ram who runs left; his right arm clasps it by the neck; below on left is a Minoan double axe; all in incuse square. There are two inscriptions: on the left in the Cypriot syllabary *ma-ri-e-u-se* (Μαριεύς) and beneath inverted the Phoenician legend ML, possibly for *milk* (king) or as an alternate form of the name Marion.

Marion was one of ten cities of ancient Cyprus to mint coins in the name of its rulers. To judge from surviving issues, the output of its mint was less than that of Salamis, Paphos, or Kition. The silver coins of all mints are on a weight standard called a stater, which seems to derive from that of Persian coinage. The stater was divided into twelve obols, and intermediate denominations of diobols (one-sixth of a stater: cat. no. 43) and tetrobols (one-third of a stater: cat. no. 41) were minted, as well as the stater and obol. Like those of other Cypriot mints, the coins of Marion bear legends in the Cypriot syllabic script, with occasional appearances of Greek and Phoenician letters, as on the reverse of this coin.

This is the earliest known coin issue of Marion. Neither Sasmas nor his father, Doxandros, is attested in any source other than these coins, whose inscription could be securely established only on the basis of numerous comparative examples. Though the name Doxandros appears to be Greek in form, there is no agreement as to the ethnic origins of the two men. The appearance of Phoenician letters on the reverse is unusual for Marion, for which there is moderate evidence of Phoenician presence or influence. The figure on the reverse is identified as Phrixos, a Classical Greek hero from Boeotia who fled sacrifice by his father, Athamas, by flying to Cholchis on the back of the ram with the golden fleece.

PUBLICATIONS
Hill 1904, 71.E2, pl. XIII.12 [as uncertain]; Babelon 1910, 2.2, 824, no. 1366, pl. 136.17.

NOTES
Robinson (E. S. G.) 1932, 209, no. 10; Masson 1983, 181–83, no. 168; Perdicoyianni-Paleologou 2008, 84, no. 3; Hermary 2002. On the Phoenician characters: Masson and Sznycer 1972, 78–81; Destrooper-Georgiades 1987, 347.

—AMS

41

One-third Stater of Marion

Cypriot, ca. 470–450 B.C.E., reign of Sasmas, king of Marion, son of Doxandros
Found by Princeton at Polis-Petrerades, trench E.F2:g12, in 2003
Silver; diam. 12.6 mm., weight 1.43 grams, die axis 5
Paphos District Museum (Princeton Cyprus Expedition R39988/NM1749)

Obverse: Forepart of crouching lion right; above, inscription in the Cypriot syllabary
reading from right to left: *sa-sa-ma-se* (Σασμᾶς).
Reverse: Ram's head right in incuse square; Cypriot syllabic inscription:
above: *ma* and below: *ri-e-u-se*, written left to right (Μαριεύς).

This is one of two certain coins of the kings of Marion found in the Princeton excavations. This coin was found in a disturbed surface level of sector Area E.F2, which would eventually contain the basilica. It is a fraction, probably one-third, of the much more common stater of Sasmas (cat. no. 40). The lion of the obverse, which resembles that on seals of Marion, is represented only by his forepart, and the reverse scene of Phrixos is represented by the ram's head, another common motif (compare cat. no. 9). The only other published example of this coin, in the Symeonides collection, was found in the area of Polis.

PUBLICATIONS

Childs 2008, 66.

NOTES

Destrooper and Symeonides 1998, 112 no. 9, 117, 122, pl. IX.9.

—AMS

42

Stater of Marion

Cypriot, ca. 450 to later 5th century B.C.E., reign of Stasioikos I, king of Marion
Provenance unknown
Silver; diam. 26 mm., weight 10.68 grams, die axis 5
London, British Museum (1902.6-7.10)

Obverse: Head of Apollo facing right with wreath, Cypriot syllabic legend of King Stasioikos:
pa-si-le-wo-se | sa-ta-si-wo-i-ko (Βασιλῆϝος Στασιϝοίχω).
Reverse: Europa on bull galloping right, in incuse square, Cypriot syllabary legend of King Stasioikos,
above: *pa-si-le-wo-se* (Βασιλῆϝος); below: *sa-ta-si-wo-i-ko-ne* (Στασιϝοίχων).

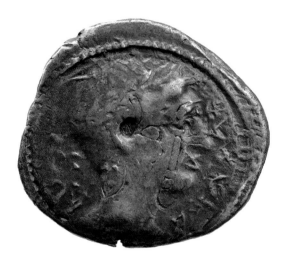

This coin has been overstruck on an earlier coin of Soloi, whose obverse *gorgoneion* and reverse ankh are still visible.

Stasioikos may have been the first king of a Greek dynasty set up in Marion after Kimon took the kingdom. Hermary sees the depiction of Europa on the reverse as a substitute for that of Phrixos on the coins of the earlier king Sasmas, establishing the claim of a different royal origin, perhaps Cretan. The regional circulation of this and other issues of Marion is attested by the presence of 150 coins of Marion, including 14 examples of this issue, in a hoard of 252 coins found in the excavations of the palace at Vouni nearby.

PUBLICATIONS

Hill 1904, 32.1, pl. VI.9; Babelon 1910, 2.2, 806, no. 1329, pl. 135, 10.

NOTES

Masson 1983, 183, no. 169; Perdicoyianni-Paleologou 2008, 91, no. 43. On Stasioikos: Perdicoyianni-Paleologou 2008. On Europa: Hermary 2002, 283. On Vouni: Schwabacher 1947.

—AMS

43

Diobol of Marion

Cypriot, ca. 330–312 B.C.E., reign of Stasioikos II, king of Marion
Provenance unknown
Silver; diam. 12 mm., weight 1.22 grams, die axis 5
London, British Museum (RPK, p162A.1 Mar.)

Obverse: Head of Zeus, left, bearded and laureate; in front in Cypriot syllabary: *sa-ta* (Σατα).
Reverse: Head of Aphrodite, right, wearing myrtle wreath, hair rolled in chignon, earring and necklace;
behind: MAPI; in front: myrtle branch; concave field.

 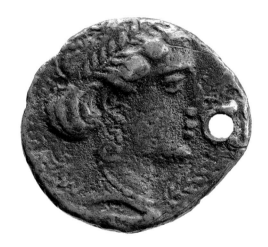

This coin is later than those in the Vouni hoard, which contained issues of Marion in the names of Stasioikos (cat. no. 42) and another king named Timocharis. Technical considerations indicate that the coins of Timocharis in that hoard were minted after those of Stasioikos. This issue, which is absent from the hoard, must be of a second king of the name, documented by Diodorus Siculus as having been removed from power in 312 B.C.E. by Ptolemy. He was the last independent ruler of Marion. The images of Zeus and Aphrodite may refer to the sanctuary at Polis-Maratheri that was dedicated to Aphrodite and possibly also to Zeus. An example of this coin found near Polis is in the Symeonides collection. While coins of this last king of Marion are known in gold, silver, and bronze, those of his predecessors are all of silver.

This coin has been pierced, possibly in antiquity, to test the quality of its silver.

PUBLICATIONS

Hill 1904, 34 no. 5, pl. VI.13; Babelon 1910, 2.2, 813, no. 1342, pl. 129.20.

NOTES

Masson 1983, 185, no.171f; Perdicoyianni-Paleologou 2008, 92, no. 43 (not distinguished from Stasioikos I); Destrooper and Symeonides 1998, 113, no. 61 and pl. X.61.

—AMS

Fragmentary Funerary Relief

Cypriot, end of the 5th century to first half of the 4th century B.C.E.
Found in a house at Paphos in 1974 and thought to have come from Polis
Limestone; h. 42.5 cm., w. 30 cm., th. 15.5 cm., d. 6 cm. (relief)
Paphos District Museum (MP 2097)

Condition: Bottom half and top right corner missing; raking cornice of the pediment mostly broken away; modern broad scratch above and to the right of the woman's head; her face is much damaged but part of her right eye and cheek are preserved near the relief ground.

This fragmentary relief belonged to a pedimental funerary stele with a side frame; all that is preserved of the figures is the head of a woman facing left near the right side. She wears a cloth wrapped in several folds around her head, leaving the upper crown of hair exposed; a narrow, undulating border of hair over the brow with internal, horizontal hair strands protrudes below the head cloth; she wears a himation (mantle) over the preserved section of her left shoulder.

A Cypriot syllabic inscription reads from right to left on the architrave; a Greek alphabetic inscription on the relief ground below it is sloppily carved and is thought to represent a later reuse of the stele. These are transcribed as follows:

zo-wi-ya-se e-pe-se-ta-se-ta-se-[(Zowiyas set this up)

---π]αρθένοι οἵαν	(. . . unmarried girls such as
---ή]μετέρας	(. . . our
---]μητρὶ λιπούσαι	(. . . leaving to [our] mother
---πλῆθο]ς ἀχέων	(. . . much grief

The height of the Cypriot signs is about 1 cm. on the architrave; the height of Greek letters varies by line: 1.2 cm. in the top lines; 1.5 cm. in the bottom line.

Although only a small part of the original relief is preserved, the original composition is easy to guess. The woman's head is close to the architrave and tilts down to the viewer's left; she must have been standing and facing a seated figure on the left in a pattern known from myriad Attic and generally Greek stelai of the end of the fifth and the whole of the fourth century. The preserved section of the pediment above indicates that the stele must have been broad enough to accommodate a seated figure. There are no other Cypriot grave stelai that follow so closely the Greek pattern of standing and seated figures. The stele cannot be earlier than the end of the fifth century and probably belongs in the first half of the fourth century B.C.E. An interesting idiosyncrasy is that the surface of both vertical sides is smooth, which means that the relief was very unusually constructed of two or more slabs.

The Greek inscription parallels in sentiment many Attic epigrams on grave stelai, though "*parthenoi*," the plural, is unusual. Covering the standing woman's hair with something that resembles a Greek sakkos is also unusual; on Attic stelai, this would indicate that she is a servant.

PUBLICATIONS
Karageorghis (V.) 1975, 817–21, figs. 34a–b; Nicolaou (I.) 1975, 156–57, fig. 2, pl. XX.5; Masson 1983, 411, no. 167o.

NOTES
Parallel Attic inscription: Clairmont 1993, no. 2.220.

—WAPC

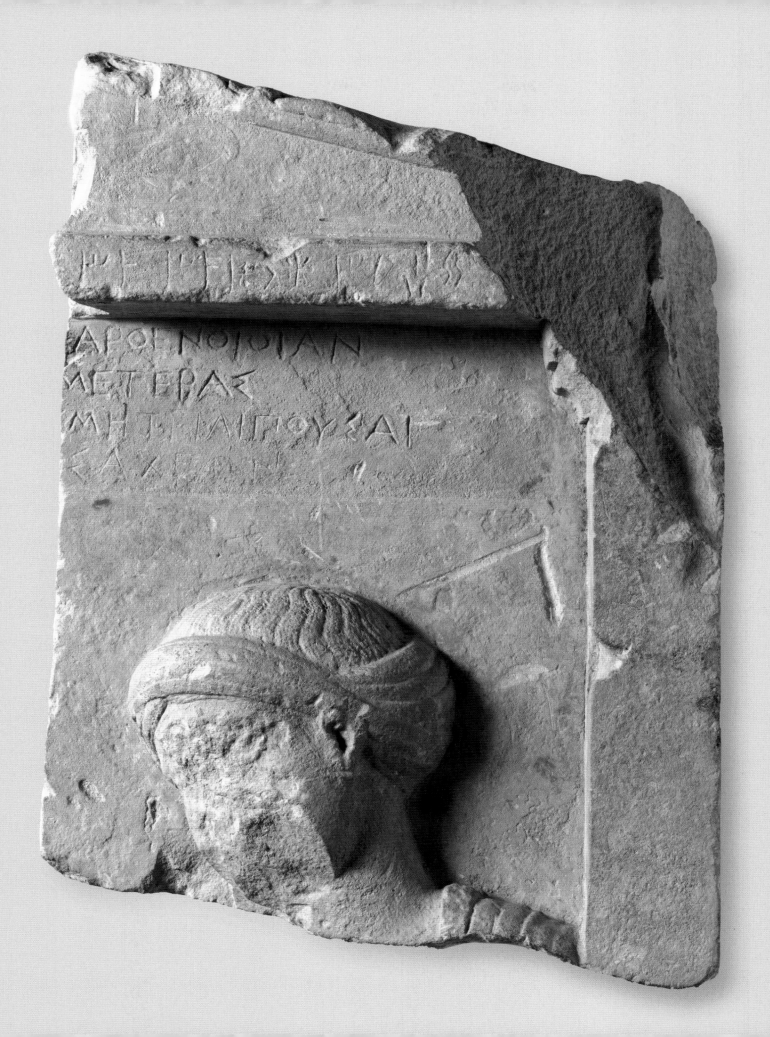

Red-Figure Wine Cup (Kylix)

Greek, Attic, ca. 520–510 B.C.E., signed by the potter Hermaios and attributed to the Hermaios Painter
Found by Max Ohnefalsch-Richter at Polis-Necropolis II, Tomb 70, in 1886
Ceramic; h. 7.6 cm., diam. 18.4 cm.
London, British Museum (1892.7-18.5 [E 34])

Condition: Repaired from large fragments; minor repainting of cracks.
The exterior glaze is worn or misfired red in places.

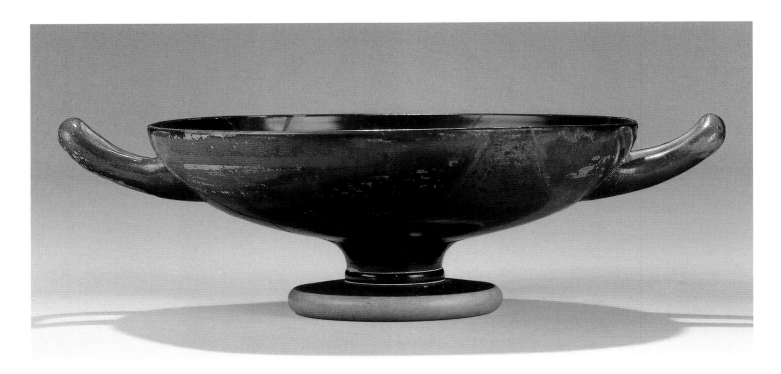

This wine cup, or kylix, is of Type C, with a broad, straight-rimmed bowl and a short, thick stem, separated from the disk-shaped foot by a fillet. The exterior is black except for the inner faces of the handles and the sides and base of the foot. The circular tondo in the interior is decorated in the red-figure technique. A nude woman bends to the right to lift a bronze basin, a *podanipter* (foot bath), which has four handles and three lion-paw feet. She wears a cloth snood, or sakkos, adorned with a wreath painted in red slip. Running around the inner edge of the frame, in red Greek letters, is the signature of the potter: ΗΕΡΜΑΙΟΣ ΕΠΟΙΕΣΕΝ (Hermaios made it).

Women are often represented bathing at a podanipter, which otherwise was standard equipment at a symposium, a male drinking party. In works of the Late Archaic period, these bathers frequently are identified as *hetairai*, prostitutes, and this woman's wreath does suggest a festive occasion. She could be preparing to bathe in private, or she might be fetching the basin for one of her clients; crapulent symposiasts sometimes are shown vomiting into them.

This is one of three cups found together in a tomb at Marion by Ohnefalsch-Richter. This cup and another were signed by the potter Hermaios, while the third was signed by Kachrylion. All three were attributed by Beazley to an

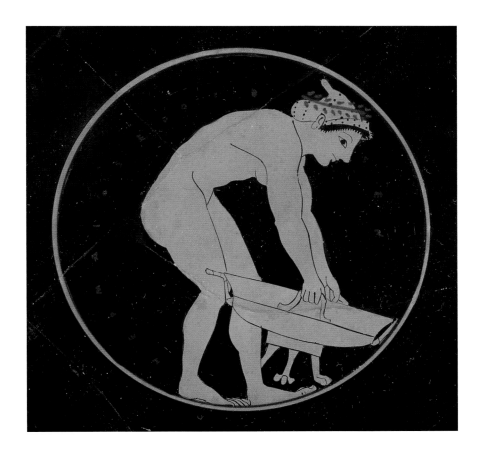

anonymous artist he called the Hermaios Painter. The same artist painted all four of the known cups signed by Hermaios, while Kachrylion's more numerous signed works were decorated by a number of painters, including Oltos and Euphronios, under whose influence the style of the Hermaios Painter was formed. Indeed, it has been suggested that some cups attributed to the Hermaios Painter are, instead, by Euphronios.

PUBLICATIONS

Smith (C. H.) 1896, 61, no. E34; *ARV*² 110, 8; Boardman 1975, fig. 109; Gjerstad et al. 1977, 58, no. 553, pl. 74.6; Peschel 1987, pl. 25.

NOTES

Cf. cups in Copenhagen (*ARV*² 63.87; painted by Oltos) and Thebes (Sabetai 2001, pl. 73). The theme persisted into the fifth century: e.g., *ARV*² 337.23. For the Hermaios Painter, see *ARV*² 110–11, 1626; *Paralipomena*, 331–32; Boardman 1975, 61. The two cups found with this one are in the Museum of Fine Arts, Boston (inv. 95.33; *ARV*² 110.1; Gjerstad et al. 1977, no. 552, pl. 74.4–5) and the State Hermitage Museum, St. Petersburg (inv. 2021 [647]; *ARV*² 110.2; Gjerstad et al. 1977, no. 554, pl. 74.7). For the reattribution of some of the artist's works to Euphronios, see Williams 1992, 82–83; Padgett 2001, 15 n. 12.

—JMP

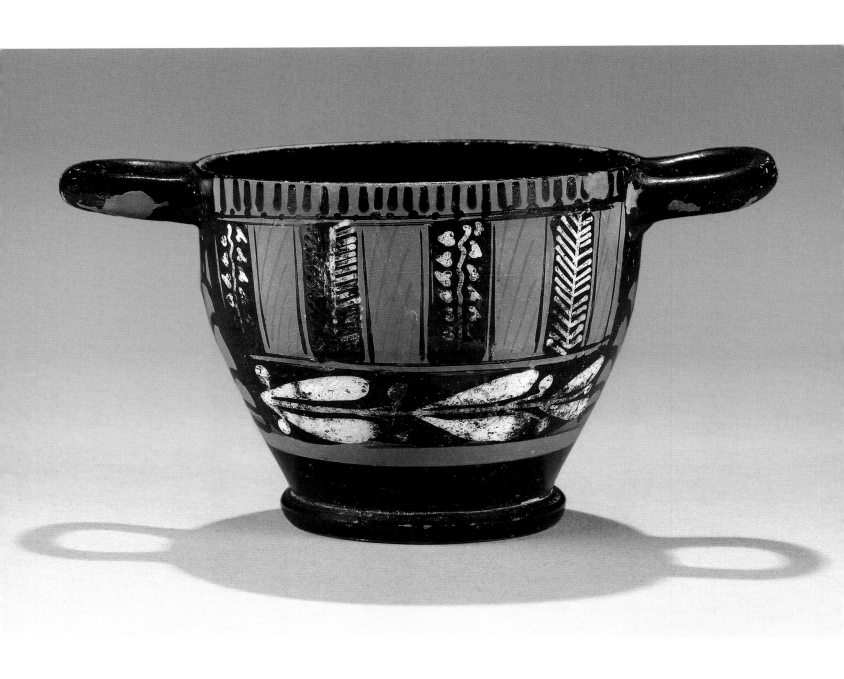

46
Inscribed Wine Cup (Skyphos)

Greek, Attic, end of the 5th century B.C.E., Saint-Valentin Class
Found by the Cyprus Exploration Fund at Polis-Oven Site, Tomb B, in 1889
Ceramic; h. 7.9 cm., w. 15.2 cm. (with handles), diam. 9.56 cm. (rim)
London, British Museum (1890.7-31.32)

Condition: Repaired from large fragments; minor surface wear.

The Saint-Valentin Class consists of small wine cups, mostly sessile kantharoi and skyphoi, with floral and geometric patterns applied in white slip over a ground of black glaze. Originating in Athens, they were widely exported: an example found at La Motte Saint-Valentin, in central France, gave its name to the class. Fragments of similar cups have been found in the Princeton excavations at Polis. Sometimes the designs are combined with red-figure ornament, such as the palmettes under the handles of this skyphos, whose shape is of Type A, with a ring base, tapering body, straight rim, and two horizontal handles. The underside is black except for a reserved disk with a dotted circle in the center. On either side is a black tongue pattern on the rim. Below that is a zone of vertical panels, alternately black and reserved, the latter with streaky, oblique brushstrokes. On the black panels, ivy vines alternate with elongated palm leaves. Below this zone is a myrtle wreath, followed by a reserved stripe. This combination of motifs is mirrored on a few other examples thought to have been produced at the end of the fifth century and the early years of the fourth. In this particular case, the dating is supported by a second vessel from the same tomb at Polis: a red-figure guttus with a ring handle and a molded lion's-head spout, a type well known from Athens in this period. These two vessels have the same pair of Cypriot Syllabic signs incised on the base, presumably added after their import to the island. The inscription reads from right to left, in the Paphian form of the script used in Polis, as *ne-re*, probably an abbreviation for a personal name. It could be a man's name, Νηρεύς (Nereus), a name shared with a god of the sea and one that was used on the island of Chios in the fourth to third century B.C.E. Alternatively,

the two signs could stand for a woman's name based on the fifty daughters of Nereus, the Nereids. The name Νηρείς (Nereis) occurs in several Roman period contexts, including at Amathous on Cyprus. Closer to the time of this tomb deposit, the same name spelled as Νηρηίς is found at Athens in the fourth century B.C.E. and elsewhere in Greece by the third century.

PUBLICATIONS

Munro and Tubbs 1890, 48; Walters 1929, 5, pl. 32.13; Howard and Johnson 1954, 194, Group VII, no. 6.

NOTES

Skyphoi of this class: Howard and Johnson 1954; *ARV*² 984–85. The second inscribed guttus (British Museum 1890.7-31.29 [E 764]): Munro and Tubbs 1890, 49; Schauenburg 1976, pl. 80.3. On names: Fraser and Matthews 1987, 327; Osborne and Byrne 1994, 329; Fraser and Matthews 1997, 314.

—JMP and JSS

47
Conoid Stamp Seal with Animals

Cypriot, 11th–8th century B.C.E.
Found by Princeton at Polis-Peristeries, trench B.D7:r14, in 1995
Pale yellow limestone; h. 2.28 cm., diam. 1.76–1.81 cm. (base), 0.55 cm. (string hole)
Polis Chrysochous, Local Museum of Marion and Arsinoe (Princeton Cyprus Expedition R17857/SS36)

Condition: Burnt; edges rounded; edges slightly chipped near heads of the two animal figures.

Seals are small objects carved in intaglio. Their designs may be impressed in clay or wax as markers of the responsibility of the seal owners in legal and administrative contexts. They were also used to mark jar handles and other clay vessels to indicate ownership, contents, or quality. Seals were highly personal items and could serve as amulets. The loss of one's seal was tantamount to the loss of one's identity. On this stamp from Polis, the wear on the top of the pierced hole shows that it was suspended from a cord, and it was probably worn as part of a necklace or suspended from a pin. This stamp seal is engraved with a bull or a cow, identifiable by the humped muscular back, and a smaller quadruped that could be a calf or a goat. If the representation is of a cow and calf, it evokes the theme of fertility common to many seals. Most common is a scene of a cow suckling a calf, as found on two stamp seals from Polis, one unpublished from the Polis-Peristeries sanctuary and the other from a tomb in Necropolis II. On this limestone stamp, the animals are shown in profile in two dimensions with the smaller animal depicted above the larger one. Conventions of artistic perspective in the ancient world, however, used such placement to indicate the positioning of figures *next to* one another in a three-dimensional field, moving "up" the figure or object that would have been obscured in order to show it. In composition and carving technique, the animals are most similar to quadrupeds on a limestone conical seal at Salamis on the east coast of Cyprus. That seal was found in a tomb with pottery that dates to the early Geometric period, as early as the eleventh century B.C.E. Limestone, a common natural resource on Cyprus, was used for stamp seals from the end of the Late Bronze Age into the Cypro-Geometric period. This example from Polis was found among debris in a pit from the early Cypro-Archaic period and may thus have been made a century or more before its final discard. The pit in which it was found contained discarded votive objects that had been dedicated in the sanctuary, as well as detritus from craft activities; thus, it is possible that the piece was used both as an administrative tool and as an amulet, which would have made it an appropriate votive dedication in a temple.

PUBLICATIONS
Unpublished

NOTES
Cow and calf: Keel 1980. Necropolis II: Ohnefalsch-Richter 1893, 366, pl. 32.29. Salamis: Yon 1971, 1, 20–21, no. 40, fig. 4, pl. 16; Chavane 1975, 151, no. 436, pl. 44. Geometric stamp seals: Reyes 2001, 22–28.

—JSS

48
Scarab with Winged Goddess

Cypriot, later 6th to early 5th century B.C.E.
Purchased from Charles Christian in 1889, found at Mari, Moni, Maroni, or Marion (Polis Chrysochous)
Carnelian; l. 1.45 cm., w. 1.02 cm., th. 0.71 cm.
London, British Museum (1889.10-15.1)

Condition: Scratches on surface with intaglio design; some chipping at rear string hole.

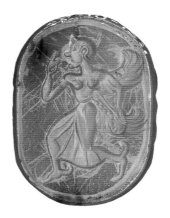

Scarabs (see cat. no. 61) were the standard shape for Cypriot seals by the later Archaic period. Many were carved out of carnelian, the reddish brown to orange color of which linked them with power. In Greek, a seal was known as a *sphragis* (σφρηγίς), which also referred to their significance as gems. Gems were thought to have protective qualities even without carved decoration. Intaglio carvings, cut into gems, especially those that featured deities, added to their power. The extreme miniaturization of these figural carvings, thought to have been crafted without the aid of a magnifying lens, lent them a magical aspect, thus encapsulating the protection offered by deities within seals as amulets.

This scarab features a goddess running to the left, as seen on the seal's surface. She has winged feet, which identify her possibly as the goddess Iris, messenger for the gods, often for the goddess Hera (cat. no. 22). She carries neither her staff (*kerukeion*) nor her jug, but in her left hand she holds an object that may be a bowl (phiale) of the kind used to pour libations (see cat. no. 22), another identifying attribute of Iris. This figure seems to be conflated with the male messenger god, Hermes, with whom she sometimes appears. Her hair is not visible; instead, she wears a short-brimmed cap that compares closely with the felt cap (petasos) worn by Hermes on a scaraboid said to be from Polis. John Boardman has described the flat and shallow carving as the Dry Style. A drill was used, however, especially for the row of dots between her waist and the bowl.

This seal was sold to the British Museum in 1889 by Charles Christian. At that time, some still considered the ancient city of Marion to be located at Mari rather than at Polis. Although published by Boardman as coming from Marion, Henry B. Walters listed this seal as from Mari(?). Thomas Kiely has shown that the objects registered with this seal are listed as from Mari, a village on the south coast that is sometimes confused with nearby Moni and Maroni.

Among these items registered together as from Mari are some that seem to come from other sites; this leaves open the possibility that the scarab with the winged goddess was found at Polis Chrysochous, ancient Marion.

PUBLICATIONS

Walters 1926, 56, no. 467, pl. VIII; Boardman 1968b, 77, 81–83, no. 206, pl. 13; *LIMC* 5 (1990), *s.v.* "Iris I," 744, 758–59, no. 6 (A. Kossatz-Deissman); Boardman 2001, 145–46, 183, pl. 334; Reyes 2001, 150, no. 360, fig. 366; Kiely on 1889,1015.1 in http://www.britishmuseum.org/research/search_ the_collection_database/.

NOTES

Gems and colors: Boardman 1991; Andrews 1994, 102; Boardman 1996, 7–9. Hermes scaraboid: Reyes 2001, 146, no. 346, fig. 352.

—JSS

49
Inscribed Ring with Athena

East Greek, last quarter of the 5th century B.C.E.
Found by the Cyprus Exploration Fund at Polis-Agios Demetrios, Tomb 66, in 1890
Gold; h. 2.07 cm. (ring), l. 1.94 cm. (bezel), weight 7.19 grams
London, British Museum (1891.8-6.86)

Condition: Gold surface scratched in places.

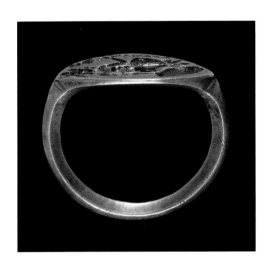

The artistic impact of the colossal sculptures of Athena designed by Pheidias for the Athenian acropolis, both the great bronze statue erected by 450 B.C.E. on axis with the gateway to the acropolis and the gold and ivory statue inside the Parthenon begun in 447 B.C.E., is evident in all forms of Greek art. Both were popular and enduring subjects that lent themselves well to summary visual quotation, especially in miniature, as on seals and seal rings. The portrayal of Athena on this gold ring, as seen in impression, retains aspects of the arrangement of these statues: she holds a winged figure aloft in her right hand and rests her left hand atop her shield. Possibly most like the bronze statue, she holds her owl rather than the goddess Nike (Victory). The owl is positioned as it is on Greek coins with its body in profile and its head turned so that one encounters it face to face. Unlike the Pheidian statues, Athena is seated rather than standing, in a pose with her owl like that on coinage of the Lycian city of Xanthos in the second half of the fifth century B.C.E. On this ring, Athena is barefoot and turned slightly toward her owl. She wears a long belted Ionic tunic (chiton) and a cloak (himation) that has fallen to her waist. Below her triple-crested helmet, her long hair falls to her shoulders. The shield faces inward, allowing the engraver to emphasize her position of repose. This heavy ring with its faceted hoop and convex surface would have fit a man's finger. A man's name, ΑΝΑΞΙΛΗΣ (Anaxiles), was written in Greek alphabetic characters between her feet and the hand holding the owl. It was carved in reverse, indicating that it was meant to be seen in impression. Names beginning with Ἄναξ-, lord or master, were especially common in the Aegean islands during this period. An Ἀναξίλας (Anaxilas) is documented on the island of Naxos in the fifth century B.C.E. Anaxiles or someone who later came to own his seal was buried in Polis with several vessels of Attic manufacture, nine of which were inscribed with the same pair of characters, using not the Greek alphabet but the syllabic script of Cyprus (compare cat. no. 46).

PUBLICATIONS
Munro 1891, 321–23, pl. XV; Marshall 1907, xxix, 11–12, no. 52, pl. II; Mørkholm and Zahle 1976, 47, 76–77, pl. II; *LIMC* 2 (1984), s.v. "Athena," 976–78, 1020–21, 1029–31, no. 203 (P. Demargne); Boardman 2001, 214, 219–20, 297, pl. 688.

NOTES
Names: Fraser and Matthews 1987, 37. Athena on jewelry: Williams and Ogden 1994, 38; Boardman 2001, 198, 288, pl. 486. Great bronze statue: Lundgreen 1997. Athena Parthenos: Nick 2002, 177–205.

—JSS

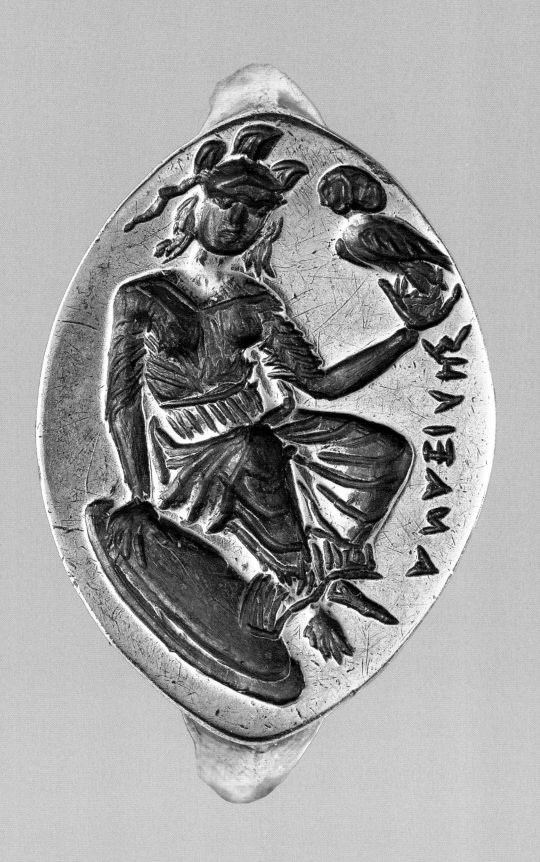

Egyptian Relief

Egyptian, end of the 6th century B.C.E.
Found by Princeton at Polis-Peristeries, trench B.D7:p15, in 2006
Limestone; h. 32.5 cm., w. 21.5 cm., th. 4.5–7.1 cm.
Polis Chrysochous, Local Museum of Marion and Arsinoe (Princeton Cyprus Expedition R50040/SC227)

Condition: The bottom surface is preserved over about 16 cm. but is chipped on the left front 11 cm. from left so that the figure's left foot is missing; there is a modern chip off the back of the bottom edge. The break along the left side is relatively straight and flat; there is a rough diagonal break at top and right side; the back is undulating and rough with no trace of tool marks.

This fragmentary Egyptian relief was found built into the east foundation wall of the early fifth-century temple in Area B.D7 on the Peristeries Plateau. On the left side stands a man facing right; the top part of the relief is missing from approximately the middle of the figure's chest. He wears a short kilt and holds a staff in front of him with his left hand; his right arm is held out in front at a lower level. The kilt is articulated by fine parallel lines that progressively curve from left to right, bending quite sharply over the left leg. Here the garment over the left thigh has parallel lines following the contour of the thigh. There is a raised narrow border along the back or left edge of the kilt with a vertical extension above the belt suggesting the bull's tail that indicated a pharaoh. A broader, horizontal hem marks the bottom of the garment. On the right edge of the fragment is an undulating ridge that is broken away at the bottom and chipped in the middle; this suggests the presence of another figure, and very small fragments of another figure, who was probably facing to the left, were found in the sanctuary building not far from the find spot of the relief. If these fragments did indeed once belong to this relief, the composition probably depicted a row of figures moving to the right and at least one figure facing to the left (a votary?).

The soft, curving folds of the figure's kilt and the emphasis on linearity point to the later sixth century B.C.E. when Egyptian art was influenced by both Greek and Persian styles. The relief could have been imported, but ancient artisans also traveled; for example, the Egyptian pharaoh Merneptah sent a sculptor to Ugarit in the Nineteenth Dynasty, so the relief may well have been carved at Marion.

PUBLICATIONS
Childs 2008, 66.

NOTES
On Merneptah: Radner 2010, 432.

—WAPC

Egyptian Male Amulet

Egyptian, late 6th century B.C.E.
Found by Princeton at Polis-Peristeries, trench B.D7:r15 Sondage I, in 1991
Faience; h. 6.1 cm., w. 3 cm., th. 1.8 cm.
Polis Chrysochous, Local Museum of Marion and Arsinoe (Princeton Cyprus Expedition R11700/FI2)

Condition: The upper chest and the head are missing, as are the legs below the upper thighs. The surface is worn, producing a lighter color except over the left thigh. There is surface damage on the belt on the right side, on both hands, and on the back at the right hip; there is a modern pick gash on the back at the lower edge of the kilt on the right side.

Found among other sacred objects in the upper levels of the bothros, or refuse pit, to the east of the sanctuary in Peristeries, this male figure in blue faience wears a traditional Egyptian kilt. His arms are held rigidly at his sides with hands clenched, and the left leg stands well forward. The kilt has a belt 0.2 cm. wide that curves down around the belly with a well-marked navel. Worn as amulets, such figures served to confer divine power on the owner and thus were powerful and inexpensive votives. Similar faience figurines of the same size depict divinities both male and female and served as votive dedications in Egypt in the Late Period and the Ptolemaic era. It seems likely that this figure, too, depicted a divinity.

Several Egyptian faience amulets and small vases have been found in the two principal sanctuaries of Marion and in the tombs excavated by the Swedish Cyprus Expedition. One aryballos (oil flask) bears the cartouche of the pharaoh Amasis. Also notable are two tiny plaques with *udgat*-eye (the eye of the god Horus), a fragmentary figurine of Bes, and a complete alabastron, whose surface has unfortunately decayed (see fig. 3.15). A similar range of faience objects, but far more numerous, was found in the tombs of Amathous.

PUBLICATIONS

Faegersten 2003, 132; Serwint 2009, 233, fig. 6, lower left.

NOTES

Friedman 1998, nos. 120, 130, 188. Amasis alabastron: Dikaios 1946, 154, pl. 1d. Marion tomb: Gjerstad 1935b, 322, Tomb 50, nos. 16a–d, pl. LIX. Amathous: Clerc 1991.

—WAPC

52
Figurine of a Woman Nursing a Child

Cypriot, second half of the 6th century B.C.E.
Found by Princeton at Polis-Peristeries, trench B.D7:r14, in 1996
Terracotta; h. 10.05 cm., w. 5.9 cm., th. 3.46 cm.
Polis Chrysochous, Local Museum of Marion and Arsinoe (Princeton Cyprus Expedition R19790/TC8477)

Condition: Broken horizontally just below waist level; damage to hair of woman behind both ears and top of head with separation of clay at mold seam visible from ear to ear at rear top of head; abrasion to hair on child's head; chipped on both sides of the woman's body just below elbows.

This fragment preserves the head and torso of a woman who nurses a young child at her right breast. Facing frontally, the woman supports an infant with her right hand under its buttocks and large left hand under the child's right thigh, while the child raises its chin to suckle at the woman's right breast and stretches a thin, attenuated arm toward the left breast. The child appears unclothed, while the woman wears a form-fitting, nearly transparent garment that crosses the torso, leaving the right shoulder and breast bare; slight traces of red pigment below the left forearm indicate that the dress was painted. Although entirely made in a mold, the surface features are indistinct, especially the woman's face, indicating that the mold was already old. Barely perceptible, the woman's almond-shaped eyes are rimmed by a subtle rendering of upper and lower lids; the broad nose flares above a mouth with fleshy upper and lower lips. The cheeks are wide and the broad jaw with thickened chin hides any trace of the neck. Red pigment on the right jaw indicates that the flesh was painted. What looks to be an Egyptianizing wig fits low over the forehead with a bundle of strands falling on the front of each shoulder. Individual locks of hair are indicated by shallow incisions. A very faint incised line parallels the edge of the wig along the hairline, suggesting the natural hairline underneath the wig. It was during the Archaic period that the image of the *kourotrophos* (child bearer) became a common figural type, and its popularity was inspired by the widespread currency of the type in Syro-Palestine during the early first millennium B.C.E. This representation of a woman holding a child that faces her is derived from Egyptian figures, particularly images of the goddess Isis nursing the young Horus. Rare on Cyprus, the type has been attributed to a workshop at Lapithos, located near the north coast of the island, although production is documented for Arsos, Idalion, and now Marion.

PUBLICATIONS
Unpublished

NOTES
Caubet, Hermary, and Karageorghis (V.) 1992, 104, no. 123. General discussions: Karageorghis (J.) 1999, 244–57, esp. pls. LXIV–LXVI; Karageorghis (J.) 1977; Sophocleous 1985, 116–22; Price (T. H.) 1978; Vandenabeele 1988. Lapithos workshop and production of an Egyptianizing *kourotrophos* type: Yon and Caubet 1988.

—NS

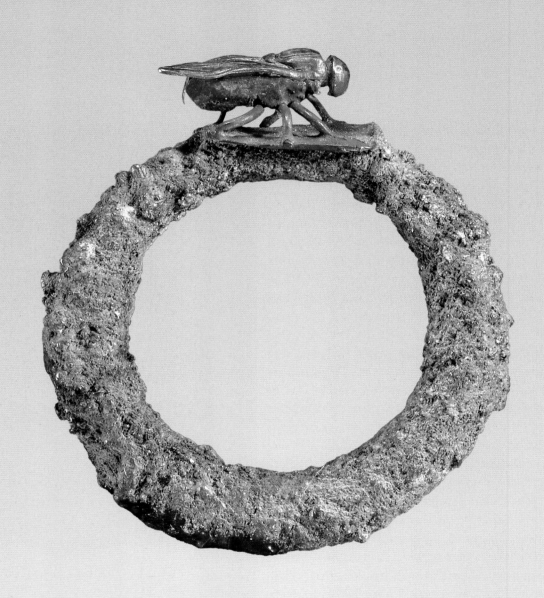

53
Ring with a Fly

Cypriot, end of the 6th century B.C.E.
Found by Max Ohnefalsch-Richter at Polis-Necropolis II, Tomb 162, in 1886
Silver and gold with solder; h. 2.4 cm. (ring), l. 0.9 cm. (fly), weight 3.95 grams
London, British Museum (1887.8-1.63)

Condition: Corroded; left wing of gold fly bent.

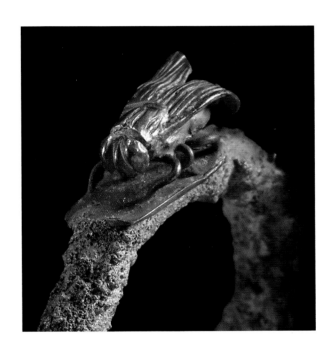

Flies fashioned out of precious stones and metals were worn as amulets and formed parts of necklaces in ancient Egypt. Fly amulets emphasize the head and wings. The fly on this ring is unusual in showing the insect standing on all six legs; at a glance, it appears to be just landing, searching for sustenance, or about to take off in flight. Miniature and yet shown life-size, the body was made in one piece together with the carved head. Cut sheets of gold form the wings, their veining represented by carved striations. The wings and wire legs were soldered to the body. The fly rests on a gold sheet soldered to the narrowest part of a ring hoop. Rings that feature insects normally have a scarab set into the bezel (cat. no. 61), the decorated surface or setting of a ring, or depict an insect on the bezel. Insects were carved in intaglio, as with a cicada on a gold ring from Polis similar in shape to catalogue number 17. Rings with insects in relief were also found in Classical period tombs in Polis, either with the backside of a cicada filling the entire bezel or with birds flanking a bee.

Insects varied in their meaning. In Athens the cicada's emergence from the soil symbolized that Athenians were native to their land. In Egypt, however, cicadas, as a kind of locust, were seen as destructive—like groups of soldiers. The bee was important for honey and in religious contexts in Egypt, being also a symbol of royalty. Yet in the Bible, the bee stood for Assyrian enemies and the fly for Egyptian foes. In the *Iliad*, Homer compared the Achaeans to a swarm of flies in their attack on Troy. The Mesopotamian *HAR-ra ḫubullu*, a classification of animals, groups flies and other insects after predatory birds. In Egypt, the fly (*ff*) was a pest, but it was admired for its persistence, a quality valued in military personnel for whom a fly amulet was an award starting in the Eighteenth Dynasty, an award later given to any civil servant. This ring came from the same tomb as an alabastron painted by the Pasiades Painter (cat. no. 21).

PUBLICATIONS

Ohnefalsch-Richter 1893, 450; Marshall 1907, 163, no. 1014, pl. XXVI.

NOTES

Polis: Munro and Tubbs 1890, 55; Myres and Ohnefalsch-Richter 1899, 128, nos. 4153–54, pl. 8; Gjerstad 1935b, 272, Tomb 34, no. 57, pls. 49.57, 156.3; Boardman 1967, 25 n. 82, 26, nos. N 12, 14–15, pl. 7; Boardman 1970, 12, 14, nos. 31, 55–57, pls. 5–6. Egypt: Andrews 1994, 62–63; Hansen 2001. Bible: Borowski 2002, 303. Mesopotamia: Foster 2002, 272–73. Athens: Clay 2010.

—JSS

54

Cylinder Seal with a Heroic Scene

Persian, Achaemenid, carved originally after 522 B.C.E. and recarved before its deposition ca. 500 B.C.E.
Found by Princeton at Polis-Maratheri, trench A.H9:v15, in 1986
White chalcedony; h. 1.87 cm., diam. 0.88–0.92 cm. (cylinder), 0.25 cm. (string hole)
Polis Chrysochous, Local Museum of Marion and Arsinoe (Princeton Cyprus Expedition R1362/SS4)

Condition: Rounded and worn with a single small chip missing above the head of the hero.

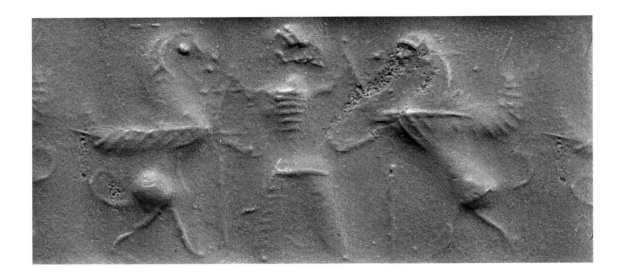

Seals in the shape of a cylinder were common throughout the ancient Near East and were the usual shape of Cypriot seals in the Late Bronze Age. In the first millennium B.C.E., cylinder seals were rare on Cyprus. Stamp seals had largely replaced them even in Mesopotamia by the eighth century. Achaemenid Persians, however, chose to draw on the tradition of cylinder seals perpetuated by the Elamites in Iran. With their repeated designs rolled out in clay, cylinder seals held a longevity of meaning passed down through generations, which helped the Achaemenid Persians to establish the legitimacy of their state. This cylinder seal from Polis is the only Achaemenid example yet found on Cyprus, a rare material testament to Persian connections with the island. As with many Achaemenid seals, this cylinder is small and carved out of chalcedony, a hard quartz stone. It may have been worn suspended from a cord in the Near Eastern fashion, attached to clothing by a pin. A hero controlling a pair of animals was a common composition throughout the Near East, but the winged bulls suggest that this seal was carved at the heart of the Persian Empire. The theme of heroic encounter symbolized protection, reinforcing the dual function of seals as administrative tools and amulets. The integrated design using the entire seal surface and the bent arms of the hero compare with

seal designs carved in the early years of the Persian Empire before 500 B.C.E., especially those used in the fortification archive (509–494 B.C.E.) at Persepolis in Iran. The Persian formal robe once worn by the hero, now seen only in the diagonal folds over the legs and chest, suggests that it was carved after 522 B.C.E. Later carving added a third foreleg to each bull, shifting the use of a foreleg for support to the more common combat pose of two forelegs raised. The lower part of the tunic with vertical folds was also added so that the hero now wears a tunic over trousers, a costume typical of Persian nomadic or Median dress. Details of Achaemenid footwear, headgear, and coiffure all wore

away and were not reengraved, which suggests that this seal may have been adapted to suit Cypriot tastes before its use as a votive offering in the sanctuary about 500 B.C.E.

PUBLICATIONS
Unpublished

NOTES
Achaemenid use of cylinder seals: Root 1996, 17–19, 23. Chalcedony: Sax 2005, 145–46. Heroic encounter theme: Garrison and Root 2001, 54–60, 63–81, 223, esp. nos. 3, 10, 139. Achaemenid dress: Merrillees (P. H.) 2005, 84–95, 100, 106.

—JSS

Loom Weight with a Seal Impression

Cypriot, 5th century B.C.E.
Found by Princeton at Polis-Petrerades, trench E.G0:g03, in 1990
Very pale brown terracotta; h. 5.4 cm., l. 1.7 cm. (impression), w. 3.5 x 4.6 cm. (bottom),
1.1 cm. (impression), weight 93 grams
Polis Chrysochous, Local Museum of Marion and Arsinoe (Princeton Cyprus Expedition R9849/SS34)

Condition: Weight repaired from two pieces, edge worn, a few chips; impressed undamaged.

Woolen and linen cloths woven on Cyprus do not survive well in the archaeological record. The type of fabric woven can often be determined based on the shape, weight, and wear marks of loom weights, especially when they are found in groups. Weavers using warp-weighted looms attached weights of various shapes, usually of terracotta, to the warp fibers through which weft fibers were passed. This pyramidal weight with a flattened top was found singly in a house and probably weighed down medium-weight fibers. Placing a mark on a weight, either an incised mark or a seal impression, was a common practice throughout the Mediterranean from the second millennium B.C.E. through the Hellenistic period and later. People might have marked weights to identify ownership or to delineate warp fibers in a fabric where special weaving techniques were required, as in tapestry design. Cypriot weavers were famous for their tapestries; bone tapestry-weaving tools were found in another house of the Classical period in Polis.

The impression on the top of this weight was made using a seal with an oval base, probably a stone or glass scaraboid, a scarab-like stamp without the features of a scarab beetle. A man faces right, as seen in the impression. He has long hair and a short beard. He wears a pointed cap, a knee-length tunic, and leggings. He bends his right arm up and holds something long and flat over his shoulder. His pose is typical of Classical Greek art, for he bends his right leg and shifts his weight to the left. The seal compares in design with Greek examples of the fifth century B.C.E. in that it isolates one figure, leaves room around it, and omits even a carved border. The dress and details of its subject, however, are Persian. The cap and the posture of the man closely resemble those found on a single male warrior on a seal used in the Persepolis treasury (Iran), a deposit of seals and impressions that dates between 492 and 458 B.C.E. Persianizing seals that blend Achaemenid and Greek subjects and styles were used throughout the Persian Empire. In the western empire at Daskyleion, Turkey, a seal used sometime between 479/8 and 375 B.C.E. depicts a single male hunter in a similar pose with a goat slung over his back.

PUBLICATIONS
Unpublished

NOTES
Cypriot weavers: Athenaeus, *Deipnosophists* II.48.b. Weaving in Polis: Smith (J. S.) 2012, 179–80. Greek and Persianizing seals, seal-impressed weights: Boardman 2001, 192–94, 309–10, 424. Persepolis treasury: Schmidt 1957, 14, 34, no. 47, pl. 12 (PT6 116). Daskyleion seal: Kaptan 2002, 116, 213, no. DS 99, pls. 292–93.

—JSS

Male Figurine of Assyrianizing Style

Cypriot, late 6th century B.C.E.
Found by Princeton at Polis-Peristeries, trench B.D7:s17, in 1997
Terracotta; h. 7.68 cm., w. 4.98 cm., th. 0.47–2.49 cm.
Polis Chrysochous, Local Museum of Marion and Arsinoe (Princeton Cyprus Expedition R21610/TC8827)

Condition: Broken at slight diagonal just above waist level. Tip of nose missing, as is top of left shoulder; damage to hair behind right ear and chipped just above left ear.

This figurine fragment preserves the head and torso of a bearded man whose facial features and costume reflect distinct Assyrian influence. Made in a mold that included the front of the face and the body, the figure stands frontally with the right arm bent at the elbow with the hand clenched in a fist and held against the chest, while the left arm is held alongside the body. This pose is characteristic of male representations from the Near East and Cyprus. The torso is covered by a red-painted garment that binds the bent right arm to the chest. This is a shawl worn by men of high status over a long linen tunic indicated by slight coloration of black pigment. The rippled surface of the edge of the woolen shawl represents its fleecy fringe, and such garments were sometimes richly decorated. The treatment of the face and hair also signals a distinct ethnic type (see cat. no. 57) and is a departure from the more general features of other votives (see cat. no. 70). The round face includes large, almond-shaped eyes outlined in black with a slight indication of the pupils in black pigment. Below the broad nose, the mouth is painted red, and a horizontal gash separates the lower lip from the upper. Large ears, painted red, are placed well back on the side of the head and show the outer helix of the ear. The forehead and temples are framed by hair depicted by a thin, painted black line, and beginning below the ears and covering the lower cheeks and chin, a manicured beard, represented as vertical striations painted black, is horizontally trimmed across the bottom and falls to the upper chest. The particular beard type and bundled locks of hair on either shoulder are characteristic of representations of Assyrian male royalty. Although the usual headgear for males in the Assyrian world is a pointed cap that reflects a military helmet (as in cat. no. 70), the figurine shown here wears a diadem of a type known for Assyrian sovereigns that could be adorned with a frontal decorative element, as the central red-painted rectangle suggests.

PUBLICATIONS
Unpublished

NOTES
Exact parallels are unknown; see Karageorghis (V.) 1993. The fringed mantle is found at Agia Irini: Karageorghis (V.) 1993, nos. 37, 47, 107, and p. 19, fig. 12; also no. 73. General discussions: Gjerstad 1935a, 642–824; Törnkvist 1972; Roaf 1990; and Bertman 2003.

—NS

III.

THE SANCTUARIES OF MARION

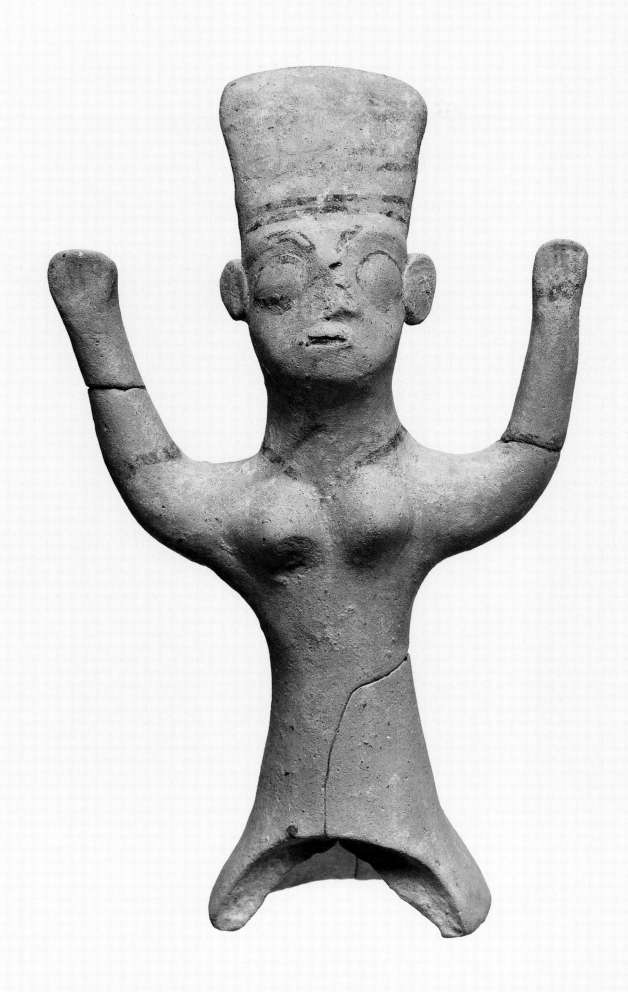

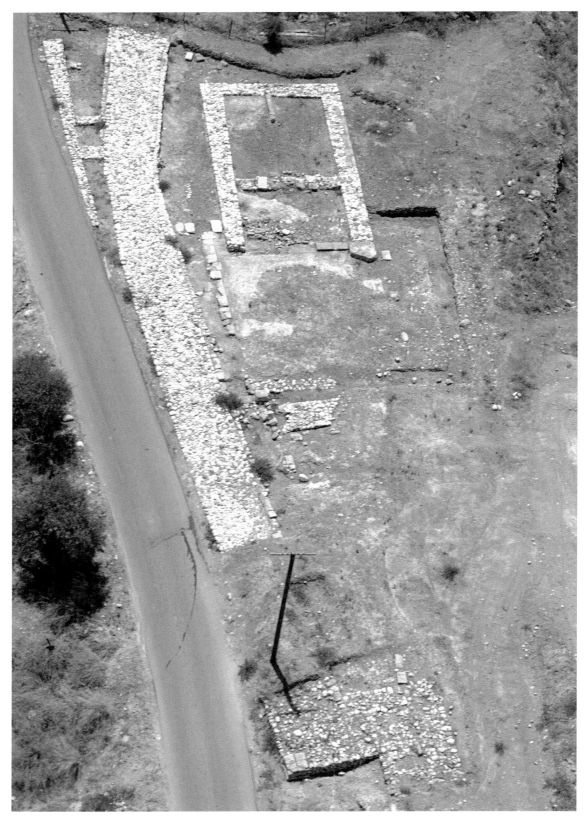

FIGURE 3.0. View of the sanctuary in Area A.H9 at Polis-Maratheri, taken from a helicopter in 2006; north is at the bottom.

III.

THE SANCTUARIES OF MARION

Joanna S. Smith, Mary Grace Weir, and Nancy Serwint

In communities throughout the eastern Mediterranean during antiquity, sanctuaries were centers for religious, social, and artistic expression. Religion was integral to daily economic and political life; cult activity, animal sacrifice, ritualized feasting, and the storage of commodities brought men, women, and children together. In sanctuaries people sought answers to questions by communicating with their gods, celebrated rites of passage according to their age and gender, and competed to assert their social standing in the community. Not only did people worship their gods in sanctuaries, but they also crafted statuary, textiles, and vessels intended as gifts for the gods in close proximity to cult spaces. These votive offerings were also aimed at a human audience as displays of wealth, status, taste, and knowledge.

In Polis Chrysochous, the imagery and cult equipment found in sanctuaries reflects the varied cultural backgrounds of those who formed the ancient cities of Marion and Arsinoe. Because most sanctuaries were frequented by the community as a whole, the volume of material remains made and deposited there was usually greater than within houses, which makes them more visible to us today. The Archaic and Classical city of Marion is known primarily through its sanctuaries and tombs (see also essay II). This predominance of tomb and temple remains a hallmark of Iron Age Cyprus even with the discovery of other aspects of its ancient settlements.

Ancient Marion had several cult places, some identifiable today only through votive objects, especially sculptures, rather than through the discovery of temple structures. Featured here are two cult areas excavated by the Princeton Cyprus Expedition.[1] The earlier, located in the eastern part of Polis in the locality of Peristeries (Map 3; Plans 1 and 2; fig 2.0), was at its largest size from the later seventh to the beginning of the fifth century B.C.E., a period known as Cypro-Archaic II.[2] The other sanctuary, sited along a ridge at the northern edge of town in the locality of Maratheri (Map 3; Plans 3 and 4; fig. 3.0), was founded sometime in the Cypro-Archaic II period and was destroyed at the end of the fourth century B.C.E., probably in 312 by Ptolemy I Soter (see essay II). It was a major cult center in the Classical period in the fifth and fourth centuries B.C.E.[3]

Some cult places may have marked the boundaries of the inhabited ancient city of Marion as in other parts of Cyprus and in Greece,[4] thus serving to protect it; however, the central location of these two sanctuaries—Peristeries embedded among houses and workshops of the eastern part of the city and Maratheri as an acropolis-like ridge between the larger inhabited plateaus—points to their importance within the urban fabric of Marion. Other possible areas of cult activity in the Iron Age were found by the Princeton team in Petrerades, but these may instead reflect cult practiced within houses (see essay II).

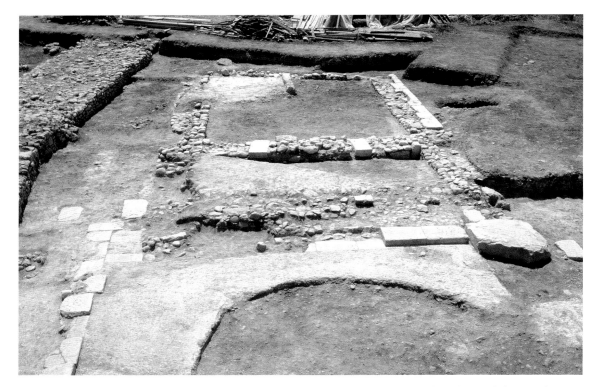

FIGURE 3.1. View looking south into the forecourt, porch, and inner temple of the sanctuary in Area A.H9 at Polis-Maratheri, 1986.

Cult Buildings

The Classical Maratheri sanctuary (fig. 3.1) has a temple building that in its axial structure would have been recognizable to visitors from many parts of the ancient Mediterranean, while the specific design of the earlier Peristeries temple buildings would have seemed more idiosyncratic, at least to the first-time visitor to ancient Marion. Early cult places such as this one were often irregular in their form.[5] Even so, the statuary in the Peristeries sanctuary, including a female statuette with Levantine features (cat. no. 57) and a nearly life-size female head with Nubian characteristics (fig. 3.2), suggests that people with connections to all parts of the eastern Mediterranean may have visited or even lived in the settlement.[6]

The temples in Peristeries and Maratheri each have a room that is a plausible holy-of-holies, or house of a deity, as in other cult places on Cyprus. What is astounding about these sanctuaries, in contrast to most others on the island, are the thousands of votive objects preserved where they were placed in antiquity due to the destruction of both sanctuaries by fire and the precise recording of their find spots during excavation. The locations of objects inside buildings, in pits, and in courtyards suggest the ways in which people deliberately shaped their world

using objects to interact with one another and their gods. Votive dedications are characterized especially by plentiful anthropomorphic terracotta figurines. Often figurines are repetitious in form, pose, and detail. Their consistency and quantity served to reinforce people's ability to communicate with the divine. Alongside these smaller votives are spectacular dedications of terracotta sculpture showing high technical mastery, as well as intrinsically valuable dedications of metal and stone.

Identification of Deities

The identification of the deities worshiped in these sanctuaries relies on the interpretation of votive dedications, especially the terracotta sculpture. As yet, no ancient written sources indicate the nature of the cult or the divinities that received worship in the Peristeries sanctuary. In that sanctuary, the many thousands of pieces of votive terracotta sculpture are primarily female, but it is the presence of a small figurine known as an Astarte type (cat. no. 63) that is the most telling. Derived from a figural type common throughout the ancient Near East and associated with the worship of a female deity involved with concerns

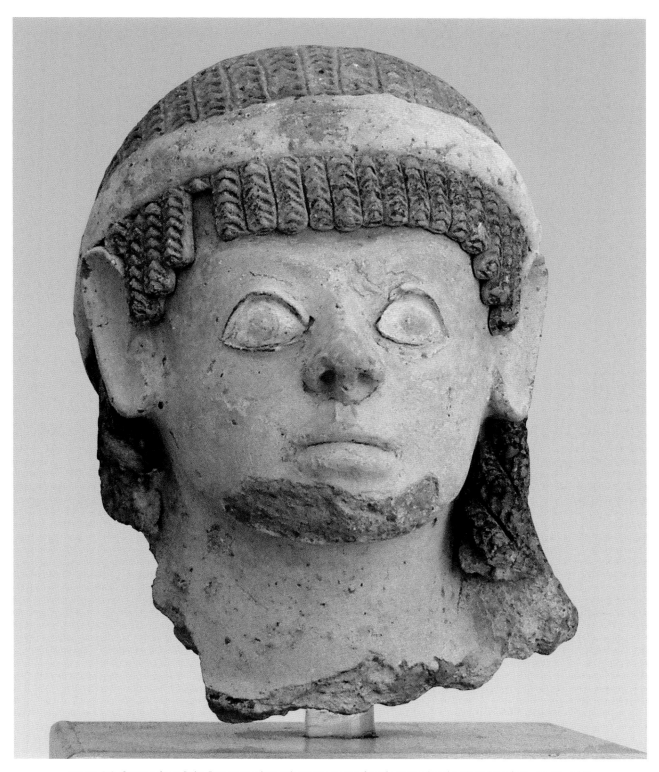

FIGURE 3.2. Cypriot, from Polis-Peristeries, late 6th century B.C.E.: female statue head with Nubian features. Found by Princeton in the bothros, trench B.D7:r15 Sondage 4, 1990. Terracotta; h. 24.05 cm. Polis Chrysochous, Local Museum of Marion and Arsinoe (Princeton Cyprus Expedition R9913/TC3078). See fig. 3.10.

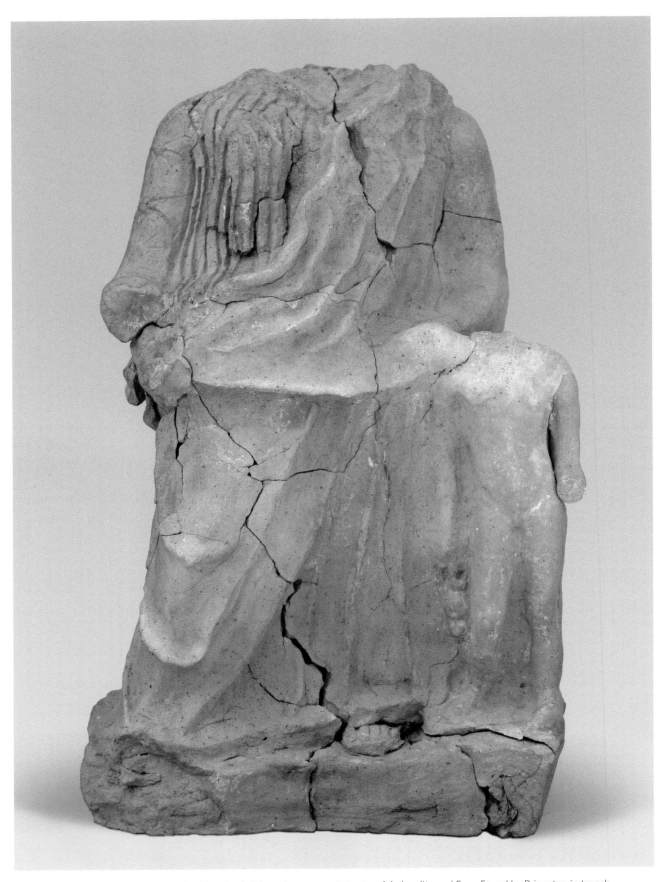

FIGURE 3.3. Cypriot, from Polis-Maratheri, 4th century B.C.E.: statuette of Aphrodite and Eros. Found by Princeton in trench A.H9:s15, 1985. Terracotta; h. 38.4 cm. Paphos District Museum (Princeton Cyprus Expedition R1612/TC 90). See fig. 2.15.

of fertility and sex, the Astarte figurine among the votive assemblage confirms worship of a goddess who had jurisdiction over fecundity, abundance, and human and natural productivity.[7]

Likewise, excavation in the Maratheri sanctuary at Marion recovered a statuette of a standing draped woman accompanied by a nude youth (fig. 3.3).[8] Identified as the goddess Aphrodite next to her young son, Eros, whose back was pierced for the inclusion of his characteristic wings, the presence of the votive allowed for the confirmation of the nature of the deity worshiped in the sanctuary. Additional figurines of Eros were also discovered, but the many examples of male votive sculpture (such as cat. nos. 70, 74; fig. 3.4), as well as the colossal Egyptianizing male statue (cat. no. 71), suggest that a male deity may also have received worship within the sanctuary. Late fourth-century B.C.E. coins of King Stasioikos II (cat. no. 43) depict both Aphrodite and Zeus; later literary evidence and inscriptions from Arsinoe also mention Zeus (see essays I and IV).[9]

Peristeries Sanctuary

In Peristeries the sanctuary buildings and votive dedications cover an excavated area of over 1100 square meters (Plan 1). The use of this area as a cult place may date back to the early first millennium B.C.E. This identification is based not on the presence of votive statuary but on finely

FIGURE 3.5. Cypriot, from Polis-Peristeries, Cypro-Geometric I/II (top) and Cypro-Archaic II (bottom): dish of White Painted type (top) and wide shallow plate of Black-on-Red type (bottom). Found by Princeton in trenches B.D7:p14 1989 Level 5 Pass 2 Batch 43 (top) and B.D7:p15 1989 Level 12 Pass 1 Batch 2 + Level 23 Pass 1 Batch 6 (bottom). Ceramic; diam. 23.5 cm. (top), 12 cm. (bottom).

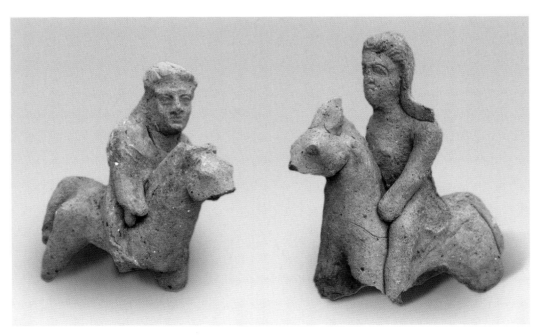

FIGURE 3.4. Cypriot, from Polis-Maratheri, mid-4th century B.C.E.: horse-and-rider figurines. Found by Princeton in trench A.H9:s15, 1985. Terracotta; h. 10.79 cm. (left), 11.52 cm. (right). Princeton Cyprus Expedition R1746/TC140 (left), R1756/TC147 (right).

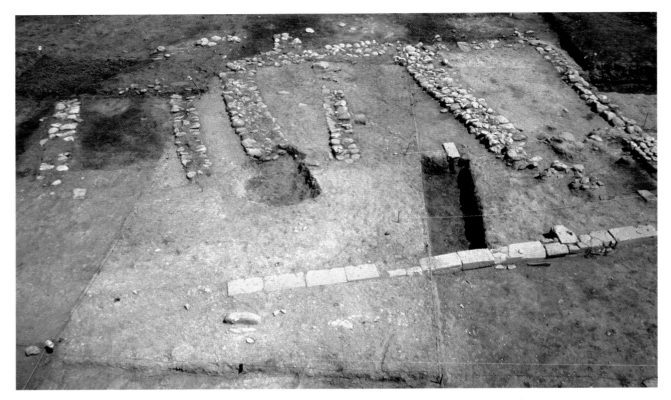

FIGURE 3.6. View of the Main Building of the sanctuary in Area B.D7 at Polis-Peristeries, looking north from the portico, across the threshold and porch, into the four rooms, 1990. The later temple building, with wider walls, overlies part of the Main Building. Parts of earlier buildings are in the background. The imprint of the obelos and the fallen plaster details of the building are visible in the foreground. Trenches B.D7:n15 and p15, quadrants m15 (left)–p14/15 (right).

crafted ceramic dishes and bottles painted with geometric designs (fig. 3.5, top), found with the earliest architectural remains underneath the larger, later temple at the site. They might have been used for gifts of food and drink or feasting in an early phase of the sanctuary.[10] Evidence for the kind of small terracotta female figurines with uplifted arms, which characterize the most common dedications at Peristeries, dates back at least to the late ninth century B.C.E., the later Cypro-Geometric period.

It was in the Cypro-Archaic II period that the sanctuary *temenos*, an enclosed or set-apart sacred piece of land, was at its largest, with a wall enveloping the cult buildings and an altar (Plan 2; Building Reconstruction 1). The site was destroyed by fire at the beginning of the fifth century B.C.E.; whether the cause of its destruction was accidental or intentional remains unknown (see essay II). A new single-room temple was built on the same alignment as the earlier temple buildings and used fragments from the earlier sanctuary in its foundations. The fire destruction of the sanctuary at its largest extent left thousands of votives in place on floors and courtyards; many were carefully buried in pits, including a large pit east of the temenos that was once used as a

cistern, which was reused as a bothros, a Greek term for waste pit and an archaeological term for an older pit used for the periodic cleanup and burial of votive material.[11]

The Main Building in the Temenos

The largest temple from the most extensive phase of the sanctuary is called the Main Building (fig. 3.6). It forms the northern part of the enclosure and is roughly square in design. Four rooms side by side face south–southeast. This building, which has a more segmented design than other structures in the temenos, is where the greatest number of fragments of large-scale terracotta sculpture were found. While primarily under life-size in scale, the sculptures are larger and of more complex manufacture than the small figurines that could be held in one hand. In keeping with the focus of ritual directed toward a goddess associated with fertility, the sculpture represented mainly females, although some male images are present (cat. no. 68). Also in this building were all the bronze vessels found for preparing and drinking wine, nearly all the objects made of faience, most of the stone sculpture, incense burners, and smaller, less common votives, such as seals and jewelry.

FIGURE 3.7. Aerial view (north at the left) of the eastern part of the treasury (bottom left) and the holy-of-holies (top left) with the threshold and porch (right), 1989. Statuary standing on the floor, including cat. no. 59 (bottom center), cat. no. 62, terracotta votives (bottom right), and a smashed torpedo amphora (top left) are seen as they were found in the sanctuary in Area B.D7 at Polis-Peristeries. Trench B.D7:p15, quadrants p15 (left)–p16 (right).

A threshold for a porch framed the two center rooms. These rooms contained all the bronze vessels—strainers, drinking bowls (cat. no. 58), and mixing bowls. The discovery of nearly all vessels and their fragments along the edges of the central wall of the building suggests that they were hung on the wall or stacked on a shelf or shelves. On the floors of the rooms were hundreds of terracotta sculpture fragments, including the lower parts of two female statues in the eastern room (cat. no. 59; fig. 3.7). These were found standing next to one another with their feet facing out toward the south. Smaller terracotta figures and a shallow plate (fig. 3.5, bottom), possibly to offer a gift of food, were found with them. Scattered behind them were fragments of an Egyptian relief (possibly once part of cat. no. 50). The luxury and artistic complexity of the objects in these rooms identify them as a treasury.

A pillared portico framed all but the westernmost room. On the porch north of the threshold and on the portico framed by pillars were many more votives. One cluster of objects on the porch included a limestone incense burner (cat. no. 62) with its two-part stone base surrounded by small terracotta figurines (fig. 3.7). Complementing the wine service inside was an iron spit (*obelos*) for cooking meat, found in the portico between the two center rooms (fig. 3.6).

The volume and density of votives make it unlikely that all those who visited the sanctuary would have entered the temple building. Ancient Greek texts mention that people could enter some temples only if invited there by the god or goddess in a dream.[12] Visits to an oracle could be determined by lot.[13] Some might enter by virtue of their social standing or the office they held.[14] Others were allowed to clean the temple, sometimes in a secret way, sweeping the altar and floor[15] or removing and burying votives or evidence of earlier animal sacrifices.[16]

Close-up viewing and handling, at least of votives in the Main Building, was probably not the norm. If the two central rooms were left open so that one could see inside, the crowd of votives would have impeded the view of individual ones. Lighting was principally with small oil lamps, which, by the movement of their flame, would have lent a certain degree of animation to the figural sculptures. Seeing figural images in antiquity would have been different from how we would view them today in a museum or study room. Light and dark would have been manipulated in

order to shape a person's experience, as when lighting was changed or a visitor walked from an indoor to an outdoor space. To "see" was as much to have an image become visible—as when one beholds or witnesses an object as part of an event—as it was to actively observe or detect.[17] These ancient works of art may well have been hidden behind doors or curtains except on prescribed special occasions. In a temple, what was important was that they stood in place of the worshiper before the deity.[18]

The shallow building remains are wall foundations consisting of river stones. After the initial building period, each successive renovation reused a greater number of older objects, such as grinding stones and fragments of pottery vessels in its walls. The reuse of building material as well as ceramics and stone tool and sculpture fragments from earlier periods is common in this kind of building (see essay I). After the Main Building was destroyed at the beginning of the fifth century B.C.E., a piece of a fine Egyptian relief (cat. no. 50) once dedicated in that building was built into one of the walls of the new temple. Reuse may have been more than simply the practical need to use materials. The use of older materials—especially sacred ones—for a new building may have lent authority and legitimacy to the new structure, almost as if foundation deposits[19] were built into the walls.

For the Main Building, rectangular cut (ashlar) limestone blocks form the threshold, pillar supports along the south side of the structure, and interior pillar or pedestal supports. One of the interior supports was covered with ash, possibly from a pillar that burned when the Main Building was destroyed. Burning here also left its mark on the bronze vessels (cat. no. 58). The greatest evidence for burnt destruction in the sanctuary was found in the area of the Main Building, which suggests that there was a considerable amount of wood used in its construction.

During excavation, traces of the mud-brick walls of the building were found collapsed and decayed. The easternmost wall—a party wall that also served as the northwest wall of the Side Building (fig. 3.8)—had fallen east, overlying part of the rubble foundations. The spread of wall fragments suggests that it was about two meters in height. Fragments of smooth white wall plaster over a rougher pebble backing were found faceup, showing that it was the interior of the wall that was plastered. Some fragments show that the wall had been plastered more than once. Plaster fragments found in other parts of the building suggest that walls of the two center rooms were treated in a similar fashion. Green clay at the base of the walls would

have made them water repellent. Textiles might have been hung in rooms as wall coverings or curtains.

Floors were also covered with lime. Unlike the plaster applied and smoothed onto the mud-brick walls, lime was sprinkled across an earthen surface to form the floors and was renewed regularly, making for compacted and increasingly thick floors over time. White lime floors were found throughout the building except in the westernmost room, which had a packed-earth floor. Most of the objects found in this room were fragments of ceramic vessels, especially fragments of storage amphorae, larger pithoi, and transport amphorae that may have contained food and drink.

The lime floor in the easternmost room was the thickest. At the entrance to the room is a stone with a roughened surface, possibly for wiping one's feet or footwear. The back of this room incorporates a closed-off door that led into a back room in the preceding eighth- to early seventh-century B.C.E. architectural phase of the temple. To the east of this older door was found an incense burner with rows of petals (cat. no. 60). To the west, midway into the room was a tall vessel in the shape of a horizontally fluted cylinder with a shallow bowl at the top, possibly another incense burner or a footed basin. A single torpedo-shaped transport amphora stood across from it on the opposite side of the room. Very little else was found here. The limited access, attention to the treatment of the floor and walls, the possibility that the visitor was meant to clean his or her feet and hands, and the inclusion of the older door suggest that this was a special room. The most likely location of the house of the goddess in the sanctuary, it compares well with scenes featuring a deity before an incense burner found on contemporary seals (cat. no. 61).

Fragments of plaster with a rounded profile were found fallen into the portico just south of the threshold, which suggests that there were plaster details to the roofing at the front of the building. Fragments of roofing found discarded in the bothros to the east may have come from this building. They are flat pieces of packed earth with traces of chaff and thicker organic materials. A few fragments of terracotta roof tiles were found, again mostly in the bothros, and it is unclear whether they were used in roofing the temple building. It is unknown whether there were any windows in the structure. Terracotta models of temple buildings found at other sanctuaries include windows as well as holes that are thought to be dovecotes.[20] Given that the modern locality name, Peristeries, means "pigeons" or "doves," the sacred birds of Astarte (cat. no. 19) and birds associated with the shepherd god in the Ancient Near East,

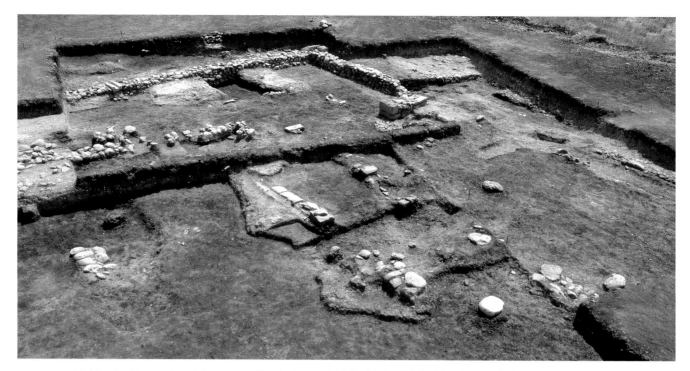

FIGURE 3.8. View looking southeast: temenos wall and entrance (right) with the Side Building (top) and Altar (center) of the sanctuary in Area B.D7 at Polis-Peristeries, 1989. Trenches B.D7:n17, n19, and q17, quadrants n18–n19 (bottom), p17–p19, q17–q19, r18–r19 (top).

it would be interesting to know if an association in this plateau with those birds has survived from antiquity.

Other Structures in the Temenos

Entrance into the temenos was from a street that ran along the south end of the enclosure (see fig. 3.8). Buried in a pit just at the entrance was the skull of a bull packed in slag, the black, lumpy waste material from bronze or copper working. This deposit may have been made to help guarantee economic prosperity to the region, emphasizing the link between the deity and the fertility of the earth, most particularly the productivity of the copper mines just to the east, at Limni (see essays I and II).[21] A second point of entry or exit was located at the northeastern end of the sacred precinct. The southeast corner is marked by an ashlar block, worn down over time by the hubs of wheeled vehicles repeatedly rubbing against it when they cut the corner. Apart from this block and at least one of the terminal stones for the walls framing the entrance, the temenos enclosure wall was built of rubble with a mud-brick superstructure. This is not surprising given that the walls on both the eastern and western sides of the sanctuary were integral to additional structures.

The structure to the east, referred to as the Side Building, extends along the length of the temenos. One could have entered the precinct at the south and walked through to exit at the northeastern corner. Like that of the Main Building, the floor of the Side Building was made of lime and preserves several layers of resurfacing, especially in its southern half. A particularly dense concentration of votive terracottas was found in this southern part of the structure. In addition to fragments of larger sculptures, hundreds of smaller female figurines of the type known as the "goddess with uplifted arms" (cat. no. 64) were discovered. Models of sacred trees (cat. no. 82) were also dedicated.

A drain was built into the temenos enclosure wall here, suggesting that liquids were poured in this room. It is possible that liquid libations, the pouring of wine or oil to honor the deity or to ascertain answers to questions, were made here. Given the material importance of the area, one that may have been accessible to any visitor to the sanctuary, it is significant that when the sanctuary was rebuilt on a much smaller scale after the destruction at the beginning of the fifth century B.C.E., a votive pit (*favissa*)[22] was dug here in which terracotta female figurines of Classical date (cat. no. 67) were placed. Evidence for another possible favissa was found just to the north in the same area, but with figurines from the Archaic period (cat. no. 65).

Directly in front of the visitor who entered the temenos from the south is a large altar, the base of which was

plastered and formed of several ashlar blocks. It was found full of ash as well as the unburned bones of sheep and goats[23] consumed in the sanctuary. It blocked direct access to the Main Building to the north. To the west is a smaller, rather open structure. In the space framed by this structure, the altar, and the southwestern temenos wall (now seen only as a cut for the wall because its stones were removed to be reused in the Roman period) are clusters of small pebbles forming surfaces of the same size as a series of large, flat, rounded stones. These may have been for the display of votives at the entrance to the sanctuary.

To access the main courtyard through the sanctuary buildings, one would have had to enter the Side Building and pass through an opening halfway along its length. This outlet exposed visitors to the bright daylight and led them to an open-air courtyard south of the Main Building. The courtyard was found covered with hundreds of votive terracottas, mostly small figurines, including the Astarte figure holding her breasts (cat. no. 63). Whether there was an enclosure wall sealing off the west side is not known. Excavation of areas to the west of the Main Building unearthed little in the way of pottery and terracottas.

Outside the Temenos

To the east and outside of the temenos is the feature called the bothros (fig. 3.9), a circular pit in the limestone bedrock that is six meters wide and three meters deep. This originally may have served as a cistern. Ceramics at its bottom are fragmentary and might have washed in during its early use in the Cypro-Geometric period. By the end of the Cypro-Geometric period (at least by the end of the ninth century B.C.E.), the pit was used for a secondary purpose: to bury votive objects and industrial waste. Ceramic vessels—large amphorae as well as smaller bowls, plates, and jugs—were thrown in whole, as were terracotta sculptures both large and small. The objects were packed densely in the pit, usually with very little soil between them.

One of the earliest votives discarded here is the notched shoulder blade of a cow, bull, or ox (cat. no. 79). These were used in scapulamancy, a form of divination or communication with the gods using a choice cut from a sacrificed animal. Slightly later in the sequence of clean-ups from the sanctuary is a terracotta figurine of a female suckling a child, a figural grouping derived from the Egyptian goddess Isis nursing her young son, Horus (cat. no. 52). An early limestone stamp seal (cat. no. 47), possibly an amulet, was also deposited. A mask of Humbaba (cat. no. 80), used apotropaically to ward off evil, is one of several masks buried here. From the time when the sanctuary

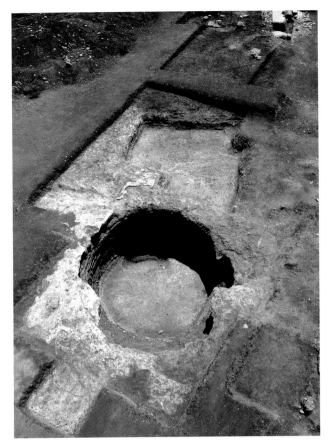

FIGURE 3.9. View looking south across the bothros and toward cuttings in the bedrock and installations along the east side of the temenos wall of the sanctuary in Area B.D7 at Polis-Peristeries, 1997. Trenches B.D7:r14, q16, s17, quadrants r14–r18 (right) and s14–s18 (left).

was destroyed at the beginning of the fifth century B.C.E. are still more votives, including a figurine wearing a necklace with a large central ornament (cat. no. 66) and a well-preserved section of an Egyptian faience amulet (cat. no. 51).

When the sanctuary was destroyed at the beginning of the fifth century B.C.E., two notable deposits were placed near the top of the bothros. These deposits contained particularly fine pieces of female statues with sculptural detail similar to those found among the more fragmentary sculptural remains inside the temenos itself. Perhaps they were taken from the remains of the Main Building. Before burial, they were stuffed with bone and ash debris similar to what was found in the altar. One deposit contained a nearly life-size terracotta head of a woman with Nubian features[24] (fig. 3.2) next to the neck of an enormous storage pithos that was full of earth containing terracotta figurine and statuette fragments, as well as some bone (fig. 3.10). The Nubian head was placed facedown with smaller female figurines and a votive tree packed around it. Another deposit used a large part of the main body of a pithos to hold the burial

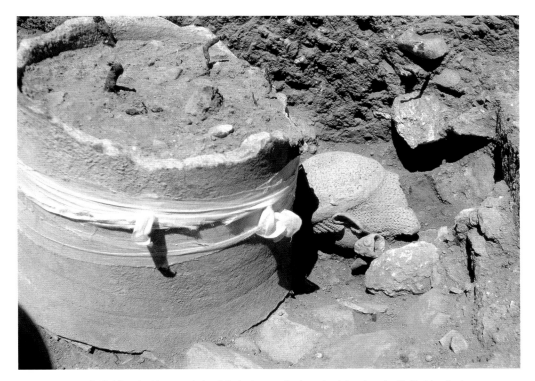

FIGURE 3.10. View looking north: burial of a terracotta female statue head with Nubian features next to the neck of a pithos in the bothros of the sanctuary in Area B.D7 at Polis-Peristeries, 1990. Trench B.D7:r15 Sondage 4, quadrants r15–s15. See fig. 3.2.

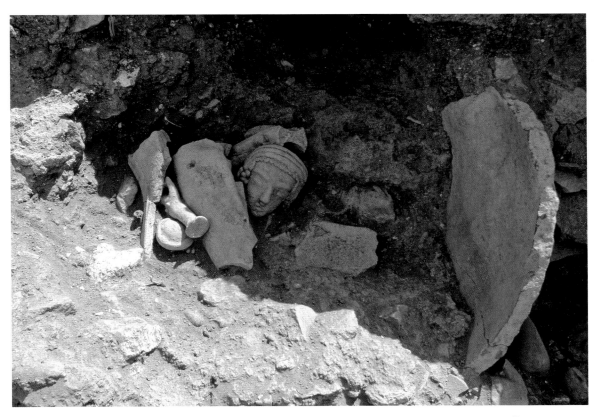

FIGURE 3.11. View looking east: burial of a terracotta female statuette surrounded by smaller terracotta figures and large fragments of the walls of a pithos in the bothros of the sanctuary in Area B.D7 at Polis-Peristeries, 1991. Trench B.D7:r15 Sondage 1, quadrant s15, 1991. See cat. no. 57.

of a female statuette that was ritually killed by twisting the head and pulling it out of the body before burial (cat. no. 57). Again, she was packed in place together with smaller votive terracottas (fig. 3.11). Among the pithos fragments lining the area below this deposit was found a fragment of a tall, horizontally fluted stand of the same type as that which stood inside the proposed house of the goddess.

In addition to the bothros, outside the temenos are two structures associated with small basins set into the earth. Each resembles a small bathtub with a seat and a lower section for the feet; one held a large grinding stone. It is believed that similar installations were used in dye-works on the island of Crete.[25] The discovery of a set of loom weights near the structure to the southeast suggests textile working. Thousands of murex shells were found in the bothros. The murex, when crushed fresh, releases mucus that was used for purple dye. A large, shallow, rectilinear cutting in the bedrock south of the bothros may have also been for the collection and use of water. Unlike the bothros, it contained very little pottery and sculpture. Large amounts of water would have been necessary for textile production involving washing, bleaching, and dyeing.

Just west of one of these basins was an installation that would have made turning a corner with a cart very tight, possibly accounting for the worn corner of the temenos enclosure wall. The quantities of lime plaster suggest that this is where the lime for the buildings was processed. Only a few terracotta figurines and statue fragments were found outside the temenos wall in the areas away from the bothros. One of these was discovered between the lime-plaster installation and the basin. The masculine gender of this Assyrian-style figurine (cat. no. 56) is atypical of votive terracottas at this sanctuary.

Metalworking, ceramic production, and the working of animal bone also took place around the temenos. Fragments of slag were found throughout the excavated area, some possibly placed as votive offerings. Tools such as loom weights and whorls for spinning were found among the votive terracottas. Fragments of crucibles and furnace lining came from areas north and southeast of the temenos wall. Additional fragments were found discarded in the bothros. Ceramic wasters from the manufacture of pottery and/or terracotta sculpture were also found, especially in the bothros pit. Chunks of red and yellow ocher were recovered, perhaps from the refinement of pigments in terracotta production.

The association of craft activity and cult space is common on Cyprus and recalls similar arrangements that were especially prevalent in ancient Greece.[26] Craftspeople not only produced artworks for use within the sanctuary, but they also shared facilities, raw material, and water resources. Waste products of animal bone and hide from sacrifices within the sanctuary would have provided needed raw materials, such as the basis for soap in the textile workshop and flux in metallurgy. Sanctuaries did not exist in isolation; they formed part of the wider urban fabric of ancient cities, helping people to find their place in the landscape and come to terms with their past, present, and future.

Maratheri Sanctuary

Just as the Peristeries sanctuary formed a center for the early city of Marion, the Maratheri sanctuary (fig. 3.0) also served as a center, especially during the Classical period. Situated on a thin strip of land between the two large plateaus, it occupied a commanding position along a ridge at the northern edge of the settlement until almost the end of the fourth century B.C.E. The sanctuary probably was located at the edge of the ancient shoreline along what was likely a silted-in lagoon by the time of the city's destruction in 312 B.C.E. Water may have filled the deep ravines on either side, emphasizing Maratheri as set apart for the gods even as it was a focal point for the city.

The Temple and Its Surroundings

The temple at Maratheri at its largest extent in the fifth century B.C.E. was about two-thirds the size of the entire known temenos area of the Peristeries sanctuary. It consisted of a double-colonnaded forecourt leading via a three-stepped staircase and porch to a roughly square space with an inner room (Plan 4; Building Reconstruction 2). It is possible that the square space beyond the porch was an open inner courtyard. The size of this space was relatively modest, just under seventy square meters, but the porch, stair, and forecourt added significantly to the size of the building. The north–south length of the temple at its greatest extent was approximately twenty-four meters. The precise width of the forecourt is not certain, since its east wall was destroyed and covered by the later construction of a wide wall. Its south wall can be traced under the later wall to a width of almost sixteen meters. At this width the colonnades would have been symmetrical.

The structure was oriented roughly north–south on a central axis that would have guided the visitor toward the inner sanctum. The axial plan of the building suggests that

FIGURE 3.12. View of a terracotta antefix (Princeton Cyprus Expedition R11707/AT56) in situ in the wall fall east of the porch of the sanctuary in Area A.H9 at Polis-Maratheri. Trench A.H9:r13, 1986.

the entrance might have been in the center of the north side, but sanctuaries in Cyprus frequently had entrances from the lateral side.[27] A possible threshold between column bases of the east colonnade and a packed layer of earth between the city wall and the temple that might have been part of a street both suggest the possibility of such a lateral entrance, perhaps in addition to an axial one. To the south of the temple, a small building of twenty-seven square meters was oriented east–west. It may belong to the same sanctuary complex. The full extent of the sanctuary is not certain since no boundary wall for the temenos has been found. In an area excavated a little over twenty meters to the north of the temple, just outside the city wall, several deposits of sanctuary-type material were found, including much terracotta sculpture (cat. no. 76). Just across the modern road from this area, the Department of Antiquities has uncovered more material of a similar sort (cat. no. 72). Whether these deposits come from the sanctuary excavated by the Princeton team or from an as yet undiscovered cult place on the north end of the ridge is not clear.

The temple contained a series of both roofed and unroofed areas, confronting the visitor with alternating brightness and shadow. The forecourt into which a visitor would have stepped when entering the building was partially covered, with colonnades supporting tiled roofs on the east and west sides. Though the columns or pillars themselves are no longer preserved and must have been made of wood, their stone bases have survived. Numerous large fragments of roof tiles were found along the line of the east colonnade. Part of a decorative roof tile called an antefix, showing a bearded male face in Classical Greek style (fig. 3.12), was found in a pile of rubble and large roof tile fragments near the northeastern corner of the porch.[28] It is probable, therefore, that the porch of the main building was also roofed. Only one antefix was found, which is slightly puzzling since in Greek temples normally there was a series of antefixes along the roof. The Marion antefix could have been displayed alone, or perhaps it was one of a pair accenting the corners, the second of which has not been found. Beyond the porch, the inner temple was probably also roofed.

The forecourt was by no means an empty space to be traversed quickly. It was used to display votives dedicated in the sanctuary by worshipers, as is indicated by the many

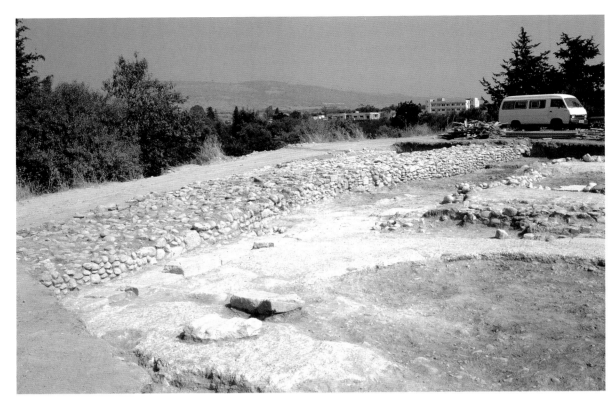

FIGURE 3.13. View of the sanctuary in Area A.H9 at Polis-Maratheri looking southeast across the curved cutting in the forecourt and toward the city wall, 1986. Compare fig. 1.7.

fragments of terracotta sculpture, limestone figures, and other types of objects found here. In addition to this crowd of dedications, a number of other features in the temple would have encouraged, or even forced, the visitor to deviate from the building's axis in walking through the space. For example, a large, circular cutting in the middle of the forecourt's lime-plaster floor was found with modern objects, such as tin-can edges, in its lowest deposits. This could have been caused by a modern intrusion, possibly the 1927 excavations by Rupert Gunnis (fig. 3.13; see essay I). But the cutting is too centered within the forecourt to be fully modern, and it has some smoothly cut edges. This suggests that there was some feature in the courtyard that has been disturbed recently, perhaps a favissa or a stone feature, such as a platform. If a built feature stood on the axis, a visitor would have had to walk around it.

After crossing the forecourt, the visitor approaching the main part of the building would have been drawn toward the southwest corner of the forecourt, where a large stone slab, measuring more than one meter square, flanked the lowest step of the staircase. Its prominent size and position indicate that its function was important, perhaps as part of an offering table or a statue base. None

of the material found near it helps to pinpoint its precise purpose, but similar prominent "altars" are found at entrances in other sanctuaries on the island.[29]

The staircase led by three steps into a porch with a lime-plaster floor, which, in turn, led through an axially placed entrance into the inner space. A disturbed feature built of clay surrounded by a rim of uncut stones was found on the axis within the inner court, just south of the entrance, and would have been a focus for anyone entering the area or even just looking into it. Although no ash or special offerings were found in association with it, other sanctuaries have altars in analogous positions in their courts.[30] It could have been a table on which to set perishable offerings, such as food or incense, rather than a place to burn offerings.

Beyond this feature, in the southeastern corner of the inner court, was a small room just under eight meters square, divided from the court by a parapet of cut limestone on the north side and a wall, probably also not full height, along its western side. The parapet, standing just under ninety centimeters, was topped by a crowning element with a projecting flange. A broad gap between it and the east wall of the court provided access to the inner room.

The inner room had a lime-plaster floor, marking it out as special from the rest of the inner court, where the floor seems to have been earthen. It is not clear how far visitors would have been allowed into the temple. The average visitor may not have been allowed to enter this space, which was likely the holy-of-holies, but the parapet wall made it possible to see into this room from the porch or the inner court.

Most of what can be seen today at the excavated site consists of the foundations and lower walls, built of unshaped rubble and cut stone ashlars. As at Peristeries, it appears that the ashlars were used where they would be most visible: in the stairs, marking the entrance between the porch and the inner court, in the outer faces of the walls of the inner court, and in the dividing wall for the inner room. In many places, the ashlars of the outer wall faces had been removed for use as building stone after the destruction of the sanctuary, leaving only the inner rubble portions behind. The entire excavated area was covered with a heavy layer of decayed mud brick that once had formed the walls above the stone foundations.

A great number of fragments of wall plaster were found among the debris from the interior of the temple. The plaster was generally white, but a few fragments were found, mostly in the area of the forecourt, that were painted in red, blue, and greenish gray. Although not enough survives of these painted fragments to get a clear idea of the pattern and extent of the painting, their presence shows that some walls must have been accented with color.

During the latter part of its life, the sanctuary was flanked on its east side and partly built over by a wide wall. The wall was constructed in at least two stages, with an earlier gate or a breach in the wall having been filled with a patch. It is most reasonably interpreted as part of the city wall of Marion, built when the city contracted by the fourth century B.C.E. (see essay II). Found within the wall were numerous fragments of material from the sanctuary, including terracotta and limestone sculpture (cat. no. 77 and the head of cat. no. 71), as well as reused building stone. Apparently the builders were using whatever material lay most readily at hand, even votives that were fragmentary before they were employed as building material. This indicates that the wall was built in haste, perhaps in response to an imminent or recent attack. Such an interpretation is supported by the historically attested upheavals in the area in the last quarter of the fourth century B.C.E. (see essay II).

When the Maratheri sanctuary was excavated, there was a thick layer of ash overlying a large part of it from its

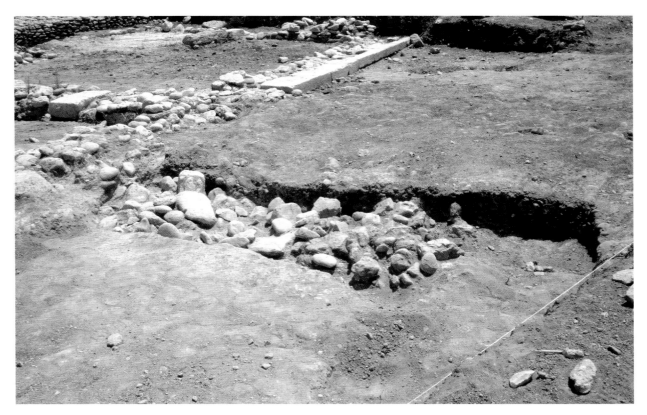

FIGURE 3.14. View from the northwest of an Archaic limestone statue in situ within the backfill of a robbed-out footing trench (trench A.H9:r13, quadrant r15) of the sanctuary in Area A.H9 at Polis-Maratheri, 1986. See fig. 2.11.

destruction by fire. Objects found within the ash layer date to the end of the fourth century B.C.E. Although the temple was not rebuilt, a few objects, such as a Ptolemaic coin (cat. no. 87) found in the soil just above the ruined city wall and a tomb containing early Hellenistic pottery excavated just to the west of the temple, indicate some later use of the area.

The final conflagration was not the only time the sanctuary was damaged in its lifetime. A thick level containing much broken pottery from the beginning of the fifth century B.C.E. was found to the east of the inner temple court, with the foundations of the city wall dug through it. Terracotta figurines (cat. no. 70) and a cylinder seal (cat. no. 54) were among the non-pottery finds in this level. This cleanup was probably from damage to part of the sanctuary, such as the forecourt or some earlier building no longer preserved. The forecourt was already damaged before the city wall was built over its east wall. Some of the ashlars set between the bases of the east colonnade show clear traces of burning, and some have been either flipped over to hide a damaged face or repaired with plaster. The repairs show that the forecourt continued in use, even after it was damaged. Pottery found in the backfill of its footing trench suggests that the removal of the forecourt's stones would have been as early as the end of the fourth century B.C.E. It is possible, therefore, that the forecourt was dismantled or partially dismantled for the construction of the city wall. The main part of the temple, however, was probably still in use when the city wall was constructed because that wall angles to avoid the porch.

Objects from the Maratheri Temple

The architecture described above was the setting in which worship took place, but it is the thousands of objects left behind by the sanctuary's users that brings their worship to life for us. Among the votives set up in the forecourt were terracotta sculptures of several different types, ranging from small figurines (cat. nos. 75, 81) to large statues. These composed the great bulk of the finds, but there were also limestone sculptures, mostly smaller in size, as well as other items. The lower half of a roughly half-life-size Archaic statue was found in the backfill of the robbed-out footing trench where the trench joins the west side of the porch (fig. 3.14).[31] Since the statue was found in rubble that could be part of the collapsed temple, it might have been used as a building stone in the Classical temple.

A taste for imported and exotic objects is demonstrated by Attic and East Greek pottery, as well as several items of faience (fig. 3.15), including a delicate alabastron found intact near the eastern colonnade and a bead from the backfill of the footing trench. Several terracotta loom weights could have been dedications. Similarly, various colored earth and mineral pigments found in the forecourt of the complex were possibly intended as votive offerings. Unlike the Peristeries sanctuary, little was found near the Maratheri sanctuary to suggest workshops. Scattered fragments of bronze could have come from bronze vessels similar to those found at Peristeries (see cat. no. 58). Terracotta lamps may be indicators of nocturnal activities, and terracotta scoops (see fig. 2.15) were perhaps for scooping

FIGURE 3.15. Objects from Polis-Maratheri, late 4th century B.C.E. Left: pendant with *udjat* eye from the naiskos (trench A.H9:t17, 1984, Princeton Cyprus Expedition R1306/FI1). Center: alabastron from the forecourt (trench A.H9:r13, 1986, Princeton Cyprus Expedition R15514/FI8). Right: bead from the forecourt (trench A.H9:r13, 1986, Princeton Cyprus Expedition R18939/FI9). Faience; h. 2.9 cm. (left), 5.36 cm. (center), 0.89 cm. (right).

incense or ash.[32] A good deal of bone, some burned, was found in the forecourt, especially in the northeast corner. This may indicate that feasting took place there.

Votives were not only placed in the forecourt. Many finds, in particular, masses of terracotta, were found in the thick layer of ashy soil covering the inner court and its inner room, abandoned at or near the places where they stood when the sanctuary was destroyed. These were found primarily at the southern end, near the parapet and west wall of the small inner room. The material included sculptural fragments ranging from figurines to large sculpture, pottery, and terracotta scoops, and other objects similar to those found in the forecourt (cat. nos. 39, 73, 74). Among these finds were fragments of a nearly three-meter-high male Egyptianizing terracotta sculpture (cat. no. 71). A head possibly belonging to it was found farther south, within the city wall near the smaller building. This colossal sculpture, standing in or near the inner room, would have made an impressive focal point for the sanctuary (see reconstruction in frontispiece). That the colossal head was found inside the city wall supports the idea, outlined above, of a partial destruction of the sanctuary, or at least damage to the votives within, before the city wall was built.

One of the most interesting features of the votive sculpture discovered in or near the Maratheri sanctuary was the evidence for the deliberate destruction of many sculptures, both male and female. Only a single human sculpture, a figurine of a draped female, was found undamaged;[33] the angle of fracture at the neckline of many sculptural pieces indicates that heads were intentionally snapped from bodies (cat. no. 74). Other sculptural fragments show conscious mutilation to the area of the head.

Many fragments of votive sculpture, including small figurines such as a delicately painted female head (cat. no. 76), larger sculptures such as a male wreathed limestone head (cat. no. 39), and the colossal statue in the interior chamber, preserve traces of burning. Pieces were clearly broken before they were subjected to the fire that ravaged the sanctuary when it was destroyed. The latest pieces of sculpture from the complex date to the second half of the fourth century B.C.E., as do ceramics found in the same layers. It would seem likely that the sanctuary suffered during the sack of the city in 312 and that Ptolemy's soldiers may well have despoiled the votive offerings. The Maratheri sanctuary preserves a graphic picture of the sudden end of the city of Marion.

NOTES

1. This essay draws on original research for the final publication of the excavations at these two sanctuaries, using the field notebooks of the Princeton Cyprus Expedition as well as its research database and the objects found in the excavations. Responsible for the contents of the essay are Smith on the sanctuary at Peristeries, Weir on the sanctuary at Maratheri, and Serwint on the many terracotta sculptures from both sites.

2. Smith (J. S.) 1997; Childs 1999, 223–27; Childs 2008, 66–67.

3. Childs 1988, 122–27; Childs 1999, 227–30; Childs 2008, 67–68.

4. Polignac 1984; Given 1991, especially at Idalion, 48–49; Morgan 1994; evidence for another sanctuary exists along the northern side of the town at the hospital, and there was one at the southwest edge of town at Agios Andronikos. Ulbrich (2008, 225, 385–94) suggested that these and other cult spaces surrounded the city of Marion.

5. The sanctuary found at Meniko-Litharkes (Karageorghis [V.] 1977b, 17–45) is somewhat similar in its segmented and circuitous design to the Peristeries sanctuary, especially in its design before its largest phase.

6. Serwint 2009.

7. See the papers in Bolger and Serwint 2002 for more on the goddess of Cyprus.

8. Serwint 1993.

9. Serwint 1993, 209.

10. Smith (J. S.) 2009, 93–97.

11. Loulloupis 1989, 69 defines a bothros. The burial of votive material outside the temenos is contrary to Greek cult practices. While the term temenos was used on Cyprus in antiquity, its precise meaning could have differed through time and from region to region. This divergence from Greek custom at Marion calls to mind the similar Akkadian term, *temennu* (Sumerian, TEMEN), and its variable meanings, which might be relevant, especially in the Cypro-Archaic period, for ancient Cypriot ideas about sacred land. This Near Eastern term in the sense of a foundation, rather than its other meaning of foundation deposit, suggests that a set apart sacred piece of land was defined by the foundations of a built complex. The significance of burying votive material inside or outside such a structure remains to be determined. On the Near Eastern terms see Ellis 1968, 147–50.

12. Pausanias, *Description of Greece* 10.32.13.

13. Aeschylus, *Eumenides* 1.30.

14. Demosthenes, *Speeches* 21.74.

15. Euripides, *Ion* 112–24.

16. Pausanias, *Description of Greece* 10.32.14.

17. Winter 2000, 24.

18. Connelly 1989.

19. Ellis 1968.

20. Caubet 1979 illustrates examples of such models with dovecotes from Idalion, Cyprus.

21. Compare Peltenburg 2007. Copper working is associated with several temples on Cyprus; see, e.g., Karageorghis (V.) and Kassianidou 1999.

22. Loulloupis 1989, 69. A favissa is a pit dug specifically for votive material, whereas a bothros is a pit originally dug for a different purpose and reused for the burial of votive debris.

23. Reese analysis referred to in Reese 1997, 471.

24. Serwint 2009, 237–39.

25. See Brogan, Apostolakou, and Betancourt 2012.

26. On Cyprus, see, e.g., Fischer 2001; for Greece, see, e.g., Linders and Alroth 1992 and Risberg 1997.

27. For example, the main temenos of the palace at Vouni; see Gjerstad 1937, 200–201, 210–12, 225, fig. 119, Rooms 121–29.

28. Childs 1988, 126.

29. For example, see Westholm 1937c, 90, plan VIII, fig. 47 for Altar 20 at the Temple of Athena at Vouni; and Caubet 1984, 108–9, fig. 1, for Altar (autel) 279 in the Archaic sanctuary at Kition-Bamboula.

30. A good comparison is the altar court of the main sanctuary of the Vouni Palace; see Gjerstad 1937, 174, 212, fig. 119, Room 124.

31. Childs 1988, 126–27.

32. For a general study of this type of object, see Buchholz 1994.

33. Princeton Cyprus Expedition R21681/ RC337.

Female Statuette

Cypriot, 6th century B.C.E.
Found by Princeton at Polis-Peristeries, trench B.D7:r15 Sondage 1, in 1991
Terracotta with red and black paint; h. 16.3 cm. (head), 22.91 cm. (body),
w. 9.93 cm. (head), 12.14 cm. (body)
Polis Chrysochous, Local Museum of Marion and Arsinoe (MMA 86 [head];
Princeton Cyprus Expedition R11662/TC4681 [head], R11666/TC4683 [body])

Condition: Head of statuette deliberately broken from body in antiquity. Ancient breaks to locks of hair on shoulders have been mended, although ends of curls are missing and disks are missing from necklace at throat. Lower body is missing below a jagged irregular break, as are lower arms and hands. Weathering of surface obscures some painted details.

This female statuette from the bothros, a votive pit east of the Peristeries sanctuary, is most remarkable because of the distinctive features of dress, physiognomy, and coiffure. The woman faces frontally and wears a tight-fitting, unbelted gown that has a squared neckline revealing a generous part of the upper torso. The long, sheer gown is of a type seen only sporadically on female votive figures, especially of statuette or statue size. Thin, attenuated arms bend at the elbow; the hands likely would have had the palms facing forward—a gesture of prayer. The statuette is adorned with two necklaces, one a simple strand of disk beads arrayed at the throat, and the other a pendant in the form of an inverted lotus blossom displayed on the bosom. In Cypriot sculpture, detail is nearly always focused on the head, and that is certainly the case here as the large head dominates the much smaller body.

Unlike much of the other terracotta sculpture in this publication, the head of the statuette was made entirely by hand to create a face that reflected a distinct ethnic type. The elongated, triangular face is dominated by large, protruding almond-shaped eyes that project beneath heavy, thick eyebrows. Thin and long, the nose displays its most distinctive feature in profile and is decidedly hooked, suggesting a profile commonly seen in the Levant. The septum of the nose is pierced by a nose ring, a practice thought to have originated in the Near East. The earliest literary reference is in Genesis 24:22, which refers to the purchase of a bride for one of the sons of Abraham. Thin lips and projecting cheekbones complete the exaggerated facial features. Although the ears are not visible, the presence of decorative ear caps or multiple earrings indicates that the ears are unnaturally high on the side of the head. The row of small snail-shell curls applied across the forehead was a common fashion throughout the eastern Mediterranean during the sixth century B.C.E. Two long coils of hair fall alongside the neck and onto the shoulders and are twisted and incised to represent braids. Behind the elaborate three-tiered headdress, the hair on the top and back of the head is intricately incised on either side of a central part; at the nape of the neck, a cloth wrap suggests that the rest of the hair on the back of the head was bunched and held by it in place. There is a circular vent hole to allow steam to escape during the firing process, while the two irregularly cut holes on the back of the torso suggest that the statuette had at one time been hung or affixed to a wall while on display. The head was crafted separately from the body, and a long projecting tenon that extended from the neck of the statuette's head was inserted into the hollow body cavity to guarantee a tight fit. When the sanctuary was destroyed and some of the votive materials from the complex were gathered for placement in the bothros, the statuette was symbolically "killed" or desanctified by twisting the head free from the body, but both pieces were packed within a piece of a large pithos fragment and carefully placed within the bothros.

PUBLICATIONS

Serwint 1992, 401, 425, pls. 39–40; Smith (J. S.) 1997, 89, fig. 14; Childs 2008, 66; Serwint 2008, 324–26, figs. 9.5, 9.6; Serwint 2009, 239–41, figs. 13–14.

NOTES

The statuette's head is unique. Other female figures from Cyprus wearing similar dress are: Moscati 1988, 112 and 592, no. 47; Karageorghis (V.) 1993, 56–57, nos. 171–72, pls. XXXVIII.1, 2, and 6; Karageorghis (J.) 2005, 174, fig. 174.

—NS

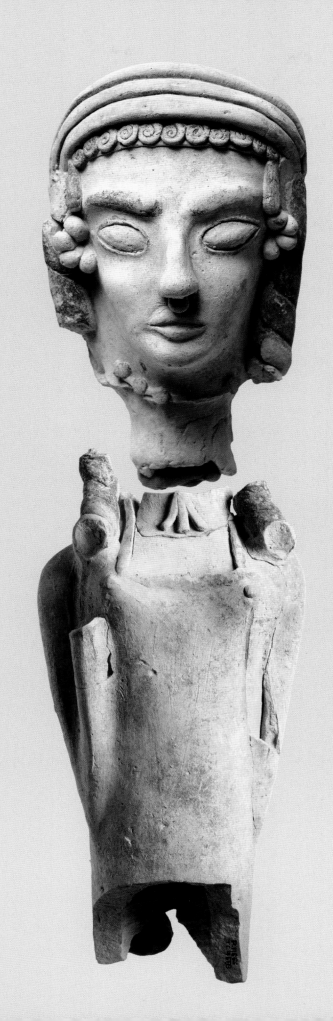

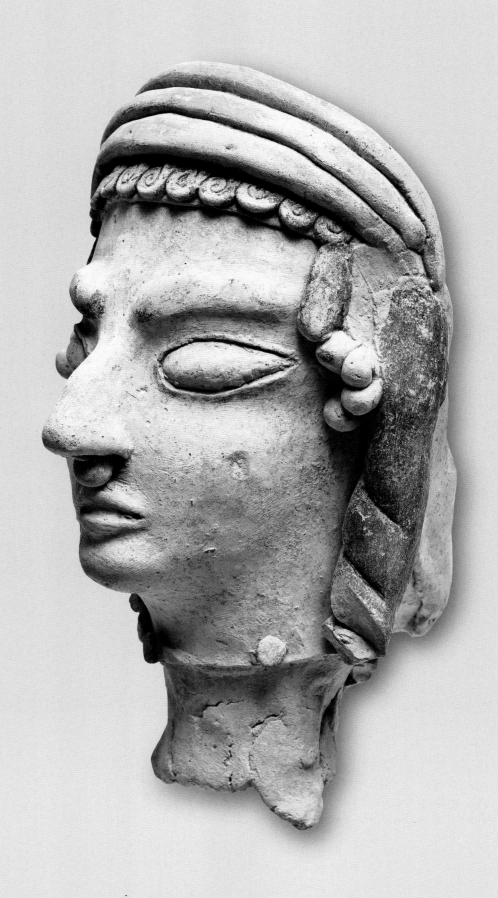

58
Bowl with Offset Rim

Cypriot, 6th century B.C.E.
Found by Princeton at Polis-Peristeries, trench B.D7:n15, in 1990
Bronze; h. 6.3 cm., th. 0.1 cm. (wall), diam. 15.6 cm.
Polis Chrysochous, Local Museum of Marion and Arsinoe (Princeton Cyprus Expedition R8371/BR275)

Condition: Composed of twenty-seven fragments; several pieces near the base are missing. The surface of the bowl is covered by small bubbles that indicate the vessel was once subjected to intense heat.

This bronze bowl with flaring rim was found in the eastern central room of the Main Building in the sanctuary at Peristeries. In addition to at least one other bronze bowl, the two central rooms of this temple contained two large terracotta statues, one of which is a statuette with sandaled feet (cat. no. 59). This bowl has a sharp carination just below the broad, flaring rim; the rim is reinforced by the metal having been folded over to double its thickness. The small bubbles on the surface indicate that the bowl has been subjected to intense heat, presumably the conflagration that destroyed the sanctuary about 500 B.C.E. The form of the bowl resembles so-called Achaemenid bowls, but instead of having a raised area in the center, it rests on a low disc foot. The form is well attested on Cyprus in the sixth century and occurs in silver and in bronze and in flatter and deeper versions; this bowl belongs to the latter category with its ratio of height to diameter of about 1:2.5. No examples of the type, however, have been found among the bronze bowls from the excavated tombs of Marion.

PUBLICATIONS
Smith (J. S.) 1997, 86–87, fig. 13.

NOTES
Matthäus 1985, 187–88, no. 458, pl. 49.

—WAPC

Detail of cat. no. 57

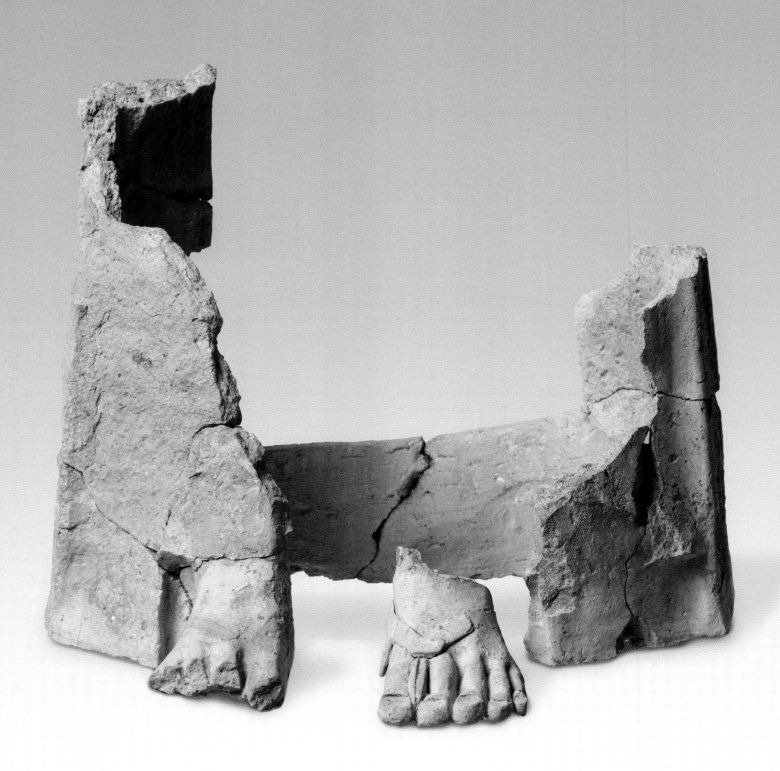

59

Statuette with Sandaled Feet

Cypriot, 6th century B.C.E.
Found by Princeton at Polis-Peristeries, trench B.D7:p15, in 1989
Terracotta; h. 22 cm., w. 25.09 cm., th. 0.59–2.82 cm. (body wall)
Polis Chrysochous, Local Museum of Marion and Arsinoe (Princeton Cyprus Expedition R8287.1–6/
TC2944.1–6 + R5128.1–4/TC2026.1–4 + R6686/TC2722 + R6687/TC2733)

Condition: Badly damaged and partially reconstructed from multiple joining fragments. Severe surface abrasion, weathering, and discoloration from intense heat.

At about two-fifths life-size, this statuette preserves the lower portion of a draped female who stands facing forward with her two sandaled feet visible beneath drapery that falls at her ankles. The statuette suffered much damage because it was still standing and facing out from the main building of the Peristeries sanctuary when that temple was burnt to the ground in the early fifth century B.C.E. Its context and form make it an excellent example of a larger offering that was dedicated in the sanctuary devoted to the worship of a female goddess. The statuette was entirely hand constructed, and the interior surface of the drapery still bears traces of the coroplast's finger marks. Simple in conception, the lower portion of the statue maintains an elliptical shape that, along with columnar and cylindrical bodies, is the hallmark of most of Cypriot human sculpture (see cat. nos. 57, 64, 66, 73). Here, the drapery folds are rather minimal and take the form of two broad swathes of cloth that fall vertically on either side of the body, while two smaller and more delicate folds fall to the ground to the outside of both feet. Traces of an applied buff slip still adhere in places on the front and side surfaces of the statuette, and one can only guess whether there might have been a decorative element that would have elaborated the simple treatment of the lower garment. The same buff slip appears on the two delicate feet that rest directly on the ground. They are represented naturalistically, as the bony structure of the toes is depicted, but the toe joints are not accurate and the elongated toes terminate in large, club-like pads dominated by a flat nail bed. The sandals are of a type worn today in contemporary fashion, with a V-shaped strap over the top of the foot and a thong passing between the large and second toes.

PUBLICATIONS
Serwint 1992, 394, 416, pl. 20.

NOTES
In the same sanctuary, a life-size terracotta foot (R4039/TC1121 + R4459/TC1272) wearing the same type of sandal was discovered and provides an exact parallel, though on a larger scale: Serwint 1992, 396, 419, pl. 27. On Cyprus, large statues were usually unshod but with articulated feet: Gjerstad 1935, pls. CCVII.1–2; CCXII.4–5; and CCXIV.1–2; Karageorghis (V.) 1993, pls. XI.4, XVI.2, and XV.1 (Agia Irini). For a coroplastic school at Idalion, see Karageorghis (V.) 1993, 53–59.

—NS

60
Bichrome Incense Burner

Cypriot, 6th century B.C.E.
Found by Princeton at Polis-Peristeries, trench B.D7:p14, in 1989
Ceramic; h. 22 cm., diam. 13.5 cm. (bowl)
Polis Chrysochous, Local Museum of Marion and Arsinoe (Princeton Cyprus Expedition
R4834/MC105 + R4835/MC106 + R4836/MC107 + R6335/MC123)

Condition: Broken and repaired from several pieces. Petals missing from each row;
lower portion not found.

Incense burners, or *thymiateria*, come in several shapes and materials (see cat. nos. 62, 93). The stand of this ceramic example is hollow and was made on the wheel to resemble the stem of a plant. Curved petals hang from two bulging nodes in the upper section of the stem. The petals were attached individually. Bronze thymiateria have cast sections of petals that hang directly from the center stem and are of the same size in all rows. Two such bronze thymiateria were found in tombs in Necropolis II at Polis just south of the Peristeries Plateau in 1886. Ceramic petaled thymiateria from the sanctuary at Meniko-Litharkes of the sixth century B.C.E. closely resemble the bronze examples, but there the upper petals are longer than and not as fully articulated as those in the lower row. On this example from Peristeries, the four preserved unpainted petals in the upper row are half the size of the three remaining in the bottom row. Those are painted red and detailed with black at the center. Most thymiateria had removable bowls with lids in which the incense was burned. The bowl at the top of this example was made separately on the wheel, hollowed out to fit the stem underneath, and attached by hand as a permanent receptacle. Traces of burning show that incense was burned in the bowl. Since its fabric is coarser than that of the stand, the bowl would have been able to withstand changes in temperature. Even so, it was warped in antiquity.

Petaled thymiateria with one, two, or three rows of petals were used by the early first millennium B.C.E. in Phoenicia and the southern Levant, but on Cyprus they began to serve funerary and sanctuary purposes only in the Cypro-Archaic period. On scarab seals (see cat. no. 61), a seated god or goddess sits on a throne before a thymiaterion with rows of petals. Sometimes a worshiper or a suppliant is shown having an audience with the deity. Like the examples from Meniko, this example was found inside a room that was set apart within a temple. The easternmost room of the main building in the Peristeries sanctuary was probably the house of the goddess. Incense may have helped to create a transformative environment, facilitating communication with the deity, perhaps even allowing for the reading of signs as in divination (see cat. no. 79).

PUBLICATIONS

Childs 1997, 40, 42, fig. 5 (without bowl).

NOTES

Petaled thymiateria: Matthäus 1999. Necropolis II: Ohnefalsch-Richter 1893, 378, pl. XLIII.9–10. Meniko: Karageorghis (V.) 1977b, 28–29, 39–40, pl. A., fig. 7. Seals showing a thymiaterion: Gubel 1987, 59–60.

—JSS

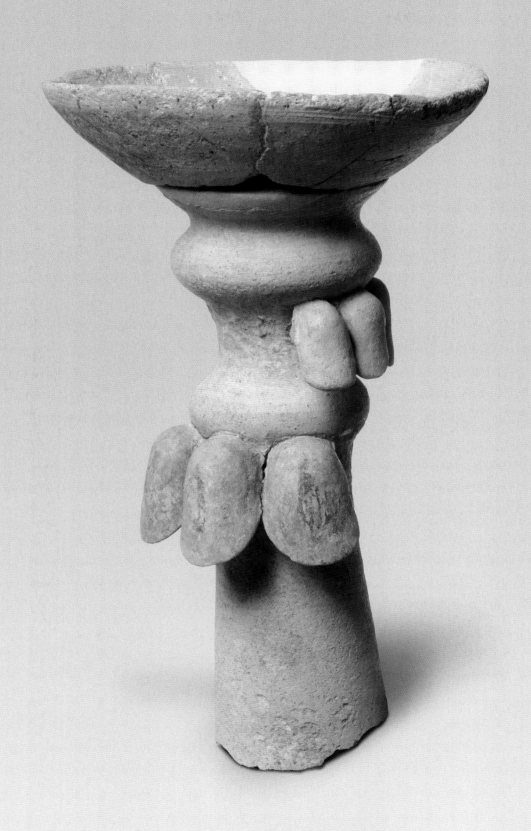

Scarab with a Seated God

Phoenician, 450–400 B.C.E.
Found by the Cyprus Exploration Fund at Polis-Agios Demetrios, Tomb 10, in 1889
Dark grayish green jasper; h. 0.89 cm. (scarab), l. 1.69 cm. (seal surface), w. 1.30 cm.
Nicosia, Cyprus Museum (D11)

Condition: Wear especially on scarab back, chipping on edges of carved surface and scarab ends. Wear on string-hole piercing with traces of bronze inside, the only remaining evidence for the original gold-covered finger-ring setting that is now missing.

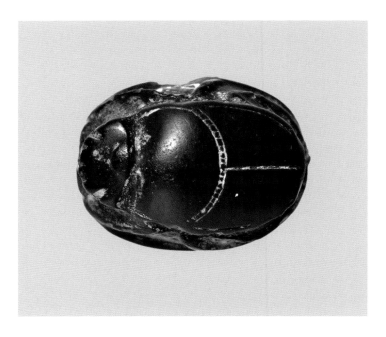

The word *scarab* derives from the Greek word for horned beetle, *karabos*, related to the ancient Egyptian word for scarab, *kheper*, the dung beetle that formed, rolled, and buried balls of dung as food. The Egyptians worshiped the god Kheper in the shape of the dung beetle who raised the sun, rolled it across the sky, and buried it at night. Kheper meant "to come into being." Both the scarab and the color green were signs of new life or regeneration. This scarab of green jasper preserves the details of the scarab beetle, including the spine along the back, the elytra that protect wings below, the divisions of the body including the head, and schematic legs on either side. The intaglio device shows a bearded god wearing a helmet and seated on a throne, the side of which is in the shape of sphinx. He wears a finely carved robe with wide pleated sleeves. As seen on the surface of the seal, he raises his left hand in a gesture, possibly of blessing, and holds a pointed staff in his right. In front of him is a thymiaterion, an incense burner, which has three registers of petals below the capped bowl from which smoke rises (see cat. no. 60). Above him is a winged disk, a conflation of a bird of prey and the sun, a symbol of protection common in Egypt and adapted in many Near Eastern cultures.

Scarab seals, first made in Egypt, were common seal shapes in the Levant, including Phoenicia. From the late sixth to fourth century B.C.E., the period of the Persian Empire, Phoenician green jasper scarabs were produced and used from Phoenicia and across the Mediterranean to Spain. Designs featuring a god or goddess in a scene of worship, or a god in combat, were especially popular among those found in the eastern Mediterranean. This Phoenician gem might have been made on Cyprus if the green jasper used came from the copper-rich resources of the Troodos Mountains. Along with other jewelry (see cat. no. 10), this scarab was placed in a tomb at Polis where two people were buried.

PUBLICATIONS

Munro and Tubbs 1890, 54, fig. 1; Myres and Ohnefalsch-Richter 1899, 136, no. 4581, pl. VIII.4603; Gubel 1987, 42, 63–64, no. 12, pl. VI; Reyes 2001, 78, no. 110, fig. 134; Boardman 2003, 63, no. 17/30, pl. 17.

NOTES

Sphinx throne: Gubel 1987, 37–75. Scarabs: Andrews 1994, 50–55. Green jasper scarabs: Boardman 2003, 3–6, 9, 18, 62–64.

—JSS

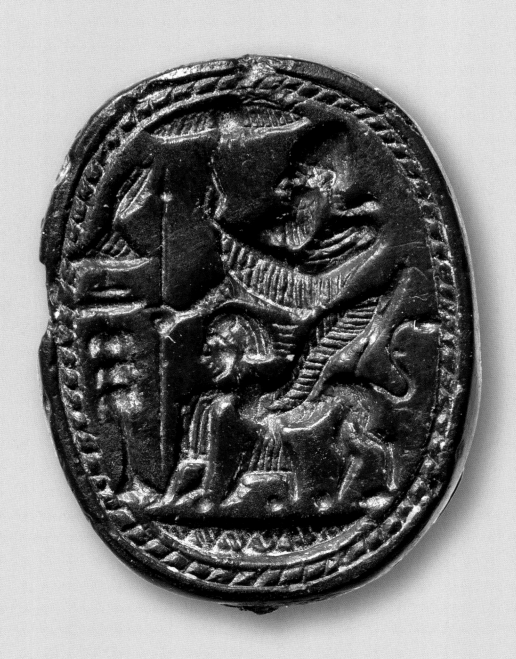

62
Altar or Incense Burner

Cypriot, 6th century B.C.E.
Found by Princeton at Polis-Peristeries,
trench B.D7:p15, in 1989
Limestone; h. 27.8 cm., w. 17.5 cm.,
th. 16 cm.
Polis Chrysochous, Local Museum of
Marion and Arsinoe (Princeton Cyprus
Expedition R6352/AS119)

Condition: Weathered and battered
but complete.

The designation altar or incense burner simply indicates that the object may have served either or both functions, since burning incense is merely a particular form of offering, while an altar might receive any kind of offering. The object is made of a block of limestone that is now much weathered but is essentially completely intact. It stood in the portico of the Archaic sanctuary of Peristeries near the entrance to one of the rooms of the main building, surrounded by numerous small terracotta figurines similar to catalogue numbers 64 and 65. Its shape is interesting because it is formed of two vertically symmetrical elements, in each case a cavetto molding surmounted by two fasciae. On the top surface is carved a shallow, slightly concave disk that could have received a bowl with offerings. There is no sign of burning here. The bottom of the object is formed by a cavetto molding, suggesting that it once stood on a base of some sort; since it was found with a plain block of very similar dimensions and a stone that probably served as a base, the three probably formed the complete altar or burner. Small limestone altars are known from the Levant and closely associated with Phoenician religious practice, but these tend to have horns on the four top corners and are not as elaborately carved as the example from Marion. The prominent use of the cavetto molding suggests comparison with a similar Phoenician incense burner/altar or possibly funerary cippus from Eleutherna on Crete. The two other terracotta incense burners in this publication also share formal connections with Phoenician examples (cat. nos. 60, 93).

PUBLICATIONS
Unpublished

NOTES
Stampolidis 1990, 99–106, pl. 1; Tore 1992, 193, no. 15; Karageorghis (V.) 1997, pl. XXXII.1; Gitin 2009.

—WAPC

63

Astarte Figurine

Cypriot, 6th century B.C.E.
Found by Princeton at Polis-Peristeries,
trench B.D7:n17, in 1988
Terracotta; h. 9.59 cm., w. 6.03 cm., th. 3.26 cm.
Polis Chrysochous, Local Museum of Marion
and Arsinoe (Princeton Cyprus Expedition
R4404/TC1240)

Condition: Broken at waist level; tips of ears and
nose missing, as well as termination of right earring;
gouge along upper right breast.

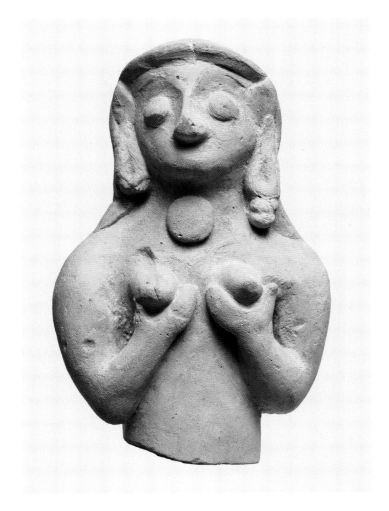

Discovered in the Peristeries sanctuary, this figurine confirms the nature of the divinity who received worship. The type of nude woman holding her breasts, as here, is known after her Phoenician antecedents as the goddess Astarte. Holding her breasts reinforces female fecundity, and nudity references human sexuality, fertility, abundance, and fruitfulness in nature. Representations of the Near Eastern goddess were known in Cyprus by the Late Bronze Age, and the type became popular during the Archaic period. The disk pendant at the throat, the teardrop pendant, and the beaded earrings adorning the figure were common attributes associated with Astarte figurines and hark back to earlier Near Eastern fertility goddesses whose sexual allure was heightened by glittering jewelry. With the present figurine, the surface is a bit misleading. Under a microscope, various colors have been detected, and it is clear that she was originally painted. Black pigment was found on her eyebrows and on the clay pellets that form the figurine's eyes. Although it might appear that she has no mouth, there are traces of brownish pigment just below her nose to indicate her lips, and her disk ears bear red paint. Her body, too, was painted red, and the nipples of her breasts were tipped with brownish paint, while the disk forming the central feature of her necklace has the remains of red pigment and very slight traces of yellow. The painted band that would have represented the rest of the necklace has not survived. The hair has been arranged very simply and falls as a single mass onto the upper shoulders and back. Her lower body would have had the pubic triangle emphasized, as this was commonly featured on other Astarte figurines found elsewhere on the island, and the figurine would have been standing with the legs positioned together. Scholarly debate continues about whether Astarte figurines were intended to represent the goddess, priestesses who were devoted to her worship, or perhaps sacred prostitutes who are mentioned in literary sources as being part of the temple cult.

Many Astarte figurines were crafted as votive objects and have been recovered from sanctuary sites elsewhere on the island. Large quantities have been found in tombs at ancient Amathous and perhaps were intended as protectors and companions to accompany the dead.

PUBLICATIONS

Serwint 1991, 218, pl. LVII.a; Smith (J. S.) 1997, 80, fig. 3; Serwint 2002, 337, 339, fig. 12; Serwint 2008, 318–19, fig. 9.3 right; Serwint 2009, 233, 235, fig. 8 right.

NOTES

Hermary 1989a, 395, no. 805 (Golgoi); Caubet, Hermary, and Karageorghis (V.) 1992, 122, no. 148. Karageorghis (J.) 1999 and Karageorghis (J.) 2005 present a range of relevant examples.

—NS

64

Female Figurine with Uplifted Arms

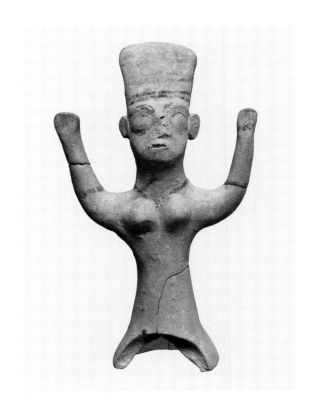

Cypriot, 7th or 6th century B.C.E.
Found by Princeton at Polis-Peristeries,
trench B.D7:r17 baulk, in 1990
Terracotta; h. 11.79 cm., w. 7.06 cm., th. 2.25 cm.,
diam. 3.8 cm. (base)
Polis Chrysochous, Local Museum of Marion
and Arsinoe (Princeton Cyprus Expedition
R8089/TC2927)

Condition: Four fragments join to produce a nearly complete figurine. Broken across arms and mended; left lower body broken and repaired; most of nose missing; back of right arm chipped; front of concave base missing.

Figurines such as this one have been found throughout the island at numerous sanctuaries dedicated to a female divinity associated with fertility and termed the Great Goddess. Because of the canonical position of the arms, the type is known as "the goddess with uplifted arms," although there is no evidence to identify the figure as a representation of a divinity. As the type is always female, the figures could represent a priestess or a worshiper, and the motif of the upraised hand with outward facing palm is a gesture known in the ancient Near East as one of reverence. Found in sanctuaries and tombs, this figurine type was ubiquitous in the Peristeries sanctuary, where scores of heads, hands, and bodies were recovered.

The production of such figurines follows a fairly stock formula: figurines are rarely taller than fifteen centimeters; at Marion, the figurines are usually solid, although at other sites they could be hollow, and the concave, flaring base allows the image to stand; handmade production is usual with the mold rarely used. Here the face is dominated by large clay pellets, outlined in black paint to represent the eyes that protrude beneath black, arching brows. The nose would have been broad, and the horizontal gash that forms the mouth still bears traces of red paint. Placed well forward on the side of the head, separately affixed clay ovals, painted red, represent schematic ears. The chin juts unnaturally forward and the head tilts backward,

supporting a towering *polos* headdress (see cat. no. 65) decorated with three pairs of horizontal black stripes. This figurine is quite subdued, but others were more elaborate (see cat. no. 66). The thin black line at the lower neck might represent the neckline of her garment or a simple necklace. Similar black bands circling the arms might mark the sleeves of her gown or signify decorative armbands; however, the black stripe at the left wrist certainly represents a bracelet, and black paint on the flattened hands defines the fingers. Separate dabs of clay were applied to form the breasts. It is thought that the figurine type was introduced into Cyprus from Minoan Crete during the eleventh century B.C.E. and gained in popularity throughout the Cypro-Geometric period (ca. 1050–800 B.C.E.), with the greatest heyday of the type occurring during the Cypro-Archaic period (ca. 800–475 B.C.E.).

PUBLICATIONS
Unpublished

NOTES
A far more elaborately painted version of this female type is cat. no. 65. Great Goddess and Aphrodite on Cyprus: Karageorghis (V.) 1977a and Karageorghis (J.) 2005; also Karageorghis (J.) 1977 and 1999; Karageorghis (V.) 1998.

—NS

65

Female Figurine with a Headdress

Cypriot, 7th–6th century B.C.E.
Found by Princeton at Polis-Peristeries,
trench B.D7:q17 baulk, in 1989
Terracotta; h. 5.2 cm., w. 4.2 cm., th. 3.13 cm.
Polis Chrysochous, Local Museum of Marion
and Arsinoe (Princeton Cyprus Expedition
R6851/TC2775)

Condition: Broken across upper neck.
Tip of chin chipped.

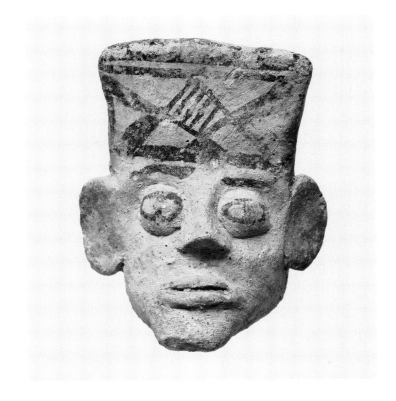

Although thousands of figurines were recovered from the Archaic sanctuary of Peristeries, none was similar in style to this female head wearing an elaborately decorated polos headdress, a high, rectangular hat normally worn by women. Here, the combination of exaggerated facial features rendered plastically and in paint is exceptional, and the physiognomy represented is far removed from the range of head types recognized among the votive corpus. The body of this figure was probably similar to that of cat. no. 64. Perhaps the most unique feature of the face, which was entirely made by hand, is its unusual slope with the arrangement of the facial features on a plane that angles forward from the bottom of the polos headdress to the tip of the jutting chin. Like the painted decoration on the headdress, the structure of the face is geometric, with the face square in shape and the area of the mouth and chin forming a triangle. Because the polos is worn low on the head, the facial features are compressed with the eyebrows rendered as two slashes of black paint below which clay pellets have been affixed, overlapping the side of the nose, to represent the eyes. Black painted ovals outline part of the bulging eyes, and a vertical stroke of black pigment marks either the iris or the pupil. The large pyramidal-shaped nose continues the geometric approach, and the lower face is dominated by an unusually large mouth with fleshy lips separated by a deep horizontal gash in which there are remains of red pigment. Two red dots mark the cheeks. Oversized ears, painted red on the front surface, occupy more than half the side of the face, and there is no attention to anatomical realism other than their oval shape. The high polos is decorated on its front surface by a black banded zone filled with triangular shapes with a central hatched lozenge. The back of the head is bulbous in an effort to emphasize its curve in contrast to the flat rise of the polos headdress. There are no traces of paint on the back of the figurine, although press marks from the fingertips of the coroplast are plentiful. The unusual style of the face, the exaggerated features, and the geometric pattern on the hat suggest an early date for this votive offering. The application of red and black pigments to highlight specific features is characteristic of terracotta sculpture from this period.

PUBLICATIONS
Unpublished

NOTES
Higgins 1967, 1–5; Higgins 1969, 7; Higgins 1970, 272–75.

—NS

66

Female Figurine with Uplifted Arms

Cypriot, 6th century B.C.E.
Found by Princeton at Polis-Peristeries,
trench B.D7:r15 Sondage 1, in 1990
Terracotta with black paint; h. 7 cm., w. 6.34 cm.,
th. 2.45 cm., diam. 4.5 cm. (base)
Polis Chrysochous, Local Museum of Marion
and Arsinoe (Princeton Cyprus Expedition
R8090.1-2/TC2928.1-2)

Condition: Two joining fragments; broken diagonally
through middle of body; ends of arms missing;
damage to hair strands on shoulders and along
forehead, disk pendant necklace, mouth, right ear,
diadem, and columnar base.

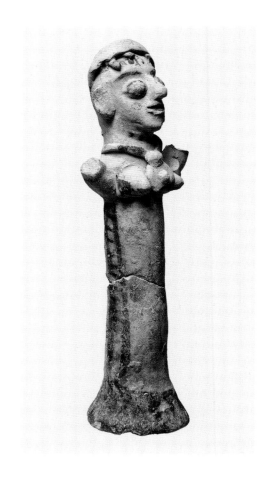

This figure represents the ubiquitous female figurine type found in the Archaic sanctuary at Peristeries: the goddess with uplifted arms (see cat. no. 64). She was entirely made by hand using the "snowman technique," so called by modern scholars because individual elements of body and head were separately handcrafted and added to the basic form: large clay pellets for eyes, a triangular-shaped nose, and outsized oval ears placed low on the side of the head. Black paint rings the eyes, marks the iris or pupil, and reinforces the arc of the elongated eyebrows, while red pigment emphasizes the horizontal gash of the mouth and simulates the blush of the cheeks. The figure stands frontally, her columnar body supported by a flaring concave base as she raises both arms in a gesture of either epiphany or reverence. High up on the throat, the figure wears a beaded necklace marked by five simple black dots, and below, nestled between two large breasts, is a more complicated necklace consisting of two disks, the larger of which bears traces of red paint and a black-painted bead at the center. There are ends of locks of black hair on either side of the breasts, but traces of hair strands are nowhere to be found on the shoulders or along the sides of the neck. Compared to other representations of this type, the figure's garment is rather simple, highlighted by a modest black wash terminating in a wide band that marks the hem, while a black ladder pattern trims the sides. It is not clear whether the black bands visible just at the break of the arms were intended to signify the edge of the gown's sleeve or to represent decorative armbands. One of the most important features of this figure can be seen only from the rear: a wide, deep groove that runs from the top of the head down into the concave base. A handful of other figurines found at Marion also are marked this way; the groove is not necessary for the figure to stand or required for the production of the object, but today it identifies pieces from the same workshop that crafted the figures. This votive demonstrates the latitude an artist had in personalizing his depiction of a type of female votive that had become a stock type (see cat. no. 64).

PUBLICATIONS

Unpublished

NOTES

Karageorghis (J.) 1977; Hadjisavvas 2003, 105, no. 5. Karageorghis (V.) 1977a; Karageorghis (V.) 1993, 94–97; Serwint 2002, 328.

—NS

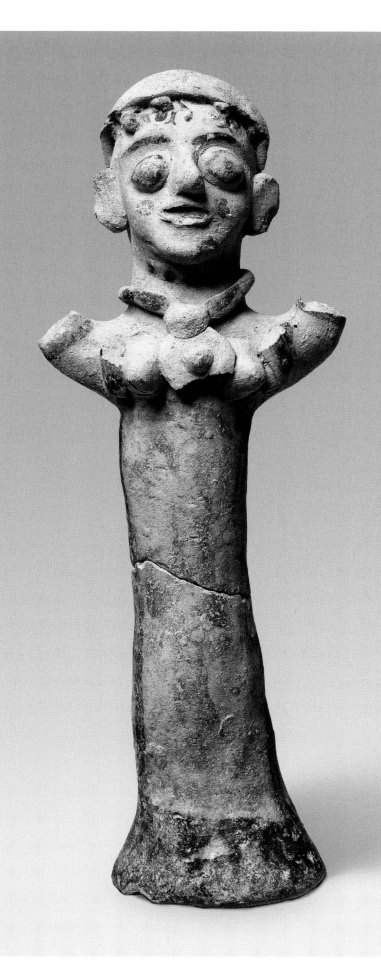

67
Figurine of a Draped Woman

Cypriot, early 5th century B.C.E.
Found by Princeton at Polis-Peristeries, trench B.D7:q17 baulk, in 1989
Terracotta with red paint; h. 18.1 cm., w. 6.68 cm., th. 1.89–4.51 cm.
Polis Chrysochous, Local Museum of Marion and Arsinoe (MMA 182; Princeton Cyprus Expedition R7026/TC2834)

Condition: Nearly complete. Lower right arm broken just below elbow. Damage to right breast as well as to front of left foot. Nose missing, as is some hair behind left temple.

This figurine is a fine example of a molded draped female votive of a type popular at Marion and elsewhere in the eastern Mediterranean in the late sixth and early fifth centuries B.C.E. Originating in the East Greek islands, possibly Rhodes, in the late sixth century, the type was circulated widely. This figurine was probably locally made but used imported molds. The woman, wearing a sheer chiton, or long tunic, pulls her skirt with her left hand, revealing her legs beneath the cloth. A himation, or mantle, is worn reflecting contemporary fashion, being draped diagonally across the torso from the right shoulder and passing under the left breast. The figure's now-missing lower right arm had been added separately and brought to the chest in the characteristic gesture of holding a small offering. A different mold was used to craft part of the head; the face and hair were included in the mold, while the diadem-like headdress was fashioned by hand. Amusing is the artist's indifference that there is no hair on the side of the head below the level of the ears, as this is where the hair in the face mold terminated, and the snake-like locks on the front of the shoulders were included in the mold used for the torso. In addition, the coroplast was clumsy in joining head to body with a heavy application of clay, which resulted in an ungainly thickened neck. Despite this awkward passage, the red pigment on the front of the figure reinforces the delicacy of the drapery.

A total of four different figurines from Marion were fashioned from the mold used for this figure's body, two found in the Peristeries sanctuary and two from the sanctuary at Maratheri, while the head mold used here was employed for another figurine having an altogether different body type. The use of the same mold for the torsos of different figurines from the two Marion sanctuaries is important because it reinforces the idea of local production for the votive figures that serviced the Marion sanctuaries.

PUBLICATIONS

Childs 1994, 110, pl. XXIX.c.

NOTES

Higgins 1967. The other Marion votive figurines that were crafted from the same body mold are R14709 and R14710 (from the Maratheri sanctuary) and R4473 (from the Peristeries sanctuary). Similar, but not identical, figurines from Rhodes are British Museum 1864.10–7.1384 from the Fikellura Cemetery, Tomb F259, at Kamiros, and Metropolitan Museum of Art MMA 74.51.1722 from the Cesnola Collection, purchased by subscription 1874–76.

—NS

68
Face of a Male Statuette

Cypriot, first half of the 6th century B.C.E.
Found by Princeton at Polis-Peristeries, trench B.D7:p15, in 1989
Terracotta with red and black paint; h. 12.35 cm., w. 9.84 cm., th. 1.48 cm.
Polis Chrysochous, Local Museum of Marion and Arsinoe (Princeton Cyprus Expedition R8717/
TC2946 + R8718/TC2947 + R5129/TC2027 + R5134/TC2032)

Condition: Restored from five joining fragments. Broken around edge of face, below chin, and across
front top of helmet. Nose missing.

The face of this nearly two-thirds life-size statuette head reflects the very early use of the mold to fashion sculpture. Introduced into Cyprus from the Near East sometime during the seventh century B.C.E., the mold was initially used sparingly by coroplasts to craft faces only. In the case of this face, the features were only hinted at in the mold, with slight modulation of the surface of the face to represent the projection of the brows, eyes, and cheeks. The pointed chin was formed from additional clay, as was the small, pursed mouth. Other contemporary mold-made statuette faces always had noses shaped by hand, so the present example likely had its nose added separately as well. Although the facial features were only hinted at in the mold, they were further elaborated in paint. The arching brows are augmented by black paint; the large, almond-shaped eyes are rimmed in black, while the convex orb of the eye is painted white, and the circular iris is rendered in black with no separate treatment of the pupil. Surface modulation of the face is slight, but the cheeks project slightly and are located unnaturally low on the face just on either side of the mouth. The surface of the face is painted red, suggesting that the individual represented was intended to be male, as it was common throughout the ancient world that depictions of men were often rendered in brown or red pigment, whereas females were painted white or pale yellow. In the case of this face, the forehead is extremely low and is bordered by a thick band of black paint, surely representing hair. Just above is a projecting reserve ledge of clay, likely indicating the edge of the figure's headgear, possibly a helmet rim.

On the interior of the face, press marks are visible where the coroplast worked the clay into the mold; however, just where the edge of the helmet rim begins, wheel marks are visible, indicating that the rest of the headgear was made on the wheel.

PUBLICATIONS

Serwint 1992, 397, 420, pl. 28.

NOTES

Good examples of statue heads with painted features were found at various sites: Idalion (Karageorghis [V.] 1993, 68–69, no. 235, pl. XLVII.3); Peyia (Karageorghis [V.] 1993, 49, no. 140, pl. XXXII.6); Salamis-Toumba (Karageorghis [V.] 1993, 40, no. 99, pl. XXV.6).

—NS

69

Male Head with a Wreath

Cypriot, end of the 6th or beginning of the 5th century B.C.E.
Found by Princeton at Polis-Petrerades in Area E.G0, test trench 23, in 1990
Limestone; h. 7.7 cm., w. 5.6 cm., th. 6.2 cm.
Polis Chrysochous, Local Museum of Marion and Arsinoe (Princeton Cyprus Expedition R7665/SC29)

Condition: Head broken at neck; the nose is mainly broken away; there is a chip out of the head and wreath above the right eye; the right cheek is chipped; all the surfaces are worn.

The head was found in a large but scattered cache of limestone and terracotta sculptures (cat. no. 78) at the northern end of area E.G0. Evidently once dedications in a sanctuary, no architectural context was found, though some twenty meters to the south some fine painted vases and a deposit of vases with two terracotta bells (cat. no. 83) suggest that a sanctuary was nearby.

This is a good example of a late Archaic male head, probably of the very end of the sixth or the beginning of the fifth century B.C.E. By this time, Cypriot sculptors had become familiar with the details of Greek Archaic forms: the eyes are almond shaped, the lips slant up from the center in a linear pattern of the "Archaic Greek smile." The hair radiates from the crown in broad bands ending over the brow in a double tier of locks, the lower set projecting slightly. At the back below the wreath is a prominent, curved mass of hair articulated in squares. The wreath is formed of elongated leaves, often identified as laurel, fastened at the back of the neck and arranged symmetrically to meet over the brow. On each side at the front is a narrow band below the wreath from which hang twelve elongated masses, possibly fruit.

The carving of the face and front hair is good, but the hair above the wreath is sloppy; the ears are rudimentary forms—hair rises up in a shallow arc above them. There are possible traces of red in the hair mass above the neck at the back.

PUBLICATIONS

Childs 1994, 111, pl. XXIX.d.

NOTES

Caubet, Hermary, and Karageorghis (V.) 1992, no. 166; Hermary 1989a, no. 246 (Idalion).

—WAPC

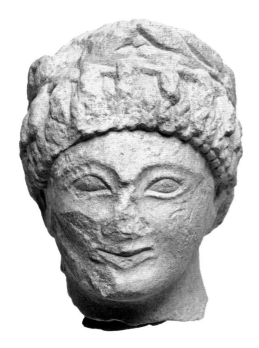
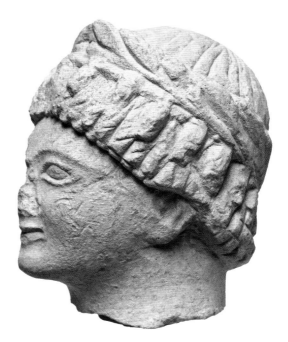

70

Figurine of a Draped Man

Cypriot, late 7th or early 6th century B.C.E.
Found by Princeton at Polis-Maratheri,
trench A.H9:v15, in 1986
Terracotta; h. 13.27 cm., w. 6.71 cm., th. 2.07 cm.
Polis Chrysochous, Local Museum of Marion
and Arsinoe (Princeton Cyprus Expedition
R21017/TC8675)

Condition: Broken diagonally through level of mid-
leg; tip of right hand, nose, pellet mouth, and part of
chin missing; damage to tip of cap, brim, and front
of left arm.

This fragment reflects a figurine type common in the Archaic period in Cyprus representing a man dressed in a long garment and wearing a brimmed pointed cap. The figure is simply fashioned using the manufacturing process termed the "snowman technique," in which individual features and body parts were added by hand. The figurine, standing frontally, is schematically rendered, suggesting its early date. His separately made arms, held alongside the body, narrow toward pointed tips to represent abbreviated hands. The coroplast has exaggerated the breadth of the figure at the shoulders, and the torso and lower body are conceived as cylindrical and fashioned simply from a single roll of clay. The face is equally schematic, and features include a now damaged, elongated nose placed high on the face above a pellet mouth, while a shelf-like chin with clay buildup represents a short beard. Disk ears are placed low and well back on the sides of the head, with the right ear positioned below the level of the left, and both are painted red. Also painted red is the tall pointed cap with a brim worn low on the forehead. Locks of black hair fall on either shoulder, and the hair on the nape of the neck is painted black as well. Although the figure's apparel is not represented three-dimensionally in clay, he wears an elaborately painted garment that takes the form of a long gown, painted red and open in the front, with three horizontal black bands (probably a belt) holding the garment together. The short sleeves terminate in three horizontal, parallel black stripes, perhaps representing armbands that

are known from large-scale sculpture in stone and terracotta, while the downward curving black line extending across the lower neck likely indicates the edge of a tunic that is held in reserve. In the middle of the chest is a black star-shaped pattern with eight radiating spokes that decorates the front of the tunic. Found in fill east of the city wall at Maratheri, the figurine was once a dedicatory offering. The ultimate inspiration for the costume and headgear is Assyrian of the eighth and seventh centuries B.C.E.; by the time this figurine was crafted, however, the pointed cap and long gown with tunic were part of a stock pictorial repertoire in Cyprus. Figurines of this type are found at many sanctuaries on the island.

PUBLICATIONS
Unpublished

NOTES
Figurines of this type were found at several sites. Examples from Kourion: Young and Young 1955. Figurines from Agia Irini: Gjerstad 1935b, pls. CCXXX.3, 16, 18. General discussion: Young and Young 1955; Törnkvist 1972; and Karageorghis (V.) 1993, 82–101.

—NS

Fist and Head from a Colossal Male Statue

Cypriot, late 6th century B.C.E.
Found by Princeton at Polis-Maratheri, trench A.H9:s15, in 1985, and A.H9:v17, in 1984
Terracotta; l. 19.8 cm. (fist), h. 23.3 cm. (head), w. 11.65 cm. (fist), 19.9 cm. (head),
th. 1.09–1.73 cm. (fist), 2.2–3.82 cm. (head)
Polis Chrysochous, Local Museum of Marion and Arsinoe (Princeton Cyprus Expedition
R2087/TC300 [fist], R496/TC5 [head])

Condition: Broken irregularly at wrist and lower arm; thumb broken and repaired. Eight joining fragments
preserving right side of face and backward-flaring headdress.

Both the fist and the head can be associated with a colossal Egyptianizing statue that once stood within the Maratheri sanctuary complex. A photographic reconstruction (see frontispiece) displays all the parts of this statue that were discovered in the excavations. As a votive dedication, the statue, which was intended to impress by its size, conveys much about the wealth and economic status of its donor. Certainly, the statue was not meant to represent an Egyptian pharaoh but rather reflects a current trend on the island that saw an appreciation of Egyptian motifs.

The right fist presumably is from a male because of the remains of red paint still visible on the outside of the thumb. The color convention for male statues in antiquity was either red or brown. The clenched fist was the common hand gesture for Egyptian royal males and influenced the configuration of hands in representations of the Greek male kouros type.

With the present fragment, the break at the wrist allows one to understand how the coroplast constructed the hand. The circular marks on the interior of the lower arm reveal that the arm was made on a potter's wheel in the form of an elongated hollow cylinder. Into this open-ended form, where the wrist would be, the coroplast inserted a clay plug to strengthen the inside of the wrist. He then manipulated the shorter portion of the cylinder that extended forward from the reinforcing plug, flattening the cylinder and bending it to shape the curling fist. He used his own fingers on the outside of the clay hand to create furrows that formed the depressions between the statue's fingers, while on the inside of the hand he also used a sharp tool to incise the space between the fingertips. On the side of the hand, he added a clay bridge

to secure the little finger to the palm; most of the thumb was added separately. The coroplast made attempts at naturalism: the thumbnail is depicted, as are the wrist bone on the side of the hand and the knuckles on the tops of the fingers. On those parts of the hand that would not have been visible, however, such as the fleshy pad of the thumb and the nails of the other fingers, there was an economy of representation.

For the life-size head, the coroplast used a mold that allowed for the inclusion of naturalistic details for the face—for example, the subtle modeling of the right cheek, the heavily lidded eye, and the fleshy lips—and captured what was intended to represent a specific foreign type. A tuft of hair still present below the lower lip is reminiscent of the Egyptian ceremonial or false beard worn by a pharaoh. The broken ledge of clay along the hairline and the upward sweep of clay as it flares off the side of the head evoke an Egyptian wig or perhaps the pharaonic *nemes* headdress. Although the head was not found in association with a body, the thickness of what remains of the face suggests that it was joined to one of substantial size, possibly the same colossal male statue to which the fist belongs and that was represented wearing an Egyptianizing kilt.

PUBLICATIONS

Markoe 1990b; Serwint 1991, 214, pl. LII.c; Serwint 1992, 389, 409–12, pls. 5–7, 9, 11; Reyes 1994; Serwint 2000; Faegersten 2003; Serwint 2009, 236–37, figs. 9–10.

NOTES

Possibly from the same colossal statue as the Maratheri fist is R1640/TC100, an over-life-size arm and clenched fist. Cf. similar examples from Agia Irini: Gjerstad 1935a, 726–27, no. 1490, pl. CCI.1; Karageorghis (V.) 1993, 15, no. 27, pl. VII.2, 25, no. 62, pl. XVI.2–3, and 752, nos. 2072 + 2073, pl. CCXIV.1–2. See also two statues from Tamassos: Karageorghis (V.) 1993, 28, pl. XVIII.2, figs. 14–15, and 50–51, no. 152, pl. XXXIV.5. Examples of Egyptianizing male heads with a false beard from Cyprus are unknown, but sixth-century statues wearing wigs or plain kerchiefs have been found at various sites. Idalion: Faegersten 2003, 271–72, nos. 7–8, pl. 2.1–2. Golgoi (Agios Photios): Faegersten 2003, 279, no. 24, pl. 7.1.

—NS

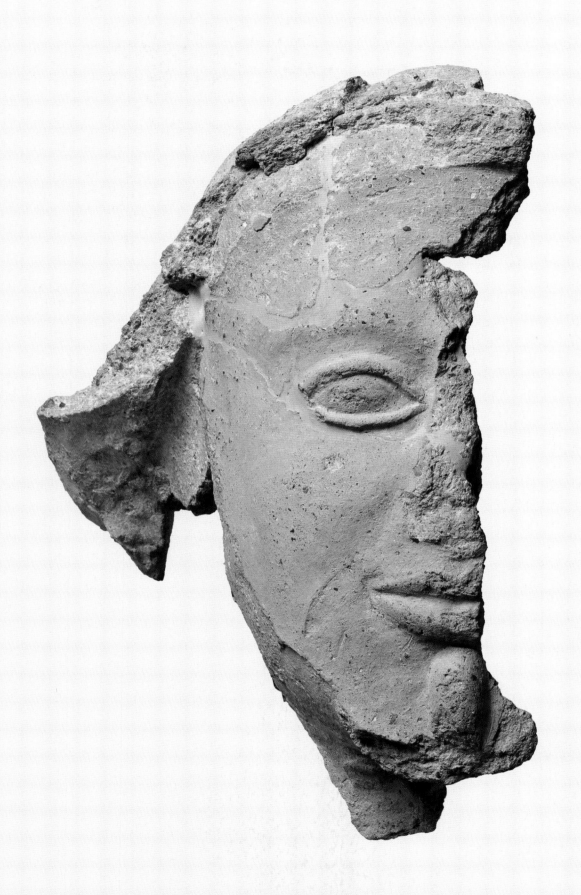

Fragmentary Female Statue

Cypriot; late 6th century B.C.E.
Found by the Department of Antiquities of Cyprus at Polis-Maratheri, rescue excavations near the sanctuary in Area A.H9 excavated by Princeton
Terracotta; h. 31 cm., w. 35.5 cm.
Polis Chrysochous, Local Museum of Marion and Arsinoe (MMA 662/912)

Condition: Fragment of body; reassembled from smaller fragments; modern retouching of cracks.

This terracotta fragment formed part of a female statue of a goddess or priestess, preserving the frontal part of the neck and the left shoulder with the beginnings of the arm. The left breast is preserved, schematically rendered. The statue is handmade of coarse sandy pinkish clay with large limestone inclusions. There is no indication of a garment on the fragment, yet it is unlikely that she was naked. Three locks of wavy hair fall symmetrically on either side of the shoulders. The neck is decorated with three different types of necklaces, worn tightly like a choker. A fourth necklace falls low between the breasts. All of the jewelry is made of rolls of clay and pellets.

The first necklace consists of three strands of circular beads made of flat disk-shaped pellets applied separately. The second necklace is composed of elongated ovoid beads set in pairs and linked by smaller ovoid pinched beads. The third necklace consists of a strand of beads, made of flat circular pellets, alternating with ovoid elongated beads set vertically. A part of a flat and possibly circular pendant appears under the necklaces, at the base of the neck, unfortunately broken, seemingly forming part of a larger pendant originally attached between the beads. The fourth necklace is much longer, falling from the shoulder onto the chest, consisting of a string of small circular beads from each of which hangs a large biconical bead.

The "choker" type, with its long Near Eastern tradition, is combined with other necklaces hanging lower on the chest or between the breasts, and is frequently seen on depictions of female figures found in the sanctuaries of the island. Usually various fertility symbols hang from these necklaces, thus relating the figures wearing them to the cult of the Great Goddess. The long triangular necklace, however, marks a development in the decoration of female figures, which is observed in the later part of the sixth century B.C.E. This type of simpler and more elegant necklace was introduced to Cyprus under the influence of Greek art, especially that of the *korai* (young girls) of Ionian and Attic art. In the sixth century B.C.E., and possibly later, it is found combined with the choker, as evidenced by the korai of Salamis. Large female terracotta statues of the Archaic period that are decorated with many necklaces are rare in the Marion area. The present fragment constitutes an interesting example of the local coroplastic art in the later phase of the Archaic period.

PUBLICATIONS
Unpublished

NOTES
The accumulation of necklaces is typical in Cypriot stone and terracotta sculptural representations of female figures in art of the Archaic period: Laffineur 1991, 172–75; Karageorghis (V.) 1993, 94–97. Fertility symbols: Yon and Caubet 1988, 5–6. Korai of Salamis: Yon 1974, 128–35, figs. 42–47.

—ER

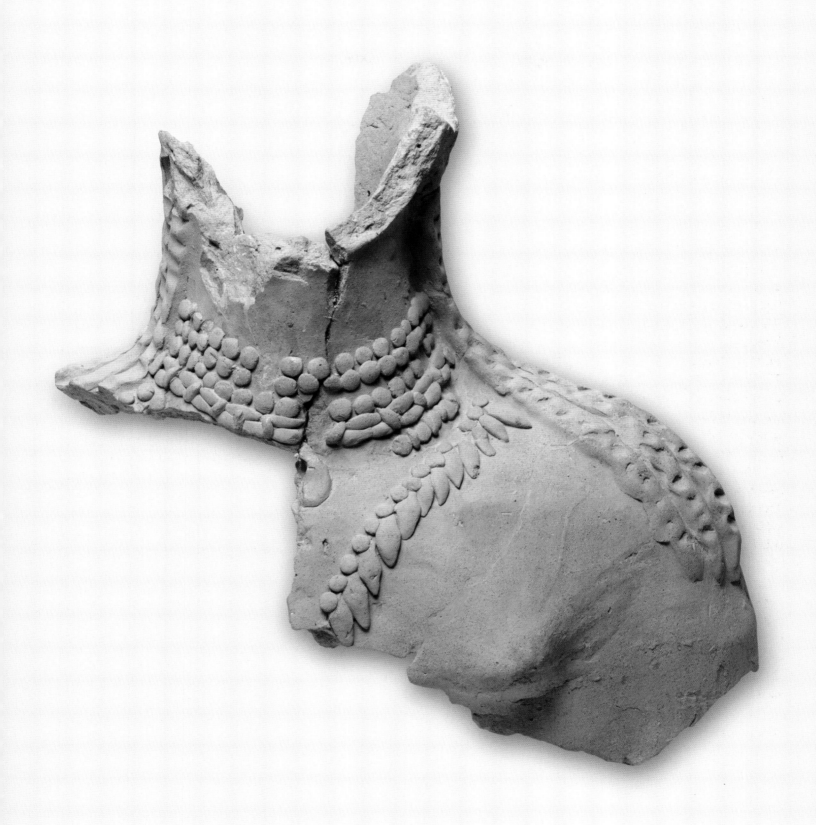

73

Tubular Statuette

Cypriot, 6th or 5th century B.C.E.
Found by Princeton at Polis-Maratheri, trench A.H9:s15, in 1985
Terracotta; h. 50 cm., w. 17.6 cm. (including arm), th. 4.16 cm., diam. 7.11 cm. (neck)
Polis Chrysochous, Local Museum of Marion and Arsinoe (Princeton Cyprus Expedition R1649/TC108)

Condition: Nearly complete except for irregular break at back of neck; head missing; damage to end of arm.

This terracotta statuette belongs to an unusual type that represents the human body as a completely schematic form in which the elongated body has been simplified into a basic shape. The undifferentiated contour depicts the figure wearing a long gown that is undecorated except for sporadic traces of dark red pigment that still adhere to the surface. Along the left side, a strip of clay has been applied to depict a stylized arm. Although missing, the hands would have narrowed at the tip of the arms. At the bottom of the body, two lumps of clay have been added and cursorily fashioned to form abbreviated feet. The surface of the body reveals concentric rills, which indicate that the potter's wheel was used to create a cylindrical form that was then slightly flattened to craft the elliptical shape of the body. Cypriot sculpture of human figures tended to focus on the head, and often less attention was paid to the body. In the case of this statuette, there is not sufficient detail to determine whether it is male or female. The open, truncated neck at the top of the sloping shoulders served as a socket to receive a head that would have had an elongated tenon-like neck (compare cat. no. 57).

One can only imagine how the head of this statuette might have looked. It is entirely possible that when it stood in the sanctuary, the head would have been naturalistic and perhaps not unlike that of the male statuette wearing a radiate wreath (cat. no. 74). Five other fragmentary bodies of exactly this kind were found in and around the Classical Maratheri sanctuary at Marion and seem to be unique to this complex. Columnar and elliptical bodies are common shapes and are frequently found among the hundreds of votive figurines recovered from sanctuaries throughout the island. The forms continue for larger sculptural works, such as the female statuette wearing sandals (cat. no. 59) and the colossal Egyptianizing statue (cat. no. 71).

PUBLICATIONS
Serwint 1991, 215, pl. LV.b.

NOTES
Karageorghis (V.) 2003, nos. 194, 197, 249; also Karageorghis (V.) 1993, nos. 18, 35.

—NS

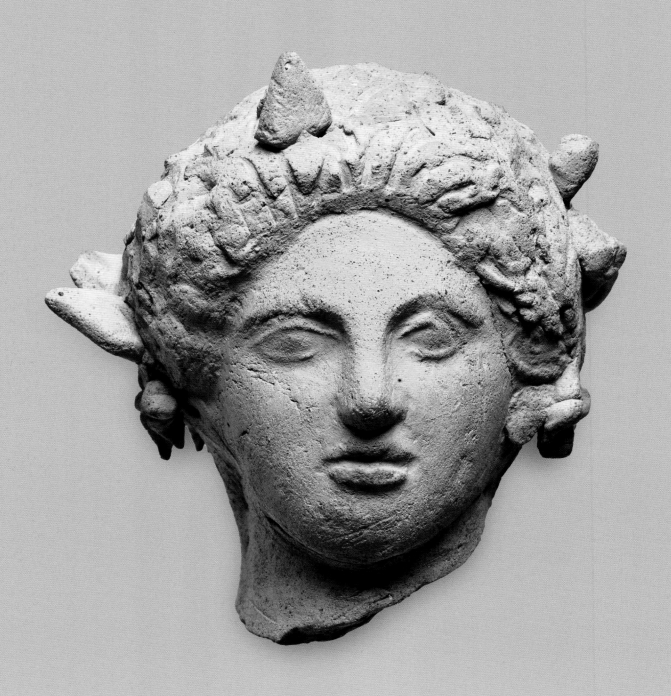

Male Head with a Radiate Wreath

Cypriot, late 5th century B.C.E.
Found by Princeton at Polis-Maratheri, trench A.H9:s15, in 1985
Terracotta; h. 9.05 cm. (with crown), 8.6 cm. (without crown), w. 8.39 cm. (with crown), 6.65 cm. (without crown), th. 1.48 cm. (back of neck), 2.55 cm. (front of neck)
Polis Chrysochous, Local Museum of Marion and Arsinoe (Princeton Cyprus Expedition R2169/TC338)

Condition: Head is broken diagonally across the neck from the lower right to the upper left; locks of hair covering ears are missing; many petals of the wreath are damaged or no longer present.

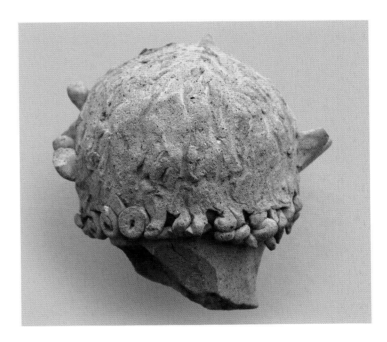

Only the face of this fine head of a male statuette was made in a mold, and all other elements—hair, neck, and wreath—were fashioned and added by hand. The mold seam is visible as a faint line at the join between forehead and hair and also underneath the chin. The face is delicately rendered with almond-shaped eyes having upper and lower lids in relief. The strong nose with angular sides betrays influence from contemporary heads in bronze, and fleshy lips are presented as though the mouth were slightly open. There is a heaviness and fleshiness to the lower face and jaw. The hair has been separately added and fitted over the head as a distinct cap of clay. Impressionistic tufts of clay mass at the temples, while the coroplast has taken a sharp tool to incise strands of hair rising off the forehead. A hint of an incised star-shaped hair pattern is visible at the crown of the head, and the back and sides of the head are sketchily incised in no discernible pattern to suggest the texture of the hair. Little rolls of clay were coiled to make either corkscrew or snail-shell curls that were added high on the nape of the neck, while small, projecting, triangular leaves, arranged in a double row and extending from ear to ear, represent a crown worn in the hair. Traces of red pigment remain on the back of the neck, indicating that the head was originally painted.

Found within the Classical sanctuary at Maratheri, the head may have fit into a tubular body (see cat. no. 73). Images of dedicants wearing wreaths were first introduced into the repertoire of votive sculpture in Cypriot sanctuaries beginning in the sixth century B.C.E., as two limestone heads well indicate (cat. nos. 39, 69). Wreaths with leaves could be combined with floral arrangements, and it is thought that they were worn by participants in religious festivals and cult rituals. This particular head displays a delicacy of treatment by a master coroplast, and the mold-made facial features reflect the influence of a Greek style that was much appreciated in the fifth century B.C.E.

PUBLICATIONS

Serwint 1991, 215–16, pl. LV.d.

NOTES

A similar but larger head was found at Mersinaki on the north coast: Karageorghis (V.) 2003, 220, cat. no. 255. Heads with wreathed crowns: Hermary 1989a, 112; Karageorghis (V.) 1993, 88; Gjerstad 1948, pl. XVII.3; and Westholm 1937a, 369, 387, pl. CXXXIV.

—NS

75
Female Figurine

Greek, Attic, ca. 340–320 B.C.E.
Found by Princeton at Polis-Maratheri, trench A.H9:r13, in 1986
Terracotta; h. 7.95 cm., w. 3.99 cm., th. 1.30 cm. (head), 0.26 cm. (body wall)
Polis Chrysochous, Local Museum of Marion and Arsinoe (Princeton Cyprus Expedition R18899.1–3/TC8367.1–3)

Condition: Broken irregularly from below left shoulder diagonally down to just above waist level on right; also broken vertically beginning at the top of the head and extending down the side of the head, along the neck, through the shoulders, and along the side of the right arm, with the break following the seam between the front and back molds of the head and body.

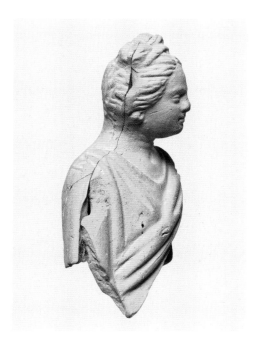

This little figurine fragment is a rarity among the mold-made votive objects recovered in this excavation because it is one of only a few examples for which separate, detailed molds were used for the front of the head and torso, while other molds that were more schematic were used for the back. The head and part of the upper torso of a delicately rendered female are preserved; she wears a V-necked chiton over which is draped a diagonal himation that passes below the right arm and is brought up over the left shoulder. The folds of drapery on the front are rather crisp, but on the back the folds are summary. The face is graceful and is a rounded oval in shape, and the molded features are very precise and clear. The small eyes are heavily lidded, the nose rather broad, and the furrow between the nose and the mouth is indicated, calling attention to the small, bow-shaped mouth that is subtly indented at either end. The attractiveness of the figure is enhanced by a coiffure that waves off the temples and sides of the face with separate strands of hair held in place by a hairband, called a *tainia*, which is partly visible on the top of the head. Behind the band, the hair has been gathered into two projecting top-knots in a style called the *lampadion* (little torch), which became fashionable during the second half of the fourth century B.C.E. On the back of the head, traces of red pigment remain on the hair at the nape of the neck. Although there is little evidence at Marion for multiple molds utilized in the construction of a single figure, the technique of this figurine reflects a common practice elsewhere in the Greek world. The drapery style, coiffure, and facial features are all characteristics made popular in Athens beginning about 340 B.C.E. and exported widely; these details as well as the exceptionally fine fabric of this figurine might suggest that it is an Attic import that was dedicated in the forecourt of the sanctuary at Maratheri.

PUBLICATIONS
Unpublished

NOTES
Compare the marble head of Aphrodite known as "The Bartlett Head": Comstock and Vermeule 1976, no. 55; Boardman 1995, 72, 86, fig. 56. Hairstyle: Higgins 1967, pls. 34.F and 44.E. In Cyprus, a good parallel is Burn and Higgins 2001, 275, no. 2914, pl. 148 (Kourion). General discussion: Boardman 1995.

—NS

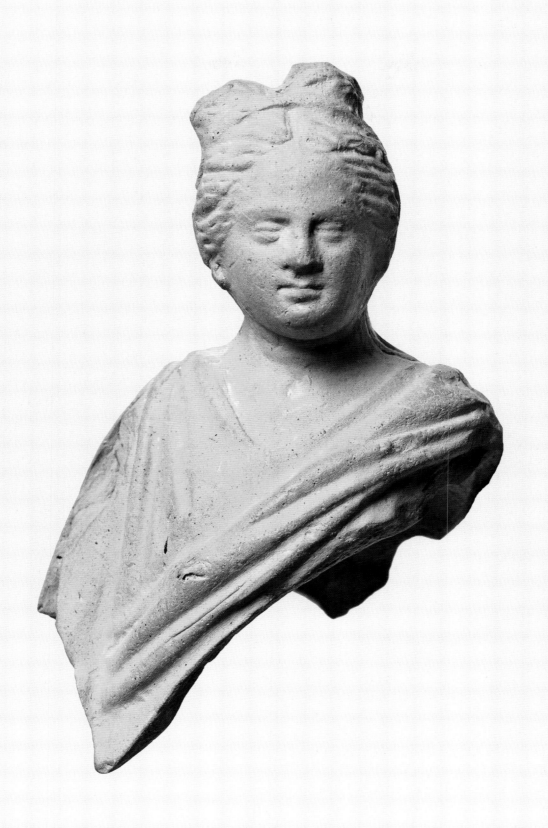

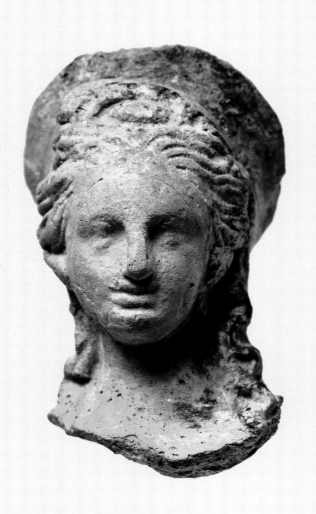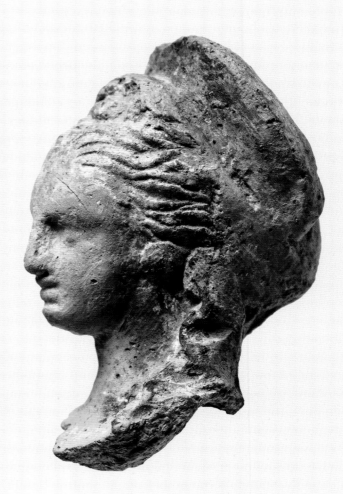

76
Head of a Female Figurine

Greek, late 4th century B.C.E.
Found by Princeton at Polis-Maratheri, trench A.H9:p06, in 1997
Terracotta; h. 5.48 cm., w. 3.18 cm., th. 3.63 cm.
Polis Chrysochous, Local Museum of Marion and Arsinoe (Princeton Cyprus Expedition R21404/TC8783)

Condition: Broken irregularly along lower back, neck, and upper front torso; slight damage to top of headdress; tip of nose missing.

The face and hair up to the *stephane* (crown) worn on the back of the head of this figurine were articulated in the mold, and it is the intricate hairstyle that contributes to the striking quality of the head. The hair gracefully waves off the temples and forehead with individual strands indicated in the mold as well as some being incised after removal. On top of the head, the hair has been gathered into a knot behind which rests the crown, and on the nape of the neck, the hair rolls upward to form a bun. Additional wavy strands, manufactured by hand, have been added on either side of the head and cascade down the neck and onto the shoulders. An elongated oval face is the setting for the delicate facial features that are softly modeled. Here, the lidded eyes, the sensitive nose, and the small, bow-shaped mouth that betrays the hint of a smile create the impression of a wistful and detached young woman. Most remarkable about the head is the amount of paint still visible. On the neck, upper torso, forehead, and temples are the remains of white slip that served as the ground for the pink paint still observed on the left cheek, the chin, and the right side of the face; the use of a white slip became a common practice in the fourth century when more delicate but fugitive colors were added after the object was fired. Red is visible in the hair, while the crown is darkened.

Blue pigment, probably Egyptian blue derived from calcium copper silicate, is seen in the groove between the hair and the crown at the top of the head. Sporadic traces of soft pink on the face are red ocher mixed with chalk or rose madder. The black discoloration on the left side of the head and neck is from burning and indicates that the head was subject to the conflagration in the sanctuary when it was destroyed. The particular style of this figurine originated in Athens shortly before 330 B.C.E., spread to central Greece where the type was produced at Thebes and Tanagra, the site that gives this figurine type its name, and thereafter was exported and copied widely throughout the Aegean and the eastern Mediterranean. That this figurine was purchased as a votive and placed in the Marion sanctuary speaks to how artisans and residents in the ancient town were receptive to current popular styles.

PUBLICATIONS
Unpublished

NOTES
Burn and Higgins 2001, nos. 2312, 2318, 2319 (Smyrna). General discussion: Jeammet 2010; Burn and Higgins 2001; Higgins 1967; Higgins 1970; Hatton, Shortland, and Tite 2008.

—NS

77
Statuette of a Draped Woman

Cypriot, 4th century B.C.E.
Found by Princeton at Polis-Maratheri, trench A.H9:u16, in 1995
Limestone with red paint; h. 23.5 cm., w. 18 cm., th. 8.65 cm.
Polis Chrysochous, Local Museum of Marion and Arsinoe (MMA 179; Princeton Cyprus Expedition R17239/SC121)

Condition: Though missing the head and parts of both arms and having been broken in several pieces, the statuette is in quite excellent condition with traces of red paint on the garments.

Found in scattered fragments in the fabric of the city wall next to the Classical sanctuary in Area A.H9, the figure stands frontally with her weight on her right leg; the left leg is set to the side. She wears a belted chiton and himation once painted red. The belt is just visible at the center of the belly. The himation is draped over her left arm and brought around the back to the right side. The missing right arm was held away from the body since there is no sign of attachment for it along the side. Given the type, the right arm was either held out to the front or, more likely, held up high, possibly holding a staff. In this regard, the unusual pattern of the drapery between the legs is noteworthy: the pattern reflects, if distantly, a common feature of Greek sculptures of the goddess Hekate. Also suggestive of the divine nature of the woman depicted are the traces of two curling locks, one over each shoulder, since long hair in the later Classical period is often a sign of divinity. There is also possibly a trace of long hair at the top of the back. Just below this, at the upper edge of the himation, is a curious element that looks like a part of a diagonal strap running from lower left to upper right, but neither "hair" nor strap is clear. The carving of the front is careful and neat; at the back, the himation is just roughed out and the chiton patterns are much simplified, though there is more detail above than below. The bottom of the base is roughly smoothed with parallel flat chisel runs.

PUBLICATIONS
Childs 1999, 228, 231, fig. 5.1; Childs 2008, 68.

NOTES
Statues of Hekate: Harrison (E. B.) 1965, pls. 32–37.

—WAPC

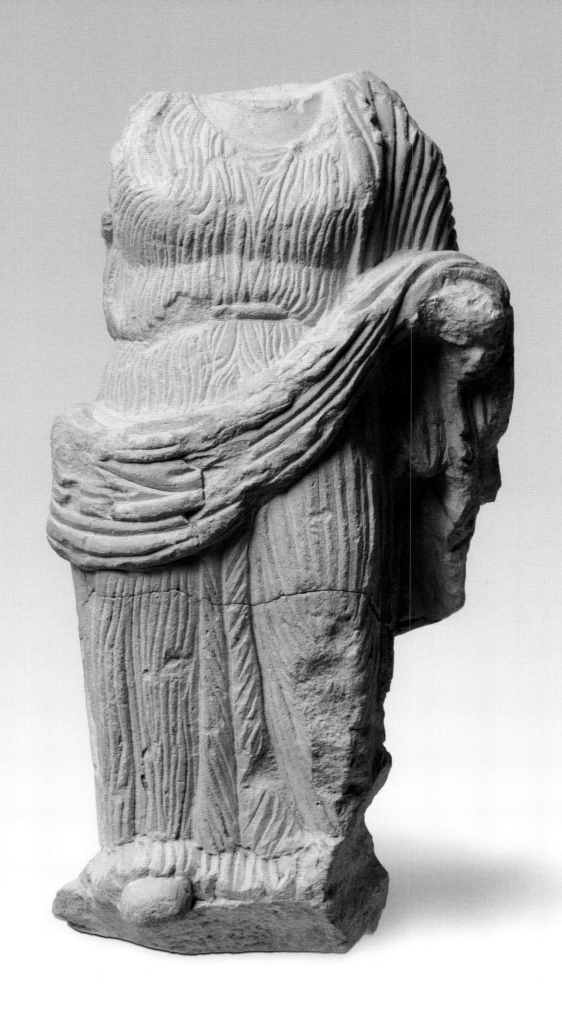

Sow and Piglets

Cypriot, 5th or 4th century B.C.E.
Found by Princeton at Polis-Petrerades in Area E.G0, test trench 23, in 1990
Terracotta; h. 6.52 cm., l. 17.1 cm., w. 13.34 cm.
Polis Chrysochous, Local Museum of Marion and Arsinoe (Princeton Cyprus Expedition R7996/TC2922)

Condition: Sow's body was broken into numerous fragments and has been mended with some restoration. Slight damage to back ridge, hooves, rear left leg, right ear, and tail. Piglets originally found detached and now conserved on base; all suffered slight damage.

Votive sculpture most often takes the form of the human figure, but animal dedications are not uncommon. This composite figure of a sow suckling seven piglets is one of the more ambitious terracotta constructions found at ancient Marion. While reclining on her left side, the sow has raised her right front and rear legs to expose twelve engorged teats. She is positioned on a base representing the ground on which the nursing piglets mass. Of varying sizes and poses, the piglets clamor to reach the sow; their little legs dangle off the base in the mad dash for food. All the piglets have been produced by hand with care taken to capture characteristic features at such a small scale: each piglet is represented with a sharp back ridge, curling tail, blunt snout, triangular-shaped face, and short ears. The nursing sow is primarily made in a mold, while the area behind the back ridge and not visible to the viewer was made by hand, as was the left side of the sow's face. The body is hollow, whereas the head is solid. Remains of red pigment are faintly visible on some of the piglets' bodies. The sow and piglets were found in fill that contained numerous fragmentary pieces of sculpture, both in terracotta and stone. Certainly removed from its original primary context, which likely was another sanctuary that has yet to be discovered, it is difficult to posit the nature of the divinity

to whom such an object would have been dedicated. In antiquity, pigs were associated with fertility because of the abundant number of young in their litters, and it is especially Demeter, the Greek goddess of the fields, the earth, and the bounty of the harvest, whose cult involved the dedication of pigs in the Attic festival of the Thesmophoria. Nevertheless, in other sanctuaries dedicated to female divinities, such as Artemis at Corfu, Athena on Lindos, and Hera at Tiryns, terracotta figurines of women carrying piglets have been found. Pigs were commonly sacrificed in Greek religious cult, with piglets more often sacrificed than the adult animal. Thus, the Marion sculpture might represent an offering that was intended to serve as a continual sacrifice.

PUBLICATIONS
Unpublished

NOTES
Karageorghis (V.) 1996, 40–41, pls. XXIII–IV; see also Hermary 1989a; van Straten 1995; and Keesling 2003. In the same trench, the Princeton team found two limestone reliefs showing a suckling animal (R9175/SC37) and nursing piglets (R11825/SC94).

—NS

Notched Scapula with an Inscription

Cypriot, Cypro-Archaic I
Found by Princeton at Polis-Peristeries, trench B.D7:r14, in 1996
Bone; l. 25.4 cm. (preserved), th. 4.42 cm. (max.)
Polis Chrysochous, Local Museum of Marion and Arsinoe (Princeton Cyprus Expedition R20396/IN73)

Condition: Fragmentary; reconstructed from five surviving pieces.

A scapula is the large triangular bone more commonly known as a shoulder blade. Animal scapulae, usually bovine, from cows, bulls, or oxen, were sometimes marked with deeply cut, irregularly spaced notches that are rectangular in section. Most come from Late Bronze Age through Classical contexts on Cyprus, but notched scapulae have also been found at several Near Eastern sites, especially Cilicia in Turkey and south along the Levantine coast. One study claims that the marks were for accounting. Their careful cutting as well as some wear on their edges suggests to some scholars that they were for making music, as a rasp or as part of a lyre. Others see them as spacers that held fibers on a loom. Most notched scapulae come from sanctuaries. This example from Peristeries was discovered in one of the earliest Archaic period deposits in a votive pit, a bothros. Other notched scapulae were found in later deposits in that bothros and in the Maratheri sanctuary (Area A.H9). Votive contexts suggested to Jennifer Webb that notched scapulae might have been used in divination, communication with the divine, which used apyromatic scapulamancy. Signs would be read on a scapula baked as a joint of meat, but not exposed directly to burning. The inscription on this bovine scapula from Polis provides evidence that supports this interpretation. On the ventral aspect, just below the row of forty-three preserved notches along the posterior border, are six signs in the syllabic script of Cyprus. Written in the Old Paphian script typical of the Archaic period in western Cyprus, the inscription reads from right to left as: *e-ro-to-me-u e-[to(?)-*. The first word is based on the verb to ask, *erotao* (ἐρωτάω), preserving either a present participle, *erotome-* (ἐρωτωμέ-), perhaps with a genitive ending indicated by the *-u*, or possibly an otherwise unattested noun, *erotomeu[s]* (ἐρωτώμευ[ς]), asker or diviner. Asking the gods for or about something was the essence of divination. The second word is broken. A scapula from a Classical period context at Tel Dor, Israel, was carved with an elaborate maritime scene rather than notches. Its Cypriot syllabic inscription tells us it was dedicated. Taking into account that the irregular notches might have been added at different times, the association of these bones with maritime cities on the coast makes it possible that one purpose of the divination was to ascertain, over the long term, the safety of travel by sea.

PUBLICATIONS
Reese 2002, 184, 189; Smith (J. S.) 2009, 160.

NOTES
Use of a scapula in accounting: Seton-Williams 1957. Use as a rasp: Karageorghis (V.) 1990. Use as a lyre: Marom, Bar-Oz, and Münger 2006. Use as a loom: Zukerman et al. 2007. Scapulamancy: Webb 1985. Cypriot syllabary in Polis: Masson 1983, 150–88; Cypriot syllabary at Tel Dor: Stern 1994.

—JSS

Grotesque Mask

Cypriot, 6th century B.C.E.
Found by Princeton at Polis-Peristeries,
trench B.D7:r14, in 1994
Terracotta; h. 13.2 cm., w. 9.73 cm., th. 1.71–2.26 cm.
Polis Chrysochous, Local Museum of Marion
and Arsinoe (Princeton Cyprus Expedition
R15940/TC7467)

Condition: Irregularly broken, preserving two-thirds
of left side of face, including the forehead, eye, nose,
cheek, and ear; gray discoloration of front surface of
mask from exposure to fire.

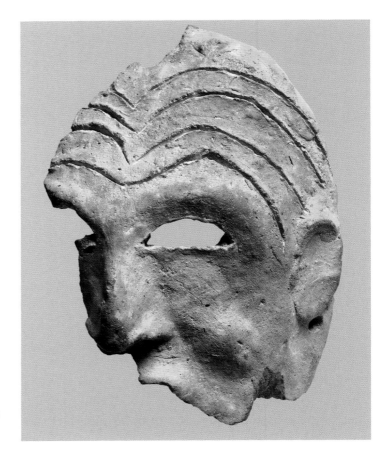

This slightly under-life-size grotesque mask has an elongated, cutout eye characteristic of Punic masks of the same period. The forehead is clumsily incised with two sets of four parabolic curves that rise above each other and extend laterally from above the nose, arching over each eye. The brow ridge thickens and meets above a narrow nose with a thin ridge and slightly flaring nostrils. In profile, the ridge has a decidedly arched curve, a nasal hump sometimes associated with representations of ancient Near Eastern ethnic types. The surface of the left side of the face is slightly modulated with the cheek pronounced and nearly bony. A schematic handmade ear is placed slightly high and forward on the side of the head with only the outer helix indicated. A small hole positioned directly below the ear could serve a dual purpose: it might function as a suspension hole to hang the mask on display or to permit the mask to be worn. The presentation of the face is attenuated, suggestive of masks known from Phoenician (Punic) colonies in the West, especially Carthage and Tharros (Sardinia). Such grooved masks reflect the monstrous giant Humbaba, whose hideous face resembled a coiled mass of intestines. Known from the Mesopotamian *Epic of Gilgamesh* as the guardian of the sacred Cedar Forest, this giant was decapitated by Gilgamesh.

Representations of Humbaba's head appear at Mesopotamian sites as cult paraphernalia, including divination tools (see cat. no. 79), because the reading of the entrails of sacrificial animals was believed to be one way to tell the future. In Cyprus, terracotta masks were known by the Late Bronze Age and early Iron Age. It is during the Cypro-Archaic period, however, that masks of the type displayed here became especially prevalent; these may be linked to the Phoenician cultural repertoire. Masks played a significant role in cult proceedings in ancient Marion; four other mask fragments were found in the Peristeries sanctuary, and the same number were recovered from that at Maratheri. Such masks, also frequently found in funerary contexts, are thought to have served to ward off evil.

PUBLICATIONS
Unpublished

NOTES
Additional mask fragments from the Peristeries sanctuary are R15256/TC7038, R28695/TC10361, R28726/TC10362, and R28741/TC10367. A similar mask is thought to be from Kourion: Karageorghis (V.) 1993, 115, mask no. 29, fig. 99, pl. LXVII.4; see also Moscati 1988, 356–57. On the role of masks in the Near East, especially Phoenicia, see Smith (S.) 1924; Culican 1975; Bertman 2003; Moscati 1988; Markoe 1990a; Roaf 1990; and Brown (S.) 1992. On masks in the Cypro-Archaic period: Karageorghis (V.) 1993, 107–22.

—NS

81

Snake

Cypriot, 5th century B.C.E.
Found by Princeton at Polis-Maratheri,
trench A.H9:r13, in 1986
Terracotta; h. 8.15 cm., w. 4.93 cm., th. 2.07–2.8 cm.
Polis Chrysochous, Local Museum of Marion
and Arsinoe (Princeton Cyprus Expedition
R14982/TC6395)

Condition: Broken irregularly through upper body,
and tip of protuberance under mouth is damaged.

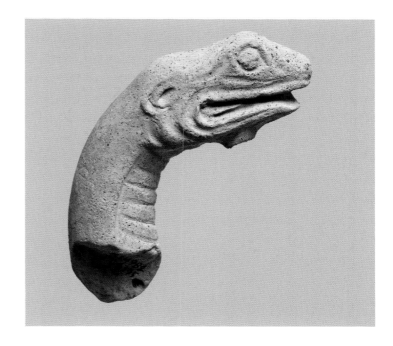

This graphic but fanciful representation of a snake has a handmade body formed from a simple clay roll that was then lightly incised horizontally below the mouth to represent folds of flesh. It was combined with a mold-made head, resulting in a menacing figure. The enlarged mouth with slightly parted jaws and prominent eyes projecting upward on top of the head reinforce the threat posed by the creature and capture the basic reptilian anatomy. The protrusions behind the eyes and the triangular configuration of the head might suggest that the intention was to represent the horned viper (*Cerastes cerastes*) or perhaps the blunt-nosed viper (*Macrovipera lebetina*) now prevalent in Cyprus and widely feared for its potent venom. It is unknown how the rest of the snake's body might have been depicted. Perhaps it was horizontally extended or curled on the ground; however, the treatment of the upper body and head suggests that the snake may have been represented in a rearing posture. The significance of the small, broken projection below the mouth is also unknown, but possibly the coroplast had in mind a bearded snake that was known in antiquity, especially in association with the horrific image of the Gorgon Medusa, whose decapitated head, at the hand of the hero Perseus, had writhing snakes for hair and served as a fearsome apotropaic device.

The figurine was recovered from the forecourt of the Classical sanctuary at Maratheri and would have been a gift dedicated to the divinity. Animal figurines were sometimes presented as offerings and, although a snake is a rather unusual votive object, in the course of excavation of the sanctuaries at Maratheri and Peristeries, the Princeton team has discovered seven different representations of snakes. Known as a powerful cult symbol that had wide circulation throughout the Aegean, the snake appeared on Cypriot pottery by the Early Bronze Age. It symbolized fertility, protection, and immortality. In the ancient world, snakes had powers of regeneration that connoted fertility because of their ability to shed their skin periodically and burrow into the earth, which was regarded as the land of the dead, and later emerge alive. The abundance of snakes on the island led the Greek grammarian and poet Parthenius of Nicaea (1st century B.C.E.) to associate snakes with the goddess Aphrodite, whose birthplace was Cyprus.

PUBLICATIONS
Unpublished

NOTES
Examples of votive snakes from Peristeries: R4624/TC1896, R11526/TC4656, and R50055/TC15357. Other votive snakes from Maratheri include R2093/TC303, R27383/TC10221, and R36588/TC10818. See also Karageorghis (V.) 1996, 47, pl. XXVIII.1–3. General discussions about snakes and cult symbols: Marinatos 2000; Papadopoulos and Kontorli-Papadopoulou 1992; and Frothingham 1911.

—NS

82
Sacred Tree

Cypriot, 6th century B.C.E.
Found by Princeton at Polis-Peristeries,
trench B.D7:p15, in 1989
Terracotta; h. 9.79 cm., w. 2.74–4.95 cm.,
th. 0.73–2.74 cm.
Polis Chrysochous, Local Museum of Marion and
Arsinoe (Princeton Cyprus Expedition R6051/TC2522)

Condition: Complete; slight surface abrasion in places;
top terminal of tree broken.

Small images of what have been termed "sacred trees" were common votive gifts in the Peristeries sanctuary. Their pedigree can be traced back in the Near East to as early as the fourth millennium B.C.E. The Assyrians in the first millennium appear to have adopted it as an imperial symbol that might have connoted divine world order maintained by the king. Earlier textual references associated specific trees with the goddess Ishtar, the Babylonian deity whose jurisdiction included the fruitfulness of nature and human fertility. Certainly the connection between trees and wooden poles with a fertility goddess continued under the Phoenicians through their devotion to Asherah, whose worship was forbidden to the Hebrews as noted in biblical accounts. Glyptic and sculptural depictions of sacred trees surely refer to a fertility goddess or her cult and may, in fact, represent her. The form of the tree can vary widely on cylinder seals and sculpted reliefs, although common representations include a net pattern or a series of loops or volutes over a central standing pole. The Marion votive provides a fine example of a self-standing tree whose trunk was formed by a partially hollow central cone over which handmade loops were attached in three vertical tiers. In the same sanctuary, over forty other examples of sacred trees were recovered with no two alike. All were appropriate gifts for the divinity that was worshiped for the sway she held over the bounty of the land and her command of human fecundity.

A composite terracotta figurine from Cyprus and now in the Louvre shows three figures holding hands and dancing around a tree. Biblical references to poles or trees known as "asherahs" are numerous for ancient Israel and Judah during the period of the Divided Monarchy and attest that they were set up near altars as part of worship of a female goddess also known as Asherah. Within the sanctuary of Apollo Hylates at Kourion, a circular area that has been dated to the fourth century B.C.E. may have served as a site where dances were held within a sacred grove. Although no such grove has been identified within or in the vicinity of the Peristeries sanctuary, the presence of so many sacred trees as votive objects confirms that the connection between deity and tree remained strong.

PUBLICATIONS
Unpublished

NOTES
Another sacred tree from Marion: Serwint 1991, pl. LVII.e. Louvre votive showing figures dancing around sacred tree: Caubet, Hermary, and Karageorghis (V.) 1992, 115, cat. no. 142. For interesting treatment of sacred trees: Albenda 1994; Parpola 1993; Porter 1993; and Giovino 2007. Issues relating to the "asherah" are addressed in Smith (M. S.) 2002, Hadley 2000, and Dever 2005.

—NS

83
Bichrome Bell

Cypriot, end of the 6th century B.C.E.
Found by Princeton at Polis-Petrerades,
trench E.G0:f06, in 1991
Terracotta with red and black paint; h. 11.1 cm.,
diam. 9.9 cm.
Polis Chrysochous, Local Museum of Marion and
Arsinoe (Princeton Cyprus Expedition R11836/
PO418)

Condition: The fabric is of a very light green color
with black inclusions; a small piece of the lower rim
is missing, and two fragments have been reattached.
There is a small hole for the attachment of a
clapper near the stem.

This bell was found together with another terracotta bell and a series of largely complete vases on an Archaic floor thought to have gone out of use about 500 B.C.E. (see fig. 2.9). The typical Cypriot terracotta bell is straight-sided, forming a dome; the flaring-out of the lower rim of this example is unusual. Its decoration is simple: eight alternating black and red vertical stripes about 1 centimeter wide taper near the top and end just below the upper stem, which is 3.1 centimeters high. An unusual vase in the group was a tripod kernos, a composite vessel that in this case is made up of three small, interconnected vases with three legs. Since a terracotta bell appears a bit nonsensical, the obvious suggestion is to consider whether the context was a sanctuary. There is some circumstantial evidence to suggest this was the case: fine painted vases and a few terracotta figurines were found just south of the deposit with the bell, and 20 meters to the north was a scatter of terracotta (cat. no. 78) and limestone sculptures (cat. no. 69), many of the latter representing *hydrophoroi* (women carrying water jars on their heads). The five other terracotta bells found on the excavation, all of the Archaic period, have been discovered in the sanctuary at Peristeries, which confirms the religious importance of the type. Terracotta bells do occur in tombs at both Palaipaphos and Amathous; Vassos Karageorghis suggested that they might be toys for deceased children, but this seems unlikely. Although a religious context is likely, the structure could have been a domestic shrine, since in the general area, several floors of the late Archaic period have been found that appear to be domestic in nature.

PUBLICATIONS
Unpublished

NOTES
Terracotta bells from Palaipaphos: Karageorghis (V.) 1983, 260, nos. 32–33, pl. CLXIII (Cypro-Archaic I); Karageorghis (V.) 1987, 12, nos. 134–35, 28, no. XIX, fig. 16, pl. XXVII. Terracotta bells from Amathous: Flourentzos 1977, 153, pl. XLIII.4 (Cypro-Archaic I). Terracotta bell in Amsterdam: Lunsingh Scheurleer 1991, 69 no. 1, pl. XIIIa (Cypro-Archaic II).

—WAPC

IV.

THE CITY OF ARSINOE IN THE
HELLENISTIC AND ROMAN PERIODS

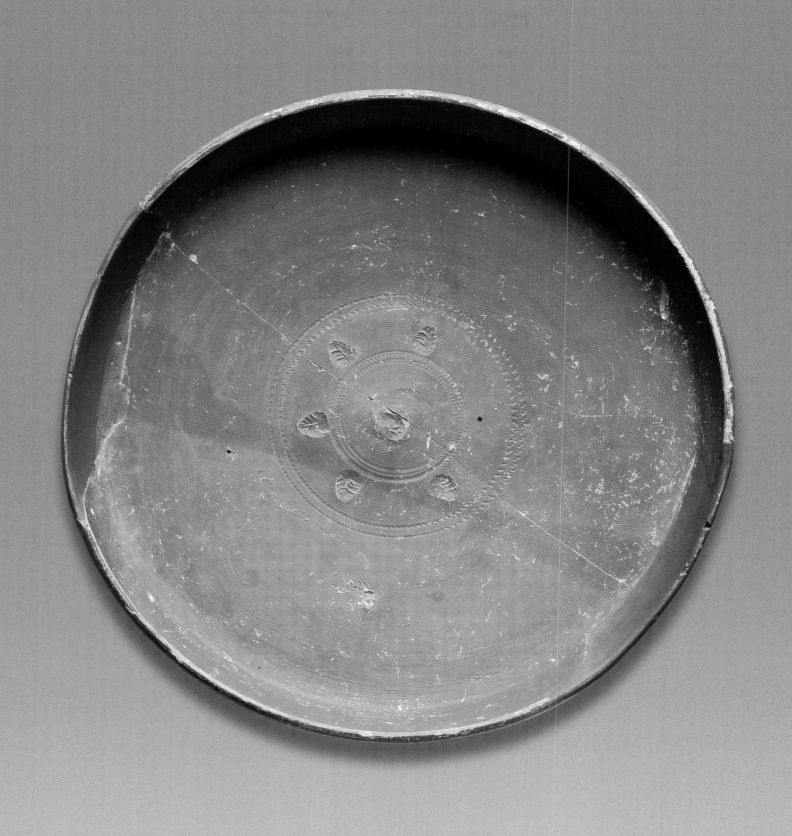

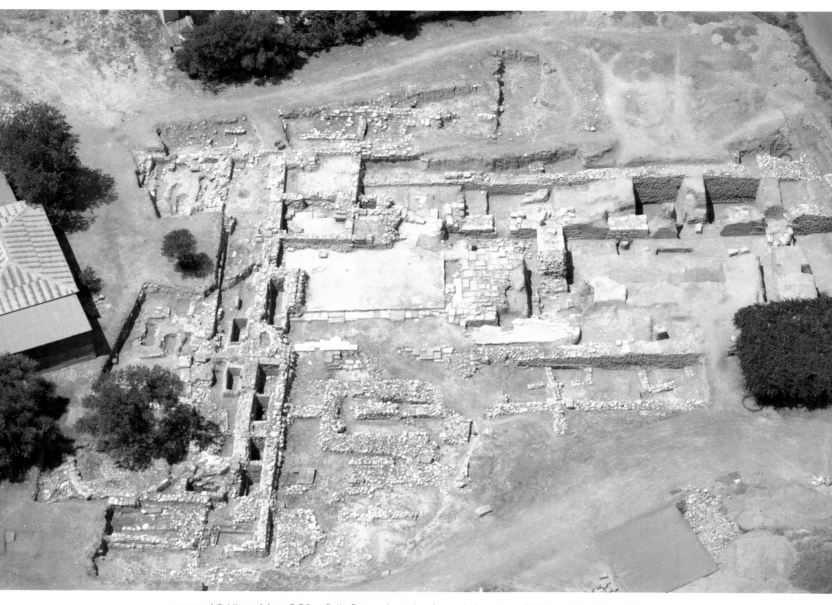

FIGURE 4.0. View of Area E.G0 at Polis-Petrerades, taken from a helicopter in 2006; north is at the right.

THE CITY OF ARSINOE IN THE HELLENISTIC AND ROMAN PERIODS

Tina Najbjerg

Cyprus in the Hellenistic Period

The Hellenistic period begins traditionally with the death of Alexander the Great in 323 B.C.E. and ends with the conquest of the eastern Mediterranean by Rome, consummated by Augustus's defeat of Cleopatra at the Battle of Actium in 31 B.C.E.[1] Alexander had brought an end to Persian rule of the eastern Mediterranean and the Near East; at the height of his power, the areas under his control reached from his kingdom of Macedon and Greece in the west, to Anatolia, Egypt, the Near East, and India in the east. For two decades after Alexander's untimely demise in Babylon, his generals and their sons struggled for power, and three of these families eventually carved out sections of the vast empire for themselves. Thus, by the end of the fourth century B.C.E., the Antigonids ruled Macedonia and Greece, the Seleucids had amassed a huge part of the Near East, and the Ptolemies had established their rule in Egypt. Like Alexander, the Hellenistic rulers adopted the institution of monarchy and wholeheartedly embraced the power that came with it, which included being worshiped by their subjects as divinities.

Cyprus was from the beginning caught in this swirling pool of political and cultural currents. Its nodal position along the sea routes that connected the western Mediterranean and Greece with the Levant and Egypt, coupled with its good harbors and a plentiful supply of copper, timber, grain, and wine, made the island a key player in the political events that helped shape the Hellenistic world. Along with the Ionian Greek cities, Cyprus belonged within the Persian sphere until Alexander liberated the island in 331 B.C.E. In the turbulent decades that followed his death, the island became embroiled in a tug-of-war between two of Alexander's former generals: Ptolemy I Soter, king of Egypt, and Antigonos Gonatas, king of Macedon, whose battles over Cyprus were fought by his son and future king of the Antigonid dynasty, Demetrios II. Ptolemy finally gained control of the island in 294 B.C.E., and Cyprus remained under the rule of the Ptolemaic kings in Egypt until it was annexed by Rome in 58 B.C.E.

The political situation in Cyprus in the third, second, and first centuries differed drastically from the preceding periods. The island had been divided into politically independent kingdoms, among them Marion. During the struggles between Antigonos and Ptolemy for control of the island, the Cypriot kings of Kition, Lapithos, Kyrenia, and Marion sided with Antigonos, while Salamis, Paphos, Soloi, and Amathous supported the Ptolemaic king (Diodorus Siculus 19.59.1) (Maps 1 and 2). Ptolemy took terrible revenge on the cities that had collaborated with his enemy, and in 312 B.C.E. he had Marion razed to the ground and its population moved to Nea Paphos (Diodorus Siculus 19.79.4). Later, he installed a governor on Cyprus, a *strategos*, who held military, political, and administrative power over the island at first, but who later was granted religious authority as chief priest, or *archireus*, and later still, was made admiral of the Ptolemaic fleet with Cyprus as naval center. In addition to functioning as a defensive buffer for the Ptolemaic kings in Alexandria, the island provided the new regime with good harbors for the Ptolemaic fleet to use

FIGURE 4.1. Hellenistic atrium surrounded by Doric columns in Tomb 3 of the "Tombs of the Kings" at Nea Paphos.

as its base; timber for the construction of the fleet; fertile land for the mercenaries to settle; copper for the production of a wide variety of copper alloy (bronze) objects, such as weapons, coins, furniture, and jewelry; and basic food supplies, including wine, oil, and grain.

Despite being controlled by the king in Alexandria and his governor, the Cypriot cities enjoyed a certain amount of self-administration and were allowed, for example, to form a union or confederation, the *koinon cyprion*, which seems to have been in charge of the pan-Cypriot festival in honor of Aphrodite at Palaipaphos. The importance and permanency of the koinon cyprion is demonstrated by the fact that it was later, under the Romans, allowed to issue its own coins, a right that Ptolemy had denied the independent kingdoms of Cyprus.

In addition to these political and administrative changes, Ptolemaic rule brought significant modifications to the urban landscapes of Cyprus. With the excellent harbor of Nea Paphos, easily reached from Alexandria, and its close proximity to timber-producing forests and to copper mines in the north, this new port city grew to become the most influential city on the island. This position was solidified when Ptolemy, snubbing Salamis, installed his governor in Nea Paphos and thus made it the seat of government on the island. The elite in the new capital became wealthy from their land holdings while transferring the pervasive Hellenic tastes of the period in art and architecture to the Paphian landscape, as illustrated by their tombs, which were carved out of the rock and shaped like Greek atria with open courtyards surrounded by Doric columns (fig. 4.1).[2]

Arsinoe in the Hellenistic Period

Ptolemy II Philadelphos founded and named three cities in honor of his sister/wife, Arsinoe (fig. 4.2).[3] Cartographic and archaeological evidence indicate that the Arsinoe that replaced the earlier city of Marion was located underneath and a little north of the modern town center of Polis

FIGURE 4.2. Ptolemaic, from Soloi, 275–270 B.C.E.: portrait of Arsinoe II (as Aphrodite?). Marble, h. 22.7 cm. Found by the Swedish Cyprus Expedition, no. 438. Nicosia, Cyprus Museum.

Chrysochous.[4] Although the name Arsinoe does not appear on the Tabula Peutingeriana, a thirteenth-century copy of a fourth-century map that delineated the entire network of Roman roads on the island (see fig. 4.15), the position of the settlement is indicated on the map by the kink in the road that led from Nea Paphos to Soloi, in the approximate area of Polis.[5] The location of Roman milestones south and east of the modern town supports the thesis that the Roman road connecting Nea Paphos and Soloi went through Arsinoe.[6] Moreover, Hellenistic tombs discovered around Polis contained grave goods whose craftsmanship and costliness pointed to the nearby presence of a prosperous citizenry and thus of a major urban settlement.[7]

Although early explorers suspected that Ptolemy II's city was located underneath Polis, archaeological evidence did not materialize until the 1980s, when excavations by Princeton University revealed the archaeological remains of a prosperous, sizable, urban development dating to the Hellenistic, Roman, and Byzantine periods, that cannot but be Arsinoe, a conclusion confirmed by a long-forgotten inscription from Polis and now in the Louvre. Princeton's excavations in Areas E.F2 and E.G0, both within the northern boundaries of Polis, have revealed Hellenistic and/or Roman walls set directly on Archaic and Classical structures, suggesting that Arsinoe, partially at least, overlay the earlier city of Marion (Map 3). Efforts to map the physical extent of Ptolemy's settlement were aided greatly when the Cypriot Department of Antiquities recently undertook a rescue excavation in the center of Polis, just a few hundred meters southeast of Area E.F2, and brought forth a series of workshops dating from the Hellenistic period (fig. 4.3).[8]

Ptolemy II's reasons for rebuilding the city that had been destroyed by his father involve the topography of Arsinoe and the Chrysochou Bay and must, to a large extent, have been based on military and economic considerations. Ptolemy I's initial occupation of Cyprus seems to have been fueled partially by the desire to create and maintain a buffer zone that would help protect the capital

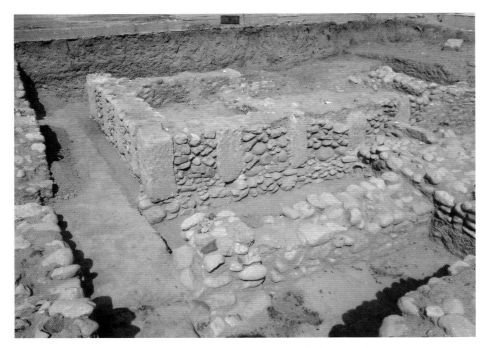

FIGURE 4.3. View of Hellenistic building foundations, including workshops excavated by Eustathios Raptou for the Department of Antiquities of Cyprus.

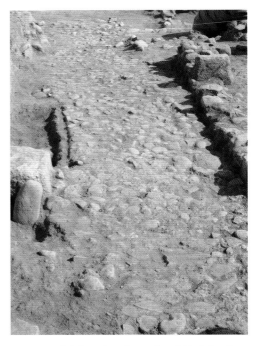

FIGURE 4.4. Paved north–south cobbled street, possibly dating to the Hellenistic period, in Princeton Area E.F2, at Polis-Petrerades, 2005.

of Alexandria in Egypt. Located on the northern coast of the island and situated on a plateau that provided a clear view of the entire Chrysochou Bay, Arsinoe not only would have served as a valuable lookout for a Ptolemaic garrison charged with patrolling the strait between Cyprus and the south coast of Anatolia, but its non-treacherous coastline coupled with the quiet waters of the bay also would have provided a natural and safe harbor for the Ptolemaic fleet. The economic advantages to establishing a new urban center in the area must have been considerable. The fertile agricultural fields of the Chrysochou Valley would have helped to feed the Ptolemaic garrisons stationed on Cyprus, and the copper mines at Limni, which already had been in use for centuries, would have quenched the royal family's increasing thirst for wealth.

Excavations underneath the modern town of Polis by Princeton and other teams paint an emerging picture of the appearance of Ptolemy II's new settlement of Arsinoe. As yet, no archaeological evidence indicates if it was ringed with a wall similar to the one that surrounded Nea Paphos or if it had a theater and/or a gymnasium, those key monuments of a truly Hellenized urban center. Enough architectural features remain, however, to point the way toward other important observations about the physical characteristics of the Hellenistic city. Walls and streets unearthed

by Princeton in Area E.F2 demonstrate that Ptolemy's architects arranged the new settlement on an orthogonal grid, thus following a trend in urban planning that had been set by Alexander. Although the dense jumble of foundations, walls, and paved surfaces in this area requires further detailed study, a few of its probable Hellenistic features, such as an ashlar-clad wall section south of the later basilica and, southwest of there, a cobbled street (fig. 4.4), which was intersected by another, more or less perpendicular alley, seem to have been laid out on a grid oriented north–south and east–west.[9] The ashlar wall was built directly on top of earlier, Classical foundations, but shifted a little from their orientation, suggesting that the third-century grid in Area E.F2 was part of an intentional, large-scale urban design to which the Hellenistic workshops and alleys excavated by the Cypriot Department of Antiquities a short distance from Area E.F2, the porticoed structure revealed by Princeton in Area E.G0 (see below), and possibly the still undated walls visible in a magnetometer survey just south of there, all seem to adhere. Roman and medieval construction in Area E.F2 continued to follow the orientation laid out in the Hellenistic period, with a few adjustments. The dense urban grid created by these later foundations and streets thus provides an excellent visual clue to this section of Ptolemy's settlement (Plan 7). If the use of the orthogonal

grid shows Greek influence, walls constructed of upright ashlars interspersed with rubble, as well illustrated by the Hellenistic walls excavated in the middle of Polis (fig. 4.3), are a distinct Punic tradition, hence the appellation *opus africanum* or *punicum*.[10]

Two distinct urban areas of the Hellenistic settlement may now be distinguished, thanks to the excavations by Princeton and by the Cypriot Department of Antiquities. The section defined by Princeton's Area E.F2 and the Hellenistic remains unearthed by the Cypriot team just to the southeast was devoted to workshops and small, modest dwellings. By contrast, architecture of a more monumental, and possibly public, nature was concentrated in the northernmost section of the ancient city, on a bluff that overlooked the Chrysochou Bay (Princeton's Area E.G0). In Area E.F2, the discovery of mold-made figurines dating to the Hellenistic period and evidence for their manufacture, such as a clay settling basin, two molds, and a rare clay patrix from which molds were created (fig. 4.5), in trenches south and southwest of the later Byzantine basilica, suggest the production of terracotta figurines.[11]

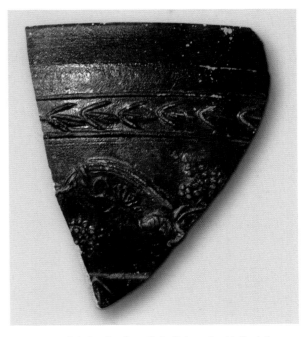

FIGURE 4.6. Cypriot, from Polis-Petrerades, Hellenistic: fragment of a molded bowl. Found in Princeton trench E.F2:h10, 1997. Ceramic; h. 6.19 cm. Princeton Cyprus Expedition R22465/PO586.

FIGURE 4.5. Cypriot, from Polis-Petrerades, Hellenistic: patrix. Found in Princeton trench E.F2: r09, 1986. Terracotta; h. 7.4 cm. Princeton Cyprus Expedition R1547/TC88.

Two large, clay-lined pits in the same area were filled with slag and waste products from metal smelting, and one had been exposed to great heat, possibly for the manufacture of glass.[12] Similar baked clay circles came to light a short distance away in the Hellenistic workshops excavated by the Department of Antiquities in 2008.[13] The nature of some of the pottery associated with the workshops, such as plain wares, lamps, and bowls—notably a fragment from a Hellenistic molded bowl (fig. 4.6)—might indicate mixed use of these workshops, common in antiquity, with families living in or above the same structure in which they worked.[14] The only feature in Area E.F2 to which a purely domestic use might be assigned is represented by two small, north–south-oriented walls and a hard-packed lime floor between them in the western section of the area, a few meters north of the cobbled street. On this floor were discovered a loom weight, two plates of the late second to first century B.C.E., including a red-slip, shallow bowl (cat. no. 85), and an oil lamp.[15]

The northern section of Arsinoe, as revealed by Princeton's excavations in Area E.G0 (Plan 5), presents a stark contrast to the dense, utilitarian nature of the urban spaces in Area E.F2. Here lies what must have been one of the key public monuments of Ptolemy II's settlement, a grand and impressively decorated building, situated on

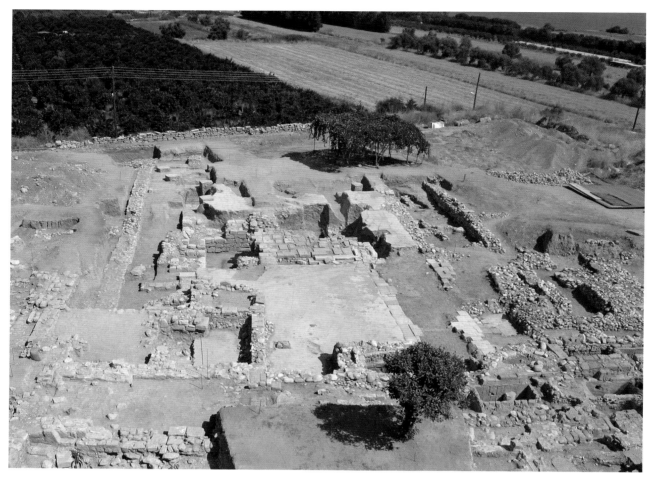

FIGURE 4.7. Porticoed structure in Princeton Area E.G0, at Polis-Petrerades. View from the south, 2003.

FIGURE 4.8. Painted wall plaster from the porticoed structure found in
Princeton trench E.G0:d09, at Polis-Petrerades, 1997.

the northernmost edge of town and perched on a bluff that overlooks, today as in antiquity, the entire Chrysochou Bay. The largest architectural construction to emerge from early Arsinoe, the structure encompasses three-fifths of the excavated space in Area E.G0 and stretches farther south underneath the Byzantine basilica that occupies the south end of the trench (fig. 4.7; Plan 6; Building Reconstruction 3).[16] Viewed from the south, the structure consisted of a large, open courtyard surrounded on all sides except the north by covered colonnades or porticos. A thick layer of concrete provided a sturdy floor for the central court, and finely cut and carefully laid limestone ashlars paved the surrounding porticos, whose sloping roofs were covered by heavy pan and cover tiles of baked clay, fragments of which lay directly on the courtyard floor.[17] The back, rising walls of the porticos would have been constructed of mud brick, then plastered and painted white, black, red, and yellow to resemble brightly colored marble slabs (fig. 4.8).[18] A plethora of fine limestone fragments from various trenches in this section of Area E.G0 belong to several columns of the Doric and Ionic architectural orders around this courtyard.[19] The three portico roofs on the east, south, and west most likely were supported by plain Doric columns, while two strikingly colorful and elaborately decorated columns of the Ionic order (cat. no. 84) probably stood at the north end, where they would have formed a monumental entrance to the rest of the building. Since not a single piece from an Ionic column shaft appeared among the hundreds of fragments, the two Ionic columns must be reconstructed as hybrid creations, whose Ionic capitals and bases were joined either by Doric shafts or by plain shafts made from plastered and painted limestone or wood, no longer preserved.[20] An equally impressive and fortunately better preserved architectural feature of the southern portico is a bottle-shaped cistern, five meters deep, hidden underneath the concrete floor in the southwest corner of the courtyard; only the stone slab that covered the narrow opening was visible at floor level.[21] The cistern was built with large stones, lined with waterproof cement (fig. 4.9), and filled with rainwater via a network of drains that guided the water from the surrounding roofs to a little opening in the neck of the cistern.[22]

To the east, the southern courtyard was flanked by a series of small rooms; to the north, it opened onto a wide hall or covered court whose floor as found was laid with uneven and very rough, reused ashlars interspersed with rubble (fig. 4.0).[23] This court or hall, in turn, gave way to another very large courtyard to the north. The

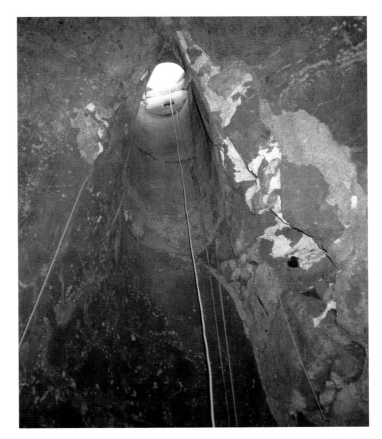

FIGURE 4.9. Interior of cistern and its entrance, view from within. Found in Princeton trench E.G0:d09, at Polis-Petrerades, 1997.

superstructure of this northern courtyard is less well understood and is harder to visualize, as it was extensively robbed of its ashlars in the medieval or Lusignan period, but the remaining extraordinarily massive foundations suggest that the rooms that flanked the courtyard on the east and the west had heavy, possibly arcaded, walls or perhaps stood two stories high.[24] Moreover, a small section of thick and very hard concrete discovered in situ in trench E.G0:d06 in 2003 on top of an extensive stretch of subfloor that spread westward into the neighboring trench E.G0:b07, demonstrates that this courtyard, too, was surfaced with a solid concrete floor (Plan 6). The north end of this court gave access to the northernmost feature of the large structure, a wide room or porch that abutted what may be the remnants of the earlier city wall.[25] The only distinguishing feature of this room was a deep, terracotta-lined well in its southeast corner.[26] The overall effect of this architectural layout was that of a long, axial building, where the main entrance, possibly at the south end, first brought visitors into the colorful southern courtyard; then they were guided by the two imposing Ionic columns into the covered hall; from there they would walk into the

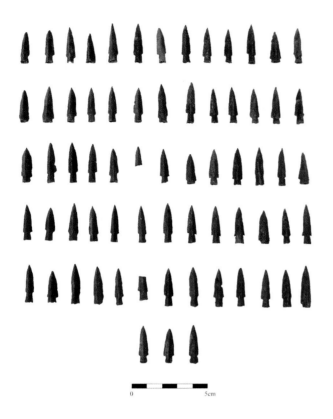

FIGURE 4.10. Scythian-type arrowheads of bronze discovered under a concrete floor in Princeton Area E.G0, at Polis-Petrerades.

trench dug centuries later through the concrete floors of the northern courtyard by people in search of building materials, in this case limestone ashlars, to be reused elsewhere (fig. 4.10).[28] Although the removal of the ashlars thoroughly upset the stratigraphy of that particular area, two arrowheads were discovered in situ in the sub-floor of the courtyard, and the rest were found close together in the jumble of broken concrete pieces from the floor.[29] The unused Scythian-type arrowheads seem to have been collected in the bowls and deliberately deposited, as part of a foundation ritual, under the concrete floor of the northern courtyard during its construction.[30] The evidence that places the construction and use of the building firmly in the Hellenistic period, however, is the cistern and its contents. Its bottle shape was characteristic of Hellenistic cisterns on Cyprus and elsewhere in the Mediterranean world;[31] the jugs and bowls found at the bottom of the cistern have dates ranging from the third to the first century B.C.E.[32]

There are frustratingly few clues as to the function of the porticoed structure and its role in the larger context of Hellenistic Arsinoe. The type of pottery found in the cistern and the additional discovery of a bone spoon on the floor above suggest that dining took place there, but these do not necessarily identify the building as a domestic space or a private abode since meals in the ancient world were taken on occasion outside the home in public spaces where groups could gather, such as in sanctuaries and clubhouses.[33] Although Arsinoe may have had a gymnasium for the physical education of its youth and the intellectual pursuits of its men, we cannot associate the Area E.G0 structure, with its relatively small courtyards and hard pavement, with a space dedicated to athletic activities. Moreover, the possibility that the porticoed structure lay on top of what might have been an Archaic and Classical sanctuary and that a Late Antique church later covered its south end, makes it tempting to assign religious activities to it as well, but no archaeological evidence, such as an altar, a cult statue, or votive figurines, has emerged to support this notion.[34] The final and best-fitting thesis to be entertained is to identify the large structure in Area E.G0 as a station for a local unit of the Ptolemaic garrison on Cyprus, a hypothesis supported by a second-century B.C.E. inscription from Polis (fig. 4.11).

The identification of the porticoed structure as a military establishment would clarify several of the building's enigmatic features. First, it might explain the dichotomy between its appearance as public architecture and the domestic nature of the pottery in the cistern and of the

open northern court with its arcaded or possibly rising lateral walls; and finally, they would pass through to the room or porch that represented the northernmost end of the entire structure.

The porticoed building, the largest Hellenistic structure uncovered by Princeton, is among the most imposing and important monuments of this period from western Cyprus. The material evidence collected in it points to a period of use between the third and first centuries B.C.E. Classical Greek walls and floors directly underneath its foundations and a tower-like structure, tentatively dated to the fourth century C.E., on top of its eastern walls provide the broadest range of dates. Within that period, a post-Classical but pre-Roman dating is suggested by the Masonry Style of the wall plaster, by the roof tiles, by the Ionic columns, by the mixed use of the Doric and Ionic orders—and the lack of the Corinthian order—and by the absence of Roman pottery in the sand that was used to fill the foundation frames.[27] A Hellenistic date is also indicated by the discovery of Hellenistic bowls in association with almost one hundred bronze arrowheads in a robbing

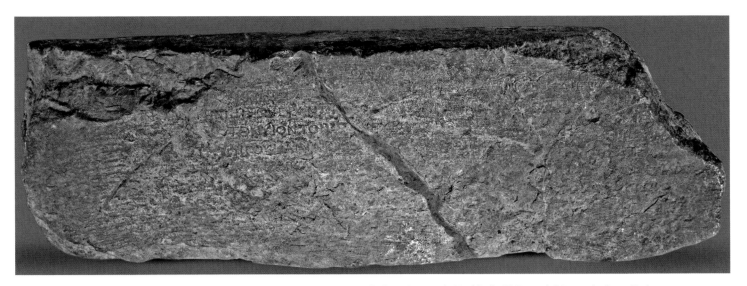

FIGURE 4.11. Inscription of Theodoros, later 2nd century B.C.E. (before 124 B.C.E.). Marble; h. 29.7 cm., l. 84 cm., th. 8 cm. Paris, Musée du Louvre, Département des Antiquités Grecques et Romaines (Ma 4240, inv. no. NIII 3454).

bone spoon. Representing the regime in Alexandria, the building needed to appear grand and imposing, but its basic function would, at the same time, have been utilitarian if soldiers slept and ate their meals here and hoisted their drinking water from its cistern. The difference in the architecture and decoration of the two courtyards may be attributed to a difference in function; the sumptuously decorated southern portico and its side rooms may have housed the officers, while the soldiers would have slept in the rooms or dormitories, perhaps two-storied, that flanked the plainer northern court. Ideally situated on a tall bluff at the edge of town, the building would have provided scouts with a perfect perch from which to look for enemy ships traversing the waters north of Cyprus. The thickening of the rubble walls in the northwest corner could possibly be the foundations for a tall lookout tower (Plan 6). Centuries later, a square tower was built on top of the southeastern wall, perhaps indicating that this area continued to be devoted to defense in the fourth century C.E. If the porticoed building housed a garrison in the Hellenistic period, the two sources of water—a cistern in the south end and a well in the north—would not have been a luxury but a necessity in case of a siege. Burial of the arrowheads in its foundations most likely represented a specific ritual through which the Ptolemaic soldiers imbued the structure with military and defensive strength.

The inscription from Arsinoe (fig. 4.11), now in the Louvre, provides an extraordinary and rare glimpse of the relationship between the Arsinoeans and their Ptolemaic rulers in the second century B.C.E. Acquired by Edmond Duthoit, a young architect attached to the French mission to the eastern Mediterranean in 1862, the find-spot is recorded as Chrysochou.[35]

> The city of Arsinoeans [honors] Theodoros, one of the Chief Friends and the head of the infantry and cavalry force both in Salamis and on the island; the son of Seleukos, Kinsman of the King, general and admiral and archpriest of the island. [He is honored] because of his virtue and the loyalty he bears to King Ptolemy and Queen Cleopatra, his sister, and Queen Cleopatra, his wife, both Benefactor Gods, and their children. [He is also honored] because of his benefaction to our own city.

The text was inscribed on the base of a statue with which the people of Arsinoe honored Theodoros, son of Seleukos, who was governor on Cyprus (144–130 B.C.E.) during the rule of King Ptolemy VIII Euergetes (146–116 B.C.E.), and the nomenclature indicates that the inscription predates Theodoros's own governorship on the island (124–ca. 118 B.C.E.) because it refers to him not as governor (στρατηγός) but as commandant of Salamis and in charge (γραμματεύς) of the island's Ptolemaic garrisons.[36] The text not only bears witness to the collective sense of pride with which the Arsinoeans viewed themselves, their city, and their good relations with one of the highest-ranking officials in the Ptolemaic regime,[37] but it also illustrates that the Hellenistic settlement, referred to as a "polis," would have been a good-sized city with its

own administration and with enough political, military, and/or economic importance for Theodoros to speak its case in his administration and for him to bestow the city with (unspecified) benefactions. That the Arsinoeans chose to show this extraordinary honor to the head of the Ptolemaic infantry and cavalry on Cyprus strongly suggests that the city hosted a local unit of this garrison, and that Arsinoe's importance to a great extent was based on its service as a military outpost for the regime in Alexandria.[38] The Arsinoeans would have erected the statue of Theodoros, and thus broadcast their allegiance to the Ptolemaic regime, in the most conspicuous and public place in their city, where it would have had the greatest audience. Although the nature of Theodoros's patronage is not known, it is likely that the commander endowed Arsinoe with a public structure that was related to his own specific role on the island as head of its military forces and one that would stand as a monumental, permanent symbol of his administration. Associating the porticoed structure in Area E.G0 with Theodoros's gift to Arsinoe—a thesis that must remain tentative for now—would place its construction or, perhaps more likely, its repair, in the late second century B.C.E., a date that fits perfectly within the range provided by the archaeological record, as discussed above.

With the new regime in Alexandria, change also came to the religious and spiritual life of Cyprus, most notably with the introduction of the ruler cult, as attested in Salamis, Kourion, Soloi, and Nea Paphos, and of the worship of traditional Egyptian deities like Isis and Serapis. Although very little is known about the religious life of Hellenistic Arsinoe, the city was characterized by the Greek geographer Strabo as containing "the" grove or precinct sacred to Zeus (τὸ τοῦ Διὸς ἄλσος). We may assume that the inhabitants of Ptolemy's new town would have identified closely with the deified queen Arsinoe as their patron goddess (see fig. 4.2), at least in the first centuries after her death.[39] An inscription from Polis that refers to a cult of Arsinoe demonstrates that the citizens there would have honored her with sacrifices,[40] and they would most likely have built a sanctuary for her, although no archaeological evidence proves this, as yet. Whether the worship of Arsinoe II replaced the earlier cult of the Goddess, whose sanctuaries formed such strong focal points of the city of Marion (see essay III), is uncertain. When comparing the remarkably high concentration of female figurines with uplifted arms from Archaic and Classical Marion to the few figurines of Aphrodite or Cybele that have emerged thus far from Hellenistic Arsinoe, it is tempting to argue

that the area's cult of the Goddess ended with the destruction of Marion in 312 B.C.E. and that the citizens of the new settlement did not revive it, at least not to the same extent as before.

Aspects of the social and economic situation in Arsinoe in the Hellenistic period may be deduced from the archaeological record. The contents of Hellenistic tombs excavated around Polis, including some from the final years of the city of Marion, attest to the presence of an exceedingly wealthy upper class that probably based its wealth on land holdings. One of the five Hellenistic tombs excavated by the Swedish Cyprus Expedition in 1929 produced, in addition to fine red- and black-slip pottery and bronze vessels, an array of luxury objects, such as glass bowls, glass beads, gold jewelry, and a plethora of gold leaves from two gold diadems.[41] One tomb revealed a coin of Alexander the Great and a golden garnet ring,[42] and another brought to light the calf-headed gold earrings (cat. no. 18) and a gold finger ring with double palmette (cat. no. 17).

The archaeological evidence from Area E.F2, however, indicates that the town also had a well-to-do middle class, some of whom probably made a living from the manufacture of terracotta objects, as discussed above, and, judging from the close proximity of the copper mines at Limni, also from the production of copper-alloy (bronze) items.[43] The tastes of these citizens may be gleaned from objects uncovered in the spaces where they lived and worked (i.e., Area E.F2), such as a red-slip plate with subtle designs stamped and rouletted onto its surface (cat. no. 85) and the fragment from a molded bowl (see fig. 4.6); both vessels were made in imitation of the more expensive metal and glass vessels used by royalty and the upper classes. The discovery of Hellenistic mold-made figurines in Area E.F2 also suggests that Arsinoe's middle classes were willing to accept less luxurious products—a trend seen throughout the Hellenistic world. Two such mold-made figurines representing comic actors (fig. 4.12) open a refreshing window into the lighter side of middle-class life in ancient Arsinoe.[44] Although today we have great difficulty identifying which of the many stock figures from ancient comedy are represented by the terracotta figurines from Area E.F2, ancient theatergoers, who would have been exposed to the plays of New Comedy in the permanent stone theaters of nearby Nea Paphos or Soloi, would have instantly recognized them.

Finally, Area E.F2 provides evidence for those at the bottom of Arsinoe's economic and social scale. In 2004, an inscription, dated by its style of lettering to the third century B.C.E., was discovered among other flat stones that

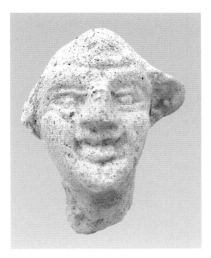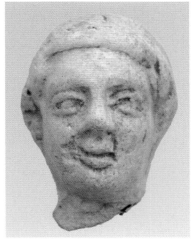

FIGURE. 4.12. Cypriot, from Polis-Petrerades, Hellenistic: figurines of comic actors. From Princeton trench E.F2:h10, 1997 (left) and 2000 (right). Terracotta; h. 3.19 cm. (left) and 3.42 cm. (right). Princeton Cyprus Expedition R22663/TC9019 (left) and R31425/TC10404 (right).

paved the north–south street east of the so-called fountain house.[45] The inscription was barely legible, the stone having been walked upon for centuries, but it seems to include the word for slavery, which not only suggests that slaves formed part of Arsinoe's lowest classes, as in all other Hellenistic societies, but also heightens the possibility that ancient Cypriot coastal societies like Arsinoe engaged in Mediterranean slave trading.

Cyprus in the Roman Period

In the first century B.C.E., the Hellenistic powers and their areas of influence, including Cyprus, gradually succumbed to Rome. Harboring a personal grudge against Ptolemy of Cyprus, who ruled the island from 80 B.C.E. on behalf of his older brother, the Egyptian king Ptolemy XII Auletes (80–58, 55–51 B.C.E.), the infamous tribune Publius Clodius Pulcher in 58 B.C.E. passed a bill, the *lex clodia de insula cypro*, that terminated Ptolemy's kingship, confiscated the royal treasury, and incorporated Cyprus into the Roman province of Cilicia. Thus, in the first years of Roman rule, the island was administered by the governors of Cilicia, among them Cicero (51–50 B.C.E.). After a brief restoration of Ptolemaic dominion under Cleopatra VII, who received the island as a gift from Julius Caesar in 47 B.C.E., Cyprus returned to its subordination to Rome after Cleopatra's defeat at the Battle of Actium in 31 B.C.E., first as an imperial province, then after 22 B.C.E. as a senatorial province, governed by a proconsul. After the reorganization of the Roman Empire in the fourth century by Constantine the

Great, Cyprus became part of the eastern Roman Empire with its capital in Constantinople/Byzantium.

Politically, economically, and in matters of religion, not much changed on the island after its annexation by Rome. Like the Ptolemaic strategos, the Roman proconsul resided in and governed from Nea Paphos, which remained the capital; the Ptolemaic garrisons on the island were replaced by Roman soldiers; the internal self-administration of the cities was allowed to continue; and the emperor Claudius (41–54 C.E.) permitted the *koinon cyprion* to mint its own coins. The Romans continued to exploit the island for its natural resources, particularly the copper mines, and to take advantage of its good harbors as bases for trade, especially that of slaves, for military excursions, and for patrolling the eastern Mediterranean basin. Like the Ptolemies, the Roman emperors encouraged the continuation of the indigenous religions, as is demonstrated by their renewal and enlargement of the sanctuaries of Aphrodite at Palaipaphos (commemorated on an Augustan provincial coin, cat. no. 88) and Amathous and that of Zeus Olympios at Salamis. Worship of the ruler also continued, with the cults of the emperors Titus and Domitian, Septimius Severus and Caracalla, and Trajan seemingly added to the existing cults at Palaipaphos, Nea Paphos, and Kourion, respectively.[46]

The greatest change to the island in the Roman period came to its urban centers. The cities of Nea Paphos, Salamis, Kourion, Amathous, and Soloi were refurbished with public structures, such as colonnaded squares, theaters, baths, aqueducts, nymphaea, amphitheaters, and even

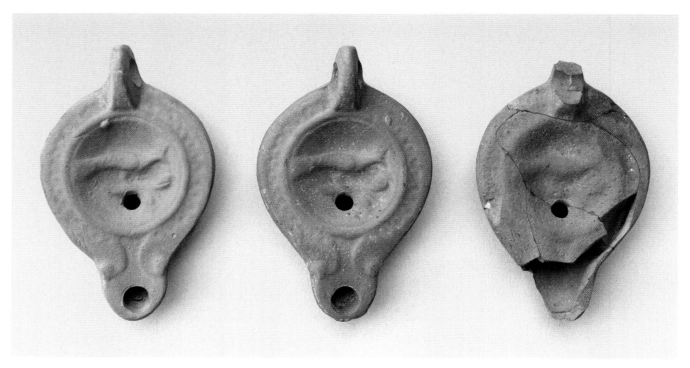

FIGURE 4.13. Cypriot, from Polis-Petrerades, Roman period: three lamps from the same mold. Found near the lamp kiln in Princeton trench E.F2:s06, 1991. Princeton Cyprus Expedition R10993/LA 211 (left), R10983/LA206 (center), R35615/LA629 (right). See fig. 4.14.

libraries.[47] In Nea Paphos, known formally in the Roman period as Augusta Claudia Flavia Paphos, splendidly decorated houses attest to the continued affluence of the Paphian elite, and excavations of an impressive and opulent structure near the civic and administrative center, containing more than one hundred rooms, the so-called Villa of Theseus, revealed the home of a high-ranking official, perhaps even the Roman governor himself.[48]

Arsinoe in the Roman Period

Only slowly are details emerging about Arsinoe in the Roman period and how the shift in power in Nea Paphos about 30 B.C.E. would have affected the daily lives of the town's inhabitants. The changes to the existing political system must have been minor; local taxes would have been paid to a Roman governor rather than to the Ptolemaic strategos in Nea Paphos, and most likely the town would have enjoyed the same amount of autonomy as earlier, with the federation of Cypriot cities, the koinon cyprion, now even being allowed to mint its own coinage. The local population may initially have been made aware of the change in regime only when portraits of the Roman emperors (cat. nos. 88–90) replaced the images of the Ptolemaic kings on the coins that circulated around town (cat. no. 87), and when soldiers loyal to the Roman emperors

and wearing different military gear replaced the Ptolemaic garrison stationed in the area.

Princeton's excavations have revealed surprisingly few physical changes to Arsinoe that can be securely attributed to the Roman period. The pottery from the cistern in Area E.G0 indicates that the receptacle itself went out of use at the end of the first century B.C.E., but whether the superstructure remained in use into the Roman period is still uncertain. Certain alterations to its architecture, such as the addition of an east–west wall and of a thin, poor-quality concrete floor to the eastern side rooms of the northern courtyard, await further study, but thus far, the area does not show obvious signs of having undergone substantial changes in this period. Excavations in Area E.F2, however, demonstrate that this section of Arsinoe continued and possibly expanded its focus on manufacturing and production. Substantial walls were built on top of the Hellenistic foundations just south of the later basilica, sometimes making use of the earlier features, as so often was done in antiquity. Just east of there, Princeton's excavations in trench E.F2:s06, 1991, uncovered a room that with a high degree of certainty can be identified as a lamp factory; a plethora of Roman lamps, some from the same mold (fig. 4.13), appeared in different strata within the room, as did two architectural features used for manufacture, one of them certainly a kiln (fig. 4.14). This important discovery

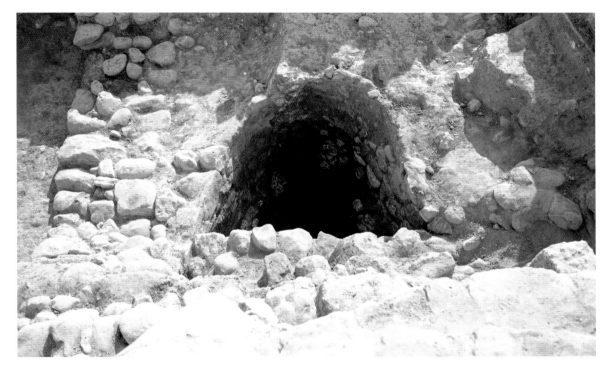

FIGURE 4.14. Roman lamp kiln, found in trench E.F2:s06, at Polis-Petrerades, 1991.

demonstrates that production of lamps took place here and that the workshop was rebuilt at some point, continuing in use for the production of lamps throughout the Roman period.

Social and economic changes in the Roman period were probably also minor: land holdings would have formed the basis of wealth for the local elite as before. The middle class would still have engaged in manufacture and trade; their activities would have been facilitated by the paving of the road that led through town from Nea Paphos to Soloi (fig. 4.15), and by the construction of a breakwater in the nearby harbor at Latchi. The copper mines at Limni would have provided the upper classes with luxury items, as they had for centuries; farmers were still cultivating the fertile valley and handing most of their agricultural produce over to the landowners and the Roman elite; and slaves, primarily from the eastern provinces, would have formed an even larger portion of the lowest ranks of society. Most slaves would have worked in the mines and the agricultural fields, but the better skilled among them would have been included in Roman households (*familiae*) as cooks, servants, and mentors. Moreover, an inscription from the reign of Tiberius (14–37 C.E.), erected by slaves who worked at a local temple to Zeus and Aphrodite, is a reminder that ancient sanctuaries required a sizable staff of slaves for their upkeep.[49]

Objects discovered by Princeton's team provide glimpses of the lives and tastes of those who lived in the town in the Roman period and help to illuminate some of the cultural changes that inevitably followed in the wake of the Roman takeover of the island. The exquisite glass beaker from a tomb (cat. no. 91) would have belonged to one of the wealthiest citizens in Roman Arsinoe; the red-slip jug (cat. no. 86), also from a tomb, represents the options of a middle-class citizen for fine tableware since the more expensive metal vessels were out of reach. The ever-increasing desire by the middle classes to acquire objects to display in their homes seems to have furthered an increase in production of domestic products in the Roman period as witnessed by the continued manufacture of mold-made lamps in Area E.F2 (see fig. 4.13). Where the figures of comic actors (see fig. 4.12) pointed to the popularity of theatrical comedies in the Hellenistic period, the discovery in Area E.F2 of a lamp decorated with gladiatorial objects (cat. no. 92) is a reminder of the Roman predilection for the bloodier gladiatorial games, which the owner of the lamp might have attended in the amphitheaters of Salamis or Nea Paphos. Another object that provides a small insight into the life of a middle-class citizen in the Roman period is the little terracotta incense burner in the shape of a tripartite temple with a moon (cat. no. 93); it must have been used in a domestic shrine to a lunar goddess who variously

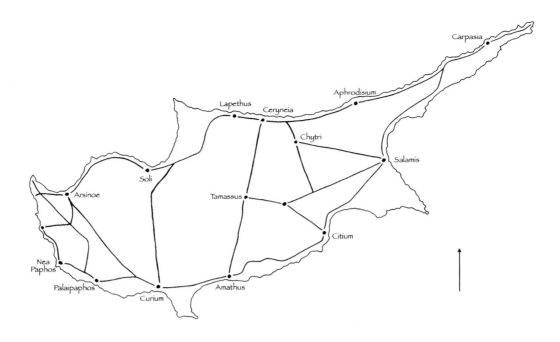

FIGURE 4.15. Map showing the network of Roman roads between the urban centers on Cyprus in the first century C.E.

can be associated with Selene, Aphrodite, Artemis, or Isis. Although very few votive figurines from Hellenistic and Roman Arsinoe have been found thus far, the incense burner and especially the inscription from the reign of Tiberius that mentions a temple to Zeus and Aphrodite tentatively suggest a renewed interest in the worship of female divinities in the Roman period, perhaps especially Aphrodite.[50] The proposed revival of the cult of Aphrodite in Arsinoe may have been prompted in part by Augustus's enlargement of Aphrodite's great tripartite sanctuary at Palaipaphos, an event commemorated on the bronze coin from Area E.F2 that once circulated among the citizens of Roman Arsinoe (cat. no. 88).

Conclusions

Princeton's excavations of Hellenistic and Roman Arsinoe have demonstrated that these periods cannot be studied in isolation, but must be looked at as a continuum of cultural expression that grew out of Archaic and Classical Marion and which, in turn, greatly influenced the Late Antique

society that followed it. Evidence from the two major excavated areas of Graeco-Roman Arsinoe, E.F2 and E.G0, suggests that the town went through a period, perhaps centuries long, of reduced prosperity after the Roman period, but that the remains of its buildings at least were visible in the fifth and sixth centuries, when Late Antique structures began to cover the Hellenistic and Roman settlement. In Area E.G0, the great porticoed structure was stripped of usable building materials, and a confusing mixture of rubble foundations and dirt fill, on top of which the Byzantine church in this area was built, rested directly on the concrete floors of the Graeco-Roman building (fig. 4.0).[51] In Area E.F2, the Hellenistic and Roman workshops, which themselves rested directly on Archaic and Classical walls from Marion, were covered with thick layers of rubble that served as a firm foundation for the Byzantine structures there (fig. 5.0).[52] The straightening of a street in Area E.F2 indicates, however, that the Hellenistic and Roman street grid in this area was still visible and more or less preserved when the Byzantine town arose.

NOTES

1. The information in this and the section on Cyprus and the Roman period was culled from the following works: Connelly 2010, 173–205; Hadjidemetriou 2002; Hill 1940, 156, 158–59, 164, 184, 186; Karageorghis (V.) 1982; Karageorghis (V.) 1985; Mitford 1980, 1329–41; Pollitt 1986; Price (S.) 1986; Fox 1986; Ling 1986; Nicolaou (K.) 1976; Walbank 1981.

2. For further references and research on Nea Paphos and its remains, see Daszewski 1985, 277–91.

3. One, according to the Greek geographer Strabo (14.6.3), was a port city near Salamis; another was located between Nea Paphos and Palaipaphos.

4. For discussions of the literary and archaeological evidence for Marion, see essays II and III.

5. Mitford 1980, 1341.

6. For a detailed study of the roads from Nea Paphos to Marion/Arsinoe to Soloi, see Bekker-Nielsen 2004, 126–30, 142–45. For the Roman milestones discovered just south of Polis, in the village of Chrysochou, and west of Soloi, in Vouni, see Mitford 1939, 184–92, nos. 1–3, pls. 22–24.1 and Bekker-Nielsen 2004, appendix, nos. 5–7.

7. British excavations in 1889–90 revealed several fourth-century tombs that had been enlarged and elaborated in the Hellenistic period (Munro and Tubbs 1890, 59, 72 with map of area and tombs in pl. 3). In 1929, the Swedish excavations found five Hellenistic tombs in Polis (Gjerstad 1935b, 181–89, 206–9, 364–66, nos. 1–3, 9, and 61; Vessberg and Westholm 1956, 20–21, fig. 17). The Princeton University team excavated a Hellenistic tomb in 1986 in trench A.H9.q16 (Childs 1999, 229); and the Cypriot Department of Antiquities continues to find tombs dating to this period.

8. For the rescue excavation in the center of Polis, conducted by the Cypriot Department of Antiquities under the direction of Eustathios Raptou, which revealed houses and workshops of the Hellenistic period, see Flourentzos and Hadjicosti 2010, section C: "Principal Salvage Excavations and Surface Surveys: Manolis Andronikou Street (Polis Chrysochou)," 87–88, fig. 127 (E. Raptou).

9. Discussions and views of the north–south ashlar-clad wall in Area E.F2 and its relationship to earlier foundations have been published in Childs 1997, 43 and fig. 8, and Childs 1999, 234–36, fig. 10. On the section of the cobbled north–south street (excavated in trench E.F2:g13, 2005, with the diagnostic pottery appearing mainly in Level 48 pass 2, and the east–west street that intersected it, found in trench E.F2:e11, 2005), see Childs 2008, 69.

10. On the use of mixed stone masonry in Cyprus, with examples, see Wright 1992, 415–16.

11. Twenty-nine Hellenistic mold-made figurines were discovered in Area E.F2, ten of which came from trench E.F2:h10, 1997; the clay settling basin and one of the molds were found in trench E.F2:h11, 2003, west extension; and the other mold and the patrix came from trenches E.F2:h10, 1997, and E.F2:r09, 1986. I am grateful to Nancy Serwint for the references and for providing me with invaluable and detailed statistics about Hellenistic and Roman terracotta objects from the Princeton excavation.

12. One of the clay circles was discovered in trench E.F2:e11 in 2005, next to the paved street of Hellenistic date in trench E.F2:g13, 2005; two others appeared in 1991 in trenches E.F2:s06 and E.F2:r06. Another baked clay circle, filled with great quantities of slag, came from trench E.F2:h10, 1997; and two rings appeared in trench E.F2:s09, 1991, one containing slag, vitrified bricks, and tiles that had been exposed to great, continuous heat, thus almost certainly connected to bronze working (Childs 1999, 234).

13. See note 8 above.

14. The fragment of the Hellenistic molded bowl was found near one of the clay-lined pits in trench E.F2:h10 in 1997, together with two figurines and a lamp handle in Levels 1 pass 8 and 45 pass 1. I am grateful to Scott Moore and Brandon Olson for cheerfully and systematically applying their expertise to thirty years' worth of Hellenistic and Roman pottery from Princeton's excavations in Areas E.F2 and E.G0.

15. The loom weight, the two plates, and the lamp all appeared in Level 31, passes 1 and 2, in trench E.F2.g10 in 2003. See also Childs 2008, 69, who dates the lamp to the third or early second century B.C.E.

16. For preliminary reports on the gradual excavation of this building, see Childs 1988, 129–30, fig. 6 and pl. 38.1; Childs 1997, 43, fig. 7; Childs 1999, 230–33, figs. 5, 7–9, 11; Najbjerg, Nicklies, and Papalexandrou (A.) 2002, 139–46; and Childs 2008, 70–74.

17. Most of the roof tiles came to light in trench E.G0:d09, 1997.

18. Najbjerg, Nicklies, and Papalexandrou (A.) 2002, 142.

19. Childs 1999, 230, fig. 5; Najbjerg, Nicklies, and Papalexandrou (A.) 2002, 142–44, fig. 6.

20. An Ionic limestone capital from Nea Paphos (Wright 1992, no. 296.2), whose detailed decoration was executed in plaster, then painted, indicates that a similar procedure may have been used for the shafts of the Ionic columns in Princeton's Area E.G0, whether their core was limestone or wood.

21. The square cover slab was still complete and in situ when unearthed in 1997 in trench E.G0:d09. Having succumbed to modern vandalism, parts of the large stone are today found at the bottom of the cistern and scattered on the concrete floor.

22. No drain pipes were ever found in association with the cistern, but a long, narrow cut in the concrete floor, leading from the southwest corner to the mouth of the cistern, points to the location of a sub-surface drain pipe that was robbed out in later times.

23. For a discussion of the reused ashlars and a photograph of the ashlar floor upon discovery, see Childs 1997, 43 and fig. 7.

24. For photographs and a detailed description of the ashlar and mud-brick foundations, see Childs 2008, 72–74.

25. Still under consideration is whether the thinly scattered remnants of a wide east–west rubble wall, excavated at the extreme north of Area E.F2 in test trench 32A in 2008, represent the remains of the Classical city wall.

26. The danger of excavating a deep cavity surrounded by soft sand prevented us from reaching the bottom of this well, which was unearthed in trenches E.G0:b04, 2006, and E.G0:c03, 2009.

27. Walls plastered and painted in the Masonry Style are known throughout the Mediterranean world from the second century B.C.E. to the first century C.E., but in Nea Paphos, the style is associated with Hellenistic structures (Nicolaou [K.] 1966, 594–96). The roof tiles from Area E.G0 are of Corinthian type C2a, which were common in the eastern Mediterranean from the sixth century into Hellenistic times (Wikander 1986, 44–48). Few Ionic columns have been found in Cyprus, and those that are most similar to the ones from E.G0 date from the fifth to the first century B.C.E. (see Wright 1992, nos. 292A–96).

28. See Olson and Najbjerg 2012. For a photograph of the robbing trench with the pieces of concrete floor at the bottom, see Childs 2008, 73, top left.

29. The arrowheads and the Hellenistic bowls in the robbing trench were excavated in 2003 in trench E.G0:b07.

30. Olson and Najbjerg 2012.

31. A Hellenistic bottle-shaped intake cistern was discovered on the island of Geronisos just northwest of Nea Paphos (Connelly and Wilson 2002, 269–80, figs. 1–7). For references to bottle-shaped cisterns in Kourion, Pergamon, Morgantina, and Carthage, all dated between the third and the first century B.C.E., see Connelly and Wilson 2002, 280, n. 14. I thank Amy Papalexandrou for the reference.

32. I am very grateful to Scott Moore and Brandon Olson for their assessment and dating of the pottery from the large cistern in Princeton's Area E.G0. Moore and Olson characterize the cistern pottery as an overwhelmingly utilitarian assemblage with little variety in form, and suggest that the majority of the vessels are locally produced water jugs dating from the third to the first century B.C.E. None of the vessels indicates votive or ritual usage of the cistern.

33. Najbjerg, Nicklies, and Papalexandrou (A.) 2002, fig. 7. The bone spoon came from trench E.G0:d09 1997, the same trench that revealed the cistern.

34. On the Archaic and Classical remains from a possible sanctuary in Area E.G0, see Childs 1988, 123; Childs 1999, 232; and Childs 2008, 74. For a discussion of the Late Antique remains at the south end, see Najbjerg, Nicklies, and Papalexandrou (A.) 2002, 146–50.

35. Paris, Louvre, Département des Antiquités Grecques et Romaines, Ma 4240, inv. no. NIII 3454: Le Bas and Waddington 1870, no. 2781,

Explications 641–42; Oberhummer 1888, 327, 333; *OGIS* no. 155; *SEG* 13 (1956) no. 589; Roesch 1967, 229, no. 4; Bagnall 1976, 50; Mitford 1953, 138, no. 11 transcribes the text based on a squeeze as follows: [Ἀρ]σινοέων ἡ πόλις | [Θεόδωρ]ον τῶν πρώτων φίλων, καὶ ἐπὶ Σαλαμῖνος καὶ ἐπὶ τῆ[ς] | κατὰ τὴν νῆσον γραμματε[ί]ας τῶν πεζικῶν καὶ ἱππικῶν δυ[νάμεων], | τὸν υἱὸν τὸν Σελεύκου τοῦ συνγενοῦς το[ῦ β]ασιλέως, ‖ [τοῦ] στρατηγοῦ καὶ ναυάρχο[υ] καὶ ἀ[ρχι]ερέως τῶν κατὰ τὴν νῆσον, | [ἀρετῆς ἕνεκε]ν κα[ὶ] εὐ[ν]οίας ἧς ἔχ[ων δια] τελ[εῖ εἰ]ς [β]ασιλέα | Πτ]ολ[εμαῖον καὶ βασίλισσαν Κλεοπάτραν τὴν ἀδελφὴν κ]αὶ βασίλισσαν | Κλεοπάτ[ραν τὴν γυναίκα, θεοὺς Εὐεργέτας, καὶ τ]ὰ τέκνα αὐτῶν, | κ[αὶ τ]ῆς εἰς ἑαυτ[ὴν εὐ]εργεσίας.

I am deeply grateful to Amy Papalexandrou for making me aware of this inscription, to Nassos Papalexandrou for translating it, and to Willy Childs for locating and photographing the original statue base in France.

36. On Theodoros's illustrious career in the Ptolemaic court hierarchy, see Mitford 1953, 163–64, 169; Mitford 1959, 104.

37. The Arsinoeans' allegiance to the Ptolemaic rulers in Alexandria, in this case the jointly ruling Cleopatra III and Ptolemy Soter II Lathyros (116–107 B.C.E.), is also expressed in another honorary inscription found in Polis (Mitford 1959, 117–18, no. 10, fig. 3).

38. On the evidence for the various Ptolemaic garrisons stationed in Cyprus, see Mitford 1953, 148–53.

39. Dorothy Burr Thompson (Thompson 1955, 205) was the first to identify the head from Soloi as a portrait of Arsinoe II. I am grateful to Nancy Serwint for the reference.

40. An inscription from Polis recorded in the nineteenth century can be restored as referring to a cult of Arsinoe: Le Bas and Waddington 1870, no. 2782; Oberhummer 1888, 319–21, no. 9; Munro and Tubbs 1890, 74–75, no. 20; Nicolaou (I.) 1993, 228, E; Anastassiades 1998, 137, no. 2.

41. Gjerstad 1935b, 206–9, figs. 73.3, 74.1–5, pl. 38.2–6 (Tomb 9).

42. Munro and Tubbs 1890, 55, pl. 5 (Tomb K.30).

43. On the continued use of the Limni mines throughout antiquity, see Childs 1988, 130. For the epigraphical evidence indicating that professions in Archaic and Classical (including fourth-century) Marion included tanners, fullers, bronze smiths, workers of bronze, and the rare πορφυρεύς, a fisher of murex shells or worker in purple dyes, see Mitford 1961, 93–99.

44. I thank Nancy Serwint for providing me with information about the figures.

45. The inscribed block was discovered in trench E.F2:g10 in 2004.

46. On Roman cults in the various sites on Cyprus, see Mitford 1990, 2176–2211; also Tatton-Brown 1985, 71–72.

47. For further research on these and other Hellenistic and Roman sites on Cyprus, refer to the various essays in Karageorghis (V.) 1985, 198–269.

48. See note 2 above.

49. On the inscription, see Mitford 1990, 2193, with references.

50. See previous note.

51. For a preliminary discussion of the medieval remains in Area E.G0, see Najbjerg, Nicklies, and Papalexandrou (A.) 2002, 146–53.

52. Childs 2008, 69, with photograph of the area.

84
Ionic Column Capital

Cypriot, Hellenistic, 3rd–1st century B.C.E.
Found by Princeton at Polis-Petrerades, trench E.G0:d09 in 1997 and trench E.G0:d10 in 1996
Limestone; reconstructed h. 54 cm., reconstructed w. 98.5 cm.
Polis Chrysochous, Local Museum of Marion and Arsinoe (Princeton Cyprus Expedition R37/AS17 et al.)

Condition: Assembled from fourteen non-joining fragments, some consisting of smaller pieces that have
been glued together. Most surfaces are encrusted with lime, but some preserve red, blue, green, and
yellow pigment.

During Princeton University's excavation of a large, porticoed building in Area E.G0, several hundred pieces of fine limestone columns, capitals, and bases were uncovered. A preliminary sorting in 2003 suggests that the excavated pieces belong to two Ionic capitals, two or three Ionic bases, and at least two Doric column shafts. For this publication, fourteen fragments were selected that all belonged to the face of one, not necessarily the same, of the Ionic capitals. Although the pieces do not join, they help reconstruct the capital as consisting of, on top, an abacus decorated with a Lesbian cyma that was painted red, green, and yellow; a (sagging?) *pulvinus* (cushion), developing into two volutes, each scroll formed by a plain groove and a raised torus, painted blue, that was flanked on each side by a thin, red ledge; and, on the bottom, a red-painted echinus decorated with an egg-and-dart pattern. No fragments belonging to the side of the capital were included in this reconstruction, but enough remain to reconstruct the sides of the abacus as having been painted in a shark's-tooth pattern. The capital would have measured approximately fifty centimeters in depth, which was half its width, and which equaled the diameter of the bottom of the echinus.

In and of itself, the capital is not unusual; its preserved coloring is a refreshing reminder of the polychrome nature of most ancient monuments and statuary, and its shape, essentially a cushion with two volutes curling down and toward each other, follows the basic pattern of the Ionic order as it was established in the stone temples of the Ionian coast in the sixth and fifth centuries B.C.E. Curious, however, is the complete lack from Area E.G0 of any fragments belonging to an Ionic column shaft, generally a

monolith with fillets separating the twenty-four flutes. All the pieces of shafts discovered on the site have wide, sharp-edged flutes, and most belong to tapered drum sections, two characteristics of the Doric column. Since one fragment of an Ionic ring base preserves a section of unfluted shaft, we may envision the Ionic capital resting on a (monolithic?) shaft that was carved with twenty-four sharp-edged flutes, and whose bottom part was left unfluted. Leaving the lowest section of columns plain, where they were most likely to get damaged, was not uncommon in antiquity, nor was the conflation of the classical orders as in these two hybrid columns, which exemplified the experimental nature of the Hellenistic period.

The evidence from Area E.G0 suggests that the porticoed building's southern courtyard was flanked on the east, west, and south by traditional Doric columns, and that the two colorful and magnificent Ionic-Doric columns stood at its north end, at the entrance to the covered

hallway that gave way to the northern part of the building (see fig. 4.7). Only about eight Ionic columns have been found and documented thus far from the island of Cyprus, suggesting that the columns from the porticoed structure in Area E.G0 would have awed the ancient viewer not only with their size and appearance but also with their rarity.

PUBLICATIONS

Childs 1999, 230–33, fig. 5; Childs 2008, 70–74; Najbjerg, Nicklies, and Papalexandrou (A.) 2002, 139–46, fig. 6.

NOTES

Other examples of Ionic capitals in Cyprus: Wright 1992, nos. 291–96. Doric column shaft with the lower register left unfluted from Amathous: Wright 1992, no. 39.6. Detailed history of the development of the Ionic capital: Bingöl 1980. Hierarchical use of the Classical orders, with examples: Onians 1988, 23–26.

—TN

Red-Slip Plate

Northern Levant, middle of the 2nd–1st century B.C.E.
Found by Princeton at Polis-Petrerades, trench E.F2:g10, in 2003
Ceramic; h. 3 cm., diam. 16 cm. (exterior rim), 9 cm. (ring foot)
Polis Chrysochous, Local Museum of Marion and Arsinoe
(Princeton Cyprus Expedition R42155/PO1411)

Condition: Repaired with reconstructed rim fragments.

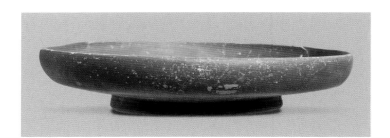

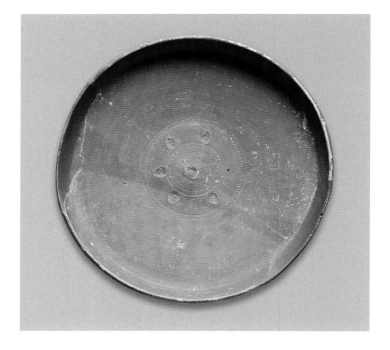

Eastern Terra Sigillata A (ESA) is characterized by a fine, hard fabric—*terra sigillata* literally means "sealed earth"—containing few visible inclusions and a series of standardized shapes, including plates and small bowls used for dining. The fabric typically varies in color from very pale brown to pink and is covered with a lustrous red to reddish orange slip. Though scholars have yet to definitively identify ESA production zones, it is most likely that the ware was produced in the northern Levantine littoral. The appearance of ESA in the middle of the Hellenistic period marks, for the first time since the Iron Age, the local production of a fine ware ceramic industry in the Levant on a grand scale. Prior to the development of ESA, Attic imports and locally produced black-slip wares dominated the area, but by the middle of the second century B.C.E., ESA supplanted a short-lived black-slip predecessor and became the standard fine ware in the Near East, dominating the eastern Mediterranean for more than two centuries. The ubiquity of ESA throughout the Near East at domestic, cultic, civic, and commercial spaces speaks to the cosmopolitan nature of the region in the Hellenistic and early Roman periods.

This plate consists of a low, flat ring foot and a slightly tapered incurved rim. The pink fabric is very fine and contains no visible inclusions, while the red slip is consistent and of high quality. The vessel floor is decorated with a central stamp surrounded by five single-ribbed irregularly spaced palmettes arranged in a circular pattern. The floral design is bounded by two pairs of double-banded rouletting. The plate is a common form, as comparable examples have been found throughout Anatolia, Cyprus, and the Levant.

PUBLICATIONS

Unpublished

NOTES

Contemporary forms with comparable decoration, vessel size, slip and fabric color, and vessel shape have been discovered at numerous Near Eastern sites including Tel Anafa: Slane 1997, pl. 7, nos. FW 69 and FW 75. In general, see Waagé 1948, 1–60; Kenyon 1957, 281–88; Papanicolaou Christensen and Friis Johansen (C.) 1971; Hayes 1986, 9–48; Slane 1997, 247–416; Kramer 2004.

—RSM and BRO

86

Red-Slip Jug (Lagynos)

Cypriot, late 1st century B.C.E.–early 1st century C.E.
Found by the Department of Antiquities of Cyprus at Polis-Ambeli tou Englezou, in a tomb, in 1997
Ceramic; h. 16.8 cm., w. 2.2 cm. (handle), diam. 4.2 cm. (rim), 7.1 cm. (ring base)
Polis Chrysochous, Local Museum of Marion and Arsinoe (MMA 237; formerly Paphos District
Museum MP 3339/458)

Condition: Complete.

Lagynoi, characterized by tall, slender necks and a single, vertical strap handle, were manufactured in a variety of fabrics. This juglet (lagynos), completely covered in red slip, belongs to a style of tableware that was produced and used throughout the Roman Empire. The style appears to have originated during the second century B.C.E. in the Levant, from where it spread to Cyprus and Asia Minor and on to Italy and the western Mediterranean. The vessels of some production centers are of very high quality, and such wares are generally known as sigillatas. The area of Paphos was host to a thriving industry of good-quality sigillata/red-slip wares that lasted possibly into the eighth century C.E. These vessels were exported all over the eastern Mediterranean. The red-slip wares of the major production centers were imitated at multiple localities, which may be the case for this vessel since its red slip is thick and unevenly applied.

The juglet has a squat biconical body and a ridged strap handle. The vessel is undecorated except for two narrow circular bands around the neck where it meets the body and four ridges on the handle. It is similar, but not identical, to a lagynos found in a different chamber in the same tomb, belonging to a different burial. The tomb included several more red-slip lagynoi as well as plain ones. This type of vessel is believed to have contained wine and would have been used primarily for dining and entertaining. During the Roman period, when fewer grave goods came to be offered in the tombs in Cyprus, vessels associated with the serving and drinking of wine continued to be popular and clearly played an important role in the funerary ritual. This lagynos, however, cannot be assigned to an individual burial or be related to other offerings on account of the extensive reuse of the tomb.

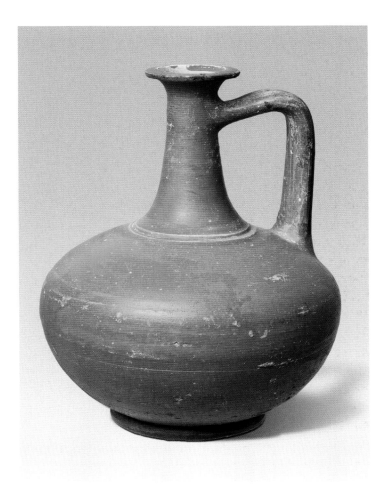

PUBLICATIONS

Jacobsen 2006; Zachariou-Kaila and Winther-Jacobsen, forthcoming.

NOTES

McFadden 1946, 473, nos. 21–22, pl. 37, 477, nos. 52–53, pl. 41; Hayes 1967, pl. 15 form 12; Hayes 1985, 89. For the tomb: Hadjisavvas 1998, 698–99.

—KWJ and EZK

Ptolemaic 24 Chilistion Piece

Mint of Alexandria, 285–246 B.C.E., reign of Ptolemy II Philadelphos
Found by Princeton at Polis-Maratheri, trench A.H9:r16, in 1996
Bronze; diam. 24.6 mm., weight 13.50 grams, die axis 5
Paphos District Museum (Princeton Cyprus Expedition R19696/NM1082)

Obverse: Head of Alexander the Great right, with horn of Zeus Ammon, wearing elephant headdress, and an aegis tied at the neck. Border of dots.
Reverse: ΒΑΣΙΛΕΩΣ ΠΤΟΛΕΜΑΙΟΥ (King Ptolemy). Eagle, wing raised, standing left on thunderbolt. There are no legible mint marks on the reverse.

With the conquest of Marion by Ptolemy in 312 B.C.E. and the change of its name to Arsinoe, the city became part of the large Ptolemaic Empire, and its local issues were replaced with coins minted in the capital city of Alexandria, Egypt. The succession of emperors named Ptolemy and the general conservatism of the coinage, as well as a dearth of modern numismatic studies, have left the dating and denomination of many Ptolemaic coins uncertain.

Most Ptolemaic coins bear a portrait of a member of the dynasty, but this type maintains the image of Alexander the Great from his widely minted issues. The latter, minted in the fourth century, depicted the hero Herakles wearing the head of a lion on the obverse and Zeus and his eagle on the reverse. On the Ptolemaic issues, Alexander himself is depicted in the guise of Zeus but also with the horn characteristic of the Egyptian god Ammon. The identification of Alexander with Zeus, king of the gods, was reinforced with the reverse type of the eagle, associated with Zeus, on top of the thunderbolt, another of the god's attributes.

This coin, like many Ptolemaic bronzes, bears a central round indentation, or dimple, on both sides, a phenomenon for which there is no generally accepted explanation. Careful observation shows that the mark was made after the blank was cast and struck with two dies, so the mark is probably connected with a trimming process after striking. The procedure, which occurs only on coins struck after the middle of the reign of Ptolemy II, helps date this specimen.

The image of Alexander was used intermittently for copper coins of this size throughout the early Ptolemaic period. Svoronos dates most issues of this type and weight to the period 267–251 B.C.E., but this precision and the identification of the weight standard as 24 chilistion must be taken as tentative. There is no evidence that this type was struck anywhere other than in Alexandria, the main Ptolemaic mint.

This specimen was found in a non-sealed context above the section of the city wall that is located right next to the sanctuary in Area A.H9.

PUBLICATIONS
Unpublished

NOTES
On the issue: Svoronos 1904–8, 69, no. 439; 70, no. 450; 72, no. 467; 73, no. 482; 75, no. 499; 76, no. 511; cf. also 149, no. 946, attributed to an Asia Minor mint under Ptolemy III. Examples of the issue were found at Kourion (Cox 1959, 50, 53–56) and Nea Paphos (Nicolaou [I.] 1990, 42, no. 3903).

—AMS

Roman Provincial Quadrans

Mint of Nea Paphos, 22 B.C.E.–14 C.E., reign of Emperor Augustus
Found by Princeton at Polis-Petrerades, trench E.F2:r06, in 1984
Bronze; diam. 15.8 mm., weight 2.92 grams, die axis 5
Paphos District Museum (Princeton Cyprus Expedition R418/NM285)

Obverse: IMP CAESAR DIVI F (Emperor [Augustus] Caesar, Son of the Divine [Julius]). Head of Augustus, bareheaded, right.
Reverse: A PLAVTIVS PROCOS (A. Plautius Proconsul). Temple of Aphrodite at Palaipaphos, with conical *xoanon* and paved semicircular court.

In addition to reforming the coinage for Italy and the Western Empire, Augustus initiated issues of provincial coinage at over 140 eastern mints. As part of his creation of a unified Roman Empire, Augustus imposed a standardized coinage on the western provinces and a universal gold coinage throughout. In certain parts of the East, however, he and his successors allowed the minting of bronze and silver provincial issues, often on a local weight and monetary standard. Two mints operated in Cyprus in the Roman period, Salamis in the east and Nea Paphos in the west, just south of Polis. The coins of each city usually bore the image characteristic of their local temples, that of Zeus Salaminios and of Aphrodite at Kouklia, Palaipaphos.

Nea Paphos is known to have been the principal mint of Cyprus in both the Ptolemaic and the Flavian periods, so it is almost certain that this coin was minted there. An earlier coin of the mint identifies Augustus alone. As this coin bears the name of the proconsul A. Plautius, it was minted after 22 B.C.E., when the province was transferred from the personal rule of the emperor to that of senatorial officials, and before the death of Augustus in 14 C.E. A tentative term of C.E. 1/2 has been adduced for the proconsulship of Plautius, which would give a more precise date for this coin issue. The issue was struck with eight obverse and thirteen reverse dies. Another issue in the name of Plautius depicts the cult statue of Zeus of Salamis, but it may also have been minted at Nea Paphos.

This coin was found in Area E.F2, which is the section of the Polis site with the most extensive evidence for the Roman period; it appears to have been devoted to workshops. Other examples of this issue have been found at excavations at Nea Paphos and Evrikou-Phoenikas.

PUBLICATIONS
Unpublished

NOTES
RPC 1, 578, no. 3906; Parks 2004, 171–75. On the series: Amandry 1987, 21–22. On the mint at Nea Paphos: Parks 2004, 39–43; Nicolaou (I.) 1990, 65–66, nos. 526–34. Evrikou-Phoenikas: Nicolaou (I.) 1984, 241, no. 31 and 245, no. 144.

—AMS

Roman Provincial Dupondius

Probably minted in Cyprus, 140 C.E., reign of Emperor Antoninus
Pius in honor of his son Marcus Aurelius
Found by Princeton at Polis-Petrerades, trench E.F2:r09, in 1986
Bronze; diam. 26.5 mm., weight 12 grams, die axis 6
Paphos District Museum (Princeton Cyprus Expedition R1143/NM519)

Obverse: AYT K AIΛ AΔP ANTΩNINOC (Emperor Aelius Hadrianus Antoninus). Bust of Antoninus Pius,
laureate-radiate right, wearing *paludamentum* (cloak).
Reverse: M AYPHΛIOC KAICAP YIOC CEBAC (Marcus Aurelius Son of the King). Bust of Marcus
Aurelius, bareheaded, right, wearing paludamentum.

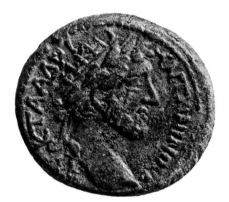

By the reign of Antoninus Pius (138–162 C.E.), there were
over 180 provincial mints active in the East, most produc-
ing coins with Greek legends. This issue does not bear the
name of Cyprus, but its minting can be placed there on the
basis of finds. Since it honors the emperor's adopted son
Marcus Aurelius, it was probably produced in the year of
their joint consulship, 140 C.E. A die study has identified
at least fourteen obverse and twenty-seven reverse dies,
indicating a large issue, probably struck at one time at a
single mint. Like the coin of Augustus (cat. no. 88), this
coin was found in Area E.F2 of the Princeton excavations.

PUBLICATIONS
Unpublished

NOTES
For examples of the issue found at Amathous: Nicolaou (I.) 1991, 177–86,
nos. 1–6, 9–12, 16, 25, 34–40, 54–55, 62; see p. 188 for a list of all coins of this
type found at Amathous. Kourion: Cox 1959, 140–41. Paphos: Nicolaou (I.)
1990, 70, no. 550 and 182–83, nos. 13–15. Salamis: Helly 1973, 209–10, nos.
19–23; Karageorghis (V.) 1978, 30, no. 2 and 40, no. 38; 44, no. 1; Callot 2004,
37 nos. 229–30. Location of the mint on Cyprus: Parks 2004, 106–10. On
the issue: Carradice 1989, 183; see also Parks 2004, 107–10, 224–29, no. 21.

—AMS

90

Roman Antoninianus

Mint of Cyzicus, 284–296 C.E., reign of Emperor Diocletian
Found by Princeton at Polis-Petrerades, trench E.F2:t08, in 1990
Silvered bronze; diam. 22.1 mm., weight 3.19 grams, die axis 2
Paphos District Museum (Princeton Cyprus Expedition R7239/NM711)

Obverse: IMP C C VAL DIOCLETIANVS P F AVG (Emperor Caesar Gaius Valens Diocletian, Pious, Happy, Augustus). Bust of Diocletian, radiate, right.
Reverse: CONCORDIA MILITVM (Concord of the Soldiers). Diocletian standing right in military dress, receiving Victory, who raises wreath toward Diocletian's head, on globe from nude Jupiter, who stands left holding staff; XXI and dot in exergue; Γ in field above.

The provincial coinage of Cyprus lasted until the middle of the second century, after which Roman coins from mainland mints circulated. The standards of the Roman silver coinage declined in the course of the second century to the point where the main denomination, the *denarius*, was replaced with a coin named an Antoninianus (after the emperor Antoninus Pius) valued at two *denarii*; the rays emanating from the emperor's head indicate the doubling of the denomination. By the end of the third century, the Antoninianus had been debased to the point that it was a copper coin with a thin silver wash.

As attested by this coin, which bears no indication of its mint, the neat marking of mint identification was also irregular. The type of the emperor receiving a figure of Victory from Jupiter with the legend proclaiming the agreement of the soldiers was used at several mints; the attribution of this specimen to Cyzicus in western Asia Minor is based on details of the obverse bust and reverse legend and is subject to revision. The XXI in the reverse exergue is probably a mark of denomination, but the monetary system before Diocletian's reform carried out between 293 and 296 C.E. is poorly understood.

PUBLICATIONS
Unpublished

NOTES
This coin was found in Area E.F2, like cat. nos. 88 and 89. Other examples of this issue were found at Kourion (Cox 1959, 40, no. 320) and at Salamis (Callot 2004, 26, no. 108); *RIC* 5.2, 253, no. 306, cf. pp. 210 and 216.

—AMS

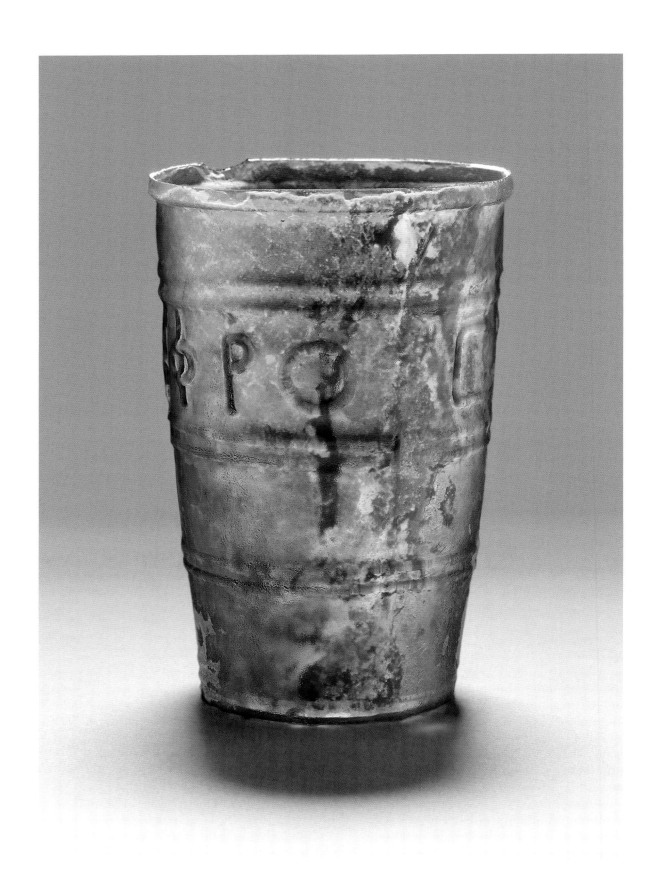

91

Inscribed Beaker

Roman, 1st century C.E.
Found by the Cyprus Exploration Fund at Polis-Site M, Tomb 12, in 1889
Glass; h. 10.38 cm., diam. 6.85 cm. (rim), 4.81 cm. (base)
London, British Museum (1890.8-8.1)

Condition: Intact; covered with light iridescent weathering and with a lime crust that has been stripped from much of the exterior.

The vessel is made of transparent greenish glass, free of sandy impurities. It was blown in a two-part mold that included its bottom. Vertical seams are visible from lip to bottom. It has an unworked lip, a vertical rim, a tall conical body bearing mold-blown decoration, and a flat base with two raised circles at its outer edge. The mold-blown decoration of the body consists of the following: three pairs of horizontal ribs and a group of three finer ones at the bottom, dividing the beaker into four equal friezes. In the upper frieze, the mold seams are flanked with two oblique lines. In the frieze below runs a Greek inscription written in angular capital letters that reads "ΕΥΦΡΟΣΥΝΗ" (Euphrosyne, good cheer). The third and fourth friezes are left blank.

According to Greek mythology, Euphrosyne was a daughter of Zeus and Eurynome, one of the Three Graces, goddesses of grace and beauty. She was also the goddess of joy, of good cheer, mirth, and merriment, as demonstrated by the meaning of her name. The invocation of her name on a beaker, a tableware vessel used in banquets for drinking wine, seems very appropriate, especially when compared to a kind of representation of the goddess known from a mosaic floor from Zeugma, Turkey. The mosaic presents a banquet scene where Euphrosyne reclines on a couch next to Akratos, the daemon of unmixed wine, who is pouring wine into her cup from a drinking horn.

PUBLICATIONS
Munro and Tubbs 1890, 57; Harden 1935, 176.

NOTES
The vessel appears to be unique. Technique: Price (J.) 1991, 56–75; Stern 1995, passim and esp. 45–48. Overview of newer mold-blown finds: Fontaine-Hodiamont, Bourguignon, and Laevers 2010, 19–313. Mold-blown glass vessels with inscriptions: Harden 1935, 163–86; Harden 1946, 81–95, 291–92; Whitehouse 2001, 13–97. Mosaic from Zeugma, now at the Gaziantep Museum, Turkey: Önal 2009, 94–95, 97.

—AA

Roman Gladiator Lamp

Cypriot, 1st century C.E.
Found by Princeton at Polis-Petrerades, trench E.F2:s06, in 1991
Ceramic; h. 2.41 cm., l. 9.1 cm. (including nozzle), diam. 6.4 cm. (discus)
Polis Chrysochous, Local Museum of Marion and Arsinoe (Princeton Cyprus Expedition R35607/LA621)

Condition: Repaired with reconstructed shoulder/neck fragment and partial base.

Constructed using a plaster mold, this lamp consists of a small filling hole situated in the center of a decorated discus, while the stylized nozzle bears a hole for a wick. The form does not have a handle and displays a rounded base set off from the body by a groove, which flares up to a slightly in-turned shoulder. Like most early Roman examples, the lamp consists of a buff clay with few visible inclusions. Three concentric grooves separate the discus from the shoulder. The discus includes a mold-made gladiatorial motif depicting a pair of greaves (armor designed to protect one's legs), two helmets, a *gladius* (short straight sword), a *sica* (curved sword), and two rectangular shields. Identical lamps have been discovered in Cyprus at Kourion and in a first-century C.E. tomb at Sphagion. Though the production area of such lamps has yet to be identified in Cyprus, the discovery of the gladiator lamp at Polis in close proximity to a lamp kiln with several other contemporary forms attests to local manufacture.

Ceramic lamps of the early Roman period typically bear a stylized discus depicting a vast array of scenes, offering a unique perspective into a fascinating social world. Popular motifs include deities, mythological creatures, wild animals, agricultural produce, imperial regalia, and images to ward off evil. The depiction of a gladiatorial scene demonstrates the popularity of the gladiatorial games and public spectacle in Roman society.

PUBLICATIONS
Unpublished

NOTES
Lamps of the same form with matching discus motifs are preserved in the Victoria and Albert Museum (Bailey 1965, pl. 5, nos. 58 and 59), while a partial discus was discovered at Tarsus in southern Turkey (Goldman and Jones 1950, pl. 107, no. 339). In general, see Bailey 1965, 1–83; Bailey 1972; Bailey 1975; Goldman and Jones 1950, 84–134.

—RSM and BRO

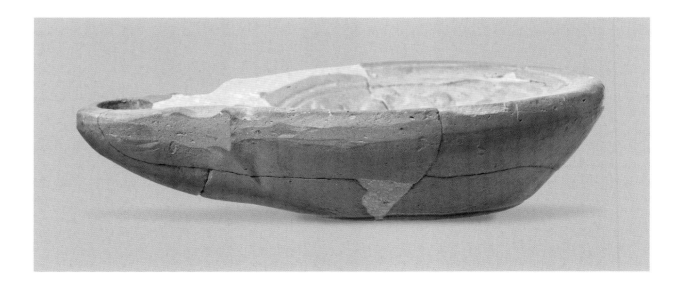

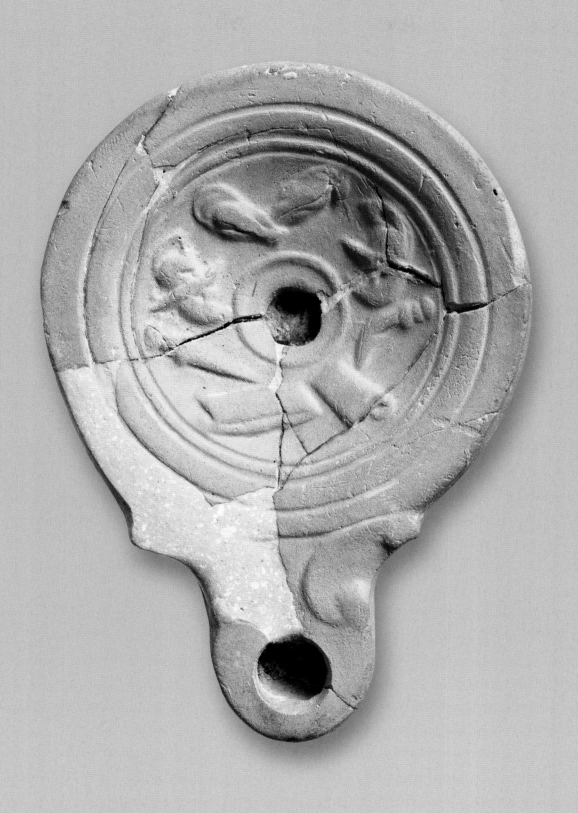

93
Incense Burner

Roman, 2nd century C.E.
Found by Princeton at Polis-Petrerades, trench E.F2:s06, in 1991
Terracotta; h. 7.94 cm., l. 12.02 cm., w. 5.98 cm.
Polis Chrysochous, Local Museum of Marion and Arsinoe (Princeton Cyprus Expedition R11765/MC195)

Condition: Restored from numerous joining fragments and now nearly complete.

Models of temples, buildings, or other architectural forms were sometimes crafted out of clay. This incense burner represents a miniature horned altar bounded by two columns. The front panel is decorated with a crescent moon and topped with a crown molding originally derived from Greek molding types. Decorative moldings such as these were regularly incorporated into temple design and certainly by the Roman period were part of a stock inventory of forms that were readily employed in various combinations on buildings throughout the empire. The nearly square altar is flanked on either side by a fluted column supported by a double torus base. In lieu of a decorative capital, each column bears a necking ring and a flat, horizontal slab with thickened corners, which carried additional elements, now missing. The receptacle for the offering of incense on the top surface bears traces of burning. Likely used in religious ritual, the incense burner bears decorative forms that reflect a pastiche of cultural influences: four-horned altars were typical of Israelite Iron Age domestic cult practice, and "horns of consecration" had an earlier pedigree in Aegean Bronze Age art; the lunar crescent commonly represented Tanit, the Phoenician lunar goddess worshiped at Carthage and other Punic sites; and the fluted columns and moldings are suggestive of Greek architectural forms that had been widely adopted by the Romans. Manufactured from a double mold, the incense burner is hollow with the front and back joined laterally with the mold seams visible on the sides of both columns.

The form that the object takes differs significantly from the other two incense burners featured here (cat. nos. 60, 62). The form of a four-horned altar adopted was thought to derive from the altar of Solomon's Temple in Jerusalem and was widely found inside and outside of Palestine. It also recalls the facade of the temple of Aphrodite at Palaipaphos (cat. no. 88). Discovered in a Roman lamp cache, the incense burner certainly could have been crafted in the workshop responsible for that stock of lamps. The distinct traces of burning on the top indicate that the incense burner had been used, and possibilities are numerous as to how it might have been employed. It may have been an object of private, domestic cult, or the little altar may have belonged to the artisan who was responsible for the lamp production; perhaps it was lit while he was busy at work crafting the many lamps that the Princeton team would later discover.

PUBLICATIONS
Unpublished

NOTES
The incense burner from Polis-Petrerades is unique, but an Israelite horned altar found at Beer-Sheba may have served as a prototype: Aharoni 1974. See, in general: Haran 1960; Moscati 1968; Groom 1981; Fowler 1984; Burkert 1985; Papadopoulos and Kontorli-Papadopoulou 1992; Karageorghis (V.) 1996; Markoe 2000; and Zevit 2003.

—NS

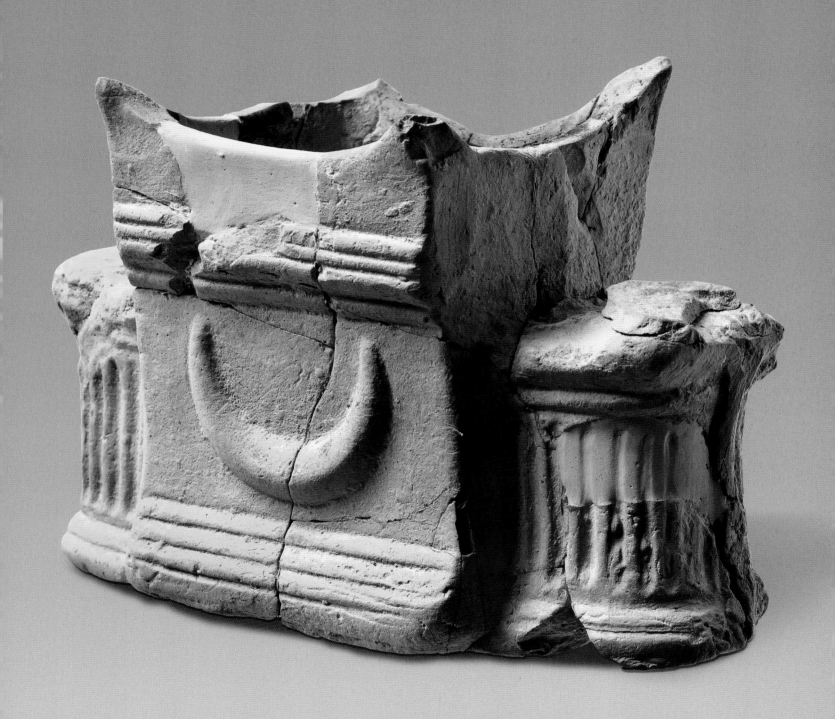

V.

ARSINOE IN LATE ANTIQUITY AND THE MIDDLE AGES

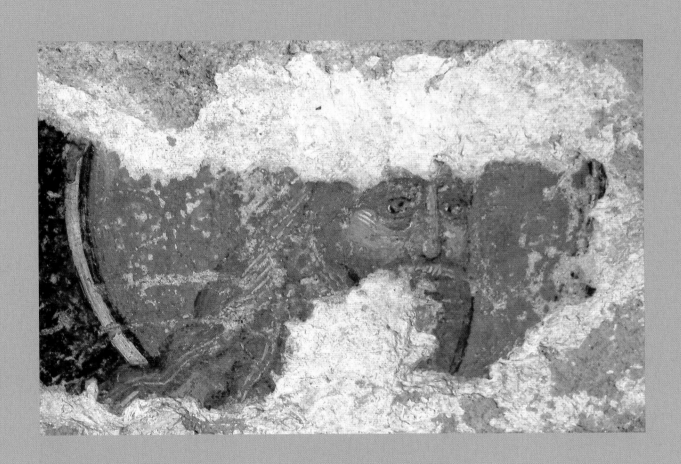

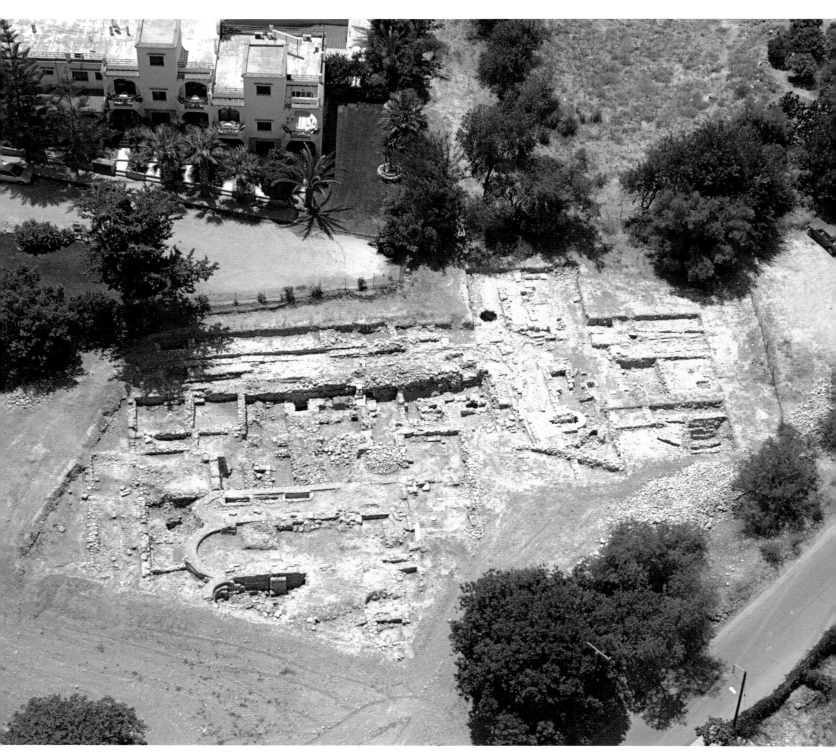

FIGURE 5.0. View of Area E.F2 in Polis-Petrerades, taken from a helicopter in 2006; north is at the bottom.

ARSINOE IN LATE ANTIQUITY AND THE MIDDLE AGES

Amy Papalexandrou and William Caraher

The post-Classical landscape of Arsinoe is best approached through its material remains.[1] These document a vibrant settlement, one significantly altered through time, political upheavals, and an infusion of Christianity, but one that retained its sense of organization, community, and civic identity well into the Middle Ages. The testimony of the archaeological record is augmented by a few surviving, if fragmentary, textual sources. Echoes of earlier commemorations, such as that to "the city of the Arsinoeans," on an inscribed statue base of the second century B.C.E.,[2] can still be detected in a very different inscription dated some seven centuries later. Found at Polis tis Khrysochou in 1960 and displayed today in the Cyprus Museum in Nicosia, this later text was inscribed on a modest limestone block and captures an important moment in the history of the Late Antique city (fig. 5.1).[3] Dated to the mid-fifth century C.E., it records the presence, whether real and literal or spiritual and implied (or both), of two high officials who cosponsored the construction of an important building at Arsinoe:

> Ἔν ἔτι (sic) Λς τῆς ἀρχιε
> ρωσύνης Σαβίνου
> ἐπὶ Φωτηνοῦ ἐπισκό[που]
> + διὰ τῶν +

In the 36th year when Sabinos was Archbishop, when Photinos was Bishop (this was erected) at their own expense.

Some nine centuries later still, another bishop in vastly different circumstances continued to represent the local community, this time in a legal document associated with the fourteenth-century ecclesiastical court at Arsinoe. It is the single surviving example of official records from any medieval Greek ecclesiastical court on the island.[4] In it, the prelate, formerly the Orthodox bishop of Paphos who had been displaced to Arsinoe by the Lusignan dynasty and its Western ecclesiastical officials, continued to represent communities in the western part of the island. The focus of this document is mundane—the tangle of complex laws designed to offer guidelines for an episcopal tribunal—but it points to the continued efforts to order and mediate affairs of the local people of Arsinoe with some measure of distinction, this despite the evisceration of his authority. Periodically throughout a simple formula recurs: "May it be known to everyone who was involved and heard the present and fullest discussion that we, by the blessing of God (as) Bishop of Arsinoe, President of the city and parish of Paphos..."[5]

These two modest texts resonate with the more impressive material remains of the city and the churches

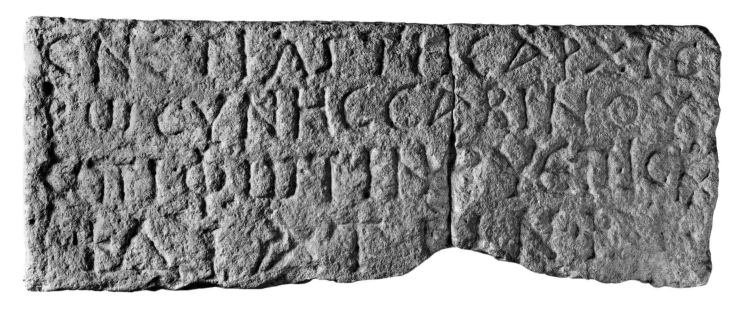

FIGURE 5.1. Inscription of Archbishop Sabinos and Bishop Photinos, 5th century C.E. Found at Polis tis Khrysochou in 1960. Limestone; h. 38 cm., l. 97 cm., th. 20 cm. Nicosia, Cyprus Museum 1960/XI-19/2 (Inscr. GR. 229).

that remained its focus for a full thousand years. They confirm the central place of the bishop among the leaders of the community, the survival of the name Arsinoe well into the later Middle Ages, the influence of the church in almost all aspects of daily life, and the close ties of the city to other regional centers. These are themes that frame the material remains of the Late Antique and medieval city of Arsinoe and underscore the continued importance of this dynamic Christian center in northwestern Cyprus.

In the fifth-century inscription found in 1960, the dedication of a Christian building may in fact refer to one of two substantial Late Antique basilicas recovered through excavations in the northern periphery of the modern town of Polis. It may also refer to an earlier predecessor of one of these churches, a different church, or another significant building in the community, since by Late Antiquity bishops played an important role in civic patronage of secular as well as sacred structures.[6] The religious landscape of Arsinoe certainly shows the wealth, or perhaps the diversity, of the Christian community, for several churches and chapels shared space within and around the city.[7] Although the inscription does not reveal the identity of a particular monument, it offers information specific to the time it was cut, including the names of two officials—the local, otherwise unattested, bishop Photinos, and his superior, the archbishop Sabinos—and the fact of their involvement on the ground and in the workings of Arsinoe.[8]

The inscription also reflects the Christianization of patronage and conceptions of time in the city. The prominent placement of the names of bishops elevated the local ecclesiastical hierarchy to the rank of eponymous leaders of the community. As a result, the passage of years and changing names of church officials presented time with a distinctly Christian cast. Meanwhile, the act of patronage and its inscription represented these bishops in the traditional role of the local elite and perhaps a general tendency at this time to overendow the island with bishoprics, so that even smaller towns joined in the new network of authority.[9] In any case, the inscriptions complement the archaeological record in showing that these oft-repaired and modified buildings stood as a testimony to the community's enduring commitment to its monuments as the center of social and religious life. The buildings, their patrons, and the dynamic relationship between the community and their built environment mark the gradual transformation from the ancient to the medieval and, indeed, to the modern town.

The Late Antique City

The post-Classical buildings recovered by the Princeton team define the actual urban space of the Late Antique city. Three excavated sites, all located within two hundred meters of one another along the village's main road north to the sea, provide evidence for a thriving population. The site nearest the center of the modern town, known as

Area E.F2 (Map 3), includes at its heart a modest three-aisled basilica (23 x 12.5 m.) embedded in a built-up and well-serviced neighborhood that saw continued investment and modification throughout the ancient and medieval periods (Plan 7). Excavations around the church have revealed workshops or domestic establishments, a Roman tetrapylon (a square gateway comprising four arches), a network of streets, and a series of interconnected water channels, drains, and wells.

The Monumental Christian Basilica and Its Environs (Area E.F2)

The seventh century is a useful focal point for the site and the building's long history. Not only did this century see the building in its most elaborate form, but it also marked a particularly turbulent era in the history of the island.[10] Nearby Paphos and Soloi (Map 2) experienced destructive raids perhaps best associated with the increased Arab presence in the eastern Mediterranean. These disruptions were the local manifestations of major political upheaval in the Levant, Egypt, Anatolia, and the Aegean, which upset centuries-old Roman patterns of exchange. While Arsinoe seems to have been spared the most destructive aspects of this period, the seventh century nevertheless marked a transitional period at the site and in the region. The architectural forms, settlement patterns, and administrative divisions associated with antiquity gave way to new forms of organization and monumentalization.

Envisioning the basilica in Area E.F2 at this juncture allows us to capture the building immediately before a series of significant structural transformations that reflect, in a highly localized way, larger changes taking place across the island (fig. 5.2).

The basilica in E.F2 sat just to the northeast of a major intersection in the city that was marked by the aforementioned tetrapylon, built during the period of Roman rule to mark an important intersection in this part of the town (fig. 5.0; Plan 8). There is no reason to think that this structure did not stand in the sixth or even the seventh century. If seventh-century visitors to the city had made a left turn at this monumental crossroad, they would have passed a well house and workshops and perhaps also the homes of local artisans en route to a gracefully arcaded narthex. Visitors continuing straight through the tetrapylon toward the east would have followed a neatly paved road (some 30 meters of which have been excavated) that runs parallel to the south side of the church. At the time of the construction of the basilica, the area between it and the street may have been a leveled courtyard or atrium. Since the leveling fills included pottery from the sixth century, this area is connected to the construction of the new church and the transformation of the neighborhood. By the seventh century, an arcaded porch graced the building's south flank and lent an air of elegance to the area. This spacious southern portico, a common feature of the churches on Cyprus, would have offered shelter from the summer sun

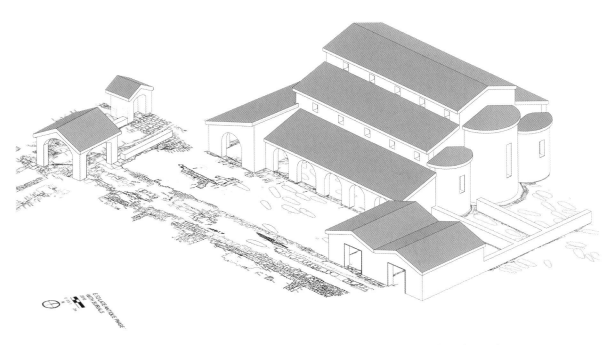

FIGURE 5.2. Preliminary reconstruction of the church in Area E.F2 from the southeast.

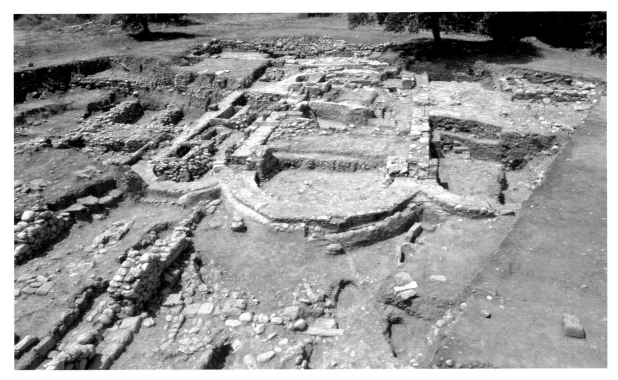

FIGURE 5.3. View of the polygonal apse of the church in Area E.F2 of Polis-Petrerades, from the east, 1989.

and winter rains. With access from both the atrium and the western narthex of the church, it provided a place of repose and shelter for local residents.

The monumental Christian basilica that superseded the earlier Hellenistic and Roman levels must have created a dynamic focal point within this section of the city. To set the church apart, careful leveling courses covered virtually all of the earlier remains in its immediate vicinity, including a small kiln just east of the sanctuary that had been used for the production of lamps in the second century C.E. (see figs. 4.13, 4.14).

The basilica itself, built in the mid- to late sixth century, according to ceramic and stratigraphic analysis, was typical of Late Antique churches erected throughout the Mediterranean at this time (Plan 8; Building Reconstruction 4).[11] Although almost nothing has survived above the level of the foundations, the basilica's three longitudinal aisles were originally separated from one another by colonnades, each consisting of marble shafts not unlike those that have been found in and around the area of Polis (see fig. 1.14). Because there is no marble on the island, these structural members had to be imported from far-distant quarries or taken from ancient buildings that served as convenient substitutes. They were crowned with sculpted capitals that afforded an elegant transition to the wooden

trusses and rafters supporting a tile roof above. It would not be surprising if these capitals (see cat. nos. 108, 109) differed from one another in design and carving style. The employment of *spolia* (reused architectural fragments) was characteristic of the period, and builders and viewers alike appreciated the variegated effect.[12]

The central aisle of the basilica would have risen higher than the two flanking aisles, with clerestory windows above the colonnades filling the central space with light from above. The aisles terminated to the east in three vaulted apses that drew the viewer's attention toward the sanctuary (or *bema*), the most sacred region of the building (fig. 5.3). Internally, this eastern component, especially its central bay, would have been set apart from the main body of the church by a small step up and a low screen accentuated with colonnettes and a horizontal epistyle beam. A *templon* screen of this type would have been visually open while physically segregating lay worshipers from officiating clergy and the altar within. A few scant remains of a marble screen and its sub-structure have been found in excavations, although not enough have survived to reconstruct its overall appearance. An abundance of small mosaic tesserae, both colored stone and gold glass, are of the size and material appropriate for embellishing walls and vaults. A colorful mosaic eye (fig. 5.4), recovered from

the area east of the church, suggests an apse program that featured human figures, perhaps Christian subjects not unlike those famous examples found in other surviving Late Antique apses on the island, most notably the churches of Lythrankomi at Kanakaria and the Angeloktistos at Kiti.[13] That this program continued into the aisles is less certain; fragments of painted fresco there suggest that mosaics may have been exclusive to the apses, playing a role in marking this part of the building as special. Finally, a narrow vestibule, or narthex, preceded the main body of the church at its west end and provided a formal space of transition, convocation, and official entry that is commonly encountered in Late Antique churches.

The architecture of the church in Area E.F2 complemented the interior decoration to create an environment distinct from everyday experience. The painted walls and *opus sectile* floors of the church played with the light patterns from the windows, and numerous lamps throughout the building created a dramatic space filled with mystery and meaning. A surviving lamp stand, executed in bronze and decorated with motifs evoking the ancient past, demonstrates the economic means to provide sophisticated and elaborate objects as the backdrop to Christian ritual (cat. no. 99). At the same time, a plethora of simple wick holders made of lead (fig. 5.5) shows the more standard form of outfitting churches with glass oil lamps that held a single floating flame of light. They were frequently grouped together in a *polykandelon*, or chandelier, and

FIGURE 5.5. Wick holder from trench EF2:n08 at Polis-Petrerades, 1986. Lead; l. 7.8 cm. Princeton Cyprus Expedition R1459/BR107 (left); drawing of lead wick holder in use in a glass lamp (right).

conveyed the notion of holy and eternal presence within the building.[14]

Visitors immersed in ritual and fascinated by the church's decoration would have recognized the building as a product of the community. They would have realized that, over time, the church represented more than the effort of a single generous patron, and that its upkeep reflected the long-standing importance of religious architecture to the community. By the seventh century, parts of the church had collapsed, perhaps soon after the building was completed, and a significant refurbishing effort led to the reconstruction of most of the nave and aisles and the addition of the arcaded narthex and south portico. There is some evidence that the cause of the building's collapse involved an event that destroyed the wooden roof. The new church used vaulting over the aisles in the seventh-century structure, in keeping with the fashion of the day and evoking a new sense of permanence and security. An awkward join between the eastern apses and the side-aisle walls reminded visitors that the most sacred area of the sanctuary remained standing even after the wood roof and parts of the nave walls had collapsed.[15]

Reinforcing the special permanence of the building were the tombs built into the eastern end of the south aisle at some point in Late Antiquity. Stepping down into a chamber at the far eastern end would have revealed three burials built against the south wall that held the remains of important members of the church hierarchy. One of these, probably sunk into the floor not long after the surviving church was constructed, revealed material signs of the deceased's high standing—an unusual occurrence at Arsinoe, where individuals were often buried without costly material goods.[16] In this case, however, a bronze cross, its surface originally adorned with incrustation or applied decoration, hung from a bronze chain and rested

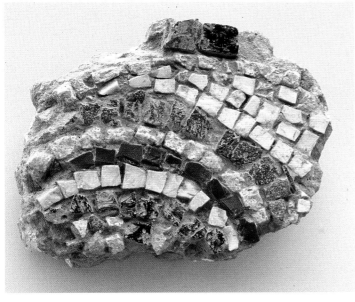

FIGURE 5.4. Mosaic eye from the east end of the church in trench E.F2:t06 at Polis-Petrerades, 1988. L. 6.9 cm., w. 5.4 cm. Princeton Cyprus Expedition R1779/MO1. See fig. 5.3.

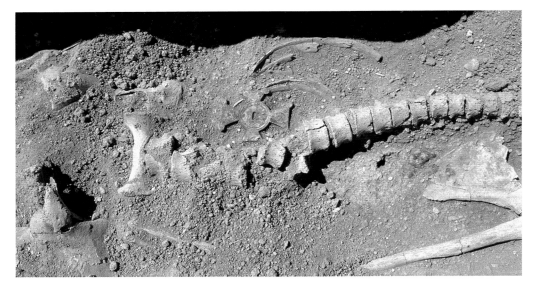

FIGURE 5.6. Bronze cross (cat. no. 101) in the context of Burial 17, trench E.F2:r08 (trench 1) at Polis-Petrerades, 1984, showing the central of three burials that line the south wall of the south aisle.

at the right hip of its former owner as a sign of his piety and important standing (fig. 5.6; cat. no. 101).

Visitors to the church in Area E.F2 after the seventh century would have had a different experience. While the basic shape of the main church appears to have remained the same, the interior walls were reinforced after several serious earthquakes and collapses.[17] The decorative marble capitals, no longer necessary in light of the thick, solid walls that now separated the aisles from one another, were reemployed as fill within heavy wall buttressing

(cat. no. 108). The cemetery that grew up around the southeastern end of the church continued to expand, eventually intruding on surrounding structures and roads that had fallen into disuse (fig. 5.7; Plan 8). The open porch along the south side of the building was walled up and used for burials, its floor and that of the courtyard to the south overtaken by residents for the sinking of graves that were shared and reused. The elegant arches of the narthex were similarly enclosed during these later centuries, with burials sunk into its floors and doorways. It seems possible that

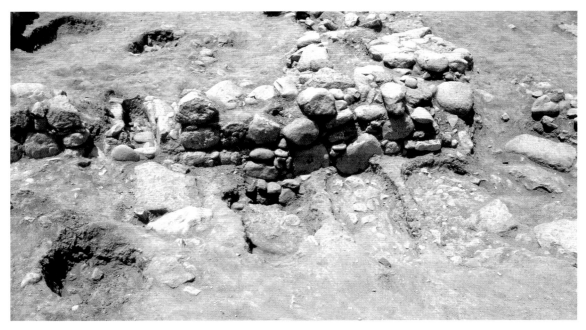

FIGURE 5.7. Burials cut into and next to a wall in trench E.F2:t06, quadrant u06 at Polis-Petrerades, 1988, from the east.

burials continued in the vicinity of the church even after the building collapsed, perhaps into the eleventh century, suggesting that the memory of the place as sacred persisted at least into late medieval times.

This later transformation of the building and its seemingly macabre surroundings has proven important to our understanding of the living community of ancient and medieval Arsinoe. The excavation of some 170 graves in this area offers a rare opportunity to recover information concerning not just the death but also and especially the health, nutrition, interrelations, demographics, work, and activities of the real and living community of people who inhabited the city and used its important monuments.[18] We also capture small hints about the inner lives of individuals through the occasional survival of material goods in their graves. For example, the recovery of a lead seal (cat. no. 94)—the quintessential proof for the existence of an important document which it once secured—demonstrates the persistence of a literate elite into the eighth century.[19] Meanwhile, an array of stone pectoral crosses points to a fashion for these small, delicate objects (cat. nos. 102–5), which may have commemorated the pious act of travel, whether within the island or farther afield to holy places where they could be purchased and thenceforth serve as signs of faith and pious achievement.[20] Such objects were also potentially worn in life as apotropaic devices intended to deflect disease and misfortune. We can even peer into customary activities and daily

work habits, such as those of a woman buried alongside a drain in the defunct street south of the basilica: she ran thread or perhaps fish line through her teeth and sewed with a homemade needle carved from a catfish bone extracted from the sea.[21] The monumental and the mundane, then, sat side by side in the neighborhood of Area E.F2, where the pretensions of the elite, the persistence of the sacred, and the memory of everyday life linked Christian space to the social, economic, and spiritual fabric of the community.

The Townscape (Area E.F1)

If we return to the seventh century, a short walk in the direction of the sea from Area E.F2 leads us first alongside a small establishment directly adjacent to the ancient road. The dynamic character of this small site, called Area E.F1, suggests that the mixed-use environment manifest in the workshops, roads, and burials around the church in E.F2 finds echoes here. A sturdy threshold offered access to more streets or alleyways, where water flowed under covered drains and a corner catchment basin offered cool respite (fig. 5.8). The function of individual rooms has not been determined, which is typical of mixed-use spaces within a townscape that was constantly changing to accommodate the different needs of inhabitants. The exceptional discovery of a complete pane of window glass (fig. 5.9), cast in Late Antiquity and fully preserved, alters long-standing perceptions that such accessories were

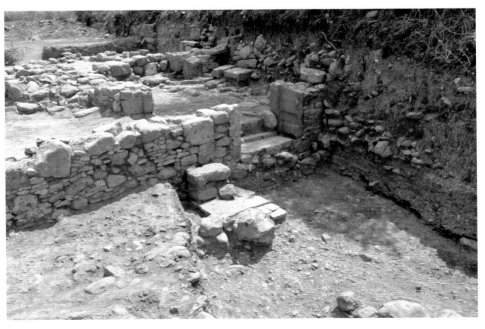

FIGURE 5.8. Area E.F1, 1989, general view from the northwest, showing threshold in situ.

FIGURE 5.9. Pane of 7th-century window glass from trench E.F1:q06 at Polis-Petrerades, 1989. Princeton Cyprus Expedition R3631/GL530.

was appropriated for the construction of another church (figs. 4.0, 5.10), larger in size (32 x ca. 18 m.) but similar in its basic layout to that in Area E.F2 (Plan 8).[23] Unfortunately, this three-aisled basilica is less well preserved than its nearby cousin, in part because of illicit digging in modern times (seeking building materials and antiquities) (see essay I) and in part because of a very long and industrious habitation period that lasted throughout the Middle Ages and into the sixteenth century. The extant remains of the building are in fact a palimpsest, its features revealing and concealing layer upon layer of changes in planning, form, and function over some thousand years of occupation.

It is interesting to speculate about the choice of this site for the construction of another Late Antique basilica, especially since its exposed location on the low promontory rendered it not only visible from the sea but also more vulnerable to attackers and the elements. The existence here of an earlier tower, its walls (1.5 meters thick) directly in front of the basilica's north wall, suggests the possibility that protective walls, or at least watchtowers, defended the exposed position along the bluff. Winds from the north can also be forbidding (and welcome!) here, so that we can imagine human events—ritual processions, the gathering of the faithful—and the open spaces that housed them perhaps being situated on the unexcavated south side of the building to protect them from the elements. Despite the location's liabilities, the ready supply of finely worked stone in the form of a ruined ancient building offered clear advantages and was certainly a driving factor in the building of a church at this place. The basilica followed (roughly) the same orientation as the earlier structure, and its builders dug down deep in order to heave up the massive paving stones of its ancient courtyard for reuse in their new construction. As was typical, resources from the ancient past provided the impetus and sustenance for the post-Classical community and its projects.

The overall impression of the original sixth-century basilica in Area E.G0 was probably similar in most respects to that of the church in Area E.F2, with the exception of a small apse projecting from the middle of its northern wall (fig. 5.10). Burials throughout the church indicate that, like the one in E.F2, the church served a mortuary function for the community. The continuous modification of the building, however, makes it difficult to understand its precise shape, arrangement, and phasing. Moreover, a complete picture of the situation in Area E.G0 is not yet possible since less than half of the church and none of the

reserved for the church and not wasted on domestic or industrial spaces. Like the church, this area was eventually used for at least one burial. Sometime during or after the late sixth or seventh century, the tomb of a woman was sunk into a wall near the aforementioned threshold. On her left hand was an iron ring and next to her knee a lead seal—again, a sign of distinction, ecclesiastical connections, and possible literacy. A second seal was found nearby.[22] We can only guess as to the nature of the documents they once secured or their significance for the deceased woman, but certainly they are a foil to the humble needle buried in the sewing woman's grave. In any case, the small site in Area E.F1 is instructive in demonstrating how industrial, domestic, and even burial space did not have firm boundaries in Late Antiquity.

The Basilica on the Bluff and Its Environs (Area E.G0)

Continuing on the northward path, one would turn toward the east along a natural bluff overlooking the stunning expanse of Chrysochou Bay. In earlier times, the bluff provided the ideal setting for a large and luxuriously decorated building (see essay IV); in Late Antiquity, the site

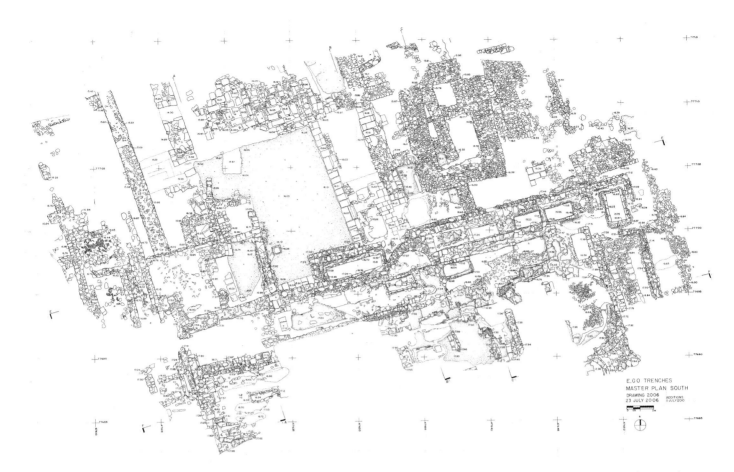

FIGURE 5.10. Master Plan of Area E.G0 south in Polis-Petrerades, 2010. Foundations of the church are visible with the apse in the lower right.

area to the south of it have been excavated. What can be determined is that, in an early phase, the church had a lavish decorative program that featured marble columns and carved sculpture, including marble champlevé panels and *transennae* (window framing) likely carved from the fine limestone of the ancient structure to the north. It also had fine floors of both opus sectile and mosaic paving, fragments of which have survived (fig. 5.11).[24]

The most striking features of the church in Area E.G0, however, are modifications made to its earliest plan for accommodating the dead. A series of deep (as much as three meters), sub-surface pits were added to the north

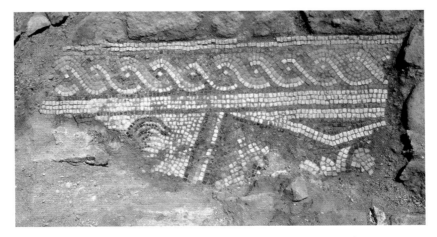

FIGURE 5.11. Fragment of mosaic floor from church in trench E.G0:h12 at Polis-Petrerades, 2000. Princeton Cyprus Expedition R33628/MO731.

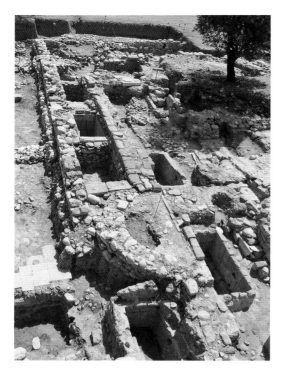

FIGURE 5.12. Aerial view of Area E.G0 in Polis-Petrerades from the west, 2001, showing ossuary pits and apse in the north wall of the church.

and east walls of the building, with additional constructed pits sunk into the floors of the north aisle (fig. 5.12). All were intended as ossuaries, as is clear from the presence of commingled human remains in each one. The long pit just west of the aforementioned apse contained the highest concentration of bones; at least thirty-five individuals were interred there. While the exact reason for these burial additions is not yet clear, the latter may have served to accommodate remains associated with an earlier church destroyed during the construction of the sixth-century building; this theory, however, does not explain why the burial pits appear to be slightly later additions to the plan of this church. Nevertheless, the reinterment of remains follows a common practice at this time for the veneration and maintenance of sacred places and may have established the continued use of the basilica at E.G0 for interment throughout its long life.

Swift and economical transfer of a community of the dead would account for disarticulation of nearly all interred bodies within the ossuary pits and also for the signs of ritual practice evident within them. While there is significant variation in the construction of the pits, they share the common feature of two superimposed square holes, or niches, arranged one above the other in their long walls. Clay lamps (cat. no. 98) dated to the seventh century

were lit and placed near or within these holes, apparently during ceremonies marking the occasion of reburial. Luxury items, such as gold jewelry, rings, coins, and especially bronze buckles, some decorated with colored glass inlay (cat. no. 100), were found together with the bones and suggest that some, at least, of those buried here could afford expensive adornment. The grave goods in these ossuaries contrast with the more modest stone crosses found in the graves of Area E.F2. Perhaps these variations reflect social and economic differentiation between the two communities who buried their dead around the church in Area E.F2 and that in Area E.G0, this despite their location within two hundred meters of each other.[25] Special circumstances and strictly local requirements probably influenced the particular layout of (or subterranean additions to) the basilica in Area E.G0.[26]

In the surrounding area, a narrow street immediately west of the building and adjacent to its narthex ran to the north, where it passed by a group of three rooms apparently connected to the sixth-century church (fig. 5.10). These postdate the initial phase of the church but relied upon the southwest corner of the ancient building for foundations. An olive press was housed in two of the rooms; the massive pressing wheel survives, as does a passage for the flow of oil along a spout into a room that likely held a pithos, or storage jar. The association of olive oil production with churches of this period is common in Cyprus, confirming once again the deep intermingling of economic, social, and religious activity at the site of this church and in Late Antiquity in general.[27]

The Medieval Remains in Area E.G0

The long life of the basilica in Area E.G0 in the immediate aftermath of the seventh century awaits further study, not only in the case of the material evidence from Polis but for the island as a whole. Consequently, it is premature to formulate conclusions at present, especially for the so-called condominium period in the eighth and ninth centuries on the island, when there was joint rule between the Arab and Byzantine empires. Ceramic evidence, including typical glazed wares from the nearby Paphos workshop, indicates continued activities at the church mainly from the early thirteenth century, long after the basilica in Area E.F2 had collapsed.[28] As at E.F2, however, the church in Area E.G0 saw the thickening and extending of walls throughout the building to partition space or support heavy vaulting overhead. The vaults, together with the walls that supported

them, were covered with a program of colorful and finely executed frescos that survived as thousands of small, multicolored pieces of plaster—all embedded in a thick fill of mortar and tile lying on top of a hard and durable plaster floor. Additions were made to the sanctuary area, and the north aisle was modified through the conversion of the flat east wall into a polygonal apse. Immediately to the north, above the defunct ossuary pits, another aisle or a side chapel was added, with a Late Antique column capital overturned to act as a support for an altar table (fig. 5.13; cat. no. 109).[29]

The area north of the church preserves numerous fragmentary hints of the site's later history. Almost immediately adjacent to the basilica stood a building of some pretension. While its state of preservation makes it difficult to assign a clear function, it may have been the house of a wealthy family. A series of attached rooms on the south side of the structure might have been stables, as suggested by their arrangement and the discovery of horseshoes in this area. A nearby midden produced spurs, strap guards, and dice, perhaps to amuse the grooms. The presence of a large pithos incorporated into the walls of one corner of the building suggests either storage or the need to collect water for local use. Another midden near these rooms produced an assemblage of glazed bowls with sgraffito decoration dated to the thirteenth century. The area also produced two hoards of coins. One of these is dated 1285–1398, with concealment following soon after.[30] In the same general area appeared a slightly earlier hoard of 430 copper coins that someone placed into a fabric pouch and carefully concealed within a wall after 1369.[31] The presence of two hoards with dates in the second half of the fourteenth century, along with various middens, may indicate that the imposing building north of the church had gone out of use by this time, perhaps in a particularly tumultuous moment in the site's history.[32]

The church, by contrast, continued to function, undergo modification, and, like the basilica in E.F2, it was gradually filled with graves. One burial deserves special mention. It was placed directly on axis with the main apse of the church and was articulated with a lime-plaster "ledge" of vertical panels incorporated into the plaster floor and surrounding the perimeter of the tomb (fig. 5.14). Immediately to the west stood a small structure consisting of a low stone *socle* supporting mud-brick walls. To the east of the tomb, a sandstone block, reused from an earlier context, was axially positioned within another low wall. The block bore a fresco depicting a bearded figure, most likely the prophet Elijah, or perhaps Adam, which was turned toward the south away from the grave (cat. no. 110). Directly in line and facing the grave, however, was the blue and red pattern of its border decoration, wing-like in appearance and sitting directly on the floor. The arrangement of the burial and the placement of the

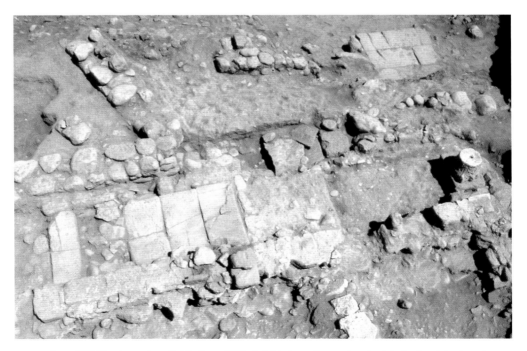

FIGURE 5.13. Overturned capital (cat. no. 109) at right above the eastern burial pits, in a late chapel north of the church in trench E.G0:h10 at Polis-Petrerades, 1995.

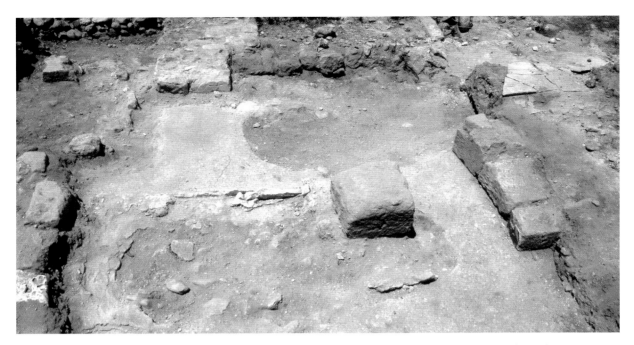

FIGURE 5.14. Trench E.G0:g12 at Polis-Petrerades, 1997, burial in central aisle before excavation (center), view looking north and showing burial on axis with frescoed ashlar (cat. no. 110) lowest at right; some gypsum paving stones of late floor in background.

painted limestone block suggest that this tomb was a site of commemorative practice or, perhaps, local cult activities. Efforts to establish a connection with the image of a revered saint are common in the Middle Ages, and a local parallel for such an arrangement is not far away: in the fourteenth century, Marchon Pantimos, bishop of Arsinoe and Paphos, was buried in nearby Magounda, directly under the feet of the Archangel Saint Michael.[33] Although merely a fragment, perhaps the frescoed ashlar at Arsinoe held meaning and value, even or perhaps especially in second use. The church in Area E.G0 subsequently received a new floor made of gypsum tiles that was installed near this particular burial. The floor is conveniently dated by a coin, perhaps dropped by workmen, found between the paving stones and the sub-floor; its presence demonstrates that renovations were still being made to the building in the years following 1460–73.[34]

The western part of the church also saw a dense series of new burials within the building, especially in the area of its spacious narthex but also outside in the area adjacent to the west wall of the church. These burials differed from the earlier Late Antique burials at the site because they generally included at least one glazed bowl with every individual, placed in various locations around the body but most frequently near the legs, feet, or arms (fig. 5.15). This follows the custom of so-called bowl burials that likely arrived in

Cyprus through contact with Westerners following the crusader conquest of the island in the late twelfth century.[35] While the bowl burials vary in date, most of those in Polis date from the fourteenth to the sixteenth century, with the earliest vessels imported from Paphos and the later examples from workshops in Lapithos.[36] The burials also sometimes included a modest water jug, apparently used for pouring water in association with the interment. Rituals of anointing the dead with a bowl or vessel from the deceased's household find echoes in contemporary practice on Cyprus, where the priest, using a bowl brought by the family to the grave, pours oil in the sign of the cross over the dead.[37] Alternatively, the bowls may have been used to burn incense, another custom perhaps brought by the Latins.[38] In one fourteenth-century burial, the combination of oil and incense may have caused a juniper wood coffin to smolder, thereby preserving part of it (fig. 5.15).[39]

It appears that families were often buried together in the same grave. The charred coffin came from a burial in the narthex, which also produced the commingled remains of six individuals, including two adult males, an adult female, a toddler, and an infant. The two bowls featured here, both dated to the fourteenth century, were recovered from this burial (fig. 5.15; cat. nos. 106, 107). The woman's teeth showed signs of wear similar to those of her predecessor from Area E.F2, and very recent research has produced

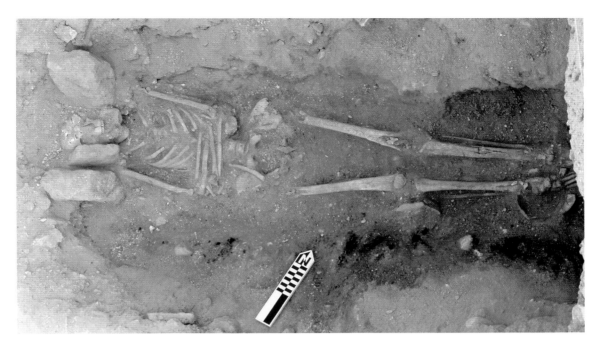

FIGURE 5.15. The intact burial of a woman in the narthex of the church in Area E.G0 at Polis-Petrerades, her head supported by stones and a roof-tile fragment. Cat. nos. 107 and 106 are visible at her right foot and right knee. Her grave cut into earlier burials and part of a coffin. View from the south.

more needles and individuals with narrow abrasions in the enamel, suggesting that pulling fiber through or alongside the teeth was common practice in work.[40] The southwest corner of the narthex preserved a particularly touching burial of a woman with a one-year-old child in the crook of her left arm. Each received a bowl, one of which was carefully placed on a shelf above the woman's head. The woman appeared to have had an icon placed on her chest.[41] Just outside the church, a burial produced the remains of a woman who seems to have suffered and died with leprosy sometime after the early fifteenth century.[42] Elsewhere in the church the abundance of lime, added to cover graves, suggests efforts to control the spread of plague from the fourteenth century on.[43] The latest burial at the site is dated after 1560 by a coin placed in the deceased individual's mouth—a rare instance of this practice in Arsinoe. The burial cut through a dense fill of plaster and debris in what would have been the north aisle of the church, suggesting the building had at least partially collapsed by the late sixteenth century. As with the church in Area E.F2, however, it continued to be an important and visible landmark in the community.

Today the successor of Arsinoe, the modern village of Polis, seems entirely set apart from the bustle of larger Cypriot cities like Nicosia, Limassol, and Larnaka. As the preceding sketch has indicated, the city of Arsinoe was deeply embedded in economic, political, and ecclesiastical networks throughout Late Antiquity and the Middle Ages. The end of antiquity saw the city as part of an urbanized landscape that included the important cities of Soloi and Nea Paphos, the smaller town of Peyia on the west coast, and the numerous villages that dotted the Akamas Peninsula.[44] The town's prosperity probably derived from its situation along the main route from Soloi to Nea Paphos together with good harbor facilities on the relatively protected coast of Chrysochou Bay. The fertile Chrysochou Valley almost certainly provided economic vigor to local residents, as did the nearby copper mines just five kilometers to the east.[45] The number of sites identified by even low-intensity regional survey projects shows that Arsinoe was, indeed, the center of a "busy countryside" in Late Antiquity.[46] Regional production fed the small-scale industrial establishments throughout the town and provided agricultural produce and manufactured goods for local consumption and coastal trade. As a community, then, Arsinoe represents another site in the growing list of mid-sized, Late Antique settlements on Cyprus whose prosperity was tied to various forms of production (agricultural, small-scale industrial, fishing, mining, and the smelting of copper) together with coastal access and the proximity of major overland communication routes.[47]

The economic organization of Arsinoe and of Cyprus benefited from the prosperity of the Late Antique eastern Mediterranean. Positioned near major markets in North Africa, the Levant, Asia Minor, and the Aegean, and poised to take advantage of trade routes extending from North Africa and Egypt to Constantinople, capital of the Byzantine Empire, Cyprus enjoyed access to most of the major avenues of wealth in the East at the time (Map 1).[48] Ceramics most likely produced in the western part of the island, particularly the widely traded Cypriot Red Slip, reveal the reach of Cypriot goods. Late Roman 1 amphorae made on the island carried Cypriot agricultural produce to Asia Minor and the Aegean.[49] The sustained agricultural prosperity of Cyprus and the easy access to the Aegean almost certainly accounted for its transfer from the Prefecture of the East to the Prefecture of the West, so that agricultural production on the island could feed the embattled imperial forces on the Danubian frontier.[50]

The period of Arab raids and the subsequent period of joint rule between the Caliphate and the Byzantine Empire, sometimes called the period of "condominium," do not appear to have forced an abrupt end to prosperity in and around Arsinoe. The churches in Areas E.F2 and E.G0 continued to function, and this is consistent with some of the sites on the Akamas Peninsula and in the immediate neighborhood of Paphos.[51] The presence of seventh- and eighth-century forms of Cypriot Red Slip at Arsinoe, for example, indicates that the site continued to engage in local exchange and production patterns. Recent research suggests that regional trade remained active throughout southern Asia Minor even into the eighth century, and it seems that the western part of the island continued to participate in at least some of this exchange.[52] It appears likely that local agricultural, religious, and civic life continued through the threat of Arab raids, even though the political and military instability of the era must have been real.[53]

There is only limited indication that economic activity continued at Polis and in the vicinity during the ninth to eleventh centuries. The failure to rebuild the church in Area E.F2 after the mid-twelfth century should not be understood to represent a general period of decline for the region or the island more generally. In fact, we know that the eleventh and particularly the twelfth century were times of economic expansion, extensive construction, and architectural innovation on the island, particularly in the northwest corner and the Chrysochou Valley.[54] In this context, abandonment of the church in Area E.F2 should be viewed as a result not of limited resources but rather of new changes—in patterns of settlement, in architectural tastes, or in communal needs—with inhabitants and economic activity migrating to other parts of the town, including Area E.G0.

The eventual arrival of the crusaders both on Cyprus and in the Levant once again linked the island to its closest neighbors and provided access to foreign markets, craftsmen, and goods. It is tempting to see the more extensive contacts between Cyprus and the Levant at this time as stimulating a greater number of monumental churches in the vicinity of Polis.[55] The major foundations at Letimbou, near Kholi, and at the Georgian monastery of Gialia date to the twelfth or the early thirteenth century.[56] These foundations reflected not only external investments in the region through the monastery at Gialia but also the willingness of either local residents or newcomers to invest in villages throughout the Chrysochou Valley. Undoubtedly, the city's continued productivity, easy access to the coast, and the proximity of the regional center at Paphos must have all contributed to the general prosperity recorded at Arsinoe. The presence of fine wares and other elite goods, the maintenance of the church in Area E.G0, and the existence of several other large-scale construction projects indicate that the fabric of the community remained dynamic into the fourteenth century and possibly later.

NOTES

1. This essay owes much to the group of specialists who comprise the post-Classical team now working at Polis: Scott Moore, Kyle Killian, Sarah Lepinski, Olga Karagiorgou, Nora Laos, and Maria Parani have all contributed their expertise to the project both in the field and through their individual research. Our bioarchaeologist is Brenda Baker, whose work since 2005 figures prominently here, especially for the later burials and the sewing woman from Area E.F2.

2. For the inscribed statue base, see essay IV.

3. The date rests on an analysis of the letter forms together with the known existence of two archbishops called Sabinos (of Constantia) in Cyprus during the fifth century. The first held office from 403/4 to 431 and the other after 457 C.E. The inscription was twice published: Nicolaou (I.) 1961–63 with a date of 451–488 and Nicolaou (I.) 1971, with an "early fifth century" date. The stone measures 38 x 97 x 20 cm. and therefore was a substantial marker of official presence in the town. The translation given here is Nicolaou's.

4. Grivaud 2005, 255; Constantinides and Browning 1993, 127–32.

5. "Γινωσκέτωσαν πάντες οἱ τὴν παροῦκσαν πληρεστάτην ἀπόφασιν ἀναλαβόντες καὶ ἀκούσαντες ὅτι ἡμεις δεῖνα ἐλέω θεοῦ ἐπίσκοπος Ἀρσενόης, πρόεδρος πόλεως καὶ ἐνορίας Πάφου..." (Sathas 1877, 522).

6. Rapp 2005, on the role of bishops in Late Antiquity, following the work of Peter Brown (Brown [P.] 1971), which remains seminal.

7. A field behind the dig house is, according to local legend, the site of a "great church" of Arsinoe. Outside of town, the remains of a small vaulted chapel (completely uninvestigated but apparently Late Antique or Byzantine in date) just south of the former military base suggest additional ecclesiastical buildings in the area. Arsinoe might be compared to the Late Antique site of nearby Peyia, on the west coast, with at least six basilicas and chapels of comparable date.

8. On Archbishop Sabinos, see Nicolaou (I.) 1961–63, 136–38.

9. Von Falkenhausen 1999, 28.

10. See Papageorghiou 1993 for a concise survey of the transition from antiquity to the Middle Ages in Cyprus.

11. Although the basilica in Area E.F2 is typical of so many basilicas constructed at this time throughout the eastern Mediterranean, recent work by the newly assembled team of scholars working on the post-Classical strata should not be underestimated. Our close reading of stratigraphy and ceramic evidence holds the possibility of overturning earlier, now outdated chronologies that were based purely on stylistic analysis. This will shed new light not only on the Polis material but also on many other Late Antique churches in Cyprus and throughout the Mediterranean basin.

12. On the perceived importance of variety, or ποικιλία, and the reuse of ancient building materials, see Saradi-Mendelovici 1990, 52–53.

13. Megaw 1974, 74–76.

14. Bouras and Parani 2008.

15. Ćurčić 1999, 75.

16. Papalexandrou (A.) 2012.

17. Ćurčić 1999, 75, where earthquake is suggested as the source of structural damage.

18. The burials in Area E.F2 were initially studied by Stacey Buck for her master's thesis: Buck 1993. This work continues under the aegis of Brenda Baker, on which see Baker and Papalexandrou (A.) 2012, emphasizing the bioarchaeological evidence. Preliminary observations can be found in Papalexandrou (A.) 2012.

19. The collection of ten seals from the Princeton excavations, of which this is one, is under study by Olga Karagiorgou.

20. Pectoral crosses of this modest type are commonly found throughout the Mediterranean in the Middle Ages, though they receive little scholarly attention. On Cyprus itself, a workshop producing picrolite crosses in the Middle Byzantine period has been discovered in excavations of the Palaion Demarcheion in Nicosia, to be published by Yiannis Violaris of the Department of Antiquities of Cyprus.

21. Baker, Papalexandrou (A.), and Terhune 2012.

22. The seal inside the tomb is dated to the late sixth or seventh century (Stephanos), the seal outside after 680 C.E.

23. Najbjerg, Nicklies, and Papalexandrou (A.) 2002.

24. Ibid., 150.

25. Papalexandrou (A.) 2012.

26. A situation similar to that of the church in Area E.G0 is found on Cyprus at the church of Saint Tychonos at Amathous, on which see Aupert 1996, 153–61.

27. Hadjisavvas 1992.

28. Papanikola-Bakirtzis 2000. The medieval ceramics are now under study by Kyle Killian.

29. This is a typical arrangement in churches of all periods in the Mediterranean. A nearby example exists in Polis itself in the church of Agia Kyriaki.

30. Metcalf 1990.

31. The copper coins are under study by Alan Stahl of Princeton University. For the copper hoard, see now Stahl, Poirier, and Yao 2011.

32. This likely owed less to human invaders than to the quick and devastating effects of the plague. The Black Death ravaged the island in 1347–48 and thereafter, with estimates of the population decreasing by as much as one-third; see Nikolaou-Konnari and Schabel 2005, 16–17.

33. Darrouzès 1951. The manuscript Paris. Suppl. fr. 74 informs us that one Marchon Pantimos, bishop of Arsinoe, died in August 1335 and was buried in the chapel of Saint Arkadios at Magounda (in the foothills east of Arsinoe/Polis). We are grateful to Tassos Papacostas for this reference.

34. We are grateful to Kit Moss for his initial reading of the coin and to Alan Stahl for offering a firm date.

35. Ivison 1993.

36. Papanikola-Bakirtzis 2000.

37. Byzantine sources confirm the practice; see Constas 2006, 135; for the modern continuation of the practice, see Papanikola-Bakirtzis 1989, 38. Recent findings using mass spectrometry on soil samples taken from bowls at the Mediterranean Agronomic Institute in Chania (MAICh), Crete, show the existence of olive oil and wine in these deposits. We are grateful to Panos Kefalas and his colleagues at the institute for this new information.

38. Ivison 1993, 252 on thymiateria and the burning of incense. Several of the glazed bowls from Area E.G0 contained carbonized matter.

39. Wood from this coffin was examined by Sturt Manning, who confirmed a fourteenth-century date and the type of wood. We are grateful to Dr. Manning and the Cornell Tree-Ring Laboratory for this information.

40. Baker and Moramarco 2011.

41. Baker discovered organic matter on the individual's chest during excavations in 2006, with what appeared to be squared edges and traces of pigment.

42. The woman was buried with a coin dated to the reign of Janus (1398–1432). The assessment of leprosy has been advanced as a possibility by Brenda Baker.

43. The practice is attested in sources, on which see Constas 2006, 134.

44. Tinh 1985; Papageorghiou 1986; Fejfer 1995; Bakirtzis 1999.

45. Childs 1988, 130.

46. Adovasio et al. 1975.

47. Rautman 2000 and Rautman 2003.

48. Bakirtzis 1999.

49. Demesticha 2000.

50. Decker 2001.

51. For a general discussion of the role of churches in understanding this complex period on Cyprus, see Papacostas 1999, 210–19.

52. Armstrong 2006.

53. For the story of the Arab raids as remembered (and inscribed) by the Late Antique inhabitants of Soloi, to the east, see Tinh 1985, 115–25.

54. Ćurčić 1999; Papacostas 1999.

55. Papacostas 1999.

56. None of these important monuments has seen proper publication, although results of the recently excavated monastery at Gialia will be made available by a team of Georgian scholars under the direction of Dr. David Mindorashvili.

Seal of Damianos, Archbishop of Cyprus

Cypriot, 700–740 C.E.
Found by Princeton at Polis-Petrerades, trench E.F2:t06, in 1988
Lead; diam. 2.62 cm., th. 0.34 cm., weight 14.37 grams
Paphos District Museum (Princeton Cyprus Expedition R2526/SS5)

Condition: Slightly chipped at the top center.

The obverse of this seal depicts the bust of a bishop-saint, possibly Saint Epiphanios, wearing the distinguishing vestment of a bishop in the Eastern Orthodox Church (*omophorion*) patterned with crosslets. The saint holds the book of the Gospels in his left hand and is blessing with his right hand. His elongated face is accentuated by his baldness, for only a few hairs may be seen covering his temples, and by his conspicuously tall forehead and long, pointed, well-trimmed beard. A dotted nimbus surrounds his head, and the whole bust is flanked by two crosslets.

The center of the reverse is occupied by a cruciform invocative monogram (Layrent Type V) reading Θεοτόκε βοήθει (Virgin Mary help). This monogram is surrounded by a circular inscription preceded by a crosslet within two borders of dots, which starts at twelve o'clock and reads:

+ΔΑΜΙΑΝѠΑΡΧΙΕΠΙΣΚΟΠѠΚΥΠΡᲧ
(Damianos, archbishop of Cyprus).

Damianos, archbishop of Cyprus, is attested also in the literature. Three more of his seals are known, all similar in type to the one found at Polis: the first one, now in a private Cypriot collection, comes from Constantia; the second one, in the Cyprus Museum in Nicosia, was found at Kourion; and the last one, of the Seyrig collection, comes from Byblos. In this respect, we are able to reconstruct part of Archbishop Damianos's network of correspondence, which obviously extended well beyond Cyprus, as attested by the specimen found in the Lebanon. The Polis specimen may have sealed a letter that Archbishop Damianos sent to the bishop of Arsinoe. Damianos's prolific record of correspondence may also be deduced from the fact that all his known seals come from different *boulloteria*. In normal use, each *boulloterion*—the iron, pliers-like instrument used for striking seals—could produce tens of seals; the owner would replace the boulloterion only if it were lost or worn out.

Among the four seals of Damianos so far known, the one from Kourion and, to a certain extent, that from Polis, stand out within the known sigillographic record of all Cypriot church officials because of their high workmanship and artistic quality. The boulloteria that produced these two seals were obviously made by a skillful engraver, whose work D. M. Metcalf has described as "far more elegant than anything previously seen on Cyprus." Furthermore, all the known seals of Damianos exhibit a close typological and, in the case of the Nicosia and the Polis specimens, an artistic affinity with the seal of Andrew, *proedros* (metropolitan) of Crete, the well-known early eighth-century theologian, homilist, and hymnographer. This observation favors the hypothesis that the respective boulloteria of these two prelates may have been the work of the same engraver.

PUBLICATIONS
Unpublished

NOTES
Dikigoropoulos 1965–66, 237–79, esp. 246. Bishop Damianos: *PmbZ*, Band 1, no. 1202. Specimen in the Cyprus Museum, Nicosia: Papageorghiou 1995, 165. Byblos specimen: Cheynet, Morrisson, and Seibt 1991, 166, no. 241. All three previously known specimens and the seal engraver: Metcalf 2004, esp. 85, 368, no. 455. The description of the monogram is according to the typology of the cruciform invocative monograms established by Laurent 1952, pl. LXX.

—OK

Roman Solidus

Mint of Constantinople, officina (workshop) Є, 430–440 c.e., reign of Emperor Theodosius II
Purchased in 1963 from Michael Symeon, found in Polis, east of the hospital
Gold; diam. 20.7 mm., weight 4.4 grams, die axis 12
Polis Chrysochous, Local Museum of Marion and Arsinoe (MMA 268; formerly Nicosia,
Cyprus Museum 1963/VIII-28/1)

Obverse: DN THEODOSIVS PF AVG (Our Lord Theodosius, Pious, Happy, Augustus). Helmeted three-quarter-facing bust of Theodosius, wearing a cuirass and pearled diadem, holding spear over shoulder with right hand, and shield over left shoulder depicting horseman spearing prostrate adversary.
Reverse: VOT XXX MVLT XXXX (Congratulations on 30 [years], Looking forward to 40) Є. Personification of Constantinople enthroned left, holding cross-globe in right hand and scepter in left, left elbow resting on shield at her side, foot on a ship's prow; in exergue: CONOB (Constantinople, Refined Metal).

The legend on the reverse of this coin shows that it was issued to celebrate a *decennalium* (ten-year anniversary) of Theodosius II's reign. Roman anniversary issues were sometimes coordinated with important centennials, and the reverse type of this coin—an enthroned personification of the city of Constantinople—shows that this issue also celebrated the centennial of the dedication of that city, which took place exactly a century earlier, on May 11, 330. The CON in the exergue identifies the mint of the coin, and the OB stands for *obrysius*, signifying well-refined gold. The Є at the end of the legend indicates that this was struck in the fifth of the ten workshops of the mint of Constantinople.

PUBLICATIONS
Unpublished

NOTES
RIC 10, 259, no. 257; Hahn 1989, 28, 60 no. 25b; Grierson and Mays 1992, no. 381.

—AMS

96

Byzantine Solidus

Mint of Constantinople, officina (workshop) Γ, 567–578 C.E., reign of Emperor Justin II
Gold; diam. 21.4 mm., weight 4.4 grams, die axis 1
Found by Princeton at Polis-Petrerades, trench E.F1:r05 extension, in 1988
Nicosia, Cyprus Museum (Princeton Cyprus Expedition R2589/NM576)

Obverse: D N IVSTINVS P P AVG (Our Lord Justin, Father of the Country, Augustus). Frontal beardless bust of Justin II, wearing a cuirass, pearled diadem, and crested helmet, and holding a shield decorated with a horseman spearing a fallen enemy. At the left, a Victory on a globe extends a crown toward the emperor.
Reverse: VICTORIA AVGGG Γ (Victory of the Augusti). Personification of Constantinople seated frontally on a throne, looking right, holding a spear in right hand and a cross-globe in left; in field left, C; in exergue: CONOB (Constantinople, Refined Metal).

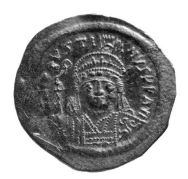 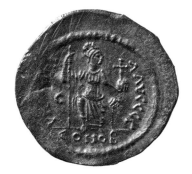

This is the only gold coin found in Princeton's excavations at Polis. Unfortunately, its context provides little information on the history of the site, as it was found in disturbed soil above a Late Antique house.

Hahn in 1975 interpreted the C on the reverse as signifying the third year of Justin's rule (i.e., 567–68), but in the revised version of his corpus in 2009, he suggested that it referred to the elevation of his adopted son Tiberius II to the rank of Caesar (i.e., presumptive heir) in 574. The CON in the exergue identifies the mint of the coin; OB stands for obrysius, signifying well-refined gold; and the gamma at the end of the legend indicates that this was struck in workshop number three.

PUBLICATIONS
Unpublished

NOTES
Hahn 1975, 38, 91, no. 3a; *DOC* 1, 200, no. 7a; Hahn and Metlich 2009, 21–22, 80, no. 3a.

—AMS

Byzantine Follis

Mint of Constantinople, officina (workshop) A, Class 1, July 11–December 25, 813 C.E.,
reign of Emperor Leo V, the Armenian
Found by Princeton at Polis-Petrerades, trench E.F2:r06, in 1984
Bronze; diam. 22.8 mm., weight 5.06 grams, die axis 12
Paphos District Museum (Princeton Cyprus Expedition R322/NM227)

Obverse: LEON BASIL (Leo Emperor). Facing bust of Leo V, bearded, wearing *chlamys* (a short mantle)
and crown with cross; holding cross potent in right hand and *akakia* (roll of silk) in left.
Reverse: M; above: cross; left: XXX; right: NNN; below: A (officina mark).

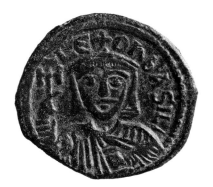 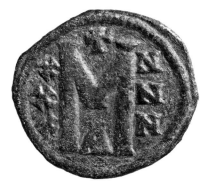

Cyprus remained part of the Byzantine Empire through the eleventh century, and coinage from mainland mints continued to circulate there. This coin can be dated to the second half of the year 813 C.E., between Leo's accession as Byzantine emperor on July 11 and the elevation of his son Constantine as co-emperor on Christmas Day of that year. The reverse type of M indicates the denomination 40 nummi, the value of the follis, the standard bronze coin of the Byzantine Empire. The letters to left and right of the M are derived from letters on the coins of earlier emperors that indicated the regnal year but by this period had become just decorative marks. The A between the legs of the M indicates workshop number one (the only one active in this period).

The coin was found in Area E.F2 in the south side aisle of the basilica, which was built in the sixth century and was in use to about 1000 C.E. This area of the building was reused, and perhaps refurbished, as a burial chapel after its original construction. The coin was discovered in the sifting of the soil of the fill underneath a later plaster floor. Coin finds are notably rare in Cyprus from this period of the "condominium" of rule of the island between the Byzantine Empire and the Abbasid Caliphate; neither Byzantine nor Islamic issues are regularly found in excavations or as stray finds. The island does not appear to have benefited from the upturn in bronze coinage found on other Byzantine sites of the ninth through eleventh century.

PUBLICATIONS
Unpublished

NOTES
DOC 3, 377–78, no. 6; Pitsillides and Metcalf 1995, 9; Metcalf 2001, 138.

—AMS

98
Byzantine Oil Lamp

Cypriot, late 6th–7th century C.E.
Found by Princeton at Polis-Petrerades, trench E.G0:g10, in 2000
Ceramic; h. 3.62 cm. (without handle), l. 9.05 cm., w. 6.85 cm.
Polis Chrysochous, Local Museum of Marion and Arsinoe (Princeton Cyprus Expedition R29841/LA499)

Condition: Good, with minor losses along the ridge on the top, some cracks, and partial flaking of the surface. Blackening around wick hole and nozzle.

Of orange clay with black inclusions, this mold-made lamp is ovoid in shape with a strong biconical profile. It rests on a low ring base and has a rudimentary lug handle. The lamp was filled with oil by means of a circular opening at the top, while the wick rested in the obliquely cut wick hole opposite the handle. Beginning at the base of the handle and encircling the wick hole at the other end, a raised ridge runs round the lamp's top. Within this outer ridge, a smaller, horseshoe-shaped one terminates in two pellets and frames the filling hole. The lamp's decoration is completed by bands of raised rays on the shoulder. Based on comparisons with related examples discovered in Cyprus and abroad, the lamp may be assigned to the late sixth or seventh century C.E.

The lamp was found, along with a second example ascribed to the sixth century C.E. (Princeton Cyprus Expedition R29842/LA500), during the excavation of one of the external burial pits constructed along the north wall of the Late Antique basilica in Area E.G0. Both lamps were located in the northeastern corner of the second burial pit from the east, in the fill overlaying a deep layer containing unarticulated human bones. Lamps are a relatively common find in Late Antique Christian mortuary contexts, and their presence has been associated with Christian burial rites and with beliefs regarding the afterlife in God's eternal light. The funerary use of lamps is also documented elsewhere in Cyprus, as, for example, in a tomb for multiple burials excavated at Amathous and dated to the seventh century C.E. The presence of the lamps in the burial pit at Polis could imply that, despite an apparent hastiness in the deposition of the dead there, some concern for observing the appropriate customs was maintained.

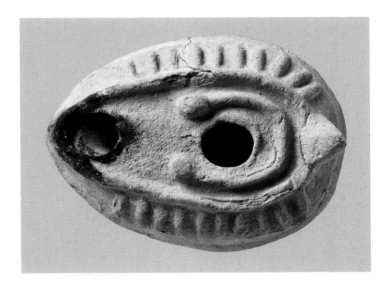

PUBLICATIONS
Unpublished

NOTES
The closest parallel is Oziol 1977, no. 776, pl. 43. Related lamps have been recovered from Amathous, Salamis, Alassa, the Kornos Cave, and Kalavasos-Kopetra, and are usually dated to the late sixth or seventh century: Prokopiou 1995, 261–64; Rautman 2003, 105, fig. 3.41 (II-6-1). J. W. Hayes has postulated a Cypriot provenance for some of the examples recovered from the island (Hayes 1980, no. 346, pl. 41). Outside Cyprus, comparable Byzantine lamps occur in various sites in the eastern Mediterranean, including the Aegean and Syria-Palestine: Prokopiou 1995, 261–64. Lamps and the afterlife: Bouras and Parani 2008, 22–23. Basilica in Area E.F2: Najbjerg, Nicklies, and Papalexandrou (A.) 2002, 147, 149, fig. 8. On the sixth-century companion lamp: Oziol 1993, no. 115.

—MGP

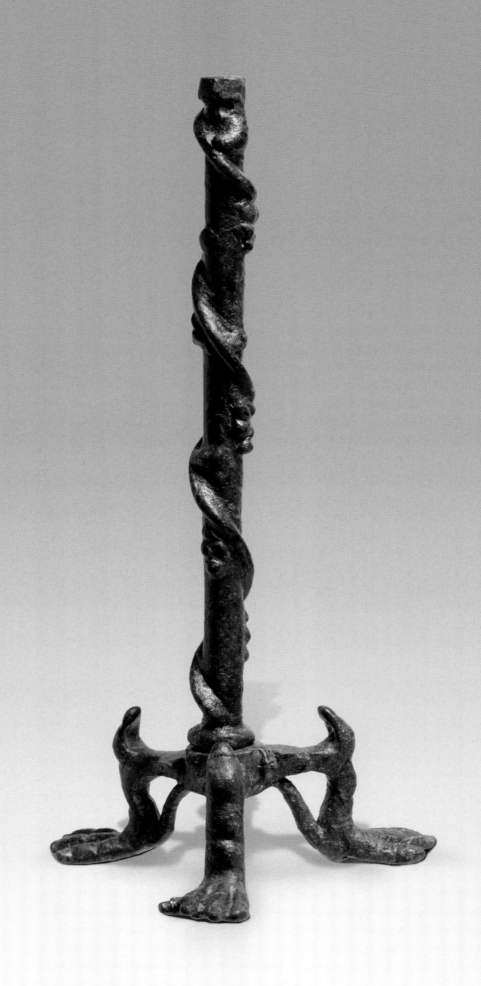

99
Lamp Stand

Cypriot, after the 4th century C.E. and before 610–641
Found by Princeton at Polis-Petrerades, trench E.F2:g10, in 2003
Copper alloy; h. 21.9 cm., weight 381 grams
Polis Chrysochous, Local Museum of Marion and Arsinoe (Princeton Cyprus Expedition
R38489/BR1442)

Condition: Top part missing; elements of the tripod base broken off.

The surviving portion of this elegant lamp stand is constructed from two parts cast separately and then joined together. The tripod base consists of three legs terminating in webbed animal feet. The decoration of the slender shaft comprises a vine with schematically rendered bunches of grapes and leaves wound around the stem from the base to the top.

The vine was an element of Dionysiac imagery in use throughout Roman and Late Antique times in both pagan and Christian contexts. Dionysos, the god of wine, was also associated with fire, and nocturnal rites with lit torches formed part of his cult. The vine on a lamp stand would certainly not be an inappropriate motif for use in a pagan milieu. With the advent of Christianity, the vine was endowed with new meaning as a symbol of Christ (John 15:1), who was also equated with light and life (John 8:12). Interestingly, vine scrolls weighted by grapes decorate the fantastical candelabrum depicted in the floor mosaic of the church of Saint John the Baptist in Jerash, Jordan, dated 529–533 C.E.

This lamp stand was discovered against the outer wall of a well, located across a paved street from the southwestern corner of the Christian basilica in area E.F2. A bronze coin of Herakleios (610–641 C.E.) recovered from the same context (Princeton Cyprus Expedition R38491/NM1682) suggests that the lamp stand was probably deposited in the well sometime during the seventh century C.E., although its date of manufacture remains undetermined due to the lack of securely dated comparable examples.

The tripod base belongs to a well-known type that is encountered on both Roman and Late Antique lamp stands. Still, the webbed feet of the Polis example are unusual, as is the shaft encircled by the vine. A number of Roman lamp stands have shafts organically shaped like tree trunks rather than shafts with vines wound around them. A square impression on the lamp stand's base, if this is indeed a stamp or an imitation of one, would suggest a date after the fourth century C.E. The practice of stamping silver vessels for control purposes is attested from that century onward. Stamps on copper-alloy lamp stands, imitating the stamps on silver examples, have been identified on the base of two stands ascribed a seventh-century date. Based on this information, the Polis stand probably dates after the fourth century C.E.

PUBLICATIONS
Unpublished

NOTES
Comparable tripod bases: Milliken 1958, 37–38; Bailey 1996, nos. Q3867–74, Q3877–81, Q3887, Q3898, Q3901, Q3911, Q3912EA; Xanthopoulou 2010, nos. CD 4.004, CD 4.010, CD 4.011. Lamp stands with tree-shaped shafts: Hayes 1984, no. 232; Bailey 1996, nos. Q3885-93, Q3896-98; Bénazeth 2001, nos. 33, 34. Stamping silver vessels: Dodd 1961, 3–5. Stamped copper-alloy stands: Mundell Mango 2003, 64–67. Cult of Dionysos: Otto 1981. Jerash mosaic: Bouras and Parani 2008, fig. 12.

—MGP

Belt Buckle

Late 5th–early 6th century C.E.
Found by Princeton at Polis-Petrerades, trench E.G0:g10, in 2000
Bronze with glass; h. 4.29 cm., w. 3.78 cm., th. 1.36 cm.
Polis Chrysochous, Local Museum of Marion and Arsinoe (MMA 109; Princeton Cyprus Expedition
R30833/BR1234)

Condition: Green glass inlay missing in three of the central petals; amber-colored glass inlay is crushed
and partially missing in one side panel. Fold of hinge on underside is slightly broken off, as are the two
rivets on either side. Traces of fabric may survive between the hinge folds.

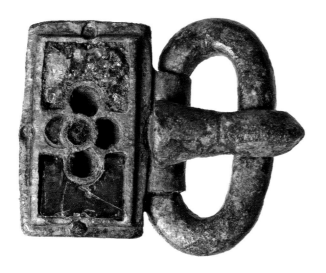

The buckle consists of a decorative cloisonné plate attached to the loop by means of a hinge folded over the axle. The prong is cast solid with the hinge. Three rivets were soldered into the frame of the plate, two of which are visible on the back. The attached plate is embellished with polychrome inlay: the central quatrefoil of green glass is nestled within a rectangular framework of amber-colored glass or glass paste. A tiny punch was used on the bronze surface surrounding the central rosette and the loop to create a border of minuscule dots, now barely visible. We can only imagine the original effect of this once sumptuous and colorful object.

The buckle was discovered near the bottom of one of the large ossuary pits attached to the north wall of the basilica in Area EG.0. It was one of six buckles, of various styles, that were associated with a meter-deep deposit of commingled human bones and fill. At the top of the fill were two oil lamps, including catalogue number 98, placed near the articulated burial of a single individual. The buckle, then, must predate or be contemporary with these late sixth- or seventh-century lamps. It indicates the presence, both in Arsinoe and in this particular ossuary (ossuary 5), of individuals, presumably male, who used buckles to close the *cingulum*, Roman belt, worn to secure tights, pants (βράκια), or a tunic. The precious metal and sophisticated decoration of the belts found in this ossuary suggest that those interred here were of high, perhaps semi-official status. Only an individual of means and high position could have afforded and enjoyed the rich and colorful effects of such sumptuous objects.

A similar, if more elaborate, plate-and-loop buckle with cloisonné panel in Munich is dated to the late fifth/early sixth century and said to be from Syria. Two others from Jordan, both, however, with a central cabochon, have been similarly dated to the late fifth/early sixth century.

PUBLICATIONS

Papalexandrou (A.) 2012, 38–39.

NOTES

Syrian buckle in Munich: Wamser and Zahlhaas 1998, 234. Jordanian buckles: Eger 2003, 170, fig. 2. Use of buckles: Russell 1982, 145–46.

—AP

101

Cross

6th–11th century C.E.
Found by Princeton at Polis-Petrerades, trench E.F2:r06, quadrant r08, in 1984
Bronze with gold and pseudomorph textile; h. 10.5 cm., w. 8.13 cm., th. 0.35 cm.
Nicosia, Cyprus Museum (Princeton Cyprus Expedition R407/BR16)

Condition: Some corrosion surrounding applied decoration; sporadic patches of what may be gold leaf visible on the surface. Remnants of the fabric on which the cross lay are still preserved on its reverse.

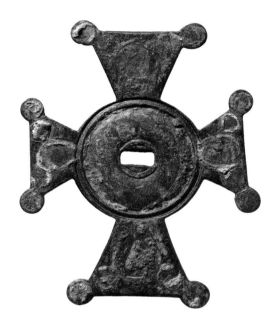

This solid-cast bronze cross is conceived as a disk with radiating arms. A border of two ridges separates the central element from the four cross-arms, which flare out and terminate in circular serifs, or drop motifs. The cross-arms are shorter on the sides, whereas the upper and lower arms differ in size, perhaps indicating an original orientation. A circular depression at the center of the cross preserves a rectangular hole for its attachment to a leather or wooden surface or to receive a central medallion. The cross was originally embellished with applied ornament of unknown material, remnants of which survive on its obverse. This formed a pattern of circles and teardrop motifs attached to the cross-arms.

The original function of the cross is unclear. It may have been used in connection with the E.F2 basilica in which it was found, perhaps as a lock plate, as architectural decoration, or as an attachment to embellish liturgical furniture. There are no attachments or fittings to indicate its use as a processional cross, and no bezel or suspension hole to suggest it was originally a pectoral cross. It may have been a simple votive cross, offered to the church in fulfillment of a vow. Whatever its original use might have been, it was eventually repurposed in service of an individual of some importance who was buried in the south aisle of the basilica near the apse. The central in a series of three constructed tombs, this sealed burial (Burial 17) contained the remains of a young adult male, aged 17–25 years. His body was interred with the bronze cross at his right hip. A number of looped bands (also bronze) were found close by, presumably for its suspension through the central hole. A coin found in the tomb indicates only that both cross and burial date after the fifth or sixth century C.E.

PUBLICATIONS
Unpublished

NOTES
Aniconic crosses such as this are far more common than those with figural imagery or inscriptions but much more difficult to date. Examples of sixth- or seventh-century processional crosses from nearby Syria-Palestine offer reasonable comparisons (Cotsonis 1994, 88–99), but so do examples of the ninth century onward. An inscribed votive cross from Dumbarton Oaks, similar in size to the Polis cross, has been assigned a seventh-century date. Its attachment to a wall or column in a church is attested by the surviving lead in which it was embedded for display (Kalavrezou 2003, 67). Applied ornament is more common after the twelfth century (Toumazes et al. 2004, 81–83). The disklike center of the Area E.F2 cross, with similar rectangular hole, can be found in a sixth-century bronze cross in the Tsolozide Collection in Athens and may suggest favoring an earlier date, contemporary with the sixth- or seventh-century church (Zapheiropoulou 2001, 39).

—AP

102

Pectoral Cross

Probably Cypriot, Byzantine
Found by Princeton at Polis-Petrerades, trench E.F2:t06, in 1989
Steatite (picrolite?); h. 2.2 cm., w. 1.8 cm., th. 0.67 cm.
Polis Chrysochous, Local Museum of Marion and Arsinoe (Princeton Cyprus Expedition R4647/ST92)

Condition: Surface lightly abraded on one side and along lower cross-arm of the opposite side, as if subjected to prolonged handling or rubbing over time.

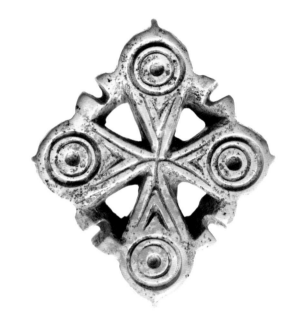

This pectoral cross pendant is diamond-shaped with a pull hole discreetly carved into the upper arm of the cross. The surface design, which is the same on both sides, was formed by carving deep, triangular sections into the stone. These form the cross-arms that are incised with fine lines and have rounded terminations articulated by drilled concentric circles. The sides are notched in the interstices of the cross-arms and have slight projections carved at the terminations so that the edges undulate.

The cross was found in the cemetery area southeast of the basilica in Area E.F2, near the juncture of the south apse and the south portico. It was not associated with a burial, but it seems a reasonable assumption that it was once part of one, given its find spot in the cemetery and the funerary association of all other pectoral stone crosses at Polis. The cross has an almost identical parallel in a picrolite cross recently excavated in Nicosia by Yiannis Violaris of the Department of Antiquities of Cyprus. Dated to the twelfth century, it was found in levels associated with Church B, below the Palaion Demarcheion, in what appears to have been a workshop that produced picrolite crosses.

PUBLICATIONS

Papalexandrou (A.) 2012, 33.

NOTES

Flourentzos 2004–5, 1684.

—AP

103
Pectoral Cross

Late Antique or Byzantine
Found by Princeton at Polis-Petrerades, trench E.F2:t06, in 1990
Faience; h. 2.04 cm., w. 1.6 cm., th. 0.62 cm.
Polis Chrysochous, Local Museum of Marion and Arsinoe (Princeton Cyprus Expedition R7277/FI4)

Condition: Decayed on one side in the area of the lower cross-arm and across the entire surface of the opposite side where decoration is largely worn off. This is due either to erosion over time or to frequent handling or rubbing by the wearer.

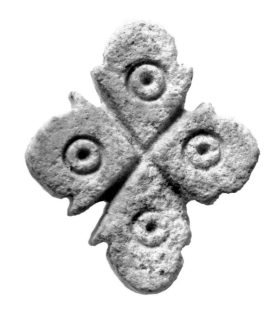

This cross pendant consists of four arms separated by an X-shaped incision at the center. The cross-arms are in the shape of petals, notched and with rounded termini. Each is embellished with a drilled circle enclosing a dot; the surface design is the same on both sides. The upper cross-arm is pierced by a round hole to accommodate a thin chain or thong. The motif of circled dots is exceedingly common in Late Antiquity and was apotropaic in function. Its presence on pectoral crosses is appropriate since the wearer believed both pendant and decoration to be beneficial in combating evil as well as in aiding devotion.

This faience cross was one of two pectoral crosses found together in a burial (Burial 11) just southeast of the juncture of the south apse and south portico. The sex of the individual was not determined, but the person certainly was a young adult, eighteen to twenty years old, and the crosses were found at the collarbone of the deceased. The companion cross differed in its material (picrolite) and square shape but shared the feature of circled dots. The young individual who wore the two pendants was no doubt considered doubly protected.

PUBLICATIONS

Papalexandrou (A.) 2012, 33.

NOTES

A glass paste version of the pendant was discovered in a sondage at the basilica of Soloi, in a late (post-12th-century) burial in the cemetery (Tinh 1985, 97). A similar pendant cross made of calcite was found in a burial at Alahan monastery, in southern Asia Minor: Gough 1985, 74, fig. 13, no. 24c. Apotropaic function of motifs: Maguire, Maguire, and Duncan-Flowers 1989, 5–6; Pitarakis 2006, 164. Age of the individual interred: Buck 1993.

—AP

Pectoral Cross

Probably Cypriot, Byzantine or later
Found by Princeton at Polis-Petrerades, trench E.F2:r06, in 1984
Stone (picrolite?); h. 3.4 cm., w. 3.1 cm., th. 0.58 cm.
Polis Chrysochous, Local Museum of Marion and Arsinoe (Princeton Cyprus Expedition R323/ST1209)

Condition: Small abrasions to the surface on one side, which is also slightly darker and rougher to the touch than the reverse. The edge of the lower cross-arm has been carved out slightly with a small tool.

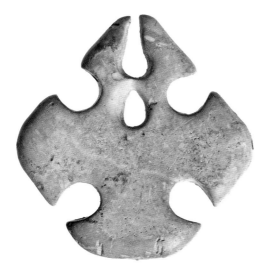

This pendant is a single piece of soft, greenish white stone into which small, horseshoe-shaped segments were carved in the corners to achieve a cruciform shape. It is lightly buffed on all surfaces except the insides of the carved channels, which are unpolished. The three lower cross-arms are rounded, flare outward, and have pointed terminations at the sides. The remaining cross-arm, at the top, is pointed, with a narrow channel cut on the vertical axis. This widens and forms a circular hole intended to accommodate a thong or chain for suspension, which by necessity would have been wider than the channel in order to remain in place. Immediately below it is a second hole in the shape of a teardrop, possibly a later addition made to replace the less useful hole above it.

While a number of stone crosses have been discovered in the E.F2 cemetery, this one is unique and may be a local product, perhaps carved from saponite or soapstone readily available in the area. It was found in the grave (Burial 11) of an older adult (sex undetermined), 10 centimeters below the mandible and therefore used as a pectoral cross that was worn around the neck of the deceased. The burial was dug into the area of the south portico of the church; the feet rested in the area of its eastern wall. In other words, the burial was placed in what had been a closure wall or perhaps a thoroughfare that was no longer in use and presumably not visible. Burial here, just below topsoil in the highest burial excavated, indicates a date well beyond the original Late Antique phase of the basilica, perhaps even later than the eleventh century C.E., after the portico had fallen out of use or collapsed.

PUBLICATIONS
Unpublished

—AP

105
Pectoral Cross

Probably Cypriot, 7th–11th century C.E.
Found by Princeton at Polis-Petrerades, trench E.F2:r06, in 1984
Stone (picrolite?); h. 3.46 cm., w. 2.12 cm., th. 0.85 cm.
Polis Chrysochous, Local Museum of Marion and Arsinoe (Princeton Cyprus Expedition R96/ST1208)

Condition: Multiple breaks, mended after excavation. Loop at top is broken off, one side-arm entirely broken near termination so that core of stone is visible, numerous scratches on surface.

The cross is stone, either steatite or the local equivalent, picrolite, which is quarried on Cyprus. Its surface is painted dark blue while the core is light green to beige; perhaps it was baked and/or polished. The upper and lower cross-arms are equal in length, as are the side cross-arms; all flare out at the terminations, which are nearly round in section and cut flat at the outer edge. There are no distinguishing features to differentiate front from back, although one side is slightly darker and may indicate that it faced the wearer. The upper cross-arm is extended and pierced laterally to accommodate a suspension loop.

The cross was discovered within a cist burial just below topsoil in the area of the south portico. Here, a cluster of graves, crudely constructed and without cover slabs, was dug into what was formerly the southeast corner of that space. The existence of glazed pottery in this level indicates a date much later than the basilica. The age and sex of the individual buried here (Burial 5) are unknown; we can only say that he or she was buried with this cross, which was found below and slightly northwest of the skull. Simple crosses of this type were commonly worn throughout the eastern Mediterranean at all times from the fifth century onward but are only sporadically published, often without context. Several examples from the area of the E.F2 basilica attest to its popularity for those buried in this cemetery. An exact replica was found in 1990 in a burial east of the basilica. It bears the same surface treatment and differs only in its smaller size.

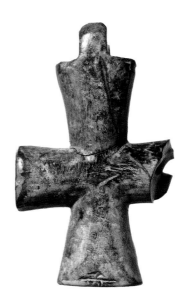

PUBLICATIONS
Unpublished

NOTES
A bone cross said to be from the eastern Mediterranean and dated to the fifth to seventh century C.E. offers a nearly identical parallel but with a blue glass inlay in the center: Wamser and Zahlhaas 1998, 199.

—AP

106

Sgraffito Bowl

Cypriot, late 13th–14th century C.E.
Found by Princeton at Polis-Petrerades, trench E.G0:d13, in 2006
Ceramic with lead glaze; h. 8.8 cm., diam. 14.88 cm.
Polis Chrysochous, Local Museum of Marion and Arsinoe
(Princeton Cyprus Expedition R49372/PO1884)

Condition: The surfaces of the bowl are well preserved, bright, and hard. The bowl was probably originally buried intact but was found broken as a result of later deposition. It was repaired after excavation. Several small pieces are still missing.

An example of a carinated bowl, a characteristic shape in Cypriot production, this vessel, with its polychromy, hard glossy finish, and lack of use wear, was probably a moderately high status piece for special occasion use. The bowl was associated with Burial 34A excavated in 2006, located in the narthex of the basilica in Area E.G0. It was found near the edge of a burial that contained the remains of several individuals, clearly used for more than a single interment. Which specific funerary activity this particular bowl was associated with is now difficult to determine.

Fired to a hard finish, the bowl was constructed from a gray fabric with fine sandy inclusions. The ring base is of medium height and is upturned in a form typical of production in the Paphos/Lemba region, south of Polis. Local production of these bowls near Paphos began at the end of the twelfth century, and the industries expanded quickly. Bowls of this type are found all over Cyprus and were exported to markets across the eastern Mediterranean.

While holding the base, the maker dipped the bowl into white glaze, covering the interior and the exterior to just below the carination in the body. The interior was then decorated by making incisions through the slip into the fabric below, a technique known as sgraffito. Concentric rings articulate the interior just below the rim and just above the carination. Below that point, the basin of the bowl is decorated with a symmetrical motif composed of a band bisecting the bowl and two arched bands. The interstices between the bands are filled with looped scribbles, called imbrication, suggesting background and foreground. Alternating splashes of brown and green highlight the four quadrants of the curved motif. The bowl was then dipped again in a greenish lead glaze covering the interior and upper part of the exterior. Before the bowl was fired, a green glaze was applied to the straight sides of the exterior above the carination. Flaws in the glaze and slip inside the bowl indicate that tripod stilts were used to stack bowls in the kiln. This is characteristic of sgraffito production after the thirteenth century. As yet, no production sites have been located in the Polis area.

PUBLICATIONS
Unpublished

NOTES
Bowls with this shape and motif are common on Cyprus, e.g., Piltz 1996, 28, no. 11 and unpublished examples on display in the Paphos District Museum.

—KLK

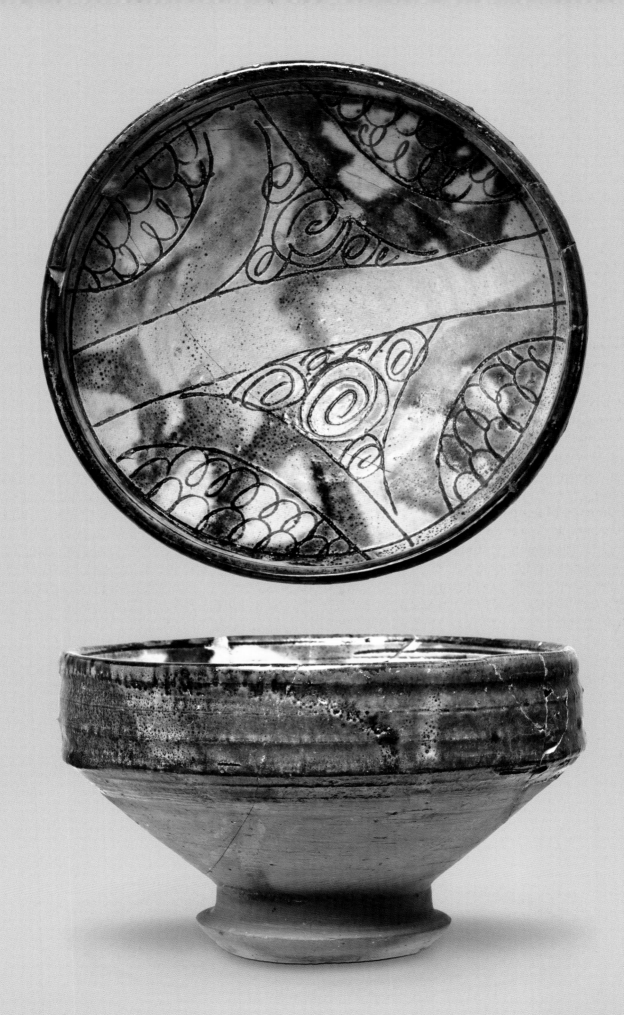

107

Sgraffito Bowl

Cypriot, late 13th–14th century c.e.
Found by Princeton at Polis-Petrerades, trench E.G0:d13, in 2006
Ceramic with lead glaze; h. 6.3 cm., diam. 13.7 cm.
Polis Chrysochous, Local Museum of Marion and Arsinoe (Princeton Cyprus Expedition R49067/PO1863)

Condition: The rim of the bowl was worn and chipped in antiquity. The glaze has cracked and has spalled in some places. The bowl appears to have been buried whole and to have broken in half under the weight of later deposition. It was repaired after excavation.

This is an example of a hemispherical bowl that is relatively uncommon on Cyprus. Few bowls of this specific size and shape have been reported from excavation. The bowl was associated with Burial 34A, excavated in 2006, located in the narthex of the basilica in Area E.G0. There were the remains of several individuals within the burial cut, and the skeletons were largely disarticulated in a way that suggests reuse of a burial context. While this intact bowl was likely part of the grave goods associated with a burial ceremony, its precise burial context seems to have been disturbed in antiquity. Other associated artifacts include iron nails, presumably from a coffin, and several fragments of pottery and roof tiles.

The bowl was thrown on the wheel using a salmon fabric with fine sandy inclusions and then was hard fired. The ring base is of medium height and has a straight profile. While holding the base, the maker dipped the bowl into white glaze, covering the interior and the upper three-quarters of the exterior. The interior was then decorated by making incisions through the slip, a technique called sgraffito. The craftsperson made a design of stylized leaves in a concentric pattern just under the rim. In the spaces outside the leaf design, the background was filled with looped scribbles, a technique called imbrication. The band of sgraffito decoration was then colored with splashes of alternating green and brown color. The bowl was then dipped in a greenish lead-based glaze that again covered the interior and upper three-quarters of the exterior. Flaws in the glaze and slip inside the bowl indicate the use of tripod stilts used to stack bowls in the kiln.

Sgraffito wares of this type are the most common decorative ceramics in Polis, and in Cyprus generally, from the twelfth through at least the sixteenth century. They have been discovered in contexts varying from domestic table use to ritual contexts, like the burial in which this bowl was found. The wear on the rim and surface of the bowl suggests that it was regularly employed as a utilitarian article prior to its eventual use as a funerary object.

PUBLICATIONS
Unpublished

NOTES
Compare Papanikola-Bakirtzis 2002, 257–8 and an unpublished bowl on display in the Pierides Foundation Museum, Larnaka.

—KLK

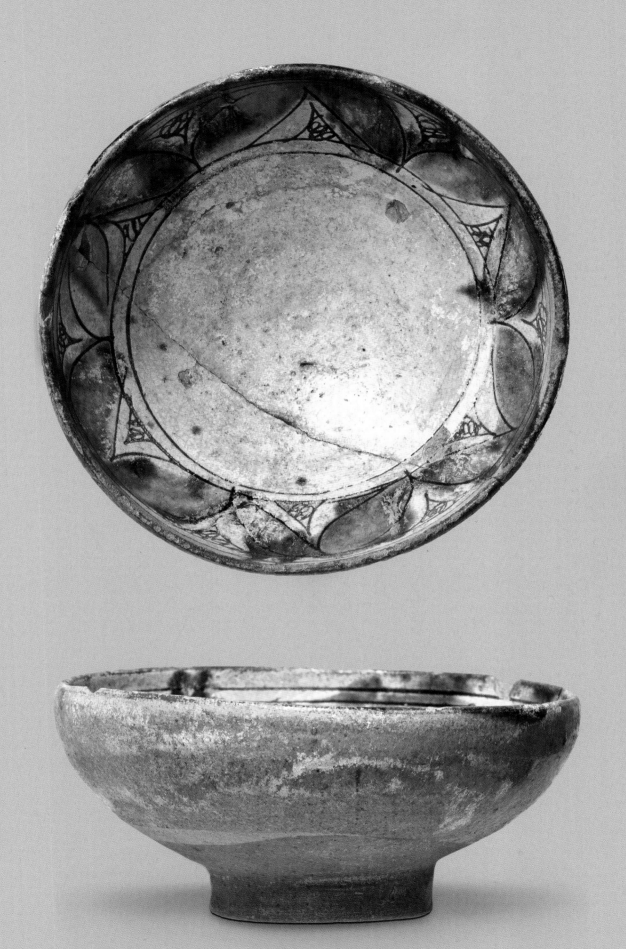

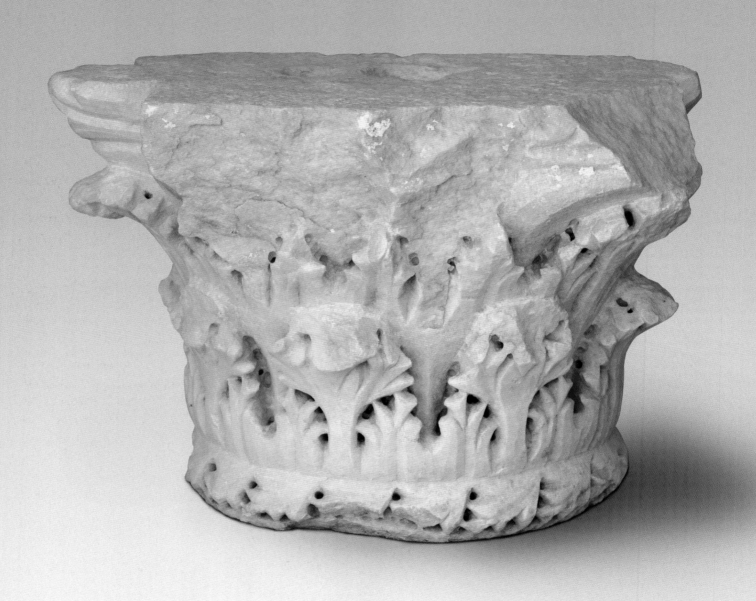

Corinthian Column Capital

Late 5th–late 6th century C.E.
Found by Princeton at Polis-Petrerades, trench E.F2:p07, in 1989
Marble; h. 30 cm., w. 52 cm. (max.), diam. 32 cm. (base)
Polis Chrysochous, Local Museum of Marion and Arsinoe (Princeton Cyprus Expedition R6385/AS123)

Condition: While the core of this capital is intact, many of its projecting sculptural elements were cut away in antiquity. Remnants of mortar from later reuse are still visible on parts of the decoration.

This capital once adorned the top of a column, probably in the arcade or architrave of a church. The astragal, bell, and volutes were all carved from a single piece of white marble, probably imported from Asia Minor. Holes on the flat top surface indicate where dowels were used to fix the capital in place. A wreath of acanthus leaves forms a narrow band of decoration separating the capital from the column on which it sat. The bell of the capital is surrounded by a double row of much larger acanthus leaves. The top of the capital originally consisted of four corner volutes in relatively low relief alternating with smaller volute buds on its straight sides. The carving is moderately shallow, but the use of drilling to decorate and provide relief adds to the textural richness of the design. This style of "fine-toothed acanthus" carving with a wreath of abbreviated acanthus at its base is typical of this period.

No volutes and only one of the intermediate buds survive. The leaves and parts of the bell were chipped off as part of a rough reshaping prior to the reuse of the capital in foundation repairs carried out at the basilica in Area E.F2, probably in the twelfth century. In 1989, excavators found the capital upside down against the foundation wall in the north aisle near the narthex. Thus, its reuse was part of an extensive renovation of the basilica. Whether this capital came from an earlier phase of the basilica or from another nearby church is not certain. The modification of the capital for use in the foundations, however, suggests that its aesthetic qualities were no longer appreciated by those who carried out the renovations.

PUBLICATIONS
Ćurčić 1999, 81, fig. 1.

NOTES
Soloi (inv. BAS 193 and Chapiteau C 6), though here without the characteristic torus molding: Tinh 1985, figs. 114b, 116. A number of exceptionally fine pilaster capitals at the Campanopetra basilica, at Salamis (AR704, AR717, AR738), appear to be products of the same workshop as the Polis capital; the schematic garland of downward-facing leaves on the torus is nearly identical in each: Roux 1998, figs. 115, 116, 152.

—KLK and AP

109

Corinthian Column Capital

5th–6th century c.e.
Found by Princeton at Polis-Petrerades, trench E.G0:h10, in 1995
White marble; h. 30 cm., w. 44 cm. (max.), diam. 28 cm. (base)
Polis Chrysochous, Local Museum of Marion and Arsinoe (Princeton Cyprus Expedition R30155/AS852)

Condition: The edges of this capital have been cut back, removing almost one-quarter of the capital on one side and all four volutes that originally projected from the corners. The carving around the bell of the capital is still sharp.

This Corinthian capital once sat atop a pier or column supporting arches or an entablature (as did cat. no. 108). It was carved from a single piece of marble that was either mass produced and shipped from the quarries of the Aegean coastland and central Anatolia or roughed out in these quarries and finished at a common workshop on the island. Four large acanthus leaves, carved in low relief, tightly hug the bell and surround the body of the capital. These leaves are conceived as flat decorative surfaces, picked out by sharp lines. The top of the capital originally consisted of four corner volutes in relatively low relief alternating with smaller volute buds on its straight sides. A shallow groove a few centimeters below the top of the capital forms a simple molding. While acanthus leaf decoration had clear associations with Classical models, the shallow, decorative aspects of the carving suggest a more abstract notion of the floral elements. This is typical of many similar capitals found in excavated sites on Cyprus and on the southern coast of Asia Minor.

This capital was found in 1995, inverted and reused as a base for an altar table. A large drill hole in what was originally the bottom of the capital once received a dowel to align it with the column underneath in its original position and later with a stone table above. Unlike the other Corinthian column capital featured here (cat. no. 108), this one was a piece of an earlier decorative program reincorporated into a new architectural setting. Whether the impetus for that reuse was ideological or practical, it represents a visible continuation of the past into a changing visual field.

PUBLICATIONS
Unpublished

NOTES
On Cyprus: two examples from the basilica at nearby Soloi (inv. BAS 77 and BAS 253): Tinh 1985, figs. 114a, 115; from the Campanopetra basilica at Salamis (AR 35, AR 936, and AR 725), a series of capitals may be products of the same workshop: Roux 1998, figs. 35, 323, 349. From the "Huilerie" at Salamis: Argoud, Callot, and Helly 1980, no. 2.72.102, pl. XXVIII.i. From Kourion come an assortment of similar examples, also of white marble and suggesting a common source: Megaw 2007, pl. 5.3, C24–28, C34–35. In Constantinople, a more elaborate capital from the sixth-century church of Anicia Juliana (Saraçhane) shows the same formal composition created by the voids behind adjoining acanthus leaf-tips: Harrison (R. M.) 1986, Corinthian Capital 3 e I, fig. 136. In Asia Minor: a capital from the bema of Church III on Gemiler Island: Asano 2010, GIII-324, pl. 68.1.

—KLK and AP

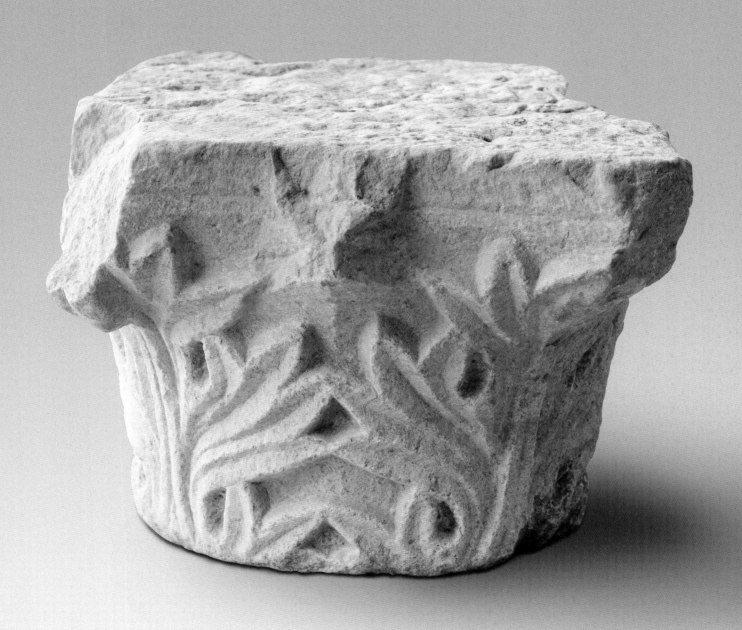

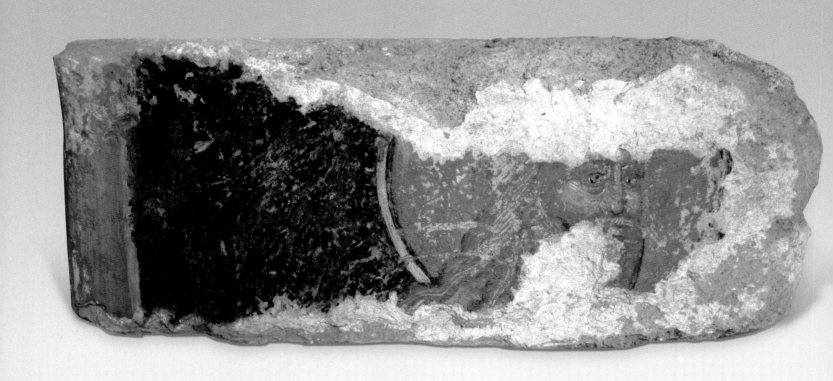

Mural Painting of a Male Saint or Prophet

Cypriot, ca. 1400 c.e.
Found by Princeton at Polis-Petrerades, trench E.G0:g12, in 1997
Limestone with painted plaster; h. 26 cm., 19 cm. (side with male head), 19 cm. (other painted side);
w. 44 cm., 38 (side with male head), 25.5 (other painted side); th. 19 cm.
Polis Chrysochous, Local Museum of Marion and Arsinoe (Princeton Cyprus Expedition R33666/AS1015)

Condition: Fragmentary.

A mural block from the excavations of a basilica in Area E.G0 preserves mural paintings on two sides. A carefully rendered head of a male figure is painted on a long side and an indistinct blue, red, and white design appears on a short side. The fresco paintings on the two sides of the block are not contemporary in date; the painting of the head was executed later than the decorative side (the plaster layer belonging to the figure extends over that of the blue, red, and white design). The paintings represent two distinct phases of decoration that are further evidenced by large quantities of fragmentary mural paintings found throughout the excavations in this area.

The block has been badly broken, damaging the painted head on three sides but leaving most of the face and the left side of the halo intact. The head is painted in a three-quarter view, facing the viewer's right, against an ocher-yellow halo. The figure's hair and beard, which are brown and highlighted with gray and white, flow over his right shoulder, extending beyond the frame of his halo into the deep blue of the painting's background. The eyes are brown and black, highlighted with white; the nose is straight, outlined with brown and white, and red paint is used to emphasize both the length of the nose and the shape of the cheekbones. A small section of a framing band is preserved to the figure's right. Painted a soft red, it is separated from the blue background of the main zone by a thin white line.

The long gray hair suggests that the figure was a prophet, perhaps Elijah, although this identification remains tentative. Certain stylistic characteristics in the painting, particularly the linear aspects and the delicate manner in which the details of the face and hair are rendered, probably place the paintings in the first half of the fifteenth century. Paintings from the cave-chapel of the

Palaia Enkleistra, near Kouklia (dated after 1439), share these stylistic characteristics, as do the roughly contemporary paintings from the church at Agios Andronikos in the modern town of Polis.

Archaeological data generally support a date in the early fifteenth century for the painting of the head. A coin dated about 1460–73 c.e. was excavated from the packing layer of a gypsum-tiled floor that extended above the block. This date serves as the latest possible date for the placement of the block in its reused position. When excavated, the red, white, and blue design on the short face of the block was situated on axis with a burial (Burial 1). In this arrangement, the painted head was placed upside down facing north.

PUBLICATIONS

Najbjerg, Nicklies, and Papalexandrou (A.) 2002, 152–53, fig. 14.

NOTES

Palaia Enkleistra, near Kouklia: Stylianou and Stylianou 1997, 391–400.

—SL

PLANS AND BUILDING RECONSTRUCTIONS

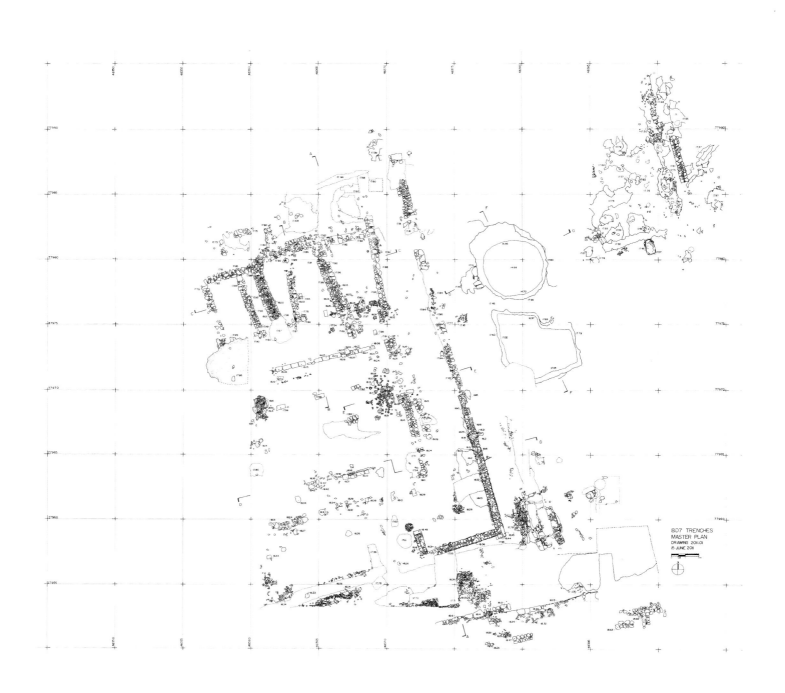

PLAN 1. Master Plan of Area B.D7 at Polis-Peristeries.

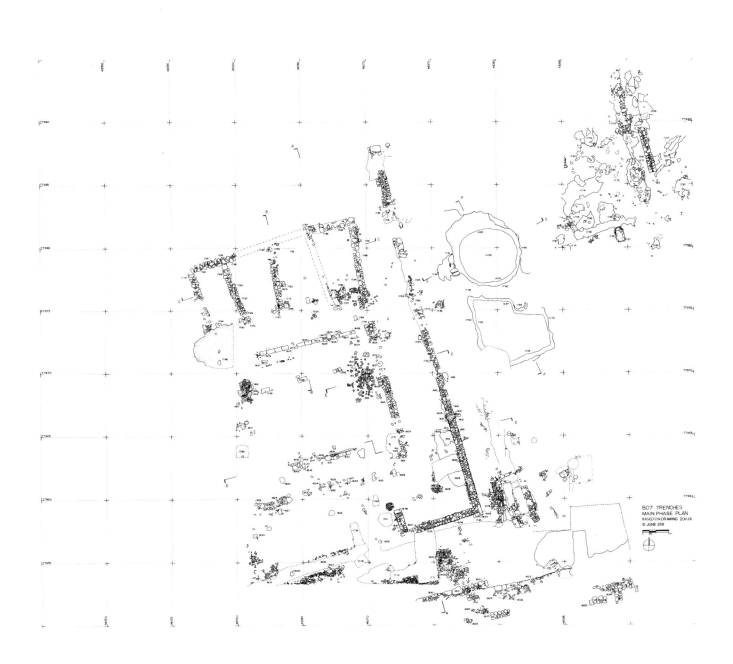

PLAN 2. Phase Plan showing Main Building phase in Area B.D7 at Polis-Peristeries.

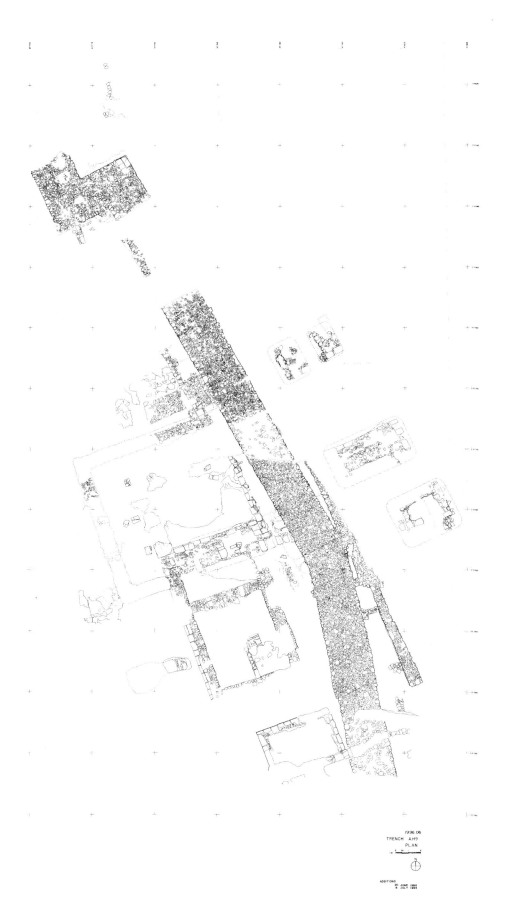

1996.06
TRENCH A.H9
PLAN

ADDITIONS
20 JUNE 1996
8 JULY 1996

PLAN 3. Master Plan of Area A.H9 at Polis-Maratheri.

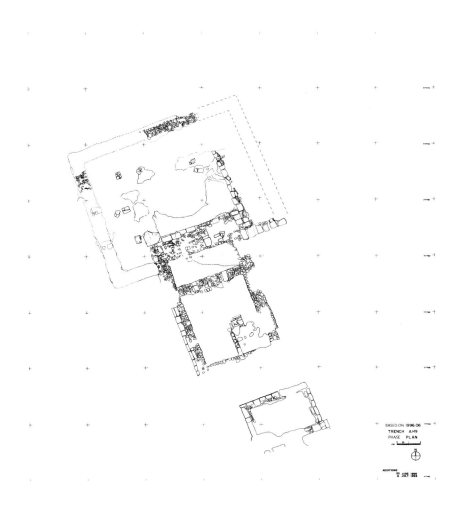

PLAN 4. Phase Plan showing pre-city-wall building phase in Area A.H9 at Polis-Maratheri.

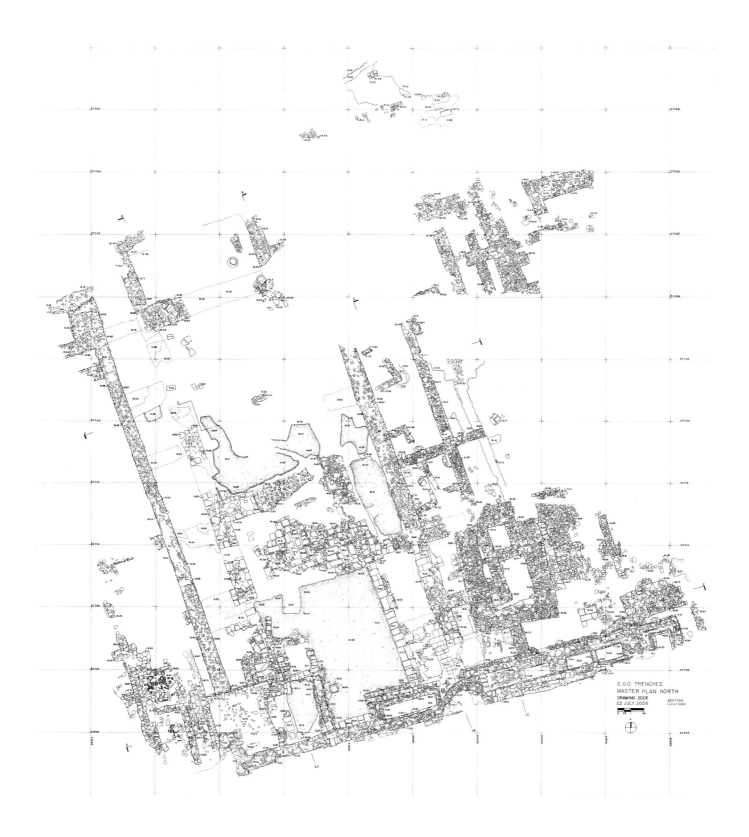

PLAN 5. Master Plan of Area E.G0 north at Polis-Petrerades.

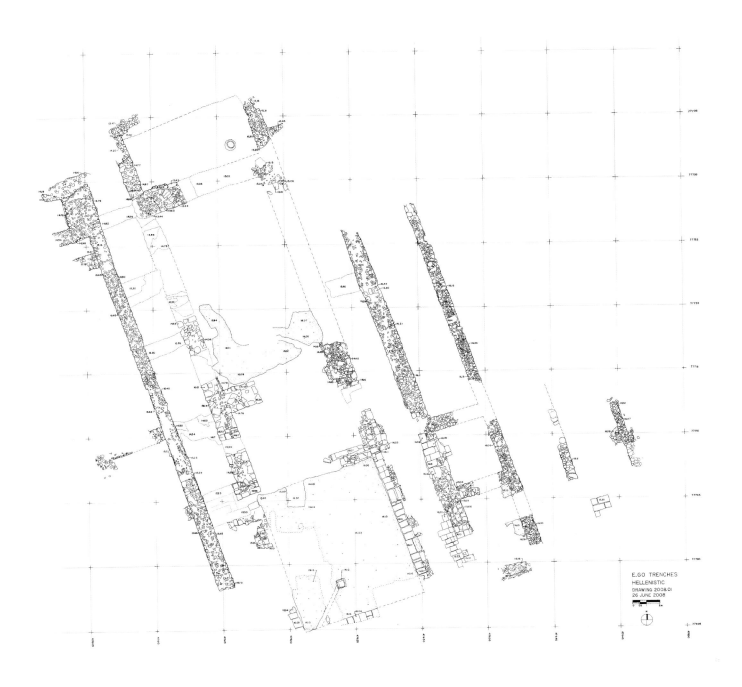

E.G0 TRENCHES
HELLENISTIC
DRAWING 2008.01
26 JUNE 2008

PLAN 6. Phase Plan showing Hellenistic building phase in Area E.G0 at Polis-Petrerades.

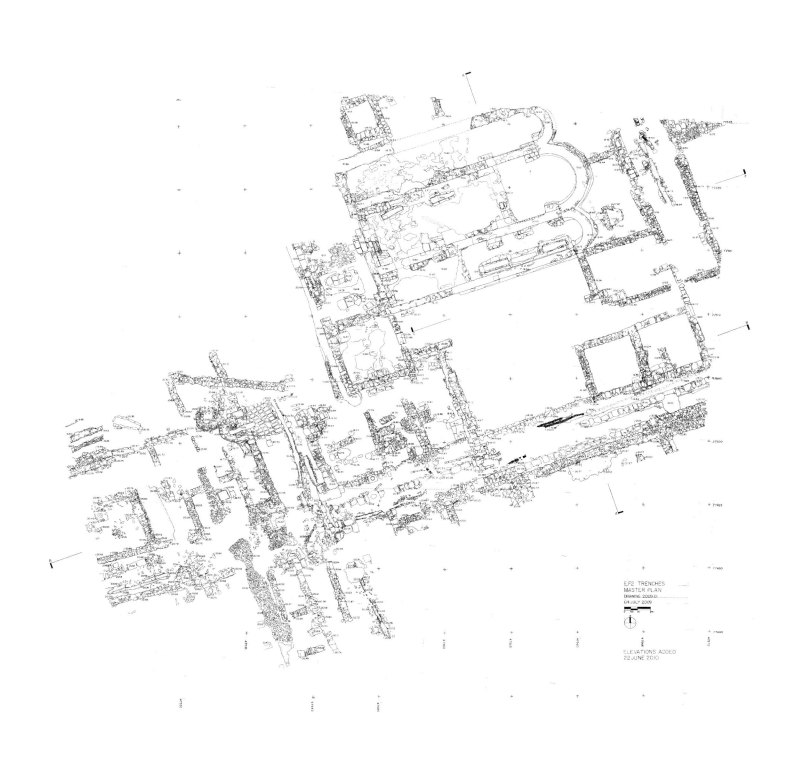

PLAN 7. Master Plan of Area E.F2 at Polis-Petrerades.

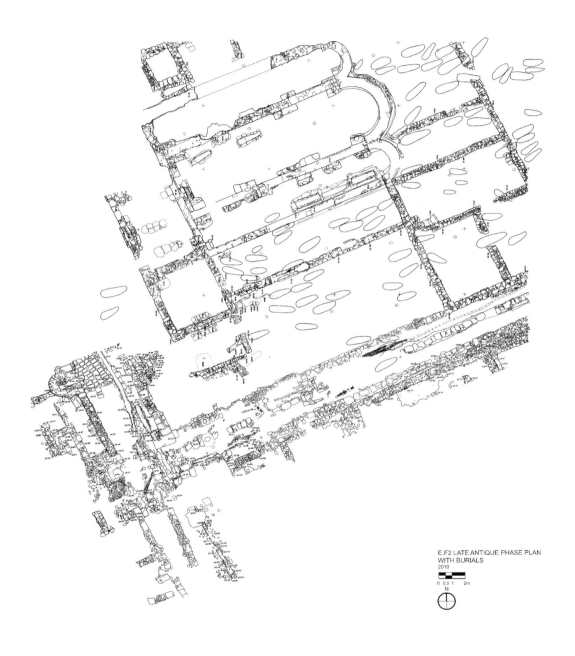

E.F2 LATE ANTIQUE PHASE PLAN
WITH BURIALS
2010

0 0.5 1 2m

N

PLAN 8. Phase Plan showing Late Antique church and later burials in Area E.F2 at Polis-Petrerades.

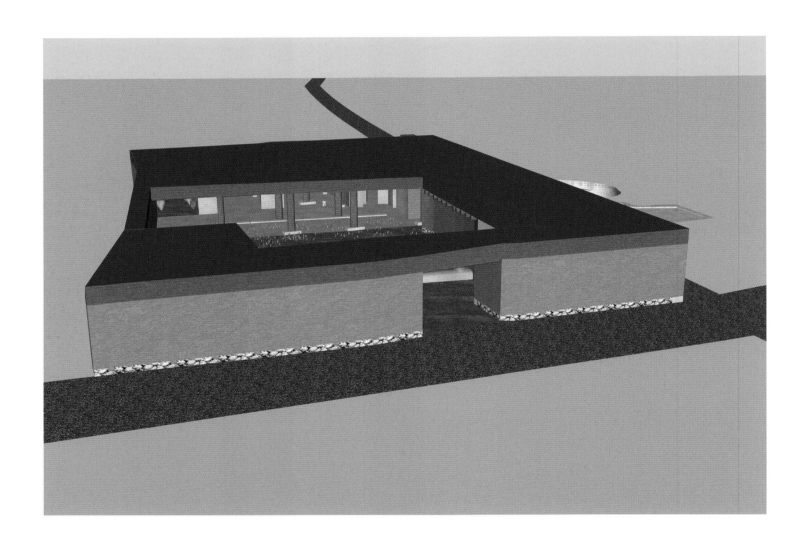

BUILDING RECONSTRUCTION 1: View of a 3-D model of the Cypro-Archaic II period Main Building phase of the Sanctuary in Polis-Peristeries (Area B.D7) with associated cuttings in the bedrock and roads (Plan 2) from the south; photorealistic textures are mostly derived from excavated building materials. Many details of this building complex are either preserved in the foundations or among the fragmentary remains and allow for the layout and height of the structures to be reconstructed (see essay III). Mud roof and mud-brick fragments suggest that the roof was flat and that the structures were made of timber-framed mud brick. The western wall of the temenos, the extent of roofing over the southern entrance, and the extension of the road to the north are hypothetical. The spread of terracotta votives and storage vessels shown here is schematic and does not represent the full range of objects found.

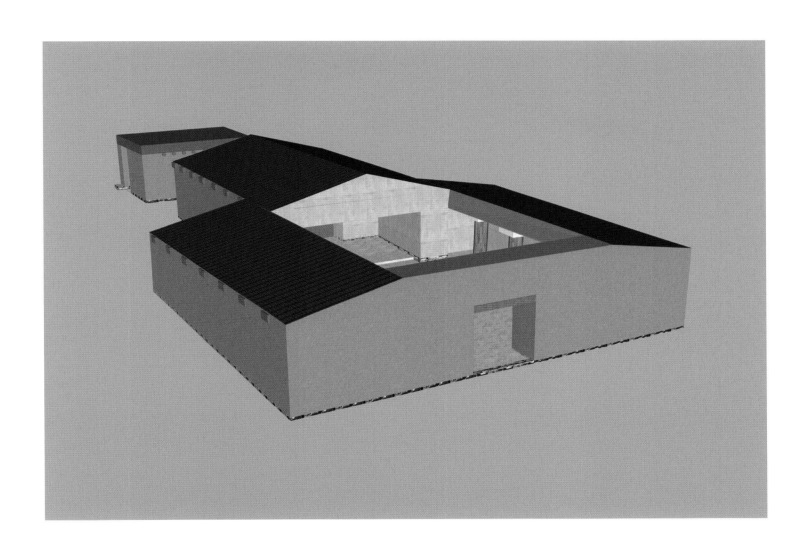

BUILDING RECONSTRUCTION 2: View of a 3-D model of the Cypro-Classical period temple and naiskos in Polis-Maratheri (Area A.H9) before the construction of the city wall (Plan 4) from the northeast; photorealistic textures are mostly derived from excavated building materials. Many details of these two buildings are either preserved in the foundations or among the fragmentary remains and allow for the symmetrical layout of the temple as well as its height to be reconstructed (see essay III). While the entrance to the naiskos is known, its exact height is not. Roof tiles suggest that at least part of the temple, especially the colonnades of its forecourt, was roofed. Its axial entrance and roof pitch are hypothetical. This view does not include the spread of objects found in its forecourt.

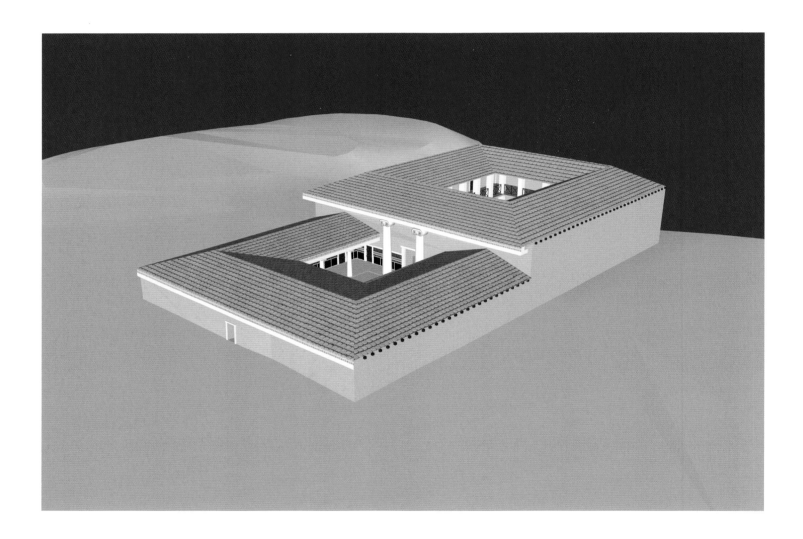

BUILDING RECONSTRUCTION 3: View of a 3-D model of the Hellenistic period porticoed building (Plan 6) and proposed ancient shoreline in Polis-Petrerades (Area E.G0) from the southeast; photorealistic textures are mostly derived from excavated building materials. Many details of this building are either preserved in its foundations or among the fragmentary remains and allow for the symmetrical layout and decoration of the building to be reconstructed (see essay IV). The height of the southern and northern courtyards is based on the proportions of Ionic (see cat. no. 84) and Doric column fragments as well as the structural support offered by the foundations. Roof tiles in the southern courtyard allow for the reconstruction of its roof, but the northern roof is hypothetical as are the gates around its courtyard. The southern edge of the south courtyard was preserved, but the portico along that southern edge was obliterated by later construction. The southern end is thus reconstructed to form a symmetrical arrangement with that courtyard's east and west porticos. The ancient coastline aligns with the edge of the modern bluff at the north end of Area E.G0.

The Telegraph

›SUBSCRIBER‹

Mr H Waring
Salamis
Pottergate Street
Aslacton
NORWICH
Nr Norwich
NR15 2JU

15726

000491S

‖¦·‖·¦·‖·¦¦‖·‖‖·¦¦‖·‖¦·¦‖·¦‖¦·¦‖·¦·‖

Your new Telegraph Subscriber Privilege Cards are attached

Dear Mr Waring

At The Telegraph we want to make sure that you continue to get the very best from your subscription.

As part of that commitment, we attach your Telegraph Subscriber Privilege Card, which is valid for one year, regardless of when your current subscription ends. You also receive an additional card for another member of your family or household, so that they too can enjoy the benefits of your subscription package.

For all the latest privileges available to you, see the enclosed 2013 Handbook. It is packed with exclusive offers and discounts including our Dining, Days Out, Beauty, Film and Golf Clubs, valid at more than 5,000 venues across the UK and Ireland.

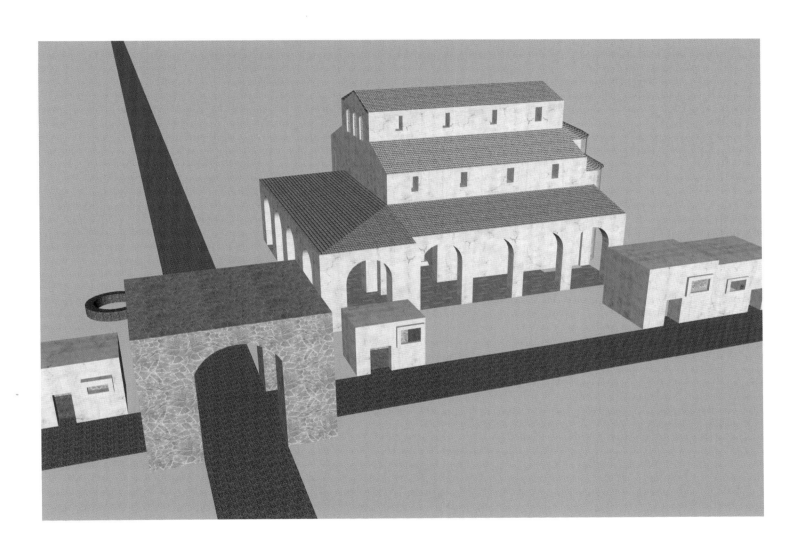

BUILDING RECONSTRUCTION 4: View of a 3-D model of the 7th century C.E. (Late Antique) church (Plan 8), surrounding structures, and roads in Polis-Petrerades (Area E.F2) from the southwest; photorealistic textures are mostly derived from excavated building materials. Many details of this church and the surrounding structures are either preserved in the foundations or among the fragmentary remains and allow for the design of the structures to be reconstructed (see essay V). The height of the church was calculated based on proportions derived from a Corinthian column capital (cat. no. 108) but may possibly be too high. Other details are hypothetical, such as the number and placement of the windows; however, the spread of transenna fragments suggests that the most elaborate windows were at the west end. The precise alignment and pitch of the roof is unknown, but the reconstruction here shows how the narthex and south cloister frame the three-aisled church with polygonal apses on its eastern end. Surrounding structures, including a tetrapylon, are shown schematically and are used to provide a sense of the urban context of the church. The extension of the road running north is hypothetical.

Abbreviations

Archives

BM GR, Original Letters Unpublished correspondence in the Department of Greece and Rome, British Museum, London

CO Unpublished correspondence in the British Colonial Office records, National Archives, Kew, London

CS Unpublished records of the Archaeological Survey of the Department of Antiquities, Cyprus

MP CM Unpublished correspondence and other documentation archived by Minute Paper in the Cyprus Museum, Nicosia

SA1 Unpublished government correspondence in the State Archives, Nicosia, Cyprus

Catalogues, Collections, and Other Books

ABV Beazley, J. D. *Attic Black-figure Vase-painters*. Oxford, 1956.

ARV² Beazley, J. D. *Attic Red-figure Vase-painters*. 2nd ed. Oxford, 1963.

CVA *Corpus Vasorum Antiquorum*

DOC 1 Bellinger, A. R. *Catalogue of the Byzantine Coins in the Dumbarton Oaks Collection and in the Whittemore Collection*, vol. 1, *Anastasius to Maurice, 491–602*. Washington, D.C., 1966.

DOC 3 Grierson, P. *Catalogue of the Byzantine Coins in the Dumbarton Oaks Collection and in the Whittemore Collection*, vol. 3, pt. 1, *Leo III to Michael III (717–867)*. Washington, D.C., 1973.

GGM Müller, C., ed. *Geographi Graeci minores*. Paris, 1882.

IG *Inscriptiones graecae.*

LIMC *Lexicon Iconographicum Mythologiae Classicae*. Zurich and Munich, 1974–2009.

OGIS Dittenberger, W., ed. *Orientis Graeci Inscriptiones Selectae*. Leipzig, 1903–5.

Paralipomena Beazley, J. D. *Paralipomena: Additions to Attic Black-figure Vase-painters and to Attic Red-figure Vase-painters*. 2nd ed. Oxford, 1971.

PmbZ Lilie, R. J., et al., eds. *Prosopographie der mittelbyzantinischen Zeit.* Erste Abteilung (641–867), Prolegomena und Bänder 1–6. Berlin and New York, 1998–2002.

RIC 5.2 Webb, P. H. *The Roman Imperial Coinage*, vol. 5.2, *Probus to Amandus*. London, 1933.

RIC 10 Kent, J. P. C. *The Roman Imperial Coinage*, vol. 10, *The Divided Empire and the Fall of the Western Parts, A.D. 395–491.* London, 1994.

RPC 1 Burnett, A., M. Amandry, and Pere Pau Ripollès. *Roman Provincial Coinage*, vol. 1, *From the Death of Caesar to the Death of Vitellius (44 B.C.–A.D. 69)*. London, 1992.

SCE I–III Gjerstad, E., J. Lindros, E. Sjöqvist, and A. Westholm. *The Swedish Cyprus Expedition: Finds and Results of the Excavations in Cyprus, 1927–1931*. Stockholm, 1934–37.

SEG *Supplementum epigraphicum graecum*

Journals, Series, and Institutes

AJA *American Journal of Archaeology*

AJPA *American Journal of Physical Anthropology*

AnatStud *Anatolian Studies*

ANRW *Anstieg und Niedergang der Römischen Welt*

ARCA *Annual Report of the Curator of Antiquities*

ASOR American Schools of Oriental Research

BASOR *Bulletin of the American Schools of Oriental Research*

BCH *Bulletin de Correspondance hellénique*

BibArch *Biblical Archaeologist*

BICS *Bulletin of the Institute of Classical Studies* (London)

BSA British School at Athens

BSA *Annual of the British School at Athens*

BZ *Byzantinische Zeitschrift*

CCA Corpus of Cypriot Antiquities

CAARI Cyprus American Archaeological Research Institute

CCEC *Cahier du Centre d'Études chypriotes*

CEF Cyprus Exploration Fund

ClAnt *Classical Antiquity*

DOP *Dumbarton Oaks Papers*

DOS *Dumbarton Oaks Studies*

IEJ *Israel Exploration Journal*

JFA *Journal of Field Archaeology*

JHS *Journal of Hellenic Studies*

JNES *Journal of Near Eastern Studies*

JRS *Journal of Roman Studies*

MedMusB *Medelhavsmuseet, Bulletin* (Stockholm)

NC *Numismatic Chronicle*

NEA *Near Eastern Archaeology*

NNÅ *Nordisk Numismatisk Årsskrift*

OJA *Oxford Journal of Archaeology*

OpArch *Opuscula Archaeologica*

OpAth *Opuscula Atheniensia*

RA *Revue archéologique*

RDAC *Report of the Department of Antiquities, Cyprus*

ReiCretActa *Rei Cretariae Romanae Fautorum Acta*

RM *Mitteilungen des Deutschen Archäologischen Instituts, Römische Abteilung*

SBMünch *Sitzungsberichte der Bayerischen Akademie der Wissenschaften zu München, Philosophisch-historische Klasse*

SCE Swedish Cyprus Expedition

SIMA Studies in Mediterranean Archaeology

WA *World Archaeology*

Bibliography

Adovasio et al. 1975
Adovasio, J. M., G. F. Fry, J. D. Gunn, and R. F. Maslowski. "Prehistoric and Historic Settlement Patterns in Western Cyprus (with a Discussion of Cypriot Neolithic Stone Tool Technology)." *WA* 6, no. 3 (1975): 339–64.

Adovasio et al. 1978
Adovasio, J. M., G. F. Fry, J. D. Gunn, and R. F. Maslowski. "Prehistoric and Historic Settlement Patterns in Western Cyprus: An Overview." *RDAC*, 1978, 39–57.

Aharoni 1974
Aharoni, Y. "The Horned Altar of Beer-sheba." *BibArch* 37 (1974): 1–6.

Albenda 1994
Albenda, P. "Assyrian Sacred Trees in the Brooklyn Museum." *Iraq* 56 (1994): 123–33.

Alexandridou 2011
Alexandridou, A. *The Early Black-figured Pottery of Attika in Context (c. 630–570 B.C.E.).* Leiden, 2011.

Amandry 1987
Amandry, M. "Le Monnayage julio-claudien à Chypre, I: Auguste." *CCEC* 7 (1987): 17–31.

Anastassiades 1998
Anastassiades, A. "Ἀρσινόης Φιλαδέλφου: Aspects of a Specific Cult in Cyprus." *RDAC*, 1998, 129–40.

Andrews 1994
Andrews, C. *Amulets of Ancient Egypt.* London, 1994.

Argoud, Callot, and Helly 1980
Argout, G., O. Callot, and B. Helly. *Salamine de Chypre*, XI: *Une résidence byzantine "L'Huilerie."* Paris, 1980.

Armstrong 2006
Armstrong, P. "Rural Settlement in Lycia in the Eighth Century: New Evidence." In *The Third Symposium on Lycia, 7–10 November 2005, Antalya*, ed. K. Dörtlük et al., 19–29. Antalya, 2006.

Asano 2010
Asano, K., ed. *The Island of St. Nicholas: Excavation and Survey of the Gemiler Island Area, Lycia, Turkey.* Osaka, 2010.

Åström 1972a
Åström, P. *The Swedish Cyprus Expedition*, vol. IV, pt. 1B. *The Middle Cypriote Bronze Age.* Lund, 1972.

Åström 1972b
Åström, P. *The Swedish Cyprus Expedition*, vol. IV, pt. 1C. *The Late Cypriote Bronze Age.* Lund, 1972.

Åström 1992
Åström, P., ed. *Acta Cypria: Acts of an International Congress on Cypriote Archaeology Held in Göteborg on 22–24 August 1991*, Part 3. SIMA and Literature. Pocket-Book 120. Jonsered, 1992.

Åström 2003
Åström, P. "Early and Middle Bronze Age Pottery: White Painted and Other Wares." In Karageorghis (V.) 2003, 46–56.

Åström and Nys 2003
Åström, P., and K. Nys. "Early and Middle Bronze Age Pottery: Black Polished and Red Polished." In Karageorghis (V.) 2003, 34–45.

Aupert 1996
Aupert, P. *Guide d'Amathonte.* Paris, 1996.

Babelon 1910
Babelon, E. *Traité des monnaies grecques et romaines*, 2.2: *Description historique.* Paris, 1910.

Bagnall 1976
Bagnall, R. S. *The Administration of the Ptolemaic Possessions Outside Egypt.* Columbia Studies in the Classical Tradition 4. Leiden, 1976.

Bailey 1965
Bailey, D. "Lamps in the Victoria and Albert Museum." *OpAth* 6 (1965): 1–83.

Bailey 1972
Bailey, D. *Greek and Roman Pottery Lamps.* London, 1972.

Bailey 1975
Bailey, D. M. *A Catalogue of the Lamps in the British Museum*, I: *Greek, Hellenistic, and Early Roman Pottery Lamps.* London, 1975.

Bailey 1996
Bailey, D. M. *A Catalogue of the Lamps in the British Museum*, IV: *Lamps of Metal and Stone, and Lampstands.* London, 1996.

Baker and Moramarco 2011
Baker, B., and M. W. Moramarco. "Groovy Teeth: Unraveling Patterns of Dental Use Wear in a Medieval Sample from Polis, Cyprus." *AJPA* 144, Supplement 52 (2011): 80.

Baker and Papalexandrou (A.) 2012
Baker, B., and A. Papalexandrou. "A Bioarchaeological Perspective on Burials and Basilicas of Medieval Polis, Cyprus." In *Bioarchaeology of the Near East and Eastern Mediterranean*, ed. M. Perry (forthcoming 2012).

Baker, Papalexandrou (A.), and Terhune 2012
Baker, B., A. Papalexandrou, and E. Terhune. "Sew long? The Osteobiography of a Woman from Medieval Polis, Cyprus." In *The Bioarchaeology of Individuals*, ed. A. Stodder and A. Palkovich, 151–61. Gainesville, Fla., 2012.

Bakirtzis 1999
Bakirtzis, C. "Early Christian Rock-Cut Tombs at Hagios Georgios, Peyia, in Cyprus." In Ševčenko and Moss 1999, 35–48.

Beazley 1989
Beazley, J. D. *Some Attic Vases in the Cyprus Museum.* Rev. ed. of 1948 original, ed. D. C. Kurz. Oxford, 1989.

Bekker-Nielsen 2004
Bekker-Nielsen, T. *The Roads of Ancient Cyprus.* Copenhagen, 2004.

Bénazeth 2001
Bénazeth, D. *Catalogue général du Musée copte du Caire*, 1: *Objets en metal*. Cairo, 2001.

Bertman 2003
Bertman, S. *Handbook to Life in Ancient Mesopotamia*. New York, 2003.

Bingöl 1980
Bingöl, O. *Das Ionische Normalkapitell in Hellenistischer und Römischer Zeit in Kleinasien*. Tübingen, 1980.

Boardman 1957
Boardman, J. "Early Euboean Pottery and History." *BSA* 52 (1957): 1–29.

Boardman 1967
Boardman, J. "Archaic Greek Finger Rings." *Antike Kunst* 10 (1967): 3–31.

Boardman 1968a
Boardman, J. "A Chian Mesomphalos from Marion." *RDAC*, 1968, 12–15,

Boardman 1968b
Boardman, J. *Archaic Greek Gems: Schools and Artists in the Sixth and Early Fifth Centuries B.C.* Evanston, Ill., 1968.

Boardman 1970
Boardman, J. "Cypriot Finger Rings." *BSA* 65 (1970): 5–15.

Boardman 1975
Boardman, J. *Athenian Red Figure Vases: The Archaic Period: A Handbook*. London, 1975.

Boardman 1981
Boardman, J. "Askoi." *Hephaistos* 3 (1981): 23–25.

Boardman 1991
Boardman, J. "Colour Questions."*Jewellery Studies* 5 (1991): 29–31.

Boardman 1995
Boardman, J. *Greek Sculpture: The Late Classical Period and Sculpture in Colonies and Overseas*. New York, 1995.

Boardman 1996
Boardman, J. "The Archaeology of Jewelry." In *Ancient Jewelry and Archaeology*, ed. A. Calinescu, 3–13. Bloomington, Ind., 1996.

Boardman 2001
Boardman, J. *Greek Gems and Finger Rings: Early Bronze Age to Late Classical*. New expanded ed. London, 2001.

Boardman 2003
Boardman, J. *Classical Phoenician Scarabs: A Catalogue and Study*. BAR International Series 1190. Studies in Gems and Jewellery 2. Oxford, 2003.

Boardman, Griffin, and Murray 1986
Boardman, J., J. Griffin, and O. Murray, eds. *Greece and the Hellenistic World*. Oxford History of the Classical World 1. Oxford, 1986.

Böhr 2002
Böhr, E. "Mit Schopf an Brust und Kopf: Der Jungfernkranich." In Clark and Gaunt 2002, 37–47.

Bolger and Serwint 2002
Bolger, D., and N. Serwint, eds. *Engendering Aphrodite: Women and Society in Ancient Cyprus*. ASOR Archaeological Reports 7. CAARI Monograph Series 3. Boston, 2002.

Borger 1956
Borger, R. *Die Inschriften Asarhaddons, Königs von Assyrien*. Graz, 1956.

Börker-Klähn 1982
Börker-Klähn, J. *Altvorderasiatische Bildstelen und vergleichbare Felsreliefs*. Baghdader Forschungen 4. Mainz, 1982.

Borowski 2002
Borowski, O. "Animals in the Literature of Syria-Palestine." In Collins 2002, 289–306.

Bouras and Parani 2008
Bouras, L., and M. G. Parani. *Lighting in Early Byzantium*. Dumbarton Oaks Byzantine Collection Publication 11. Washington, D.C., 2008.

Brehme 2001
Brehme, S. "Max Ohnefalsch-Richter (1850–1917)." In Brehme et al. 2001, 23–26.

Brehme et al. 2001
Brehme, S., M. Brönner, V. Karageorghis, G. Platz-Horster, and B. Weisser. *Ancient Cypriote Art in Berlin: Antikensammlung, Museum für Vor- und Frühgeschichte, Münzkabinett*. Nicosia, 2001.

Brogan, Apostolakou, and Betancourt 2012
Brogan, T., S. Apostolakou, and P. P. Betancourt. "The Purple Dye Industry of Eastern Crete." In *KOSMOS: Jewellery, Adornment, and Textiles in the Aegean Bronze Age, Copenhagen, 19–23 April 2010*, ed. R. Laffineur and M.-L. Nosch, 187–92. Liège, 2012.

Brönner 2001a
Brönner, M. "The Ancient Cypriote Material in the Museum für Vor- und Frühgeschichte." In Brehme et al. 2001, 15–22.

Brönner 2001b
Brönner, M. "The Ohnefalsch-Richter Collection in the Museum für Vor- und Frühgeschichte, Berlin." In Tatton-Brown 2001a, 198–206.

Brown (A. M.) 1983
Brown, A. M. "A Pair of Gold Spiral Earrings." In *Ancient Art from Cyprus: The Ringling Collection*, ed. N. Kershaw, 75–77. Sarasota, Fla., 1983.

Brown (P.) 1971
Brown, P. "The Rise and Function of the Holy Man in Late Antiquity." *JRS* 61 (1971): 80–101.

Brown (S.) 1992
Brown, S. "Perspectives on Phoenician Art." *BibArch* 55, no. 1 (1992): 6–24.

Bruneau 1965
Bruneau, P. "Le Motif des coqs affrontés dans l'imagerie antique." *BCH* 89, no. 1 (1965): 90–121.

Buchholz 1989
Buchholz, H.-G. "Max Ohnefalsch-Richter als Archäologe auf Zypern." *CCEC* 11–12 (1989): 4–27.

Buchholz 1994
Buchholz, H.-G. "Sakralschaufeln im antiken Zypern." *RDAC*, 1994, 129–54.

Buck 1993
Buck, S. "Life on the Edge of the Empire: Demography and Health in Byzantine Cyprus." Master's thesis, Arizona State University, 1993.

Burkert 1985
Burkert, W. *Greek Religion*. Trans. John Raffan. Cambridge, Mass., 1985.

Burn and Higgins 2001
Burn, L., and R. A. Higgins. *Catalogue of Greek Terracottas in the British Museum*, vol. 3. London, 2001.

Callot 2004
Callot, O. *Salamine de Chypre*, XVI: *Les Monnaies: Fouilles de la ville, 1964–1974*. Paris, 2004.

Calvet and Yon 1977
Calvet, Y., and M. Yon. "Céramique trouvée à Salamine, fouilles de la ville." In Gjerstad et al. 1977, 9–21.

Carradice 1989
Carradice, I. "The Coinage of Roman Cyprus." In Tatton-Brown 1989, 182–87.

Castle 1971
Castle, W. T. F. *Cyprus: Its Postal History and Postage Stamps*. 2nd ed. and enl. London, 1971.

Catling 1962
Catling, H. W. "Patterns of Settlement in Bronze Age Cyprus." *OpAth* 4 (1962): 129–69.

Caubet 1977
Caubet, A. "Stèles funéraires de Chypre au Musée du Louvre." *RDAC*, 1977, 170–77.

Caubet 1979
Caubet, A. "Les Maquettes architecturales d'Idalion." In Karageorghis (V.) 1979, 94–118.

Caubet 1984
Caubet, A. "Le Sanctuaire chypro-archaïque de Kition-Bamboula." In *Temples et Sanctuaires: séminaire de recherche, 1981–1983*, ed. G. Roux, 107–18. Lyon, 1984.

Caubet, Hermary, and Karageorghis (V.) 1992
Caubet, A., A. Hermary, and V. Karageorghis. *Art antique de Chypre au Musée du Louvre du chalcolithique à l'époque romaine*. Paris, 1992.

Caubet et al. 1998
Caubet, A., S. Fourrier, A. Queyrel, and F. Vandenabeele. *L'Art des modeleurs d'argile antiquités de Chypre coroplastique*. Paris, 1998.

Cesnola 1877
Cesnola, L. P. di. *Cyprus: Its Ancient Cities, Tombs, and Temples, A Narrative of Researches and Excavations during Ten Years' Residence as an American Consul in That Island*. London, 1877.

Chavane 1975
Chavane, M.-J. *Salamine de Chypre*, VI: *Les Petits Objets*. Paris, 1975.

Cheynet, Morrisson, and Seibt 1991
Cheynet J.-C., C. Morrisson, and W. Seibt. *Les Sceaux byzantins de la collection Henri Seyrig*. Paris, 1991.

Childs 1988
Childs, W. A. P. "First Preliminary Report on the Excavations at Polis Chrysochous by Princeton University." *RDAC*, 1988, pt. 2, 121–30.

Childs 1994
Childs, W. A. P. "The Stone Sculpture of Marion: A Preliminary Assessment." In *Cypriote Stone Sculpture: Proceedings of the Second International Conference of Cypriote Studies, Brussels-Liège, 17–19 May 1993*, ed. F. Vandenabeele and R. Laffineur, 107–15. Brussels and Liège, 1994.

Childs 1997
Childs, W. A. P. "The Iron Age Kingdom of Marion." *BASOR* 308 (1997): 37–48.

Childs 1999
Childs, W. A. P. "Princeton Excavations at Polis Chrysochous, 1994–1997, Interim Report." *RDAC*, 1999, 223–36.

Childs 2008
Childs, W. A. P. "Princeton University's Excavations of Ancient Marion and Arsinoe." *NEA* 71, nos. 1–2 (2008): 64–75.

Christou 1998
Christou, D. "Cremations in the Western Necropolis of Amathus." In *Proceedings of the International Symposium Eastern Mediterranean: Cyprus-Dodecanese-Crete, 16th–6th cent. B.C. Organized by The University of Crete, Rethymnon and The Anastasios G. Leventis Foundation, Nicosia, Rethymnon, 13–16 May 1997*, ed. V. Karageorghis and N. Stampolidis, 207–15. Athens, 1998.

Clairmont 1993
Clairmont, C. W. *Classical Attic Tombstones*. Kilchberg, 1993.

Clark and Gaunt 2002
Clark, A. J., and J. Gaunt, eds. *Essays in Honor of Dietrich von Bothmer*. Allard Pierson Series 14. Amsterdam, 2002.

Clay 2010
Clay, D. "Autochthony." In *The Oxford Encyclopedia of Ancient Greece and Rome*, ed. M. Gagarin and E. Fantham. e-references edition: http://www.oxford-greecerome.com/entry?entry=t294.e151. Oxford, 2010.

Clerc 1991
Clerc, G. "Aegyptiaca." In Karageorghis (V.), Picard, and Tytgat 1991, 1–157.

Cohen 2006
Cohen, B. *The Colors of Clay: Special Techniques in Athenian Vases*. Los Angeles, 2006.

Coldstream 1981
Coldstream, J. N. "The Greek Geometric and Plain Archaic Imports." In Karageorghis (V.) et al. 1981, 17–22.

Collins 2002
Collins, B. J., ed. *A History of the Animal World in the Ancient Near East*. Leiden and Boston, 2002.

Collombier 1991
Collombier, A.-M. "Organisation du territoire et pouvoirs locaux dans l'île de Chypre à l'époque perse." *Transeuphratène* 4 (1991): 21–43.

Comstock and Vermeule 1976
Comstock, M. B., and C. C. Vermeule. *Sculpture in Stone: The Greek, Roman, and Etruscan Collections of the Museum of Fine Arts, Boston*. Boston, 1976.

Connelly 1989
Connelly, J. B. "Standing Before One's God: Votive Sculpture and the Cypriot Religious Tradition." *BibArch* 52 (1989): 210–18.

Connelly 2010
Connelly, J. B. "Cyprus in the Age of Empires." In Hadjisavvas 2010, 173–205.

Connelly and Wilson 2002
Connelly, J. B., and A. I. Wilson. "Hellenistic and Byzantine Cisterns on Geronisos Island." *RDAC*, 2002, 269–80.

Constantinides and Browning 1993
Constantinides, C. N., and R. Browning. *Dated Greek Manuscripts from Cyprus to the Year 1570*. DOS 30. Texts and Studies of the History of Cyprus 18. Washington, D.C., and Nicosia, 1993.

Constas 2006
Constas, N. "Death and Dying in Byzantium." In Krueger 2006, 124–48.

Cook 1933–34
Cook, R. M. "Fikellura Pottery." *BSA* 34 (1933–34): 1–98.

Cook and Dupont 1998
Cook, R. M., and P. Dupont. *East Greek Pottery.* London and New York, 1998.

Cotsonis 1994
Cotsonis, J. A. *Byzantine Figural Processional Crosses.* Dumbarton Oaks Byzantine Collection Publication 10. Washington, D.C., 1994.

Cox 1959
Cox, D. H. *Coins from the Excavations at Curium, 1932–1953.* Numismatic Notes and Monographs 145. New York, 1959.

Crewe and Graham 2008
Crewe, L., and L. Graham. "The Pottery." In "First Preliminary Report of Excavations at Kissonerga-Skalia, 2007," by L. Crewe, P. Croft, L. Graham, and A. McCarthy, 112–16. *RDAC*, 2008, 105–19.

Culican 1975
Culican, W. "Some Phoenician Masks and Other Terracottas." *Berytus* 24 (1975): 47–87.

Ćurčić 1999
Ćurčić, S. "Byzantine Architecture on Cyprus: An Introduction to the Problem of the Genesis of a Regional Style." In Ševčenko and Moss 1999, 73–91.

Curtis 2005
Curtis, J. "Jewellery and Personal Ornaments." In Curtis and Tallis 2005, 132–36.

Curtis and Tallis 2005
Curtis, J., and N. Tallis, eds. *Forgotten Empire: The World of Ancient Persia.* Berkeley and Los Angeles, 2005.

Darrouzès 1951
Darrouzès, J. "Évêques inconnus ou peu connus de Chypre." *BZ* 44 (1951): 97–104.

Davidson and Oliver 1984
Davidson, P. F., and A. Oliver Jr. *Ancient Greek and Roman Gold Jewelry in the Brooklyn Museum.* Wilbour Monographs 8. Brooklyn, N.Y., 1984.

Daszewski 1985
Daszewski, W. A. "Researches at Nea Paphos, 1965–1984." In Karageorghis (V.) 1985, 277–91.

Dawkins 1932
Dawkins, R. M., ed. *Recital Concerning the Sweet Land of Cyprus Entitled 'Chronicle.'* Vol. 1, by L. Makhairas. Oxford, 1932.

Decker 2001
Decker, M. "Food for an Empire: Wine and Oil Production in North Syria." In *Economy and Exchange in the East Mediterranean during Late Antiquity: Proceedings of a Conference at Somerville College, Oxford, 29th May, 1999,* ed. M. Decker and S. A. Kingsley, 69–86. Oxford, 2001.

Delestre and Hoffmann 1887
Delestre, M., and M. Hoffmann. *Catalogue des objets antiques trouvés à Arsinoé de Chypre, sculptures, inscriptions chypriotes, poterie phénicienne, terres cuites & bijoux, dont la vente aura lieu a l'Hôtel Drouot, sale no. 4, les vendredi, 27 et samedi, 28 mai 1887 à deux heures.* Paris, 1887.

Demesticha 2000
Demesticha, S. "The Paphos Kiln: Manufacturing Techniques of LR1 Amphoras." *ReiCretActa* 36 (2000): 549–54.

Deppert-Lippitz 1985
Deppert-Lippitz, B. *Griechische Goldschmuck.* Mainz, 1985.

Deppert-Lippitz 1998
Deppert-Lippitz, B. "Greek Bracelets of the Classical Period." In *The Art of the Greek Goldsmith,* ed. D. Williams, 91–94. London, 1998.

Despini 1996
Despini, A. *Greek Art: Ancient Gold Jewellery.* Athens, 1996.

Destrooper-Georgiades 1987
Destrooper-Georgiades, A. "La Phénicie et Chypre à l'époque achéménide: Témoignages numismatiques." In *Phoenicia and the East Mediterranean in the First Millennium B.C.,* ed. E. Lipiński, 339–55. Orientalia Lovaniensia, Analecta 22. Studia Phoenicia 5. Louvain, 1987.

Destrooper and Symeonides 1998
Destrooper, A., and A. Symeonides. "Classical Coins in the Symeonides Collection. The Coins Circulated in Marion during the Vth and IVth Centuries." *RDAC*, 1998, 111–25.

Dever 2005
Dever, W. G. *Did God Have a Wife?: Archaeology and Folk Religion in Ancient Israel.* Grand Rapids, Mich., 2005.

Dikaios 1946
Dikaios, P. "Two 'Naucratite' Chalices from Marium." *JHS* 66 (1946): 5–7.

Dikaios 1961
Dikaios, P. *A Guide to the Cyprus Museum.* 3rd rev. ed. Nicosia, 1961.

Dikigoropoulos 1965–66
Dikigoropoulos, A. I. "The Church of Cyprus during the Period of the Arab Wars, A.D. 649–965." *Greek Orthodox Theological Review* 11 (1965–66): 237–79.

Dikigoropoulos and Megaw 1958
Dikigoropoulos, A. I., and A. H. S. Megaw. "Early Glazed Pottery from Polis." *RDAC*, 1940–48 [1958], 77–93.

Dodd 1961
Dodd, E. C. *Byzantine Silver Stamps. DOS* 7. Washington, D.C., 1961.

Ducrey 1977
Ducrey, P. "Menaces sur le passé." *Études de lettres*, ser. 3, 10 (1977): 1–18.

Edlund-Berry 2003
Edlund-Berry, I. "Erik Sjöqvist: archeologo svedese e ricercatore internazionale alla Princeton University." *Unione internazionale degli Istituti di Archeologia, Storia, e Storia dell'Arte in Roma. Annuario* 45 [2003–2004] (2003): 173–85.

Eger 2003
Eger, C. "Dress Accessories of Late Antiquity in Jordan." *Levant* 35 (2003): 163–78.

Ellis 1968
Ellis, R. S. *Foundation Deposits in Ancient Mesopotamia.* New Haven, Conn., 1968.

Faegersten 2003
Faegersten, F. *The Egyptianizing Male Limestone Statuary from Cyprus: A Study of a Cross-Cultural Eastern Mediterranean Votive Type.* Lund, 2003.

Fejfer 1995
Fejfer, J., ed. *Ancient Akamas:* vol. 1, *Settlement and Environment.* Aarhus, 1995.

Fischer 2001
Fischer, B. "Le Rôle des sanctuaires dan l'économie chypriote." *CCEC* 31 (2001): 51–58.

Fivel 1989
Fivel, L."Ohnefalsch-Richter (1850–1917), essai de bibliographie." *CCEC* 11–12 (1989): 35–40.

Fivel 1996
Fivel, L. "Ohneflasch-Richter, vendeur d'antiquités chypriotes (1895)." *CCEC* 25, no. 1 (1996): 29–35.

Fleischer 1983
Fleischer, R. *Der Klagefrauensarkophag aus Sidon.* Istanbuler Forschungen 34. Tübingen, 1983.

Flensted-Jensen 1996
Flensted-Jensen, P. "Pseudo-Skylax' Use of the Term Polis." In *More Studies in the Ancient Greek Polis*, ed. M. H. Hansen and K. Raaflaub, 137–67. Historia Einzelschriften 108. Stuttgart, 1996.

Flourentzos 1977
Flourentzos, P. "Four Archaic Terracottas from Cypriot Private Collections." *RDAC*, 1977, 150–53.

Flourentzos 1992
Flourentzos, P. "An Unknown Collection of Attic Vases from the Cyprus Museum." *RDAC*, 1992, 151–56.

Flourentzos 1994
Flourentzos, P. "A Workshop of Cypro-Classical Terracottas from Marion." *RDAC*, 1994, 161–65.

Flourentzos 1996
Flourentzos, P. *Cyprus Heritage: The Art of Ancient Cyprus as Exhibited at the Cyprus Museum.* Limassol, 1996.

Flourentzos 2004–5
Flourentzos, P. "Chroniques des fouilles et découvertes archéologiques à Chypre en 2003 et 2004." *BCH* 128–29 (2004–5): 1681–85.

Flourentzos and Hadjicosti 2010
Flourentzos, P., and M. Hadjicosti, eds. *Annual Report of the Department of Antiquities for the Year 2008.* Nicosia, 2010.

Fontaine-Hodiamont, Bourguignon, and Laevers 2010
Fontaine-Hodiamont, C., C. Bourguignon, and S. Laevers, eds. *D'Ennion au Val Saint-Lambert. Le verre soufflé-moulé. Actes des 23e Rencontres de l'Association française pour l'Archéologie du Verre, Colloque international Bruxelles-Namur 17–19 octobre 2008.* Brussels, 2010.

Fontan 2007
Fontan, E. "Chypre au Louvre: Présentation des collections dans les galeries du musée." *CCEC* 37 (2007): 53–70.

Foster 2002
Foster, B. R. "Animals in Mesopotamian Literature." In Collins 2002, 271–88.

Fowler 1984
Fowler, M. D. "'BA' Guide to Artifacts: Excavated Incense Burners." *BibArch* 47, no. 3 (1984): 183–86.

Fox 1986
Fox, R. L. "Hellenistic Culture and Literature." In Boardman, Griffin, and Murray 1986, 332–58.

Frankel and Webb 1996
Frankel, D., J. M. Webb et al. *Marki Alonia: An Early and Middle Bronze Age Town in Cyprus, Excavations, 1990–1994.* SIMA 123, no. 1. Jonsered, 1996.

Franzius et al. 1970
Franzius, W., et al. "Badisches Landesmuseum, Neuerwerbungen 1969." *Jahrbuch der Staatlichen Kunstsammlungen in Baden-Württemberg* 7 (1970): 113–48.

Fraser and Matthews 1987
Fraser, P. M., and E. Matthews, eds. *A Lexicon of Greek Personal Names.* Vol. 1, *The Aegean Islands, Cyprus, Cyrenaica.* Oxford, 1987.

Fraser and Matthews 1997
Fraser, P. M., and E. Matthews, eds. *A Lexicon of Greek Personal Names.* Vol. 3A, *The Peloponnese, Western Greece, Sicily and Magna Graecia.* Oxford, 1997.

Friedman 1998
Friedman, F. D., ed. *Gifts of the Nile: Ancient Egyptian Faience.* New York, 1998.

Friis Johansen (K.) 1951
Friis Johansen, K. *Attic Grave-Reliefs of the Classical Period: An Essay in Interpretation.* Copenhagen, 1951.

Frothingham 1911
Frothingham, A. L. "Medusa, Apollo, and the Great Mother." *AJA* 15 (1911): 349–77.

Garrison and Root 2001
Garrison, M. B., and M. C. Root. *Seals on the Persepolis Fortification Tablets.* Vol. 1, *Images of Heroic Encounter.* University of Chicago Oriental Institute Publications 117. Chicago, 2001.

Gill 2011
Gill, D. W. J. *Sifting the Soil of Greece: The Early Years of the British School at Athens (1886–1919).* BICS Supplement 111. London, 2011.

Giovino 2007
Giovino, M. *The Assyrian Sacred Tree: A History of Interpretations.* Orbis Biblicus et Orientalis 230. Fribourg, 2007.

Gitin 2009
Gitin, S. "The Late Iron Age II Incense Altars from Ashkelon." In *Exploring the Longue Durée: Essays in Honor of Lawrence E. Stager*, ed. J. D. Schloen, 127–36. Winona Lake, Ind., 2009.

Given 1991
Given, M. "Symbols, Power, and the Construction of Identity in the City-Kingdoms of Ancient Cyprus ca. 750–312 B.C." Ph.D. diss., Cambridge University, 1991.

Gjerstad 1934
Gjerstad, E. "Lapithos: The Necropolis at Kastros." In *SCE* I, 172–265.

Gjerstad 1935a
Gjerstad, E. "Ajia Irini." In *SCE* II, 642–824.

Gjerstad 1935b
Gjerstad, E. "Marion." In *SCE* II, 181–459.

Gjerstad 1937
Gjerstad, E. "Vouni. The Palace." In *SCE* III, 111–290.

Gjerstad 1944
Gjerstad, E. "The Colonization of Cyprus in Greek Legend." *OpArch* 3 (1944): 107–23.

Gjerstad 1946
Gjerstad, E. "Four Kings." *OpArch* 4 (1946): 21–24.

Gjerstad 1948
Gjerstad, E. *The Swedish Cyprus Expedition*, vol. IV, pt. 2. *The Cypro-Geometric, Cypro-Archaic, and Cypro-Classical Periods*. Stockholm, 1948.

Gjerstad 1980
Gjerstad, E. *Ages and Days in Cyprus*. SIMA. Pocket-Book 12. Göteborg, 1980.

Gjerstad 1994
Gjerstad, E. "'The Born Field Archaeologist': Erik Sjöqvist." In *"The Fantastic Years on Cyprus": The Swedish Cyprus Expedition and Its Members*, by P. Åström, E. Gjerstad, R. S. Merrillees, and A. Westholm, 33–35. SIMA and Literature. Pocket-Book 79. Jonsered, 1994.

Gjerstad et al. 1977
Gjerstad, E., Y. Calvet, M. Yon, V. Karageorghis, and J. P. Thalmann. *Greek Geometric and Archaic Pottery Found in Cyprus*. Skrifter Utgivna av Svenska Institutet i Athen 26. Stockholm, 1977.

Goldman and Jones 1950
Goldman, H., and F. Jones. "The Lamps." In *Excavations at Gözlü Kule, Tarsus*, vol. 1, *The Hellenistic and Roman Periods*, ed. H. Goldman, 84–134. Princeton, 1950.

Goodwin 1984
Goodwin, J. C. *An Historical Toponymy of Cyprus*. 4th edition. Nicosia, 1984.

Goring 1988
Goring, E. *A Mischievous Pastime: Digging in Cyprus in the Nineteenth Century, with a Catalogue of the Exhibition "Aphrodite's Island: Art and Archaeology of Ancient Cyprus" held in the Royal Museum of Scotland, Edinburgh, from 14 April to 4 September 1988*. Edinburgh, 1988.

Gough 1985
Gough, M., ed. *Alahan: An Early Christian Monastery in Southern Turkey*. Toronto, 1985.

Grierson and Mays 1992
Grierson, P., and M. Mays. *Catalogue of Late Roman Coins in the Dumbarton Oaks Collection and in the Whittemore Collection: From Arcadius and Honorius to the Accession of Anastasius*. Washington, D.C., 1992.

Grivaud 2005
Grivaud, G. "Literature." In Nikolaou-Konnari and Schabel 2005, 219–84.

Groom 1981
Groom, N. *Frankincense and Myrrh: A Study of the Arabian Incense Trade*. London and New York, 1981.

Gubel 1987
Gubel, E. *Phoenician Furniture: A Typology Based on Iron Age Representations with Reference to the Iconographical Context*. Studia Phoenicia 7. Louvain, 1987.

Gunnis 1936
Gunnis, R. *Historic Cyprus: A Guide to Its Towns and Villages, Monasteries and Castles*. Nicosia, 1936.

Hadjicosti 1993
Hadjicosti, M. "The Late Archaic and Classical Cemetery of Agioi Omologites, Nicosia." *RDAC*, 1993, 173–93.

Hadjidemetriou 2002
Hadjidemetriou, K. *A History of Cyprus*. Nicosia, 2002.

Hadjisavvas 1992
Hadjisavvas, S. *Olive Oil Processing in Cyprus: From the Bronze Age to the Byzantine Period*. SIMA 99. Nicosia, 1992.

Hadjisavvas 1998
Hadjisavvas, S. "Chronique des fouilles et découvertes archéologiques à Chypre en 1997." *BCH* 122 (1998): 663–703.

Hadjisavvas 2001
Hadjisavvas, S. "Chronique des fouilles et découvertes archéologiques à Chypre en 2000." *BCH* 125, no. 2 (2001): 743–77.

Hadjisavvas 2003
Hadjisavvas, S., ed. *From Ishtar to Aphrodite: 3200 Years of Cypriot Hellenism: Treasures from the Museums of Cyprus*. New York, 2003.

Hadjisavvas 2010
Hadjisavvas, S., ed. *Cyprus: Crossroads of Civilizations*. Nicosia, 2010.

Hadley 2000
Hadley, J. M. *The Cult of Asherah in Ancient Israel and Judah: Evidence for a Hebrew Goddess*. New York and Cambridge, 2000.

Hahn 1975
Hahn, W. *Moneta Imperii Byzantini. Einschliesslich der Prägungen der Heraclius-Revolte und mit Nachträgen zum 1. Band von Justinus II. bis Phocas (565–610)*. Österreichische Akademie der Wissenschaften, Philosophisch-historische Klasse 119. Vienna, 1975.

Hahn 1989
Hahn, W. *Die Ostprägung des römischen Reiches im 5. Jahrhundert (408–491)*. Österreichische Akademie der Wissenschaften, Philosophisch-historische Klasse 199. Vienna, 1989.

Hahn and Metlich 2009
Hahn, W., and M. Metlich. *Money of the Incipient Byzantine Empire, Continued (Justin II–Revolt of the Heraclii, 565–610)*. Vienna, 2009.

Hansen 2001
Hansen, N. B. "Insects." In *The Oxford Encyclopedia of Ancient Egypt*, ed. D. B. Redford, vol. 2, 161–63. Oxford, 2001.

Haran 1960
Haran, M. "The Uses of Incense in the Ancient Israelite Ritual." *Vetus Testamentum* 10, no. 2 (1960): 113–29.

Harden 1935
Harden, D. B. "Romano-Syrian Glasses with Mould-Blown Inscriptions." *JRS* 25 (1935): 163–86.

Harden 1946
Harden, D. B. "Two Tomb-Groups of the First Century A.D. from Yahmour, Syria, and a Supplement to the List of Romano-Syrian Glasses with Mould-Blown Inscriptions." *Syria* 24 (1944–45) (pub. 1946): 81–95, 291–92.

Harrison (E. B.) 1965
Harrison, E. B. *The Athenian Agora: Results of Excavations Conducted by the American School of Classical Studies at Athens*. Vol. 11, *Archaic and Archaistic Sculpture*. Princeton, 1965.

Harrison (E. B.) 1988
Harrison, E. B. "Greek Sculptural Coiffures and Ritual Haircuts." In *Early Greek Cult Practice: Proceedings of the Fifth International Symposium at the Swedish Institute at Athens, 26–29 June, 1986*, ed. R. Hägg, N. Marinatos, and G. C. Nordquist, 247–54. Skrifter utgivna av Svenska instituet i Athen 38. Stockholm, 1988.

Harrison (R. M.) 1986
Harrison, R. M. *Excavations at Saraçhane in Istanbul: The Excavations, Structures, Architectural Decoration, Small Finds, Coins, Bones, and Molluscs*, vol. 1. Princeton, 1986.

Haspels 1936
Haspels, C. H. E. *Attic Black-figured Lekythoi.* Paris, 1936.

Hatton, Shortland, and Tite 2008
Hatton, G. D., A. J. Shortland, and M. S. Tite. "The Production Technology of Egyptian Blue and Green Frits from Second Millennium B.C. Egypt and Mesopotamia." *Journal of Archaeological Science* 35 (2008): 1591–1604.

Hayes 1967
Hayes, J. W. "Cypriot Sigillata." *RDAC*, 1967, 65–77.

Hayes 1980
Hayes, J. W. *Ancient Lamps in the Royal Ontario Museum.* Vol. 1, *Greek and Roman Clay Lamps: A Catalogue.* Toronto, 1980.

Hayes 1984
Hayes, J. W. *Greek, Roman, and Related Metalware in the Royal Ontario Museum: A Catalogue.* Toronto, 1984.

Hayes 1985
Hayes, J. W. "Sigillate Orientali." In *Atlante delle forme ceramiche II. Ceramica fine romana nel bacino mediterraneo, tardo ellenismo e primo imperio. Enciclopedia dell'arte antica*, 1–96. Rome, 1985.

Hayes 1986
Hayes, J. W. "Sigillate Orientali." In *Atlante delle forme ceramiche II. Enciclopedia dell'arte antica*, Supp. 2, 9–48. Rome, 1986.

Helly 1973
Helly, B. "Les monnaies." In *Excavations in the Necropolis of Salamis*, vol. 3, ed. V. Karageorghis, 204–13. Salamis 5. Nicosia, 1973.

Hermary 1989a
Hermary, A. *Musée du Louvre, Département des antiquités orientales: Catalogue des antiquités de Chypre: Sculptures.* Paris, 1989.

Hermary 1989b
Hermary, A. "Témoinage des documents figurés sur la société chypriote d'époque classique." In Peltenburg 1989, 180–96.

Hermary 2002
Hermary, A. "Les Ascendances légendaires des rois chypriotes: Quelques messages iconographiques." *CCEC* 32 (2002): 275–88.

Hermary 2004
Hermary, A. "Monuments funéraires et votifs à Chypre: les stèles et les reliefs en pierre." In *Sepulkral- und Votivdenkmäler östlicher Mittelmeergebiete (7. Jh. v. Chr.–1. Jh. n .Chr.). Kulturbegegnungen im Spannungsfeld von Akzeptanz und Resistenz. Akten des Internationalen Symposiums Mainz, 1.–3. November 2001*, ed. R. Bol and D. Kreikenbom, 73–83. Möhnesee, 2004.

Hermary and Markou 2003
Hermary, A., and E. Markou. "Les Boucles d'oreilles, bijoux masculins à Chypre et en Méditerranée orientale (VIIᵉ–IVᵉ siècles avant J.-C.)." *CCEC* 33 (2003): 211–36.

Herrmann 1888
Herrmann, P. *Das Gräberfeld von Marion auf Cypern.* Programm zum Winckelmannsfeste der Archäologischen Gesellschaft zu Berlin 48. Berlin, 1888.

Herscher 1976
Herscher, E. "South Coast Ceramic Styles at the End of Middle Cypriote." *RDAC*, 1976, 11–19.

Herscher 2003
Herscher, E. "The Ceramics." In *Sotira Kaminoudhia: An Early Bronze Age Site in Cyprus*, ed. S. Swiny, G. Rapp, and E. Herscher, 145–204. CAARI Monograph Series 4. ASOR Archaeological Reports 8. Boston, 2003.

Herscher and Fox 1993
Herscher, E., and S. C. Fox. "A Middle Bronze Age Tomb from Western Cyprus." *RDAC*, 1993, 69–80.

Higgins 1967
Higgins, R. A. *Greek Terracottas.* London, 1967.

Higgins 1969
Higgins, R. A. *Catalogue of the Terracottas in the Department of Greek and Roman Antiquities, British Museum.* Vol. 1, *Greek: 730–330 B.C.* London, 1969.

Higgins 1970
Higgins, R. A. "The Polychrome Decoration of Greek Terracottas." *Studies in Conservation* 15 (1970): 272–77.

Higgins 1980
Higgins, R. *Greek and Roman Jewellery.* 2nd ed. Berkeley, 1980.

Hill 1904
Hill, G. F. *Catalogue of the Greek Coins of Cyprus.* London, 1904.

Hill 1940
Hill, G. *A History of Cyprus.* Vol. 1, *To the Conquest by Richard Lion Heart.* Cambridge, 1940.

Hill 1972
Hill, G. *A History of Cyprus.* Vol. 4, *The Ottoman Province, The British Colony, 1571–1948.* Cambridge, 1972.

Hoffmann 1977
Hoffmann, H. *Sexual and Asexual Pursuit: A Structuralist Approach to Greek Vase Painting.* London, 1977.

Hogarth 1889
Hogarth, D. G. *Devia Cypria: Notes of an Archaeological Journey in Cyprus in 1888.* London, 1889.

Houby-Nielsen 2003
Houby-Nielsen, S. "The Swedish Cyprus Expedition 1927–1931 and Its Relation to Contemporary Prehistoric Archaeology in Sweden." In Karageorghis (V.) et al. 2003, 1–12.

Houlihan 1986
Houlihan, P. F. *The Birds of Ancient Egypt.* Warminster, 1986.

Howard and Johnson 1954
Howard, S., and F. P. Johnson. "The Saint-Valentin Vases." *AJA* 58 (1954): 191–207.

Hutchinson and Cobham 1907
Hutchinson, J. T., and C. D. Cobham. *A Handbook of Cyprus.* London, 1907.

Ivison 1993
Ivison, E. *Mortuary Practices in Byzantium (c. 950–1453): An Archaeological Contribution.* Ph.D. diss., University of Birmingham, 1993.

Jacobsen 2006
Jacobsen, K. W. "Pots for the Dead. Pottery and Ritual in Cypriote Tombs of the Hellenistic and Roman Period." In *Old Pottery in a New Century. Innovating Perspectives on Roman Pottery Studies. Atti del convegno*

internazionale di studi, 22–24 April 2004, ed. D. Malfitana, J. Poblome, and J. Lund, 389–96. *Monografie dell'Istituto per i Beni Archeologici e Monumentali* 1. Catania, 2006.

Jeammet 2010
Jeammet, V. *Tanagras: Figurines for Life and Eternity. The Musée du Louvre's Collection of Greek Figurines.* Valencia, 2010.

Jeffrey 1918
Jeffrey, G. *A Description of the Historic Monuments of Cyprus: Studies in the Archaeology and Architecture of the Island.* London, 1918; reprint London, 1983.

Johnston 1981
Johnston, A. W. "Imported Greek Storage Amphorae." In Karageorghis (V.) et al. 1981, 37–44.

Kalavrezou 2003
Kalavrezou, I., ed. *Byzantine Women and Their World.* Cambridge and New Haven, Conn., 2003.

Kaptan 2002
Kaptan, D. *The Daskyleion Bullae: Seal Images from the Western Achaemenid Empire.* Achaemenid History 12. Leiden, 2002.

Karageorghis (J.) 1977
Karageorghis, J. *La Grande Déesse de Chypre et son culte, à travers l'iconographie, de l'époque néolithique au VIᵉ s. av. J.-C.* Collection de la Maison de l'Orient méditerranéen, Série archéologique 4. Lyon, 1977.

Karageorghis (J.) 1999
Karageorghis, J. *The Coroplastic Art of Ancient Cyprus, 5: The Cypro-Archaic Period Small Female Figurines B. Figurines Moulées.* Nicosia, 1999.

Karageorghis (J.) 2005
Karageorghis, J. *Kypris: The Aphrodite of Cyprus: Ancient Sources and Archaeological Evidence.* Nicosia, 2005.

Karageorghis (V.) 1959
Karageorghis, V. "Chronique des fouilles et découvertes archéologiques à Chypre en 1958." *BCH* 83, no. 1 (1959): 336–61.

Karageorghis (V.) 1962
Karageorghis, V. "Chronique des fouilles et découvertes archéologiques à Chypre en 1961." *BCH* 86, no. 1 (1962): 327–414.

Karageorghis (V.) 1965a
Karageorghis, V. "Chronique des fouilles et découvertes archéologiques à Chypre en 1964." *BCH* 89, no. 1 (1965): 231–300.

Karageorghis (V.) 1965b
Karageorghis, V. *Nouveau Documents pour l'étude du Bronze Récent à Chypre: Recueil critique et commenté.* Études Chypriotes 3. Paris, 1965.

Karageorghis (V.) 1966
Karageorghis, V. "Chronique des fouilles et découvertes archéologiques à Chypre en 1965." *BCH* 90, no. 1 (1966): 297–389.

Karageorghis (V.) 1967
Karageorghis, V. "Nouvelles tombs de guerriers à Chypre en 1968." *BCH* 91, no. 1 (1967): 202–45.

Karageorghis (V.) 1969
Karageorghis, V. "Chronique des fouilles et découvertes archéologiques à Chypre en 1968." *BCH* 93, no. 2 (1969): 431–569.

Karageorghis (V.) 1974
Karageorghis, V. "Kypriaka I." *RDAC*, 1974, 60–74.

Karageorghis (V.) 1975
Karageorghis, V. *Cypriote Antiquities in the Pierides Collection, Larnaca, Cyprus.* Athens, 1975.

Karageorghis (V.) 1977a
Karageorghis, V. *The Goddess with Uplifted Arms.* Scripta Minora in honorem Einari Gjerstad, 1977–1978. Lund, 1977.

Karageorghis (V.) 1977b
Karageorghis, V. *Two Cypriote Sanctuaries of the End of the Cypro-Archaic Period.* Centro di Studio per la Civiltà Fenicia e Punica 17. Serie Archeologica 22. Rome, 1977.

Karageorghis (V.) 1978
Karageorghis, V. *Excavations in the Necropolis of Salamis*, vol. 4. Salamis 7. Nicosia, 1978.

Karageorghis (V.) 1979
Karageorghis, V., ed. *Studies Presented in Memory of Porphyrios Dikaios.* Nicosia, 1979.

Karageorghis (V.) 1982
Karageorghis, V. *Cyprus, from the Stone Age to the Romans.* London, 1982.

Karageorghis (V.) 1983
Karageorghis, V. *Palaepaphos-Skales: An Iron Age Cemetery in Cyprus.* Ausgrabungen in Alt-Paphos auf Cypern 3. Konstanz, 1983.

Karageorghis (V.) 1985
Karageorghis, V. *Archaeology in Cyprus, 1960–1985.* Nicosia, 1985.

Karageorghis (V.) 1986
Karageorghis, V. *Acts of the International Archaeological Symposium "Cyprus between the Orient and the Occident," Nicosia, 8–14 September, 1985.* Nicosia, 1986.

Karageorghis (V.) 1987
Karageorghis, V. "The Terracottas." In *La Nécropole d'Amathonte. Tombes 113–367*, vol. 3, by V. Karageorghis and A. Hermary, 1–52. Études Chypriotes 9. Nicosia, 1987.

Karageorghis (V.) 1990
Karageorghis, V. "Miscellanea from Late Bronze Age Cyprus II: A Late Bronze Age Musical Instrument?" *Levant* 22 (1990): 157–59.

Karageorghis (V.) 1993
Karageorghis, V. *The Coroplastic Art of Ancient Cyprus*, 3: *The Cypro-Archaic Period Large and Medium-Size Sculpture.* Nicosia, 1993.

Karageorghis (V.) 1996
Karageorghis, V. *The Coroplastic Art of Ancient Cyprus*, 6: *The Cypro-Archaic Period Monsters, Animals, and Miscellanea.* Nicosia, 1996.

Karageorghis (V.) 1997
Karageorghis, V. "A Phoenician Type Funerary Cippus from Cyprus." *CCEC* 27 (1997): 121–26.

Karageorghis (V.) 1998
Karageorghis, V. *The Coroplastic Art of Ancient Cyprus*, 5, pt. 1: *The Cypro-Archaic Period Small Female Figurines A. Handmade/Wheelmade Figurines.* Nicosia, 1998.

Karageorghis (V.) 2000
Karageorghis, V. *Ancient Art from Cyprus: The Cesnola Collection in The Metropolitan Museum of Art.* New York, 2000.

Karageorghis (V.) 2001
Karageorghis, V. *Ancient Cypriote Art in Copenhagen: The Collections of the National Museum of Denmark and the Ny Carlsberg Glyptotek.* Nicosia, 2001.

Karageorghis (V.) 2002
Karageorghis, V. *Ancient Art from Cyprus in the Collection of George and Nefeli Giabra Pierides.* Athens, 2002.

Karageorghis (V.) 2003
Karageorghis, V. *The Cyprus Collections in the Medelhavsmuseet.* Nicosia, 2003.

Karageorghis (V.) and Des Gagniers 1974
Karageorghis, V., and J. Des Gagniers. *La Céramique chypriote de style figuré. Âge du fer, 1050–500 av. J.-C.* Rome, 1974.

Karageorghis (V.) and Kassianidou 1999
Karageorghis, V., and V. Kassianidou. "Metalworking and Recycling in Late Bronze Age Cyprus: The Evidence from Kition." *OJA* 18, no. 2 (1999): 171–88.

Karageorghis (V.) et al. 1981
Karageorghis, V., J. N. Coldstream, P. M. Bikai, A. W. Johnston, M. Robertson, and L. Jehasse. *Excavations at Kition* IV. *The Non-Cypriote Pottery.* Nicosia, 1981.

Karageorghis (V.), Picard, and Tytgat 1991
Karageorghis, V., O. Picard, and C. Tytgat, eds. *La Nécropole d'Amathonte, Tombes 110–385*, vol. 5. Études Chypriotes 13. Nicosia, 1991.

Keel 1980
Keel, O. *Das Böcklein in der Milch seiner Mutter und Verwantes: im Lichte eines altorientalischen Bildmotivs.* Orbis Biblicus et Orientalis 33. Fribourg, 1980.

Keesling 2003
Keesling, C. M. *The Votive Statues of the Athenian Acropolis.* Cambridge and New York, 2003.

Kenyon 1957
Kenyon, K. "Terra Sigillata." In *Samaria-Sebaste: Reports of the Work of the Joint Expedition in 1931–1933 and of the British Expedition in 1935*, vol. 3, *The Objects from Samaria*, ed. J. Crowfoot, G. Crowfoot, and K. Kenyon, 281–88. London, 1957.

Kilinski 1994
Kilinski, K., II. "Contributions to the Euboean Corpus: More Black Figure Vases." *Antike Kunst* 37 (1994): 3–20.

Kitromilidès 2006
Kitromilidès, P. M. "Esquisse d'une périodisation de la vie intellectuelle chypriote, 1571–1878." *CCEC* 36 (2006): 125–41.

Kramer 2004
Kramer, N. *Gindaros: Geschichte und Archäologie einer Siedlung im nordwestlichen Syrien vom hellenistischer bis in frühbyzantinische Zeit.* Internationale Archäologie 41. Rahden, 2004.

Krueger 2006
Krueger, D., ed. *Byzantine Christianity.* People's History of Christianity 3. Minneapolis, Minn., 2006.

Krpata 1992
Krpata, M. "Max Hermann Ohnefalsch-Richter Bibliography and Biographical Remarks." *RDAC*, 1992, 337–41.

Laffineur 1986
Laffineur, R. "L'Orfèverie." In *Amathonte, III: Testimonia 3,* by R. Laffineur, A. Hermary, and A. Forgeau, 7–133. Études Chypriotes 7. Paris, 1986.

Laffineur 1991
Laffineur, R. "La Bijouterie chypriote d'après le témoignage des terres cuites: L'exemple des statuettes d'Arsos." In Vandenabeele and Laffineur 1991, 171–81.

Lambert 1970
Lambert, W. G. "The Sultantepe Tablets: IX. The Birdcall Text." *AnatStud* 20 (1970): 111–17.

Laurent 1952
Laurent, V. *Documents de sigillographie byzantine: la collection C. Orghidan.* Paris, 1952.

Le Bas and Waddington 1870
Le Bas, P., and W. H. Waddington. *Voyage archéologique en Grèce et en Asie Mineure: fait par ordre du gouvernement français pendant les années 1843 et 1844.* Vol. 3, *Inscriptions grecques et latines recueillies en Grèce et en Asie Mineure.* Paris, 1870.

Lemos 1991
Lemos, A. *Archaic Pottery of Chios: The Decorated Styles.* Monograph, Oxford University Committee for Archaeology 30. Oxford, 1991.

Lezzi-Hafter 1976
Lezzi-Hafter, A. *Der Schuwalow-Maler. Eine Kannenwerkstatt der Parthenonzeit.* Mainz, 1976.

Linders and Alroth 1992
Linders, T., and B. Alroth, eds. *Economics of Cult in the Ancient Greek World: Proceedings of the Uppsala Symposium 1990.* Acta Universitatis Upsaliensis, BOREAS 21. Uppsala, 1992.

Ling 1986
Ling, R. "Hellenistic and Graeco-Roman Art." In Boardman, Griffin, and Murray 1986, 380–408.

Lipiński 1991
Lipiński, E. "The Cypriot Vassals of Essarhadon." In *Ah, Assyria . . . : Studies in Assyrian History and Ancient Near Eastern Historiography Presented to Hayim Tadmor,* eds. M. Cogan and I. Eph'al. Scripta Hierosolymitana 33. Jerusalem, 1991.

Loulloupis 1989
Loulloupis, M. C. "A Rural Cult Place in the Soloi Area." In Tatton-Brown 1989, 68–83.

Lubsen-Admiraal 2004
Lubsen-Admiraal, S. *Ancient Cypriote Art: The Thanos N. Zintilis Collection.* Athens, 2004.

Luce 1933
Luce, S. B. *CVA: United States*, 2: *Providence: Rhode Island School of Design*, fascicle 1. Cambridge, Mass., 1933.

Luckenbill 1927
Luckenbill, D. D. *Ancient Records of Assyria and Babylonia.* Vol. 2, *Historical Records of Assyria from Sargon to the End.* Chicago, 1927.

Lundgreen 1997
Lundgreen, B. "A Methodological Enquiry: The Great Bronze Athena by Pheidias." *JHS* 117 (1997): 190–97.

Lunsingh Scheurleer 1991
Lunsingh Scheurleer, R. "Five Terracottas from Cyprus." In Vandenabeele and Laffineur 1991, 69–75.

Lusignan 1580
Lusignan, É. de. *Description de toute l'îsle de Cypre, et des roys, princes, et seigneurs, tant payens que Chrestiens, qui ont commandé en icelle.* Paris, 1580.

Lusignano 1573
Lusignano, S. *Chorografﬁa, et breve historia universale dell'isola de Cipro principiando al tempo di Noè per in sino al 1572.* Bologna, 1573.

Maguire, Maguire, and Duncan-Flowers 1989
Maguire, E. D., H. P. Maguire, and M. J. Duncan-Flowers. *Art and Holy Powers in the Early Christian House.* Urbana, Ill., 1989.

Maier 1989
Maier, F. G. "Priest Kings in Cyprus." In Peltenburg 1989, 376–91.

Maier 1994
Maier, F. G. "Cyprus and Phoenicia." In *The Cambridge Ancient History*, vol. 6: *The Fourth Century B.C.*, ed. D. M. Lewis, J. Boardman, S. Hornblower, and M. Ostwald, 297–336. 2nd ed. Cambridge, 1994.

Maier 2008
Maier, F. G. *Nordost-Tor und persische Belagerungsrampe in Alt-Paphos,* III: *Grabungsbefund und Baugeschichte.* Ausgrabungen in Alt-Paphos auf Cypern 6. Konstanz and Mainz am Rhein, 2008.

Maliszewski 1994
Maliszewski, D. "Polis-Pyrgos Archaeological Project: A Preliminary Report on the 1992/1993 Survey Seasons in Northwestern Cyprus." *RDAC*, 1994, 167–74.

Maliszewski 1995
Maliszewski, D. "Polis-Pyrgos Archaeological Project: Second Preliminary Report on the 1994 Survey Season in Northwestern Cyprus." *RDAC*, 1995, 311–16.

Maliszewski 1997
Maliszewski, D. "Notes on the Bronze Age Settlement Patterns of Western Cyprus, c. 2500–c. 1050 B.C." *RDAC*, 1997, 65–84.

Maliszewski 1999
Maliszewski, D. "Polis-Pyrgos Archaeological Project: Fourth Preliminary Report on the 1998 Study and 1996/1997 Survey Seasons in Northwestern Cyprus." *RDAC*, 1999, 339–50.

Maliszewski 2003
Maliszewski, D. "Polis-Pyrgos Archaeological Project: Notes on the Survey Artefacts from Northwestern Cyprus." *RDAC*, 2003, 351–76.

Maliszewski 2006
Maliszewski, D. "Some Thoughts on the Visit of Eugen Oberhummer to Western Cyprus in 1887." *RDAC*, 2006, 407–13.

Maliszewski 2007
Maliszewski, D. "Neolithic, Chalcolithic and Bronze Age Sites in Northwestern Cyprus: First Assessment." *RDAC*, 2007, 87–104.

Maliszewski et al. 2003
Maliszewski, D., N. Serwint, J. S. Smith, and B. J. Walker. "Polis-Pyrgos Archaeological Project: Fifth Preliminary Report on the 1999–2001 Research Seasons in Northwestern Cyprus." *Thetis* 10 (2003): 7–38.

Marinatos 2000
Marinatos, N. *The Goddess and the Warrior: The Naked Goddess and Mistress of the Animals in Early Greek Religion.* London and New York, 2000.

Markides 1917
Markides, M. *Cyprus. Annual Report of the Curator of Antiquities, 1916.* Nicosia, 1917.

Markoe 1990a
Markoe, G. "The Emergence of Phoenician Art." *BASOR* 279 (1990): 13–26.

Markoe 1990b
Markoe, G. E. "Egyptianizing Male Votive Statuary from Cyprus: A Reexamination." *Levant* 22 (1990): 111–22.

Markoe 2000
Markoe, G. *Phoenicians.* Berkeley, 2000.

Marom, Bar-Oz, and Münger 2006
Marom, N., G. Bar-Oz, and S. Münger. "A New Incised Scapula from Tel Kinnot." *NEA* 69, no. 1 (2006): 37–40.

Marshall 1907
Marshall, F. H. *Catalogue of the Finger Rings, Greek, Etruscan, and Roman, in the Departments of Antiquities, British Museum.* London, 1907.

Marshall 1911
Marshall, F. H. *Catalogue of the Jewellery, Greek, Etruscan, and Roman, in the Departments of Antiquities, British Museum.* London, 1911.

Massei 1978
Massei, L. *Gli Askoi a figure rosse nei corredi funerari delle necropoli di Spina.* Testi e documenti per lo studio dell'antichità 59. Milan, 1978.

Masson 1964
Masson, O. "Petites inscriptions chypriotes syllabiques trouvées à Marion (1960)." *RDAC*, 1964, 187–88.

Masson 1983
Masson, O. *Les inscriptions chypriotes syllabiques: Recueil critique et commenté.* Reprint, augmented. Études Chypriotes 1. Paris, 1983.

Masson 1985
Masson, O. "Eléments de la vie quotidienne dans l'épigraphie chypriote." In *Chypre: La vie quotidienne de l'antiquité* à *nos jours: Actes du colloque*, 87–89. Nicosia, 1985.

Masson 1992
Masson, O. "Encore les royaumes chypriotes dans la liste d'Esarhaddon." *CCEC* 18 (1992): 27–30.

Masson and Sznycer 1972
Masson, O., and M. Sznycer. *Recherches sur les Phéniciens à Chypre.* Hautes Études Orientales 3. Geneva and Paris, 1972.

Matthäus 1985
Matthäus, H. *Metallgefässe und Gefässuntersätze der Bronzezeit, der geometrischen und archaischen Periode auf Cypern: mit einen Anhang der bronzezeitlichen Schwertfunde auf Cypern.* Prähistorische Bronzefunde 2.8. Munich, 1985.

Matthäus 1999
Matthäus, H. "Zu Thymiateria und Räucherritus als Zeugnissen des Orientalisierungsprozesses im Mittelmeergebiet während des frühen 1. Jahrtausends v. Chr." *CCEC* 29 (1999): 9–31.

McFadden 1946
McFadden, G. H. "A Tomb of the Necropolis of Ayios Ermoyenis at Kourion." *AJA* 50 (1946): 449–89.

McGovern 2009
McGovern, P. E. *Uncorking the Past: The Quest for Wine, Beer, and Other Alcoholic Beverages.* Berkeley, 2009.

Megaw 1974
Megaw, A. H. S. "Architecture and Decoration on Cyprus: Metropolitan or Provincial?" *DOP* 28 (1974): 57–88.

Megaw 1979
Megaw, A. H. S. "The Head and Feet Fragments and Another Stele from Marion." In Karageorghis (V.) 1979, 139–54.

Megaw 1988
Megaw, A. H. S. "The British School at Athens and Cyprus." *RDAC*, 1988, 281–86.

Megaw 2007
Megaw, A. H. S. *Kourion: Excavations in the Episcopal Precinct.* Washington, D.C., 2007.

Merrillees (P. H.) 2005
Merrillees, P. H. *Catalogue of the Western Asiatic Seals in the British Museum. Cylinder Seals,* vol. 6: *Pre-Achaemenid and Achaemenid Periods.* London, 2005.

Merrillees (R. S.) 1974
Merrillees, R. S. "Archaeological Notes III: Some Notes on Tell el-Yahudiya Ware." *Levant* 6 (1974): 193–95.

Merrillees (R. S.) 2005a
Merrillees, R. S. *The First Cyprus Museum in Victoria Street, Nicosia.* Nicosia, 2005.

Merrillees (R. S.) 2005b
Merrillees, R. S. "Towards a Fuller History of the Cyprus Museum." *CCEC* 35 (2005): 191–214.

Mertens 1977
Mertens, J. R. *Attic White-Ground: Its Development on Shapes Other than Lekythoi.* New York, 1977.

Metcalf 1990
Metcalf, D. M. "The Currency of Lusignan Cyprus in the Years around 1400 in the Light of a Coin Hoard Excavated at Polis." *RDAC*, 1990, 241–84.

Metcalf 2001
Metcalf, D. M. "Monetary Recession in the Middle Byzantine Period." *NC* 161 (2001): 111–55.

Metcalf 2004
Metcalf, D. M. *Byzantine Lead Seals from Cyprus.* Texts and Studies of the History of Cyprus 47. Nicosia, 2004.

Milliken 1958
Milliken, W. M. "Early Byzantine Silver." *Bulletin of the Cleveland Museum of Art* 45, no. 3 (1958): 35-41.

Mitford 1939
Mitford, T. B. "Milestones in Western Cyprus." *JRS* 29 (1939): 184–98.

Mitford 1953
Mitford, T. B. "Seleucus and Theodorus." *OpAth* 1 (1953): 130–71.

Mitford 1959
Mittord, T. B. "Helenos, Governor of Cyprus." *JHS* 79 (1959): 94–131.

Mitford 1961
Mitford, T. B. "Further Contributions to the Epigraphy of Cyprus." *AJA* 65 (1961): 93–151.

Mitford 1980
Mitford, T. B. "Roman Cyprus." In *ANRW* 2, *Prinkipat,* vol. 7, no. 2, 1235–1384. Berlin and New York, 1980.

Mitford 1990
Mitford, T. B. "The Cults of Roman Cyprus." In *ANRW* 2, *Prinkipat,* vol. 18, no. 3, 2177–2211. Berlin and New York, 1990.

Moon 1971
Moon, C. B. "An Investigation of the Attic Askos and Its Geneology." Ph.D. diss., New York University, 1971.

Morgan 1994
Morgan, C. "The Evolution of a Sacral 'Landscape': Isthmia, Perachora, and the Early Corinthian State." In *Placing the Gods: Sanctuaries and Sacred Space in Ancient Greece,* ed. S. E. Alcock and R. Osborne, 105–42. Oxford and New York, 1994.

Mørkholm and Zahle 1976
Mørkholm, O., and J. Zahle. "The Coinage of the Lycian Dynasts Kheriga, Kherêi, and Erbbina." *Acta Archaeologica* 47 (1976): 47–90.

Moscati 1968
Moscati, S., ed. *The World of the Phoenicians.* London, 1968.

Moscati 1988
Moscati, S., ed. *The Phoenicians.* Milan, 1988.

Mundell Mango 2003
Mundell Mango, M. "Three Illuminating Objects in the Lampsacus Treasure." In *Through a Glass Brightly: Studies in Byzantine and Medieval Art and Archaeology Presented to David Buckton,* ed. C. Entwistle, 64–75. Oxford, 2003.

Munro 1889
Munro, J. A. R. "Review of *Das Gräberfeld von Marion auf Cypern, Achtundvierzigstes Programm zum Winckelmannsfeste der archäol. Gesellsch. zu Berlin,* by Paul Herrmann." *JHS* 10 (1889): 281–83.

Munro 1891
Munro, J. A. R. "Excavations in Cyprus. Third Season's Work—Polis tes Chrysochou." *JHS* 12 (1891): 298–333.

Munro and Tubbs 1890
Munro, J. A. R., and H. A. Tubbs. "Excavations in Cyprus, 1889. Second Season's Work. Polis tes Chrysochou-Limniti." *JHS* 11 (1890): 1–99.

Murray 1887
Murray, A. S. "Two Vases from Cyprus." *JHS* 8 (1887): 317–23.

Myres 1914
Myres, J. L. *Handbook of the Cesnola Collection of Antiquities from Cyprus.* New York, 1914.

Myres and Ohnefalsch-Richter 1899
Myres, J. L., and M. Ohnefalsch-Richter. *A Catalogue of the Cyprus Museum with a Chronicle of Excavations Undertaken since the British Occupation and Introductory Notes on Cypriote Archaeology.* Oxford, 1899.

Najbjerg, Nicklies, and Papalexandrou (A.) 2002
Najbjerg, T., C. Nicklies, and A. Papalexandrou. "Princeton University Excavations at Polis/Arsinoe: Preliminary Report on the Roman and Medieval Levels." *RDAC*, 2002, 139–54.

Negbi 1978
Negbi, O. "Cypriote Imitations of Tell el-Yahudieh Ware from Toumba tou Skourou." *AJA* 82, no. 2 (1978): 137–49.

Nick 2002
Nick, G. *Die Athena Parthenos: Studien zum griechischen Kultbild und seiner Rezeption.* Mitteilungen des Deutschen Archäologischen Instituts, Athenische Abteilung Beiheft 19. Mainz am Rhein, 2002.

Nicolaou (I.) 1961–63
Nicolaou, I. "Inscriptiones Cypriae Alphabeticae, 1960–64." *Berytus* 14 (1961–63): 136–38.

Nicolaou (I.) 1971
Nicolaou, I. *Cypriot Inscribed Stones.* Department of Antiquities, Cyprus, Picture Book 6. Nicosia, 1971.

Nicolaou (I.) 1975
Nicolaou, I. "Inscriptiones Cypriae Alphabeticae XIV, 1974." *RDAC*, 1975, 152–58.

Nicolaou (I.) 1984
Nicolaou, I. "A Hellenistic and Roman Tomb at Eurychou-Phoenikas." *RDAC*, 1984, 234–56.

Nicolaou (I.) 1990
Nicolaou, I. *Paphos* 2: *The Coins from the House of Dionysos.* Nicosia, 1990.

Nicolaou (I.) 1991
Nicolaou, I. "The Coins." In Karageorghis, Picard, and Tytgat 1991, 177–88.

Nicolaou (I.) 1993
Nicolaou, I. "Inscriptiones Cypriae Alphabeticae XXXII, 1992." *RDAC*, 1993, 223–32.

Nicolaou (K.) 1964
Nicolaou, K. "Ἀνασκάφη Τάφων εἰς Μάριον." *RDAC*, 1964, 131–85.

Nicolaou (K.) 1966
Nicolaou, K. "The Topography of Nea Paphos." In *Mélanges offerts à Kazimierz Michałowski*, ed. M. L. Bernhard, 594–96. Warsaw, 1966.

Nicolaou (K.) 1976
Nicolaou, K. "Arsinoe, Cyprus." In *Princeton Encyclopedia of Classical Sites*, ed. R. Stillwell, 97. Princeton, 1976.

Nikolaou-Konnari and Schabel 2005
Nikolaou-Konnari, A., and C. Schabel. *Cyprus: Society and Culture, 1191–1374.* Leiden and Boston, 2005.

Nielsen 1983
Nielsen, A. M. *Cypriote Antiquities in the Ny Carlsberg Glyptotek, Copenhagen.* SIMA 20, no. 8. CCA 8. Göteborg, 1983.

Nys 2003
Nys, K. "Iron Age Jugs with Plastic Decoration on the Shoulder." In Karageorghis (V.) 2003, 273–75.

Oberhummer 1888
Oberhummer, E. "Griechische Inschriften aus Cypern." *SBMünch*, 1888, 305–48.

Ohnefalsch-Richter 1893
Ohnefalsch-Richter, M. *Kypros: The Bible and Homer. Oriental Civilization, Art and Religion in Ancient Times, Elucidated by the Author's Own Researches and Excavations during Twelve Years' Work in Cyprus.* London, 1893.

Olson and Najbjerg 2012
Olson, B., and T. Najbjerg. "A Deposit of Scythian-type Arrowheads from Polis Chrysochous (Ancient Arsinoe)." *RDAC*, 2012 (forthcoming).

Önal 2009
Önal, M. *Zeugma Mosaics: A Corpus.* Istanbul, 2009.

Onians 1988
Onians, J. *Bearers of Meaning. The Classical Orders in Antiquity, the Middle Ages, and the Renaissance.* Princeton, 1988.

Osborne and Byrne 1994
Osborne, M. J., and S. G. Byrne, eds. *A Lexicon of Greek Personal Names.* Vol. 2, *Attica.* Oxford, 1994.

Otto 1981
Otto, W. F. *Dionysus, Myth and Cult.* Trans. R. B. Palmer. Dallas, 1981.

Oziol 1977
Oziol, T. *Salamine de Chypre*, VII: *Les Lampes du Musée de Chypre.* Paris, 1977.

Oziol 1993
Oziol, T. *Les Lampes au Musée de la Fondation Piéridès, Larnaca, Chypre.* Nicosia, 1993.

Padgett 2001
Padgett, J. M. "Ajax and Achilles on a Calyx-Krater by Euphronios." *Record of The Princeton University Art Museum* 60 (2001): 2–17.

Padgett 2003
Padgett, J. M., ed. *The Centaur's Smile: The Human Animal in Early Greek Art.* Princeton and New Haven, 2003.

Padgett 2009
Padgett, J. M. "Attic Imports at Marion: Preliminary Results of the Princeton University Archaeological Expedition to Polis Chrysochous, Cyprus." In *Athenian Potters and Painters*, vol. 2, ed. J. H. Oakley and O. Palagia, 220–31. Oxford and Oakville, Conn., 2009.

Papacostas 1999
Papacostas, T. "Byzantine Cyprus: The Testimony of Its Churches, 650–1200." D.Phil. thesis, Exeter College, Oxford University, 1999.

Papadopoulos and Kontorli-Papadopoulou 1992
Papadopoulos, T. J., and L. Kontorli-Papadopoulou. "Aegean Cult Symbols in Cyprus." In Åström 1992, 330–59.

Papageorghiou 1986
Papageorghiou, A. "Foreign Influences on the Early Christian Architecture of Cyprus." In Karageorghis 1986, 490–504.

Papageorghiou 1991
Papageorghiou, A. "Chronique des fouilles et découvertes archéologiques à Chypre en 1990." *BCH* 115, no. 2 (1991): 789–833.

Papageorghiou 1993
Papageorghiou, A. "Cities and Countryside at the End of Antiquity and the Beginning of the Middle Ages in Cyprus." In *The Sweet Land of Cyprus: Papers Given at the Twenty-Fifth Jubilee Spring Symposium of Byzantine Studies, Birmingham, March 1991*, ed. A. A. M. Bryer and G. S. Georghiallides, 27–51. Nicosia, 1993.

Papageorghiou 1995
Papageorghiou, A. Ἡ Αὐτοκέφαλος Ἐκκλησία τῆς Κύπρου. Κατάλογος τῆς Ἔκθεσης. Nicosia, 1995.

Papalexandrou (A.) 2012
Papalexandrou, A. "Polis/Arsinoë: A Cypriot Town and Its Sacred Sites." In *Approaches to Byzantine Architecture and Its Decoration: Studies in Honor of Slobodan Ćurčić*, ed. M. J. Johnson, R. Ousterhout, and A. Papalexandrou, 27–46. Farnham, 2012.

Papalexandrou (N.) 2006
Papalexandrou, N. "A Cypro-Archaic Public Building at Polis tis Chrysochou, 1999–2003: Preliminary Report." *RDAC*, 2006, 223–37.

Papalexandrou (N.) 2008
Papalexandrou, N. "A Cypro-Archaic Public Building at Polis Chrysochou, 2006–2007: Interim Report." *RDAC*, 2008, 251–62.

Papanicolaou Christensen and Friis Johansen (C.) 1971
Papanicolaou Christensen, A., and C. Friis Johansen. *Hama: Fouilles et recherches de la Fondation Carlsberg, 1931–1938*. Vol. 3, pt. 2, *Les Poteries hellénistiques et les terres sigillées orientales*. Nationalmuseets Skrifter, Større beretninger 8. Copenhagen, 1971.

Papanikola-Bakirtzis 1989
Papanikola-Bakirtzis, D. *Medieval Cypriot Pottery in the Pierides Foundation Museum*. Nicosia, 1989.

Papanikola-Bakirtzis 2000
Papanikola-Bakirtzis, D. "First Preliminary Report on Glazed Pottery." Unpublished.

Papanikola-Bakirtzis 2002
Papanikola-Bakirtzis, D. "Medieval Glazed Ceramics." In Karageorghis (V.) 2002, 238–59.

Papoutsaki-Serbeti 1983
Papoutsaki-Serbeti, E. *Ό Ζωγράφος τῆς Providence*. Athens, 1983.

Parks 2004
Parks, D. A. *The Roman Coinage of Cyprus*. Nicosia, 2004.

Parks 2009
Parks, D. A. "Engendering Hellenistic and Roman Tombs: The Contribution of the Swedish Cyprus Expedition." *Medelhavsmuseet* 5 (2009): 207–19.

Parpola 1993
Parpola, S. "The Assyrian Tree of Life: Tracing the Origins of Jewish Monotheism and Greek Philosophy." *JNES* 52, no. 3 (1993): 161–208.

Patton 2006
Patton, K. C. *Religion of the Gods: Ritual, Paradox, and Reflexivity*. Oxford and New York, 2006.

Payne 1931
Payne, H. *Necrocorinthia: A Study of Corinthian Art in the Archaic Period*. Oxford, 1931.

Peltenburg 1989
Peltenburg, E., ed. *Early Society in Cyprus*. Edinburgh, 1989.

Peltenburg 2007
Peltenburg, E. "Hathor, Faience and Copper on Late Bronze Age Cyprus." *CCEC* 37 (2007): 375–94.

Perdicoyianni-Paleologou 2008
Perdicoyianni-Paleologou, H. *Prosopography of Cypriot Syllabic Inscriptions*. Sources for the History of Cyprus 15. Albany, N.Y., 2008.

Peristiane 1910
Peristiane, I. K. *Γενική Ἱστορία τῆς Νήσου Κύπρου*. Nicosia, 1910; reprint 1995.

Peschel 1987
Peschel, I. *Die Hetäre bei Komos und Symposion in der attisch-rotfigurigen Vasenmalerei des 6.–4. Jh. v. Chr.* Frankfurt and New York, 1987.

Petit 1995
Petit, T. "Objets égyptisants et idéologie royale à Amathonte." *Transeuphratène* 9 (1995): 131–47.

Philip 1983
Philip, G. "Kissonerga *Skalia* Ceramics." In "The Prehistory of West Cyprus: Ktima Lowlands Investigations, 1979–82," ed. E. J. Peltenburg et al., 46–53. *RDAC*, 1983, 9–55.

Philipp 1981
Philipp, H. *Bronzeschmuck aus Olympia*. Olympische Forschungen 13. Berlin, 1981.

Pierides 1971
Pierides, A. *Jewellery in the Cyprus Museum*. Department of Antiquities, Cyprus, Picture Book 5. Nicosia, 1971.

Pilides 2008
Pilides, D. "'Welcome, Sir, to Cyprus': The Local Reaction to American Archaeological Research." *NEA* 71, nos. 1–2 (2008): 6–15.

Pilides 2009
Pilides, D. *George Jeffrey: His Diaries and the Ancient Monuments of Cyprus*. Nicosia, 2009.

Piltz 1996
Piltz, E. *The von Post Collection of Cypriote Late Byzantine Glazed Pottery*. Jonsered, 1996.

Pitarakis 2006
Pitarakis, B. "Objects of Devotion and Protection." In Krueger 2006, 164–81.

Pitsillides and Metcalf 1995
Pitsillides, A. G., and D. M. Metcalf. "Islamic and Byzantine Coins in Cyprus during the Condominium Centuries." *Ἐπετηρὶς τοῦ Κέντρου Ἐπιστημονικῶν Ἐρευνῶν* 21 (1995): 1–13.

Plaoutine 1938
Plaoutine, N. *CVA: France*, 14: *Musée du Louvre*, fascicle 9. Paris, 1938.

Polignac 1984
Polignac, F. de. *La Naissance de la cité grecque, cultes, espace et sóciété 8e-7e siècles avant J.-C.* Paris, 1984.

Pollitt 1986
Pollitt, J. J. *Art in the Hellenistic Age*. Cambridge, 1986.

Porter 1993
Porter, B. N. "Sacred Trees, Date Palms, and the Royal Persona of Ashurnasirpal II." *JNES* 52, no. 2 (1993): 129–39.

Pottier 1926
Pottier, E. *CVA: France*, 5: *Musée du Louvre*, fascicle 4. Paris, 1926.

Prag 1973
Prag, K. "Archaeological Notes II: A Tell el-Yahudieh Style Vase in the Manchester Museum." *Levant* 5 (1973): 128–31.

Price (J.) 1991
Price, J. "Decorated Mould-Blown Glass Tableware in the First Century A.D." In *Roman Glass: Two Centuries of Art and Invention*, ed. M. Newby and K. Painter, 56–75. Occasional Papers from The Society of Antiquaries of London 13. London, 1991.

Price (S.) 1986
Price, S. "The History of the Hellenistic Period." In Boardman, Griffin, and Murray 1986, 309–31.

Price (T. H.) 1978
Price, T. H. *Kourotrophos: Cults and Representations of Greek Nursing Deities*. Leiden, 1978.

Prokopiou 1995
Prokopiou, E. "Αμαθούντα. Ανατολική νεκρόπολη. Τάφος οστεοφυλάκιο του 7ου μ.Χ. αιώνα." *RDAC*, 1995, 250–79.

Pryce 1931
Pryce, F. *Catalogue of Sculpture in the Department of Greek and Roman Antiquities of the British Museum.* Vol. 1, pt. 2, *Cypriote and Etruscan.* London, 1931.

Raban 1995
Raban, A. "The Heritage of Ancient Harbour Engineering in Cyprus and the Levant." In *Proceedings of the International Symposium, Cyprus and the Sea,* ed. V. Karageorghis and D. Michaelides, 139–89. Nicosia, 1995.

Raber 1987
Raber, P. "Early Copper Production in the Polis Region, Western Cyprus." *JFA* 14, no. 3 (1987): 297–312.

Radner 2010
Radner, K. "The Stele of Sargon II of Assyria at Kition: A Focus for an Emerging Cypriot Identity?" In *Interkulturalität in der Alten Welt: Vorderasien, Hellas, Ägypten und die vielfältigen Ebenen des Kontakts,* ed. R. Rollinger, B. Gufler, and M. Lang, 429–49. Wiesbaden, 2010.

Rapp 2005
Rapp, C. *Holy Bishops in Late Antiquity: The Nature of Christian Leadership in an Age of Transition.* Berkeley, 2005.

Raptou 1997
Raptou, E. "Note sur les coutumes funéraires de Marion à l'époque classique." *RDAC,* 1997, 225–37.

Raptou 1999
Raptou, E. *Athènes et Chypre à l'époque perse (VIᵉ–IVᵉ s. av. J.-C.): Histoire et données archéologiques.* Collection de la Maison de l'Orient 28. Série archéologique 14. Lyon, 1999.

Rautman 2000
Rautman, M. "The Busy Countryside of Late Roman Cyprus." *RDAC,* 2000, 317–31.

Rautman 2003
Rautman, M. "Valley and Village in Late Roman Cyprus." In *Recent Research on the Late Antique Countryside,* ed. W. Bowden, L. Lavan, and C. Machado, 189–219. Leiden and Boston, 2003.

Reese 1997
Reese, D. "Zooarchaeology on Cyprus." *RDAC,* 1997, 469–84.

Reese 2002
Reese, D. "On the Incised Cattle Scapulae from the East Mediterranean and Near East." *Bonner zoologische Beiträge* 50, no. 3 (2002): 183–98.

Rehm 1992
Rehm, E. *Der Schmuck der Achämeniden.* Münster, 1992.

Reinach 1891
Reinach, S. *Chroniques d'Orient: Documents sur les fouilles et découvertes dans l'Orient hellénique de 1883 à 1890.* Paris, 1891.

Reyes 1994
Reyes, A. T. *Archaic Cyprus: A Study of the Textual and Archaeological Evidence.* Oxford and New York, 1994.

Reyes 1997
Reyes, A. T. "Notes on the Iron Age Kingdoms of Cyprus." *BASOR* 308 (1997): 65–68.

Reyes 2001
Reyes, A. T. *The Stamp-Seals of Ancient Cyprus.* Oxford, 2001.

Rice 1987
Rice, P. *Pottery Analysis: A Sourcebook.* Chicago, 1987.

Richter 1961
Richter, G. M. A. *The Archaic Gravestones of Attica.* London, 1961.

Richter 1970
Richter, G. M. A. *Kouroi, Archaic Greek Youths. A Study of the Development of the Kouros Type in Greek Sculpture.* 3rd ed. London, 1970.

Risberg 1997
Risberg, C. "Evidence of Metal Working in Early Greek Sanctuaries." In *Trade and Production in Premonetary Greece: Production and the Craftsman, Proceedings of the 4th and 5th International Workshops, Athens 1994 and 1995,* ed. C. Gillis, C. Risberg, and B. Sjöberg, 185–96. SIMA and Literature. Pocket-Book 143. Jonsered, 1997.

Roaf 1990
Roaf, M. *Cultural Atlas of Mesopotamia and the Ancient Near East.* New York, 1990.

Robertson 1992
Robertson, M. *The Art of Vase-Painting in Classical Athens.* Cambridge, 1992.

Robinson (D. M.) 1933
Robinson, D. M. *Excavations at Olynthus.* Vol. 5, *Mosaics, Vases, and Lamps of Olynthus Found in 1928 and 1931.* Baltimore, 1933.

Robinson (E. S. G.) 1932
Robinson, E. S. G. "Greek Coins Acquired by the British Museum in 1930–31." *NC,* ser. 5, 12 (1932): 209–12.

Roesch 1967
Roesch, T. "Théodoros, gouverneur de Chypre." *RA,* 1967, 225–38.

Rohde 1990
Rohde, E. *CVA: Deutsche Demokratische Republik,* 3: *Staatliche Museen zu Berlin, Antikensammlung,* fascicle 1. Berlin, 1990.

Roos and Wirth 2002
Roos, A. G., and G. Wirth. *Flavius Arrianus,* 2: *Scipta Minora et Fragmenta.* Leipzig, 2002.

Root 1996
Root, M. C. "The Persepolis Fortification Tablets: Archival Issues and the Problem of Stamps versus Cylinder Seals." In *Archives et sceaux du monde hellénistique (Archivi e sigilli nel mondo ellenistico), Torino, Villa Gualino, 13–16 gennaio 1993,* ed. M.-F. Boussac and A. Invernizzi, 3–27. *BCH Supplément* 29. Athens, 1996.

Roueché 2001
Roueché, C. "The Prehistory of the Cyprus Department of Antiquities." In *Mosaic: Festschrift for A. H. S. Megaw,* ed. J. Herrin, M. Mullett, and C. Otten-Froux, 155–66. BSA Studies 8. London, 2001.

Roux 1998
Roux, G. *Salamine de Chypre,* XV: *La Basilique de la Campanopétra.* Paris, 1998.

Rupp 1987
Rupp, D. W. "Vivre le Roi: The Emergence of the State in Iron Age Cyprus." In *Western Cyprus: Connections: An Archaeological Symposium held at Brock University, St. Catherines, Ontario, Canada, March 21–22, 1986,* 147–68. SIMA 77. Göteborg, 1987.

Russell 1982
Russell, J. "Byzantine *Instrumenta Domestica* from Anemurium: The Significance of Context." In *City, Town, and Countryside in the Early Byzantine Era,* ed. R. L. Hohlfelder, 133–64. Boulder and New York, 1982.

Sabetai 2001
Sabetai, V. *CVA: Greece*, 6: *Thebes, Archaeological Museum*, fascicle 1. Athens, 2001.

Saradi-Mendelovici 1990
Saradi-Mendelovici, H. "Christian Attitudes toward Pagan Monuments in Late Antiquity and Their Legacy in Later Byzantine Centuries." *DOP* 44 (1990): 47–61.

Sathas 1877
Sathas, K. N. *Assises du royaume de Jérusalem et de Chypre*. Venice, 1877.

Sax 2005
Sax, M. "The Seal Materials, Their Chronology and Sources." In Merrillees (P. H.) 2005, 143–51.

Schaar, Given, and Theocharous 1995
Schaar, K. W., M. Given, and G. Theocharous. *Under the Clock: Colonial Architecture and History in Cyprus, 1878–1960*. Nicosia, 1995.

Schauenburg 1976
Schauenburg, K. "Askoi mit plastischen Löwenkopf." *RM* 83 (1976): 261–71.

Schaus 1986
Schaus, G. P. "Two Fikellura Vase Painters." *BSA* 81 (1986): 251–95.

Schmidt 1957
Schmidt, E. F. *Persepolis II*: *Contents of the Treasury and Other Discoveries*. University of Chicago Oriental Institute Publications 69. Chicago, 1957.

Schwabacher 1946
Schwabacher, W. "The Coins of the Vouni Treasure: Contributions to Cypriote Numismatics." *OpArch* 4 (1946): 25–46.

Schwabacher 1947
Schwabacher, W. "The Coins of The Vouni Treasure Reconsidered." *NNÅ* 12 (1947): 67–104.

Serwint 1991
Serwint, N. "The Terracotta Sculpture from Marion." In Vandenabeele and Laffineur 1991, 213–19.

Serwint 1992
Serwint, N. "The Terracotta Sculpture from Ancient Marion: Recent Discoveries." In Åström 1992, 382–426.

Serwint 1993
Serwint, N. "An Aphrodite and Eros Statuette from Ancient Marion." *RDAC*, 1993, 207–21.

Serwint 2000
Serwint, N. "A Colossal Statue from Ancient Marion." In *Periplus. Festschrift für Hans-Günter Buchholz zu seinem Achzigsten Geburstag am 24. Dezember 1999*, ed. P. Åström and D. Sürenhagen, 173–82. SIMA 127. Jonsered, 2000.

Serwint 2002
Serwint, N. "Aphrodite and Her Near Eastern Sisters: Spheres of Influence." In Bolger and Serwint 2002, 325–50.

Serwint 2008
Serwint, N. "Gender in the Sanctuary: Votive Offerings and Deity at Ancient Marion." In *Gender through Time in the Ancient Near East*, ed. D. Bolger, 313–34. Lanham, Md., 2008.

Serwint 2009
Serwint, N. "In the Shadow of the Swedish Cyprus Expedition at Ancient Marion: The Issue of Ethnicity and Cross-Cultural Exchange." *Medelhavsmuseet* 5 (2009): 229–45.

Seton-Williams 1957
Seton-Williams, M. V. "The Lamps and Miscellaneous Objects." In *Myrtou-Pigadhes: A Late Bronze Age Sanctuary in Cyprus*, by J. du Plat Taylor, 75–79. London, 1957.

Ševčenko and Moss 1999
Ševčenko, N., and C. Moss, eds. *Medieval Cyprus: Studies in Art, Architecture, and History in Memory of Doula Mouriki*. Princeton, 1999.

Sheedy 2008
Sheedy, K. A. "The Marion *kouros* in the British Museum." In *La Sculpture des Cyclades à l'Époque Archaïque: Histoire des ateliers, rayonnement des styles: Actes du colloque international organisé par l'Éphorre des antiquités préhistorique et classiques des Cyclades et l'École française d'Athènes, 7–9 Septembre 1998*, ed. Y. Kourayos and F. Prost, 335–65. *BCH Supplément* 48. Athens, 2008.

Shefton 1999
Shefton, B. B. "The Lancut Group. Silhouette Technique and Coral Red. Some Attic Vth Century Export Material in Pan-Mediterranean Sight." In *Céramique et peinture grecques: Modes d'emploi. Actes du colloque international École du Louvre, 26–27–28 avril 1995*, ed. M.-C. Villanueva Puig et al., 463–75. Paris, 1999.

Sibley 2001
Sibley, D. A. *The Sibley Guide to Bird Life and Behavior*. New York, 2001.

Sjöqvist 1934
Sjöqvist, E. "Lapithos: The Necropolis at Vrysi tou Barba." In *SCE* I, 33–162.

Sjöqvist 1940
Sjöqvist, E. *Problems of the Late Cypriote Bronze Age*. Stockholm, 1940.

Slane 1997
Slane, K. "The Fine Wares." In *Tel Anafa*, vol. 2, pt. 1, *The Hellenistic and Roman Pottery*, ed. S. Herbert, 247–406. Journal of Roman Archaeology Supplementary Series 10. Ann Arbor, Mich., 1997.

Smith (C. H.) 1896
Smith, C. H. C*atalogue of the Greek and Etruscan Vases in the British Museum*. Vol. 3, *Vases of the Finest Period*. London, 1896.

Smith (J. S.) 1997
Smith, J. S. "Preliminary Comments on a Rural Cypro-Archaic Sanctuary in Polis-Peristeries." *BASOR* 308 (1997): 77–98.

Smith (J. S.) 2009
Smith, J. S. *Art and Society in Cyprus from the Bronze Age into the Iron Age*. Cambridge, 2009.

Smith (J. S.) 2012
Smith, J. S. "Tapestries in the Bronze and Early Iron Ages of the Ancient Near East." In *Textile Production and Consumption in the Ancient Near East: Archaeology, Epigraphy, Iconography*, ed. M.-L. Nosch and H. Koefoed, 159–86. Ancient Textile Series 12. Oxford, 2012.

Smith (M. S.) 2002
Smith, M. S. *The Early History of God: Yahweh and Other Deities in Ancient Israel*. Grand Rapids, Mich., 2002.

Smith (S.) 1924
Smith, S. "The Face of Humbaba." *University of Liverpool Annals of Archaeology and Anthropology* 11 (1924): 107–14.

Snodgrass 1985
Snodgrass, A. M. "Greek Archaeology and Greek History." *ClAnt* 4 (1985): 193–207.

Sophocleous 1985
Sophocleous, S. *Atlas des représentations chypro-archaïques des divinités.* SIMA. Pocket-Book 33. Göteborg, 1985.

Sotheby & Co. 1933
Sotheby & Co. *Catalogue of Antiquities, Native Art, etc.* London [December 12], 1933.

Sparkes and Talcott 1970
Sparkes, B. A., and L. Talcott. *The Athenian Agora: Results of Excavations Conducted by the American School of Classical Studies at Athens.* Vol. 12, *Black and Plain Pottery of the 6th, 5th, and 4th Centuries B.C.,* Princeton, 1970.

Stahl, Poirier, and Yao 2011
Stahl, A., G. Poirier, and N. Yao. "A Perplexing Hoard of Lusignan Coins from Polis, Cyprus." In *Proceedings of the XIV International Numismatic Congress, Glasgow 2009,* ed. N. Holmes, vol. 2, 1625–31. Glasgow, 2011.

Stampolidis 1990
Stampolidis, N. "A Funerary Cippus at Eleutherna: Evidence of Phoenician Presence?" *BICS* 37 (1990): 99–106.

Stanley-Price 2001
Stanley-Price, N. "The Ottoman Law on Antiquities (1874) and the Founding of the Cyprus Museum." In Tatton-Brown 2001a, 267–75. Oxford, 2001.

Stern 1994
Stern, E. M. "A Phoenician-Cypriote Votive Scapula from Tel Dor: A Maritime Scene." *IEJ* 44, nos. 1–2 (1994): 1–12.

Stern 1995
Stern, E. M. *Roman Mold-Blown Glass: The First through Sixth Centuries.* Rome, 1995.

Storrs 1945
Storrs, R. *Orientations.* London, 1945.

Stylianou and Stylianou 1997
Stylianou, A., and J. A. Stylianou. *The Painted Churches of Cyprus: Treasures of Byzantine Art.* Nicosia, 1997.

Svoronos 1904–8
Svoronos, J. N. Τὰ Νομίσματα τοῦ Κράτος τῶν Πτολεμαίων. 4 vols. Athens, 1904–8.

Swiny 1991
Swiny, S. "Foreword." In *Cyprus: Its Ancient Cities, Tombs, and Temples, A Narrative of Researches and Excavations during Ten Years' Residence as an American Consul in That Island,* by L. P. di Cesnola, 1–6. Nicosia, 1991 [reprint of Cesnola 1877].

Symons 1987
Symons, D. "Rupert Gunnis (1899–1965)." *CCEC* 7 (1987): 3–10.

Tatton-Brown 1985
Tatton-Brown, V. "Archaeology in Cyprus, 1960–1985: Classical to Roman Periods." In Karageorghis (V.) 1985, 60–72.

Tatton-Brown 1986
Tatton-Brown, V. "Gravestones of the Archaic and Classical Periods: Local Production and Foreign Influences." In Karageorghis (V.) 1986, 439–52.

Tatton-Brown 1989
Tatton-Brown, V., ed. *Cyprus and the East Mediterranean in the Iron Age: Proceedings of the Seventh British Museum Colloquium, April 1988.* London, 1989.

Tatton-Brown 2001a
Tatton-Brown, V., ed. *Cyprus in the 19th Century A.D.: Fact, Fancy, and Fiction.* Papers of the 22nd British Museum Classical Colloquium, December 1998. Oxford, 2001.

Tatton-Brown 2001b
Tatton-Brown, V. "Excavations in Ancient Cyprus: Original Manuscripts and Correspondence in the British Museum." In Tatton-Brown 2001a, 168–83.

Tempesta 1998
Tempesta, A. *Le Raffigurazioni mitologiche sulla ceramica greco-orientale arcaica.* Rome, 1998.

Thompson 1955
Thompson, D. B. "A Portrait of Arsinoe Philadelphos." *AJA* 59 (1955): 199–206.

Tinh 1985
Tinh, T. T. *Soloi: Dix campagnes de fouilles, 1964–1974.* Vol. 1, *La Basilique.* Sainte-Foy, 1985.

Tore 1992
Tore, G. "Cippi, altarini e stele funerarie nella Sardegna finicio-punica: alcune osservazioni preliminari ad una classificazione tipologica." In *Sardinia antiqua: Studi in onore di Piero Meloni in occasione del suo settantesimo compleanno,* ed. E. Atzeni, 177–94. Cagliari, 1992.

Törnkvist 1972
Törnkvist, S. "Arms, Armour and Dress of the Terracotta Sculpture from Ajia Irini, Cyprus." *MedMusB* 6 (1972): 7–55.

Toumazes et al. 2004
Toumazes, Y., A. Pace, M. R. Belgiorno, and S. Antoniadou. *Crusades: Myth and Realities.* Nicosia, 2004.

Ulbrich 2008
Ulbrich, A. *Kypris: Heiligtümer und Kulte weiblicher Gottheiten auf Zypern in der kyproarchaischen und kyproklassischen Epoche (Königszeit).* Alter Orient und Altes Testament 44. Münster, 2008.

Vandenabeele 1988
Vandenabeele, F. "Kourotrophoi in the Cypriote Terracotta Production." *RDAC,* 1988, pt. 2, 25–34.

Vandenabeele 1992
Vandenabeele, F. "Cypriot Jugs with Terracottas on the Shoulder Holding an *Oinochoe* or a Bull's Head." In *Acta Cypria: Acts of an International Congress on Cypriote Archaeology Held in Göteborg on 22–24 August 1991,* Part 2, ed. P. Åström, 371–85. SIMA and Literature. Pocket-Book 117. Jonsered, 1992.

Vandenabeele 1997
Vandenabeele, F. "The Pictorial Decoration on the Cypriote Jugs with Figurines Holding an Oinochoe." In *Four Thousand Years of Images on Cypriote Pottery, Proceedings of the Third International Conference of Cypriote Studies, Nicosia, 3–4 May 1996,* ed. V. Karageorghis, R. Laffineur, and F. Vandenabeele, 129–36. Brussels, Liège, and Nicosia, 1997.

Vandenabeele 1998
Vandenabeele, F. *Figurines on Cypriote Jugs Holding an Oinochoe.* SIMA 120. Jonsered, 1998.

Vandenabeele 2001
Vandenabeele, F. "Collecting Vases with Figurines/Protomes in the Nineteenth Century A.D." In Tatton-Brown 2001a, 184–86.

Vandenabeele and Laffineur 1991
Vandenabeele, F. and R. Laffineur, eds. *Cypriote Terracottas. Proceedings of the First International Conference of Cypriote Studies, Brussels-Liège-Amsterdam, 1989.* Brussels and Liège, 1991.

van Straten 1995
van Straten, F. T. *Hiera Kala: Images of Animal Sacrifice in Archaic and Classical Greece.* Religions in the Graeco-Roman World 127. Leiden, 1995.

Vermeule and Wolsky 1990
Vermeule, E. D. T., and F. Z. Wolsky. *Toumba tou Skourou: A Bronze Age Potters' Quarter on Morphou Bay in Cyprus.* Cambridge, Mass., 1990.

Vessberg and Westholm 1956
Vessberg, O., and A. Westholm. *The Swedish Cyprus Expedition*, vol. IV, pt. 3. *The Hellenistic and Roman Periods in Cyprus.* Stockholm, 1956.

Vickers 1970
Vickers, M. "A Note on a Rattling Attic Black Glaze Cup in Dublin." *JHS* 90 (1970): 199–201.

Villing 2005
Villing, A. "Persia and Greece." In Curtis and Tallis 2005, 236–43.

Von Falkenhausen 1999
Von Falkenhausen, V. "Bishops and Monks in the Hagiography of Byzantine Cyprus." In Ševčenko and Moss 1999, 21–33.

Waagé 1948
Waagé, F. O. "Hellenistic and Roman Tableware of North Syria." In *Antioch-on-the-Orontes*, vol. 4, pt. 1, *Ceramics and Islamic Coins*, ed. F. Waagé, 1–60. Princeton, 1948.

Walbank 1981
Walbank, F. W. *The Hellenistic World.* London, 1981 [reprint Cambridge, Mass., 1981].

Walters 1893
Walters, H. B. *Catalogue of the Greek and Etruscan Vases in the British Museum.* Vol. 2, *Black-Figured Vases.* London, 1893.

Walters 1926
Walters, H. B. *Catalogue of the Engraved Gems and Cameos, Greek, Etruscan, and Roman, in the British Museum.* London, 1926.

Walters 1929
Walters, H. B. *CVA: Great Britain*, 5: *British Museum*, fascicle 4. London, 1929.

Wamser and Zahlhaas 1998
Wamser, L., and G. Zahlhaas. *Rom und Byzanz. Archäologische Kostbarkeiten aus Bayern.* Munich, 1998.

Webb 1985
Webb, J. M. "The Incised Scapulae." In *Excavations at Kition V: The Pre-Phoenician Levels, Part II*, by V. Karageorghis, 317–28. Nicosia, 1985.

Webb 2001
Webb, J. M. *Cypriote Antiquities in the Nicholson Museum at the University of Sydney.* CCA 20. SIMA 20. Jonsered, 2001.

Westholm 1935
Westholm, A. "Amathus." In *SCE* II, 1–141.

Westholm 1937a
Westholm, A. "Mersinaki." In *SCE* III, 340–98.

Westholm 1937b
Westholm, A. "Vouni. The Necropolis at Korakas." In *SCE* III, 298–339.

Westholm 1937c
Westholm, A. "Vouni. The Temple of Athena." In *SCE* III, 85–111.

Westholm 2012
Westholm, A. *The Wonderful Years on Cyprus.* Trans. A. Wohl and I. Brylde. Nicosia, 2012 (forthcoming).

Whitehouse 2001
Whitehouse, D. *Roman Glass in the Corning Museum of Glass.* Vol. 2. Corning, N.Y., 2001.

Wikander 1986
Wikander, O. "Two Cypriote Pan-Tiles in Stockholm." *MedMusB* 21 (1986): 44–48.

Williams 1986
Williams, D. "In the Manner of the Gorgon Painter: The Deianeira Painter and Others." In *Enthousiasmos: Essays on Greek and Related Pottery Presented to J. M. Hemelrijk*, ed. H. A. G. Brijder, A. A. Drukker, and C. W. Neeft, 61–68. Allard Pierson Series 6. Amsterdam, 1986.

Williams 1992
Williams, D. "Euphronios's Contemporary Companions." In *Euphronios peintre*, ed. M. Denoyelle, 79–95. Paris, 1992.

Williams 2005
Williams, D. "From Phokaia to Persepolis: East Greek, Lydian and Achaemenid Jewellery." In *The Greeks in the East*, ed. A. Villing, 105–14. British Museum Research Publication 157. London, 2005.

Williams 2009
Williams, D. *Masterpieces of Classical Art.* London, 2009.

Williams and Ogden 1994
Williams, D., and J. Ogden. *Greek Gold: Jewellery of the Classical World.* London, 1994.

Wilson 1975
Wilson, V. "The Iconography of Bes with Particular Reference to the Cypriot Evidence." *Levant* 7 (1975): 77–103.

Winbladh 1994
Winbladh, M.-L. "The Cyprus Collections in the Medelhavsmuseet." In *The Swedish Cyprus Expedition: The Living Past*, ed. E. Rystedt, 19–44. Medelhavsmuseet Memoir 9. Stockholm, 1994.

Winbladh 1997
Winbladh, M.-L., ed. *An Archaeological Adventure in Cyprus: The Swedish Cyprus Expedition 1927–1931, A Story Told with Contemporary Photographs and Comments.* Stockholm, 1997.

Winbladh 2003
Winbladh, M.-L. "The Cyprus Collections in the Medelhavsmuseet." In Karageorghis (V.) 2003, 13–23.

Winter 2000
Winter, I. J. "The Eyes Have It: Votive Statuary, Gilgamesh's Axe, and Cathected Viewing in the Ancient Near East." In *Visuality before and beyond the Renaissance: Seeing as Others Saw*, ed. R. S. Nelson, 22–44. Cambridge, 2000.

Wright 1992
Wright, G. R. H. *Ancient Building in Cyprus.* Leiden, New York, and Cologne, 1992.

Xanthopoulou 2010
Xanthopoulou, M. *Les Lampes en bronze à l'époque paléochrétienne*. Bibliothèque de l'antiquité tardive 16. Turnhout, 2010.

Yon 1971
Yon, M. *Salamine de Chypre*, II: *La Tombe T. I. du XI^e s. av. J-.C.* Paris, 1971.

Yon 1974
Yon, M. *Salamine de Chypre*, V: *Un Dépôt de sculptures archaïques: Ayios Varnavas, Site A*. Paris, 1974.

Yon and Caubet 1988
Yon, M., and A. Caubet. "Un Culte populaire de la Grande Déesse à Lapithos." *RDAC*, 1988, pt. 2, 1–16.

Young and Young 1955
Young, J. H., and S. H. Young. *Terracotta Figurines from Kourion in Cyprus*. Philadelphia, 1955.

Zachariou-Kaila 2001
Zachariou-Kaila, E. "Eine Gruppe von Bronzekesseln aus Zypern." *RDAC*, 2001, 213–22.

Zachariou-Kaila and Winther-Jacobsen, forthcoming
Zachariou-Kaila, E., and Winther-Jacobsen, K. *Polis-Chrysochous–Ambeli tou Englezou: The Hellenistic–Roman Tomb P.M. 3339* (forthcoming).

Zapheiropoulou 2001
Zapheiropoulou, D. *Συλλογή Γεωργίου Τσολοζίδη: Το Βυζάντιο με τη ματιά ενός συλλέκτη*. Athens, 2001.

Zevit 2003
Zevit, Z. *The Religions of Ancient Israel: A Synthesis of Parallactic Approaches*. New York, 2003.

Zournatzi 2005
Zournatzi, A. *Persian Rule in Cyprus: Sources, Problems, Perspectives*. Meletemata 44. Athens and Paris, 2005.

Zukerman et al. 2007
Zukerman, A., L. Kolska-Horwitz, J. Lev-Tov, and A. M. Maier. "A Bone of Contention? Iron Age IIA Notched Scapulae from Tell eṣ-Ṣâfî/ Gath, Israel." *BASOR* 347 (2007): 57–81.

Index

Image Credits

Amanda Anderson, Angela Dai, Alice Fuller, Emma Lawless, and Nikitas Tampakis: Building Reconstruction 1 (created in Google SketchUp in COS/ART/HLS 495 in the spring of 2012 with revisions in June 2012).

Richard Arietta, Vladimir Costescu, Kynan Rilee, Rafael Romero, Nikitas Tampakis, and Robert Timpe: Building Reconstruction 3 (created in Google SketchUp in COS/ART/HLS 495 in the spring of 2012 with revisions in June 2012).

Brenda Baker: fig. 5.15.

Logan Bellew: frontispiece (photos); figs. 3.4, 3.15, 4.8, 4.13, 5.9; cat. nos. 71 (fist), 84 (photo), 110 (detail).

© The British Museum / British Museum Images: cat. nos. 1, 9, 10, 13, 21, 31, 40, 42, 43, 45, 46, 48, 49, 53, 91; courtesy of the Department of Greece and Rome: fig. 1.4; cat. no. 46 (detail).

Elisabeth Childs: figs. 2.1, 3.2, 3.3; cat. nos. 6 (inset), 39 (page 138).

William A. P. Childs: figs. 2.6, 4.11.

Courtesy of the Department of Antiquities, Cyprus: figs. 1.5, 1.6, 1.12 (after Nicolaou 1964, 135, fig. 2), 1.14, 5.1; cat. nos. 3–6, 8, 11, 12, 14–20, 22–30, 32–38, 39 (pages 89, 139), 41, 44, 47, 50–52, 54–83, 85–90, 92–110.

Courtesy of the Department of Lands and Surveys, Cyprus: map 3 (2008 orthophotomap).

Esri: maps 1, 2 (Bing Maps aerials).

Jeffrey Evans: frontispiece (digital compilation); cat. nos. 9 (impression), 54 (impression).

Mary Gough: fig. 5.5 (drawing, from Bouras and Parani 2008, fig. 4).

Dolan Halbrook: fig. 4.1 (with permission).

Louis Joutel: fig. 1.3 (left, from "New Discoveries at Cyprus," *Harper's Weekly* XXXI no. 1589, 4 June 1887, p. 408).

Isabel Kasdin, Horia Radoi, Prerna Ramachandra, Eleanor Taranto, Nikitas Tampakis, and Mary Thierry: Building Reconstruction 4 (created in Google SketchUp in COS/ART/HLS 495 in the spring of 2012 with revisions in June 2012).

David L. Kornblatt: fig. 3.5 (photographs); cat. no. 27 (detail).

Yingxue Li, Elliot Lopez-Finn, Carmina Mancenon, Ian McLaughlin, Tobechukwu Nwanna, Aislinn Smalling, and Nikitas Tampakis: Building Reconstruction 2 (created in Google SketchUp in COS/ART/HLS 495 in the spring of 2012 with revisions in June 2012).

Elliot Lopez-Finn: fig. 3.5 (drawings).

Musée du Louvre: Réunion des Musées Nationaux / Art Resource, NY / photo: René-Gabriel Ojeda: cat. nos. 2, 7.

Courtesy of the Medelhavsmuseet, Stockholm: figs. 1.1, 1.2, 1.7–1.10, 1.11 (after Gjerstad 1935b, 293, 360, figs. 117.1 [combined with 117.4], 117.2, and 154.1–2), 2.5 (Gjerstad 1935b, fig. 134.1–3), 4.2.

Miko McGinty and Claire Bidwell: maps 1–3 (design).

Tina Najbjerg: fig. 4.15 (drawing, modified from Bekker-Nielsen 2004, fig. 14); cat. no. 84 (drawing).

Max Ohnefalsch-Richter: figs. 1.0 (Ohnefalsch-Richter 1893, pl. CCXVIII, which was adapted from Munro and Tubbs 1890, pl. III), fig. 1.3 (right, Ohnefalsch-Richter 1893: pl. CLXXIV.2).

Brandon Olson: fig. 4.10.

Amy Papalexandrou: fig. 5.5 (photo).

Courtesy of the Princeton Cyprus Expedition: figs. 1.15, 2.0, 2.2–2.4, 2.7–2.15, 3.0, 3.1, 3.6–3.14, 4.0, 4.4–4.7, 4.9, 4.12, 4.14, 5.0, 5.3, 5.4, 5.6–5.8, 5.10–5.14; cat. no. 74 (detail); plans 1–8.

Courtesy of Eustathios Raptou: figs. 1.13, 4.3.

Joanna S. Smith: cat. no. 79 (drawing).

Krista Ziemba and Elise Chassé: fig. 5.2.

Contributors

Anastassios C. Antonaras (AA) is an archaeologist and museologist in the Museum of Byzantine Culture at the Hellenic Ministry of Culture and Tourism (aantonaras@culture.gr).

William Caraher (WC) is an associate professor in the Department of History at the University of North Dakota; he began working with the Princeton Cyprus Expedition in 2010 (william.caraher@und.edu).

William A. P. Childs (WAPC) is an emeritus professor in the Department of Art and Archaeology at Princeton University; he began the Princeton Cyprus Expedition in 1983 and is director of the project (wchilds@princeton.edu).

Olga Karagiorgou (OK) is a senior researcher in the Research Centre for Byzantine and Post-Byzantine Art at the Academy of Athens; she began working with the Princeton Cyprus Expedition in 2008 (karagiorgou@academyofathens.gr).

Thomas Kiely (TK) is the Curator of Ancient Cyprus in the Department of Greece and Rome at the British Museum (tkiely@thebritishmuseum.ac.uk).

Kyle L. Killian (KLK) is an adjunct professor in the Departments of Anthropology, History, and Social Sciences at California State University at Chico; he began working with the Princeton Cyprus Expedition in 2010 (kkillian@csuchico.edu).

Sarah Lepinski (SL) is a post-doctoral fellow in the Scholars Program at the Getty Research Institute; she began working with the Princeton Cyprus Expedition in 2010 (sarah.lepinski@gmail.com).

R. Scott Moore (RSM) is a professor in the Department of History at the Indiana University of Pennsylvania; he began working with the Princeton Cyprus Expedition in 2009 (rsmoore@iup.edu).

Tina Najbjerg (TN) is an independent scholar living in Redwood City, California; she began working with the Princeton Cyprus Expedition in 1990 and is now the head of research and publication for Hellenistic and Roman Arsinoe (najbjerg@alumni.princeton.edu).

Brandon R. Olson (BRO) is a Ph.D. candidate in the Department of Archaeology at Boston University; he began working with the Princeton Cyprus Expedition in 2010 (brando@bu.edu).

J. Michael Padgett (JMP) is the Curator of Ancient Art at the Princeton University Art Museum; he began working with the Princeton Cyprus Expedition in 1996 (mpadgett@princeton.edu).

Amy Papalexandrou (AP) is an independent scholar and an adjunct lecturer in the Department of Art and Art History at the University of Texas at Austin; she began working with the Princeton Cyprus Expedition in 1988 and is now the head of research and publication for Late Antique through medieval Arsinoe (apapalex@yahoo.com).

Nassos Papalexandrou (NP) is an associate professor in the Department of Art and Art History at the University of Texas at Austin; he began working with the Princeton Cyprus Expedition in 1990 (papalex@austin.utexas.edu).

Maria G. Parani (MGP) is an assistant professor of Byzantine art and archaeology in the Department of History and Archaeology at the University of Cyprus; she began working with the Princeton Cyprus Expedition in 2003 (mparani@ucy.ac.cy).

Eustathios Raptou (ER) is an archaeological officer of the Department of Antiquities, Cyprus, at the Paphos District Museum (mouseiopafou@cytanet.com.cy).

Nancy Serwint (NS) is an associate professor of art in the Herberger Institute for Design and the Arts at Arizona State University; she began working with the Princeton Cyprus Expedition in 1983 and is assistant director of the project (nancy.serwint@asu.edu).

Joanna S. Smith (JSS) is an associate professional specialist in the Department of Art and Archaeology and a lecturer in the Departments of Art and Archaeology and Computer Science at Princeton University; she began working with the Princeton Cyprus Expedition in 1988 and is assistant director of the project (joannas@princeton.edu).

Alan M. Stahl (AMS) is the Curator of Numismatics in the Department of Rare Books and Special Collections of Firestone Library and is a lecturer in the Departments of Art and Archaeology, Classics, and History at Princeton University; he began working with the Princeton Cyprus Expedition in 2006 (astahl@princeton.edu).

Mary Grace Weir (MGW) is a Ph.D. candidate in the Department of Art and Archaeology at Princeton University; she began working with the Princeton Cyprus Expedition in 1995 (MaryGWeir@aol.com).

Kristina Winther-Jacobsen (KWJ) is an associate professor of classical archaeology in the SAXO-Institute at the University of Copenhagen (kwjacobsen@hum.ku.dk).

Eftychia Zachariou-Kaila (EZK) is a senior archaeological officer of the Department of Antiquities, Cyprus, at the Cyprus Museum, Nicosia (ef.zach@cytanet.com.cy).